ILLUSTRATED CATALOGUE
OF THE
INTERNATIONAL EXHIBITION
1862

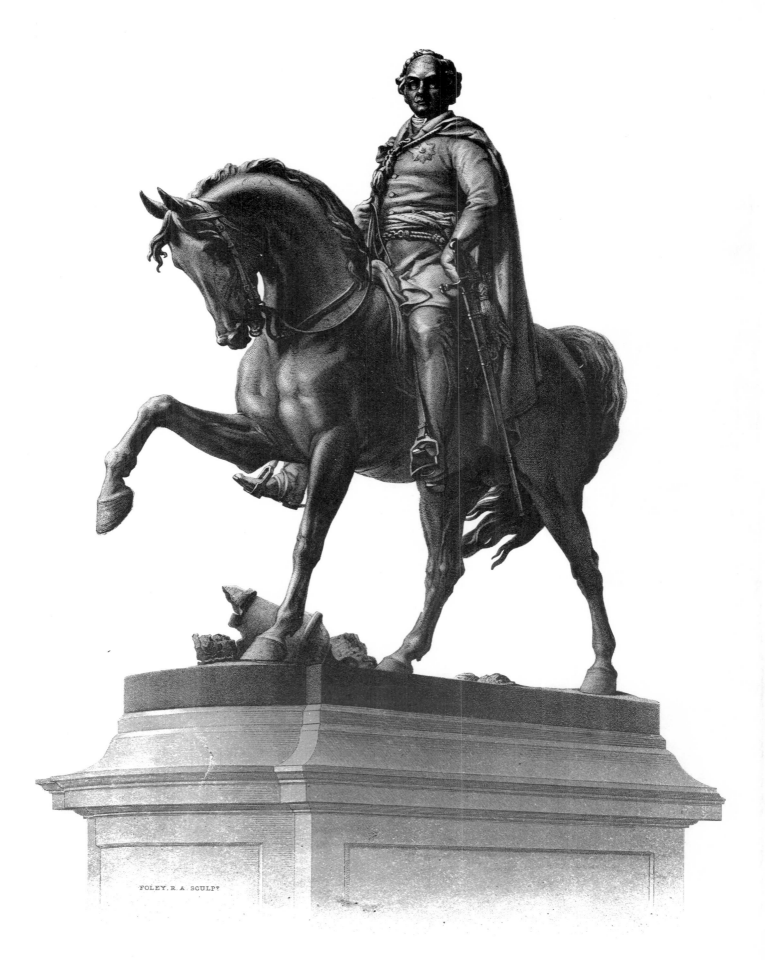

FOLEY. R. A. SCULP?

HARDINGE

ENGRAVED BY R. A. ARTLETT, FROM A DRAWING BY F. ROFFE.

THE ART JOURNAL

ILLUSTRATED

CATALOGUE

OF THE INTERNATIONAL

EXHIBITION

1862

T.W.Reeve.del.

EP PUBLISHING LIMITED 1973

Copyright © 1973 EP Publishing Limited
East Ardsley, Wakefield
Yorkshire, England

originally published by James S. Virtue, London, 1863

ISBN 0 85409 894 1

Please address all enquiries to EP Publishing Ltd
(address as above)

Printed in Great Britain by The Scolar Press Limited, Menston, Yorkshire

ADVERTISEMENT.

———◆———

"The Art-Journal Illustrated Catalogue of the International Exhibition," is submitted to Subscribers and the Public in full confidence that the Editor has redeemed his pledge to render it " a Report of Progress, a Volume of Suggestions, a Teacher from the lessons of many Master minds, and an enduring Reward to those who labour for renown as well as for the ordinary recompense that is expected to accompany desert."

The work was undertaken, and has been carried through, not only without cost to any Manufacturer whose productions are engraved, but without augmenting the price of the Journal, although a considerable addition has been made to its pages during the months of the years 1862 and 1863.

We were justified in expecting a large amount of public support, and we have not been disappointed. This Illustrated Catalogue has found its way into every country of the Globe, and into the workshops of nearly all the leading Manufacturers of the World, where it will act as a teacher of the valuable lessons that are taught by Comparison.

Our purpose was to represent, as far as possible, every producer, British or Foreign, whose works were either honourable to himself or suggestive to others. It is needless to state that, although nearly 1,500 of such works—the productions of more than 350 Manufacturers—are engraved in this Volume, the list by no means includes all that were entitled to the distinction. The Public will not require assurance that we have done all we had the power to do, or that, in thus giving permanent value to a collection of the Manufactured Art of All Nations, we have discharged our duty, liberally and equitably, to the Exhibitors.

No apology will, therefore, be required for extending this Catalogue greatly beyond the limits originally proposed for it. It appeared an absolute necessity to represent the Exhibition to an extent somewhat commensurate with the wealth of Art-Manufacture it contained.

This Illustrated Report will be received as the only Record of the Exhibition of 1862, by which its lessons may be circulated and perpetuated; for the " Official Illustrated Catalogue "—although produced by levying a large tax on the Manufacturer, and with all the advantages that could be given to it by patronage, amounting to pressure, on the part of the Royal Commissioners—can be regarded only as a failure, prejudicial and not beneficial to the Exhibition of the Productions of All Nations in the year 1862.

ADVERTISEMENT.

Fortunately, we were steadily aided by the Artists to whom the task of producing the engravings was chiefly confided, whose neglect would have been fatal to our scheme, and to whose zealous co-operation we are mainly indebted for its success. To the artist, Mr. W. J. Allen, by whom a very large proportion of the drawings on wood were executed, our thanks are especially due, and also to the engravers, Messrs. Nicholls Brothers, and Messrs. Butterworth and Heath, upon whom the responsibility of their execution principally devolved. We owe much also to the aid we derived from the London Stereoscopic Company, and to Mr. Poulton, Photographer, of the Strand, for his able and constant services. Indeed, but for the assistance afforded us by the Art of Photography, it would have been difficult, if not impossible, for us to have so effectually completed our task.

The Work has received all the advantages it could obtain from the art of the Printer; and it will be obvious that the efforts of the Proprietor have been directed to its production, without regard to the expenditure necessary to achieve excellence in all its departments.

The anxiety and labour incident to the production of this Volume few can understand, and none over-estimate. The results are now placed before the Public. If the toil has been severe, those by whom the task was undertaken may, it is hoped, enjoy the satisfaction that arises from a duty discharged and a purpose thoroughly accomplished.

LONDON: OFFICE OF THE ART-JOURNAL,
13, *Burleigh Street, Strand.*

THE TABLE OF CONTENTS

TABLE OF CONTENTS.

EXHIBITORS OF WORKS ENGRAVED.

TABLE OF CONTENTS.

TABLE OF CONTENTS.

WORKS IN SCULPTURE.

WORKS IN SCULPTURE—ENGRAVED ON STEEL.

IN 1862, the second Great Exhibition of the Art-works of all nations was held in London. As early as the 14th of March, 1860, her Majesty the Queen was graciously pleased to issue a Charter of Incorporation to Royal Commissioners, defining their duties, and investing them with full powers. The Commission, under the presidency of the Prince Consort, consisted of the Earl Granville, K.G., Lord President of the Council; the Duke of Buckingham and Chandos; C. Wentworth Dilke, Esq. (afterwards created a baronet); Thomas Baring, Esq., M.P.; and Thomas Fairbairn, Esq.; with F. R. Sandford, Esq. (subsequently knighted), as Secretary.

The proposal to test by anticipation the popularity of the project, by forming a Guarantee Fund of £250,000, was successful beyond expectation. By the 15th of March, 1860, the formal Guarantee Deed was duly executed to the stipulated extent; but eventually it was signed by 1,157 persons, to the amount of £451,000. Upon the security of this deed the Bank of England advanced the sum of £250,000, for the purpose of erecting the building and of making the necessary preparations for the Exhibition itself.

It was determined that the Building should be erected on a site adjoining the gardens of the Royal Horticultural Society, and in the immediate neighbourhood of the South Kensington Museum, within a short distance also of the ground occupied in 1851 on the occasion of the first International Exhibition. It was further resolved that pictures and drawings, the works of both foreign and British artists, should be associated with the productions of Industry, and that they should be exhibited in a portion of the building to be erected in brick specially for the purpose of forming picture-galleries. The Commissioners undertook to communicate with all colonial and foreign exhibitors, and to form and conduct all the arrangements necessary for rendering the Exhibition, in the largest and most comprehensive sense, "International."

On Thursday, May the 1st, in accordance with their original intention, the Commissioners opened the Exhibition with a State ceremonial, on which occasion H.R.H. the Duke of Cambridge, who was supported by the highest dignitaries of the land, and by the Crown Prince of Prussia and Prince Oscar of Sweden, represented Her Majesty the Queen. The day was auspicious, and the ceremonial, though deeply impressed with painful associations, passed off in a satisfactory manner. A second ceremonial took place on Friday., July 11th, when the declaration of the prizes was formally made. The Exhibition was finally closed on Saturday, November the 15th.

The site for the building having been arranged with the Commissioners for the 1851 Exhibition, the Commissioners at once proceeded to grapple with what they have themselves designated their "main difficulty—that of securing the erection of a suitable building, which should be ready at a sufficiently early date in the year 1862 for the reception of the objects to be exhibited." Having decided not to apply to an open competition for a design—"while we were con-

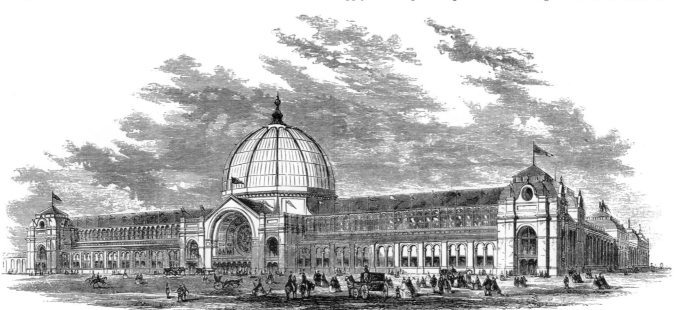

Drawn by T. R. Macquoid.] EXTERIOR: VIEW FROM PRINCE ALBERT ROAD. [Engraved by J. & G. Nicholls.

sidering," say they in their official Report, "how far it would be possible to obtain designs from a select list of competitors, it was reported to us that there was already in existence a plan of a building, adapted for a Great Exhibition of Works of Art and Industry, which had been prepared with special reference to the particular site that had been granted for the Exhibition of 1862. We were informed," the Report continues, with exquisite *naiveté*, "that the author of this plan, Captain Fowke, R.E., an officer

of skill and experience in the art of construction, who had been employed by Her Majesty's Government in the British Department of the Paris Exhibition of 1855, had framed it so as to meet the many practical defects which experience had shown to exist in the buildings both in Hyde Park and the Champs Elysées." Forthwith the plan of this fortunate Engineer officer was brought before the Commissioners, and, " after some alterations," having been " approved" by the Building Committee, it was formally " accepted," and it was determined at once to carry it into effect with all possible speed. The joint tender of Messrs. Kelk and Lucas Brothers, was accepted on 23rd February, 1861.*

The total number of visitors of all classes who, from first to last, entered the Exhibition, appears from the returns to have been 6,211,103. The average number of visitors present on each day was 36,328; and the greatest number present on any one day (that day was Thursday, the 30th of October) was 67,891. The average number on the four weekly shilling days were, on the Mondays, 44,307 persons; on the Tuesdays, 45,936; on the Wednesdays, 43,988; and on the Thursdays, 44,806; while on the Fridays and Saturdays, when the rate of admission was 2s. 6d., or upwards, the average numbers were severally 22,138, and 19,594. These numbers include the officials, the exhibitors, and all persons who were in any way employed in, or connected with, the Exhibition.

Included amongst the visitors, properly so called, are the children and students of 713 schools, amounting to 35,570 persons. Of these, the female students of the Schools of Design, 800 in number, were admitted on 2s. 6d. days by tickets presented to them by the Queen.

The admissions were—by season tickets, of which there were two classes, severally charged £3 3s. and £5 5s., the latter including, with admission to the Exhibition, admission also to the adjoining gardens of the Royal Horticultural Society; or by payment at the doors as follows:—2nd and 3rd of May, £1 for each person; from 5th to 17th of May, 5s.; from 19th to 31st of May, 2s. 6d., except on one day in each week, when the charge was 5s.; and after the 31st of May the price of admission was 1s. on four days in each week, and on the other two days either 5s. or 2s. 6d.

The ground covered by the main building is about 16 acres in extent, and it measures about 1,200 feet from east to west, and 560 feet from north to south. The annexes covered a further space of about 7 acres. The total area roofed in was 988,000 square feet, or 60,000,000 cubic feet. In 1851 the Exhibition Building covered 799,000 square feet; and the Exhibition Building at Paris in 1855 covered 953,000 square feet. In 1862, in London, there was a

further uncovered space, used for purposes of the Exhibition, of 35,000 square feet; but at Paris the more favourable nature of the climate enabled the authorities to occupy the larger uncovered space of 547,000 feet. Thus the total areas, covered and uncovered, occupied by the two exhibitions, of Paris in 1855, and London in 1862, occupied severally 1,500,000, and 1,023,000 square feet.

The total area of the 1862 Exhibition Building, including the space obtained from the galleries, was 1,291,827 square feet. Of this space 147,000 feet were taken up by offices, refreshment-rooms, entrances, staircases, &c., leaving 1,144,827 feet available for exhibiting purposes. Eventually, there were 26,336 exhibitors in the 36 classes of the Industrial Department of the Exhibition; of these, 8,485 were natives of the United Kingdom and the British colonies and dependencies, and 17,851 were Foreigners. The French exhibitors were 4,030 in number. The horizontal space occupied by the British and Colonial exhibitors in these Classes was 229,759 square feet, with 146,229 vertical feet; and the horizontal space occupied by the foreign exhibitors was 159,977 square feet, their vertical space being 138,341 feet; and the space occupied by passages was, in the British and Colonial Department, 406,576 square feet; and in the Foreign Department, 215,495 feet.

The British packages amounted to 38,123; the articles not packed were 12,994 in number; and the foreign packages were 28,779; total, 79,896. Also pieces of fittings and cases, consisting of wood, iron, and glass: English, 41,635, and Foreign, 4,113; total, 45,748. In 1851 the British packages were 16,305; the articles not packed were 3,757; and the Foreign and Colonial packages were 12,550; total, 32,612. The heaviest piece of machinery received in 1851 weighed 9 tons: in 1862, one piece weighed 35 tons, and many weighed from 12 to 20 tons each.

The Industrial Department comprehended the following 36 Classes:—1. Mineral Products; 2. Chemical Products; 3. Substances used for Food; 4. Animal and Vegetable Products; 5. Railway Plant; 6. Carriages; 7. Manufacturing Machines and Tools; 8. Machinery in General; 9. Agricultural and Horticultural Implements; 10. Civil Engineering; 11. Military Engineering; 12. Naval Architecture; 13. Philosophical Instruments; 14. Photographic Apparatus and Photography; 15. Horological Instruments; 16. Musical Instruments; 17. Surgical Instruments and Appliances; 18. Cotton; 19. Flax and Hemp; 20. Silk and Velvet; 21. Woollen, Worsted, and Mixed Fabrics; 22. Carpets; 23. Printed or Dyed Fabrics; 24. Tapestry, Lace, and Embroidery; 25. Skins, Furs, Feathers, and Hair; 26. Heather; 27. Clothing; 28. Stationery, Printing, and Bookbinding; 29. Educational Works and Appliances;

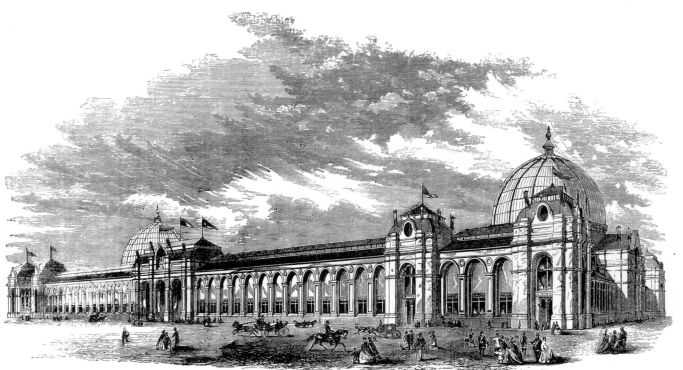

Drawn by T. R. Macquoid.]　　　　EXTERIOR: VIEW FROM THE CROMWELL ROAD.　　　　[Engraved by J. & G. Nicholls.

30. Furniture; 31. Hardware; 32. Cutlery; 33. Jewellery and Precious Stones; 34. Glass; 35. Pottery; 36. Miscellaneous.

The Fine Art Department comprised 4 Classes, severally assigned

* We have given one view of the interior of the building, showing the Nave, and two views of the exterior, which show the principal front and one of the ends.

to Architecture, Painting, Sculpture, and Engraving. In Architecture 633 works were exhibited, and 197 artists were represented from the United Kingdom and the Colonies; from Foreign Countries, 350 works, and 107 artists. In Painting there were 1,874 British works, the productions of 545 artists, and the Foreign works were 1,496,

produced by 777 artists. The works of Sculpture were 321 British, by 96 artists, and 580 Foreign, by 256 artists. The engravings were 823 British, by 152 artists, and 452 Foreign, by 175 artists. Total, 6,529 works, by 2,305 artists. The horizontal space occupied was 10,186 square feet, and the vertical space was 83,096 square feet.

The number of persons employed as Jurors, who were engaged incessantly for two months in examining and deciding on the merits of the objects exhibited, was upwards of 600; and the Juries awarded nearly 7,000 medals, and about 5,300 honourable mentions.*

In the erection of the 1862 Exhibition Building the principal materials used were—Bricks, 17,250,000; Lime, 5,611 cubic yards; Sand, 18,352 cubic yards; Ballast, 8,632 cubic yards; Cement and Plaster, 47,105 bushels; Cast Iron, 4,953 tons; Wrought Iron, 2,269 tons; Timber, 439,178 cubic feet, and 2,238,722 lineal feet in battens and planks; Stone, 6,877 cubic feet, also 62,831 superficial feet, 6 inches thick and less; Zinc, 225,864 superficial feet; Lead, 74½ tons; Felt, 623,000 superficial feet; Slating, 71,260 superficial feet; Glass, 667,542 superficial feet, forming 216,808 panes; Putty,

95½ tons; Nails, 133½ tons; and £138,348 was paid for labour. The iron columns used measured upwards of 82,025 feet; and if the 1,266 girders were placed end to end, they would reach a distance of 6 miles. About 30,000 mechanics and 50,000 labourers were employed in the building at various times, in addition to the workmen employed elsewhere in the preparation of the materials. The Picture Galleries afforded altogether 2,428 linear feet of wall space, in halls 50 feet wide, 43 feet high, lighted from above; and the Auxiliary Galleries 25 feet wide, 17 feet high, and also top-lighted, furnished 2,356 additional linear feet.

The admissions by payment at the door, with the day tickets, produced £328,858; the season tickets added £79,602. Of these tickets 5,773 were sold at £5 5s., 17,719 at £3 3s., 26 at £2 10s., 919 at £1 10s. and 3,363 at 10s.: total, 27,800 season tickets. The gross amount was £89,248, of which £8,672 was paid to the Royal Horticultural Society, and a further sum of £903 was allowed as commission to agents; the refreshment contracts produced £29,285; the official catalogues added £3,919; the licences to photograph, £1,925; the

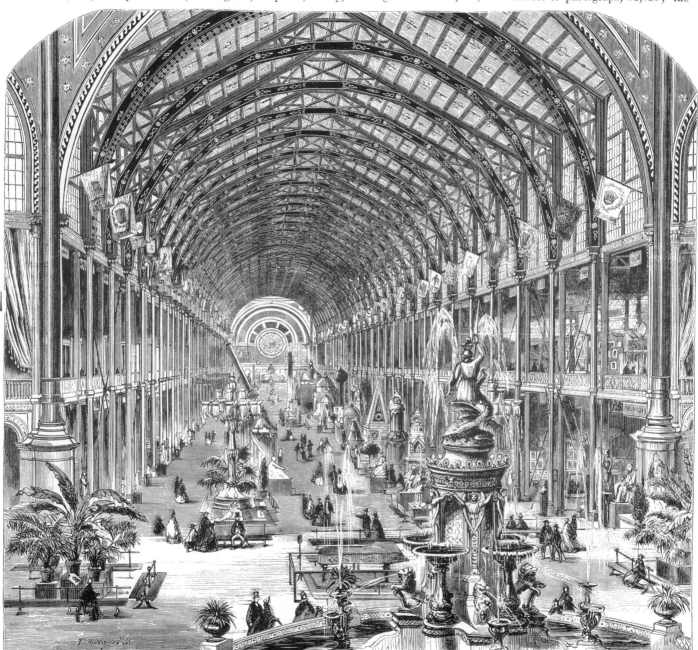

Drawn by T. R. Macquoid.] INTERIOR: THE NAVE, LOOKING WEST. *[Engraved by J. & G. Nicholls.*

umbrella stalls, £2,118; the retiring rooms, £1,000; the commission on the sale of photographs and medals in the building, £1,241; and the remaining £612 was obtained from various minor sources of

income. The entire amount received by the Royal Commissioners was £459,631. This sum includes £11,000, the contribution from the contractor, Mr. Kelk; or, in other words, it includes the sum of £11,000 not claimed by that gentleman, in accordance with the terms of an agreement, dated September 16, 1862, by which

* The medal itself we have engraved on the following page; it was designed and executed by the eminent artist, Leonard Wyon, and it merits very high commendation.

THE INTERNATIONAL EXHIBITION.

agreement also the whole of the property of the Commissioners was made over to the contractors.

The expenditure of the Commissioners may be said, in round numbers, to be also represented by precisely the same sum as their receipts, viz., £459,631: the Great Exhibition of 1862, that is to say, *cost almost exactly what it produced.* No demand had to be made on the Guarantee Fund, on the one hand; and, on the other hand, the Exhibition left the Commissioners without the building, or any part of the building, in which it had been held, without any other property arising from it, and also without any cash balance. Hence the result of the financial statement of the Commissioners is the simplest of simple equations—no loss, no gain, an Exhibition self-supporting, neither less nor more.

As a matter of course, in addition to their becoming the proprietors of the entire building, with the "whole of the property of the Commissioners," the contractors, Messrs. Kelk and Lucas Brothers, have received the lion's share of the outlay. The cash payments made to these gentlemen amount to £320,678.

The buildings also cost £3,600 for "design and professional superintendence," and £4,722 for "drawings, plans, models, &c." The exact amount paid for the design of Captain Fowke, so opportunely discovered by the Commissioners, is not specified in their Report.

The other items of expenditure as set forth in the Report are as follows:—Roads and approaches, £13,358; salaries and wages, £45,778; police, £19,435; insurance and fire brigade, £4,087; general expenses for maintenance, fuel, water supply, &c., £5,550; advertisements, £2,466; printing and stationery, £4,407; carriage of pictures, &c., £4,201; postage, £790; office furniture, £1,458; incidental expenses, £1,645; and medals, £6,409. We reserve, to form a small group by themselves, three other items: "preliminary expenses and law charges," £3,668; "computation of space and general arrangements," £3,675; and "ceremonials" (May 1 and June 11), £4,136. The sum of £7,330 paid as interest for the temporary loan from the Bank of England, with a few minor charges, make up the disbursements of the Royal Commissioners. An outlay of £13,350 was necessary in order to render this costly edifice approachable; and the cost of working the Exhibition amounted to £106,000!

Thus, while the Great Exhibition of 1851, an entirely novel and unprecedented enterprise, left a noble sum of money clear gain, the Exhibition of 1862, with all the advantages of precedent and experience, left no balance whatever; and this remarkable and very important difference is found to have resulted solely and entirely from the vast increase of the expenditure in 1862 above that of 1851. And this increase, which is mainly chargeable upon the Exhibition Building, in return obtained only the national disgrace of the wretched "shed" that was the Fowke version of the Paxton Crystal Palace.

Even in 1851 only a vague general statement of receipts and expenditure was published in the official Report of the Royal Commissioners; but now this rather important matter is disposed of in a *single page*, bearing the characteristic title of a "financial analysis." No explanation is vouchsafed with reference to any single item, nor are any details whatever inserted. The three words "Salaries and Wages" are held by the Commissioners to be fully equivalent to

the moderate sum of £45,778 0s. 3d. expended on their own officials and *employés!* Again, while we record our own high sense of the eminent services of the police force employed last year in connection with the Great Exhibition, we should have been glad to have been enabled to explain to our readers the rather startling fact that in the "Report" this single word "Police" is followed by such a sum as £19,435 19s. 11d. In like manner it would have been satisfactory to have understood the real signification of several other items that appear in this "analysis." And so also it is not by any means pleasing to have been left by the Commissioners to discover that the Exhibition Building, even when shorn of its "leading original feature," cost for materials alone upwards of £180,000, *together with the building itself;* while, at the end of a statement of quantities of building materials, a single line accidentally discloses the additional expenditure for labour to have been nearly £140,000. But still worse is the manner in which the "financial analysis" of this Report deals with the "Official Catalogues." An "Industrial Catalogue" and a "Fine Arts Catalogue," each sold for one shilling, are stated in the body of the Report, at page 55, to have been produced "wholly at the cost" of the Commissioners; and 250,000 copies of each are further said to have been issued. Under the head of "receipts," the sum of £3,919 1s. 10d. is entered from the sale of these "Official Catalogues," but no account is rendered either of the expense of producing them, or of the manner in which half a million shilling books were disposed of, so that they should only realise a sum less in amount than £4,000. The official "Illustrated Catalogue" does not appear in the "financial analysis" at all.

The excellence of all the arrangements, the ability, zeal, and assiduity of all the officials, the complete satisfaction of everybody with everybody and with everything, and the cordial thanks of the Commissioners most graciously rendered as eminently merited, are all carefully recorded in the Report; nor is the co-operation of Mr. Henry Cole, and a few other distinguished individuals not actually in office, without becoming acknowledgment. Thus, liberal in its use of rose-colour, this official document is consistent throughout, treating its various topics *more suo,* and dealing with the Great Exhibition of 1862, and with all that appertained to it, after the sublime and privileged fashion of Commissioners. Other less dignified records have set forth the intense dissatisfaction that prevailed on every side—the heart-burnings, the annoyances, and the blunderings, that characterised the official administration throughout. That the Exhibition was a success was the result of its own meritorious elements —a result achieved triumphantly, notwithstanding an astounding combination of administrative incapacity and official perverseness. The greatness of the loss experienced by the nation in the early death of the Prince Consort could have no more impressive illustration, than the contrast between the administration of the Exhibition of 1851, under his presidency, and that of 1862, after he had been called away. As his truly princely presence was grievously missed on the occasion of the opening ceremonial of last year, so was the want of his clear perception and calm judgment and admirable tact most painfully felt in even the minor details of the practical working of the entire Exhibition.

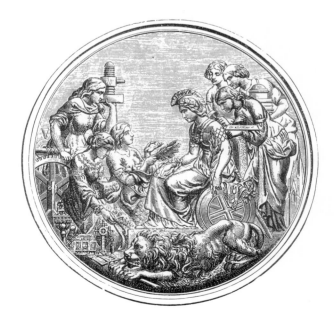

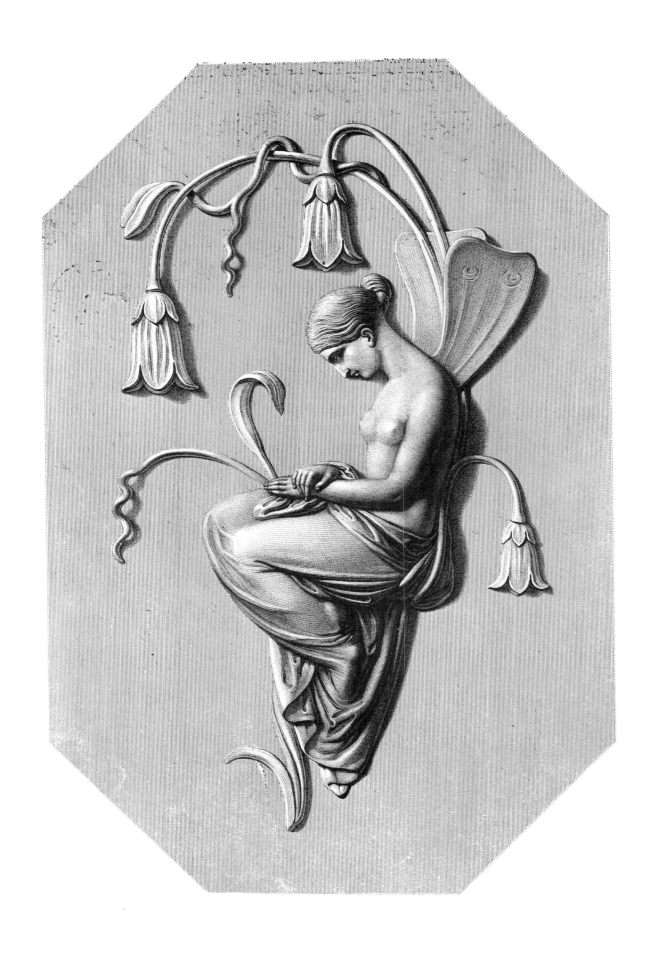

BLUE-BELL.

ENGRAVED BY W. ROFFE, FROM THE BASSO-RELIEVO BY R. WESTMACOTT, R.A.

IN THE COLLECTION OF THE RIGHT HON^{BLE} THE EARL OF ELLESMERE.

THE ART JOURNAL

ILLUSTRATED — CATALOGUE — INTERNATIONAL

WE commence the ART-JOURNAL CATALOGUE of the INTERNATIONAL EXHIBITION with selec-

Mortimer." The first object on this page is an elaborately chased CLARET JUG, in oxydised silver.

is of plain silver, a half oval, mounted upon three crossed rifles, neatly and correctly modelled. It

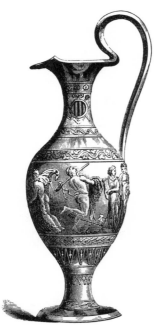

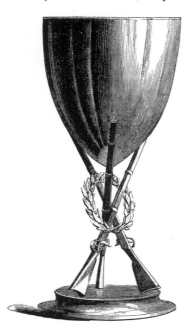

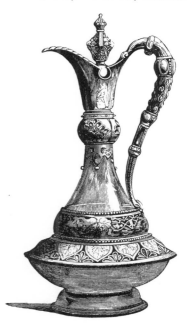

tions from the contributions of the renowned house of HUNT and ROSKELL, famous during the early part of this century as that of "Storr and

On the right is another CLARET JUG, designed by H. H. ARMSTEAD, an artist whose works are justly high in public estimation. The centre CUP

is designed as a prize for shooting matches, and rifle regiments; and its simplicity and thorough fitness will largely recommend it for that purpose.

THE INTERNATIONAL EXHIBITION, 1862.

THIS EXHIBITION marks another epoch in our national history. That of 1851 was heralded with high hopes, and its successful consummation was overlaid with the flowery rhetoric of prophecy. Through its potent spell the triumphs of war were to be dimmed by nobler victories, and that jubilee of the Nations was to be the dawn of more abundant glories, mingled with perpetual Peace. These visions were gorgeous as "apples of gold in pictures of silver;" but, alas for the prophets! their aspirations and predictions went up as the crackling of thorns; and, instead of ushering in the reign of universal love, the Nations marched from that temple of Concord to the shrine of Janus. Disappointment blunts enthusiasm,

and many who hailed the previous Exhibition are disposed to doubt the prospects and purposes of its successor. The potsherds of failure may strive with the prophets of success; our effort shall be to point out the benefits which the Exhibition, rightly used, is calculated to confer upon the industrial Art of England and of the World. The Sections shall be gone over in detail, and the results gathered up into a generalised focus, so that, by applying the great fixed principles of Art to these results, readers may be able to determine how far the present Exhibition will help forward, or in what way its misdirection may retard the upward progress of, industrial civilisation. What a fulcrum is to a lever, a fixed starting point is to a standard for estimating results. The former Exhibition did not inaugurate the reign of universal peace, but it did a great work notwithstanding; and to comprehend what that work was is essential to an intelligent appreciation of the Exhibition now before us.

On this page we engrave. first, a VASE, designed by Mr. FRANK HUNT—an *élève*, as well as a son, of one of the firm—for Goodwood Races, 1857. It

ready become celebrated—the PAKINGTON SHIELD —richly chased and embossed—presented to the Right Hon. Sir John Pakington, Bart., M.P.,

"by the county and city of Worcester, in grateful recognition of his services for twenty-four years as chairman of the County Quarter Ses-

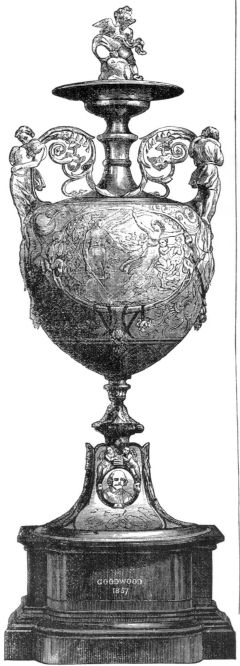

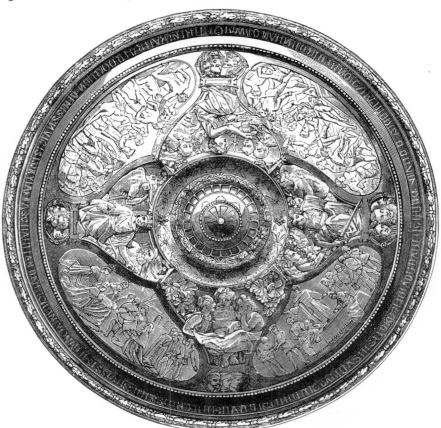

sions." Four *alti-relievi* present Justice, Education, the Colonies, and Marine, typically embodied as females. Four *bassi-relievi*, one in each quarter of the circle, illustrate remarkable

events in English history. To each subject are annexed three medallion portraits, in high relief, of those heroes of the gown or the sword who have made England famous. The artist of this

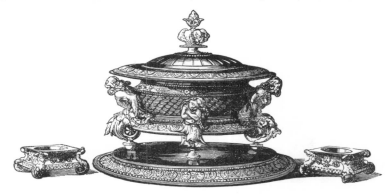

is of oxydised silver, chased in low relief, with subjects from the "Midsummer Night's Dream." The second illustration is a work of Art which has al-

very beautiful work is Mr. H. H. ARMSTEAD. The SOUP TUREEN and "SALTS" (also designed by Mr. Armstead) are portions of a Testimonial

presented to William Howard, Esq., late Acting Advocate-General of Bombay, for sustaining the legal interest in that important Presidency.

Let us take a retrospective glance over the past before attempting to measure the present, or cast the horoscope of the future; call back to memory the former night-gloom, that the dawn may be more vividly felt and welcomed. Into the earlier causes which produced and perpetuated ignorance of Art in this country no present inquiry is necessary. The struggles that produced the Commonwealth, the reaction which ended in the Restoration, the debauchery and bigotry that overthrew the old dynasty, and the changes inaugurated by the new, left no space in the national mind for the cultivation of Art; and a nation going through the crucible which refines serfdom into citizenship, had higher and still more important aims and ends. The first and second Georges were no improvement on their kingly predecessors, and during all these reigns the only Art in England, as practised by our countrymen, was indifferent portraiture. That was done in a style which set at nought the fascinations and stunted the

delights of fancy. Then, artists were drudges to conventional forms; they manufactured portraits by haphazard, and in that one trade held a monopoly of Art both pictorial and industrial. They were the prototypes of that zeal for production which was the bane of Art in the age that followed. A portrait begun, their one idea was to see it ended, and the success of the work was on a level with their aspiration. Without expression, and devoid of beauty, the repetition of stock patterns extinguished at once the enthusiasm of the artist and the interest of the public; and it was not wonderful that Art and its professors should both sink under the weight of imbecile caprice. Fashion treated such Art as it deserved, and numbered its votaries among the painter-stainers and upholsterers of the period. With portrait painting at zero, what could be expected in Art-industry? The age of great names followed, but even when Reynolds, and Gainsborough, Hogarth, and Hayman, and Wilson,

THE INTERNATIONAL EXHIBITION.

The articles we have selected for representation on this page are from the collection

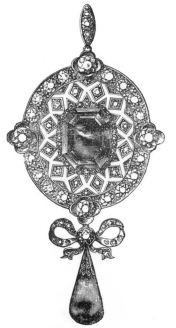

of Mr. HANCOCK, of Bruton Street. The central object—by far the most important—is a VASE, designed and modelled by MONTI,

and produced (as we are informed by the inscription which occurs on the base) in 1861, for her Majesty the Queen, by whom it has been presented as a Yacht prize. It

manufacturer. Not many years ago, little or nothing was attempted in England beyond the coarse setting of rare jewels

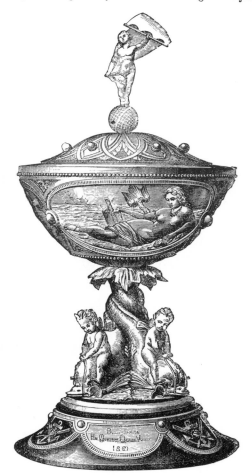

in weight of gold; now the skill of the designer and artizan is exercised to give value to that which, however intrinsically valuable, thus receives additional worth. The BRACELET at the foot of the page is in the so-called "Holbein style," and is

of a large emerald for centre, another for drop, and is set in brilliants. The BROOCH,

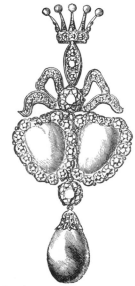

immediately beneath it, is made up of rubies, emeralds, pearls, and diamonds, and is in the same style as the bracelet. The two remain-

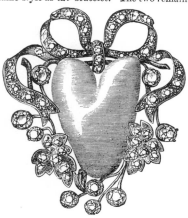

ing articles also are BROOCHES. The upper one is composed of two "hearts" of pearl

is of massive silver, elegant in form, and admirably executed. The "subjects" are, of course, all indicative of the Ocean, and are fine examples of the sculptor's art. The other engravings are of jewels. Such works mark the gratifying progress of the British

composed of emeralds, pearls, and diamonds, set in variegated enamel. On the left side of the vase is a LOCKET, composed

united, and set in brilliants with pearl drop: the lower one of a single pearl—remarkable for its great size—is likewise set in diamonds. The whole of the objects represented are elegant in design and costly in material. The jewellery we have engraved the actual size.

had redeemed pictorial Art from the degradation of preceding reigns, the lordly intelligence of England was contented with styles of Art-industry which a South Sea islander would have spurned as beneath the ornamentation of his tomahawk. There were a few great exceptions: Gibbons had produced wood carvings, and Chelsea was producing china; as Wedgwood afterwards manufactured earthenware, and Bewick exercised his genius on birds. In many departments some one stood out conspicuous for the taste infused into his work, and some of these productions of the past rank among the industrial Art-treasures of the present. But these men were artists, rather than manufacturers—some of them solitary workers, producing what was not then wanted, and all of them so inspiring their works with their own individual thought and power, that the light which burned so brightly around their lives was extinguished by their deaths. They were comets, more or less brilliant, and with longer or shorter trains

of followers or pupils; but they promulgated no fixed principles, and therefore left no basis for permanent successors. The vast productive power which was steadily and rapidly rising around them took but little knowledge of their light, or glanced at it as a beacon rather than a guide, remaining uninfluenced by the teachings of these high examples. Nor were the schools of Art more successful. From the private schools supported by the generosity of Fowlis and Sir James Thornhill down to this present, academies have exercised an influence, direct or indirect, upon a section of the people; but, in spite of these influences for nearly a hundred years, the deterioration in public taste was steady and persistent. The most worthless works of Sir James Thornhill and his co-decorators are magnificent contrasted with the best styles in fashion thirty years since; and no consolation for this degeneracy of taste among the few can be found in the more strongly developed taste of the many.

The two objects here represented are exhibited by Mr. HARRY EMANUEL, Court Jeweller, Brook Street, Hanover Square. The CUP is cut from a single piece of topaz, and is mounted in solid and pure gold, enamelled. At the foot is

artist, M. CHESNEAU, has been occupied two years in its completion. The model and execution are entirely his own. The work is *répoussé* throughout, and is one of the most excellent and highly finished examples of the goldsmith's art that has been made in England. The other object is an oxydized silver EWER, 26 inches in height, of fine workmanship and elegant

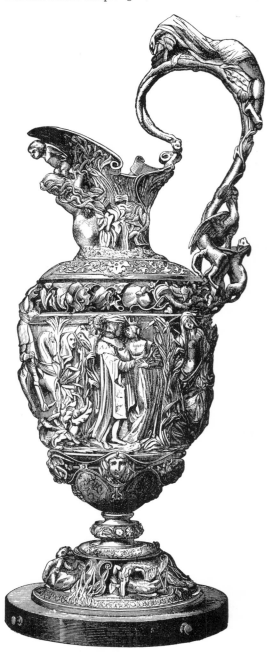

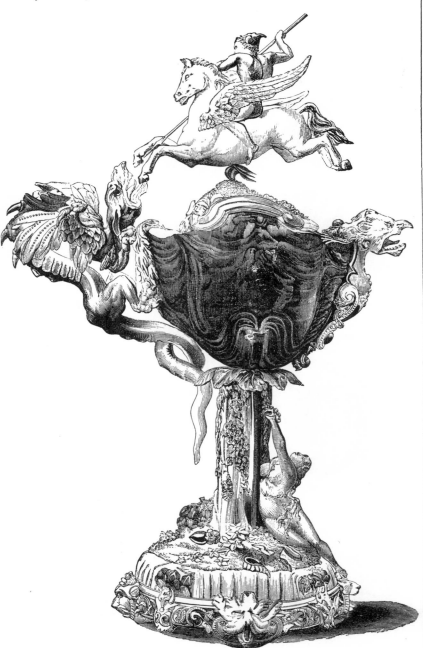

Andromeda chained to a rock, from which gushes a stream of water; the dragon is ascending to the attack of Perseus, who, borne on Pegasus, surmounts the cover. The costly nature of this work of Art may be imagined, when it is known that the

design. Represented thereon is the story of "Undine," which the artist has conveyed by portraying the most salient incidents of Lamotte Fouqué's well-known romance. The chasing is exquisite; each plant, animal, and accessory is of an aquatic character; the design and execution are of the highest order. Both objects confer honour on the eminent jeweller.

Baseless theories have been elaborated from the humbling fact. Much-wronged artists have blamed academies, and jaundiced theorists have traced it to climate, or hunted for it amidst the subtle speculations of psychology; but it will more probably be found in the combined action of two natural and ever-present laws,—the one especially applicable to the movements of creative thought, the other applicable to all classes of mind placed under a certain class of circumstances. In the exact sciences the law of progress seems different from that which controls the development of genius through the Arts. In the one the discoveries of a Newton or a Cavendish remain as sure foundations on which their successors build stone upon stone, until the structure, fitly framed together, becomes the glorious temple of demonstrably harmonious truth. In Fine Art, the genius of a Reynolds and a Gainsborough, a Hogarth and a Richard Wilson, emerge from the surrounding gloom; and

when their light has done its work, the realm of Art darkens gradually but surely, until again illumined by another constellation. As the tide-wave flows, recedes, and flows again, so is the course of progress, individual and national. Great thinkers in Art seem to arise, press forward, and recede in waves; and, as each successive billow forces forward some new truth, the flood-tide of knowledge keeps rising around the world. But each succeeding wave is dependent on the back-swoop of its predecessor, and the sea-trough of the one is as essential as the foam-crest of the other. It has been so with the Arts in England, and however depressing it may be to those who live through the ebb waves of retrogression, theories based upon the experience of these back-flows in a nation's progress are as worthless as half-truths in a problem of morality. The theories which traced English backwardness in Art to a misty climate and lack of brains, were propounded by those who lived

THE INTERNATIONAL EXHIBITION.

From the extensive and admirable contributions of Mr. Alderman Copeland, M.P., we make many selections. They include specimens of all the higher branches of Ceramic Art, together with those of the ordinary commercial character; for the attainment of high excellence in both of which he received ample testimonials in 1851,

and at Paris in 1855. We have selected such productions as seemed best calculated for representation by wood engraving, which sufficiently identifies form and arrange-

ment of the designs. These are rendered in enamelling and gilding, of excellent and elaborate character. Among the specimens of Ceramic statuary are groups, statuettes, and busts, from models by Gibson, R.A., Marshall, R.A., J. H. Foley, R.A., Marochetti, A.R.A., R. Monti, J. Durham, &c.—a special department of the art in which the

highest excellence is attained by this establish-

ment. The Art-direction of the Works is under

the superintendence of Mr. T. Battam, F.S.A.

In a future notice we shall have ample op-

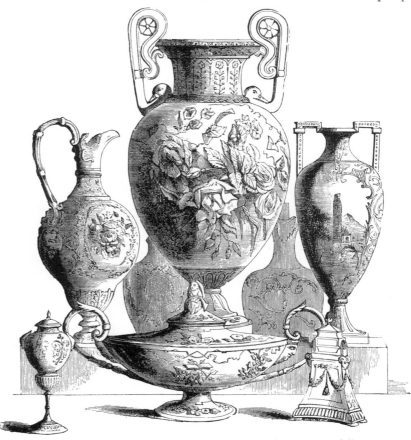

portunity of referring to the several artists engaged in the decoration, modelling, &c.

through the darkest period of that interval which separated the splendours of Gainsborough from the glories of Turner; and, overlooking what appeared sufficiently universal in the world's history to be taken as a general law, foreigners sought, through a shallow effort in philosophy, to fasten upon the British people physical incapacity for excelling in pictorial and industrial arts.

Another general and more definite law lent its potent aid against Art in England. A sensuous philosophy was deadening the national soul, and a dull routine was eating out spiritual earnestness, when the novelty and fascination of productive powers undreamt of by the wildest visionaries were beckoning to untold wealth. Nor was it wonderful that prospects opened up by these new-born powers should rivet national attention on themselves, or that, under a period of incessant wars, utility should become supreme lawgiver. Patriotism was easily linked to the car of fortune-making, and while the earth

and elements conspired to heap up wealth through mere production, the utilitarian philosophy combined with the ignorance of the producers to place Art among the *effete* appendages of courts, or among the useless vagaries of fools. Nor were artists without influence in accelerating the spread of this delusion, however unintentional on their part. Reynolds had discoursed upon the grand style, and condemned multiplicity of details. To the people it was detail that cost the money, so that utility and the grand style became "hail fellows, well met," and went forth hand in hand on the self-satisfying mission of at once saving money and elevating Art from that littleness of style which had been its supposed bane in England. The consequences were irresistible. The goddesses and angels of Thornhill were, as decorations, succeeded by a compound of Grecian *bas relievos* and Franco-Greek scroll-work for ceilings; while the other portions of the house were not unfairly represented by those often

The name of WEDGWOOD is almost sacred in the history of British Ceramic Art. The Manufactory at Etruria sustains its old renown by the exhibition of many excellent examples of the "jaspar ware," the production of which, just a century ago, gave to the great founder of the

house both fame and fortune. Several examples are shown in the second group. Its merit consists in the soft, smooth, yet "unglossy" surface of the body, and the delicacy and sharpness of the bas-reliefs—all the results of one baking; it is, therefore, a rare and difficult achievement

of the potter's art, and, we believe, Messrs. Wedgwood alone make it: sometimes reproducing from the old models which immortal Flaxman designed, and his associate, immortal "Josiah," executed; but also introducing new forms with modern ornamentation, more adapted to the re-

quirements of the present day. The other group, and the VASES at the side, are of subjects of varied character and size, which contain the

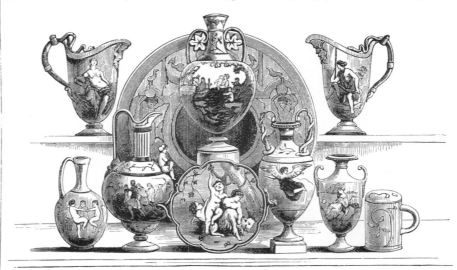

tion which makes the fictile art of our epoch. His subjects are frequently adapted from classic tasteful—his original works. They are very bold and free in treatment, highly effective, and veri-

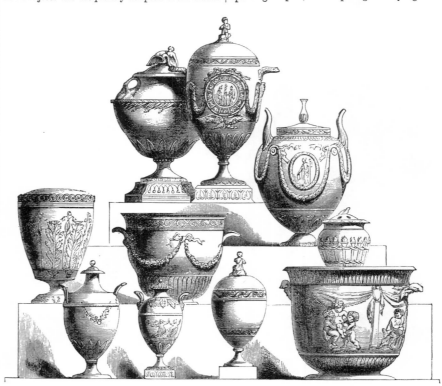

paintings of M. LESSORE, a French artist long established in England, whose free and facile pencil has very largely contributed to the perfec-

works of Art; others consist of pastoral groups, sporting Cupids, and topics generally light and

table examples of pure Art—PICTURES, painted by a true ARTIST on the material of the POTTER.

exquisitely sculptured marble chimney-pieces which artists like Joseph Nollekens acquired fame by carving. Even these ceilings showed subjects painted on the panels, and the wood-work was moderately or more elaborately carved, as may be seen in the houses of such localities as Red Lion Square, or in dwellings still farther west. But popular notions of the grand style and the love of money brought down such detail by rapid strides, till plain whitewashed plaster, with two flat horizontal, supported by two perpendicular, marble slabs, for a chimney-piece, and plain or papered walls, came to be the bantling born from this union of perversity and greed. Splendid and patriotic efforts were made by individuals to rescue England from its delusive degradation; but the nation was deaf as an adder to the charmer. The rapid increase of wealth, and the shaking of the nations, stimulated free thought and political agitation. Adam Smith and Cartwright,

Cobbett and Sir Francis Burdett, Jeremy Bentham and Lord Eldon, monopolised and divided the thoughts and energies of England; and while the mechanical skill which had raised the producing capabilities of Britain to a height unexampled in the world's history, was appreciated and rewarded, the skill which would have made production more beautiful and more valuable had so sunk under neglect as to have become a thing all but forgotten, if not a long lost source of wealth. This was the state of what is now known as Industrial Art, although then such a combination of words was unknown to the people, when the agitation that culminated in 1832 gave the nation time to breathe and look around it. And from the survey arose those influences and agencies which have so marvellously regenerated the industries of England. Take cheap literature as an example. The penny stories and ballad tracts of 1825 are as much inferior to the PENNY MAGAZINE issued by Lord

This page contains examples of the productions of the WORCESTER PORCELAIN WORKS; the lead-

ing group consisting of COMPOTIERS, &c., of a

dessert service for her Majesty, painted in

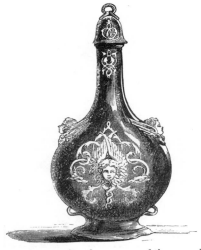

monochrome, after the manner of the enamels of Limoges, but on a fine turquoise ground. The upper group consists of VASES and other objects,

in what is termed the "Raphaelesque Porcelain." In the centre of the column is one of the plates of

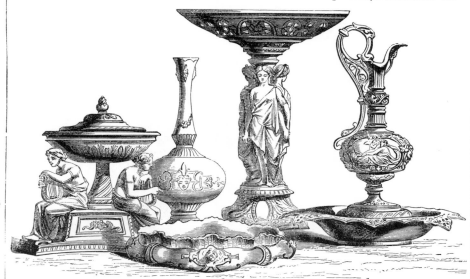

Queen's service) by Mr. THOMAS BOTT. The general design of the Queen's service was

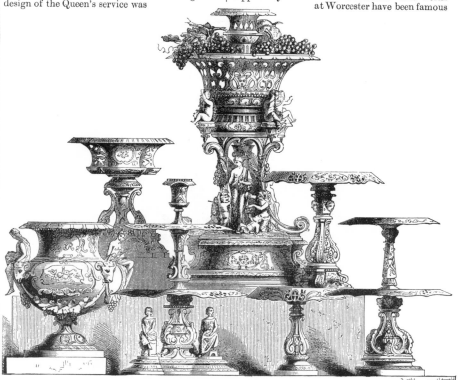

for upwards of a century; and although retrograding for a time, of late years they have effectually regained their high character, under the wise

the Queen's service; the other two objects are Worcester enamels—painted (as are those of the

supplied by Mr. THOMAS W. REEVE. The works at Worcester have been famous

direction of Mr. R. W. BINNS, F.S.A.—a gentleman of knowledge and taste, who has long been earnestly striving to advance the art of the potter.

Brougham and his co-workers, as an empty wallet is to a well-filled purse; but the contrast between the woodcuts of the first volume of that serial and those of the ART-JOURNAL of to-day, furnish a yet more wonderful demonstration of national progress.

The issue of the PENNY MAGAZINE may be taken as the birth of that Art-progress in which we now rejoice, and to Lord Brougham and his coadjutors, although they knew it not, is a great proportion of the honour due. They started the huge ball of public indifference and ignorance, though they did it indirectly, and others have kept in motion what they first successfully moved. It had long been acknowleged that, for certain trades connected with the Fine Arts, some portion of Art-education was advantageous; but the task of catering for the practical popular elevation of the people gradually awakened thoughtful men to the conviction that beauty must be as elevating in the workshop as in the mansion or the studio, and that theories

derived from the ancients were useless unless reduced to practice. Other influences, still more potent, appeared to support the pioneers of cheap and useful knowledge. The Art-knowledge of France, combined with its growing powers of production, began to threaten the undisputed superiority of England in the world's market, so that the very wealth-love which had well-nigh extinguished Art, and banished it from the industry of England, was glad, in prospect of defeat, to recall its banished counsellor.

In the year 1835-6, the House of Commons, with the consent and approbation of all parties, appointed a committee to investigate and report upon the state of Art in this country, but with special reference to the connection between Art and manufacture. That committee reported that "the Arts had received little encouragement in this country;" the "great want of instruction in design among our industrial population;" and that, "from merely economical reasons, it

The house of "MINTON & Co.," of Stoke-upon-Trent, is renowned not

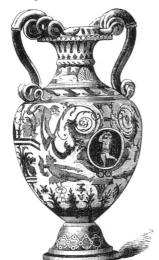

only in Great Britain but over the

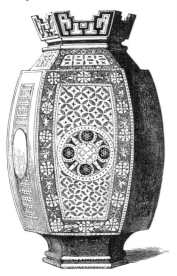

World: its fame was established in

1851, and is fully sustained in 1862. We have selected several objects for

engraving on this page. The principal is a Parian figure of PRINCE ALFRED, with his Shetland pony, modelled by the Baron MAROCHETTI. The Italian

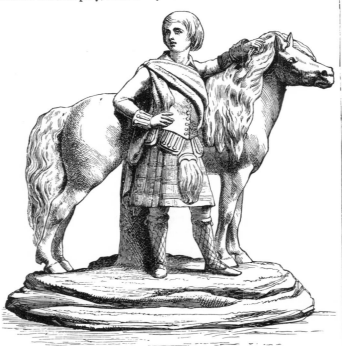

VASE is Majolica, decorated from a design by Mr. ALFRED STEVENS. The VASE, Louis XVI, contains groups after BOUCHER—the painting being exe-

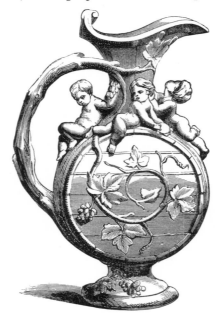

cuted by a process not hitherto employed. The LANTERN is in Parian, and is remarkable for its lightness, and the successful manner in which the deco-

rations are carried out. The VASE on the opposite side is in Parian. The

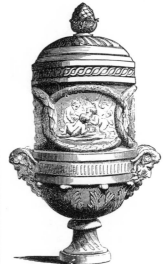

Ewer is a Palissy Vase. The FRIEZE

is a reproduction of a fine work by

Lucca della Robbia. The terminating bit is a specimen of ENCAUSTIC TILE.

equally imports us to encourage Art in its loftier attributes, since it is admitted that the cultivation of the more exalted branches of design tends to advance the humblest pursuits of industry, while the connection of Art with manufacture has often developed the genius of the greatest masters in design." These proceedings show how even the most enlightened politicians then groped in the dark concerning Art. The committee had reached a great general truth, but evidently knew not how to act; they recommended this country to follow the footsteps of continental nations; but could give no reason why, except that France had museums and schools, and England had none. However impotent in logic, the report of that committee was sound in feeling; and, although at that moment industrial Art in France was sinking under the weight of the copying so influentially recommended to this country, the leading ideas of that report were unassailable, and its results beyond present calculation.

In 1837, a school of design was opened at Somerset House. Other schools of design arose throughout the country. The cardinal and inherent defect was want of practicability. For these schools and their direction, titles were considered of more value than brains, and political position as preferable to practical knowledge. They imitated the nations of the continent after the British fashion, by excluding the element that gave the continental Art workman the superiority he so conspicuously enjoyed. In the chief towns and cities of France the instruction, in almost every description of manufacture, was given by practical men—those whom the workmen involuntarily honoured as the legitimate heads of their several crafts and callings; and such teachers taught with all the authority and success which accompanies the precepts and examples of experience combined with superior skill. In Switzerland, the school of design for watch making was taught by a watchmaker; in

It is difficult to classify the works of Messrs. WILLS BROTHERS, for they are executed both in terra-cotta and in metal; some of them, that is to say, are produced in cast iron, in electro bronze, and in silver; but they are chiefly the productions of their own modest establishment in Euston Road,

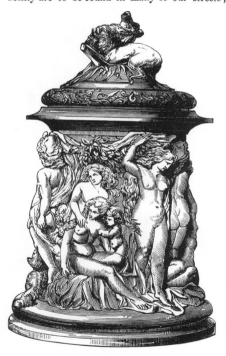

where they are modelled, moulded, and baked in red clay. These gentlemen are true artists, not scorning or slighting the artisan-toil without which genius often works in vain. Evidences of their ability are to be found in many of our streets;

rors, flower vases, tankards, bells, &c. Any of these productions will bear minute examination: they are generally admirable as designs—results of matured study in the best schools

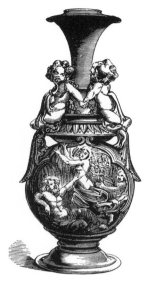

—and are carefully manipulated, having a degree of sharpness and clearness such as we do not often see in issues of the kiln, composed of

materials comparatively worthless until skill and talent have given to them beauty and value. The lover of Art will perhaps value these elegant objects in terra-cotta more than their copies in

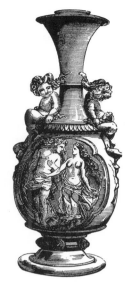

metal, and in that case the demand on his purse will be very limited indeed. Our present page, of the productions of Messrs. Wills Brothers,

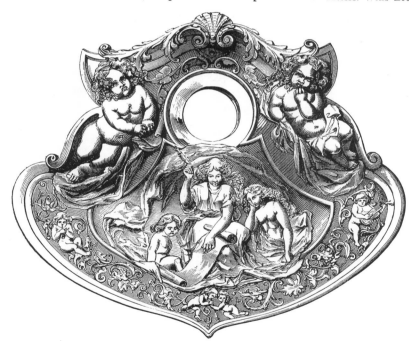

the Fountains, latest of our social boons, are principally of their creation. They have boldly entered into competition with the Art-workers of the Continent in associating Art with utility; and the works they exhibit consist of a variety of useful articles—inkstands, hand and swing mir-

consists of a SALT-CELLAR, a FLACON, two VASES, and an INKSTAND; and, as we have intimated, they are exhibited both in "common clay," and in iron, bronze, and silver. It is to be lamented

that we have in England so few artists who, able to execute works in sculpture, will "condescend" to give grace and beauty to things comparatively humble, for the ordinary uses of "every-day life."

France, weaving by a weaver; in Berlin, casting of metals was under a practical man; and so of all the other specialities of tuition; while these men and their pupils were alike stimulated and instructed by the lectures of professors, in which the general principles of high Art were brought to bear upon the general principles of taste and the improvement of Art-industry. In England, these common sense principles were as nearly as possible reversed. Practical men, as teachers, were persistently excluded. Artists, with sufficient influence, social or political, were the only teachers; and the results were what ought to have been anticipated—failure in the schools and intrigue among the masters. For a season the novelty of copying kept both pupils and manufacturers in hope; but as that novelty wore off, it was succeeded, in students, by feelings of contempt for men ignorant of the specialities they had come to teach, and of chagrin on the part of manufacturers that, through specious promises,

they had been duped into wasting their money, and interfering with the regular order of their establishments, for what did not, and probably never would, yield them any practical advantage. The malcontents multiplied without, and intrigue intensified within. Some parties were to blame, and the most conspicuous persons to the public were the masters,—men, some of whom had been but too glad to "sacrifice" their position as artists for a permanent income offered by the State. The directors being blind leaders of the blind, were the easy prey of interested influence, and, in the battle of the masters which ensued, red tape and politic mediocrity triumphed over artistic genius. How all this bore upon the Exhibition of 1851, as well as on that now before us, will by and by appear. Meantime it is impossible to forget, and it would be unwise to ignore, the fact that these earlier schools, even with their ignorant direction and impractical tuition, stimulated the students with higher thoughts; and

The house of Fourdinois of Paris has long been famous, not only in the capital of France but throughout Europe. Its contributions to

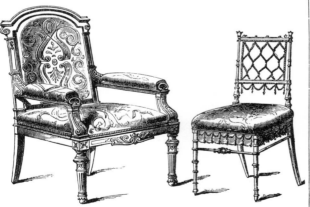

the International Exhibition are worthy of its high fame. These consist of various articles of furniture, principally carved, and executed

by artisans who are in reality artists, and who have bestowed a large amount of time and skilled labour in giving existence to works that are beyond doubt examples of Art of the rarest excellence. The larger Cabinet we engrave was exhibited at the French Exhibition of 1855: it is of walnut wood; every portion

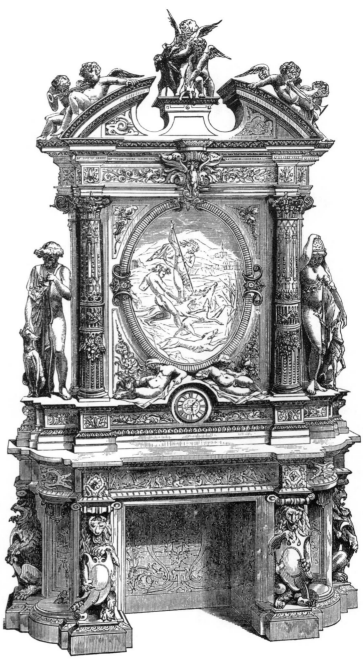

of which manifests knowledge and thought. The smaller Cabinet is specially produced for England. The two Chairs—which are introduced mainly to fill the page—are evidences of the grace bestowed on the minor issues of this "house."

to these institutions England owes a debt of gratitude scarcely repaid. They had many shortcomings, and endured some mismanagement, but they had the redeeming quality of linking genius to industry, and brought the influence of our highest artistic minds to bear upon and stimulate youthful aspirants after fame in paths of industrial Art. In this achievement they were to some extent successful; and to the designers educated directly or indirectly in these schools, England owes a very large proportion of that progress she can now so confidently proclaim. The masters, like artists and men of genius, knew nothing of the tricks of experts or the intrigues of politicians, but they raised the enthusiasm, and diffused the broad light of artistic feeling over the minds of their pupils; and in that light the country now rejoices. The cost and alleged mismanagement of these schools are not now before us, or it might be shown that, while the teachings of genius are nationally cheap, the lessons of

mediocrity are dear at any cost; and that confusion combined with inspiration is infinitely more valuable than insipidity gasping under the pressure of the most unimpeachable routine.

The opening of these schools called forth a new class of wants. Ushered into existence with considerable parliamentary *éclat*, and several branches of trade feeling, from falling commercial returns, that something must be done, subscriptions for these establishments in the larger towns were easily secured; but the little seed sown had fallen on stony ground, and, as trade revived, the zeal of the few who had felt the necessity of combining Art with industry had waxed cold, while the mass of the manufacturers knew nothing and cared nothing about the subject. Decreasing local subscriptions were the consequence; and, as money became scarce, jealousies and irritations multiplied, so that the whole fabric of Art-education, which had been so promising in prospect, was threatened with disruption,

Messrs. TROLLOPE, the eminent firm of Parliament Street, contribute among other works a very elegant and richly carved CABINET, in the early Italian style. It is of ebony, inlaid with woods of various centre panelling, very richly carved. The designer is Mr. RICHARD BEAVIS; the

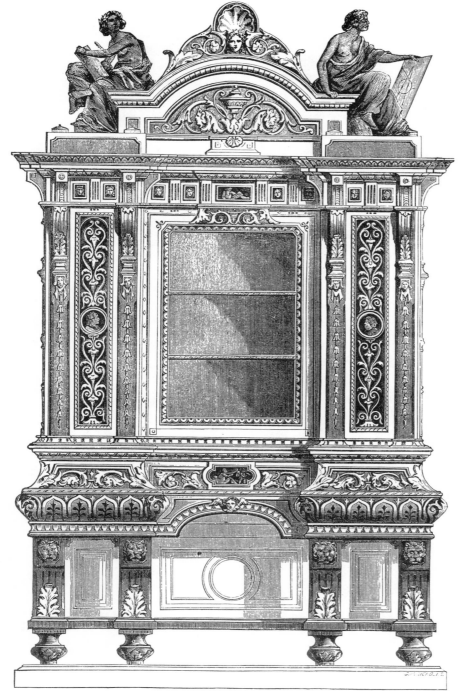

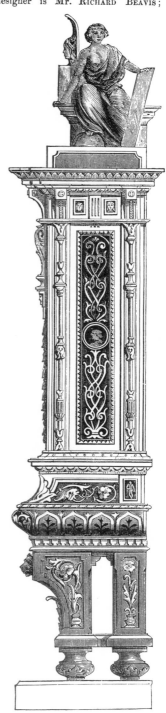

kinds, and having, in the frieze of cornice, panels of Limoges executed by COPELAND, and illustrative of the woods used in cabinet work. The top is an exquisite piece of workmanship, consisting of a fine modelling is by Mr. MARK ROGERS.

if not also with annihilation. It was in this crisis of the industrial Art-history of England that the ART-JOURNAL launched forth to do battle on behalf of the dispirited and sinking cause; and, in the national elevation of industrial Art, this Journal has, from then till now, been a powerful and conspicuous agent. Others, with more or less precision, discoursed upon the reforming and ennobling influences of Art, by which was meant pictures and statues; but the ART-JOURNAL seized the great truth, and raised it as an ensign for the nation—that beauty is cheaper than ugliness, that a knowledge of Art is essential to successful industry, and that, so applied, it not only bears a high commercial value, but diffuses a reforming and elevating influence throughout the masses of the population. The ideas promulgated by statesmen in parliament, and by many out of parliament, had to be combated with keenness and resisted, often without success, and always to the annoyance of opponents. With them copying and reproduction was the end most talked of, if not the goal of their ambition. Send to France for specimens—one to buy velvets and silks, "in short, normal examples in all departments of ornament," not only to exhibit, but to exercise the students in carefully copying them; another, "to copy such works as those in the chamber of Mary de Medicis, in the Luxembourg," for the same chief end of being copied by the students. The ART-JOURNAL followed the less popular mode of urging that the students should, through the stimulating power of great principles, be taught to think, and that the most perfect power of copying bears the same kind of relation to design that a knife and fork does to a good dinner. The official plan was to teach mechanical dexterity, on the unwise supposition that quantity was more valuable than quality. We, on the contrary, maintained that the only Art-education worth paying for was that which would stimulate the ability to think through form. The

Messrs. WRIGHT & MANSFIELD, Cabinet Manufacturers and Upholsterers, of Great Portland Street, exhibit many admirable examples of their trade. We have selected two for engraving on this page: the lower object is a fine specimen of cabinet furniture of the "English style" of the eighteenth century; a dwarf BOOK-CASE of "ginn wood," with enriched columns and mouldings of carved ebony, and having the frieze of the cornice and panels of the door relieved with plaques of Wedgwood ware. The other is an elegantly carved CABINET, of the same style and period, richly gilt

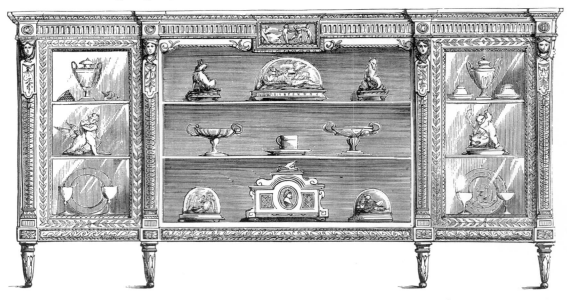

and effectively relieved. Both these pieces of furniture are highly creditable to the designer and producer, and to the workmen also who have so ably seconded their efforts. They are entirely productions of English Art-manufacture. It will be especially gratifying to examine the numerous proofs of progress in this particular branch of Art-industry, and to compare the works exhibited in 1851 with those shown in 1862. Ample evidence

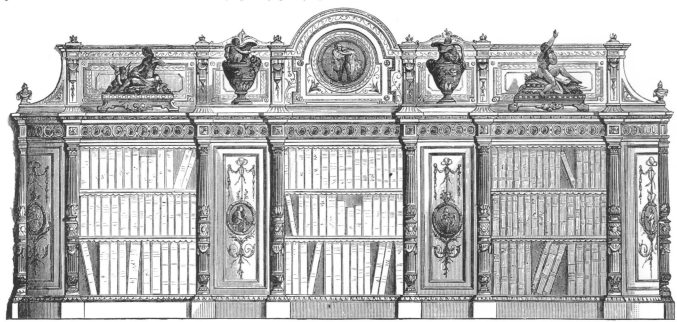

is afforded of advance in taste,—the heavy and sombre furniture that was formerly considered indispensable has been removed, while lighter, more graceful, yet not less convenient and comfortable, objects have been substituted by nearly all our manufacturers. It is, however, to the advanced character of the workmanship that we desire to direct special attention. If our artisans cannot compete with those of France in wood-carving, they may challenge comparisons with their rivals in perfection of finish, and in the accuracy with which all details are carried out.

minds of students, awakened by the counsels of genius—practical, if possible—would each find their own legitimate style of expression; for a man's style in design is as much a portion of his individuality as in literature, music, or the Fine Arts. Mechanical dexterity may be acquired under the drill of dull mediocrity, but this JOURNAL has ever contended that such education is worse than worthless to the great industrial interests of this country, and that there was more hope in the waywardness of genius than in the teaching of drawing destitute of thought. It is unnecessary to claim more than strong conviction and general consistency in pursuing that course, and it is but justice to acknowledge that the high artistic feeling of those who then presided over the schools, did much to thwart and counteract the lifeless promptings of their political and departmental superiors. Whatever the form assumed, it was practically on this rock that the old schools were wrecked. Genius and Art-teaching parted company, and the ART-JOURNAL preferred suffering with the outcast to flattery of the enthroned.

The persistent reiteration of these truths year after year was at that period attended with no small sacrifice, and nothing but a conviction of their inherent vitality and power could have sustained a serial devoted to such work; but the struggle with ignorance, and indifference, and interests, was manfully sustained; and although others have succeeded in snatching the solid profit, the ART-JOURNAL can never be deprived of the more enduring praise. This devotion to Art-industry had to encounter the opposition of two great and powerful interests, besides those already named, and the indifference of an uneducated public. Manufacturers objected to bear what they regarded as a new income-tax imposed by Art-notions on their annual profits, and it was only line upon line, and precept upon precept, that slowly, but surely, dispelled that dark delusion from their

The works of Mr. H. G. ROGERS are so well known, and have long been so highly appreciated

that any notes concerning them are needless.

The first subject on this page is an oval MINIA-

TURE FRAME, carved in box-wood, in the Italian style, and composed of winged genii, dolphins,

wreaths, and a basket of southern fruit. Below it is a frame of the severer style of decoration, known to *virtuosi* by the style and title of *cinque-*

FINIAL, a replica of one of Mr. Rogers's beautiful adornments of St. Michael's Church, Cornhill. The two remaining subjects are both productions in box-wood, which Mr. Rogers executed for

testimonial from the " Manchester Exhibition of Art-Treasures." The page terminates with a circular *encadement* in the most exquisite style of

cento, distinguished chiefly by its paucity of foliated ornament and abundance of strap-like scroll work. The third object on the first column is a

Miss Burdett Coutts. The ornamental composition containing the words—" A thing of beauty is a joy for ever," forms the central portion of an elaborate frame, destined to hold that lady's

the period of the Medicis. Although of diminutive size, it is a perfect *bijou* of wood carving. The terminal boys in the centre support a shield.

minds. Artists were equally shortsighted. They wanted elaborate essays on high Art, or the *matériel* of the studio, sparkling gossip, or vivid imaginings; but they overlooked the lessons of all history as bearing on their own best interests, for an educated industry and commerce have ever been the most munificent patrons of the Fine Arts; and that labouring to permeate manufacturers with the necessity for combining beauty with their own productions was the true method of inspiring them with that love of Art, which now makes British merchant princes its noblest mainstay. The late Prince Consort deserves abounding gratitude for his noble thought and energetic action in reference to the Exhibition of 1851; but it was the course of Art industrial training thus rudely sketched, that made such an exhibition possible. William IV. could not have called such an industrial trophy into being, although he had combined the eloquence of Demosthenes with the wisdom of Plato. Neither the

materials, nor the spirit for the productions were in existence, and that great display was but a gathering together of the results of that Art-education and Art-agitation, which had been progressing during the previous twenty years.

That Exhibition was the means to an end. It was got up as a great show, that it might become a great teacher. It was the means of allowing a national stock-taking in Art-industries, rather than a competition either among themselves or with other nations; and while in form it was an international contest, it was, in fact, for this country only a mustering of the forces preliminary to entering on the race for fame. It enabled each to measure each, so that future conflict might be prepared for; and in this spirit the British section was, both by our own and by other European nations, judged. By some, indeed, and for now obvious reasons, this tone was carried to excess; and while individual foreign exhibitors were not spared,

From the eminent and long-established firm of PELLATT & Co. we have selected several objects in engraved glass—a class of manufacture in which they have arrived at great excellence, carefully and continually studying purity of form and grace in ornamentation, and eschewing the

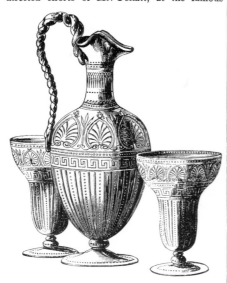

grotesque—too much adopted of late in this material. As we shall show, the more recent of British productions in glass are of the best order; largely in advance of such as were famous in times not long past; and for such improvement there can be no doubt we are much indebted to the rightly-directed efforts of Mr. Pellatt, at the famous

"Falcon Works;" and at whose Western establishment, in Baker Street, most of these fine Art-works are found. Our difficulty in this case has not been to find objects worthy to engrave, but to select from a mass of beautiful specimens —many of them being rare examples of the art of

the engraver in any "style." It is unnecessary to direct special attention to either of those we have

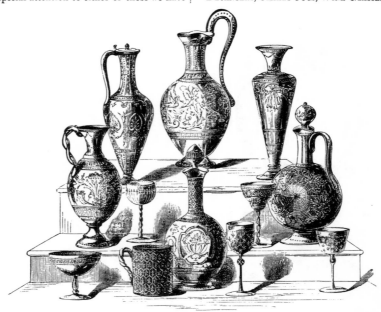

CUPS, WATER JUGS, GOBLETS, &c., engraved generally with floral ornament, sometimes in arabesque, and occasionally with Greek borders and figures

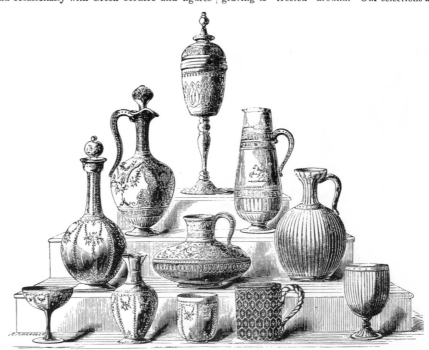

obviously made from the more choice productions of Messrs. Pellatt; but in all their articles for

gathered into groups. They consist of table-glass —DECANTERS, CLARET JUGS, WINE GLASSES, &c.—

from the antique. The decoration is sometimes supplied by the glass—left plain—while the engraving is "frosted" around. Our selections are

ordinary use, we observe the same evidence of good taste in design and excellence in execution.

foreign design, as the product of foreign systems of tuition, was magnified at the expense of English genius and capacity, in a manner altogether unwarranted by the ornamental qualities of British products.

Nationally that exhibition startled England, chiefly by showing how much its artificers had to learn and its designers to unlearn. Generation after generation had gone on plundering from the French, until what was called French taste came to be considered as the highest standard in all that produced beauty in industrial Art. It was but poetic justice to find that in the world's competition the glitter by which cupidity had been tempted was anything rather than pure gold. Nor were the teachers much wiser than the taught in that year of trial, and there were few specimens of any manufacture exhibited that more grossly violated all true principles of design and adaptability than the gorgeous and costly carpet

designed for one of the most important rooms in Windsor Castle. That was not a design for a carpet so much as the decoration—very badly arranged—for one of the four walls of a room. It consisted of a centre and four side panels, worked out in violent contrasts; and objectionable in many other ways. But if this style was honoured at Windsor, what could be expected in Berkeley Square? and it was madness to rail at the manufacturers who required to make for Whitechapel examples not more false, although less expensive, than what obtained the highest approbation by those who then directed and controlled our schools of Art, both masters and pupils. When such was the quality of the fountain, what could be expected from the stream? and with such misleading from one of the great luminaries in design, it was not wonderful that those constrained alike by interest and emulation to follow a master so honoured in his art, should rush headlong into the vortex of

THE INTERNATIONAL EXHIBITION.

We represent on this page a variety of objects in glass, designed and manufactured by Messrs. DOBSON & PEARCE, of St. James's Street. The WATER JUGS and WATER GOBLETS in the first column, are of good design and very richly en-

Every article we have engraved exhibits some novelty, considerable taste, and is admirably exe-

cuted: no attempt has been made to produce anything that is intended to be effective only in pro-

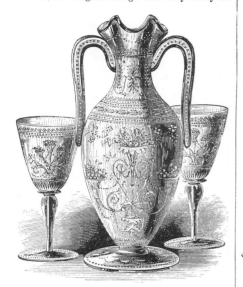

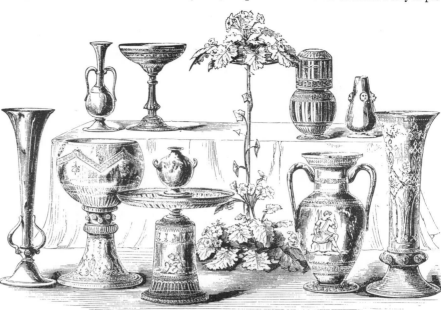

graved. The upper ones, of Etruscan form, are ornamented with original Raffaellesque designs; those below, also of Etruscan form, are enriched with engraved Grecian borders. Of the two

portion as it is grotesque. Messrs. Dobson and Pearce have long maintained a foremost position

in their important trade: they are justly renowned for productions that combine excellence in ma-

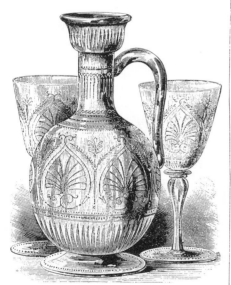

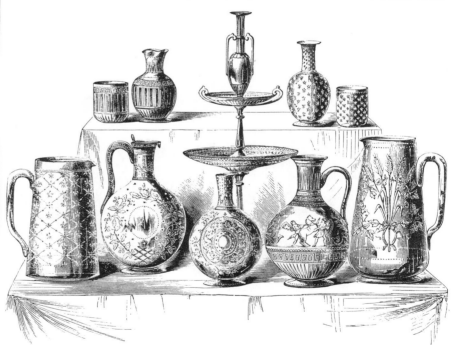

groups, the first consists principally of FLOWER VASES of varied shapes, in the centre of which is one of Mr. MARCH's prize FLOWER-STANDS: the second is composed of several richly engraved objects—CLARET JUGS, BEER JUGS, WATER BOTTLES, and an EPERGNE FOR FRUIT AND FLOWERS.

terial with grace and beauty in ornamentation, and to them the country is largely indebted for

the pre-eminence it holds in this particular art— an art that is rapidly gaining ground in England.

absurdity. Notwithstanding all this, there were many hopeful symptoms even about the absurdity of these English designs, more hopeful than about the conventionalities of those who mainly inspired them; and this element of hope sprung from the vital force which the previous Art-teaching—however imperfect and misdirected—had infused into the industrial Art-thought of England. In other countries, such as France, design was cramped, if production was perfected by traditions of the fathers; in England the new impulse sought to worship at the shrine of nature, and teachers pointed to the human form as the highest object of artistic study, whether for Art supreme or subordinate. It is unnecessary to settle whether that process of tuition was right or wrong; none will deny its existence, and few could fail to see its influence upon all that bore on the higher branches of Art-industry in the British section of the Exhibition. The naturalism through nearly all departments of metal work, from chandeliers to silver plate, was only an example of what was more or less visible throughout the British sections; and that was as manifestly the first rude embodiment of the newly taught truth, as shadow is the consequence of sunshine. The dignity and importance of the human form, as taught by the masters of design, appeared equally conspicuous in the efforts of English exhibitors. The workers in silver vied with the weavers of silk, and the pastrycook challenged the wood-carver to a passage of arms over the human form divine. All this was absurd, but even the absurdity had an invigorating tendency; and in the energy of ignorance there was greater hope than in the restraint which traditional authority was imposing on other national styles rapidly degenerating into mannerism. Nationally neither France, Austria, nor Russia produced such solecisms in design as were to be found in the British section; but the newly-awakened life that gave birth to these anomalies indi-

In the manufacture of Chandeliers in glass, England has long maintained the highest position: in pure, crystal glass, that is to say, no foreign producers enter into competition with those of this country. Their use has become so general, as to be almost universal: there is no public building, hardly a shop in London, which does not receive "illumination" from brilliant lights which cast little or no shadow, and are at all times exceedingly pleasant to the eye. No doubt much of this result is owing to the singularly small cost at which they can be produced: it is scarcely an exaggeration to say, that twenty years ago pounds must have been paid to obtain the object that may now be procured for shillings.

The public is largely indebted for this beneficial service to the house of DEFRIES & SONS, of Houndsditch, wholesale manufacturers of glass,

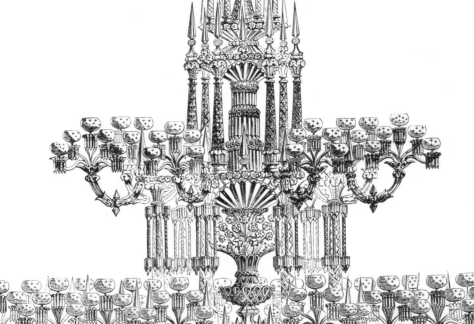

whose principal productions, however, are of chandeliers, which they export to all parts of the world; not only to countries where refinements are familiar friends, but to places as yet remote from civilisation, enlightening people to whom a "drop" of the crystal metal is as rare and beautiful as the diamond of equal size would be to us. One of the works of Messrs. Defries we engrave on this page: it is very large, and possesses considerable merit in design and arrangement. The dome (surmounted by a Prince of Wales' coronet and plume) is of one piece of glass, elaborately cut, and supported by eight crystal pillars, resting on a base formed of prisms: the centre tier, surrounded by the same number of

columns, surmounted by graceful spirals, rests on a base of prisms, from which the upper tier of lights springs from eight arms, each arm having a cluster of seven lights. This tier of lights is again supported by the same number of columns, and each column is surrounded by four smaller pillars. These columns rest on the main body of the chandelier, from which spring sixteen arms, similar in design to those of the upper tier, each arm bearing a cluster of seven lights. The main body of the chandelier is constructed of prisms, three feet six inches in length (a size, we believe, never before attained), forming one large prismatic dish, under which two other dishes are formed in a similar way, the whole terminating with a richly cut spire. One of the most effective points in this composition is the vase which occupies the centre of the lower columns, out of which springs a bouquet of crystal flowers. This description of a gorgeous and very beautiful work, of immense size and most elaborate workmanship, seems needed to accompany the engraving. The designer is Mr. PERRACINI.

cated the power that has carried this country onward in her industrial career. In some departments of the French section the naturalistic element was as rampant as in the English, but in a more unhealthy form. In the one case it was nature ignorantly followed and imperfectly appreciated; in the other, it was nature rendered gross through form, and the grossness made endurable through manipulative skill. With Englishmen, destitute of conventional knowledge, the convolvulus was turned into a gas bracket, with a desire to render it as elegant as his imperfect knowledge of the outline of a Venus would permit. Frenchmen, full of conventional experience, formed enormous natural roses on the basis of the Silenus, and adopted these monstrosities in form as ornamentation for carpets, paper-hangings, and silk dresses. English design displayed the imperfections of ignorance, French design the perversion of knowledge; and while the Exhibition of 1851 taught Englishmen

their own shortcomings, it with equal eloquence pronounced much they had learned from France to be vicious in principle and false in practice. This was a great and much wanted national lesson, and the improvement of the British section of the present Exhibition over the same department of its predecessor must, in great measure, be placed to the destruction of that British delusion respecting the perfection of French design.

Another lesson which the former Exhibition taught the nation, and especially those engaged in Art-industries, was, that thought, to be valuable in any walk, must be harmonious—that the isolations of genius were imperfect, and therefore comparatively worthless, creations. Thought in design, like thought in writing or discourse, must be consistent with itself and fitly clothed, and in these qualities of unity and dress English Art-workmen had, then, almost everything to learn. We refer not to those nicer *traits* of

THE INTERNATIONAL EXHIBITION.

Messrs. FEETHAM, of Clifford Street, exhibit a large variety of works in iron, wrought and cast, and also of works in combined iron and brass, or bronze. We have selected for engraving a sculptured statuary CHIMNEY-PIECE, which manifests considerable skill, as well as much artistic beauty. The grate is of ormolu and steel, porcelain being judiciously introduced. At the sides are engravings of FIRE DOGS, one of which is a statuette of

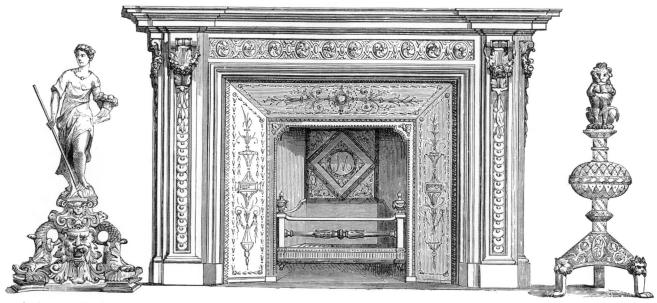

Ceres in bronze. In this department of Art-industry England will certainly occupy a very prominent position; the artists of France may, and do, surpass us in the application of pure Art to metal, but they do not reach us in that combination of grace with convenience which mainly constitutes comfort. The leading object on the page, however, is a pair of IRON GATES, with sideways, and four iron pillars supporting vases of flowers. The whole is of wrought iron, with hammered iron foliage and flowers. This remarkable work, one of the most successful achievements of modern Art, was designed and executed for the Earl of Dudley, and will be placed at his seat, Witley Court, Worcestershire. Those who are able to compare works of this class with such as were produced some twenty or thirty years back, will receive ample

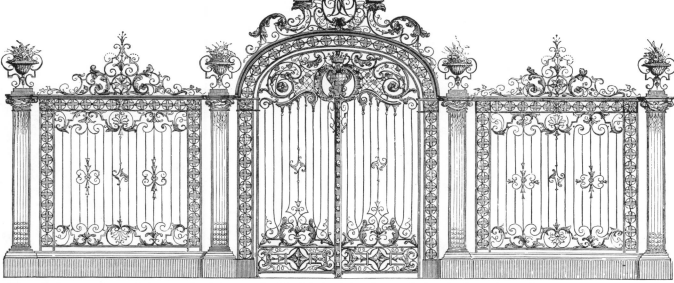

evidence of advancement; our designers and artisans may not yet have reached the excellence that was attained by their forefathers in wrought iron, but they are rapidly proceeding towards the excellence that made an Art-glory of the entrance to a "stately home of England" a century ago.

unity by which the Greeks overcame the optical illusions of nature, and by curves restored that apparent solidity to straight lines, which these lines failed, unaided, to produce; but to more ordinary examples, where improbabilities and want of care spoiled hundreds of clever thoughts, and where, in struggling to catch hold of nature as a guide, the soul of nature was eluding the material grasp. But it was not so much in form or design as in colour that the Exhibition of 1851 revealed our national poverty; and when all the hideous crudities, which had been destroying taste for years, were, in new and intensified combinations, brought into one spot, the astounding ignorance revealed made the show appalling, and the mind sink at the way in which all other countries had outstripped us in the race for fame. While France and, through her influence, other nations had, through their artisans and philosophers, been determining the most instructive harmonic ratios, we were still disputing over the *jejune* problem, whether the primary colours numbered three or seven. The consequence was, that the Exhibition found our manufacturers unsettled, even in the elementary principles of colour, and unskilled in its most primitive combinations, so that even second-rate colourists, like France, towered above the crudities of England, as artistic giants. And so they were by comparison; but it will probably be found in this second international competition, that it was better for England to have learned nothing in colour, than to have learned amiss, and that the feeling of national ignorance then, has been more profitable to us now than the higher but still imperfect knowledge which enabled the French to bear off the palm of victory from us in 1851. This acknowledged ignorance sent us back to nature, and to a comparison of that with the higher schools of Art, both in form and colour; revising not only the errors of practice, but what was far more important, the errors in principle,

From the long and justly renowned establishment of BARBEZAT (successor to André) of PARIS, we have selected and engraved several subjects. They are all in cast iron; yet the designs are sufficiently good and graceful to bear execution in the precious metals. The centre object is a mural fountain; on either side is an admirably moulded figure, while two vases complete the group, No special "style" is adopted at these

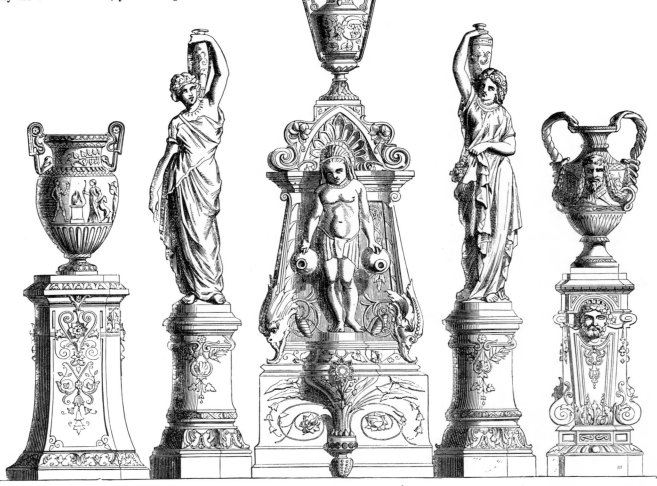

works; their artists evidently think for them- | selves; and are by no means slavish followers of | predecessors. At the base of the page is engraved

part of a balustrade, commissioned by the Emperor. Nearly all the issues of this firm are admirable examples of Art, of the best possible order: they may supply studies to manufacturers more practically useful than will be obtained by days of "learning" in our "Schools of Design."

which our designers had been holding fast as indubitable truths. Not the copying of a plant or flower, but a study of the laws of growth, was what the decorative or constructive Art-workman most required, because from these laws invaluable instruction for all Art-manufacturers is gathered. In bulbous roots, the potter, the glass-blower, and the modeller may find all the types which have given value to the productions of Etruscan skill; some of the finest specimens in the collection of Sir William Hamilton apparently boasting no higher prototype than a well-grown turnip, a well-developed melon, or a well-formed onion. Workmen whose range is colour, find in plants the laws of natural harmony complete, teaching the marked distinction which nature never fails to make between greens suitable for white flowers, as distinguished from greens in harmony with flowers red, yellow, or blue. Designers and artisans connected with construction, discover in the proportion of flowers to stems, and the mode in which the one is attached to and supports the other, much that guards them against many of those inverted and misapplied forms that were the disfigurement rather than the ornament of so many clever works in 1851. And although a closer study of nature would have taught such lessons, without the teachings of contemporary practice, yet, as all more clearly see their neighbour's errors than their own, many caught glimpses of great constructive and decorative truths from their industrial violation, who would never have discovered them in the great storehouse of industrial and artistic principles. The effect upon the public was, if possible, more important and almost as rapid as upon the designers and artisans. A public, able to appreciate and willing to purchase, was a necessity as important as artists able to produce; and the manufacturers had long found refuge from ridicule at their follies in the shadow of an unenlightened public. The Great Exhibition

THE INTERNATIONAL EXHIBITION.

The IRON WORKS of COALBROOKDALE have for many years past maintained the capability of England to compete with the foreign producer—not only in objects of magnitude and commercial importance, but in articles that combine elegance with utility, and are among the wants of the many. Their "exhibits" in 1862 far surpass those of 1851.

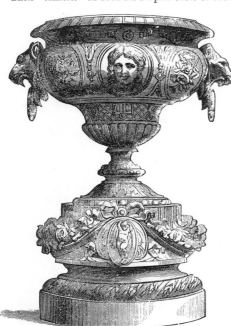

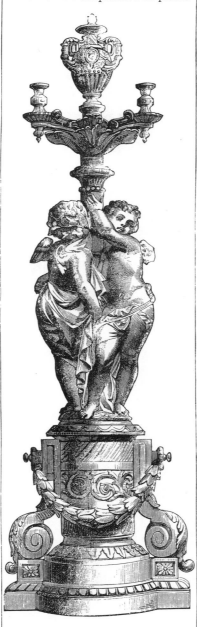

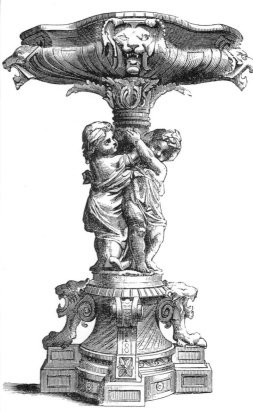

others M. CARRIER, the renowned designer of Paris; and to subjects hence supplied has been accorded ample justice by skilful manipulation — so sharp and delicate in finish as to bear comparison with produc tions in bronze. The VASES for gardens and conservatories are of beautiful design; the larger VASE and the CANDELABRUM are designed by M. Carrier; the small FLOWER-POT, with figures in low relief representing the four seasons, is from a design by

M. GUINET. The VASE at the head of the third column is especially fine. It is designed also by M. Carrier. These are but selections from the large number of works exhibited by the enterprising company at COAL-

BROOKDALE — convincing proofs, however, that while they manufacture for the "million," literally gladdening the hearts of hundreds of thousands in every part of the globe where "a sea-coal fire" is a necessity and a

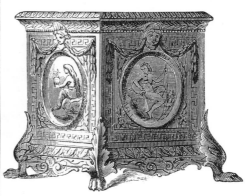

luxury, and fabricate huge machines that move vast ships and weighty carriages over land and sea,—they give due consideration to the requirements of refined life.

The intelligent and indefatigable manager, Mr. CHARLES CROOKES, has this year summoned to his aid artists of experience and ability — among

proved that although education in taste, as in other studies, is the work of time, the unenlightened public showed itself an apt pupil when the eye became the gate of knowledge; for before the Exhibition closed, the naturalistic mania had run its day, and in all but the management of colour, and some of the conventional treatment of metals, the French style, which had dominated with the public for three previous generations, was dethroned by general consent.

Internationally it was at least equally important; and although not within our brief, the political and commercial effects of the Exhibition were among its most important international results. In the one case, the Exhibition led not very indirectly to reduced tariffs and increased postage facilities among the nations; in the other to a flood-tide of industrial prosperity, which was disturbed, rather than destroyed, by the panic of 1857, and which has greatly add d to the commerce of the country. M. Thiers sought to extract another idea

out of its international character, which many received as a truth, who, if not quite satisfied with the accuracy, were, nevertheless, captivated by the brilliancy of the generalisation. Democratic France manufactured for the aristocracy, while monarchical England supplied the people of the two worlds. The opinion contained a germ of truth, but it was more remarkable for antithesis than sound criticism. The opinion was not true, if objects of expensive grandness be among such wants; and while in the smaller works of *vertu* the French stood pre-eminent, both Austria and England exhibited more evidence of wealth, and so far from the antithesis of M. Thiers being correct, examination of the French section showed that wealth or a wealthy aristocracy was not in France, and that the British aristocracy was, in all but minor matters, supplied by British products. In all the more noticeable qualities of Art-industry, England was distanced by continental nations in the elements of Art-

From the productions of the BRITANNIA WORKS, of HANDYSIDE & CO., of Derby, we select the four objects, in cast iron, en-

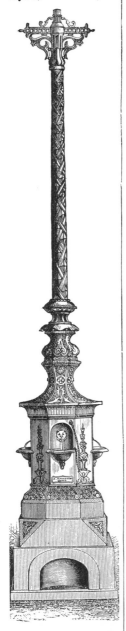

graved on this page. The establishment is more renowned for its machinery—huge and powerful "utilities"—than for its Art-issues: but, happily,

its means of promoting taste and creating beauty are not neglected. We engrave a LAMP-PILLAR, so constructed as to act also as a street-side fountain; a large FOUNTAIN for garden or conservatory; a VASE, with copies of the "Night" and

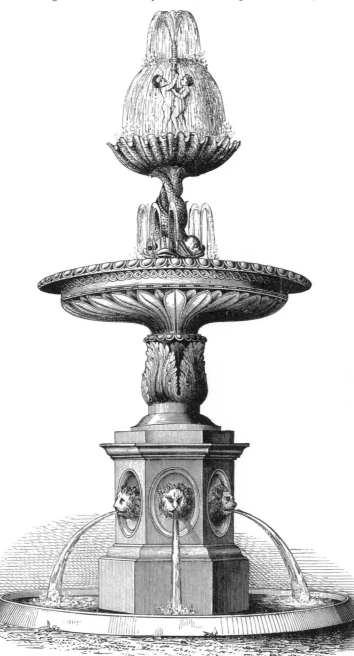

"Morning" of Thorwaldsen in high relief; and a simple but cheap and easily erected FOUNTAIN, of good character and design. These works are of cast iron, and are therefore readily accessible to persons of moderate resources. A variety of vases, some original, but chiefly admirable copies from antique models, are produced at

these works, and many of them are shown at the Exhibition. The advances that have been, of late years, made, in

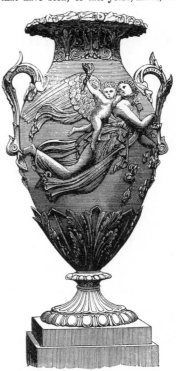

rendering the great source of England's wealth—Iron—contributory to the improvement of taste, are especially gratifying. The "common" grate of the cot-

tage parlour is now frequently as elegant in form as the "costly" grate of the aristocratic drawing-room, and that without adding to the expense of its production.

progress. The position of France in design has already been referred to as the tutelar divinity of English producers; but in crudity of thought, there was perhaps nothing in the British section which equalled the china-ware camellia tree, exhibited in the Austrian section. But while less might be learned by our countrymen in quality of thought, they were conspicuously indebted to other nations for lessons on the style in which thoughts ought to be worked out, and the effects produced by work when really finished. From the French our countrymen might have learned the method of arranging colours in the fitting up of stalls, and the still more important lesson of managing colours, in the production either of harmony or brilliancy; but it was in the rude attributes of force, rather than in the calm dignity of power over colour, that the French excelled, and in the former quality they had no rivals. Whatever the cause, the result was undeniable, that in the production of brilliancy and—to use

an expressive vulgarism—"loud" harmonising, the French artists stood out from all competitors, leaving others in the murky shade of baffled incompetence. In this contest French daring was crowned with incomparable success. Their ambition was not founded on the highest aspirations, and their triumph was limited by their desire; but that they achieved what they aimed at, was in itself a great success. In this they taught us an invaluable lesson, not from its absolute truth, but for its full realisation of intention—a lesson which, with all the efforts made by our designers, they have not yet mastered completely. In carpets, for example, while the dyes of the English makers were individually as vivid as those of France, in the mode of combination the French as sensibly gained, as the British lost, in cumulative brilliancy and force. And although in both cases these carpets were outrivalled in point of taste, yet the one was an objectionable success, the other an objectionable failure. How to

THE INTERNATIONAL EXHIBITION.

This page contains selections from the works of Mr. ANGELL, Jeweller and Goldsmith; he ex-

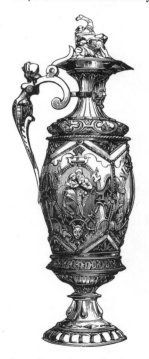

hibits many rare examples of Art; but his attention is mainly

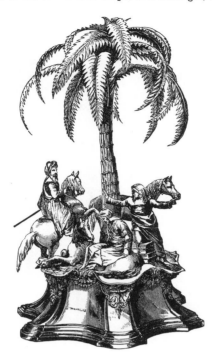

bours to give the advantages of taste and grace—purity of form and refinement in ornamentation. The four JUGS are very varied in character; they are either in silver or silver gilt; that at the bottom of the third column was presented by the manufacturer as a prize to one of the Rifle Corps; it is silver gilt, the moresque orna-

ment being produced by cutting through the gilding, so as to show the silver underneath in contrast. The CENTRE PIECE, for a table service, represents a halt in the Desert—figures reposing under the shade of a palm-tree, aroused by an alarm of enemies approaching. The group consists of a massive silver TEA-SERVICE,

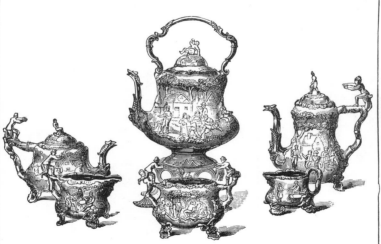

chased in high relief, the designs being adapted from pictures by Teniers. Mr. Angell's collection is a very large one, consisting of the several productions of the goldsmith's art in great variety; some, as we have intimated, being of the highest order, but the majority being elegant utilities. He also exhibits jewellery of varied and

beautiful character, and fully sustains the position he has long held among British manufac-

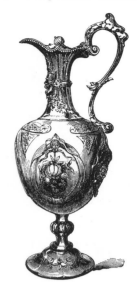

turers in the precious metals. In few of the Art-manufactures produced for the Exhibition of

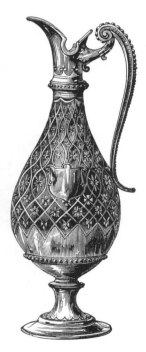

1862 is there so much evidence of advancement as in the work of the jeweller and silversmith.

directed to the production of works such as are general requirements, and to these he la-

achieve anything perfectly is a lesson worth learning, and this the French taught in the Exhibition of 1851.

Another lesson taught us by the French was beauty of production, and our artisans profitably embraced that golden opportunity. Manipulative dexterity was also prominent in all they executed. The difference between French finish and British in all the branches of Art-industry was extraordinary, and at that period the French stood pre-eminent among the nations for skill of workmanship. However worthless their thought in any given design, or puerile their conceit, or conventional their forms, all was redeemed and raised beyond the range of commonplace or vulgarity by that beauty of finish which so distinguished all the works from France. It was here that the weakness of England and the strength of France were most conspicuous; but instead of going over particular examples, or framing lame excuses, our manufacturers and artisans accepted their defeat

with courage, and set themselves to repair it with determination. How far they have succeeded will be seen, when bringing forward the progress of Art as applied to manufacture.

Internationally we were taught important lessons by France, but the teachings of Italy were still more impressive, although delivered with less show and ostentation. The one appealed to the eye, the other left its impression on the intellect; and while the dazzling brilliancy soon wore off, the convictions of the head settled down into an all-permeating mental power. There was nothing popularly attractive about the ceiling decorations from Milan, or the wood-carvings from Florence and Sienna, or the hundred other objects of interest which came from the different states of Italy; but there was that quiet power about them all, which laid hold upon minds engaged in such works everywhere, and which exercised what may be called an involuntary influence, stronger and more reproductive than direct non-

G

Mr. PHILLIPS, the eminent Jeweller, of Cockspur Street, exhibits a large number of admirable works, distinguished by refined taste and perfection of finish, as well as

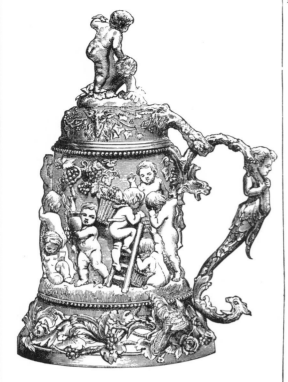

by the costly character of the materials employed. The page is commenced by a TANKARD, displaying high artistic skill. It is 13 inches high, formed of a single piece of

ivory, representing a vintage; and is mounted in oxydised silver, finely chased, with Bacchic subjects, executed from entirely original models. The BRACELET centre is a guardian angel, in pure gold, surrounded by diamond stars. The

principal object, however, in Mr. Phillips' fine collection is a TRIPOD in the style *cinque cento*. The cover is composed of one rare and matchless onyx, about three inches in diameter, and marked with perfect concentric rings in rich brown and white tints, extending from the centre to the outer edge. The height of the Tripod is about six inches, composed

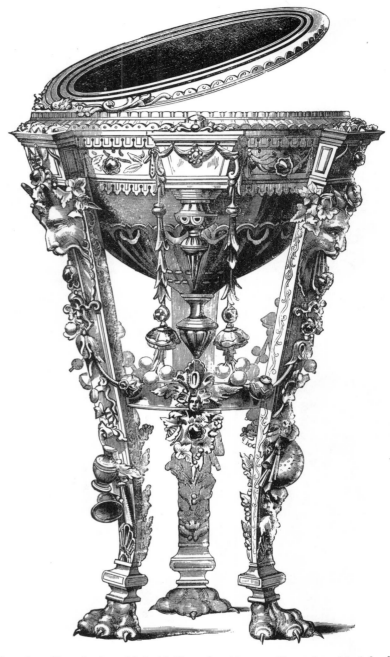

of massive gold, profusely enriched with diamonds, rubies, emeralds, pearls, and lapis-lazuli. The masks, feet, and mouldings are exquisitely enamelled, the former representing War, Music, and the Vintage, with their corresponding attributes. It is executed from original designs, and is a work of surpassing excellence, to which engraving can do but limited justice.

intellectual imitation. The decorations of Montagnara were seen at a glance to be unsuited to British homes. They were evidently productions suited to a different climate, prepared for mansions where the sun is treated as an intruder, and where light is an evil to be combated and subdued, rather than as a gladdening guest whose radiance is to be courted and encouraged. Neither had the carved work of Barbetti those attractions so conspicuous in French cabinet work of a similar description. There were no wonderfully carved birds, with marvellously cut feathers, and little of that naturalistic reality which delighted so many in the wood-carvings of France; but on leaving the French for the Italian courts, artistic minds felt that they had passed from a lower to a higher atmosphere of thought, and that while the one had addressed the fancy with success, the other, with at least equal success, appealed to the serious mental powers, demanding and securing a high involuntary homage. It was alto-

gether a higher style of Art and decoration—a withdrawing the feelings from the pleasing twistings and wanderings of a clever conventional and sparkling naturalism, and bringing them back, through a nobler style of ornamental treatment, to that school whose great artists bestowed their genius on decorative works. The one was the prettiness of ornament suffusing pictorial representation, the other the dignity of pictorial Art inspiring ornamental treatment; and our stolid countrymen were more susceptible to Italian grandeur than capable of appreciating Gallic vivacity in Art-industry. It may be difficult, perhaps impossible, to point out any such direct influence arising from the Italian section of that Exhibition as is visible in the imitation of French carpets or paper-hangings by British manufacturers; but it will probably be as impossible to escape from the conviction that the solid grandeur of Italian ornamentation has exercised a deeper and more widespread influence

The Cup we have here engraved is of silver gilt, and was manufactured by Messrs. GARRARD, of the Haymarket, for her Majesty, by whom it was presented as a birthday present to the infant Prince—her godson and grandson—of Prussia. The design is throughout very fine.

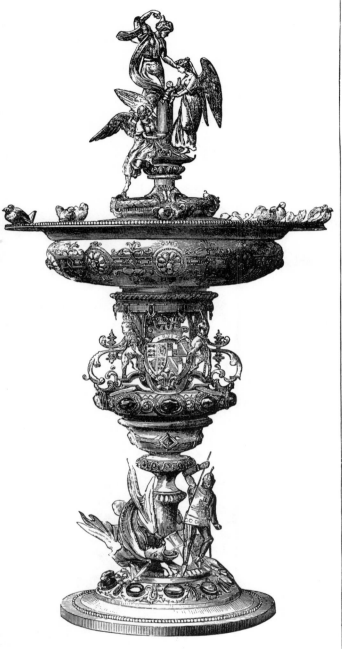

On the base are figures of St. George and the Dragon, typical of the triumph of Truth over Sin: on the centre of the shaft are the arms, on the one side of the Queen and Prince Consort, on the other those of Prussia. The "INSIGNIA OF THE STAR OF INDIA," is also here

represented. The collar of the Order is composed of the lotus and the heraldic rose of England, alternately, ornamented by palm branches in saltier as the emblem of Peace. The "Investment Badge," pendant from a riband of

light blue, is composed of a diamond star of five points, to which i 'tached a portrait of her Majesty in onyx cameo, enriched by the motto of the Order, in letters of gold on blue enamel. The Order of India was instituted in 1861.

upon the British section of the present Exhibition than the more gorgeous attractions of our French allies.

The only other international Art-teachers in the Exhibition of 1851 were that semi-barbarous group which represented the productions of China, Tunis, India, and Persia. These may, for convenience, be classed under one head, and named the Indian sections, because, although different in many phases of ornamentation, they were nevertheless all members of one family of ornament, and their lessons, so far as these were practical and influential, were all in one direction. Never did the people, and particularly those connected with design or manufactures, know the gorgeous power of barbaric splendour till they saw its productions in that Exhibition; and so novel and overwhelming was the sight, that even after that gathering became matter of history, these Indian sections had so captivated the minds of those influential in the Art-education of the country, that

there appeared no small danger of our Art-students and Art-studies being confined to the manufactures of the East. How far such a consummation would have been desirable or possible is perhaps not worth either thought or discussion; but why it ever could have been so, and the causes which prevented the national mind from catching the *furore* which so suddenly and strongly seized the then Art-controlling minds of the country, are questions worth glancing at in their proper place. In the Exhibition of 1851, the lessons of these Indian sections were confined to the Art-teachers of England, whatever effect these productions may have had on the manufacturers and Art-workmen of other nations. We shall therefore expect to find the influence of these Indian teachings developed more through the Art-instruction of the country than through those general products of industry and commerce which that Art-teaching has barely and most indirectly reached. That these Indian sections had some

The SERVICE OF PLATE (manufactured by Messrs. SMITH and NICHOLSON), of which the centre and side pieces form a portion,

was presented to James Allan, Esq., one of the managing directors of the Peninsular and Oriental Steam Navigation Company,

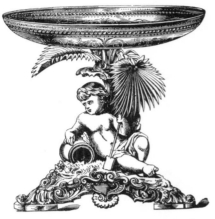

by the entire body of its *employés* ashore and afloat, and was a spontaneous expression of their affection and esteem for that

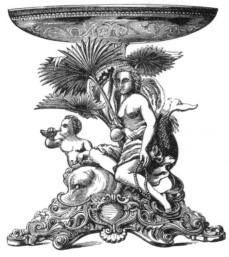

gentleman, as the inscription indicates. It was accompanied by a handsomely illuminated address, bearing the signatures of about one thousand subscribers. Mr. Allan has been associated with

the company from its infancy, first as Secretary, and now, for a period of thirteen years, as one of the managing Directors. The work of the eminent silversmiths is in all respects excellent in design and in execution. The composition bears apt relation to the special purpose of the famous "company" which Mr. Allan "manages."

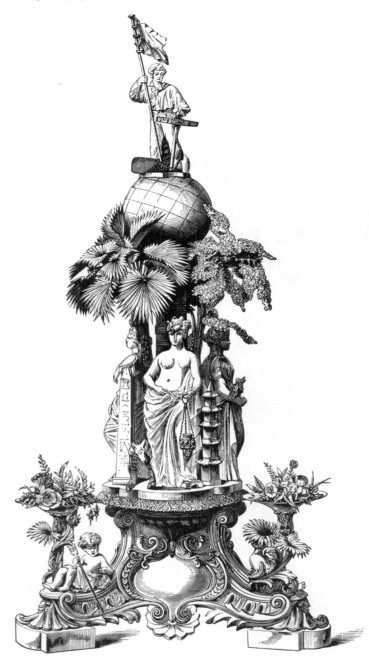

Surrounding the column are three figures, emblematic of Europe, Asia, and Africa—the three divisions of the World with which the Peninsular and Oriental Company trades. The column is surmounted by a British sailor, holding the "Union Jack."

influence on the manufacturers and general public cannot be doubted, and is not disputed. All that is predicated at present is, that these Indian sections exercised no such influence on the manufacturers and the public as the European sections already noticed, while they exerted a much greater influence upon the teachers of Art—at least for a season—than all the other industrial Art sections of that Exhibition put together.

These were the great national results, although chiefly produced by the process of unlearning.

In few words, the grand lessons of that magnificent gathering were nationally these: it taught our designers that the French style which they had been following, was in the main false; that although England had some genius, and considerable energy, based on an impulse after nature in its highest forms, that, nevertheless, we were destitute of style, and equally destitute of Art-workmen capable of

carrying out ideas in an artistic spirit. The public were astounded rather than instructed; their old belief was shaken rather than any special new truth imbibed, and the improvement in public taste was more an inference from the losing of an old faith, than from any hearty concurrence with, or intelligent appreciation of, styles which had become more popular.

The results internationally have been already indicated, and may be recapitulated in three sentences—that from the French we could learn the value of finish in production, and the commercial importance of more highly skilled workmen; from the Italians, as a whole, a higher style of thought in ornamental and decorative Art; and from the Indian sections, that the barbaric splendours of the East were associated with principles which the western nations had either never known or forgotten, but which could be incorporated with valuable results to the industrial combinations of Europe.

THE INTERNATIONAL EXHIBITION.

In "stained glass," of late years, considerable advance has been made: the subject has received the careful consideration of archæologists and scholars. All that could be learned from the works of early imitated the faults of predecessors: while they have adopted what is valuable, they have avoided what is erroneous, in productions of great masters in the art. On this page we supply examples of the works of Messrs. LAVERS AND BARRAUD, of Endell Street, Bloomsbury, engraving one "light" of the great West Window of St. Peter's Church, Lavenham, Suf-

artists has been wisely and rightly applied to such improvements as chemistry has placed at the disposal of the moderns. Glass painters, however, have not folk, in which eight events in the life of the apostle are illustrated. The subject engraved represents the angel releasing St. Peter from prison. The three-light WINDOW represents our Lord in the temple, discoursing with the doctors. Both these works are admirable specimens of the art, and do great credit to their producers. They were designed by Mr. ALLEN.

Before the Exhibition of 1851 was closed, it was felt to have become a new and living power in England. In accordance with previously expressed ideas, Parliament and its official advisers had concluded that a collection of objects and illustrations, displaying the various antique and modern styles of Art-industry, was indispensable to a successful system of Art-education, and upon the propriety of securing such aids there could be no difference of opinion. The Exhibition offered an opportunity of which advantage was wisely taken, and, with all but universal approbation, £3,000 was nationally devoted to the purchase of objects to be selected as examples by commissioners named for that purpose; the objects then bought, added to what had previously belonged to. Schools of Design, formed the nucleus of the present Kensington Museum. Whether the money was judiciously laid out it is now of no practical importance to inquire, because, whatever difference of opinion there may be on other points concerning the action and ramifications of the Department of Science and Art, and in spite of great diversities of opinion as to many articles in detail, the collection, as a whole, is not only valuable to those engaged in pursuits connected with the higher branches of industry, but eminently useful as a practical education of the public mind in much that is characteristic and beautiful in the past, and also as a means of keeping those interested in such subjects abreast of modern progress. When the Exhibition of 1851 was closed, the new energies and activities which had been called forth naturally sought exercise in new developments; and the official power it had created, as well as the unofficial intellects it had stimulated, sought new methods of proving their zeal to be practically combined with knowledge. Official reports, and an immense illustrated catalogue, were prepared and published at great expense; but no ingenuity or knowledge has ever been able to make blue books popular among the

Messrs. HEATON, BUTLER, AND BAYNE, of Cardington Street, London, exhibit STAINED GLASS WINDOWS both in the west transept and in the

Harpenden. The church, which has a fine square

Norman tower, has lately been restored. The heraldic

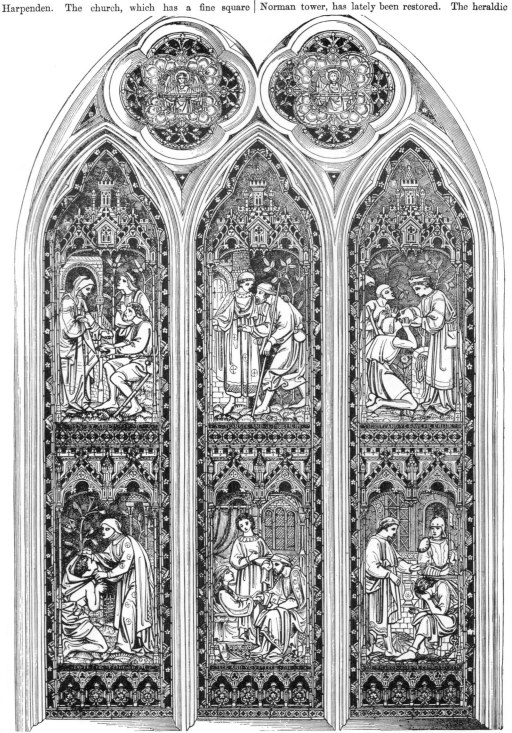

gallery. We select for illustration the "Act of Mercy Window," shown in the transept. It is a memorial window and will be erected by Dr. Spackman, in St. Nicholas Church,

light is a portion of a window exhibited in the gallery.

The designs and the execution are by partners in the firm.

British public, and the huge catalogue was rather a specimen of what the combined force of authority and money could produce, than an effort to shed the light of the Exhibition upon Industrial Art, and over the artificers and artisans of England and the world. The literature of the Commissioners was official, intended for State purposes, and serviceable for nothing else. To the ART-JOURNAL was left the honour of producing what, by universal consent, has been declared by all competent and independent judges the most popularly useful, as well as the best, Illustrated Catalogue of the Great Exhibition. Now, when comparison of what was with what is has become indispensable to the intelligent appreciation of the progress made in the respective departments—and as the comparison will be better understood when followed with the eye—readers will do well to keep that former volume before them while studying the subjects illustrated and referred to in this Illustrated Record of the present International Exhibition.

Besides the official literature, there was what may without offence be called a semi-official literature, which sprung from the impulses awakened; and to this class belong the lectures on the results of that Exhibition delivered before the Society of Arts. These were undertaken at the suggestion, and were delivered under the auspices, of the late Prince Consort; but whatever the importance of the historical knowledge and erudition displayed, and that in itself is most valuable, the practical advantages likely to be conferred by these lectures on the industrial prospects of the nation must have been disappointing to those who looked forward to their delivery and publication with hope. No intelligent workman or manufacturer will willingly remain ignorant of the history of his craft or calling; and the lives of his illustrious predecessors, as well as the various steps by which his *specialitie* rose from rudeness to its present state, will become interesting intellectual recreation; but the first want of the artisan, as such, is to know

In the various examples of their

Exhibition, the Messrs. HART, of Wych Street, sustain their high reputation as artists in metal-work. The specimens engraved have been selected chiefly with a view to show how happily the Gothic style admits

MALLET. The remaining object is a

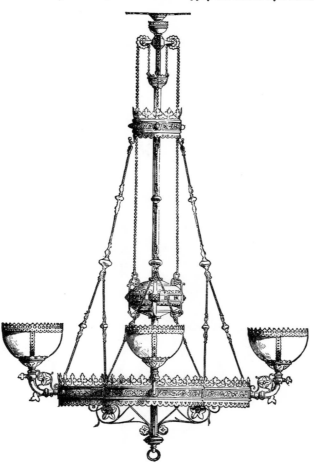

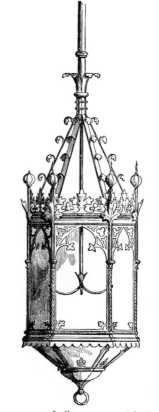

of being applied, in metal-work, to the requirements of modern life. The first is a MODERATOR LAMP, with a lofty stand; the second a GAS CHANDELIER, at the side of which is a GAS PENDENT LAMP; in the centre

TABERNACLE, of gilt copper, enriched with

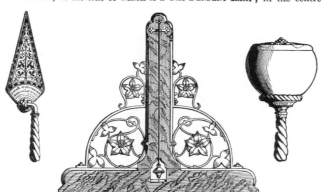

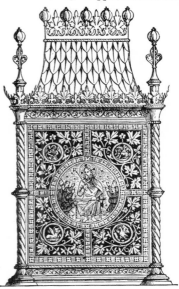

productions contributed to the

of the page is a MASON'S LEVEL of oak and brass, with TROWEL and

enamels and other decorative processes.

how to do his work, and, if any do the same kind of work better, the absolute or probable methods by which the superiority is produced. Historical knowledge trains the man, but it is only practical knowledge that can improve the workman; and in this most essential kind of information—as essential to employers as to employed—these lectures were far from prolific. They, however, raised a semi-official standard for the future. They combined the influence of royalty with the prestige of learning, to point out the good from the bad, or the better from the worse; and, although all but silent on what the industrious should do, they with no uncertain sound warned them what to avoid. This was valuable when the discrimination of the teacher was just; and in none of those prelections was there more judgment combined with practical instruction than in some of the lectures bearing upon the relations of Art to manufactures and general industry. One remarkable feature of official thinking at that

period was the influence which the Indian section had produced. Nor was this influence confined to England. M. Blonqui reported to the Academy of France that the productions of British India deserved the attention of the technologist as much as that of the philosopher and economist; that Indian Art had a style as distinct in itself as the Art of France was, and equally distinguished, combined with an originality elegant and tasteful. The government committee, Mr. Owen Jones, and Dr. Lyon Playfair, were equally explicit. Public speakers stepped from their path to proclaim the beauties of "Barbaric Art;" those who spoke exclusively on Art were no exception to the general rule, and much of what was said was both true and important, although much was also merely fashionable. The subject is referred to now because the practical issue has become nationally interesting.

The pleasing fact cannot be gainsayed, that Britain has made

The "SERVICE" which supplies the principal engravings on this page is exhibited by Madame TEMPLE, of Regent

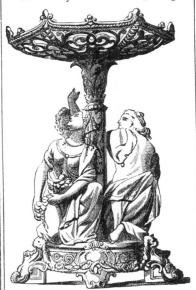

Street and of Brighton, expressly and exclusively for whom it is manufactured

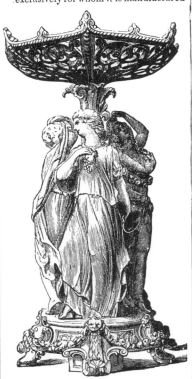

by Mr. Alderman COPELAND. It is composed of groups of figures sup-

porting perforated comports, in Ceramic statuary and porcelain. Upon pedestals of great richness arise columns wreathed

with ivy, scrolls, and acanthus foliage, against which are grouped female figures, with various insignia, expressive of

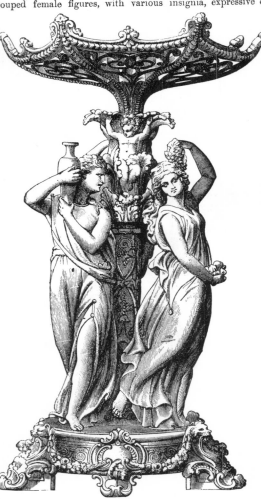

Joyfulness, Gratitude, and Abundance, supporting elaborately perforated baskets. The plates are of fine porcelain, with per-

forated borders, and three compartments of festoons and baskets of flowers, richly gilt in matt and chased gold. The groups of figures and baskets have been modelled by Mr. BEATTIE, of London, from designs suggested by Madame Temple. It is greatly to the honour

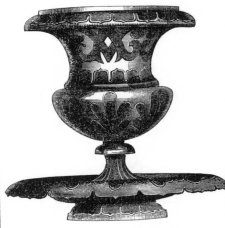

of the British manufacturer that a service so admirable is entirely the work of English artists and artisans. The two other objects which make up the page, are engraved from works in glass, the produce of Bohemia. The

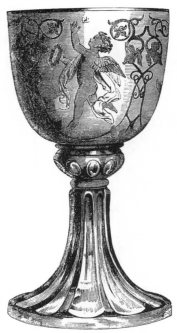

CUP is of great beauty, carved by the eminent artist ZACH, expressly for Madame Temple, who is a large and liberal contributor to the Exhibition of works selected from the best manufactories of several Continental countries, as well as from those of England.

more than anticipated progress in the application of artistic truths to industry, and especially to those characterised as manufactures; but the curious fact remains, that with all these influences bearing in one direction, the progress of the country has not been towards India in Art. Even in carpets, where the Indian style was most likely to have found favour, while there has been a striking change of style since the Exhibition of 1851, the Indian type has never predominated; and whatever its indirect influence, it has not held its own ground as an objective *specialitie*. There are reasons for this apparent anomaly—this want of national fructification in a style which laid such hold on the teaching minds of this country. Works may be beautiful in themselves, and appreciation of them may be complete, but from lack of adaptability or other causes, we may admire the beauty, without being prepared to adopt it. Take carpets, for example, and nothing could surpass the skill and general harmony of the Indian products. The low mellow tone and rich natural bloom they displayed, showed a very high feeling, not altogether traditional, for balance and disposition of colour; still we are apt to forget that even these specimens would be more brilliant under the blazing light of the East, than in the murky atmosphere of our island home. But suppose it was not so, there is another reason why the people of this country would not, as a rule, be likely to prefer this type of colour, however abstractedly beautiful in its own place, and for its own purposes. Colour is one of the ministers of pleasure, and that is dependent on balance and compensation. In India the pictures most popular are frost scenes, and the carpets which produce most agreeable sensation are those of a rich neutral tint, where, upon the whole, blue predominates, and where intensity of light makes most unobtrusive patterns appear marked with agreeable strength. In this country the scenes most popular

The porcelain manufactory of Messrs.

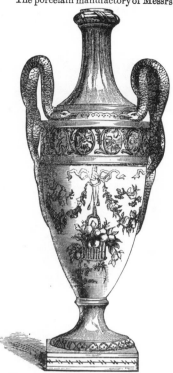

ROSE, of Coalport, has been famous

for more than a century, always upholding the renown of British Art. The Exhibition furnishes proof of their capability to compete with any establishment in Europe. Our selections are chiefly of VASES, of which they, in conjunction with Messrs. DANIELL, of New Bond Street, London, show a large variety, of many forms, and all good—good in

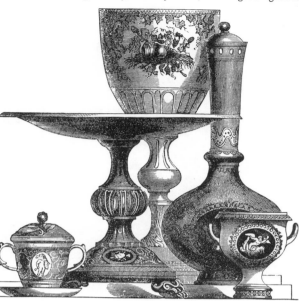

design and character, and admirably painted. We may especially regret in this case that our engravings cannot have the advantage of colour, for in that respect the Manufactory holds the highest rank, chemistry having done as much as Art to sustain the proud position it occupies. The great advance in all productions of Ceramic Art

cannot fail to gratify those who desire to

promote British Art-industry in one of its

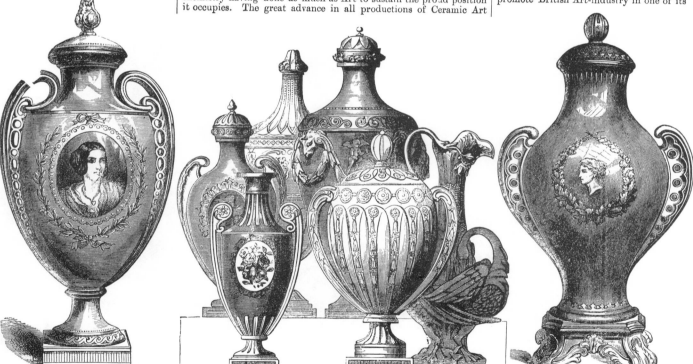

most important branches. Such advance is appa- | rent in the ordinary class of productions as well | as in those of higher order—an encouraging fact.

as pictures are those of sunny glades and sparkling brooks, represented in mid-day brilliancy or evening glory; and carpets, as well as other objects of domestic arrangement, partake of the same essential difference—a difference not dependent merely on better or worse taste, but also to no small extent amenable to the law of adaptation. We cannot eat what the Easterns eat, nor live as they live; and it seems a plain perversion of a physical law to suppose that what secures the highest enjoyment to them in the combinations of colour, should yield to us also the highest source of enjoyment. We require more brilliancy and intensity, in consequence of atmosphere, before we reach what their qualities are to them, and also additional quantity, from our different modes of life. The Indian uses his carpet for prayer, and he takes care that its general tone shall be pleasant, but that the pattern shall not be such as to attract the

mind from his devotions. The soundness of the principle is indisputable; but while the carpet of a room should be subordinate to all upon it, there is as little doubt that it should form an unmistakable portion of the room's adornment, both in distinctness of design, and in richness of colour. This is the Indian principle applied to British wants; but, as will, by-and-by, be shown, it is not a principle exclusively Indian, although the clever application of it to their own wants took Europe by surprise in 1851. Besides this inherent dissimilarity dependent on physical causes, there is another obvious reason why the Indian type of ornamentation, at least in its Indian form, should not obtain a hold over the producing and consuming classes of Britain. In India and throughout the East, carpet-weavers, like all the other craftsmen, are artists, i.e., men who work out their own ideas, whether inherited from tradition, or

From the contributions of Messrs. BATTAM

AND SON, Gough Square, Fleet Street, we have

selected for representation: a group of ETRUS-

CAN URNS, VASES, and a TAZZA—of various

shapes and sizes, in terra-cotta, which ably illustrate the progress of Art-manufacture in the reproduction

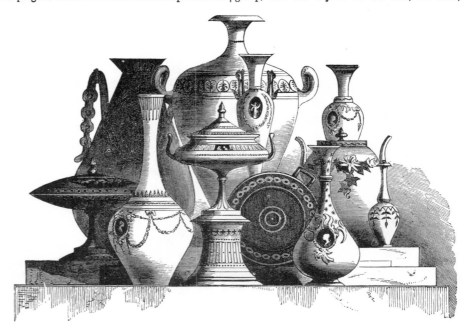

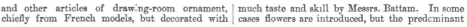

and other articles of drawing-room ornament, chiefly from French models, but decorated with

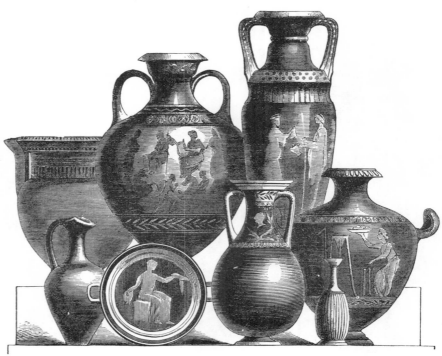

designs are figures, cameos, and chased gold ornaments. It cannot fail to interest our readers to know that in the very heart of the city of London,

of these famed works of the ancients. The upper group, and the objects on the side, are vases,

much taste and skill by Messrs. Battam. In some cases flowers are introduced, but the predominant

close to its densest and darkest thoroughfare, there is a manufactory in which many beautiful works of Art are designed, modelled, painted, and produced.

attained by individual judgment or caprice. They produce only for the few, the manufacturing workmen of this country produce for the many. Work done by machinery—especially work connected with Art—can never be so artistically varied as fabrics produced individually by the hand. In the eloquent words of Dr. Whewell, " the machine, with its million fingers, works for millions of purchasers, while in remote countries, where magnificence and savagery stand side by side, tens of thousands work for one. There Art labours for the rich alone; here she works for the poor no less. There the multitude produce only to give splendour and grace to the despot or the warrior whose slaves they are, and whom they enrich; here the man who is powerful in the weapons of peace, capital, and machinery, uses them to give comfort and enjoyment to the public, whose servant he is, and thus becomes rich, while he enriches others with his goods."

Nothing can be added to the justice or force of this contrast, and while it represents the difference between British and Indian textile fabrics, it also indicates the reasons why the Eastern style could never become ours, however beautiful in character or perfect in production. There are qualities which are the common property of all successful ornamentations. The higher appreciation of the good lines; the more careful and artistic filling up of spaces with details in unison with the quality of outline; and in a less degree to the improved knowledge of the influence of colour, either for good or evil, according to its arrangement and distribution. These are the forms in which England's progress has been displayed, and these are as much the properties of Italian as of Indian or Tunisian Art; and while the intellectualism, combined with the former, has made it influential, because founded on examples which have been systematised almost into canons, the

M. JULES WIESE, the eminent jeweller of Paris, is a German, though long settled in the capital of France. An idea of his productions may be obtained from our engravings

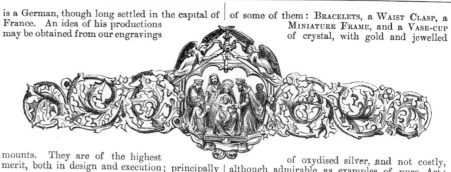

of some of them: BRACELETS, a WAIST CLASP, a MINIATURE FRAME, and a VASE-CUP of crystal, with gold and jewelled

mounts. They are of the highest merit, both in design and execution; principally

was the principal artist of M. FROMENT MEURICE,

of oxydised silver, and not costly, although admirable as examples of pure Art:

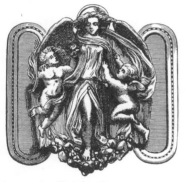

and is a worthy disciple of a great master. He

correct in drawing and modelling, and sharp and clear in manipulation. They are valuable indeed for all the qualities that Art-lovers seek in personal decoration. M. WIESE is at once the artist,

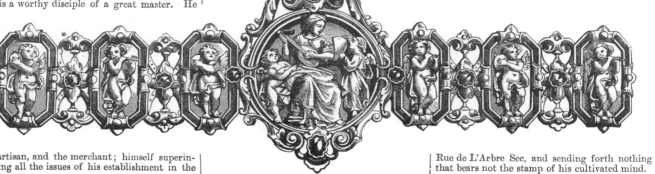

the artisan, and the merchant; himself superintending all the issues of his establishment in the

Rue de L'Arbre Sec, and sending forth nothing that bears not the stamp of his cultivated mind.

traditional and passive character of the other is but little calculated to impress itself on the industry of an energetic and intellectual people. Indian Art carried us back to the study and re-examination of first principles, but, as the present Exhibition shows, it was with the higher minds of Italy, and not with the oracles of the East, that our countrymen have communed in the application of these principles to British manufacture. Nor have the French been more successful in securing popularity for any special type of Indian Art in connection with their manufactures. The gorgeous show which, by its harmonious brilliancy, dazzled them, as it did some of the British public, lived out its short season of applause; but in Paris, as in London, the eye soon became satiated with walls of gold, with carpets of rich, indefinite, neutral tints, without the only qualities which made them valuable, or even endurable—the artistic and individual labour which could afford to diaper a handkerchief with a thousand colours, as M. Blonqui expressed it, and lavish all that beauty which nature had scattered over the winged creation, on fabrics wrought for dress. This was a species and style of Art, however attractive and beautiful in its barbaric splendour, wholly unfit for a different, and, as we think, higher, scale of civilisation; for while its first principles might be correct or even perfect—and they were vastly more perfect than our own—the motive power for the development both of moral intention and material force, rendered them all but impracticable inutilities for the various civilisations of Europe. The Indian section, and its popularity, made change easier and improvement more rapid. It assisted those who had been groaning over the falsity of that vulgar naturalism which was perverting the national taste, and eating out the first elements of legitimate design from the industrial Art of Europe, to resist the further inroads of vulgarity; and for this help we cannot be too grateful:

Messrs. Howell and James, of 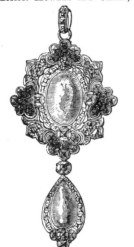 *bijouterie* and works in *or-molu*. We have selected for engraving some of their

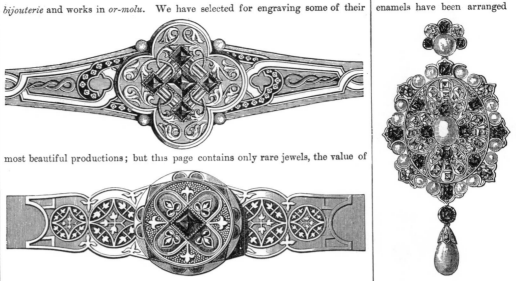

enamels have been arranged

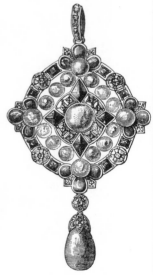

most beautiful productions; but this page contains only rare jewels, the value of

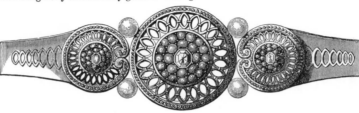

Regent Street, jewellers to the Queen,

which is greatly enhanced by graceful setting. The series of Bracelets in various

The Brooches and Lockets are deserving of equal commenda-

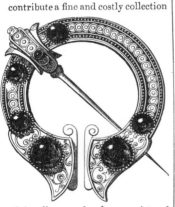

"styles" which occupies the centre of the page is especially elegant. They are

tion. Such an assemblage of "adornments" does credit to

contribute a fine and costly collection

valuable for the costliness of the materials of which they are composed, for their

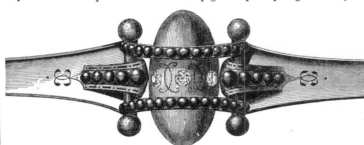

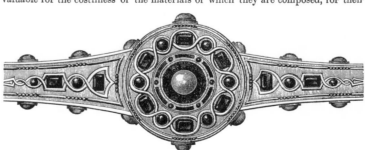

of jewellery, and a large variety of | simplicity of design, and the harmony of colour with which the various stones and | the skill of the British Jeweller.

but with this its mission closed, for it had no aggressive power capable of stamping its impress on the western nations.

Another predicted element of progress after the close of the Exhibition of 1851, was the reconstruction and improvement of our schools of Art. From the commencement of these institutions, they had undergone change after change, till it became difficult to trace the germ of 1837 in the transformations of 1850. But even these did not suffice, and again the system of Art-education was to be remodelled and improved. At first the schools of design were academies for the purpose of instructing artisans with a taste for drawing in those principles and that practice common to all Art, and as far as possible in those *specialities* with which each was industrially connected. These institutions were supposed to fail, and, whether they did or not, the system was declared imperfect, and a normal school for training teachers was added to

the School of Art; but further and more sweeping changes were at hand. After the Exhibition of 1851, Mr. Owen Jones, then a semi-official authority, said, speaking of design, "The time has arrived when it is generally felt that some change must take place, and we must get rid of the causes of obstruction to the art of design which exist in this country. There now seems to be a general feeling and desire for Art, and something must be done. I think the government may be induced to assist in forming schools throughout the country on a different footing from that on which they are at present established. We see in the ornaments and articles from India the works of a people who are not allowed by their religion to draw the human form, and it is probable that to this cause we may attribute their great success in their ornamental works. Here, in Europe, we have been studying drawing from the human figure, but it has not led us forward in the art of ornamental design. Although the study of the

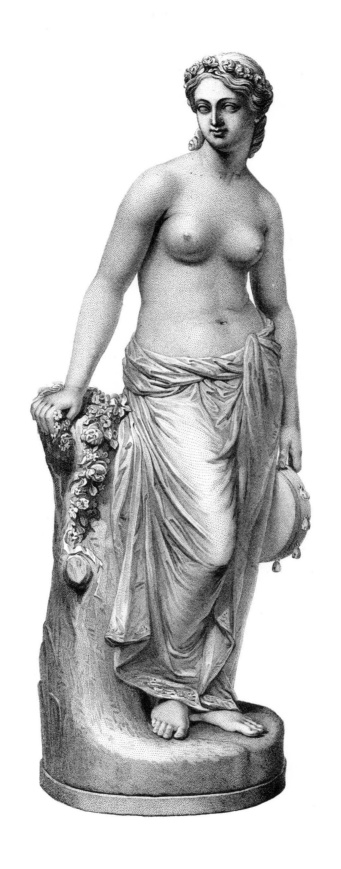

THE DANCING GIRL REPOSING

FROM THE STATUE BY W. CALDER MARSHALL, R.A.

IN THE EXHIBITION OF THE INDUSTRY OF ALL NATIONS.

Unlike most of the other manufac-

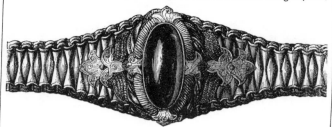

with which they have been designed, and the low price at which they are produced. The whole of the specimens we have engraved on this page are distinguished by good taste and artistic workmanship; upon all of them the enameller, the sculptor, and the skilled designer, have

reap his reward. It is, indeed, his

turers of jewellery, Mr. RICHARD A.

been employed. The enamels are especially worthy of notice. Many of them seem to be cameos, and, by a peculiar manner of setting, have a

"speciality," to bring grace and beauty

GREEN, of 82, Strand, exhibits works

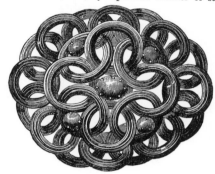

very beautiful appearance. The coral ornaments are remarkable for a novel arrangement that has been adopted in the mounting: a coral

within the reach of ordinary pur-

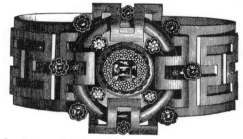

which are remarkable less for their

bead is placed in a polished gold cup, and by this means is produced a fine reflection. We have, at various times, strongly urged upon manu-

chasers, and not to produce them only

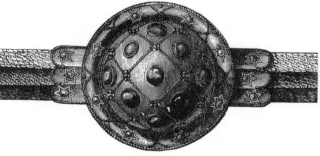

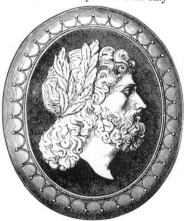

intrinsic value than for the beauty

facturers the very important truth that beauty is often cheaper than deformity, and that it is for their interest to employ artistic skill in the ornamentation of articles of ordinary use. Mr. Green appears to have been influenced by such conviction, and we have little doubt that he will

to be the exclusive privilege of wealth.

human figure is useful in refining the taste and teaching accurate observation, it is a roundabout way of learning to draw for the designer for manufactures;" and Mr. Jones hoped that, "in the formation of elementary schools, a better means might be formed for producing the desired result." Mr. Henry Cole was still more explicit, and in summing up the advantages of that Exhibition said, "Already the intention exists of making drawing a part of our national education, and out of that intention sprang the Department of Science and Art. It is impossible to note the progress of Industrial Art in this country, and ignore the action of that Department on the national mind, and it is difficult, amidst the strife of conflicting interests and opinions, to determine the value of its operations. Tested by the popular standard of 'paying for results,' if these are sought for in designers educated in the schools, the aspect is far from encouraging; for, estimated by this standard, every artist produced

would have cost the country his own weight in gold. Other considerations, however, must not be overlooked, and these will be best stated by the officials most deeply conversant with the system, and most interested in its permanence and success." In the evidence attached to the report of a committee appointed by Parliament in 1860, to investigate into the affairs and working of this department, Mr. Cole says (p. 37), in answer to a question from the chairman, Mr. Lowe, M.P., "I am loth to speak of my own case, but I am bound to do so; I think that I am very unjustly treated. In 1852 I was appointed to take charge of twenty schools of design which were in a little confusion, and to try and put them in order; I was appointed at £1,000 a year. Since 1852 the schools have increased from twenty to eighty, and the pupils have increased from 3,200 to 85,000 at the present time. The cost to the state, as I pointed out, has decreased from more than £3 in 1852 to 9s.

Among the largest and most important exhibitors of cabinet-work are Messrs. JACKSON AND GRAHAM, of Oxford Street. The most remarkable of their contributions is the BUFFET, or sideboard, we have selected for representation on this page. It is of pollard oak, and in the style of the Renaissance. We regret we cannot give this work any descriptive notice; but the details speak for themselves. The whole of the carving

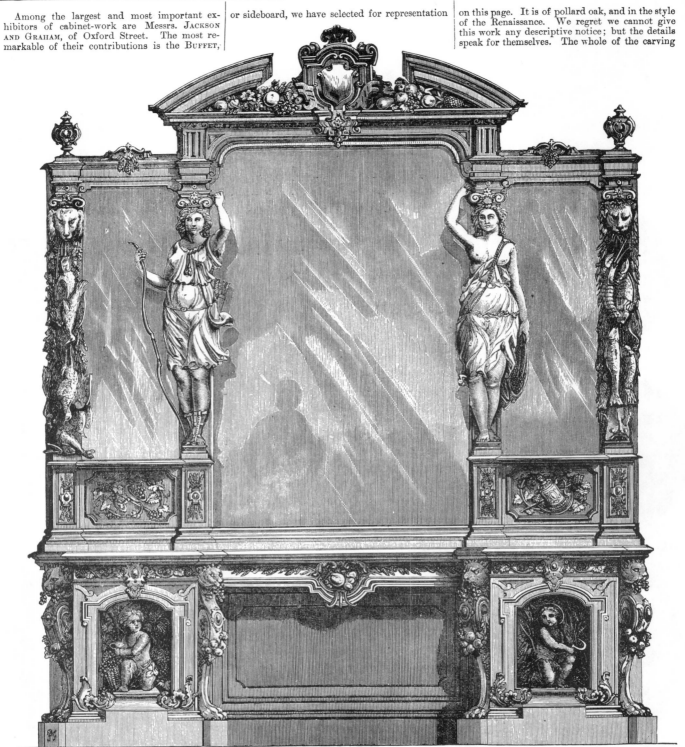

is left "dead," whilst the intricate mouldings and framing are veneered with polished oak. The designer is M. LORMIER, draughtsman to the firm.

per student in 1860." Mr. Cole then complains, that while his duties have been so largely increased, he has had no corresponding increase of salary, and that commercially he was worse paid with £1,200 in 1860, than he was with £1,000 in 1852. But the personal question is not before us, and the object of this quotation is to show the official estimation and increase of the schools. Whether the 85,000 pupils included all who were being taught drawing in the common schools under certificated masters from Kensington, does not clearly appear, but on either supposition one or two questions arise as to the influence exerted by these institutions on our Art-Industrial progress. If the eighty schools of design, with 85,000 students, are teaching a ratio of knowledge equivalent to that taught by the twenty schools with 1,200 students in 1852, one of two results would seem to be inevitable; either the great numerical increase, combined with the improved method of tuition, ought to be producing a proportionate increase of designers, both in quantity and quality, or the country must be paying not for "results," but for organisation. Or, which is more probable, this 85,000 did include all under the teaching of the Kensington system throughout the country, and, if so, the reduction of cost per student had no direct bearing on the real question under investigation. To teach a boy his A, B, C, naturally costs less than to perfect him in the classics, and the cost of teaching lads in the common schools to draw, however important, cannot be reasonably compared with the expense of educating those who could already draw in the higher elements and principles of Art. The one was confided to such artists as Dyce, Redgrave, and their compeers—artists whose time was valuable, and required to be paid for, but whose influence and skill as instructors were worth all the money cost; the other is taught by men not incompetent, perhaps, for their work of teaching boys the mystery of imitating forms, but who are not

The house of GILLOWS, Upholsterers and Cabinet Makers, has been famous for upwards of two centuries, having been established, first at Lancaster, so early as the reign of Charles II.;

keeping its renown from that far-off day to this, ranking always among the very best of British manufacturers. The object we engrave on this page is a richly carved SIDEBOARD of their manu-

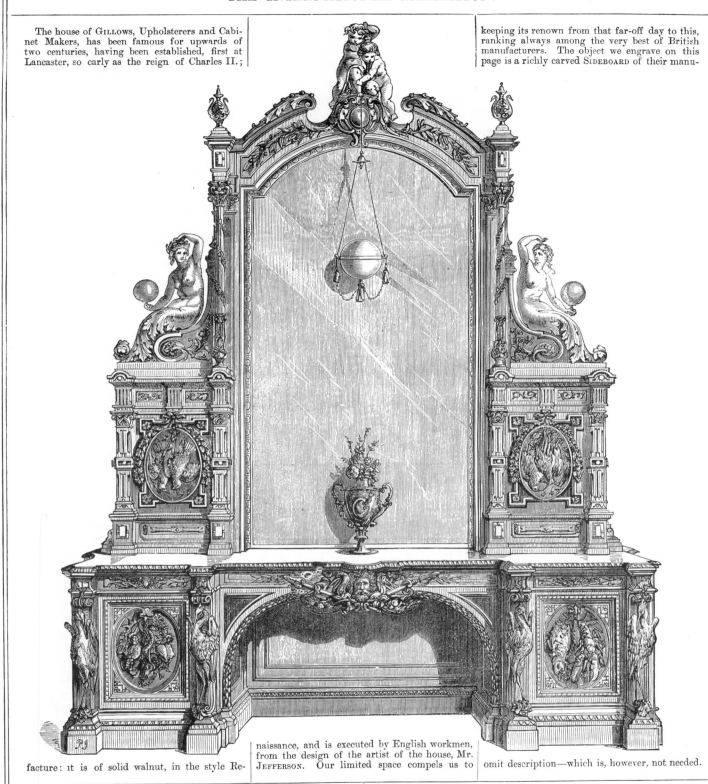

facture: it is of solid walnut, in the style Renaissance, and is executed by English workmen, from the design of the artist of the house, Mr. JEFFERSON. Our limited space compels us to omit description—which is, however, not needed.

conspicuous for any knowledge of the higher elements of Art. And it would be as just to compare the hedgerow lessons of the Irish tutor with the scholarly influence and enthusiasm inspired by the prelections of an university professor, as to compare the high teachings of Dyce with the small tricks of a certificated drawing-master. In 1852 the annual cost of Art-teaching and its cognates was £15,000; and during the sixteen years of its existence it had cost the state £87,000. In the year 1860 the annual cost had reached £103,382, while the cost from '54 to '60—a period of seven years—had risen to an aggregate of £539,321; so that if money has any living power in the propagation of such interests, the influence of these schools ought to have been prodigious on the Art-progress of the country. The Commissioners should take some means of showing how many designers the nation has secured, and of what quality, from their exhibited works, in lieu of this half million sterling. And if the

works from designs by those educated under the old system could be distinguished from those educated under the new, it would be highly satisfactory, as showing the relative merits, as we have the official relative cost, of the two systems. It would be unreasonable, however, not to make due allowance for what lawyers would call change of venue on the part of the Department. They have not confined their labours to the production of designers, that is, of results most easily tested. They, in the education of teachers and children in the common schools, have been laying a basis on which a nobler superstructure can be erected—a generation elevated by, if not cultivated in, the daily practice of Art. And adequate allowance ought to be made for this underground excavation. There always will be different opinions respecting better or worse plans of tuition; but apart from such difference there can be but one opinion on this, that every system must produce some points not hypothetical

From the many excellent contributions of **Mr. J. M. Levien**,

the eminent upholsterer of Davies Street, Berkley Square, we make a selection to occupy this page. The small CABINET is of

tulip wood, inlaid with plaques of Sèvres china. The cabinet is in the "Pompeian

style," of various coloured woods, and inlaid with ebony and ivory. The principal

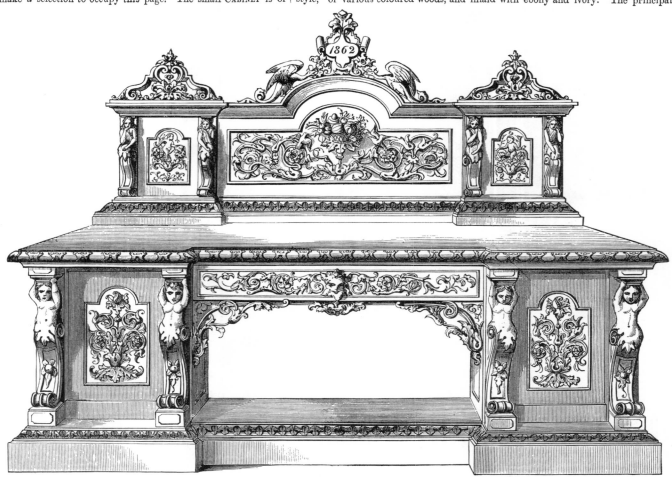

object, however, is a SIDEBOARD of the woods of New Zealand, richly carved by able Art-workmen.

These beautiful woods were first discovered, twenty years ago, by Mr. Levien, who, after working them

for some time in the colony, introduced them into his extensive manufactures in England.

or perspective, but actual and present, which exists on public approbation—and Art is no exception to the general rule. Among the lads who were at school ten years ago will be found the present men of action in affairs of industry and commerce. The university men of ten years ago are now the rising or risen men, at the bar, in the church, and in the senate. The students of ten years ago are the artists rising to eminence in their profession—men who are making for themselves a name and position which will support the artistic reputation of their country. And it is not unreasonable to expect that those who have been students of design, and educated chiefly at the national expense, shall show some of that power and vitality so conspicuous in other kindred walks of study. The plea of national inaptitude or incapacity is put out of court because it will not be alleged—nor will it be believed—that pattern drawing is more difficult than painting pictures, or that a design for a piece

of furniture is more difficult to create than a good statue. What the public are entitled to expect, and what they will probably insist upon obtaining is, that reasonable measure of general ability from students taught designs, and that proportional individual pre-eminence which other conventional institutions produce in law, physic, literature, theology, and the Fine Arts. Without this no system of tuition can be considered successful, and nothing but average success can render permanence either probable or possible. Many affirm that the Art schools of the Department at Kensington and elsewhere do not produce this average of ability, and few dispute the assertion that the students educated there have not been publicly known for their influence in promoting the Art-progress of the country. They may—we may say must—have exercised some influence for good; but faith falters respecting the virtue of a leaven which makes no sign, while all other leavens are active, and when

THE KEAN TESTIMONIAL manufactured, in oxydised silver, by

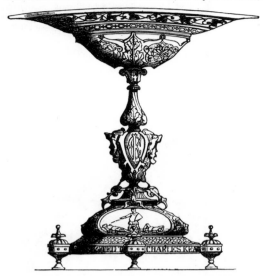

Messrs. HUNT AND ROSKELL, and designed, and in part executed,

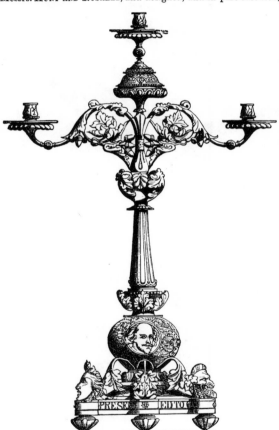

by Mr. H. H. ARMSTEAD, is engraved on this page. The work

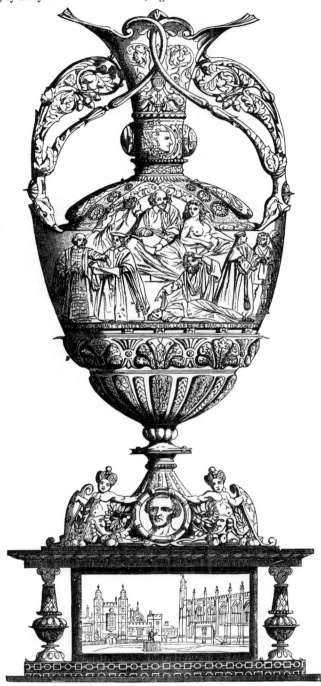

is of the very highest order of Art. The centrepiece contains illustrations from Shakspere; the pedestal having the inscription—"Presented to Charles John Kean, Esq., F.S.A., by many of his fellow-Etonians, together with numerous friends and admirers

among the public, as a tribute to the genius of a great actor, and in recognition of his unremitting efforts to improve the tone and elevate the character of the British stage."

progress is achieved without the prominent agency of the power established to produce it. The works exhibited in this International Exhibition will be arbiters between the opponents and supporters of the present system. Should the designs by students educated by the Department be reasonable in number and respectable in quality, even although no distinguished ornamentist has appeared among them, the unseen will be accepted on the credit of what is tangible; but if these designs be meagre in quantity and poor in spirit, portions of the public and public men will roughly compare the products with the price, and no influence will be able to save an inefficient system conducted at such enormous cost—a cost not too great if the aim is reached, but beyond defence if the work and workers inadequately sustain the system they represent.

If the Indian sections, and the change of Art-education in the Schools of Design, with increased number and increased cost, have

not exerted much influence, the not unreasonable question is—what has produced the change, if national progress in the Industrial Arts be a reality, and not a myth? Such interrogations can be condensed into a sentence with distinctness, while to answer them, when that can be done, may require many pages of elaborate, mingled with much hypothetical, writing. Such a case is the present,— the influences which have been at work during the last eleven years, cannot be always separated from each other, even when springing from different directions; nor can the precise value of each be more than probable, and sometimes inferential, deductions. The official method of dealing with this question will, perhaps, be much more simple and comprehensive. The general progress may be placed on the one side, and the Department of Science and Art, with its annual charge, on the other, and the country may be invited to accept the *quid* for the *quo*. But, in the face of other influences far more

The eminent manufacturing firm of Messrs. ELKINGTON & CO., of London and Birmingham, are extensive contributors. We have selected, as

preliminary examples of their works, the three objects engraved on this page. The largest is the silver cup called the "QUEEN'S CUP," presented last year by Her Majesty to the members of the Royal Mersey Yacht Club, and won by

the *Æolus*, owned by Mr. C. J. Cooper, jun., of Glasgow. The design is strictly of a nautical character; the lid surmounted by a schooner-yacht, under full canvas; the body of the cup, on which

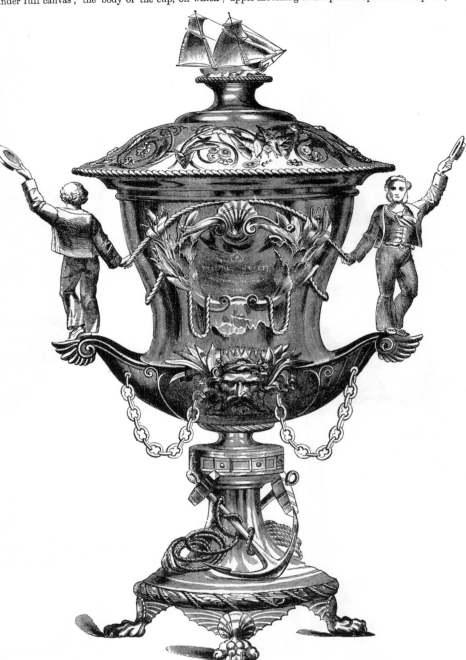

and the lower part is ornamented with anchors and cables. On the opposite column is an elegantly designed WATCHSTAND of oxydised silver, with gilt ornaments. It is followed by a fine bronze VASE, a

is the inscription, rests on a basin of shell-like form; and on each of the handles, as supporters, stands a sailor "holding on" by a rope. The upper moulding of the plinth represents a capstan, portion of the drinking-fountain, designed by Mr. C. H. DRIVER, architect, to be placed in Kennington Park. It is the gift of Felix Slade, Esq., and will cost between three and four hundred pounds.

powerful, such a conclusion would be unwarrantable, both as regards the nature of the progress made, and the causes by which it has been produced. The Exhibition of 1851 was itself one grand cause of the progressive movement which followed; not so much from its influence upon the Art teachers, as from its influence upon the multitude of minds who saw its contents. It was impossible that hundreds or thousands of workmen should see what others had done and were doing in their individual trades—taking stock, not of general effects only, but studying the individual detail of objects, similar in use, but different in form, ornamentation, or construction—without being benefited by the mere mental exercise, and carrying away some portion of what they saw from others superior to themselves as draughtsmen or craftsmen. The evanescent nature of such impressions—for they seldom reach to the maturity of knowledge—would have perished like spring blossoms nipped with frost, had there been no illustrated

Press, to revive impressions, and transmute them into knowledge founded on matured opinions. Such publications as the *Illustrated London News* spread abroad among the people what each had personally examined, and what others, considered more or less competent, preferred; and in this way these illustrated serials, first carefully examined, and then preserved for reference or pleasure, have exercised an untold and inestimable influence on the public mind of England and of Europe. These messengers of Art, not only influenced the fathers as to how things might be bettered in the workshops, but they stimulated the households of the nation, the wives and children, to compare and form preferences—a step essential to national improvement. Such preferences would often, as a matter of course, be unwise, and all the influences could not be elevating, because many, very many, of the articles of furniture, for instance, were false in taste, and the selections for these illustrated serials were sometimes

The principal object on this page is a fine CENTRE-PIECE, manufactured by Messrs. SMITH & NICHOL-

son, of Duke Street, Lincoln's Inn Fields, some of whose works we have previously illustrated. This, which is of massive proportions and good design,

is the testimonial presented in 1861, at a public dinner presided over by the Premier, to the Right

Hon. Sir William Goodenough Hayter, Bart., M.P., on his retirement from official life, by 365 members of the House of Commons, who thus testified their esteem for the right honourable baronet· "in remembrance," as the inscription

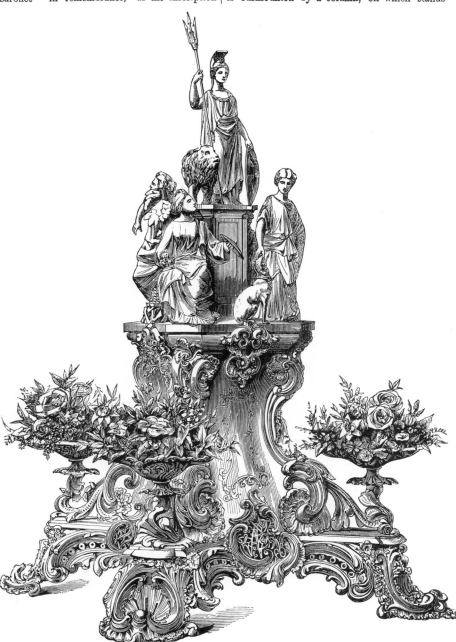

"Britannia," holding the trident, and accompanied by the traditional "lion." Around the base are four female figures, intended to represent "Loyalty," "Fidelity," "Justice," and "Industry," each with appropriate ensigns. The smaller

states, "of the courtesy, firmness, and efficiency, with which he performed the duties of political secretary to the Treasury, between the years 1851 and 1859." The pedestal is richly chased, and is surmounted by a column, on which stands

objects are from the same excellent manufactory. The one is a DESSERT-STAND, part of a very elegant "Service;" the other is a CUP and COVER, recently made for St. John's College, Cambridge, as a Volunteer's Challenge Cup.

ridiculous—the worst among the bad. But, in spite of all drawbacks, these publications did then, and have done since, more for instructing and improving the popular mind respecting Art in all its bearings than any, or, indeed, than all other agencies put together.

In this education the ART-JOURNAL has occupied the most prominent and influential position; but it will detract nothing from that recognised influence to assert that the most potent individual power in the industrial Art-progress of England since 1851, has been the Illustrated Art-Journal Catalogue of the Great Exhibition. It has been the companion, if not the text-book, of every designer in this country, no matter what his *specialitie*, and the reference-book of all interested, to any considerable extent, in the manufacture or sale of those industries it professed to illustrate. To the designer it has been a *repertoire* of ideas: he may not have sought designs, but he has both sought and found hints, both of what to adopt and to avoid,

and not in Britain alone, but throughout the civilised world; and it will continue to be a standard work of reference, because the very imperfections of many of the objects it perpetuates, are suggestive to those interested in combining beauty with novelty and utility. Another element has exercised a powerful and, upon the whole, most beneficial influence upon the progress of industrial Art in England. One of the two great defects in the British section in 1851 was the want of attention to form, and the surplus of ornamentation. These are therefore the grand defects in the teachings of those illustrations whose influence has been so important. Another influence arose to supply the necessary want, and to magnify the value of forms, to the neglect of other considerations. The phase of truth which this section of the Art-loving people has embraced, was the precise truth wanted by the British public, and without believing that truth and beauty are only to be found in Gothic, it would be

The very beautiful and elaborate specimen of MOSAIC PAVEMENT engraved on this page, is contributed by Messrs. MINTON, HOLLINS, AND CO., of Stoke-upon-Trent. It will be seen that the general form of the design consists of a central octagonal panel, surrounded by four square and four polygonal panels, and a guilloche border enclosed by a broader one, which contains eight emblematic medallions. These are in encaustic tiles, as are also four small subjects in the square panels next the octagon; in the centre of which is a classical head or medallion, ten inches in dia-

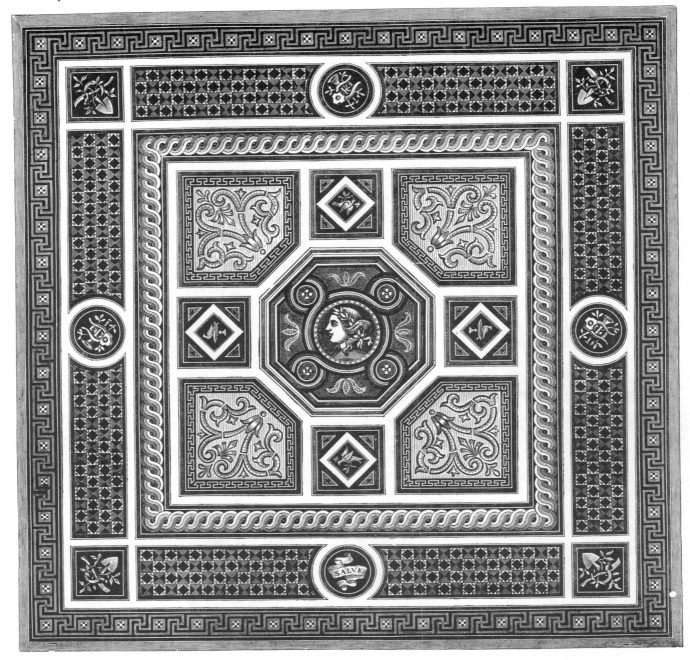

meter, which is composed of more than 8,000 pieces of tesseræ; and to show the immense amount of labour and ability called forth in the manufacture of this small piece of pavement, it has been carefully estimated to contain 150,000 pieces, every one passing singly through the hands of skilled workmen. We rejoice to accept this elaborate and admirable work—and others of equal merit contributed by the same firm—as evidence that the mantle of the late Herbert Minton, in this his favourite pursuit and speciality, has fallen upon worthy successors at Stoke-upon-Trent.

folly to deny the beneficial influence which the advocates of that style have exercised on industry. They have taught all interested the value of a good line, and that simplicity combined with elegance is more beautiful than florid ornamentation. They have urged this truth with such persistence and success, that to them must be ascribed a considerable share of honour, as helpers in our national progress. Their direct influence has increased largely in the public eye. They made Gothic fashionable among a class of young architects, just as Pre-Raphaelism was made fashionable among a section of young painters. They have secured the perpetuation of Gothic churches, Gothic schools, and a few Gothic halls, dwellings, and warehouses, just as there have been Gothic chairs, book-bindings, and ladies' ornaments; but the major portion of this has been the result of fashion, and is even now passing away, while the indirect influence of the zeal is teaching truths which are rapidly incor-porating with the industrial mind, and which will leave their impress on industrial Art. Those who admire and select Gothic furniture and furnishings, except for churches, are few, and their number will probably decrease; but those who delight in simplicity and beauty of outline, which is one of the central truths of Gothic, have multiplied exceedingly. This number will go on increasing, and to the advocates of Gothic must be awarded the credit of having aroused producers, as well as a high class of purchasers, to the importance of the subject. These artistic sectaries have, through their influence and zeal, purified what popular illustrated literature has taught, and their joint efforts and action has been immeasurably more powerful in the production of industrial Art-progress in England than all other influences and agencies combined.

The Kensington Museum has been already mentioned, and it is impossible to doubt its enlightening influence, for neither designer

A PICTORIAL MOSAIC PAVEMENT, thirteen feet three inches by ten feet six inches, suitable for entrance hall, or vestibule, manufactured by Messrs. MAW & CO of Benthall Works, Broseley, Shropshire, from a design by Mr. M. DIGBY WYATT, is the principal object engraved on this

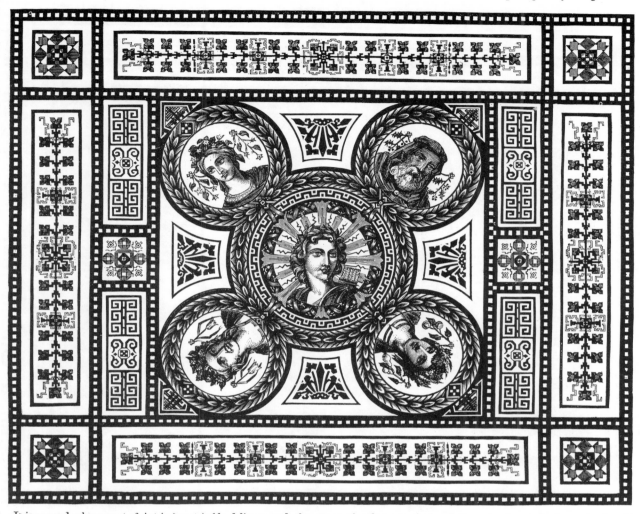

page. It is a grand achievement of Art in burnt clay: the flesh tints are graduated with remarkable delicacy, and the range of colours in the *tesseræ* enables the most elaborate pictorial representations to be similarly rendered with an amount of detail approaching a finely finished

painting. The bulk of the *tesseræ* in which the pavement is executed, is of quarter-inch cubes, above eighty thousand of which, with other sizes, enter into its composition. We also give engravings of some of Maw & Co.'s MAJOLICA TILES. Each represents a tile six inches square.

nor producer can spend a day more profitably than there; and although the students—that is, all who go to learn—bear but a small proportion to the visitors without a purpose, and because they are admitted without charge, even these are involuntarily benefited by the objects with which they are brought into contact. Admitting the influence of this museum, therefore, the fact cannot be overlooked that those most likely to be interested and influenced by such a collection, gather more instruction from the Hotel Cluney, in Paris, than from our Museum. It ought not to be so, for the one collection is at least not inferior to the other; but the fact is undeniable, that in Art, as in other matters, the far-off fowls have fair feathers, and most Englishmen will be more vividly impressed with what they see in Strasburg or Milan, than with what they see at Hampton Court or Kensington. Everybody sees, or can see, the specimens there, and for a designer to take them as his base is like scuttling his own ship, or hoisting himself on his own petard. There is both charm and instruction in being able to compare the living with the dead—the France of Watteau with the Paris of to-day, or the modern Florentine with the decorations of San Miniatta; and objects dragged from their place and purpose, however valuable as parts, are neither so impressive nor instructive as similar objects viewed with their legitimate surroundings. It is for these reasons, among others, that all designers and manufacturers who can afford it visit continental nations as matter of business; and therefore we conclude that facility of intercourse, since 1851, has exercised more influence on British progress in this department than the Kensington Museum, advantageous and admirable as that is. National temperament, and national respect for common sense, have also been productive, the former, by rejecting developments which the latter had demonstrated to be absurd, and through these and other influ-

Messrs. John Hare & Co., the eminent floor- | cloth manufacturers, of Bristol, having produced | a work of singular merit, we are gratified to

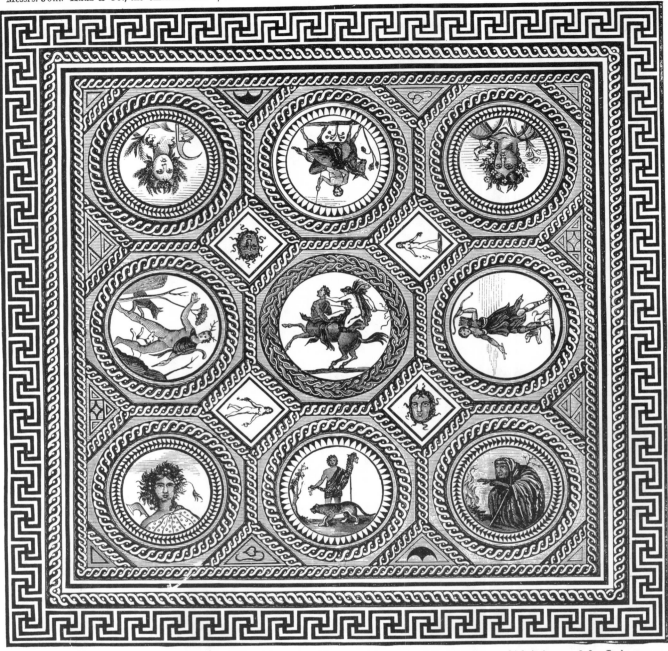

engrave it, as by no means an unworthy asso- | ciate of the more ambitious encaustic tile pave- | ments by which it is preceded. It is a copy of

the Roman Mosaic pavement discovered not long | ago at Cirencester—the ancient Corinium—or | rather a restoration of that venerable remain.

ences, conjoint and separate, the Art-industry of England has risen from what it was in 1851 to what it is in 1862; and the remaining question is, how should the quality and quantity of that be ascertained?

In the Exhibition of 1851 the principle of judgment was simple, and its application was therefore comparatively easy. It was occasionally difficult to determine between the real claims of competitors whose works were nicely balanced in the scales of merit; but the only question was to determine superiority, and the doubt being removed, the award followed as a matter of course. It will, and ought to be, very different with this Exhibition of 1862. Here the principles of judgment to be of value must be complex in their character, and therefore much more difficult in their application. Nothing will be easier, nor more useless, than to laud or depreciate individual works in well-sounding rodomontade, or sparkling denunciation—to blame a

child for not displaying the strength of a man, or to flatter industrial stagnation with the soothing remark that this, that, or the other individual or firm sustain former reputation, which simply means that they have not degenerated; but in a world of progress, and as respects the matter in hand, sustaining old positions ought to be held as equivalent to absolute industrial retrogression. It is in no blindness to the difficulties of making progress one of the main elements of approbation, that its necessity of being made a prominent test is insisted on, but from a conviction that without the element of progress being prominently kept in view, substantial justice will neither be done to the exhibitors nor the public. The Exhibition ought not to be degraded into the position of a grand bazaar, a place where rival nations and producers may expose their wares and take orders, although there will probably be no lack of influence to induce efforts for lowering to that position. It ought rather to be used as

Some of the cast-iron productions of Mr. WILLIAM HOOD, of Nos. 12 and 23, Upper Thames Street, are contained on this page. Excepting a LAMP-POST of good

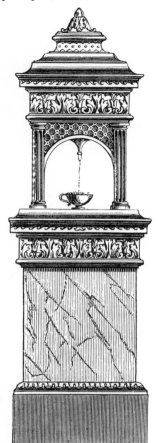

many of our public places—boons of incalculable value as con-

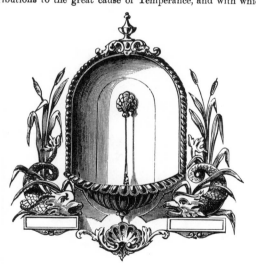

tributions to the great cause of Temperance, and with which

It is obvious that such valuable works can be, and are, produced at greater or lesser

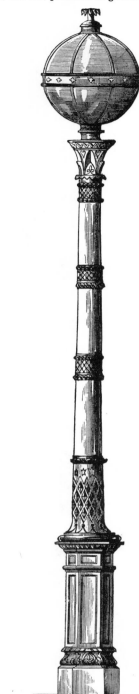

design, they consist of DRINKING-FOUNTAINS, produced to answer the large and growing demand for these social boons which benevolence has, of late years, given to so

the honoured name of "GURNEY" is so intimately associated.

cost, either in cast iron or in bronze, and in association with either stone or rich marble.

an arena for the display of national and industrial progress, where productions will be as much tested by evidence of progression as by any other characteristic. If Lyons outshone Spitalfields in silks, or Genoa surpassed Turin in velvets—if Birmingham put the japanned wares of Paris to flight, or Sheffield cut out the Zollverein in 1851—wisdom and equity alike conspire to show, that however satisfactory it may be to commerce to find out where the absolutely best silks, velvets, japanned goods, or cutlery are, to be had now (and this is all-important, so far as the Exhibition is made a mart), the points of interest for those devoted to the study or encouragement of Industrial Art are, first, the comparative progress which the manufacturers in such localities have made towards the former excellences of the other; and second, in what respects former superiority has been excelled by those who carried off the chaplets of victory in the former contest. Without this element of progress the labour alike of com-

missions and critics will be worthless, for while not insensible to the exciting delights and commercial advantages to the Exhibition as a gorgeous show, it would be beneath the enlightened and onerous duties of jurors in the Art or Art-industry Department, as it would be wholly beside the life-purpose of the ART-JOURNAL, to treat this concentration of the civilised industry otherwise than as a great teacher. The grand questions to be determined are the rates and ratios of industrial progress both at home and abroad, the Exhibition of 1851 being the starting-point; and no decisions which ignore this consideration can either be useful or satisfactory to the nations, however they may gratify the feelings or answer the business purposes of those who get medals or rewards. From this position it would follow almost as a matter of course that in all the higher classes of rewards the special and progressive beauties of the objects securing it should be set forth, so that not only the public but the producers in the

From the contributions of Messrs. GEORGE WRIGHT

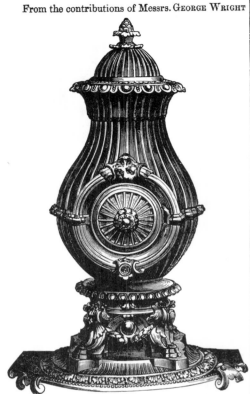

& Co., of Burton Weir, Sheffield, we select

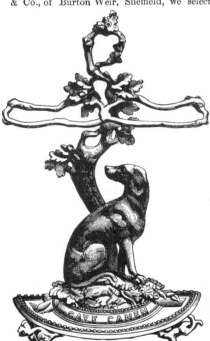

three objects; two of them being of little note,

although good in their way—a small UM-BRELLA STAND, and one of "WRIGHT'S

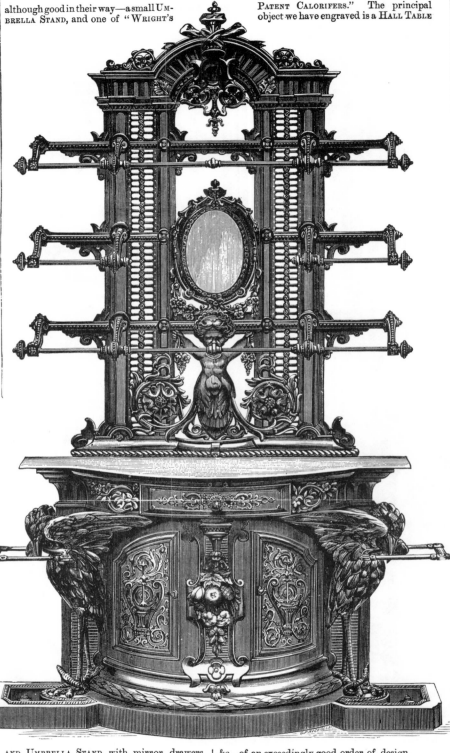

COAT AND UMBRELLA STAND, with mirror, drawers,

PATENT CALORIFERS." The principal object we have engraved is a HALL TABLE &c., of an exceedingly good order of design.

same branch of industry might benefit by the instruction. Nothing could be expected to come before the public, and those engaged in several branches of Industrial Art, with greater authority than the deliberate verdict, for reasons succinctly given, of the jurors in several of these classes. Take the difference between wood and stone construction for example—and there are few subjects upon which all classes are more at sea than this—and although many see that there must be an essential difference, and much has been written round and round the subject, still a perplexing halo of obscurity enshrouds it from the public ken.

Some qualities by which merit should be estimated appear to be obvious to all. The opposing principles of France and Greece, of Louis XIV. and the age of Phidias, have each had their admirers and advocates in the recent history of their country. The one may be said to represent the picturesque, the other the beautiful: the one heaps together forms and shapes incongruous, gathering them up into a reasonably well-balanced whole; the other is contented with less variety, but elaborates the individualities into separate forms of beauty, and out of these combines its structural unity of elegance and beauty. The one addresses itself to the senses, the other appeals to the intellect and the soul; and while the one merely attracts, or at worst dazzles the mind with its surface appearance of wealth and splendour, the other, through its great power, although slow to challenge the attention of the ignorant, secures the applause of the few, and successfully keeps its ground, and grows in interest with each new opportunity of study. It is the same way with works of Fine Art in modern exhibitions as with what is called the magnificence of this redundant French style. The eye is fascinated, it may be, with the first gleam, but there is nothing left for after thought to muse on—it is all outside. The Greek principle was

THE INTERNATIONAL EXHIBITION.

The famous manufactory of Messrs. STUART AND SMITH, of Sheffield, and John Street, Adelphi, London, contributes many admirable works to the International Exhibition. We engrave two of them on this page. The first is a mediæval Gothic Dining-room or Hall GRATE. It is fin-

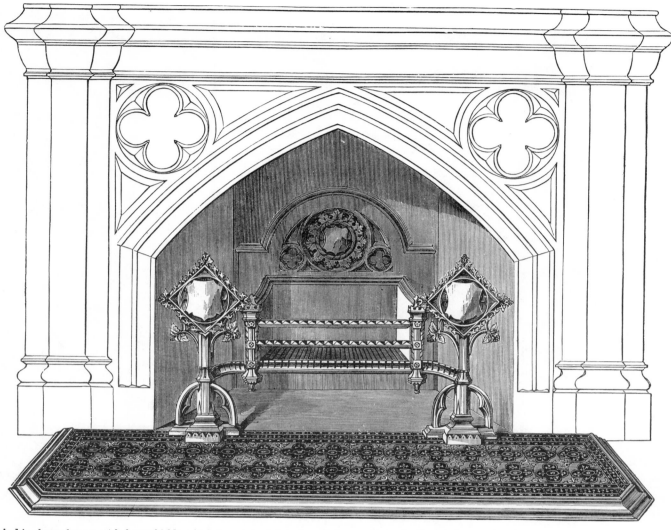

ished in electro-bronze, with brass shields, which are intended to bear the arms of the family in whose mansion it may be used. The grate can have either an encaustic tile hearth (as we have represented it), or an ordinary FENDER, such as that we introduce as its accompaniment. Both

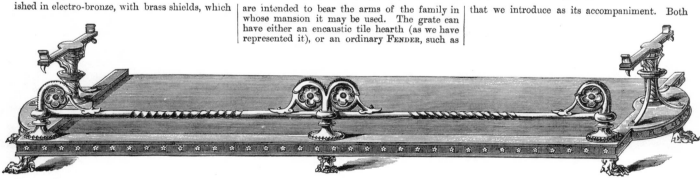

these productions of the great Iron Capital fully uphold the high character the firm has gained, not in England alone, but in all parts of the world.

entirely the reverse, there being little to attract compared with the abundance for meditation and reflection. Unfortunately, recent experience proves that whatever the artistic merits of the two, the style of France has driven the principles of Greece out of the popular market. When genius has, by new combinations, created a novel and united whole, the highest rewards are due; but novelty alone deserves neither consideration nor applause. What is wanted, and what ought to be rewarded and approved, is not mere novelty, but the perfection of what is, and the adaptation of Art-truths to modern necessities, and especially the genuine development of each industry within its legitimate sphere. The question of what is called "styles" is of course perfectly open, but not so the hashing up two or more styles together into an unsatisfactory unit, as in furniture, or similar articles. This was one cardinal defect very apparent in the Exhibition of 1851; and the jurors then could do comparatively little to mark their disapprobation of such combinations, for under the much abused name of Renaissance many showy articles passed not only without rebuke, but with positive approbation, which would have made the great revivalists start with astonishment. On this occasion there will be no excuse for official leniency, or, as it might now be called, perversion of judgment; for the education, through the press and otherwise, which the designers and producers may have acquired during the last eleven years, is more than sufficient to make such incongruities inexcusable. If the Renaissance be the style accepted by the public—and it will be difficult to find another with so many popular qualities—the duty of those having authority is to seek and encourage the refining and purifying of that style to the greatest possible extent, approving and rewarding those approximations towards the Greek arrangements, both in quality and quantity of

The HONITON LACE DRESS, that occupies this page, is exhibited by Messrs. HOWELL AND JAMES, of Regent Street. It is a work of great beauty, and will bear comparison with the finest fabric of Brussels. The design is graceful, yet very elaborate, every portion being covered. The border is composed of a scroll and floral chain, supporting a cornucopia, with bouquet of tulip, roses, escallonia, &c. A medallion, with very fine

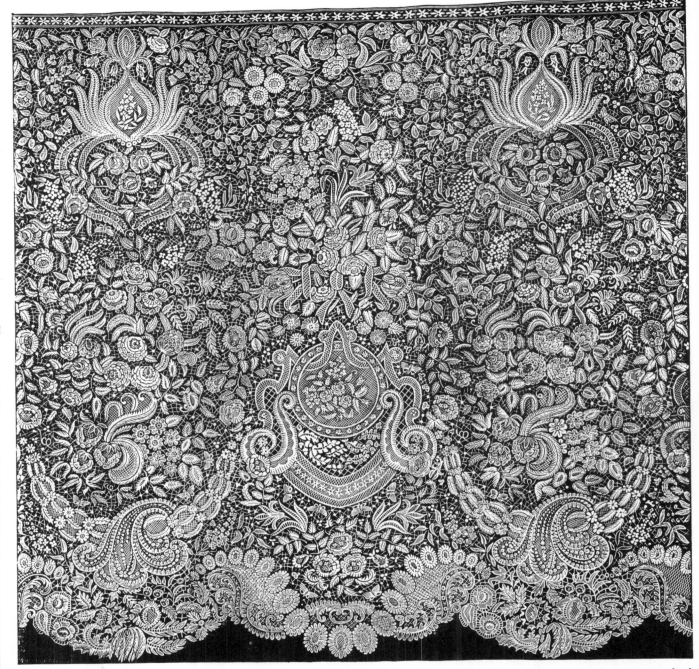

bouquets of rose, shamrock, and thistle, and a band of oak beneath. Encircling the medallion is a wreath of roses, amaryllis, tulips, and coreopsis.

The large bouquet in centre is composed of a variety of flowers, among which are ænothera, campanula, mysotis, phlox, roses, nuttalia, &c.

On the upper part of the dress is a wreath of laburnum, oxalis, and calendula. Perhaps no British production has ever surpassed this work.

detail, i.e. that the details shall not only be well understood, but as perfect as possible in their individual excellence, as well as so arranged as to produce a refined rather than a striking effect. If, on the contrary, those specimens of the Renaissance which approximate towards the French rococo are honoured and rewarded, the jurors may display the instinct of successful shopkeepers, although they would not only ill discharge, but retard and betray the higher interests of industrial Art-progress in England. Dread on this point is not mere idle fear, for the class to which the jurors generally belong have thought but little on such subjects, and are still under a vague idea that France is the arbiter of taste. In machine-made goods—and among these all may be classed except those which are individually finished by hand labour, and where the mind of the individual workman has more or less scope for the display of individual talent—for these manufactures the principles of Art require

to be reduced into a science, as in the ratios of colour suitable for the production of a pleasing chintz, where the most certain application of principles ought to be of infinitely more weight than the hap-hazard productions of a pleasing pattern. Unless the jurors proceed upon some principle how can the manufacturers be expected to do so? and until principles are recognised as the basis of industrial Art, progress must be impeded in the world's race for pre-eminence. This necessity could be illustrated to almost any length, and from a great variety of manufactures, system being the basis of our whole manufacturing superstructure; and it is as applicable to the production of patterns as to the manufacture of fabrics.

Another point should be well understood, namely—that no one individual shall obtain either honour or reward for another man's work. Unless this be considered imperative, the medals become a delusion and a farce—the evidence, not of genius, but of money, and utterly

We engrave on this page two examples of Lace, contributed by Messrs. Debenham, Son, and Freebody, of Wigmore Street. The first is a rich Brussels Flounce, of the finest quality, of the "point à l'aiguille" and "plat" mixed. It is designed by M. Bonnod, of Brussels. The second

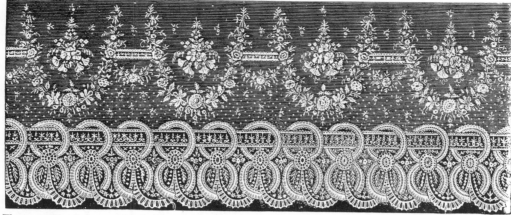

is a deep Honiton Flounce. The design consists of bouquets of wild flowers, with a border of ferns and ivy in *guipure*. Both the small and large

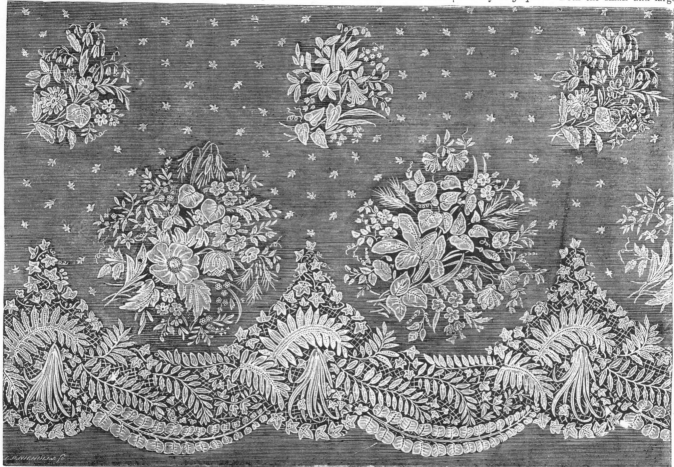

bouquets are varied alternately. The flowers selected are those most common in this country: the beautiful wild flowers that adorn our fields and lanes. The leading idea having been to produce a thoroughly English work, no recourse has been had for assistance to foreign designers.

valueless for the purposes for which they are ostensibly given, viz., to stimulate and reward the Art-element in connection with the producing powers of England. Every man, before he has his award, ought to show that what he is rewarded for is the product of his own skill, not as an individual act, but that it is *bona fide* his, through the industry which he employs. If, for example, retail shopkeepers exhibit goods, the manufacturer, and not the seller, should have the merit of the articles, and upon this principle all such cases will be treated by the Art-Journal. So, if a manufacturer sends to Paris or elsewhere, orders a design from one of the best artists, has it all prepared for execution by French workmen, brings it here to finish, then exhibits it as his, and is rewarded with a medal in the English section, the transaction is a direct practical fraud, not only against all the *bona fide* English competitors, but upon the public; and jurors who wink at, or, by collusion, support such courses, become

as reprehensible as the original perpetrator of the fraud, and ought to be—as they probably will, if such occasion arises as it did in 1851 —as publicly and severely censured.

Another point, and the last we can dwell upon, is as to the line which ought to separate Industrial from Fine Art, in the estimation of the jurors and the public. It is one admittedly difficult to draw, but that it can be drawn is seen in every-day experience, and the jurors could not set themselves to a more useful preliminary task, than to embody, in some specific form, this widely-felt practical distinction. In the precious metals, for example, the former method for estimating the value of a presentation service has its weight in ounces, and so long as that remained the test, such ornamentation as it had was evidently industrial. How different when standard prevails!—when silver and gold are not estimated by weight, but by the art with which they are adorned, the relations are so changed as

This page contains four engravings of LACE, selected from the extensive collection exhibited by Mr. W. VICKERS of Nottingham, who has long and

clearly. Various articles are made of this description, chiefly shawls, scarfs, mantles, tunics, flounces, &c. &c., in imitation of the real lace of Chantilly

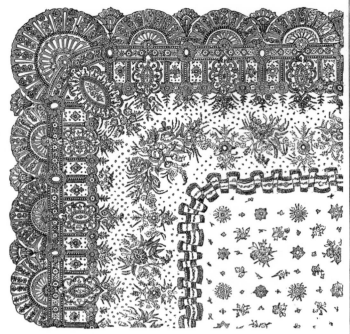

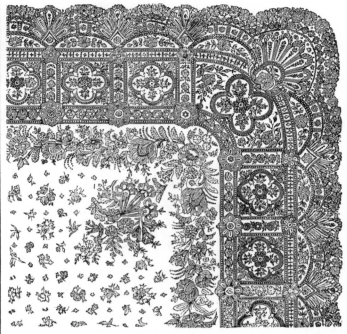

honourably upheld the renown of England in this important branch of its staple manufacture. These examples are the produce of the Pusher lace

and Bayeux, to which it bears a close resemblance in the structure of the net, and the general effect produced. As will be supposed, however, much

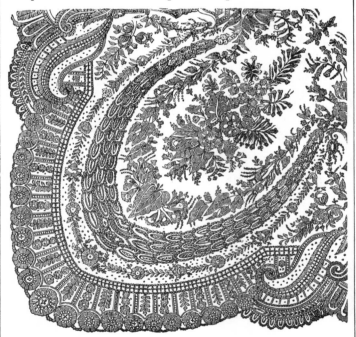

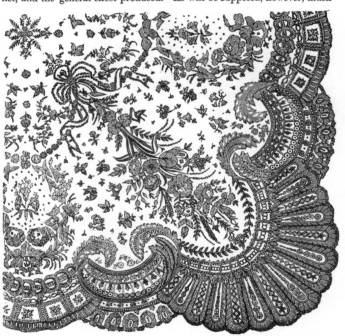

machine. The fabric, on leaving the machine, undergoes the process of embroidery by hand, in order to define the outline of the design more

difference exists in the price of the two fabrics, the one being wholly the produce of hand labour, whilst the other is principally machine-made.

to upset all former standards of comparison or excellence, and the objects cease, in many cases, to be Art-manufactures, and become works of Fine Art. When production is multiplied, as in bronzes, the question is settled; but when work is executed wholly by hand, it is difficult to see why the difference of material should make the difference between an artist and an Art-workman. Would Foley or Calder Marshall be Art-workmen if they chiselled figures in metal, and artists if they chiselled them from marble? And if not, why should men whose works are valued for their Art alone, such as Barbetti, of Florence, and many others, both in France, Italy, and England—men who are as much artists as the members of the Royal Academy—be permitted to come in under a lower standard, and carry off the medals devoted to industrial Art-competitors? These artists in gold and silver, brass, ivory, and wood, might devote a life to the production of a great work, and if the quality of thought was

equal to the time bestowed, it would be a work of Art—not of Art-manufacture—and would be valued and bought as such; but would it be reasonable or fair towards those who had to manufacture for the regular market, to allow that life-long work to come in with the certainty, and almost for the purpose, of carrying off the honour due to the best industrial Art-manufactures? The question will not bear discussion; but although so palpably unfair to the manufacturers proper, it is not so easy to secure a well-defined remedy for the wrong. Still it is one to which the Commissioners are bound to direct speedy and earnest attention, because a remedy for an injustice so palpable ought to be looked for at once, although the only prospect of finding it lays in a division of the classes to which the difficulty is applicable.

This introduction to the great theme of the year 1862—the INTERNATIONAL EXHIBITION—leads to the subject now actually before us.

THE INTERNATIONAL EXHIBITION.

The six subjects introduced on this page are taken from the WOOD-CARVINGS executed in com-

petition for prizes offered, recently, to Art-workmen by the Council of the Architectural Museum; they represent the carvings to which prizes were

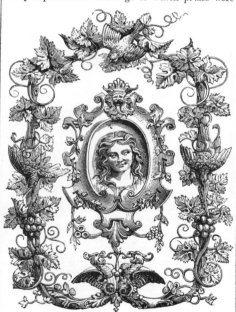

awarded. The first is designed and executed by H. REYNOLDS, of the Caledonian Road; by the side

of this is an example intended for a window, by

C. J. HERLEY, of Taunton; the next is a panel, by

J. SEYMOUR, also of Taunton. The fourth subject

is a panel, by E. DUJARDIN, of Walworth; the fifth, by A. ANGUS, of Vauxhall Bridge Road, repre-

sents the portion of a window. The last, by J. H. WICKS, of Coleshill Street, Eaton Square, is a panel of grotesque ornament. They are all excellent in

design; the carving is spirited and delicate: they give suggestions to many classes of manufacturers.

The BUILDING and the opening spectacle demand attention before passing to the Art-industries displayed in the International Exhibition: the first because of the opprobrium it has encountered; the other because of its universally recognised success. On the 1st of May the detail of the structure was still *unfinished*, and much had to be accomplished by exhibitors, but the general effect within was sufficiently attractive to hide what want of time, or want of head, had left doubtful or defective. In 1851 the highest award in architecture was conferred on Sir Joseph Paxton for his magnificent idea. Captain Fowke may not be so fortunate in 1862. The one was a creation, the other is an adaptation; and while that displayed the revellings of genius, this rests on the lower platform of constructive capacity. The gulf which separates creative power from acquired knowledge is both wide and deep. To become the medium of a new revelation is an honour rare among all thinkers, and not less rare among architects than others; so that whatever may be said against the work of Captain Fowke certainly does not prove that the professional architect who might have been selected would have produced a grander edifice. The elevations display two cardinal defects—the one arising from neglect of a central truth of Art, the other arising from inexperience as an architect. It has become rather a fashion to set up a wall of separation between the artist and the architect, and to enforce the *jejune* idea as a dogma that a painter can be no authority in architecture. This was the ground taken in the battle of the styles respecting the Foreign Office, and it has unfortunately become the creed of many young architects. The Exhibition building suggests that Captain Fowke may have been afflicted by the delusion, because the grand defect of the elevation to Cromwell Road is a violation of one of the best established principles of pictorial composition. The leading outline is weak in the centre,—a defect produced by the end

We engrave on this page some of the very excellent and valuable contributions of Messrs. JACKSON AND SONS, of Rathbone

Place, who have long been renowned for the production of works in papier-mâché and in "composition," lending large and effectual

aid to the architect, and producing the groundwork of nearly all the best looking-glasses which the gilder issues as the produce of his workshop. Our selections from the

works of this justly famous firm are limited to four

style Louis Seize; a MIRROR in the same style; a

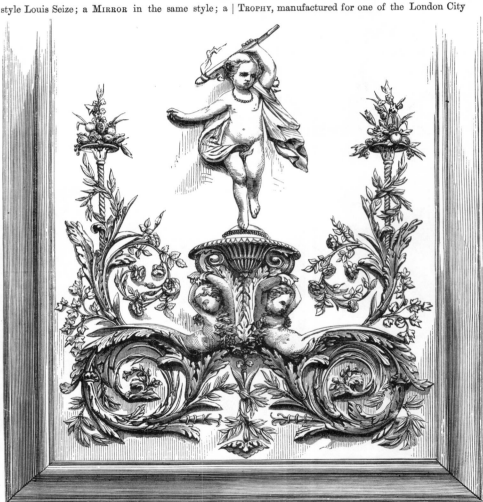

companies; and part of a rich Louis Seize WALL

specimens; they consist of a FLOWER-STAND, in the

TROPHY, manufactured for one of the London City

PANEL of carton pierre, with very elegant floral border.

towers and domes, and into which a good painter would never have been ensnared. The elevation plan of a building is essentially a picture, governed by the fundamental laws of Art; and it was this truth, embodied by the artist-architects of Italy, which rendered their constructions what they are. Invert a pointed arch, and behold the effect. Captain Fowke has, by the domes, inverted the lines of his composition in Cromwell Road, and the result in brick is precisely what it would have been in figures, trees, or cattle, upon canvas. The other defect, traceable to inexperience, is seen in the construction of the domes. The east and west fronts look reasonably well in the plans. When seen close to the eye, the domes do not appear out of linear harmony with the lower parts of the building, but experience would have made allowance for distance from the eye when built, and set the domes upon "drums" sufficient in height to

carry the eye clear above the roof and front of the structure. It is this not allowing for height which forms the bane of so many works that look well on paper; and that this is applicable to sculpture, as well as to architecture, may be seen by glancing at the statue of Shakspere, seated on a pedestal, placed in one of the British courts midway down the nave of the Exhibition. Some of the details in the south front are equally objectionable. The small windows give a mean, stable-like appearance to what otherwise displays some noble lines, and the mass of brickwork above seems as if ready to fall upon and crush these lights out, from their obtrusive insignificance.

The interior of the building is every way more perfect. In adaptability to purpose, it is all that any architect would probably have produced; and although it wants the fairy-like magnificence of the glass hive of '51, with two exceptions the interior combines in a

From the numerous contributions in papier-mâché of Mr. BIELEFELD, Wellington

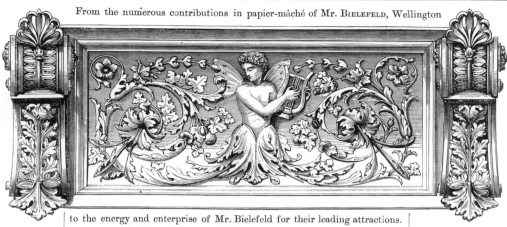

to the energy and enterprise of Mr. Bielefeld for their leading attractions.

Street, Strand, we make a selection to occupy this page. The house has established its fame

for the production of various aids to the architect and deco-

rator. Many of the more prominent mansions and public structures of England, are indebted

He exhibits specimens of an entirely new material, called *patent siliceous*

fibre, applicable for a variety of building purposes, and also an example of

the material used in the internal lining of the new reading room at the British Museum. The upper and central pieces on this page are portions of an elaborate CORNICE, the bays between trusses having

alternately the figure with lyre and foliage, and medallion heads of Mendelssohn and other great composers, designed for a music hall. We have selected several detached pieces of Mr. Bielefeld's works, with especial view to

their value as suggestions to many orders of manufacture. On all occasions when such materials present themselves, or are to be obtained, we should bear in mind how essentially one manufacturer may

aid another, not only without prejudice, but with | positive gain to himself, by aiding the Art-progress | that is influencing every class of our productions.

creditable degree the qualities of utility and constructive power. The exceptions are the nave and the domes, and no small share of the apparent defects in both is traceable to the raised daïs below these semi-glass globes. The nave wants width, if not also height, to support its length, and the height becomes sadly shorn of its proportions from the platform below the domes, which seem to pull the nave roof down upon the frightfully appalling trophies placed beneath. It may be remembered that this raised level of the floors under the domes was at one time set forth as an advantage—a point of adaptation which would become a benefit rather than a disfigurement to the general effect. It might have seemed so; but now when the full result has been realised, the deteriorating influence upon the whole design has been strikingly conspicuous, especially upon the effect of the nave. Some of the other parts of the building, such as the picture

galleries, are good in construction; and while setting forth the defects of the exterior, the general constructive arrangement of the interior is nearly all that could have been expected, taking size, cost, and purpose into practical consideration. Many details might have been improved, but alterations would have cost both money and time; and that this vast edifice should be raised from its foundation to its present state without observing, both during progress and after completion, many things that would have been improvements, was one of those impossibilities which only unreasonable men could hope to see realised. Externally the case is far otherwise. There, the defects arise from neglect of obvious and well-understood axioms in Art, and for such neglect there can be no complete exculpation from the all but universally condemnatory verdict both of professional and public opinion.

The interior decorations must be treated apart from the construc-

In the production of carton pierre and papier-mâché, as might be expected, there has been considerable improvement of late years, as well in the manufacture of the materials as in their application. With the decorator, such application has,

ings, curved surfaces, cornices, and intersecting ribs, however complex, and it has

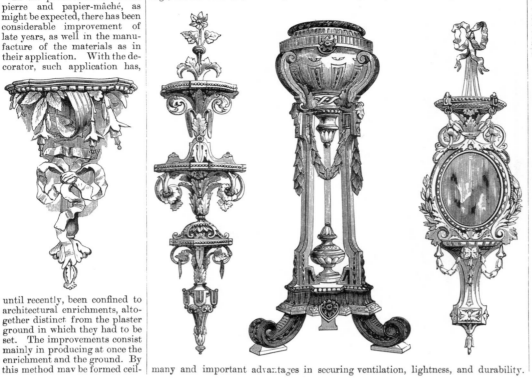

In these materials, Messrs. WHITE AND PARLBY, of Great Marylebone Street, are large exhibitors. The whole of their productions are correct in style, and many of them essentially original in design. The fancy

until recently, been confined to architectural enrichments, altogether distinct from the plaster ground in which they had to be set. The improvements consist mainly in producing at once the enrichment and the ground. By this method may be formed ceil-

many and important advantages in securing ventilation, lightness, and durability.

objects here engraved are a Louis Seize FLOWER-STAND, two BRACKETS of floral character, some hanging SHELVES, with mirror, in the style Louis Seize, and a large CABINET in the same style, but composed of

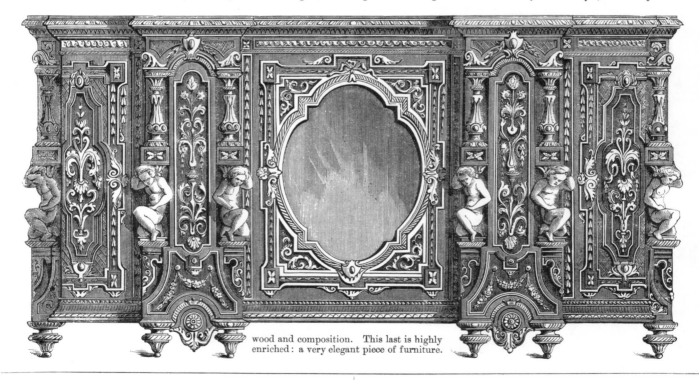

wood and composition. This last is highly enriched: a very elegant piece of furniture.

tion of the building, and in justice to all parties the history of this branch of the work ought to form a portion of its permanent record. At a comparatively early period, a committee of taste seems to have been formed for the purpose of determining the style of, and guiding to completion, the internal and external decorations. That committee, with the aid of the staff at Kensington, laboured, it is said, with energy in their vocation, but their success was not equal to their zeal; and after various unsuccessful efforts, they resigned their functions practically, if not nominally, and at the eleventh hour threw the whole decorations into the hands of Mr. Crace. This was a grave act for the committee of taste, and the heads of that department from which the Art-education of the country in decoration is supposed to flow; but the responsibility thus thrown up by the committee was at once accepted by the practical tradesman, and he has fulfilled his trust with creditable skill. The principles adopted in these decora-

tions were laid by him before a meeting of the Society of Arts. That paper, as well as the discussion which followed, has been reviewed in the ART-JOURNAL of May, 1862, and there is little to add to those remarks beyond the fact that portions of these decorations are now very different from what they were when Mr. Crace read his defence of them as they then were, amidst so much applause. Had time and other means permitted, Mr. Crace would probably have treated the whole structure in the same improving style, and although he could never have made it on its present basis other than a second-rate example of constructive decoration, yet as much could have been effected in the other sections of the building by bringing the parts together, as was at the last hour effected in the compartments so amended. The other departments of the decorations were a great assistance to the general effect. The flags, whatever may be said of their heraldry, were highly serviceable for their colour; while the throne

M. MATIFAT, of Paris, has long occupied a high place among the bronze manufacturers of the French capital; and his reputation is established in this country—many of "the stately homes" of England having received their best adornments from his fertile fancy and

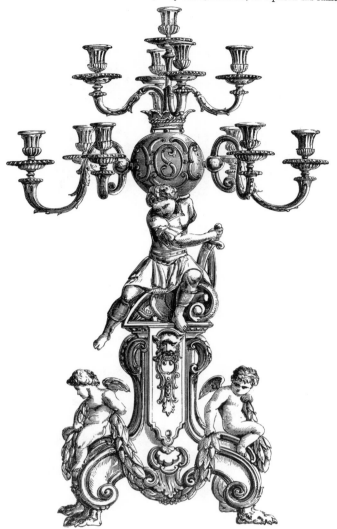

of the contributions of M. Matifat; they serve, however, to uphold his fame.

Among his other works exhibited are vases, tazzi, and minor objects in bronze,

thorough experience in Art. The CHANDELIER here engraved has been executed for the Duchess of Sutherland, a lady by whom M. Matifat has been long and largely patronised; the CANDELABRUM also has found a place among us. The BRACKET is of good form. These are but a few

on which taste and skill have been rightly exercised with the very best effect.

and other fittings of the same temporary character, were made to bear a legitimate and effective part in the great whole. Nothing could redeem the want of head so conspicuous in the disfigurement of the nave by the unfortunate trophies, which, although generally respectable when taken singly—that is when tried by the retail trade standard of taste—yet are so incongruous in construction, and so placed without reference to symmetry or pictorial effect of form or colour, as to defy all other kinds of help of a permanent character to hide the inartistic mass. Who may be specially responsible for this deplorable spectacle of huddled-up absurdities may be of little moment to the public, whose only duty seems to be that they should pay and be thankful; but it deeply concerns the national reputation to protest against the projectors of this nave deformity being taken as any evidence of genuine national taste, or rather want of it. No shopkeeper, from Eastcheap to St. John's Wood, would have made

such a medley of the arrangement of his own goods, nor displayed such total incapacity for grasping the effect of detail, grouped into a concentrated whole. In this, as in other kindred matters, head, head, head! has been the great and crying want, and as the Commissioners have sown, so will they and the guarantors probably reap. With the masses of the people—that is with those who, after all, are to save the scheme from financial bankruptcy, and the Commissioners and their *employés* from bankruptcy in reputation—the result of first impression is everything. The higher and more intelligent class of skilled workmen will, no doubt, overlook all such considerations of show, and visit the Exhibition as bees visit gardens, looking till they find what they want, and neglecting all besides. But such workmen after all form but a small section of the industrious population, and for the overwhelming mass of the people, the Exhibition must be a grand and striking show, or it is nothing, and will be so

Messrs. EDWARDS AND SON, of Great Marlborough Street, are

amongst the more prominent exhibitors in the hardware depart-

ment of the Exhibition. On this page we represent a STOVE, and

its appurtenances, which have been manufactured by them. It is a warm-air pedestal stove, in the Italian style, and is admirably designed and very highly finished in

all its parts. The ornamentation is at once appropriate, and of an exceedingly good

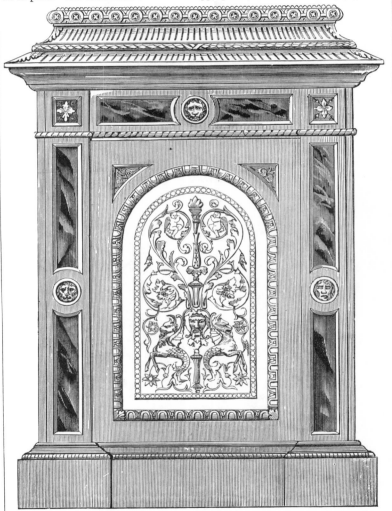

and pure character. The design is by Mr. JOHN EDWARDS, a son of the manufacturer, and it may certainly vie with any production of its class in the Exhibition.

treated. Their imaginations require to be captivated that their mental powers may be stimulated and instructed, and it would be as idle to expect them to delight in uninviting natural scenes, however full the soil may be of botanical rarity and beauty, as to hope to see the working masses busying themselves about details of what presents no striking grandeur in its general effect. If this want of general attraction be supplied, instead, by conspicuous deformity, how much less the chances of popular enthusiasm and support!

There is another, and, to the advance of Art-education and progress, a still higher consideration, which the Commissioners were bound to have taken into account. They have never professed to treat the Exhibition as a show, except so far as concerns the "getting in the shillings." In that they are not chargeable with much remissness of duty. But this international display has ever been put forward as

a national teacher, and in that aspect alone has it received the encouragement and support of those interested in popular Art-education. The Commissioners were therefore bound to see that in every part of the Exhibition under their control the purpose for which the whole was intended should be steadily kept in view, and inflexibly carried out. It no doubt required firmness in dealing with applicants for space, and, as an excuse, it has been said that permission for the erection of the trophies in the nave was literally wrung out of the Commissioners; but if they had only displayed half the determination about nave space that has been acted on respecting some other matters, none but the most favoured would have operated with success upon official firmness. The reason given for the disfigurement is therefore not conclusive, while the duties due by the Commissioners to general Art-education are undoubted and undeniable. How, then,

The Stove and Fenders illustrated on this page are selected from many admirable works contributed by Hoole, of Sheffield—a name known and appreciated throughout the world as that of one whose productions are always of the very highest merit. The "Green Lane Works," Sheffield, were established at the close of the last century by the father and uncle of the present proprietor, Alderman Henry E. Hoole, F.S.A., who rebuilt them

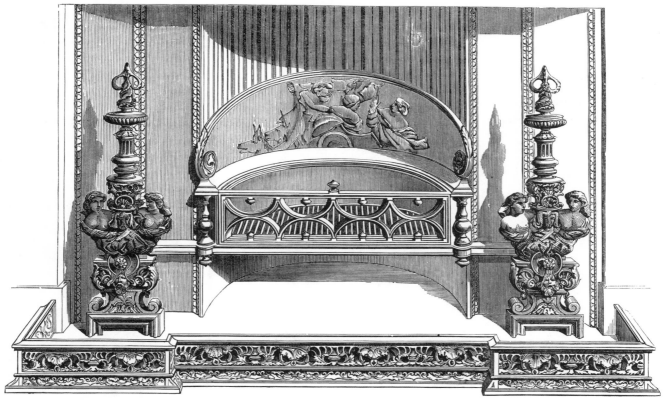

a few years ago. They are now the most complete and perfect of their class in the kingdom, possessing all facilities for producing stove grates and fenders of the cheapest, and also of the costliest, description. The very beautiful grate and fender we engrave above were designed by Mr. A. Stevens, who was for some time associated with Mr. Hoole. The pillars are original in design, and admirably display the peculiar talent of the artist. The back represents the "Rape of Proserpine," in bas-relief; the sides are to be decorated by porcelain, from designs by the same artist. The whole

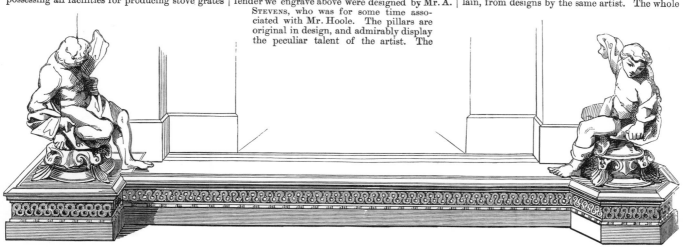

work is executed in the superior style that has given renown to Sheffield, and for which Mr. Hoole is justly celebrated, having gained the Council Medal in 1851, La Médaille d'Honneur in 1855, and also the Grand Medal of the Society for the Encouragement of Arts and Industry.

has this portion of the duty been discharged, and what is the Art-teaching of the arrangement of these trophies in the nave to the masses of the common people? These are questions more important than any bearing on the mere spoiling of a show. Suppose the entire community educated up to the standard which produced this arrangement of the nave, would that be any improvement on the present ignorance in such matters? If not, the first and most important intention of the principal part of the Exhibition is lost in regard to its original and highest purpose, and it is degraded from being a teacher of what to practice into a beacon of what to avoid. The Commissioners, personally, could not be expected to undertake or know much about such work, but, having assumed the responsible duty of providing Art-teaching for the nation through means of an International Exhibition, they were reasonably entitled to see that what they had undertaken to provide was at least moderately well secured. In this they have signally failed, and unless this failure be redeemed, it will go far along with other causes to seal the fate and neutralise the high advantages of this gathering of international industries. But what permanent decorations could not do was effected on the opening day by the multitudes assembled, and the various military and other showy costumes displayed on that occasion. Every available standing-point was occupied, and the variety and brilliancy of colour worn by the spectators so attracted the eye, and became the leading effect, that these trophies became all but unimportant in the *tout ensemble*. It is not so now, and the want of arrangement here will continue to irritate the eyes of all susceptible to mere order, to say nothing of beauty of arrangement, so long as the Exhibition lasts. The state of matters beyond—the gaunt red-brick looking walls of the space above the courts—may be unfinished, and therefore not a subject for criticism; but these,

This page contains engravings of several excellent works in cast-iron, the manufacture of Mr. WILLIAM ROBERTS, of Northampton, designed and modelled by

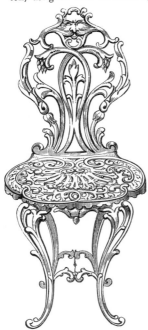

Mr. HENRY W. MASON. The "Lion Foundry," at which they are produced, was established early in the present century.

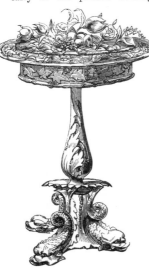

The objects introduced are a HALL CHAIR, a FLOWER-STAND, the top of a SMOKING TABLE (with shells to receive the ashes—its STAND terminates the page), a

HAT AND UMBRELLA STAND, combined with a HALL TABLE and

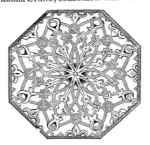

MIRROR above (arranged to economise space in a small hall),

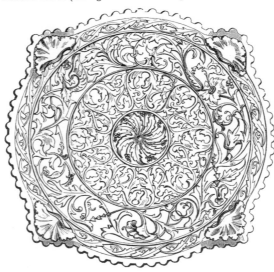

and a CONSOLE TABLE, with marble top. These are all good

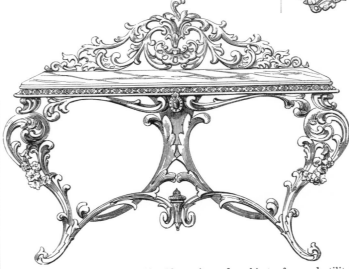

castings: the designs are of considerable merit; and as objects of general utility

they will attract and deserve attention, inasmuch as they supply evidence of marked advance in the pro-

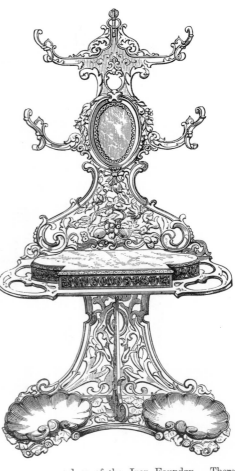

duce of the Iron Foundry. There are now few establishments of the

class without the aid of a true artist.

and the style of the picture galleries, may become useful for aftr illustrations.

The opening ceremonial, with its meagre pageant, has been already described in every variety of form, by more vivid and imaginative pens, and from these, readers, present and prospective, must draw their information; but the aspect of the building, with tens of thousands robed in elegance or splendour—one living swarm of anxiety and beauty rising from far down the nave, till, with unbroken swoop, sparkling and resplendent, it rose in the far-off orchestra—that was a picture rarely equalled for suggestive gorgeousness. Music is not within range of Art-industry, but when over the living and industrial glory of the scene, the soft and solemn harmonies of Sterndale Bennett stole, they soothed all into delicious day-dream; and when the majestic grandeur of the Hallelujah and the "Amen" swelled from those myriad tongues, the feeling became oppressive with sublimity.

The Exhibition having been declared open, the vast concourse separated, each to visit the speciality to which duty or choice attracted. Following the same course, we shall now endeavour to conduct readers of the ART-JOURNAL through the several sections, separating the chaff from the wheat, and presenting what we consider the latter in a form as condensed as justice to the interests of industrial Art, of the producers, and the public will permit.

Now it is felt how far the several sections are from being finished, and how utterly impossible it is to begin anything like a systematic comparative review of any one class, either with reference to the difference between articles exhibited in '51 and '62, or between the different nations now exhibiting. It would not only have been most convenient, but also most useful, if we could have begun at what may be called the foundation of Industrial Art—the materials used in the building trades—and traced the application of Art to these,

This page is occupied by an EBONISED BOOK-CASE, in the Pompeian style, manufactured and exhibited by Messrs. HOWARD AND SONS, of Berners Street, designed by Mr. VANDALE, artist to the house, being a portion of a suite of library furni- ture. It is richly decorated with carved, gilt, and coloured ornamentations, and is a fine copy of a pure model, the authorities for which are so readily available to the Art-producers of our epoch. In this work it is sought to reproduce the style and ornamentation of which so many valuable relics are found among the ruins of Herculaneum and Pompeii, and to combine them with the requirements of modern life. The form is simple, and the decorations are strictly subor-

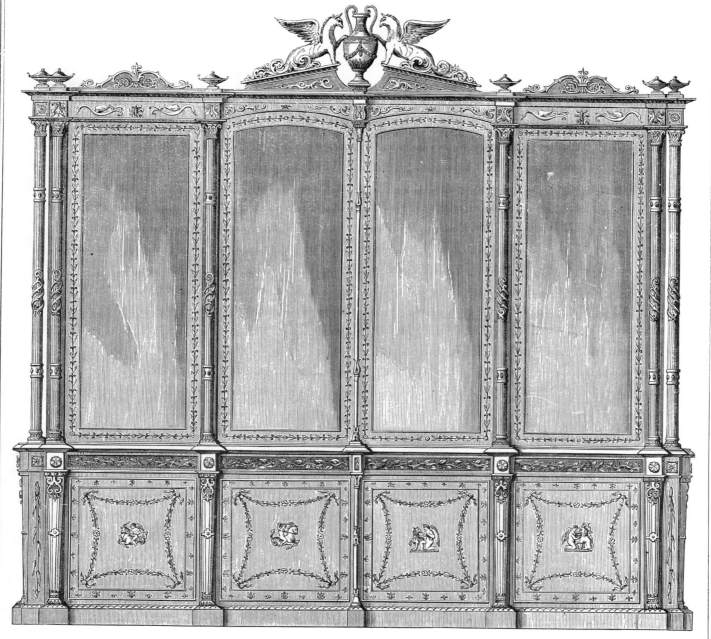

dinate to it. All the surface ornament is incised, by which means the gilding, colour, and surface are better preserved, and rendered more capable of being kept in order. The four compartments of the frieze draw forward, on depressing the adja- cent bronze ornament, and form a table or rest for books opposite to each door. Whilst the artist and manufacturer have adhered closely to this beautiful style, utility has in no case been sacrificed to it. The work is excellent in all respects. This object is but one of many valuable contributions of this eminent firm.

or how they might be most successfully applied; and the exhibits in wood, stone, or marble, in a finished state, would have formed the natural starting-point, while the raw materials of these depart- ments might, and, no doubt, would, have suggested hints for the consideration of those engaged in such industries; but many of the best specimens are still hidden from the eye, and to have done such work by halves would neither be agreeable nor useful. Similar difficulties were encountered by attempting to begin at the other end of the Industrial Art scale; while many of our English workers in gold and silver were ready, their continental rivals were not, and to save all appearance of partiality, it was deter- mined to throw system overboard, and begin at that point where there was most general forwardness. This, as it happened, is glass staining, and to that we devote present attention, till the other and more generally important sections are changed from chaos into order.

GLASS PAINTING.

The origin of glass staining is a disputed honour, and in such con- flicts we are for the present neutral. Unlike painting, sculpture, or the many branches (such as mosaic) cognate to perfect architecture, glass painting was an art exclusively ecclesiastical and Christian in its origin and development. It was the application of the principles and ideas of mosaic to the new wants of architecture for the adorn- ment of the church; and the early masters of this art on glass atoned for their want of variety and pictorial effect by the beauty and bril- liancy of their ornaments and colour. With them a window was an integral portion of the structure, both in outline and quantity and quality of decoration; and many of the specimens executed at that early period were esteemed then, and are yet admired, as high ex- amples of the original principles on which the art was based,—

MESSRS. FILMER AND SON, of Berners Street, Cabinet Makers, Upholsterers, and Decorators, exhibit a large collection of meritorious works—seldom of an ambitious order, but calculated to promote the grace and comfort of English homes.

Their chief contributions are a LADIES' WARDROBE of delicate and refined workmanship, of walnut-wood, relieved by ebony and white-wood mouldings, and a DINING-ROOM TABLE of pollard

oak—good as a work of Art, and manufactured on a novel plan, "to open to an increased diameter by an extension of the framework, the top being preserved entire, and quarter-circle leaves introduced in several series round the circum-

ference, thus preserving at all sizes the perfect circle." We introduce also on this page two ex-

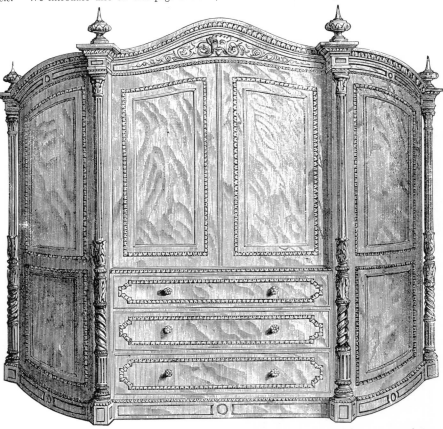

of the Female School of Art. The schools of the Department of Science and Art supply us with so

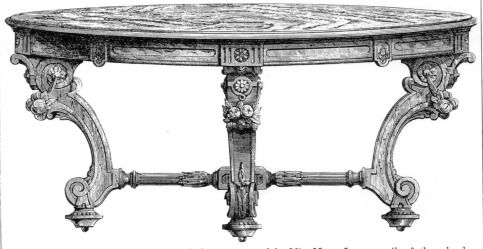

of the students to aid the Art-progress of the age. The first is designed by Miss CHARLOTTE JAMES, the

amples of chintz block-printed "FURNITURES," produced for this firm; they are designed by pupils

little evidence of their usefulness to manufacturers, that we rejoice to receive these proofs of the ability

second by Miss MARY JAMES, pupils of the school at Queen Square, under the direction of Miss Gann.

depending for perfection, as it did, on the harmonious arrangement of coloured light.

Marcilla the Frenchman, an old prior, who afterwards made Arezzo his home, so constructed his designs that the joinings of lead and iron by which the glass was bound together formed parts of his design; and this he did with so much skill that his works could not have been complete without them. These joinings became the deepest shadow of a fold, or the sharp relief of some other portion of the drapery or subject; so that what in so many inferior hands became a defect, was in his converted into a beauty and advantage. Besides, he only used two shadow colours, but these with such discrimination and effect, that his glass staining, while realising its own proper qualities of breadth and depth, had some of the fascinations of pictures. In France and the Low Countries especially, those who followed this branch became historical painters

upon glass, instead of on panel or on canvas—a total perversion of the original principle, the one being to produce light through well balanced colour, arranged in thoughtful form, the other being an attempt to imitate oil painting or fresco in a style of relief, which must make the transmutation of light a subordinate object, and where prevalence and multiplicity of shadow must interfere with the breadth and brilliancy of the general effect.

In France declension was as great as in the Netherlands, while in Germany it was not till 1818 that M. Frank, of Nuremburg, checked its current, and from the manufactory at Munich gave a stimulus to that revival which has since become so general. But even in 1851 the general principles of this branch of industrial Art seemed to be so very generally misunderstood, that almost every example was based upon the pictorial principle; and although that gave a certain quality of depth, it was false in cha-

The PARQUET FLOORING of Mr. ARROWSMITH, of New Bond Street, has been largely used in England.

The designs—of which there is an immense variety—

are all appropriate, usually "quiet," so as not to dis-

turb the harmony of rooms and furniture in which

they may be placed. The parquet is, we believe, machine-made.

From the extensive establishment of Mr. WILKINSON, of Old Bond Street, we select one object, a DRAWING-ROOM CABINET and BOOK-CASE, with large glass frame above. It is a

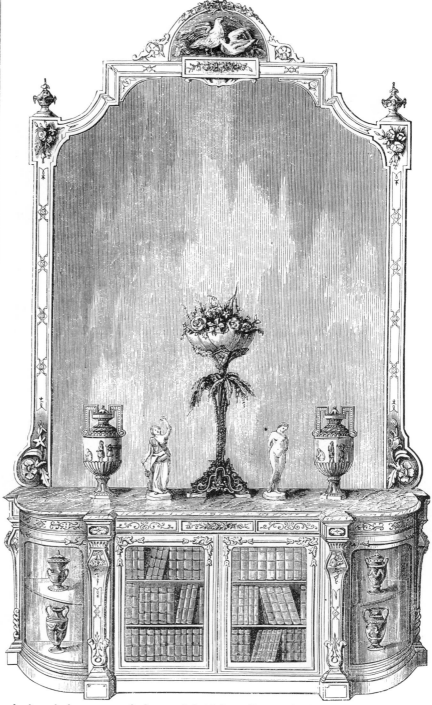

work of much elegance, very finely carved, but demanding examination to appreciate its merits.

racter, and not unfrequently equally indifferent in effect. Some of the best remembered works then sent were from Austria, Italy, and France; yet the most popular of the glass pictures seen in 1851 were, whatever their other merit, but questionable examples of successful glass staining. They had all the faults of historical pictures by which the lower class of artists had brought down the art of glass staining from its first high and noble purpose, without those counter-balancing beauties which genius so often confers even upon works un-dertaken and carried out on false principles. It is neither necessary, nor would it be agreeable, to point back to the special works referred to as defective in the former Exhibition, but such as were most free from objections were engraved in the ART-JOURNAL CATALOGUE, and those interested will, by reference to them, find indications of the same imperfections in the highest works then exhibited. In the British section, while there is considerable improvement manifested since 1851 in the depth and dignity of colour by nearly all those who exhibit stained glass, it is but still too evident that the pictorial predominates over the flatter and more legitimate style of treatment, and that, in too many cases, what in general effect gives the appearance of depth, is sometimes only opacity in shadow, which is bad even in pictures, but, necessarily, far worse when found in connection with stained glass. The object here is to set forth general principles, and indicate the results achieved without pointing out individual works, especially when such examples could only be condemned; but, without specially selecting specimens to be avoided, those interested will see at a glance the works which are executed after sound principles as compared with those based on principles that are false. Flat treat-ment of glass is an essential and primary quality, but flat treatment, unless combined with good drawing, clearness and depth of colour,

JOHN BETTRIDGE & Co. (late Jennings and Bettridge), of Birmingham, who, as manufacturers of works in papier-mâché, have taken

and kept "the lead" during the greater part of the present century, uphold the renown of the old establishment by the exhibition of a large

variety of productions in their trade—a trade that, issuing from Birmingham, supplies half the world. We have selected from their numerous

contributions a WORK-TABLE, one of their many

TEA-TRAYS, and that which forms their *pièce de ré-*

sistance, a BEDSTEAD. It is designed by Mr. FITZ-

COOK, and is perhaps the nearest approach to

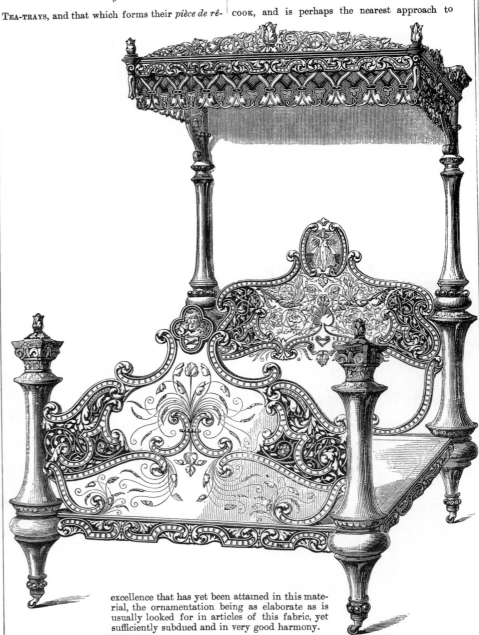

excellence that has yet been attained in this material, the ornamentation being as elaborate as is usually looked for in articles of this fabric, yet sufficiently subdued and in very good harmony.

breadth of style, and the just balancing of parts, will never make high-class glass staining. In some of the examples exhibited flatness is obtained in the flesh, but combined with a semi-opaque red brick-dust colour, which is anything but pleasing. In other cases flatness and clearness are skilfully secured; but these, in one or two instances are allied with bad, because affected, mediæval drawing, while in others they are found in connection with colour so thin and poverty-stricken as to make them worthless. In this department there appears to be a greater tendency to affectation in bad drawing than in almost any other, and glass stainers seem to believe that if they wish to represent an ancient warrior or saint, he must be badly drawn. This idea, which has been nursed in other quarters, is rank delusion, born of and fostered by a confusion of ideas. The fathers of this art, like those of painting, did everything—drawing included—as well as they possibly could. Up to the discovery of

the Greek statues, the artists of Europe had devoted themselves to the expression of feeling rather than of form, and therefore their drawing was always poor, and often very bad; but the saints and heroes of those days, as men, stood as well upon their legs as moderns, and the probabilities are that physically they were better rather than worse in their muscular development. What, then, would be thought of a picture by Maclise, or any of the other historical painters, where the figures were provided with feet that could not walk, and with bodies out at every joint, if indeed they had joints at all? And why should that be tolerated on glass which would be universally ridiculed in pictures? Attention to the costume of a period is essential to historic truth, but this affectation of bad drawing, because the fathers of this craft could draw no better, is both a historic and artistic falsity. Another defect most conspicuous in some examples of stained glass exhibited by British manufacturers

The CARPET that heads this page is the "Patent Axminster," manufactured by Messrs. TEMPLETON, of Glasgow, and exhibited by Messrs. SEWELL, HUBBARD, & BACON, of Old Compton Street, for whom it is specially produced. The design is from the fertile and most useful pencil of Mr. DIGBY WYATT, to whom so many of our British manufacturers are very largely indebted. It is harmonious both in colour and ornamentation.

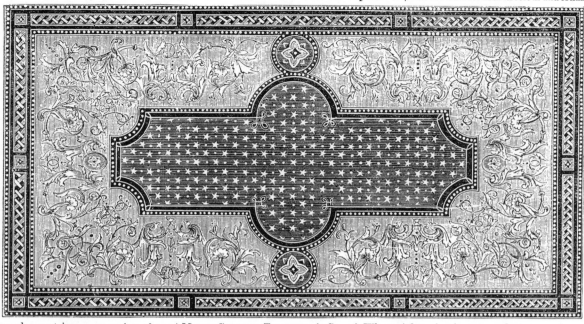

This page also contains an engraving of one of the many excellent carpets manufactured by Messrs. GREGORY, THOMSONS, & Co., of Kilmarnock, and No. 314, Oxford Street, London. This firm aims less at producing grand compositions, of which a single example only is to exist, than

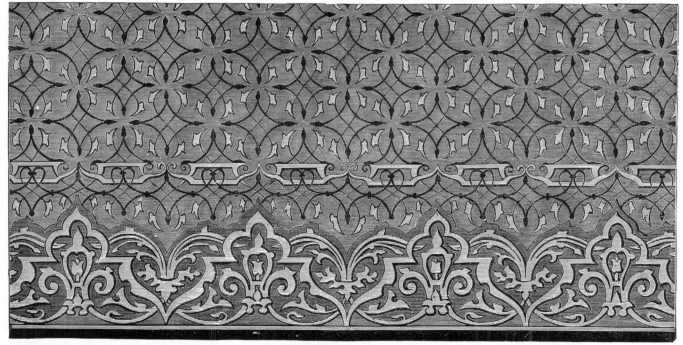

such as are requirements of the many—indispensable necessities in every English home. All the productions of their looms are meritorious, generally pure and simple in character. That we engrave is designed by Mr. WM. PARRIS; it is in the "style" of the ordinary issues of this house.

is the unwise scattering of lights. It may well be doubted whether this branch of Art-industry is open to a wide range of pictorial subjects, and there seems sufficient evidence in this Exhibition to prove that it is not, as at present developed, because there is nothing more destructive of that sublime dignity which this medium diffuses over a church or hall than the scattering of a number of small heads, which, at a distance, form mere small light spots over the compartment of a window; and several otherwise admirable examples of stained glass seen in this International Exhibition are sadly marred—or we might use stronger language and say wholly spoiled, for any large and worthy purpose—by this system of small and spotted treatment. From these and other well-known examples, the general conclusion seems to be, that not only a large style, but great simplicity of subject, is demanded by the conditions which control this department of Art, and that the more these are kept in view, in conjunction with what may be called the technical qualities already insisted on, the more is stained glass fitted for its purpose.

Among the British examples which stand out prominent for containing the greatest excellences mingled with the fewest defects, and which also display the largest developments of progress in the right direction, are those of J. Hardman & Co., of Birmingham, whose specimens are of a high order, in colour and intention, but sadly marred by smallness of style. Those by Harrington & Sons, illustrating the progressive periods of glass staining, from early English down through the period of declension and revival, are also full of good intention; but, instead of confining these examples to literal copies of the respective periods, the specimens here exhibited are all the products of one style in essence, and that style is the present. The form of ornament is no doubt different in some from others, and so is the character of the figures; but the spirit and characteristics of

Messrs. THOMAS ADAMS & Co., lace manufacturers, of Nottingham, contribute many excellent examples of their manufacture. We have engraved three specimens, the principal object being a CURTAIN, specially produced for the Exhibi-

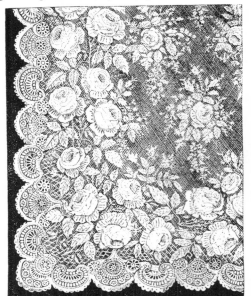

tion, as a tribute to the year of grace 1862. This curtain is 2 yards wide, and 4½ yards long; in the width of it there are 2,460 threads, each one of which is operated upon independently, with instruments governed by the Jacquard. To pro-

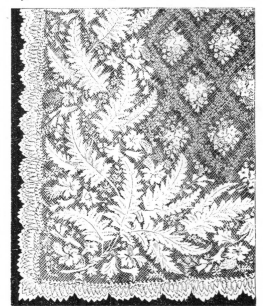

duce all the objects which compose the pattern, not one of which is repeated throughout either the length or breadth, 11,508 cards have been required. By these arrangements the work comes off the machine perfect; all the threads used for the cur-

tain are so arranged in the machine, as to form part of the net, or ground-work, when not

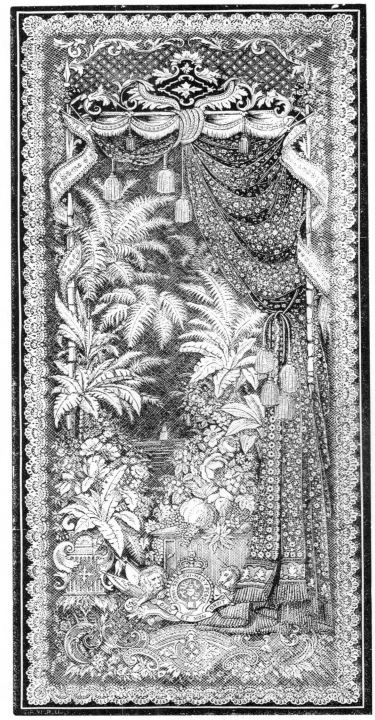

required for the purpose of making the pattern, so that no superfluous threads remain.

development are essentially one, and so far from that being a defect, it is an enhancement of value when truly carried out. This is not always the case, as in the example of what is called Italian,—the best examples of Italian containing only two shadow tints, while this example is rather highly pictorial in its treatment; but, even with such defects, these windows by Harrington stand out conspicuous, both in style and colour, among the works by which they are surrounded and confronted. Ward & Hughes exhibit a window for St. Ann's, Westminster, which is highly commendable for largeness of style and quality of drawing, especially the centre panel; but it is marred by that opaque, bricky colour which proves still more fatal to some of the works exhibited by others. The windows by Charles Gibbs are conspicuous for fulness of tone; and those by Alexander Gibbs do credit to the artist. Others, like Holland & Son, Warwick, Claudet & Houghton, and O'Connor, send works all conspicuous for

some merit, which will be easily discovered by viewing them in connection with the introductory remarks already made; and, as already stated, our purpose is only to set forth progress, and not to dwell upon hideous distortions or appalling mistakes, of which, unfortunately, this Class XXXIV. contains so many examples. Even creditable glass staining appears to be confined to very few firms; and how some of the productions here exhibited, for public and private purposes, could, by an obliquity of sentiment or vision, be mistaken for ornamental, must, one would suppose, surpass the comprehension of all but the most illiterate in matters of taste or internal embellishment. In the foreign section, France comes next to Britain in the display of quantity; and in the fragment from the subject called 'The Glorification of the Martyr,' the grandeur of style, the airy elegance and truthful drawing, and the massive breadth and clear contrast, without harshness of colour, is more con-

Messrs. DANIEL WALTERS AND SONS, of Newgate Street, exhibit furniture-silks in great variety portant fabric at their mills at Braintree and Notley, in Essex. We give on this page four examples No. 1 is a composition of the Hibiscus flower and the Umbrosa leaf, woven in three colours in

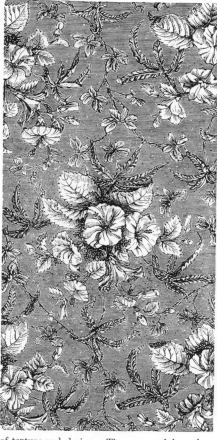

of texture and design. They are, and have long been, leading British manufacturers of this important amples of their very beautiful productions, copied, for the most part, from natural leaves and flowers. "Brocatelle;" No. 2 is an "all-silk damask" of the period Louis Seize, woven in two shades of

one colour; No. 3 is the Concier flower, all silk, woven in two colours, but, from the peculiarity of the manufacture, having the effect of three; No. 4 is the Chestnut, all silk, woven in three colours. The productions of Messrs. Walters are entirely for decorative and upholstery purposes.

spicuous than in any English specimen; but still the treatment, even in this work, is pictorial, and less perfect in style than the dull, opaque, badly coloured, but well drawn and legitimately treated window, by Bourgeois, of Rheims. There are some other examples from France that will secure attention from the public; and the two portraits—one of the artist, and the other of a gentleman—are new methods of self-glorification for the vulgar, but they are worthless as specimens of stained glass. Austria sends nothing in stained glass, and Belgium only one specimen, which is respectable in feeling, but indifferent in all other qualities; while Italy sends two specimens, one of small account, but the other, a 'Virgin and Child,' which, although apparently low in colour, yet, both in sentiment and style, maintains the historic dignity, beauty, and classicality of the Italian school,— although it does not maintain the simplicity and purity of colour for which the best period of Italian glass painting is so conspicuous.

FURNITURE.

These Courts are getting into that state, when at least the major portion of the articles can be seen, although they will evidently be unfinished even after the present part of the ART-JOURNAL is in the hands of our readers: still, this section is more forward than many of the others; and to that, therefore, we shall now invite attention.

The difference between the furniture exhibited in 1851 and 1862 forms one of the most striking characteristics of the Exhibition; and while this difference is visible among all the competing nations, it is most conspicuously apparent in the manufactures of this country. Then the leading ideas were either exclusively French, or Renaissance so overlaid with *rococo* as to make the latter predominant over the former. Now the French styles there displayed are scarcely visible, except among the least important class of works; and while

The material called KAMPTULICON is a modern invention, now in extensive use, principally for

covering floors; it is composed of three non-

absorbent, water-repelling materials, India rubber, gutta-percha, and cork : its recommendations

are, that it is not affected by damp, is a non-conductor of heat, and deadens sound. In nearly

we engrave on this page are those of Messrs.

designs are, as they ought to be, simple; the manufacturers state, indeed, that they have been " care-

all our public buildings, hospitals, railway offices, hotels, &c., it has been adopted. The examples

TAYLER, HARRY, & Co., of Gutter Lane. The

ful to figure the cloth with only such patterns as will leave the ground as much as possible exposed."

the British makers have gone straight to Italy for style, even the French makers of most eminence are now less French in style than some of the Italians from Turin. It will be remembered that some of the specimens which secured most vulgar attention in 1851 were either naturalistic, grotesque, or Gothic. Buffets supported by dogs; tables supported by impossible pelicans; sideboards surrounded by huge bunches of laboriously-cut grapes and vine leaves; cabinets in the form of temples, in one or other of the four orders, or as in the Austrian courts, where Gothic played so popular a part in furnishing a book-case and bed, from the Royalty of Austria to the Royalty of England. In the present Exhibition these perversions of Art-industry have all but disappeared, and the change is as general as it is gratifying. There are still some lingering remnants of the old delusions; but, if the history of even these could be traced, it would probably be found that they are portions of old stock, sent only for

chances of sale, and with no serious intention of competition. As such they will certainly be treated; and, as they reflect no honour on the exhibitors, or even influence the public taste for evil, it is unnecessary to inflict the pain of unfavourable notice in detail upon their unfortunate producers.

Only two styles seem to have guided the higher class of workers for this international contest in these national furniture Courts—Renaissance and Louis XVI.—and both of these are based upon classic models. The latter, being French ornament on a Grecian outline, has influenced some of our largest exhibitors; and it seems not unsuitable for our square rooms and panelled wardrobes; but after all that can be done for it by genius and gold, it has a meretricious *café* aspect, destructive to the worthy realisation of elevated magnificence. Like a common-looking woman sparkling in gold and finery, this Louis XVI. style wants the quiet power of re-

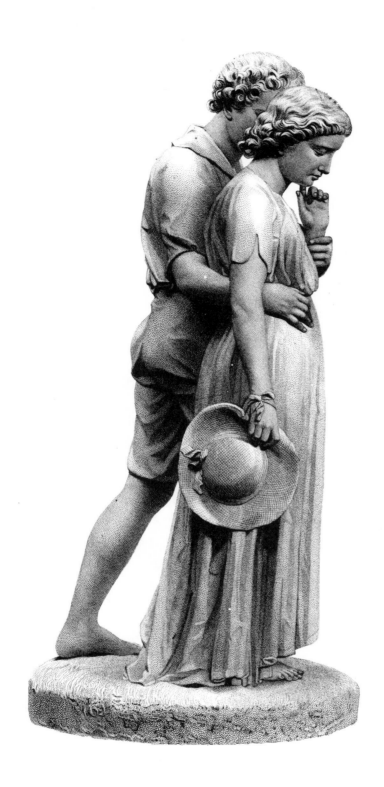

PAUL AND VIRGINIA.

ENGRAVED BY J. H. BAKER FROM THE GROUP BY J. DURHAM.

LONDON JAMES S. VIRTUE.

It is impossible to rate too highly the works of MM. CH. CHRISTOFLE & Co., of Paris, whose very large collection forms the principal adorn-

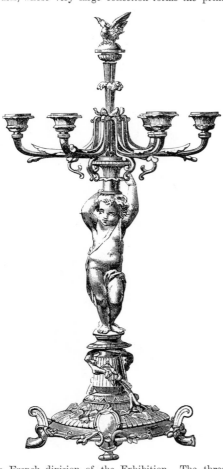

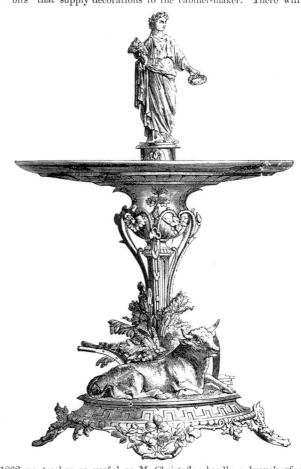

ment of the French division of the Exhibition. The three objects we engrave may convey some idea of their merits; but every article contained in their court supplies evidence of refined taste, from the costly plateau to the "bits" that supply decorations to the cabinet-maker. There will be, in 1862, no teacher so useful as M. Christofle; hardly a branch of Art-manufacture that will not be in his debt. The establishment is the most

extensive of its class in Europe, giving employment to twelve hundred workmen in the manufacture of silver plate, and in that which, at far less cost, has equal beauty and worth (in so far as Art is concerned), the electro-plate—such as in England is usually associated with the name of Elkington.

fined dignity, and seeks to make up with glitter what it wants in grandeur and repose. Still it is a good step forward upon the style of Louis XIV., which was that so prominent in 1851; and had the nations, and especially England, made no further progress, it would have been ample cause for legitimate congratulation. But we have gone far beyond that; and while in some branches of detail, which will be noticed by-and-by, we are still inferior to others, we are at least superior in this—that, taking the various national stand-points in 1851, in general purity of style, the British manufacturers of furniture have made higher and more influential progress than those of any other exhibiting nation. This progress is at once encouraging and substantial, because it is permeating, not spasmodic, in its action. In France, where the same leaven has been working, the action has been fitful, leaving its impress upon one article, and unfelt on others produced by the same maker, of which many prominent examples could be given; while on others, and these rather the major portion, the influence of anything like a pure Italian style is still unfelt. In this country these positions are, as nearly as possible, reversed; and while it is difficult to find articles uninfluenced by this higher style, where that has been adopted at all, there are comparatively few British exhibitors of furniture where this power seems to have been wholly unfelt. This is a hopeful state of things for England, and proves that, in this class at least, she has outrun continental competitors in the rate of progress. True there is much still both to learn and unlearn—much of the old French leaven to purge out, and much of the higher art of Italy and Greece to master, especially in details; but the tide of former malignant influences has been successfully turned, and now that the cardinal forms and principles have been changed from bad to better, the details will also, by additional time and knowledge, be

We devote a column of this page to a selection of BROOCHES, of Aberdeen Granite, the

manufacture of Messrs. RETTIE, of Aberdeen,

(placing these "common" yet graceful objects by

the side of a grand work of Art in silver). Messrs.

Rettie are very famous for articles of this class.

The silver CENTRE-PIECE represented on this page is manufactured by Messrs. GARRARD, of the Haymarket, and is intended for the dining-table of his Highness the Mahrajah Dhuleep Sing. It has

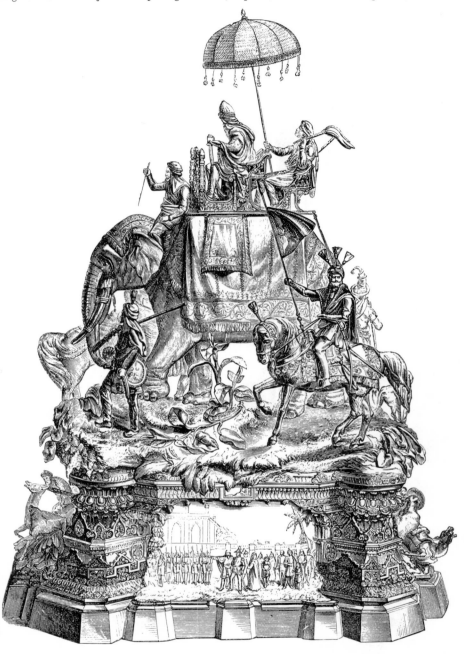

been designed to record an interesting incident in the history of his Highness' father, the late Mahrajah Runjeet Sing. The Mahrajah, riding on an elephant, is in the act of rising from his hondah to receive from his Turcoman attendant a horse, the possession of which he has coveted. The figures on one side of the group are an acali and a fakir, and on the other a sirdar, or standard-bearer. The small groups at the ends of the base represent various scenes in a stag hunt with the chetah—a favourite sport in India. The *bassi relievi* on the base are very finely executed. The plate is of massive silver and of prodigious size, weighing about two thousand ounces.

changed from wrong to right. Already in some cases that has been reasonably well achieved, and there is nothing of its class, in any part of the Exhibition, better—if, indeed, there is anything so thoroughly good, taking outline and detail combined—than the book-case by Wright and Mansfield, Portland Street. There the beauty of the parts is gathered up into a beautiful whole, with a simplicity bearing the impress of power—which is not so fully realised in the mantelpiece intended to match, but does not, from the over-use of gold, which breaks the masses into small parts. Among other similar articles, an *escritoire* by Knight, of Bath, and a book-case by Macfarlane, of Glasgow, show, although not to the same extent, the widely-spreading influence of purer forms. In drawing-room furniture there are many very good but few very perfect developments. Among these must be placed a magnificent *cheffonier*, by Johnstone and Jeanes, the under portion of which is as beautiful in detail as it is exquisite in form and excellent in workmanship; but the pure Italian which inspired that portion becomes tainted with old virus above, and this otherwise fine work is damaged by over, and therefore vulgar, ornamentation on the top. Indeed, this work looks the joint product of essentially different minds—the one elegant and enlightened beyond most of his compeers, the other wanting in the appreciation of beauty, and still overclouded with the delusion that plenty of ornament will hide the absence of fine outline. The ebony furniture by Fox also deserves notice. Although purer in intention than in carrying out of detail, it is a creditable effort. Other dining-room furniture claims attention; and first, one of the smallest and simplest but most perfect sideboards is by Aspinall—an article remarkable for refined simplicity, and, even with the ornamental detail on the top (which is more adapted for iron ornament than befitting wood), this is a work of high simplicity in taste.

THE INTERNATIONAL EXHIBITION.

On this column we have engraved two of several excellent works contributed by Messrs. REID AND SONS, of Newcastle-on-Tyne. They are portions—the CENTRE-PIECE and one of the *assiettes*

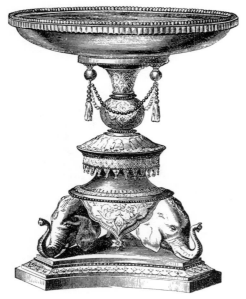

montées—of a DESSERT SERVICE. The style is Indian; the chief feature of the composition is three elephants' heads, admirably

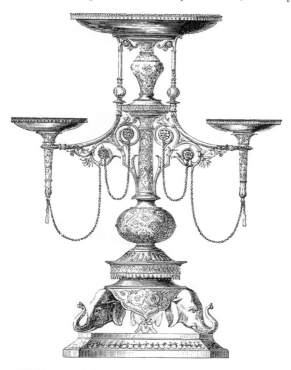

modelled in frosted silver, resting on a plain, bright, tripod plinth, and supporting a canopy, from which springs the centre stem.

The STOCKTON-ON-TEES CUP, manufactured by Messrs. HUNT AND ROSKELL, admirably designed and modelled by Mr. R. ROSKELL, is a vase of elegant form, bearing on one side a *relievo* of the fall of Phæton; on the other that of his sisters

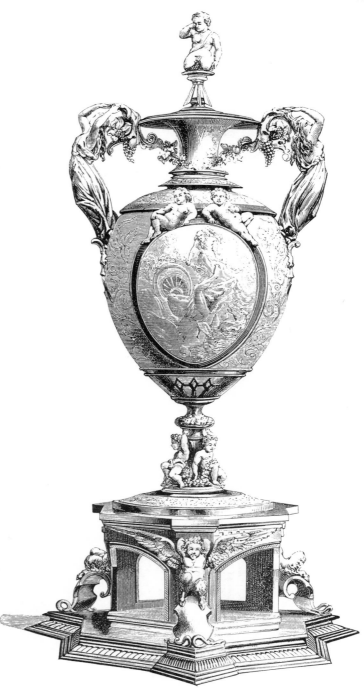

weeping over his body. It is of oxydised silver, and is one of the many Art-productions which have, in 1862, added even to the repute of this long famous house.

The sideboard by Trollope and Sons, as well as the cabinet we have engraved, are each worthy of attention, although not entitled to equal praise, because, although the rounded form of the sideboard pedestal gives it increased utility, yet the ornaments are wanting in refinement, and have too much relief. A large sideboard by Ogden, Manchester, is conspicuous for its massive dignity of "block," and the novel yet appropriate form of its pedestal; and had the panels of these been supported, by repeating in larger size the arch, with its carved panel above, this would have been greatly enhanced as a work of Industrial Art. The breaking up of the pedestal fronts into small panels, in order that tawdry festoons might be placed on the stiles, was a great blunder, and has reduced what would have been a grand into a merely very good sideboard. The sideboard by Whytock, of Edinburgh, is also massive in its general forms, although the quality of some of the details does not support the dignity of the general outline.

There are several other very good specimens of drawing-room furniture, but without points sufficiently interesting, either for novelty or beauty, to make them of more than general importance as examples of that almost universal progress displayed by this branch of British Art-industry. In bedroom furniture there is the same general progress visible, but with variations of style peculiar, and often admirably suitable to the purpose. The marked characteristic of this class of furniture in the British courts is the great superiority of that now exhibited over what was displayed in 1851. Then everything was crowded with ostentatious ornament, and show was the object aimed at. Now everything, or nearly so, is staked upon simplicity. Beauty of outline has been substituted for laborious ornamentation; and in so striking a change it is not wonderful that the golden mean has frequently been missed, and that lines and stringy ornaments have been made too important in many of the best speci-

The leading objects on this page are two examples

of CARVED CORAL, from the extensive collection of

Mr. PHILLIPS, of Cockspur Street, who is, we believe,

the largest dealer in Europe in the wrought material

of the finer qualities. The NECKLACE is of the rare and costly pink colour, very beautifully

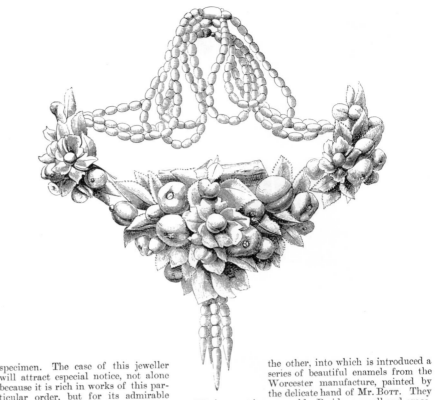

specimen. The case of this jeweller will attract especial notice, not alone because it is rich in works of this particular order, but for its admirable productions in other branches of the trade. We give two NECKLACES, one a Greco-Etruscan copy,

the KNIGHT'S CROSS of the "Sovereign and Illustrious Order of St. John of Jerusalem:" an

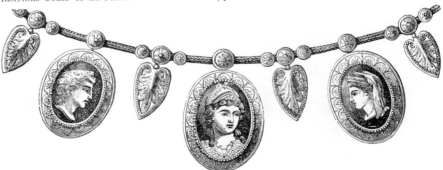

this Order Mr. Phillips is the jeweller. An engraving of the Cross, or *Crachat*, cannot fail

carved into a floral group; while the CUPIDON, bearing a bird and flowers, is a finely sculptured

the other, into which is introduced a series of beautiful enamels from the Worcester manufacture, painted by the delicate hand of Mr. BOTT. They are set in pure gold. Besides a small and graceful JEWEL-CASE of oxydised silver, we engrave

Order that has existed more than eight hundred years, and which has recently been revived. Of

to interest many of our readers, as well as members of the ancient and honourable Order.

mens exhibited, and in nearly all the inferior works, where the same influence has been at work. In this class of furniture, the bedroom *suite*, by Bird and Hull, is conspicuous for its simplicity and taste. A wardrobe by Purdie, Bonner, and Carfrae, and some polished deal furniture by Dyer and Watts, also display what can be effected by the simplest means skilfully directed. There are, of course, many more costly and elaborate specimens,—articles painted, polished, and gilded,—and some of them are very beautiful, and show the same general refinement of style which was already noticed in the furniture for public rooms; but, as the glory of the present Exhibition over the former is that better results have been secured by less expensive means, it is only necessary to point to those types of the class which carry this great truth most successfully into practice.

In French furniture the same great principles have been influencing the makers. Italy, and not France, has become the well of inspira-

tion; and the most perfect and most costly works of Fourdinois, such as the ebony cabinet in the nave, and the huge mantelpiece beside it, derive all that is important or beautiful about them from the Rennaissance, while all that is meretricious is as visibly traceable to the lower style of France. The ebony cabinet is a charming piece of furniture, and perhaps as good as Art-industry can be expected to produce; for to carry the carving into a higher style would make it a work of Art proper. Even in this some of the details are less pure than could have been wished, but as the same truth is more conspicuously seen on the large mantelpiece, it can be made more palpable to the general reader. The Italian, like all true styles, is founded on the great general law that the base of a subject should have breadth and solidity enough to carry all above it, and that the gradation of ornament should correspond with that of the general outline,—that is, that the heavy base should not be frittered away into

Mr. WERTHEIMER, of New Bond Street, is among the most valuable contributors to the Exhibition, from

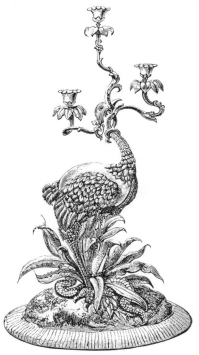

his extensive collection of *objets de luxe :* he is a large importer of the choicest productions of the best fabri-

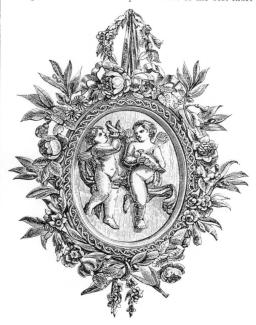

cants of the Continent. Those we engrave are, however, his own productions, and consist principally

of works in ormolu, admirable as castings, but receiving increased worth and beauty from the labours of the chaser. Evidence of this is supplied by the STORK CANDELABRUM, the FRAME,

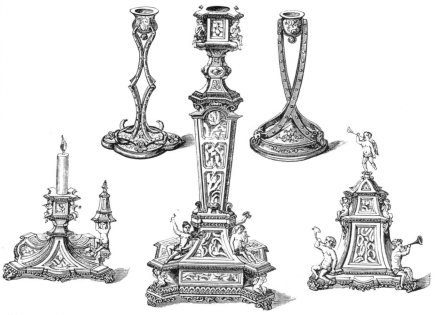

attract general notice and universal admiration, is the CONSOLE TABLE, which, as a production of Art, will not be surpassed by any of similar character contained in the Exhibition, British

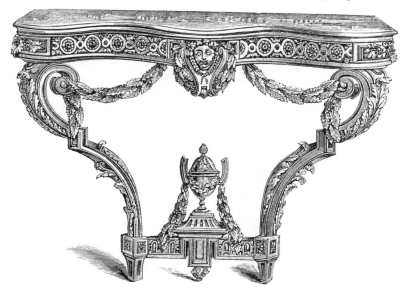

steel. In the centre is a Bacchante head, from which garlands of laurel leaves are suspended : they are exquisitely wrought. The legs and the base are of equal excellence. There is no

(one of four representing the Seasons), and a variety of CANDLESTICKS and INK-STANDS, of the class to which Mr. Wertheimer has paid special attention. But the work that will

or Foreign. Our engraving does it but limited justice. It is after the renowned Goultiere, of the time of Louis Seize, and is most beautifully chased in "mat" gold, with plain parts of silvered

portion of this very remarkable work that has not received the largest possible amount of care and labour; the result is in the highest degree satisfactory.

small ornaments, and the lighter top overloaded with heavy ones. The main lines of this mantelpiece scientifically fulfil this condition, and, up to a few days ago, it looked comparatively grand in general effect. The mass of marble sustained the upper portion with stability, but the style, which is essentially French, has intervened—the mass of marble has been cut up by small brass ornaments, beautiful enough in themselves, but entirely destructive to dignity and breadth, and so attractive from brilliancy, that the stability of support for the large figures and large forms above is weakened—almost destroyed. This has ever been the French treatment of the Italian style, and it is one from which our designers are not free, but to which they are now less addicted than their Gallic neighbours. There is a good French book-case (No. 2,868, France), where both the quality of form and the distribution of colour is more than respectable; and another book-case, by Kneib (France), where the Italian style is skilfully

maintained; and a door where Ghiberti has been the source of inspiration. No. 2,877, a wardrobe, by Mazaroz, Paris, and a cabinet by Writh, Paris, are also good examples of their respective styles; and the same may be said of a wardrobe and ebony cabinet by Pecoquereau and Lemoine, both of Paris. There are many other far more showy and popularly imposing works, and many of them containing admirable individual parts, but these are either so neutralised with parts objectionable, or parts indifferent, as to prevent special reference to them unaccompanied with special condemnation. We may now affirm with certainty that, although the better work, especially in carving and the like, is still with the French, as it was in 1851, the higher style is as decidedly with the British manufacturers as a class; and that in this triumph of style over manipulation our own countrymen occupy the strongest and most conspicuous position. The Austrian department, which attracted so much attention

The house of DIXON, of Sheffield, has been

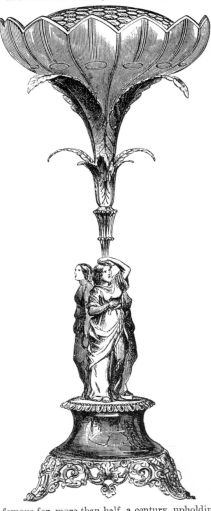

famous for more than half a century, upholding

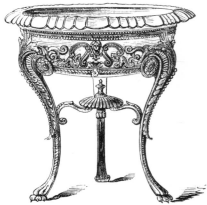

the renown of the great capital of hardware for

the production of articles which take its name. The Sheffield plate has long obtained distinction and favour throughout the world, and was un-

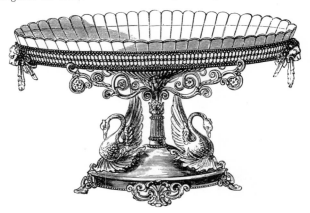

ancient and honoured system, which Time rather aided than impaired. Messrs. James Dixon & Sons, we believe, retain the old plan, but also adopt the

rivalled until Science gave to electro-plating a higher place—at least it is so considered generally, although there are many who prefer the

new, and the firm still keeps the rank it has held so long—foremost among the best manufacturers of England. We engrave of their works a FLOWER-

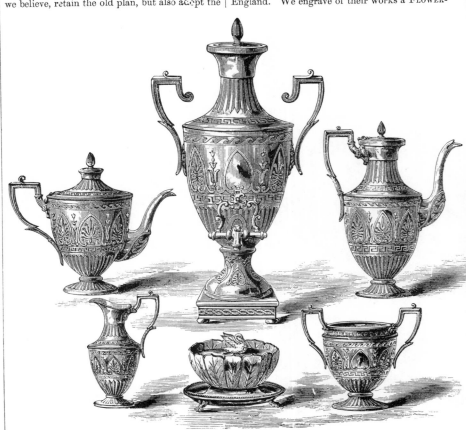

STAND, supported by figures; portions of two DESSERT SERVICES, and a TEA SERVICE, of good form and ornamentation. They are not only

excellent in design, the workmanship is of the best order—no unimportant element in the fabrication of works that are intended for continual use.

in 1851 by its specimens of Gothic furniture, sends few examples to the present gathering, but one of these, a bed by Schmidt, is highly respectable, and some of the clock-cases are very good; but beyond this, there is nothing entitled either to particular comment or special commendation. Brussels sends a good book-case, desk, and chest combined, and an attractive pulpit; and Denmark sends a book-case, the upper part of which is more than respectable: but in none of these sections have any of our manufacturers anything to learn. So far as what is exhibited is mere matter of trade or show, they are beyond our circle of observation. Italy sends little, and much of that little far from good; for, as already said, the furniture from Turin is largely intermixed with that love of show so characteristic of the style called French; and while it is impossible for spectators to overlook the attractiveness of the mirrors, tables, bedsteads, chairs, and cabinets from Turin, and while in detail those interested will

find in many of these articles much to admire and profit from, yet, as a whole, the display is an exhibition of false style—a cross between French and Italian—in the opposite direction of that visible in the French Courts. There it is Italian outline marred by French detail; from Turin it is French outline made out with Italian detail: and to the higher class of manufacturers, Cæsar and Pompey must be very much alike, specially Pompey. Without, therefore, dwelling on the defects culminating in the large stand studded over with statuettes of this display from Turin, or on the beauties of detail seen most easily on some of the tables and smaller objects, we shall leave the doubtful for the genuine, and ask attention to that example of Italian furniture, a large carved seat, which stands in the entrance to the Italian Courts. In that beautiful specimen, having neither name nor number on it when we write, the highest and purest efforts of modern Italian industrial Art

From the collection of MAPPIN & CO., of Oxford Street, we select a varied "lot," illustrative of the several productions of

therefore we have chosen to engrave on this page objects that are the daily requirements of all families,

—FLOWER VASES, a SUGAR BASIN, a BREAD-KNIFE HANDLE, a BUTTER-KNIFE, and SCISSORS. Some of them

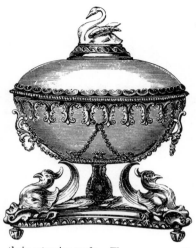

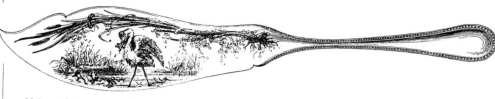

would do credit to any mansion, no matter how high, while they are brought by "prices" within the reach

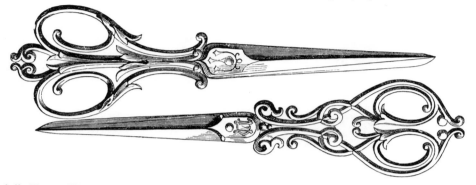

their extensive trade. They are generally —indeed almost invariably—of a good order, though designed and manufactured rather for the many than the few. It is exceedingly satisfactory to find, in esta-

of all. There will be few circumstances connected with the Exhibition of 1862 so encouraging as that which

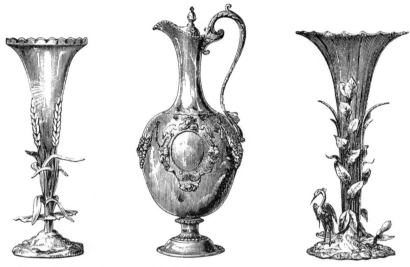

supplies evidence of advance in taste and in design of articles usually catalogued as of the "common"

blishments such as this, Art entering as an element into all its issues, conveying perpetual lessons of fitness combined with grace, adopting simplicity as a prominent feature, and illustrating the position that beauty is cheaper than deformity. It is

order. The stall of Messrs. Mappin & Co., although by no means the only one to which we may direct

attention with a view to illustrate this position, may be adduced as a case very strongly in point.

seem to be literally lavished, and the details are as pure as the general outline is perfect. Whoever be the maker of this article, he is no ordinary man even for Italy, and there is nothing entitled to be compared with it for unity in any of the foreign Courts, and the only article in the British Section is the book-case first noticed. Even with it there is this wide difference, that the makers of the book-case have made Wedgwood the artist for the higher kinds of ornamentation, the heads introduced being plaques by that eminent Englishman: in the seat at the Italian entrance, the maker seems to have been his own artist, and with surpassing skill, amounting to genius, he has worked out his own highest details. This is a work in the true Italian style for the education and study of our furniture makers; and whatever the present public verdict may be, he who permeates his mind with this style and quality of work, and is able to reproduce it in spirit adapted to the requirements of the hour,

will, beyond any doubt of ours, be he who eventually shall win the day. Some of the frames by Guesti, also from Italy, are likewise beautiful. Having now indicated rather than illustrated the leading specimens in the general furniture Courts, it may be expected that something should be said about the style and execution of those specimens which are found in the so-called Mediæval Court. In asserting that the Gothic has disappeared with the grotesque and naturalistic styles in furniture, the reference was to those portions of the Exhibition which represent the general public. Into the Court which represents the Ecclesiological Society, nothing but Gothic has been admitted: and, thus exhibited, they are fairly entitled to all the converts and popularity for their works which they may create. It is no part of our design or desire to speak disrespectfully of the devotees to Gothic, and we have already given them a fair share of credit for the general progress in Art-industry; but it is really dif-

Mr. Asprey, of New Bond Street, dressing-case and travelling-bag manufacturer to the Queen, exhibits

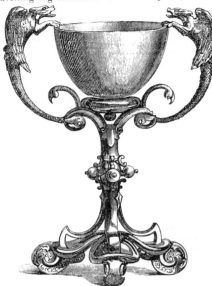

largely. As specimens of the skill and taste that have been applied to the manufacture of the branch

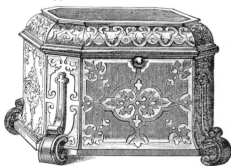

of trade of which Mr. Asprey is an eminent representative, we have engraved a Cup in oriental agate,

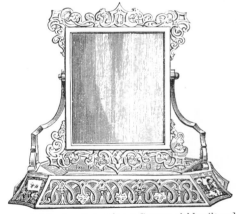

mounted in chased ormolu; a Casket, richly gilt and

engraved; a Mirror, with porcelain slate at the back for memoranda. The Dressing-Case, with

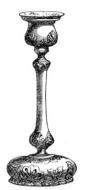

and costly finish, and is one of the most complete

the Blotting-Book and Candlestick that form parts of its fittings, is remarkable for its high, rare,

works of its purpose and character that has ever

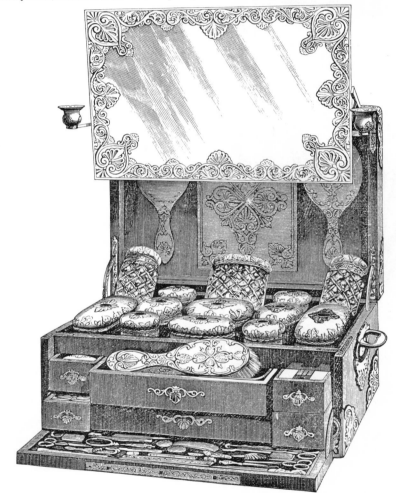

been produced. The case is of walnut-wood, the

outside ornaments being richly gilt and engraved.

ficult to see what is expected to be gained for Art by many of the objects exhibited in this Court, whatever may be their merit as founded on "authority"—that is, not on any laws of elegance or beauty, but upon what some one else did four, six, or eight hundred years ago, the further back the better. These specimens, with of course exceptions, are only remarkable for their surpassing affectation, if not ugliness, and must help to render ridiculous that mania which insists on calling them beautiful, or even better than other affectations in opposite directions.

The general conclusions from this study of the whole of the furniture exhibited, have been already in part anticipated; but these may be recapitulated, so that they may be seen at a glance in connection with those not previously stated. First, that the progress since 1851 has been general, but the rate of progress has been most conspicuous among the British makers; second, that in all countries the change has been towards the Italian more than towards any other style; third, that although as in 1851, the French are still considerably ahead of our industrial Art-workmen in manipulation—especially in comparing our best works with their best in carvings and the like—yet that, as a rule, the outline and style of the English productions are superior to those of France; and fourth, that the general character of furniture ornamentation is not high relief in carving, but such a relief as shall obtain protection for the ornaments by the framework and outlines of the construction; and while there is much to condemn in heavy ornamentation, there is the opposite error of weak and stringy forms to be equally avoided, whether for inlays or carving in relief. Other opportunities may present themselves for illustrating these points at length, and with fit examples, of which the Exhibition gives us so large a supply, both for description and illustration.

This page contains engravings of works in terra-cotta, produced at Coalbrookdale by the COALBROOKDALE IRON COMPANY. They consist of

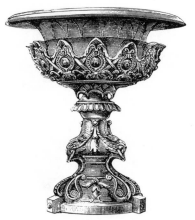

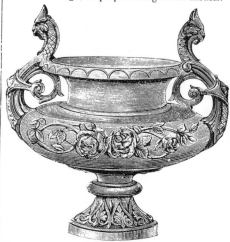

this purpose they have employed artists, both English and foreign, to prepare designs and models.

ORNAMENTAL VASES and FLOWER VASES. The company, finding a growing taste for objects of

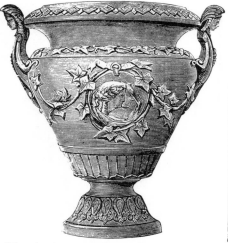

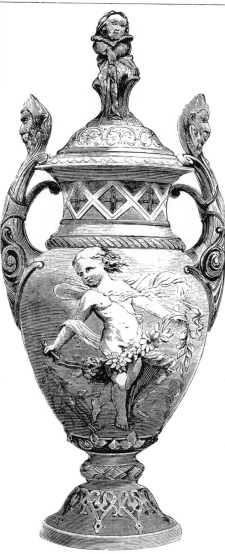

Those they now exhibit are but the "first fruits" of their contributions to the demands of the many; others of still greater importance will follow in

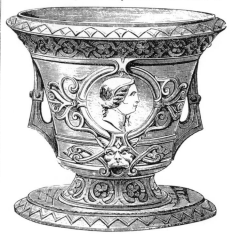

this order, have recently turned their attention to a further development of their magnificent beds of clay, which, being of the finest quality, are well adapted to productions in terra cotta, and for due course. With their abundant resources, however, there can be no doubt of their largely ad-

vancing this branch of Art-industry. We may hail, therefore, with exceeding satisfaction, the promise thus held forth by these renowned works.

METAL WORK.

This class embraces Art-industries from the casting of colossal figures to the chasing of the smallest finger-ring; and to exhaust the vast subject would be impossible within available limits; those departments must, therefore, be selected which come most prominently before the public for the specific beauty of the objects, or which most fully embrace the more prosaic domain of general utility. On whatever path we enter, one great general truth is as apparent as if written with a pen of light—the same truth which has already been set forth respecting furniture—that in metal work progress is visible everywhere since 1851, but most in the British section, with one exception. The advance in furniture has been marked and substantial; the progress in metal work has been rapid—almost brilliant—and while some other nations have improved upon their former productions, the British workers in iron and brass have outstripped all competitors, and in some kinds of works—and those of the highest class—they carry off the palm from all competing nations. This is a triumph for English energy and genius which must be as invigorating as it was unexpected, and which shows, in spite of all gainsayers, that, both for design and manipulative skill, England is beginning to lay aside the continental go-cart, and trust in her own inherent strength, artistically as well as mechanically.

In the introduction to this essay, the advocates of Gothic were debited with a due share of influence in helping on the general Art-progress of the country. Their mission has been to insist on the value of good lines, and nowhere has that influence been so noteworthy as in metal work. There is much of that which is strictly Gothic,

The Vases, Statues, Busts, *bassi relievi*, and other works in terra-cotta, as well

as the Jugs, Moulded Bricks, Tiles, and

Architectural Ornaments exhibited by Mr. JOHN MARRIOTT BLASHFIELD, arc

made at his works in Stamford, Lincolnshire, from

the clays found in the oolite beds of the neighbour-

hood, and from the clays of Dorsetshire and Corn-

by a mill; it is subsequently compressed into moulds, and

worked up by the modeller. Mr. Blashfield has estab-

lished a high character throughout Great Britain for the

purity of his designs and the excellence of his models.

wall. The clay is mixed with fine sand, flint, and other substances, and brought into a stiff paste

and intended for the decoration of the church, and some of these examples are beautiful; but, even apart from this special class of metal work, the influence which has produced the *specialitie* is visible throughout many other departments of this widely varying class.

As a beginning must be made, let it be with the gates, of which there are some fine specimens; and as these are of both wrought iron and cast iron, the question at the threshold is whether the same style is applicable to both classes of iron work? Some general principles are so equally applicable to both as to require no enforcement or illustration, because they are those universally applicable to all Art. The weight of ornament, for example, should be below, forming a base for what rises above, instead of this rule being reversed, which is oftener than once done in otherwise creditable constructions. But, apart from these general principles, there seems good grounds

for believing that the character of cast iron work ought to differ from the style applicable to wrought iron. The one—cast iron—appeals to utility, and is attainable by the multitude; the other—wrought iron—especially of an ornamental character, is so expensive as to limit it to the service of the wealthy, whether that wealth is represented by individuals, or voluntary combinations, or corporations. The mode of production, as well as the uses and the nature of the productions, seem to suggest a difference of ornamental treatment between cast and wrought iron, and it would be well to have this difference so defined that the peculiarities of the one should not be mistaken for the characteristics of the other. One general law ought to control all ornamental iron work for outside purposes in this country, viz., adaptation to climate; for what may suit the sunny skies of Italy, however beautiful in detail or general effect, may be

THE INTERNATIONAL EXHIBITION.

We have already given examples of the excellent executed in terra cotta, silver, and silver-bronze, this page a LOOKING-GLASS, the subject Sabrina,

by themselves. We have engraved on from the "Comus" of Milton; a

productions of Messrs. WILLS BROTHERS, Euston

HAND MIRROR, the subject Diana and Actæon; a VASE, modelled in *alto relievo*, of the battle of Hastings; an EPERGNE, with figure of a youthful Mars; and a "SALT," surmounted by a figure of Venus. These are works in which "high Art" is happily combined with general utilities; and are truly Art-manufacture.

Road; they are true Art-works, designed and

most unsuitable for the changing atmosphere of England; and there are various examples of this adaptation to climate being completely overlooked by some of our workers in iron. If, for instance, ornaments are formed to hold rain, instead of to throw it off, as in several instances could be pointed out, it seems evident that, however venerable the authority for such ornaments, and however beautiful they may be for other circumstances, they form a clear violation of all sound ornamentation for gates in this country, where the chief enemy is rust, because such ornamentation nurses the destroyer; and what is true of vases is equally true of all other forms of gate ornamentation which tend to the same result. A bunch of flowers or fruit, or both, whose terminal stalks rest in a vase, is practically a source of destruction to the flowers, and therefore a specimen of false decoration, whatever the individual merit either of flowers or vase. This is a truth of Art-industry which many of these makers have yet to understand. But there are other special distinctions. Cast iron gates cannot, as a rule, exist in this country without paint, and as the frequent application of that, however carefully laid on, must fill up the details of ornamental casting, it follows that the smaller and more minute such details are, the more certain is their speedy destruction; so that the prominent character of all such cast iron work ought to be dependent for effect on breadth and general outline, rather than on number of individual details. Again, the form of the ornament ought to be such as to give the least possible comfort to the enemy—rain; and the forms of the detail those which shall be best able to resist the annihilating process of the other enemy—paint. If an ornament produced upon the concave principle be more likely to harbour rain, paint, and dust than a convex ornament,

We have selected for engraving two of the STAINED GLASS WINDOWS of Messrs. BALLANTINE AND SON, of Edinburgh. The one, a memorial window, to the late Thomas subject is the Crucifixion—a composition on a large scale—which is carried across the entire breadth of the window, each compartment having its canopy, base, and Mosaic groundwork, thus securing the necessary architectonic distinctness. In the tracery, angels are represented, and also

B. Crompton, Esq., of Farnworth, for Prestolee Church, Lancashire, consists of five upright lights, with elaborate tracery. The scrolls with appropriate inscriptions. The slip we have engraved from a vestibule light executed for the Chevalier Burns, K.H., with heraldic bearings, the Order of the Knights of the Guelphs, &c.

which is notoriously the case, then the sound principle of ornamentation for gates and other iron castings for outside work, will as much as possible eschew the worse and embrace the better style. Take the common example of an ordinary scroll, and if the "eyes" of the foliage are so placed as to catch and retain the rain with the leafage turned upwards, these "eyes" will also be harbours for the dust, and will probably soon be half lost through paint. If the foliage is so modelled as to indicate, while it covers, the "eye" with a downward swoop, neither rain, nor dust, nor paint, can much hurt the detail, while greater breadth will be secured in the general effect. The carrying out of this principle would make sad havoc among the stock patterns of many of the iron founders, and therefore it cannot be secured at once; but it seems so obvious to common sense, which is the basis of all true ornamentation, that true progress can only be expected to be made when manufacturers set out

in this direction, determined to carry the largest amount of utility into the principles of industrial ornamentation.

The conditions which govern productions in ornamental wrought iron are different, especially when this is applied to interior decorations. Here also, however, it must be insisted on that littleness is no part of good design, but the contrary; and this truth requires to be urged, for there are evidently ideas abroad among some of the best makers wholly opposed to sound principles on this point. In all Art smallness of parts gives littleness of style: and with a defect so radical the most exquisite workmanship is wasted. Take the gates from Norwich as an illustration, and this may be done with better grace because we fully join in that general admiration which this fine specimen of Art in iron has extracted from all visitors. But even for interior decoration the style of the details—the stringy tendrils and the multiplicity of lines and leaves—is a mistake; and

THE INTERNATIONAL EXHIBITION.

This page contains engravings of two of the many excellent works in painted glass, contributed by Messrs. O'Connor, of Berners Street. The Single Light is a figure of Aaron,

designed for her Majesty the Queen. The main subjects represented are the birth. death, resurrection, and ascension of our Lord. At the base, upon one

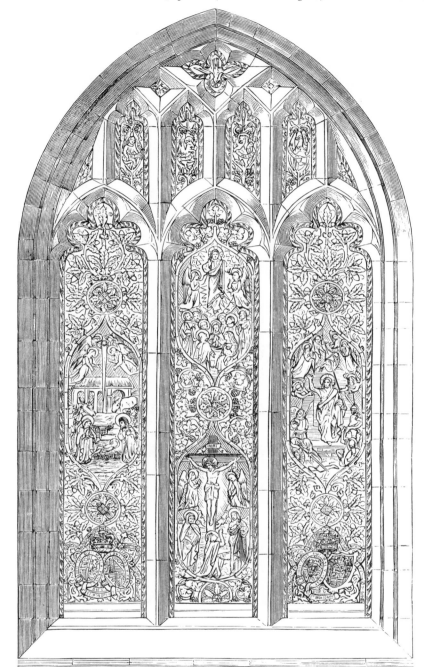

side, are the armorial bearings of her Majesty and the late Prince Consort (the name can never be written without grief), and on the other are those

one of the series of Old Testament worthies at Eton College Chapel, executed by these artists. The Three-Light Window is especially interesting: it is a memorial window to her late Royal Highness the Duchess of Kent,

of the late Duke and Duchess of Kent. In the examples contributed by Messrs. O'Connor, evidence is supplied that they can deal well with figures of life-size painted on glass, by careful and natural

drawing judiciously combined with brilliant colouring, showing that truth may be obtained in this class of Art as surely as in wall frescoes, or any of the highest styles of ecclesiastical Art decoration.

while it is impossible not to admire the beauty of the workmanship, it is equally impossible to refrain from regret that what might have been a grand work has, through excess of beautiful detail, been frittered away into what is merely pretty in parts, but wanting in dignity and unity of effect. As examples of outside gates, all these difficulties are increased, without any compensating advantages. The public are no doubt told that galvanised iron does not rust, which, if true, may disarm one strong objection to such a style for gates, because it would be all but impossible to paint them carefully except at enormous cost; but dust, if not rust, would soon mar the beauty of such work, and reduce what is now so much admired as an effort of skill in iron work, into a choked and dirty mass of unprofitable inutility, in spite of the talent—almost genius—displayed in its production.

In the cathedral screen (6345), similar objections might be taken to a few of the details—as, for example, parts of the upper scrolls—but in this work these are as nothing compared with its general and striking excellence, both of outline and detail. It is, of course, Gothic, and fully represents what may be called the period of progress, if such a term may be allowed to a style so ample in its decorations, and may we say florid in its general characteristics. To enter on the details of this work is a labour which would require a chapter for itself—nor would it be labour lost—but these are presented for the study of readers in one of the woodcuts in this Catalogue. There is another work exhibited by this company equally beautiful in detail and workmanship, but which seems to raise a question of principle that may as well be noticed now. One of the cardinal truths, or, at least, most often repeated dogmas, of the devotees of Gothic, is that ornament ought to spring out of construction, and that ornament not based on utility is necessarily false.

Messrs. COX AND SON, of Southampton Street, Strand, Manufacturers of Church Furniture, Works in Metal, and other branches of Ecclesiastical Art, exhibit several painted glass windows in

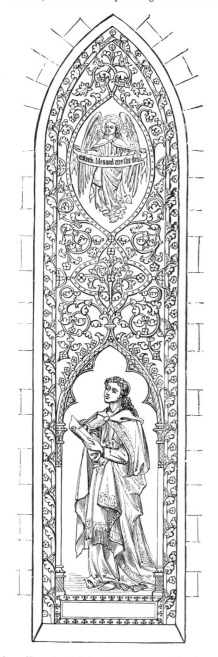

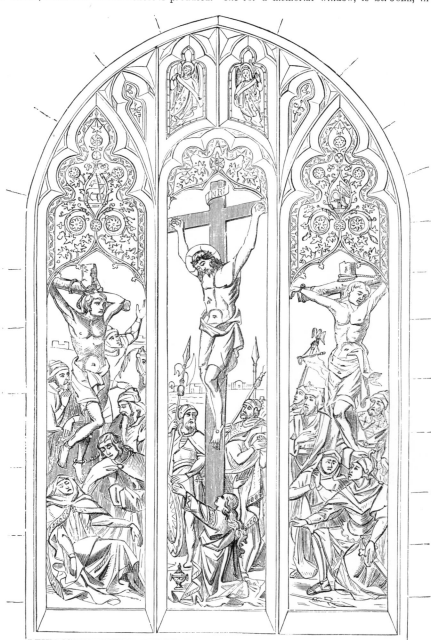

is intended to occupy the east end of Wimbledon Parish Church, Surrey. The figures are nearly life size, and the drapery being in large masses of colour, a rich and brilliant effect is produced.

The other engraving is of a large SINGLE-LIGHT MEMORIAL WINDOW, executed for Worthing Church. The subject, which is a very suitable one for a memorial window, is St. John, in a

the gallery devoted to that purpose. The large THREE-LIGHT WINDOW which we engrave is, in some points, a study from Michael Angelo's celebrated picture of 'The Crucifixion.' This window

listening position, with the scroll and stylus in his hand, in the act of writing; in a medallion above is an angel holding a scroll, commanding St. John to " write blessed are the dead that die in

the Lord." In addition to these windows this firm also exhibit a small memorial window for Haversham Church, and a richly-coloured panel, representing "The Adoration of the Magi."

That is a fair, although general, summary of their statements in detail, and it may be accepted as a generally wholesome truth. The most important work placed recently in one of the side courts of the nave by this company is the tomb for a bishop, destined for one of the cathedrals; but whether for the interior or the exterior of the building would not be very easily gathered from the construction adopted. If for the former, it is difficult to see the utility of the covering over the recumbent figure, supported by four pillars, unless the structure, covered with something like imitation fancy tiles in metal, is meant to represent a canopy, although it looks far more like a protection from rain for an outside construction. If, however, this was its real purpose, the style and quality of the metal work would be wholly out of place for such a destination. The objections can, no doubt, be answered in fine words representing symbolism and assumed scientific progress. The stock terms of

iconography, and the deep thoughts they are supposed to represent, may satisfy the ecclesiologists, and confuse the people, while the talk about galvanised iron may silence many, but neither of these courses will answer the simple question why those whose creed depends on constructive utility being the basis of ornament, should cover a tomb for the interior of a church, or adopt a style of metal work for outside purposes which bears the impress, from its creation, of premature decay. This latter is an important question for those who are tempted by the real beauty of this charming class of iron and metal work, while the former merely touches the consistency of those whose architectural creed we have been anxious not to misrepresent. But, while indicating such difficulties, it must also be said that this, and the other articles furnished by the same company, display the highest point of our national progress in iron work; and it is something to rejoice over that it is by far the highest specimen

Messrs. WILLIAM FRY & Co., of Dublin, whose Tabbinets have been long famous throughout the world, exhibit several examples of the beautiful fabric

for which Ireland is still pre-eminent. This column, however, contains engravings of two of their productions in SILK FURNITURE HANGINGS, for which

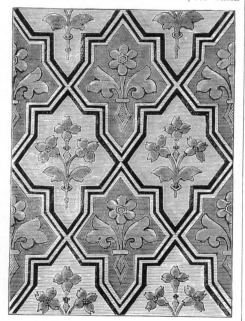

the firm has also established a high character. These are of good design, rich and very substantial in fabric, and in all respects creditable to the country.

The engravings that follow are of two CURTAINS, exhibited by Messrs. S. WILLS & Co., Lace Manufacturers, of Nottingham. They are of

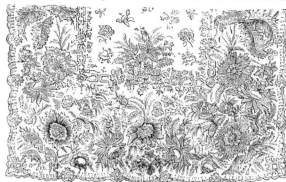

although agreeable and effective when "spread out," are of broken and disturbed forms when

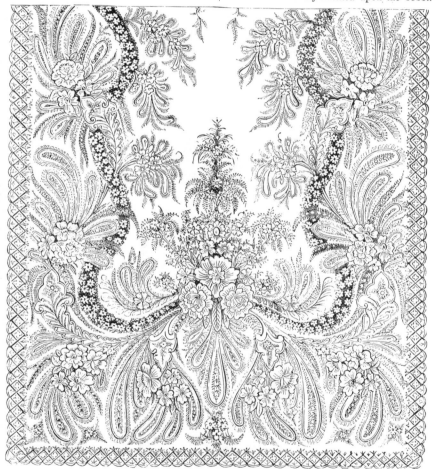

net lace-loom, and therefore require no clipping of threads in any part of the pattern. There are few more cheering facts supplied by the

graceful design, "folding" well—a very important matter in articles of this class. Some of those which are contained in the Exhibition, in the positions they are made to occupy. These curtains are entirely finished upon the bobbin

Exhibition, than the evidence it affords of the great advance that has been made by Nottingham in the production of works of this order.

of iron work within the walls of the Exhibition, alike for beauty of outline, unity of detail, and artistic ornamentation. By many other exhibitors this last-named element of success has been sadly neglected; and although it forms no part of our intention to single out individual works or makers for disparagement, yet it is impossible not to see and make known the departures from propriety or harmony of effect produced by thoughtless decoration. One destroys the effect of an otherwise creditable gate or screen by brass or "gun-metal" birds or beasts, or still life, so arranged as to violate every rule of Art in the disposition of effect; turning the panel, in reality, upside down—no doubt upon the theory of making all show that will, and bringing the brass work mostly on a level with the eye. Another employs large ornaments of the same kind to sprawl from the centre of his panel, with breadth and weight sufficient to overwhelm the weak and puny centre, instead of the opposite principle of using corners to

vignette off the centre, which is that adopted in all best Art—not as a mere exercise of arbitrary authority, but in obedience to laws imposed both by æsthetical and optical necessities. A third reverses all ideas respecting the uses to which gates are put, and instead of adding to the sense of strength and security which they are constructed to inspire, heaps the decorations of the drawing-room, in vulgar profusion, on the entrance-barrier to the park; while a fourth, amidst much that is good, mounts "adaptations" of the Roman capital on pillars of Gothic ornamentation, to which are attached gates of something like Grecian scroll-work, the whole surmounted by French scroll ornaments. These are all blunders of greater or lesser gravity, and show that, while the workers in cast-iron have made progress in design, they have still much *thought* to undergo before they can claim more than toleration for their work. True, in designs for iron gates, or cognate subjects, the exhibitors of other countries

We engrave on this page two of the LACE CURTAINS exhibited by

fabric, which possesses the three important advantages of greater durability, increased transparency of ground, and additional clearness and sharpness of pattern. It has,

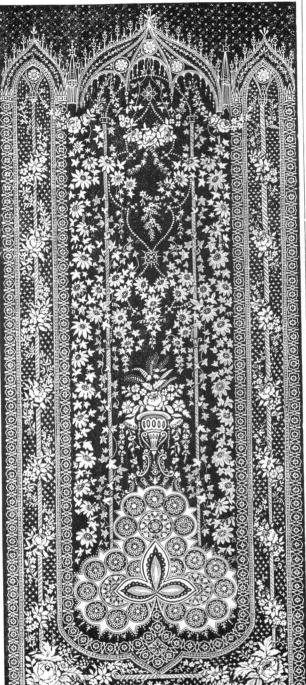

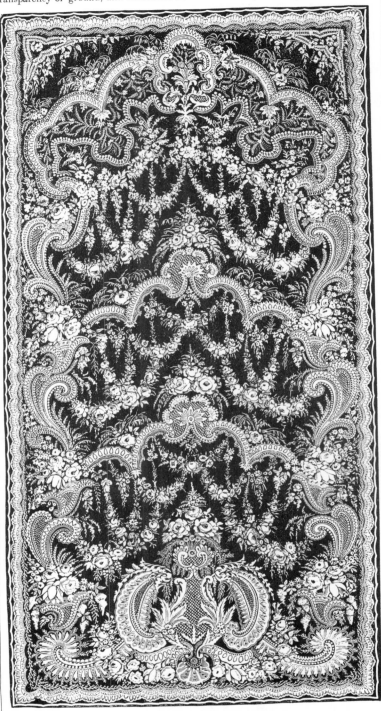

Messrs. COPESTAKE, MOORE, & Co., of Nottingham. This is a new

therefore, obvious advantages which cannot fail to recommend it for general use.

are far from perfect, and of these the French are the principal; but, although the large French screen which stands in the nave, and the gates which open into the French Court from the east, especially the former, are greatly inferior to some specimens exhibited by British makers in general character of design, yet these French articles are free from those glaring incongruities which so disfigure the products of many British iron-workers in the same class of manufacture.

Grates may be called a British "institution," and throughout this International Exhibition, the only examples of this most essential part of home decoration are in the British section. Even stoves for halls are almost nowhere else represented, and here, as elsewhere, the improvement since 1851 is remarkable. Then, it will be remembered that the leading characteristic of this class of manufactures was florid ornamentation; now there is just enough of that to enable visitors to contrast what was, with what is, the prevailing style.

But while the advance has been obvious, the change has not been all gain; for if unmeaning ornamentation has been overcome, ungainly baldness and affectation have too often taken its place. This last delusion has a quaint character; but baldness in itself is no evidence of advancing taste. Our forefathers made grates of heavy bars, without much form and without any ornamentation, simply because they could do no better; but for manufacturers in these days to indulge in such conceits, and call them beautiful, is the vainest effort ever made to reverse the wheels of progress, and substitute the ignorance of semi-barbarism for the development of civilisation. Besides, they burned wood, while we burn coal, and the grate fitted for the one is not best fitted for the other, even in construction. The same thing is seen in the grate appendages. Now, fire "dogs" seem to be valued for their size; and huge, often ill-formed masses of metal are erected on each side the fire, without reference to anything,

Messrs. DEBENHAM, SON, AND FREEBODY, of whose contributions in lace we have already given examples, supply us with others. The two we engrave are both British productions, and both are of great excellence. The first is a black Buckinghamshire LACE FLOUNCE, thirty-eight inches deep, of elaborate design and of a quality that will compare favourably

p. 48 of the ILLUSTRATED CATALOGUE. The one is by hand, the other by machine, hand-aided. It is only within the last three or four years that large articles in fine lace have been made in Buckinghamshire; the workers there have not

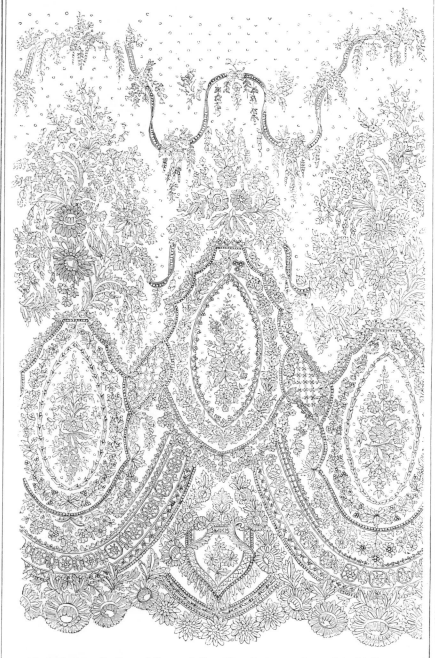

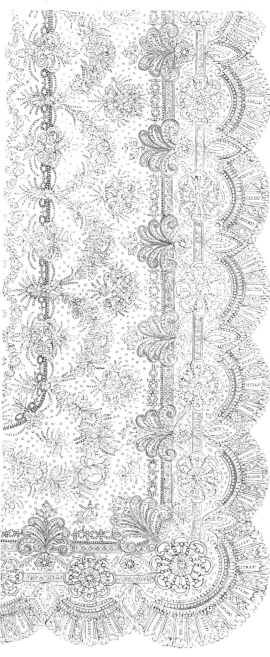

with the best productions of Caen and Chantilly. It is manufactured by E. GODFROY, of Buckingham. The second is a black Pusher LACE SHAWL, of novel design and extra quality, designed and manufactured by Mr. W. VICKERS, of Nottingham, of whose many admirable contributions, contained in his own case at the Exhibition, we have given four specimens at

only improved in the fabric—their designs are of a higher character than they used to be. It is but requisite for English ladies to examine this and similar productions—British work—to admire, appreciate, and, we trust, to patronise.

except that in old grates, before the artisan could make fire-irons which could be handled with facility, the dogs made to support the rude tongs and poker were, not only large, but ugly. There is, no doubt, authority for such misshapen things, but in a world of progress only the most perverted insipidity could hope to make the people of this age prefer ugliness to beauty, simply because ugliness or rudeness was the type patronised by their fathers. The specimens of this class among these grates are so numerous as to make allusion to individual objects unnecessary; and although a bare bar is preferable to an over-ornamented absurdity, yet clumsy bars represent society in a state of infancy, while legitimate ornamentation is the evidence of increased civilisation. It is not, of course, that simplicity and clumsiness have any necessary connection, far less that they are synonymous terms, but the huge "dogs" necessitate thick, massive bars, and these pressed into small space make the clumsiness more conspicuous than the simplicity.

Grates, as here exhibited in many stalls, seem to be in the transition period of taste; and that thoughtless groping after Gothic, which was formerly devoted to furniture in wood, seems, after being driven out of that department, to have found refuge in grates: so that out of all which have been specially got up for this International Exhibition, fully one-third is, in some form or other, a specimen or modification of Gothic, from its baldest to its most florid type. Not content with the door-posts and lintels, some of these makers must also have the well-known "I.H.S.," in mysterious symbol, on the stoves; and illustrations of Scripture story honoured by the smoke and soot which gather on the backs of grates for burning coal, will doubtless be considered as mingling religion with our common things, and as the evidence of peculiar devotion to the doctrines of the church. Those who believe in such service are entitled to enjoy their liberty of choice. But for designers and makers to

In representing the COALBROOKDALE COMPANY, we

are compelled to consult rather the space we have

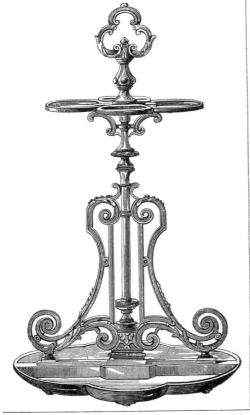

to occupy than the variety and merits of the numerous admirable works exhibited by them. We

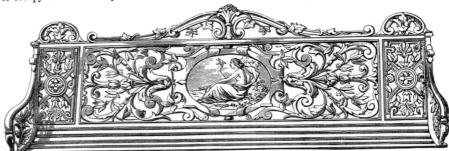

engrave on this page two UMBRELLA-STANDS, of good and convenient form, the back of a GARDEN CHAIR, and one of the wings of the large and high GATES that attract the eyes of all who arrive at the building by the south-east entrance.

They are "entrance gates" of cast iron, consisting of four ornamental pillars, with figures of Victory as finials, and six panels or doors,

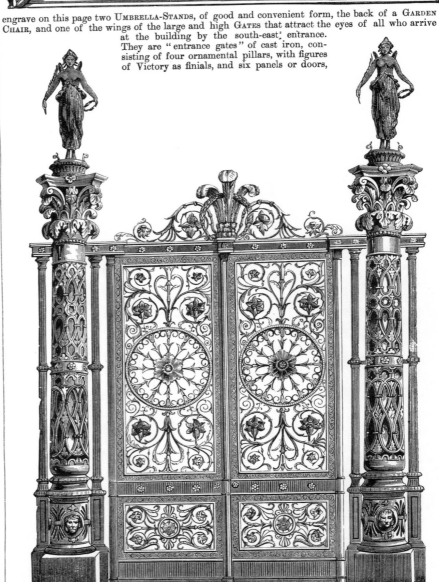

each 14 feet high, by 4 feet 10 inches wide, cast in one piece. The centre arch is 25 feet high.

attempt to form a style out of such peculiarities, and trade out of such subjects, seems little else than endeavours to make a combination of affectation and cant the basis of worthless delusion and fashionable folly. Among the good designs for stoves, some by Hoole, of Sheffield, and Stuart and Smith, of the same town, challenge admiration, particularly a drawing-room stove belonging to the first, and some similar productions exhibited by the second firm named; although in all examples the "dogs" are of the present inordinate and newly fashionable size—that is, fashionable among the vulgar rich, for the real leaders of *ton* would never tolerate anything so outrageous. Feltham shows some creditable small stoves, and one of the best small Gothic grates in the Exhibition; and a hall stove exhibited by Edward and Son, which is engraved in this Catalogue, displays good outline and creditable ornament, although it could have spared the

brass lines with advantage to solidity and dignity of general effect. There is also a good dining-room grate exhibited by Critchley and Co., Birmingham, and some partly enamelled stoves for drawing-rooms and parlours, which combine elegance with cheapness and utility; while there are large numbers of makers who have very much improved upon what were the prominent characteristics of the same class of articles in 1851, but who still retain a strong leaven of over-ornamentation, under the mistaken idea that splendour of effect depends on the amount of ornament. Indeed, this feeling seems stronger amongst the manufacturers of grates than among many other industries, and a feeling that this is wrong appears to have driven so many to the opposite extreme. The oscillation, therefore, may settle into a legitimate style—not the style of our ancestors who burned wood, nor of wood-burning countries, but a style which

The well-known firm of ROBERTSON AND CARR, Chantrey Works, Sheffield, contribute some excellent productions to the International Exhibition, comprising Gothic, Tudor, and Mediæval stoves and fenders, which are faithfully rendered in design. The STOVE here represented is the design of Mr. R. W. BILLINGS, London, and was manufactured for Dalziel Castle, Scotland. This combination of fire-grate and dogs constitutes a

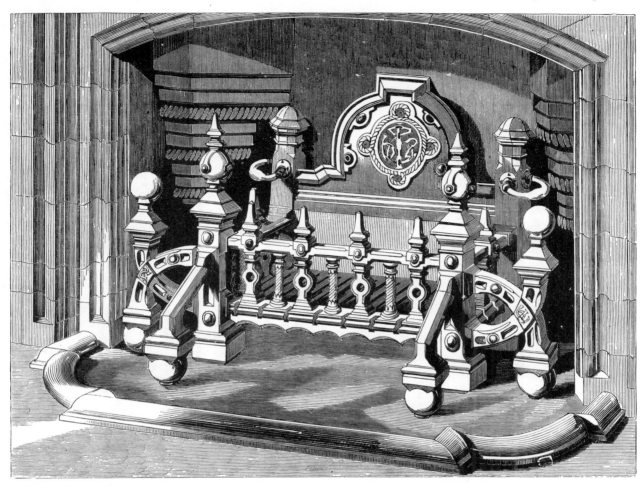

design purposely made so that no particular style of architecture shall predominate. It may be considered suitable to the period when Elizabethan architecture became established in the sixteenth century. In some respects the present design differs from fire-grates in general—it has not a particle of foliation about it, nor any vegetable or animal feature that could fairly be supposed incapable of standing fire, or which

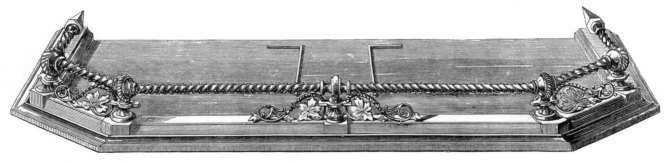

could be inconsistent with metal work for such use. The FENDER is a quiet and good design, of mediæval character. These works, and others contributed by the same eminent firm, materially assist in upholding the high reputation long ago obtained by the world's factory of steel and iron.

shall combine elegance of outline with ornaments suitable to those utilities which almost constant use and coal-burning impose—a medium between bare black bars and those elaborate and over-decorated specimens of burnished steel, which would each take a servant to keep them clean, and would still not be what they ought to be.

In metal castings of an ornamental character, or in the department of higher Art, this country does not sustain so prominent a position, either positively or relatively. One evidence of *felt* inferiority by British iron-casters may be found—that in nearly all the specimens exhibited, and, so far as we have seen, without any exception in all the works of higher class, there is no appearance of work left as if come from the mould, that is, no exhibition of pure, untouched casting; while in the French courts some of the most interesting works displayed are exhibited untouched. In this branch, therefore, of metal work, we are still a long way behind France and some of the other continental states. Nor does the rate of progress since 1851 seem to have been fully maintained by this section of our artisans, for while the quality of design produced is, beyond all question, better, the skill displayed in the process of production has not kept pace with the improvement of the forms produced. There are, no doubt, some small examples of beautiful rough casting, both in copper, brass, and iron—as, for example, in the Coalbrookdale Company's stall in iron, and in Elliot's, of Sheffield, in the other metals; but these are evidently small and exceptional specimens, making, in the fact, the exceptions which show the rule. That there are other and larger works shown now than in 1851 is also beyond dispute; as, for example, the Una and the Lion reclining, exhibited by Mr. Potter, in bronze, and the Cromwell in iron, after the statue by Mr. Bell—although it is difficult to see what connection this cast, exhibited by the Coalbrookdale Company, has in common with

Messrs. RITCHIE, WATSON, AND Co., Etna Foundry, Glasgow, exhibit a variety of CAST-IRON CHIMNEY-PIECES, stove grates, &c., in various styles of Art; also several kitcheners, American cooking-stoves, &c., together with an ORNAMENTAL BALCONY, intended as a specimen of unfiled cast-ing. Hitherto, ornamental goods of this description have been almost exclusively produced in the Sheffield and Coalbrookdale districts, but the great impetus given to Art-manufactures by the former Exhibition of 1851 is strikingly illustrated in the present instance; not that design alone is the only feature worthy of notice, but that the price

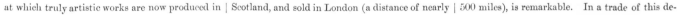

at which truly artistic works are now produced in Scotland, and sold in London (a distance of nearly 500 miles), is remarkable. In a trade of this de-

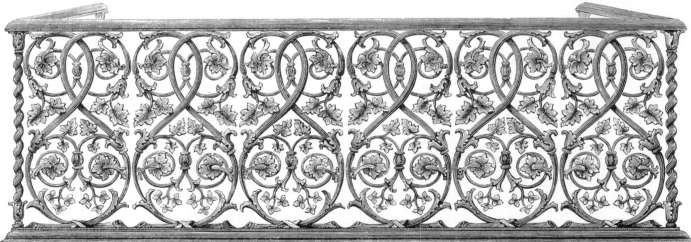

scription, the manufacturer must necessarily look for remuneration to the quantity he "turns out" being large, and not to a limited sale at a high price.

the river genii by which it is supported. But size, although in itself a sign of success in casting, can only be looked upon as a secondary evidence of superiority; and if the castings have to be filled up and painted after being done, before they are presentable to the public eye, while rivals can present their works of the same kind without such hiding of defects, the conviction of British inferiority in this department of industry seems a self-evident conclusion. Into the causes of this lagging among the iron casters, as compared with some other artisans in the race for fame, it is not the time or place to enter, because they result from circumstances which it would take both time and space to make intelligible and useful; but the fact, now patent to all Europe, ought to be laid seriously to heart by those whom it more particularly concerns, because, with the rapid advance in all other branches of Art-industry, casting must either keep pace in this country, or the trade of the higher class must pass to those who can do it best. In many of the smaller articles—railings, panels, and such like—the general character of the fillings and forms is at least equal, and in some instances superior, to that of anything exhibited by other countries; and even the casting of these is respectable for the purposes to which they are applied: but this at best is only negative success, with which neither British manufacturers nor the British public can remain long satisfied. The multiplicity of examples forbids reference to such specimens in detail even for commendation; but attentive examination of the departments of the different exhibiting nations will lead others, as it has led us, to what some may think a most untoward conviction. With regret we confess that there is nothing among the castings in the British section to compare with the works of Barbezat and other foreigners of the same class, while the bronze castings in the British section are not comparable with works

This column contains two of the productions

Mr. ALEXANDER GRAY, of Edinburgh, exhibits the GRATE and FENDER we have engraved under-

neath. They are of remarkably good character, and fine examples of the skill of the Edinburgh firm.

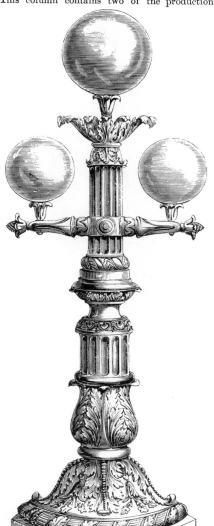

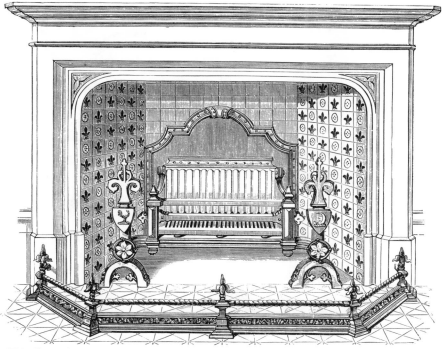

This GRATE is of a high order of merit; it | may vie, indeed, with any production of its class

of Mr. W. HOOD, of Upper Thames Street: a

massive HALL LIGHT, and a MURAL FOUNTAIN.

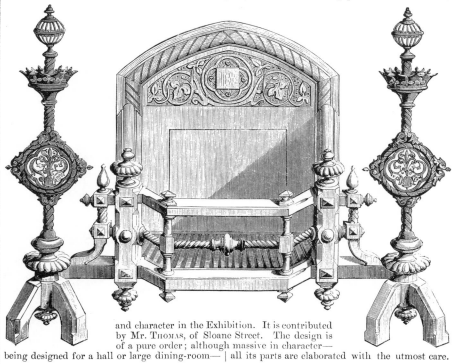

being designed for a hall or large dining-room—

and character in the Exhibition. It is contributed by Mr. THOMAS, of Sloane Street. The design is of a pure order; although massive in character— all its parts are elaborated with the utmost care.

at the recent Florence exhibition. This class of cast metals of the larger and higher character is the weak point of the British manufacturer, and here our countrymen have much to learn and little to teach.

In brass work and its cognates the progress has been as visible, since 1851, as in the department of wrought iron. Every one who saw the former Exhibition must remember the absurdities then displayed from many—indeed, from the majority of manufacturers, and how the naturalistic delusion culminated in chandeliers, &c., made to imitate natural flowers with green leaves and coloured glass. Happily all this is now gone, and there is not even a remnant of this huge folly to be found among the British workers in brass. There are, no doubt, other blunders visible, and evidently springing from the same root—chandeliers of more than doubtful form, and bedsteads painted to compete with the most florid style of chintzes; and

these may appeal to a large section of buyers who are not yet educated up to the point of discarding show for substance, or the gaudiness of colour for the beauty of outline, in such formations. But even these form a small section of the present exhibits in this class, and we may well congratulate the country on the legitimate progress made in this branch of business. Much of the brass work exhibited in the French department, and some in the German and Austrian courts, is beautiful, and in finish and colour is equal, or perhaps superior, to some exhibited by British workmen; and it is admitted that the best examples of French work in this class are, upon the whole, superior to the best examples of British skill. But even such an admission is itself the highest panegyric that could be offered on our rate of progress, because the difference between the same classes in 1851 was almost infinite in favour of France. These remarks of course apply only to brass work proper, because in gilded

The manufactory of Sir JAMES DUKE AND NEPHEWS

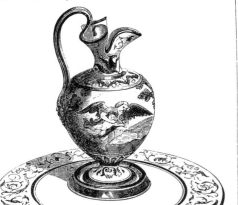

(Messrs. J. and C. Hill) is the Hill Pottery, at Burslem,

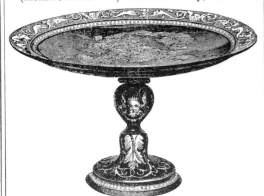

Staffordshire an old establishment, although but re-

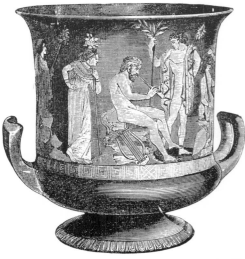

cently taken by the gentlemen who now conduct it. The

works they exhibit are very varied, many of them being of great excellence. Of the few

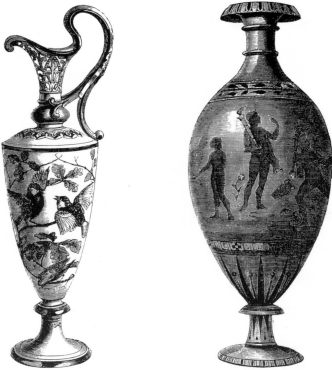

we have engraved, the more prominent are admirable copies from famous Etruscan models.

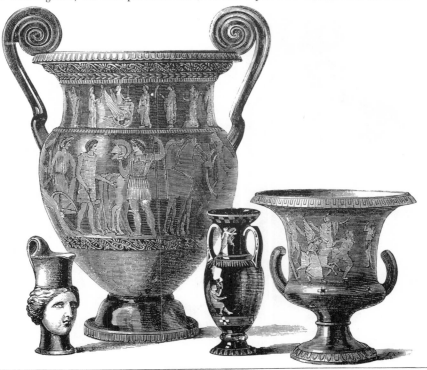

work we are still "nowhere" when compared with our Gallican neighbours. On the other hand they are as far behind the British manufacturers in at least equally important considerations. Take the brass chandeliers of Barbedienne as perhaps the best produced by France, although some of the smaller exhibitors show superior forms; or take the most costly and best works of the Zollverein of the same kind,—and neither are to be compared for elegance and beauty of outline with the chandeliers exhibited by such makers as Winfield or Messenger, although those of the latter are marred by their strongly Gothic type—too Gothic for ordinary interiors, and not sufficiently Gothic for churches. Other makers there are, both foreign and English, whose works well merit attention, but some of the best of these will be found engraved in the illustrations to this ART-JOURNAL CATALOGUE, and to these therefore the attention of readers is

directed. The general conclusions from minute observation of these classes of metal works are—that in wrought iron work our manufacturers are far ahead of all competing nations; that in the smaller class of iron castings we hold a respectable position; that in the larger and more artistic styles of iron and bronze castings, we are very far behind; and that while in brass works of a special class we excel other nations in form, yet in brass castings, such as those exhibited by Christofle, of Paris, and in brass finishing and colour, we are still considerably inferior to the manufacturers of France, and even of some other continental states. The progress that has been made since 1851 ought to show our manufacturers there is no room for despair and many grounds for hope; and the success that has been achieved ought to stimulate them to renewed exertions in those departments to which attention has hitherto been least directed.

The ROYAL PORCELAIN MANUFACTORY of Meissen—known to fame as that of "DRESDEN"—contributes largely to the Exhibition. It may be a question as to whether the ancient and

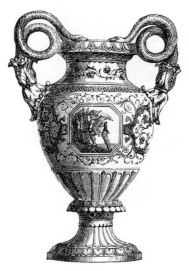

time-honoured factory upholds its early renown, but there can be no doubt as to the merit of many of the works shown as the produce

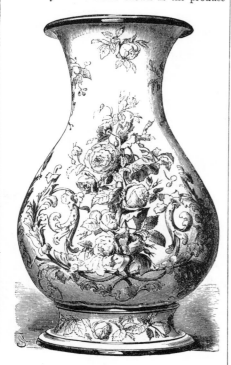

of the existing establishment. The forms are not novel; but the skill of accomplished artists has been employed in their production, and

many of the adornments are *pictures* of a high order.

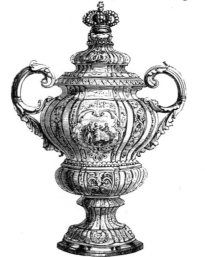

The objects exhibited are very varied as well as nume-

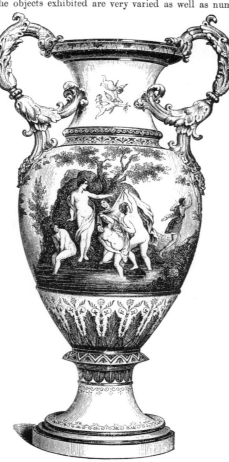

rous. They consist of fire-places, groups of figures—in a

word, every class of articles capable of being produced by Art Ceramic. We confine our selections, for the present, to VASES. If, however, the works of the Royal Dresden

Manufactory exhibit excellencies in many *parts*, as a whole they are not satisfactory, and certainly need in no way alarm the British manufacturer, although he may be indebted to them for many useful lessons. Collectors will make comparisons prejudi-

cial to the modern productions; while those who are familiar with the treasures of the "Green Vaults" at Dresden will marvel that so little beneficial use has been made of the many exquisitely beautiful models therein contained.

CARPETS.

It may be considered exceptional to leave the other departments of metal-work and break off to carpets, but variety is essential in all things, and in nothing more than in the subject-matter of a long discourse. The carpets displayed in this International Exhibition are, with some striking exceptions, very different in design from those exhibited in 1851. Then, the leading specimens were not coverings for floors, but paneled decorations for walls—not indeed quite so much so as what Mr. Tapling calls a "screen carpet," in the side court of the nave (an unrefined cartoon of the Emperor Napoleon and Queen Victoria, with a sheet on which is inscribed "French treaty," or words equivalent); but still the majority of what were then considered the great works in carpet were all of this wall-decoration character, from those for the palace,

designed by Louis Gruner, to those "got up" by some of the spirited Yorkshire manufacturers. Now, with one or two exceptions, all this is changed so far as British makers are concerned, and the change has been mainly in the right direction. That such an alteration should have produced some crudities and confusion of ideas among those engaged was only to be expected, and therefore faults may be overlooked in rapid progress in a legitimate path; but false principles deserve no such tender treatment, because if these are left to luxuriate without comment or rebuke, the results may be as radically mischievous as those which have so happily been discarded. In the majority of cases it has already been seen that a carpet is something entirely different from a wall decoration; it has now to be discovered that it is something equally far removed from a tiled floor on the one hand, and a French shawl on the other, and that while it ought to have a distinct quality

Messrs. GOODE, of South Audley Street, exhibit, in great variety, examples of all the better classes of Ceramic Art. The SERVICE we engrave was

manufactured for them, from their designs, by Messrs. Minton, of Stoke-

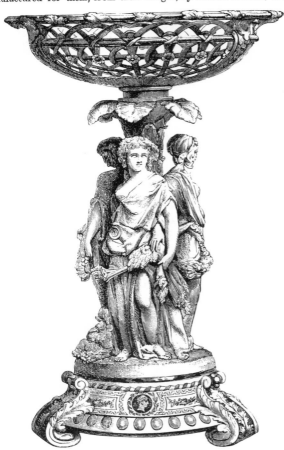

upon-Trent; the leading pieces consist of figures supporting perforated baskets, slightly tinted with colour, and judiciously "touched" with gold, the

groups being of Parian. They are arranged with much skill, and admirably modelled; the manufacture is exceeding careful, and elaborate finish is

apparent in all the parts of this extensive and very beautiful service. It is to such works as these we may refer when endeavouring to show the great advance that England has made, of late years, in Ceramic Art. They

are productions that exhibit our progress in Art as well as in Manufacture, and confer honour on the admirable establishment that sends them forth.

of general forms, the quality of its details ought to be equally specific. That, for example, bands to imitate bedstead bottoms, although placed in diamond shapes, are not agreeable things to walk on, any more than ribbons, on which one could not move without the feeling of danger from entanglement; neither is it more pleasant to trample musical instruments under foot, however beautifully executed in relief through weaving. In all such cases, the better the work, from a nationalistic point of view, the worse the carpet for the legitimate purposes of that article, because all such objects would naturally be avoided in places of traffic or promenade. To an English matron, if she think at all on such subjects apart from the anxious thought of out-rivalling Mrs. Grundy, the primary thoughts about a carpet are that it shall first be comfortable, which includes "tidy," and that it shall then be ornamental, not in the sense of attracting attention by its gaudiness, but ornamental in unison

with all other objects upon it and around it: that it shall not only form a comfortable and solid basis for the feet, but that it shall "set off" the furniture, the decorations on the walls, and if necessary, as in a drawing-room, the inmates of the room also. None would seriously differ in words from this description of the legitimate uses of carpets, however taste might differ respecting the style that would best secure these ends. The wall-decoration style failed, and has been very generally discarded, although in some instances a reflex of that style is still adopted in the form of what may be called single paneled carpets—a style so certain to follow that from which it sprung, that nothing but the names which have by popular rumour adopted it, makes it of more than momentary interest. In urging objections to this reflection of an exploded style for carpets, a clear distinction must be made between things that differ; and because these carpets have borders, it does not necessarily follow that

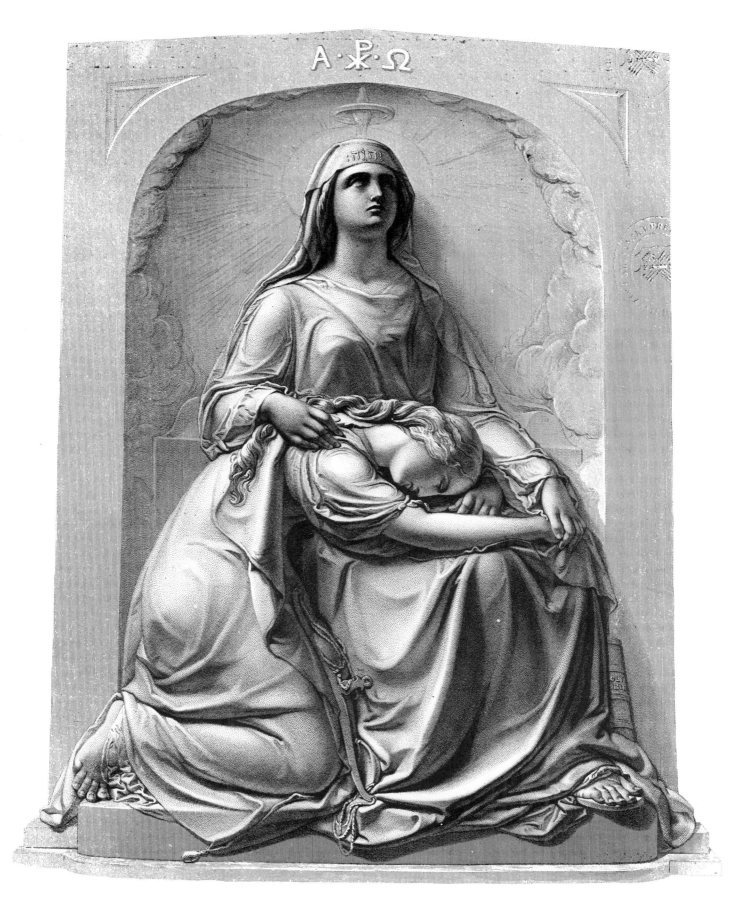

RELIGION CONSOLING JUSTICE

FROM A MONUMENT BY J. EDWARDS

TO THE LATE RIGHT HON^{BLE} SIR JOHN BERNARD BOSANQUET. ONE OF HER MAJESTY'S JUDGES

DRAWN BY F. R. ROFFE. ———— ENGRAVED BY R. A. ARTLETT.

THE INTERNATIONAL EXHIBITION.

Messrs. W. P. AND G. PHILLIPS, of Oxford Street and New Bond Street, are large exhibitors of works in Ceramic Art, and in cut and engraved glass. They are not manufacturers,

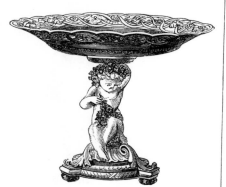

except in this sense—that they give "commissions" and furnish designs to the several manufacturers, and obtain productions made exclusively and specially for them. Several other leading and valuable contributors to the Exhibition are thus placed; and it is, beyond question, a part of our duty to represent their works, although in so doing

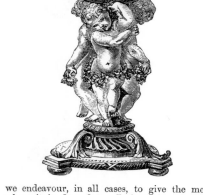

we endeavour, in all cases, to give the merit where it is first due. It is to be regretted,

through "dealers." This is a wilful abandonment of that hope of distinction which is ever the surest

stimulus to exertion; few men work heartily and

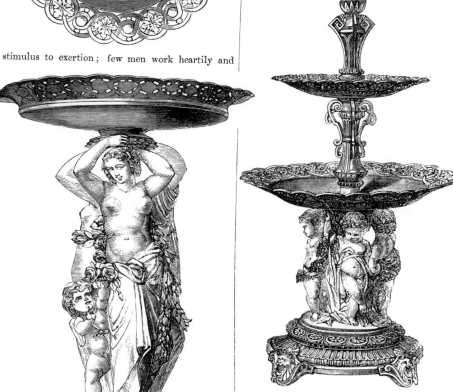

however, that some of our best producers do not exhibit at all in their own names, but only

zealously with a view to pecuniary profit alone. The objects we engrave on this page are produced for

Messrs. Phillips, at MINTON'S renowned Manufactory, Stoke-upon-Trent; they are designed by PHŒNIX, and consist of the usual pieces of a DESSERT SERVICE; the comports are supported by figures representing the four Seasons, while the baskets have groups of dancing-boys for their supports. These baskets are perforated, and ornamented with much delicacy and taste. The centre-piece is a remarkable work, with much originality of style, and good arrangement. Three graceful figures are placed above three shells, and bear a large basket for fruit or flowers. The whole of the figures are of

"Parian," lightly touched with colour and gold. The service altogether is one of the best of the

many excellent productions of British porcelain manufacture issued from Stoke-upon-Trent.

all borderings are wrong. On the contrary, for many purposes the principle of a border judiciously applied is both advantageous and ornamental, while what we have called the single-paneled style can seldom or never be either the one or the other as regards general effect. If, for example, you have first a broad border itself divided into panels, with corners terminating in one distinctly different colour, with a centre filling not reaching to the panels, but looking as if one piece of carpet was laid over the plain centre to a huge border, however admirably the details are carried out, grave essential defects must be the result. First, the room is necessarily reduced in apparent size; and second, the border panelings are spoiled by the furniture destroying the leading lines: but if in addition to these inherent blemishes the details should be equally defective—if French corners should be connected with Italian scrolls in colours, and a piece of "strap work" should be placed crumbcloth fashion upon a decided

self-coloured ground—whatever the value of the individual parts, the inherent evils of the style are intensified manifold, and for all the purposes of a carpet this reflection becomes almost as vicious as the now discarded absurdities springing from the same root. Or, worse still, suppose the wall-panel style out of favour for carpets, and its place supplied by a broad light border with rich dark centre, that centre cut up into one large and two smaller white circles spreading across the carpet from border to border, and these circles each radiant with groups of flowers of brightest hues, which are again repeated in the border, is anything gained in the ornamentation of a room by such a paraphrase of the now all but obsolete style? Quite the reverse, that being in every way better than this, inasmuch as the one was founded on a principle, however erroneous; while the other is equally erroneous, without pretensions to being founded upon principles of any kind, but is a mere hap-hazard aggregation of in-

This page contains a 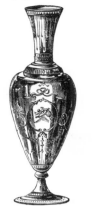 selection from the several 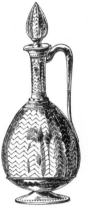 works in CRYSTAL GLASS, 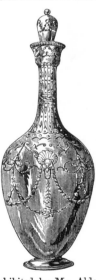 exhibited by Mr. Alder-

man COPELAND. The glass is made "according to order" by Mr. THOMAS WEBB, of Stourbridge; the designs, both in regard to form and decorative enrichment, are supplied by Mr. Copeland, and the works are executed by his own artists, and under their superintendence, in London. In cases such as this, and they are very numerous at the International Exhibition,

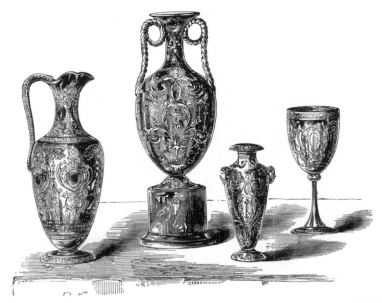

(few actual glass-makers exhibiting), the producer may be regarded in the light of a manufacturer. In the clearness, brilliancy, and purity of the metal, no country of the world can compete with England; nor has any British manufacturer surpassed the works that issue from

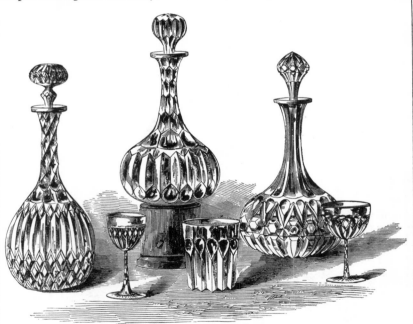

the establishment of Mr. Thomas Webb, to whom so many of the exhibitors are largely indebted. Other opportunities will occur for dealing with this important subject at length. Mr. Copeland's "exhibits" are of the best order, both as to "cut" and engraved glass.

Many of these objects are perfect examples as to form and ornamentation, and do honour to the firm by whose direc- 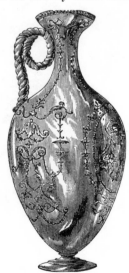 tion they have been produced.

congruities. Other specimens are exhibited even worse than the classes just indicated, but these are the mere remnants of the style so popular in 1851, and, whatever their merits as examples of skilful manipulation, they are of no account when viewed in relation to their professed purposes, either of utility or interior embellishment. But if some of the British manufacturers have shown little progress in this department, the other exhibiting nations have shown positive, and we may say universal, stagnation. The French, who, next to the British, exhibit the largest number of carpets, are precisely where they were in 1851 in design, although there is some improvement in texture and general quality.

The difference between the French and English treatment of ornament, pointed out in the introduction to this essay, is fully developed in carpets, where the French pervert flowers from their simple, natural beauty into forms based upon the grossest known to artistic schools.

As printers and dyers, these makers of French carpets are unapproachable by British manufacturers, while their dextrous and artistic management of colour in flowers and scroll work is entitled to all praise; but all these qualities, although they make clever works, will not make good carpets; and however bold the assertion, it is nevertheless a striking truth, that the French do not exhibit either progress or ability in this branch of Art-industry, while the British manufacturers, with a few insignificant exceptions, and one or two glaring perversions, display not only increasing ability, but unexampled progress. Among these are prominently two carpets (neither of them made by the exhibitor), and the designers' names in these, as in nearly all the British sections, are carefully, and, we may add, most unjustly concealed, the one a large Scoto-Axminster, exhibited in one of the furniture courts by Whytock, of Edinburgh, the other, in the East Gallery, by Smith, of London. Both of these

THE INTERNATIONAL EXHIBITION.

It is no easy task to select from the extensive contributions of Messrs. ELKINGTON & Co. what will best exhibit the taste and skill manifested in their productions. There is one object, however, which at once arrests the attention of every visitor, for there

exquisite in workmanship: this is a TABLE, in silver

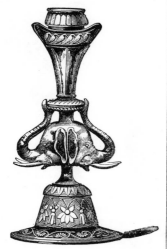

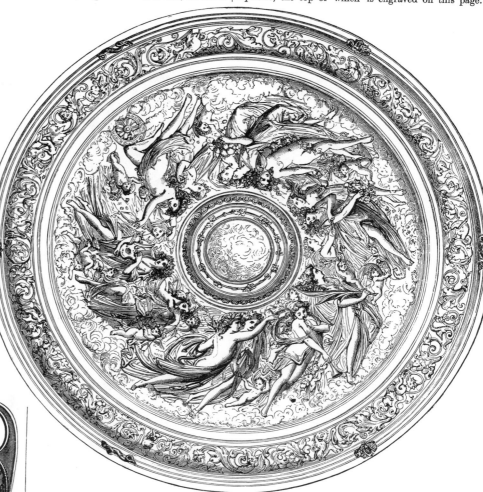

repoussé, the top of which is engraved on this page.

hibit the taste and skill manifested in their productions. There is one object, however, which at once arrests the attention of every visitor, for there

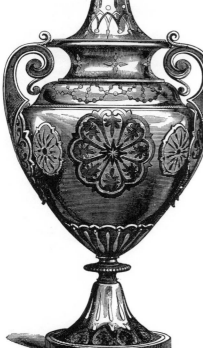

is no finer work of its class in the whole building— we might indeed say, none so truly artistic and

The design and execution is by MOREL LADEUIL, one of the artists in Messrs. Elkington's establishment. It is in all

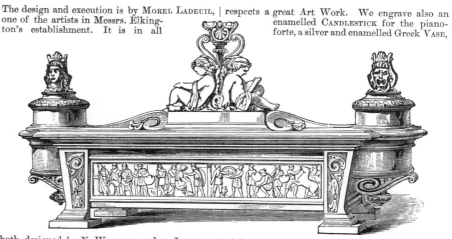

both designed by N. WILLEMS, and an INKSTAND

respects a great Art Work. We engrave also an enamelled CANDLESTICK for the pianoforte, a silver and enamelled Greek VASE,

of Greek pattern, designed by the late E. JEANNEST.

carpets have borders, and the unity of tone and treatment throughout is most creditable, although they are not to be referred to as a standard by which carpets, which only cost half the price, can be justly tried. They may, however, be used as examples of successful colour and design, and in these respects they occupy a high place among all the carpets exhibited. Although both are low in tone—so low as to form an obstacle to their general use in the present state of taste, as examples of what could be adopted in general commerce—yet much higher tones of colour could be brought into use for the current markets, if the contrasts were equally well balanced; because harmonious effect does not consist in lowness of tone or the opposite, but in the skilful balancing of one colour against another in quantity as well as quality of tint; and this may be effected in the brightest as well as in the most sombre hues, although it requires greater knowledge to secure

harmony in the former than in the latter class of colours. An example of this will be found in the carpets exhibited by Henderson and Co., Durham, the one called Greek, the other Pompeian, placed in the furniture courts, in which the colours are much more vivid, but still harmonious; and whether the forms be absolutely what they profess or not, still the general effect is equally harmonious, while the colours are brilliant. Among the Brussels description of carpets, some creditable specimens will be found in those exhibited by Morton and Co., of Kidderminster; and one, very good both in form and colour, is exhibited by Boyle and Co. (4254); there are also some good parts in various other specimens—for example, in one shown by Woodward Brothers, especially the centre and inside borders, although these are marred by a centre pattern which seems to have no business there, and an outside border out of tone with what it is made to surround. There are

Messrs. LONDON AND RYDER, of New Bond Street,

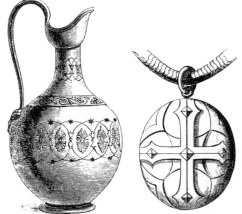

exhibit a case of beautiful works in Jewellery and in

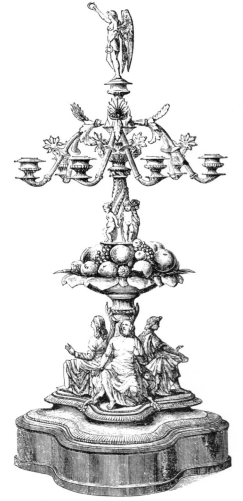

Plate. From these we have made a selection—en-

graving a CLARET JUG and a CUP, of graceful forms and ornamentation, and

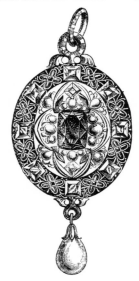

various JEWELS of exceedingly good and original designs. The CANDELABRUM is the "Goodwood Prize" of

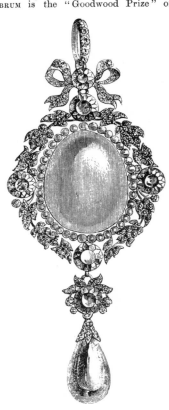

1862, and is a judicious attempt to combine utility with ornament. The

base is composed of three figures, representing Homer, Virgil, and Milton. It is surmounted by a figure of

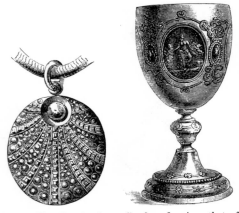

Fame. The CUP is also a Goodwood prize—that of 1860. It illustrates the story of Pegasus by medallions

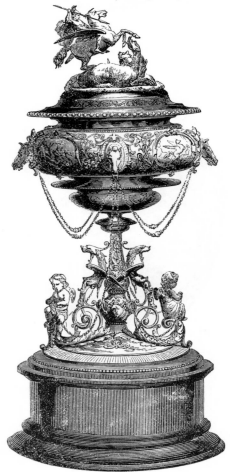

in relief; on the summit, Bellerophon is represented, mounted on the winged horse, conquering the chimera.

also a vast number of specimens of carpeting in many styles—all highly creditable to the respective manufacturers—among which one or two by Southwell hold a creditable place; but while these all show a marked advance on those exhibited in 1851, and are positively as well as relatively good, yet they offer no points sufficiently conspicuous to warrant detailed observation. There are also one or two specimens from the Netherlands of peculiar make, and one especially, in the court set apart for Holland, with a good centre; but, although in material and make these look as if they would wear for generations, the general character of design employed is not such as can be considered consistent with sound taste in carpet manufacture. Into the other question of relative price it would be impossible for us to enter within reasonable space, but as that is for the public an important element, the juries in all the sections will,

doubtless, devote to it a full share of attention in their various estimates and awards,—not as regards the exhibitors, however, for many carpets hung on these walls have been bought ready for placing there, without either labour or thought by those whose names have been suspended over them. To this important distinction we shall probably return in reviewing the awards of the jurors.

PRECIOUS METALS.

In 1851 the difference between the silver and gold work of this and other continental nations formed one of the strong contrasts in the Exhibition. In our home manufactue the naturalistic style was rampant in many of its worst forms; while among foreigners, and especially the French, the works were divided between the picturesque

THE INTERNATIONAL EXHIBITION.

This VASE, accurately copied from a renowned antique, is manufactured and exhibited by Mr. E. R. PAYNE, of Bath.

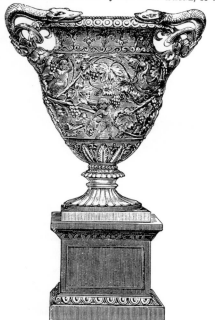

A very graceful SALT-CELLAR, manufactured by Messrs.

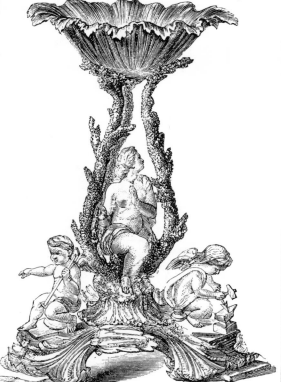

REID AND SON, Goldsmiths and Jewellers, Newcastle-on-Tyne.

The ST. GEORGE'S CHALLENGE VASE, of silver, of which we give an engraving on this page, is from the design of Mr. EVAN ORTNER, of St. James's Street, produced and exhibited by him for Lieut.-Colonel Lindsay, by whom (and by the St. George's Rifles, which

he commands) it is presented for competition to the Volunteers of Great Britain. It is a very beautiful work, designed with great ability, and executed in a manner the most creditable to the art. The artist is an active member of the corps, and has laboured *con amore*. At the base is a group representing St. George in the act of striking the prostrate dragon. The handles are formed of two dragons; and the lid, or cover,

is surmounted by an unhelmed figure of the knight on foot, the face being a likeness of Lieut.-Colonel Lindsay. The vase is placed upon a pedestal of serpentine marble, the height of the whole being about 2 feet 6 inches. On the pedestal, in silver letters and in relief, in mediæval type, is the following inscription: "The St. George's Challenge Vase, presented to the Volunteer Battalions of Great Britain." The JEWEL PRIZE, which is engraved in connection with the Vase, represents the Cross of St. George, and is composed of red enamel mounted in gold (but is also made in silver and in bronze), having in the centre of the cross a medallion of a white

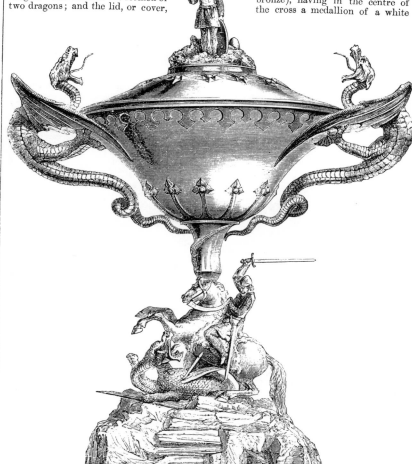

enamelled ground, upon which is a well-executed device of St. George and the Dragon.

and florid renaissance, the one adopted for figures, and the other for branched candelabra and similar forms. But the striking peculiarity was, that while among French makers these figures and branches were rarely, almost never, combined, among the British silversmiths that, or some similar combination, was all but universal in articles for general use. One marked change since then is found in the nearer approximation of style adopted by both countries, each evidently borrowing from the other, so that while we have fewer, the French have more, of these admixtures of figures and scroll-work than in the previous display; and while it may be admitted that both nations have made progress, the advance is certainly most clearly seen in the British section. To settle the principles which ought to govern such works is no easy matter, because these in turn must be ruled by conditions not only varying, but, in some respects, almost antago-

nistic. Utility, ornament, and Art has each its respective code, and articles to be treated successfully must be governed by the code belonging to each; tried by these standards, whatever may have been accomplished, there will still be found much both to learn and unlearn by the workers in precious metals. If utility be the object, as in the case of the great mass of works in this Exhibition, that does not necessarily exclude ornament; but it ought to make this wholly subservient to the value of fine forms, which will always produce more lasting pleasure to the eye—in a tea-service, for example—than in any amount of even beautiful ornament, to say nothing of its practical advantages. If this be so, it would seem to determine further that what ornamentation there is on such works ought to consist more of surface decoration than of ornamental adjuncts almost independent, or in bold relief; and of this

The British carriage manufacturer maintains in the present year the high position he has long held both in his own country and on the continent, not only for elegance of design but also for utility of construction. The first CARRIAGE engraved on this page is an improved light "Craven"

barouche, contributed by Messrs. HOOPER & Co., of the Haymarket, London. This carriage is hung on under and C springs, with a perch of improved construction, made of wood, so connected with iron by rivets and hammered edges, as to act on the principle of a tube with a wooden

centre, combining lightness with greatly increased strength and safety. By the improvements introduced in the general construction of the individual and combined parts, the utmost strength, with the minimum of weight, is obtained. The carriage is an example of the most recent intro-

ductions to effect beauty of outline, lightness, and ease.

Messrs. ROCK AND SON, of Hastings, have, in

former similar exhibitions, obtained due honour for their carriages. They were awarded medals in 1851 at London, and at Paris in 1855. In

the present Exhibition they have a SOCIABLE, engraved below. It has what are termed "interchangeable heads," so as to convert it, as pleasure

or convenience requires, either into a coach, a landau, or a barouche. The space to which we are limited in our illustration does not permit us

to show how the transformation is effected, but we have seen it exemplified, and can speak of it as a very simple process. The improvements ex-

hibited in this carriage, which has been recently patented, are applicable to the Dioropha (Messrs. Rock's patent), and to other vehicles built by them.

truth there are some very good examples in the Exhibition, both French and English—as, for example, some original, surface-looking, decorated tea sets in the court of Christofle, of Paris, and a set in Greek forms exhibited by Muirhead, where the intention is excellent, although both forms and details are mere reproductions of well-known specimens aforetime produced in bas-relief or alto-relief in marble, but now transformed into forms for engraved silvers. Yet while the idea of securing surface decoration is commendable, that must not be taken to imply approbation of attempting to adapt what the Greeks used in one style and material to another material, and to a style very nearly the reverse, although the adaptation has here been effected with considerable skill; for it is perhaps more desirable that we should have worse results produced on harmoniously sound principles than better effects secured at the expense of important truths in the application of Art to industry. Ornamentation in relief is

illustrated in hundreds of cases in the silver and Sheffield courts of the British section, as also by some examples in the courts of France, one notable instance being a beautiful Jaspar vase in the stall of Jules Wiese; but how much finer would it have been without the gold ornament in relief on the pedestal stalk! In design it is emphatically not all gold that glitters, and many instances could be pointed out, in the best works of foreigners in metals, where this truth has been generally lost sight of. What is true of tea sets is equally so of all articles of utility made in silver or in gold, from a tea-spoon upwards; and in all such works beauty of outline ought to be the first consideration, surface decoration the second: ornament, in the commercial sense of the word, ought to hold the last and least worthy place, if at all tolerated—which will be less and less the case as Art-knowledge and higher tastes increase. If, on the other hand, silver or gold work is meant exclusively, or nearly so, for ornament,

Another eminent firm of carriage-builders is that of Messrs. SILK AND SONS, of Long Acre, who exhibit a FAMILY LANDAU, hung on horizontal springs. It has a hind-seat, the occupants of which will find no inconvenience on account of the head; for though this is constructed so as to lie almost flat, it will be observed in our engraving that there is considerable space between it and the hind-seat. The pillars of the front window also fall clear of each other. Both externally and internally this landau is elegantly decorated and fitted up. The body is painted a dark trans-

parent green: the under-carriage and wheels are of a rich crimson colour. The inside is lined with silk of neat and chaste design; and the lamps and mountings are composed of brass.

Three of the CARRIAGES (of which we engrave one) in the Belgian department were manufactured by Messrs. JONES FRÈRES, Coach-builders, of Brussels. This establishment was formed by Mr. John Roberts Jones, of London, father of the present proprietors, who settled at Brussels in the year 1802, and made several carriages for the Emperor Napoleon I. In 1815, when the Nether-

lands and Belgium were formed into one kingdom, he was appointed coach builder to the Royal Family of the House of Orange. Mr. J. R. Jones obtained the Bronze Medal at Harlem in 1825, and his sons and successors, who represent the present firm, obtained the Silver Medal at Ant-werp in 1840, at Brussels in 1841, and the Grand Golden Medal in 1847, at the Brussels Exhibition, and were then appointed coach-builders to King Leopold and the Belgian princes, and subsequently to King William III., of Holland, and to the present Prince of Orange; they also obtained the Prize Medal at the London Exhibition of 1851, and the *Medaille de Première Classe* at the Paris Exhibition of 1855, when King Leopold honoured them with the decoration of Chevalier de l'Ordre de Leopold. They have introduced into Belgium English inventions and improvements.

its production ought to be governed by those laws which have in the best periods been applied to the ornamental. What those laws are, and how to define them in words, is difficult; for although every artist knows the difference between what is pictorial and what is ornamental in a figure—as, for instance, the difference between Canova's 'Dancing Girl Reposing,' which is ornamental, and the 'Venus de Medici,' which is high Art—or in a tree, such as that fir in Leslie's 'May-day in the Reign of Queen Elizabeth,' in the present Exhibition, and the trees of Turner or Constable, which are pictorial or classic—yet that distinction is not easily compressed into few words. Ornamental Art may be understood as that adaptation of natural forms which conveys the greatest amount of pleasure to the eye; while the higher Art, which, for want of a more expressive term, has been called "pictorial," appeals not to the eye only, but to the mind of the spectator. For example, among the silver work exhibited, many of the articles—such as the two magnificent candelabra in the Berlin Court from Volgold and Son, some small candlesticks by Christofle, and the exquisite dessert service by Elkington and Co.— show that the same principle runs through all sizes and styles of work purely ornamental, and that when the eye is satisfied, ornament seems to have fulfilled its mission. Whether this would be the natural boundary line between Art and Art-industry, however important, cannot now be entered on; the more immediate question as to whether the ornaments exhibited fulfil this condition lies before us. Here, as a rule, there seems nothing for it but to confess national defeat; for nothing is to be gained by attempting to ignore the fact, that in this quality of the ornamental in industry the French are, in many departments, as well as in gold and silver work, still far ahead of English manufacturers. Bearing in mind that the ornamental has been taken as a lower, because conventionalised, style, there

This engraving represents the CARRIAGE exhibited by CORBEN AND SONS, Great Queen Street, London; it is here shown as a luxurious, sociable Barouche, but it has also a Clarence top, which fixes on, and converts it into a close carriage: it is called a "Dioropha" when combining both forms. The painting is ultramarine blue, relieved with fine lines of vermilion, and glazed with carmine; the lining is of rich drab silk and satin, the lace white silk, with blue figures, elaborate plated lamps and door-handles; these, with the lamps and lace, were designed specially for this carriage, and the whole is made as light as possible, consistent with durability. The hind part is represented as being on Corben's inverted C springs and leather braces, which, without being heavier than elliptic springs, render it as easy and noiseless as a carriage on the ordinary C springs and heavy perch; they are introduced to remedy the hard motion and drumming noise in carriages which have elliptic springs.

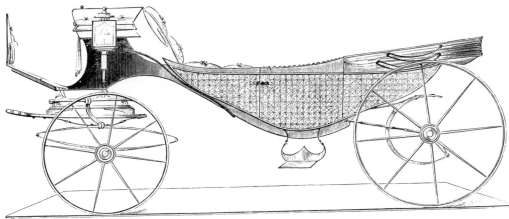

The private STATE CARRIAGE of the King of Prussia, engraved below, is a gorgeous, but not over-decorated example of the builder's manufacture, and is admirably constructed in all its parts. It is the work of Mr. JOSEPH NEUS, of Berlin, carriage-builder to the Court of Prussia; the decorations were designed by Mr. Neus, and for the most part executed in his establishment. Compared with most of the vehicles we have en-

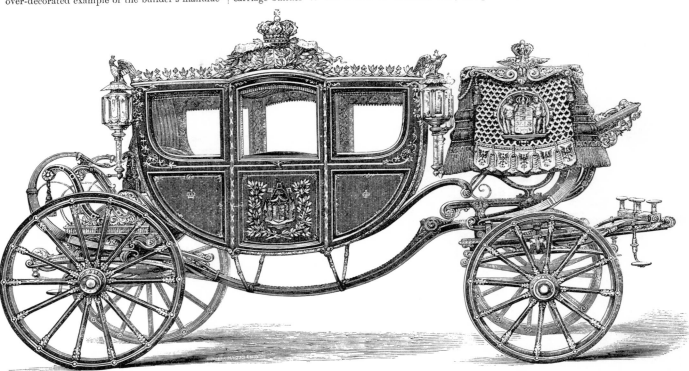

graved, it has a cumbersome appearance. This was unavoidable, considering the uses to which it is to be applied—those of semi-state. On the panel of the door is the royal crest, in old German style of ornament; the panels themselves are crimson and dark brown, with richly gilt mouldings; the metal decorations are of silver; the inside is lined with whitish grey silk, in which the King's arms are worked. The hammer-cloth is very splendid. In the centre of it are the royal arms of Prussia. At the angles of the top are the Prussian eagle, and in the centre the royal crown.

is nothing exhibited in these metals so generally and harmoniously exemplifying this type as the large centre-piece exhibited by Christofle, where the mind never thinks of men, women, and horses, or even of the metal, but simply of ornament, so that both in composition and detail the artist and the manufacturer have achieved their purpose. There are also numerous examples, especially in the British section, where this kind of success has been entirely missed, and, in some instances, under circumstances of peculiar discouragement to the industrial Arts' interests of this country. The testimonial to Sir George Hayter, exhibited by Smith and Nicholson, is a case in point. This piece of plate, presented by probably a majority of the present House of Commons to Sir George Hayter, is, like that just mentioned from France, almost exclusively ornamental in its aim, having no special utility. In purpose, therefore, the two objects are similar, but how dissimilar in all other respects is seen by the most casual observer. This testimonial, instead of suggesting ornament to the mind, is redolent of nothing but weight of silver; and instead of the eye being satisfied with the completeness of intention, the mind is set to speculate upon the probable cost. Neither the general form nor the detail fulfil the first demands of ornamental Art, the pedestal being *rococo* of the most florid type, while the figures—each, no doubt, with some wise idea laden—are a mixture between the styles pictorial and classical, so that it is impossible for such unity of sentiment to exist between the parts as to constitute a whole. There are several other testimonials in silver, having the same ornamental object, and showing the same defects of legitimate style; but this presented to Sir G. Hayter has been selected because it helps the nation to guage the true state of the legislative mind on Art subjects, and especially on subjects of industrial Art, although all Art is one in essence, the difference consisting in the application of

THE INTERNATIONAL EXHIBITION.

We again engrave some of the many attractive JEWELS exhibited by HOWELL AND JAMES; also a CLOCK and object on this page, however, is the JEWEL CASE presented to the Rev. Dr. Raffles, of Liverpool. It is a silver casket,

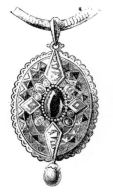

CANDELABRUM, in ormolu, in the style "moresque;" from the designs of Mr. F.

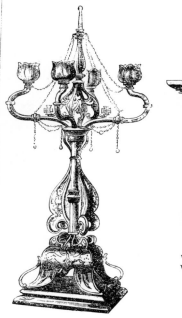

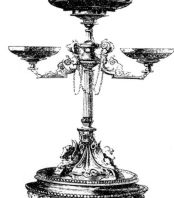

with medallion portrait of the venerable and estimable clergy-

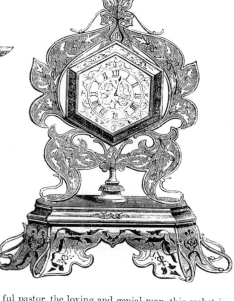

man, to whom it was presented by his congregation as a testimonial to the value of his services as minister of Great George Street Chapel, Liverpool, during a period of fifty years. It bears this inscription: "To the Rev. Thomas Raffles, D.D., LL.D., &c., the eloquent preacher, the faith-

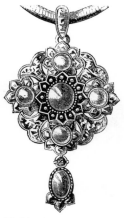

E. HULME. In addition we give a silver CENTRE-PIECE, presented to the Rev. C. E.

ful pastor, the loving and genial man, this casket is presented, to commemorate a pastorate of fifty years." An illuminated copy of a very beautiful and touching address to the good Doctor—a treasure indeed—is enclosed within. The figures represent Faith, Hope, and Charity, and four panels

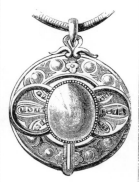

Armstrong, of Frickley-cum-Clayton, by his congregation after thirty years' ministry. The principal

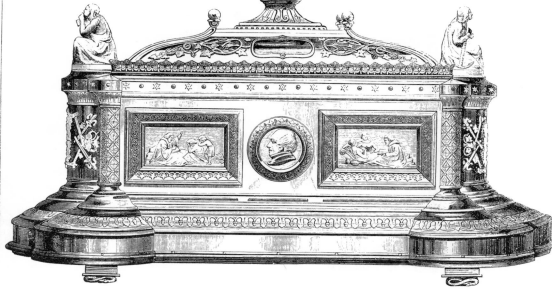

are designed to express the four great essentials of Charity. The work is modelled and designed by Mr. F. M. MILLER.

the same principles to different purposes and objects. When this testimonial was projected, a committee of taste was doubtless chosen; these would as certainly be considered the most Art-enlightened of the party—and behold the result is this piece of silver! Is it surprising, after such a display of legislative ignorance and incompetency in managing their own affairs, that the Art objects of the nation, whether in education or otherwise, should only have escaped from helpless confusion by being forced under the tyranny of inartistic routine? If this is all they can do for those whom they delight to honour, what can they be expected to do for those they govern, and attempt to teach, in things pertaining to Art? If the few bring such depth of ignorance of artistic principles to bear upon their own wants, what can be expected either from the many, or those employed to supply such articles? When this is the standard of the picked gentlemen of England, what is to be expected from

those merchants and tradesmen who honour each other with so many ounces of silver made up into an heirloom?

The next division of these sections embraces what may, or rather ought to be, treated of as Art proper. The question underlying this, however, is most important, determining as it does not only the value of the work produced, but also the legitimate principles of production. That mere size has never been an essential element of any style, may be seen from the huge ornamental fountains in Paris, and the full sized ornamental figures of many sculptors, here exhibited both by British and foreign artists. The question then is, what is the highest style for the works of most value in gold or silver, whether in larger or in smaller size? Obviously not the ornamental, unless intended for mere purposes of decoration; and the only two remaining are the picturesque and the nobler style of sculpture. The picturesque may be popularly explained as a pleasing combination of

Another visit to the stall of Messrs. ELKINGTON & Co.

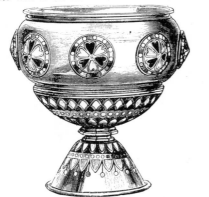

has supplied us with the engravings for this page. The

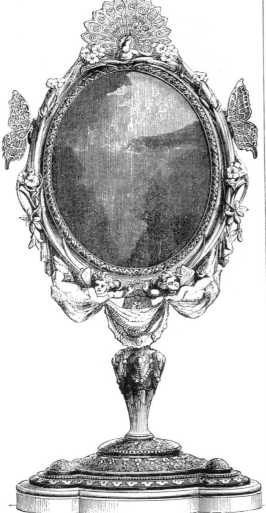

two upper illustrations are a VASE and STAND of silver

enamelled, the ornamentation of which is in the Persian style. Below these, on the left, is

The butterflies form a conspicuous and beau- | tiful part of the ornamentation. The large

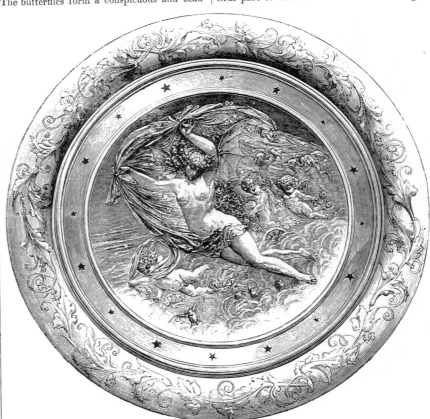

a BOUDOIR MIRROR, in the Louis Seize style: the framework is gilt, enamelled with jewels.

circular engraving is from a comparatively small TAZZA, of silver *repoussé*, exquisitely designed by M. LADEUIL; the centre of this presents an allegorical representation of NIGHT.

incongruities, such as the Dutch painters and our modern painters of *genre* make familiar both in figure and in landscape; while the higher style of sculpture may be taken as fairly represented by the statues of Gibson (without the colour), the Greek Hunter in the Italian Court, the Cleopatra and Sybil in the Roman Court, and many other statues, both British and foreign. Between these two styles there is no room for choice in works of silver, where Art is to form the standard of value. However attractive the merely pictur-esque may be in landscape or in colour—and there is no doubt that it appeals most successfully to the least educated—yet from the days of Phidias downwards, it has been rejected as a style by all great sculptors of all countries and ages. If what, for want of other words, we call the nobler style be best, then it follows, as matter of necessity, that the highest class works are not those imbued with the picturesque in style. This brings us face to face with the greatest works of all exhibiting nations in silver, and forms the test by which such works are to be tried. In this higher walk there is, unfortunately, no English competitor. It is not meant to undervalue the real progress made, or the amount of artistic thought and skill displayed, by British artists engaged in this branch of Art,—and very interesting points of comparison could be extracted from these several works, some of which are indeed highly creditable to them, such as the vase and shield of Mr. Pair-point,—but with all these good qualities the English artists are still so far behind as not to entitle any of their works to be placed in the first rank of this Art, and it is only the highest class works which can be referred to in the discussion of first principles. Even among foreigners there are few; and from among these the

THE INTERNATIONAL EXHIBITION.

Messrs. Thomas, New Bond Street, exhibit many silversmith's art; their attention has evidently been directed to the production of We engrave a Silver Toilet Glass, and a Rifle Cup, a glass Claret

 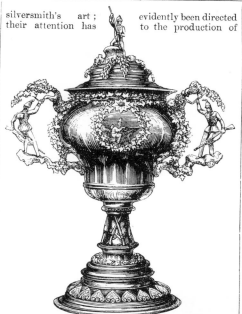

beautiful and highly finished specimens of the such articles as would be required in daily use.

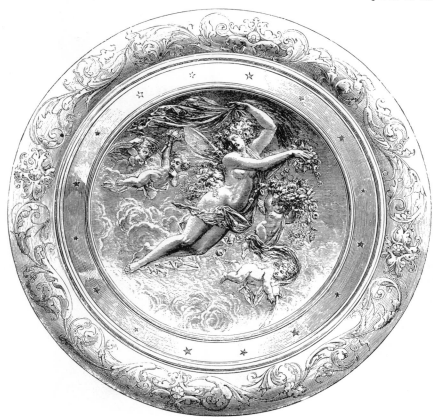

Jug, and a Water Jug, all of high merit.

The above—Morning—is a companion Tazza to that on the opposite page, the work of Messrs. Elkington.

style of the three most eminent shall be glanced at, with the view of estimating the value of each, however cursorily, because it is increasingly evident that as wealth accumulates, a considerable portion of artistic talent will be employed in this department. That comparisons are odious has passed into a proverb, and nothing but a desire to be understood by those most deeply interested could render a comparison of the works of three living artists justifiable; but all three are so eminent in their respective walks as to extract the usual danger of daring such a task. One of the finest individual works exhibited is a table and stand by Elkington and Co., designed and executed in silver by Morel Ladeuil, a Frenchman, and the principal artist of that spirited firm. The subject is too long for description; suffice it for the present purpose that the design displays at once thought and the artistic

power of expressing it. The next artist, Antoni Vechte, also a Frenchman, has works displayed both in Hunt and Roskell's Court and in the French picture gallery, where a vase by this master is classed as a work of high Art. The third work is the shield presented to the Crown Prince of Prussia, on his marriage, by some portion of his probably future subjects. The merit of these works as pictorial compositions is essentially a general subject, while the style best adapted for Art in silver is the special case for present investigation. Assume each to be perfect both in thought and composition, is there any difference of style? if so, which is the highest of the three, and why is the best superior to the others? Full answer cannot be given in few words, but if the table of Elkington be considered more ornamental, the works of Vechte more pictorial, and the shield of the Prince Royal of Prussia more legitimately

The TESTIMONIAL here engraved is manufactured by Messrs. HUNT AND ROSKELL, designed by Mr. ARCHIBALD J. BARRETT, and was presented to Thomas Brassey, Jun., Esq. It is a silver Tazza, surmounted by a figure of Science, on a base modelled as coral, and surrounded by a cable border. On the plinth are figures of a sailor, a navigator, a miner, and an engineer.

This "CUP"—the Doncaster Cup of 1860—is manufactured by Messrs. HUNT AND ROSKELL. It is designed, and partly chased, by Mr. H. H. ARMSTEAD. The story told by the artist is that of St. George. The principal incidents of the poem are illustrated by me-

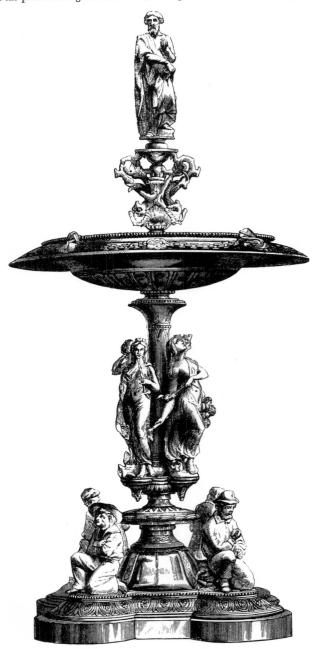

The four figures surrounding the stem represent, respectively, the Elements. The inscription is as follows:—" Presented to Thomas Brassey, Jun., on his attaining his majority, as a token of the respect and esteem in which his father is held by those connected with him in his many great works, and as an earnest of their attachment to his family."

dallions; the handles being formed by the great winged dragon of the legend.

sculpturesque in style, it would fairly describe the characteristics of the three artists, a conclusion which would make the Berlin shield the work highest in style. Other elements must, however, be taken into account, because in Art an inferior style well expressed is often more valuable than a superior one indifferently developed, and it is here that Elkington's table stands out conspicuous from its compeers: it is all but the perfection of ornamental expression, more perfect than the higher pictorial thought of Vechte in its style of development, and very much beyond the expression of the yet higher style adopted in the Berlin shield. Morel displays elegant fancy, elaborated with surpassing care and skill; Vechte exhibits the wealth of pictorial versatility, eloquently and artistically uttered; while the Prussian artist struggles with defective utterance to express a still higher and more dignified style of Art. Each will find admirers and imitators,

but it would show wisdom in the coming men in this art to combine the labour of the first with the severity of the last, rather than to aim at leaping into the seductive cleverness displayed by Vechte, but which would infallibly degenerate into looseness in feebler hands. His style displays extraordinary power, but it is in the striking facility of doing rather than in the artistic grandeur of the work done: a style unapproachable in manipulative effects, but wanting in that combined dignity and purity of thought and form so conspicuous in the shield of Flaxman, and which is as nearly as possible midway between the limping severity of the Prussian shield and the elegant ornamentalism of the table exhibited by Elkington. As a model, Flaxman is a safer guide than any of the foreign artists named, eminent as they are, because his style, although less popular, combines the best qualities of each, and presents the higher result without the

Mr. JOHN BALLENY, of Birmingham, exhibits

several examples of the satisfactory Art-progress

of that town. Some are of pure gold; others imi-

tations. We engrave three BROOCHES; one being a substitute for, and, perhaps, superior to, jet.

Messrs. LAMBERT, of Coventry Street, whose case contains many admirable articles in jewellery and plate, exhibit one work of very great excellence—one that competes with and approaches in merit the productions of the best foreign aids of the goldsmiths; it is a SHIELD, "embossed and chased," as well as designed, by Mr. THOMAS PAIRPOINT. It tells the story of Boadicea, and represents the leading incidents in the life of the unhappy yet heroic queen. The subject is, therefore, thoroughly British, and so is the young and promising artist who has produced this fine work.

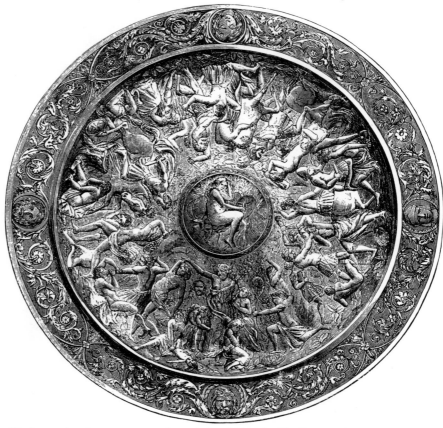

We have selected for engraving three of the WATCH-CASES, of which a large variety is exhibited, by Mr. BENSON, of Ludgate Hill, in the large and prominent erection that contains his

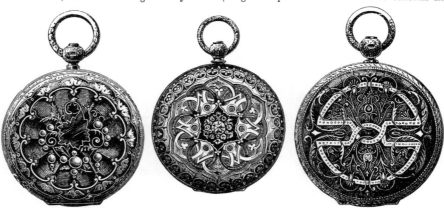

monster clock. To this department of Art-manufacture Mr. Benson has paid especial attention. The watch-cases, however, and generally the "works," are of Swiss design and execution.

alloy attaching to clever picturesqueness on the one hand, or to the most perfect ornamentalism on the other.

The next most important phase of precious metal work is that in which colour is introduced, either in the form of enamelling or otherwise. In the British section there are comparatively few examples of this style, and by far the most successful is that dessert service, based on the Greek outline, already referred to as exhibited by Elkington and Co., where the introduction of colour is managed by Willms, a French artist, with a success highly creditable. It is also used by some of the makers of church vessels, sometimes with more or less, but never with any striking, success; and there are some specimens remarkable only for being deplorable failures. In this, however, the English are not alone, for it is impossible to conceive anything more tawdry in effect than some of the French examples of these metal and coloured combinations, chiefly used in

the service of the church, although there are, of course, higher examples, as in the tabernacle exhibited by Rudolphi, of Paris; yet even here the style of combination seems to partake more of that barbaric pomp which appeals to the eyes of the unenlightened than of the enlightened thought, which at once produces and springs from a civilisation based upon the spiritualism of Christianity. Be that as it may, however, the Moorish looking bracelets, and other adornings for women exhibited by the same and some other French makers, are much more effective both in their detail and in their unity of combination; and indeed some of them, such as many of the bracelets and other articles by Rudolphi, are superior to anything of the same style exhibited by any other exhibiting nation. In what may be called the higher developments of the style, neither French nor English can compete with the specimens from Russia—as in the magnificent Bible, where the success has

The Royal Porcelain Manufactory of Prus-

sia—Berlin—has contributed liberally, and most

beneficially, to the Exhibition. Every class and

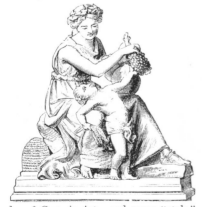

order of Ceramic Art—and every "style"—

from the costly and magnificently decorated vase, to the com-

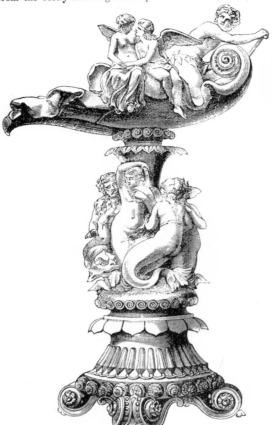

paratively insignificant tea-cup, will be found among the

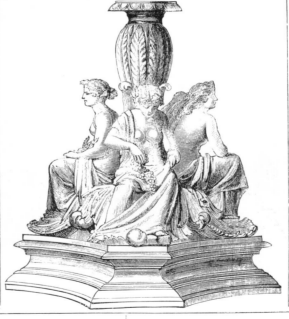

"goods" that decorate the eastern daïs

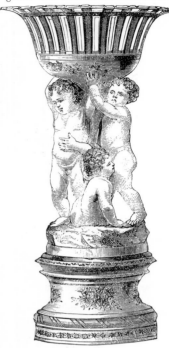

of the nave—the place of honour. We

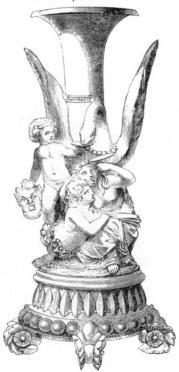

have left ourselves no space for details.

been achieved by the use of only two colours, and where the effect of magnificence is secured, to a great extent, from the colours being massed instead of scattered up and down in small quantities, as is too often the case with artisans of the West; and in the other large books exhibited in the Russian section the same principle of massing is carried out, although many more colours are introduced, and, upon the whole, with wonderful success. Here we come into contact with the strong, distinctive peculiarities of the Art that has existed from time immemorial in the Greek Church, and which still retains a portion of that spirit, however derived, which renders the works of pagan Greece so exquisite in material purity. There are, however, some examples, both here and in the Indian section, of what modern ideas, based upon the French model, can effect for these far off and semi-barbarous people; and if there be such a

thing as national shamefacedness, the western nations must, in both cases, feel it most abundantly. Who can compare the simple but elaborate beauty of the Indian silver work, carried out in the Indian style, with the "testimonials" manufactured, we suppose, in India, and presented to eminent Englishmen, in deference to English ideas of taste, without feeling humbled at the bitter irony of such deference to our higher civilisation? Or who can look upon the purity of thought, and absolute elegance and beauty, of some of the Caucasian jugs and cups which adorn the Russian section, and compare these with what Russia has evidently acquired from France, without feeling that western civilisation is but a babe when compared with eastern barbarism in the elemental principles of high industrial Art? But while our humiliation on such points ought to be complete, it is based upon what was rather than what is, and the consolation lies

THE INTERNATIONAL EXHIBITION.

We give examples of EARTHENWARE from the manufactory of Mr. FURNIVAL, of Cobridge, Staffordshire Potteries, exhibited in the stall of Messrs. Pellatt and Co. Excepting the FLOWER POT, they are household utilities, the requirements of all families. In such productions good forms and ornamentation are of the very highest importance, for they are teachers, imperceptibly yet continually ministering to refinement. Our mansions may in a thousand ways aid the civilisation that Art promotes; but in our comparatively humble homes its lessons must be obtained from few ob-

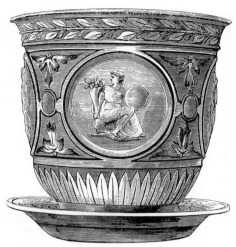
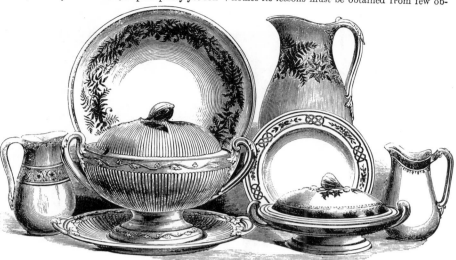

jects. Mr. Furnival manufactures for the many, but in no one of his works do we find the coarse or impure taste that, not long ago, was the almost invariable guide of those who catered for the millions.

Underneath we give engravings of objects selected from the very attractive collection of Messrs. GRAINGER, of Worcester. This long-established firm exhibits examples of its semi-porcelain, for the production of which it has obtained considerable renown. The works we engrave, however, are remarkable and highly meritorious novelties—being "perforated Parian"

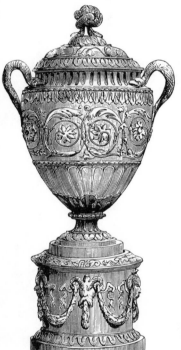
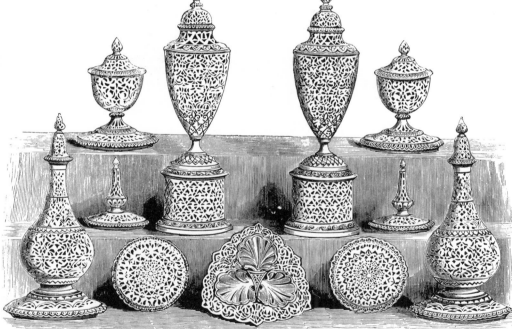

imitations of ivory. The manufacture is one of much difficulty. The perforations are produced by a small knife. The object is, as will be supposed, exceedingly light. Few more graceful decorations for the chimney-piece have ever been issued. The VASE, also engraved, is an example of Messrs. Graingers' "new material,"—recommended by its semi-vitrified character, great strength, and desirable deadness of surface.

in knowing that the best elements of all styles are found in that which the western nations are now following. As already stated, it forms no part of our desire to point out the individual bad things, even when important lessons might be taught from defective principles adopted, or when both the rules of Art and optics are boldly defied; otherwise, this section of precious metals would have furnished more material for such censure than almost any other section in the Exhibition: for although the general progress here, as elsewhere, has been vast since 1851, yet nowhere so much as in this silver do the vulgar rich love to see themselves reflected in, and surrounded by, this fancied magnificence; and many of the displays in this Court show that this class has not only used, but abused, the privilege of making themselves ridiculous. But it would be as cruel as it would be useless to hold up men's taste to scorn who only work to order, and who must either please their customers or forego their patronage; for in this, perhaps, more than in many crafts, men often sustain loss by not being able to come down to the vulgarity of an employer, and to blame them for meeting such half way would be only adding insult to the injury previously inflicted. For the evidence of progress, besides those already named, readers might be referred to many other stalls among almost every exhibiting nation, for in spite of much, very much, that is merely vulgar, there is also very much which, if not entitled to be called beautiful, may yet with great propriety be held up as good both in form and arrangement; but instead of specifying individual merit, we prefer proclaiming the pleasing general truth that upon no stall—from those of Denmark, Holland, and Russia, to those of France, Austria, and England—can the intelligent visitor look, without finding many objects which gratify, if they do not fully satisfy, the refined in taste; while those examples in

Messrs. WRIGHT AND MANSFIELD,

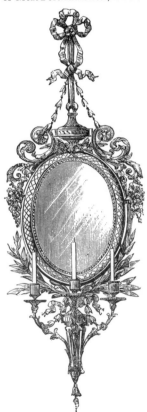

of Great Portland Street, some of

whose admirable works we have already engraved, furnish us with

other proofs of their taste and skill in the manufacture of furniture. The principal object on this page is a CHIMNEY-PIECE, with mirror above, designed *en suite* with the dwarf Book-case already pictured. It is of Gean wood; the columns and details in relief

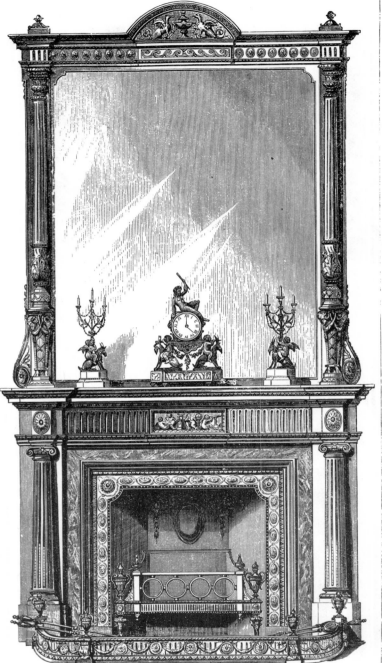

are ebony, very elaborately and exquisitely carved, and partly gilt. In the frieze of the cornice, medallions of Wedgwood ware are introduced. The grate, fender, &c., are highly finished, and are excellent specimens of the ability of Messrs. FEETHAM, of Clifford Street. The other engraved objects comprise a CANDELABRUM, a GIRANDOLE, and CLOCK-

CASE, carved in wood, and finished in gold, fine specimens of Art-manufacture. The details of the whole are gleaned from the works

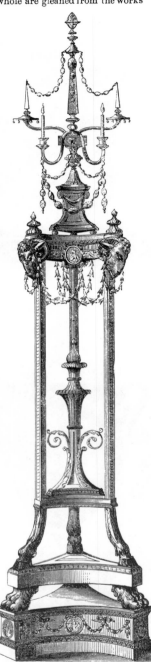

of the Messrs. (Adelphi) ADAM, and may be considered as indicating the style of English decorative furniture of the eighteenth century.

which progress is not so visible will be as readily found by a moderate amount of individual discrimination. The principles which have been thus applied to works either of utility or ornamentation in silver, are of course equally applicable when true to all forms of imitation, from the commonest "Britannia metal" to the best double-plated "nickel;" and to such wares some of these principles apply with double force, for it is evident that raised ornament, plated, must, from the point of utility, be more objectionable than raised ornament in silver—a point which makers get over by ornaments consisting wholly of silver. But although this gets rid of the objection as to wear, it never touches the question of taste, as deducible from the principles already urged in this review of the works in gold and silver exhibited.

The only other important branch of this subject is that in which iron plays a prominent part, and here the unfinished shield in iron, by Fauniore Brothers, in the French Court, deserves attention; although by far the grandest specimens of iron, combined with gold and silver work, are a clock-case, an ink-stand, &c., for a library *en suite*, exhibited in the Spanish Court section of the nave, and which, for pure and legitimate style, as well as for high artistic development, have few equals, and no superiors, among any of the exhibiting nations. These articles and their ornamentation teach our workers in metals lessons equally profound and utilitarian, for here the most unobtrusive details are harmonised into dignified grandeur. Of the bronzes little remains to be said, so far as that metal has been used in its ordinary forms—in statues such as those displayed in the Elkington trophy in the nave, or in clocks or statuettes by the many French, Austrian, German, Russian, and British makers of such articles—except to point out the clear traces of national or individual styles which some of these works exhibit; but

THE INTERNATIONAL EXHIBITION.

We engrave on this page some of the contributions of Messrs. POOLE AND MACGILLIVRAY, Upholsterers and Cabinet Makers, of Princes Street, Cavendish Square. They are among the purest examples of furniture in the Exhibition,

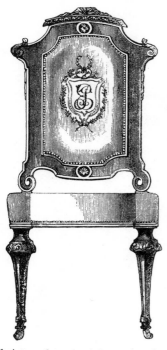

designed with simple and appropriate grace, while they are excellent specimens of workmanship. The principal object is a JEWEL CASE, or circular cabinet, for holding and properly displaying beauti-

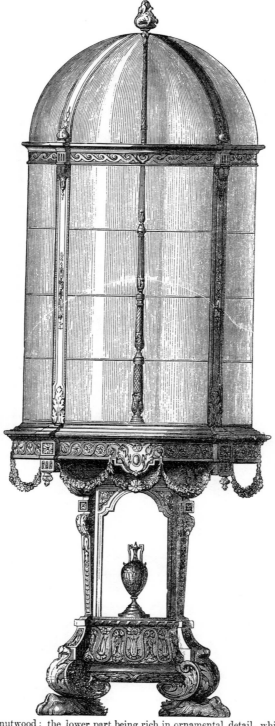

ful Art works, not of large size, that require to be examined near the eye, and which can gain nothing, whatever they might lose, by being subjected to another sense—the sense of touch. It is, of course, made to revolve, so that all its

contents may be seen by several persons at once. The work is of walnutwood; the lower part being rich in ornamental detail, while the upper part is rightly left plain, so that exterior decoration may not be out of harmony with the gems within. There is much originality in this graceful production, the value of which collectors will at once see and appreciate. Of the two

drawing-room CHAIRS, one is richly carved and gilt, the other is of carved walnutwood. The frames are new and good. The manufacturers seem to have successfully studied how to be original with

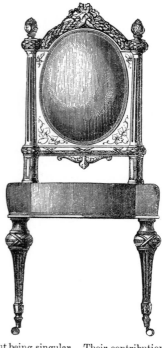

out being singular. Their contributions are designed in pure taste, and delicately and minutely finished. A few years have, indeed, effected vast improvements in all the productions of the British cabinet-maker—now very satisfactory.

there are at least two applications of bronze exhibited, which seem to deserve attention, if not for their absolute novelty, at least for the beauty of effect produceable. There are, first, the bronze gilded ornaments applied by the Onyx Marble Company (French Court) to the decoration of those beautiful manufactures in which the transparent marble plays the important part, and the gilded bronze bears the same relation to it which it or some other gilded metal did to the vases in malachite, exhibited by the Russian government in 1851. Then it was special, now this company have made it a commodity of general commerce—a distinction sufficiently important to warrant commendation, apart from the exquisite taste with which it frequently appeared in the new forms. The other example is what is called "oxidised" bronze, specimens of which are to be seen in the large trophy from Berlin, under the eastern dome. When bronze is moulded into shapes as beautiful as these from Berlin, and oxidised

in this style, it assumes a far higher quality than in its ordinary tints, and is better fitted both for the quiet tone of a library, and for many purposes both of utility and ornament, as the work-box and the library-table set in this stall visibly demonstrate. How much metals, like all other substances, depend on treatment for effect, may also be seen here; for the same material, differently treated, seems of less than half the value of this all-over oxidised bronze.

The conclusions drawn from the examination of the works in precious metals displayed in this International Exhibition are briefly these:—That decided progress has been made in most of the articles of utility, as regards form, and less progress is visible in the matter of ornamentation. That the best style of ornamentation for such articles is either engraved work or low relief. That in articles purely ornamental the French are still considerably superior to the

The SIDEBOARD engraved on this page is designed and manufactured by Messrs. JOHN TAYLOR AND SON, Upholsterers, of Edinburgh. It is executed in Italian walnut. The back is in three compartments; the centre being a niche, in which is placed a figure holding a falcon in one hand, and a dead heron in the other—thus illustrating the favourite sport of the olden time. On both sides are pilasters and trusses, surmounted by cornices, enriched by carved ornament in keeping with the supposed period of the work. The slab is supported by massive trusses, with Bacchanalian masks, and cereals running down the centre

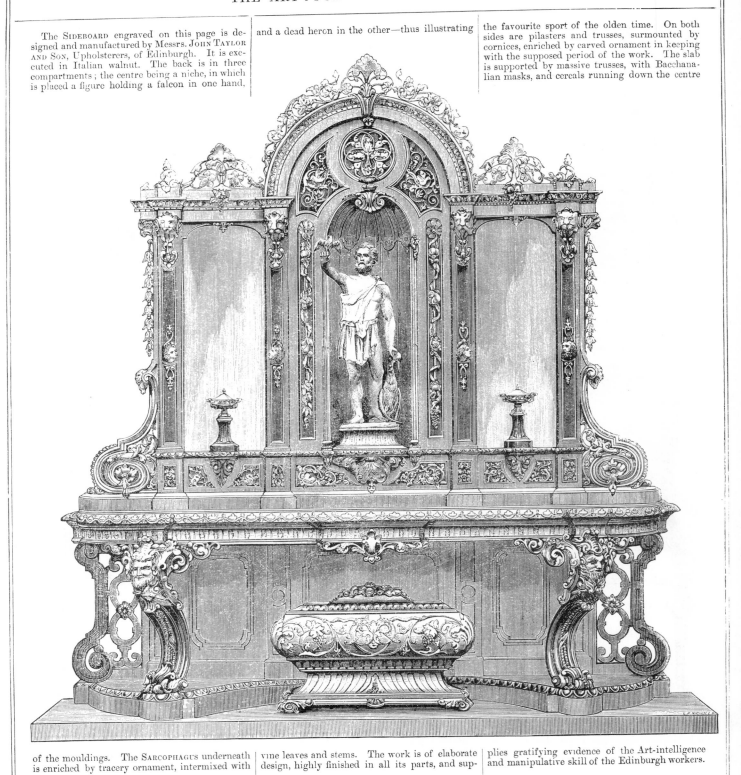

of the mouldings. The SARCOPHAGUS underneath is enriched by tracery ornament, intermixed with vine leaves and stems. The work is of elaborate design, highly finished in all its parts, and supplies gratifying evidence of the Art-intelligence and manipulative skill of the Edinburgh workers.

English makers. That in the higher class of works, those exhibited by English firms are, upon the whole, the most perfect, although these are, generally, the productions of foreign—principally French —artists. That in the combination of colours with metals, the Russians seem to have conquered French taste combined with English science; and that both Spain and India at least successfully challenge the workers in metal of any other exhibiting state. Out of these conclusions there is little glory to be gathered for England, although there is good ground for hope that the progress visible is but the first-fruits of a prolific harvest.

GLASS.

The position of England in this section of the Exhibition presents a marked contrast to what is seen in several others. Here we stand, not only relatively first in the rate of progress, but absolutely first, both in quality of material and artistic development. The causes which have led to this result are as interesting as they are nationally important; and although it may be impossible to trace them all, two or three seem so to rest upon the mere surface of the subject, as to compel notice, however briefly. The abolition of fiscal restrictions on glass had, of course, a great effect upon that trade—infusing new energy, by stimulating competition—a competition necessarily confined within the two lines of quality on the one hand, and improved form on the other. Still, as in some other cases, competition might have taken the form of cheapness, and contented itself with that; but these glass manufacturers have shown the nation a lesson worth learning, viz., that, while the elements of cheapness for the many need not be forgotten, the elements of Art, successfully applied, can also be turned to high commercial advantage, when intended only

The accompanying engravings are specimens of | Mr. SEDLEY, of Regent Street, Upholsterer and | tions of his trade: we engrave two "EASY CHAIRS"

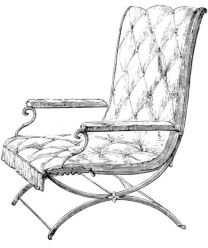

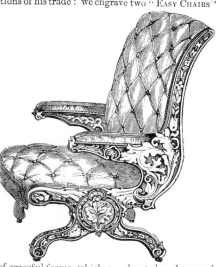

Wood-carving, by Mr. W. H. BAYLIS, of 69, Judd | Cabinet Maker, exhibits many excellent produc- | of graceful forms, which are elevated or depressed

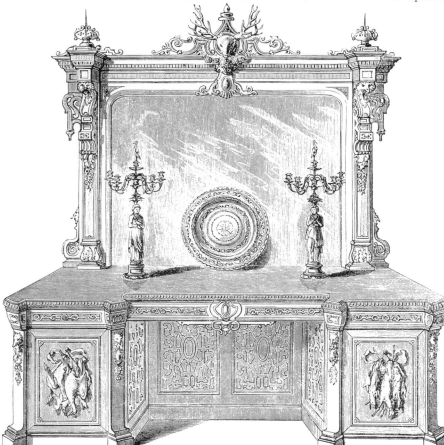

Street, being FRAMES for miniatures or other pur-

poses, and a JEWEL CASE carved in boxwood. | by a simple process. His principal work, however, | engraved—very excellent in design, and highly
The whole are designed and executed by the artist. | is the elaborately carved SIDEBOARD in oak we have | meritorious as an example of good workmanship.

for the few; and that while a world-wide supremacy may be raised upon the simple power of production, it may also be combined with an equal supremacy in the highest scientific and artistic qualities of the article produced. This lesson these glass manufacturers have taught their countrymen for the first time in the history of industrial Art in Britain; and valuable as the lesson is for the immediate advantages produced, it is almost infinitely more valuable for the hope and encouragement it heralds. Hitherto, the feeling of natural inferiority in taste, and especially in the lighter and more elegant articles of utility or embellishment, has rested like a nightmare upon many sections of our manufacturers and artisans. Rank and fashion at home have combined with continental self-interest to deepen and perpetuate this feeling; but now that *cordon* has been broken at its strongest point, and the workers in glass have scaled the barriers, and shown themselves victors, this cause for national despondency is gone, and what has been accomplished in glass, can, with the same attention to governing principles, be achieved by all other craftsmen. True, the principles upon which success in glass depends are less complex than in many other kinds of manufacture—for in Art these are all reducible into the questions of adaptation and form—but the same is true of furniture, metals, marbles, and other kindred materials, where the same measure of success has not been secured. Workers in glass might, like workers in wood or metal, have based their forms upon the style of Louis XIV., or on the most vicious types of the later Renaissance, and great manipulative triumphs might have been secured in such a course. Fortunately for themselves and Europe, our glass manufacturers have taken the wiser course of founding the revival of their art upon the

We engrave a drawing-room PIER TABLE, designed and executed by Messrs. FRY & Co., Upholsterers, Dublin, for Shane's Castle, County Antrim. The carving is in limetree, gilt, having a slab of statuary marble on top, and a mirror at back, the entire standing on a carved plinth of walnut and gold.

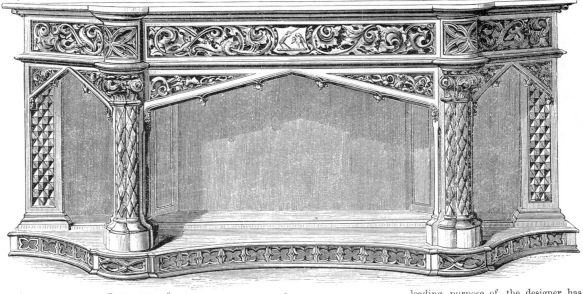

This engraving represents a SIDEBOARD of pollard oak, contributed by Messrs. WHYTOCK, of Edinburgh, being one of several excellent examples of cabinet work manufactured by that firm. Many portions are admirably carved, but the leading purpose of the designer has obviously been to let all enrichments remain subservient to purity of style and dignity of outline. The production is greatly creditable to the eminent Edinburgh establishment.

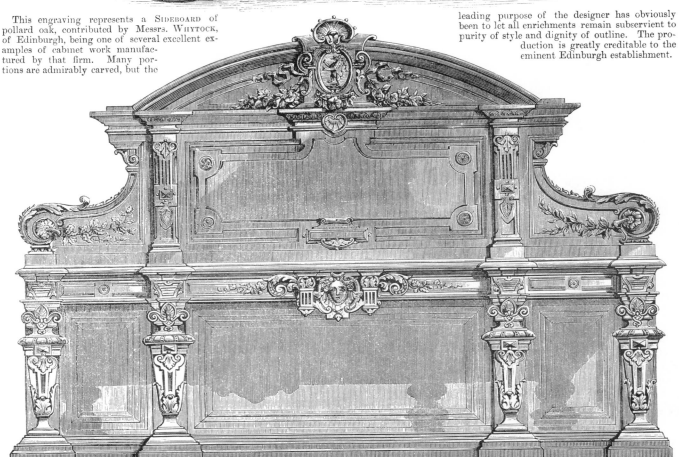

forms of Greece, and their ornamentation has been in accordance with the purer forms adopted. Whether these Grecian forms were the results of profound geometrical knowledge, or merely of a keen appreciation of nature, will probably never be satisfactorily settled, but, so far as we know, two facts appear indisputable, from a broad survey of antique examples—first, that we never meet an inverted form, as is sometimes the case in the Italian glass and pottery, among those Helenic productions; and second, that all their water-holding vessels find their types in the bulbous or other roots, while all their drinking vessels appear to have their types in flowers. An intelligent and enlarged generalisation would also, perhaps, reveal the further fact that these flowers, when modified into drinking vessels, were each suspended on an adaptation of its own distinctive stalk. Knowingly or unknowingly, the British workers in glass have, to a great extent, embodied the same principles in their best productions; and hence, we believe, springs their very marked success. They have not only caught the forms, but also the harmonies of nature, and these, produced in material which has no equal in purity, have made the glass work of the English section the admiration of competing nations. Would that others followed the same example, whether their *specialité* leads them to deal with simple form, or to that combined with colour; for the harmonies of nature would teach in both as truly as in either separately; and when manufacturers and artisans know this in other branches, similar success will reward their efforts.

In 1851 the glass exhibited by Austria attracted a large share of attention, and most justly, for many reasons, but most of all for its surpassing depth and brilliancy of colour. Then both Austrian and

THE INTERNATIONAL EXHIBITION.

We select from the several objects exhibited by Mr. E. White, of Cockspur Street, a Clock and Clock-Case of very great merit, both in design and execution. It is an eight-day clock, "Cambridge chimes," in carved oak Gothic case, with crockets, crestings, finials, and side panels

Mr. Thomas H. Kendall, of Warwick, who exhibits some excellent examples of carved wood, is the successor and was the pupil of the late

Mr. Willcox, who established a high reputation in this branch of Indus-

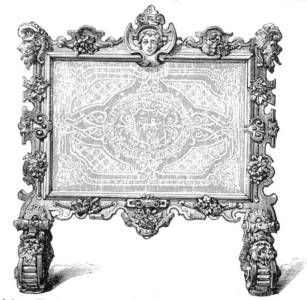

trial Art. He, however, produced no better works than those of the manu-

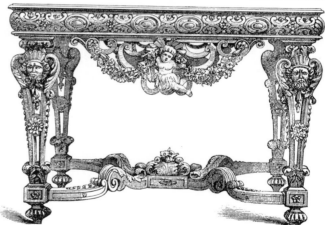

in polished metal. The work is designed by Mr. Philip H. Delamotte, and is of a very pure order, adhering to "authorities," but so adapting the style as to render it highly effective thus applied. It is also admirably executed, being an excellent example of British manipulative skill.

facturer who has succeeded him. We engrave two Brackets; also a small Table, beautifully designed and carved, and an oak Fire-Screen.

French makers were, as a rule, far ahead of British manufacturers in the elegance of form displayed in the overwhelming proportion of the articles exhibited. Now Bohemia still enjoys its former reputation as regards colour, although even in this there are great differences of quality, as in the ruby-coloured specimens shown by the various makers in the Austrian Court, some being beautiful, while there are others as indifferent as any shown by English makers. Still there are no other exhibiting nations which successfully compete with the best specimens of ruby exhibited by Austria, the fault of the English being either a thinness of colour, or when greater depth is obtained, purity is lost, and the charming ruby is represented by a semi-opaque brick-dust red. But with colour Austrian excellence ends, for although the dessert services at the entrance to the Austrian Court are rich-looking, and not devoid of elegance, the mass of glass exhibited by Austria has nothing either in quality of metal or beauty of form to

recommend it. The metal—that is, the uncoloured crystal—is dirty and opaque in quality, worse in this respect than the commonest moulded glass exhibited, or even sent out, by British manufacturers of respectable standing; while the forms employed are bad beyond endurance, as, for example, in the two large semi-opaque vases where the upper part is formed out of a portion of two vases badly put together, and where the style of ornamentation employed is poor if not paltry—as paltry as the two candelabra which so fully keep the worst qualities of these vases in countenance. One of the leading vices of Austrian and French ornamentation is conspicuously brought out in this class, viz., their neglect of the adaptation of ornamentation, or even forms, to the material in which these are employed. With them an ornamental form is a fixed conventional idea, applicable to all substances alike, so that whether a candelabrum be made of glass or porcelain, brass or

We give on this column three examples of the

ENCAUSTIC TILES of Messrs. T. & R. BOOTE, of

Burslem. They are made by a process, of which

Messrs. Boote are the inventors and patentees.

We engrave two of several excellent works manufactured by Messrs. ROBERT STRAHAN & Co., of Dublin. One is a CIRCULAR TABLE of oak, supported by three chimeras,

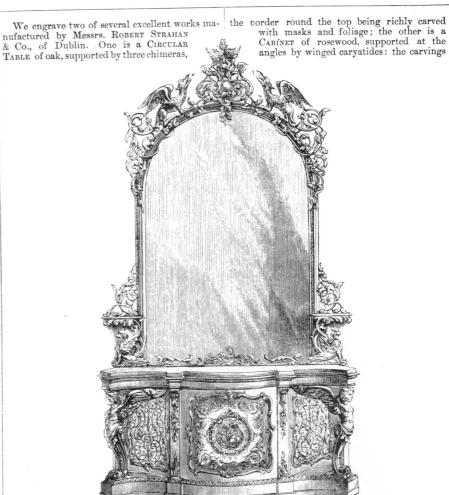

round the frame of the glass are delicately cut

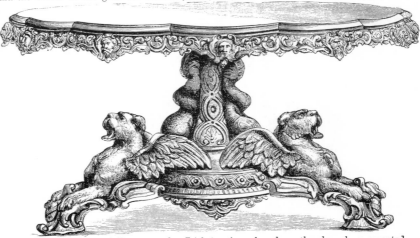

to the designer, and especially so to the Irish

the border round the top being richly carved with masks and foliage; the other is a CABINET of rosewood, supported at the angles by winged caryatides: the carvings

in sycamore. These works are highly creditable

artisans by whom they have been executed.

carved wood, it essentially represents the same idea and is based on the one familiar type. As it happens, that type is metallic not crystallised, and hence in these Austrian, and in many French, specimens the transparent brilliancy and prismatic sparkle that constitute the great charm of the peculiar substance is lost, while the characteristics of other substances, such as brass or silver, are not obtained. It would take more space than can be spared to explain how failure is produced, and by what forms of ornamentation it can be remedied; but if readers will glance at the two magnificent candelabra, at the entrance to the nave from the eastern dome, by Osler, and then at those near the western dome contiguous to the Austrian Court, they will see at once the difference in results. From the forms and angular cuttings employed by Osler their works sparkle from base to apex in prismatic brilliancy; from the forms and ornamentation employed by the Austrians, the brilliancy is lost, and it might be opaque china or transparent glass. This department helps to throw light upon another question, that has recently secured attention, respecting the obligation of English exhibitors to foreigners, for the Art-industry displayed by English firms. But is there no *per contra?* The position of a people is to be tested by what they buy, rather than by what they export; and the highest homage rendered to British taste is by those who unwittingly place what they sell at home side by side with what they make for us. This involuntary testimony crops out every now and then throughout the Exhibition, and one of the most conspicuous instances is found in this Austrian glass. Among many attractive objects there are very few articles remarkable for refined beauty; for although some stained glass is occasionally good in form, when not destroyed by coloured ornamentation, and one vase with gold ornament is better than good, yet there is nothing which ranges above that—nothing which, apart from costly display (of

From several very beautiful contributions of the eminent decorators, Messrs. PURDIE AND COWTAN, Oxford Street, we engrave the CHIMNEY-

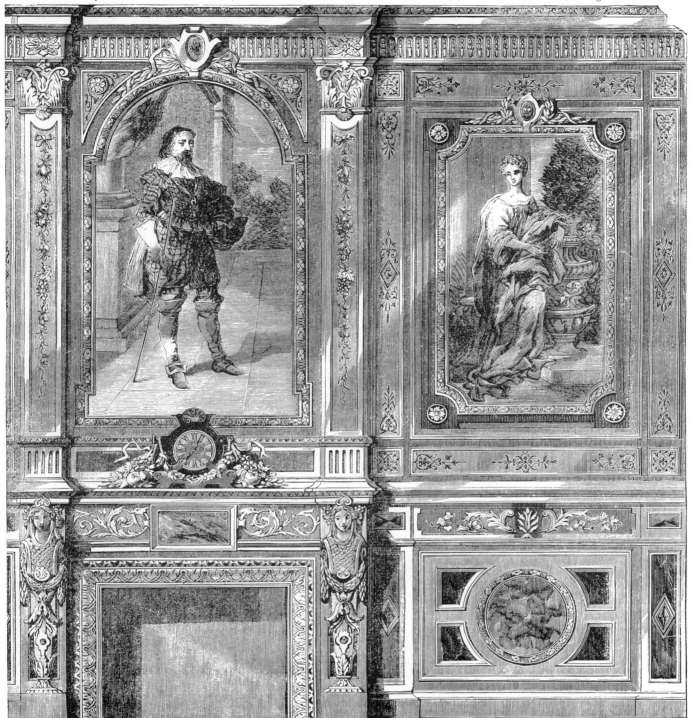

PIECE and SIDE PANEL of a dining-room wall, in the style Renaissance, intended to exemplify the application of high Art to house decoration.

that there is abundance), challenges admiration from intrinsic loveliness, or on which the mind can dwell with pleasure, as a high-class specimen of industrial Art—the Art reigning supreme over the industry. And even among the good things, by far the best, for purity of form and colour, is found upon the stall of Blumberg, whose trade is chiefly, if not exclusively, confined to British markets. In this case, Bohemian hands work out British thoughts or preferences, and Austria gets back in superior taste more than it gives in manipulative dexterity. What is so visibly true of glass is equally true of many other products made up of British generalisation and foreign handicraft detail, so that the question of employing foreign workmen in this country is at least a compound one, involving heads as well as hands; and the standard of national thought on such a subject is more ultimately important than the measure of national dexterity. Heckert, of Berlin, exhibits what

may be called the last remnant of that naturalistic treatment of glass so rampant in nearly all classes in 1851. In another part of the Zollverein, Count Hute—for such matters are not beneath the dignity of aristocracy on the Continent—exhibits some good forms in glass, and some creditable adaptations of forms already familiar; and there is a massive service in glass from Bavaria, in which the old baronial style and feeling is carried out with commendable unity —a style which some English makers have attempted with very indifferent success.

France displays some highly creditable glass, the metal being, in one or two instances, admirable in transparency and colour; the body tints, as in all other cases when the French work in this style, are also exquisite, and there are some novel, and several imitations of former styles, of Italian decorations; but, while the forms now exhibited by the French makers would have been very good in 1851,

Messrs. HAYWARD, of Oxford Street, exhibit in the British Lace department a Honiton Guipure TUNIC FLOUNCE, possessing much novelty of design, and great merit in execution. The *pattern* is well defined,

and so admirably blended with the *guipure*, or open-work, as to give the flounce a very light and graceful effect. Messrs. Hayward also show a COIFFURE and two HANDKERCHIEFS

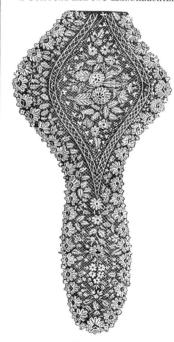

in Honiton Guipure, of which we give engravings. They also exhibit largely in the Foreign Lace department. Some idea may be formed of the extent to which Lace is used as an article of fashionable attire, when

we mention that this establishment gives employment to about two thousand women and children in its manu-

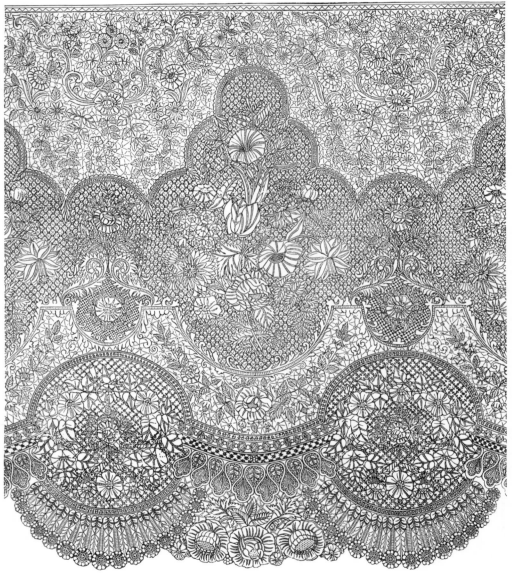

facture; and it is especially gratifying to know that the works of English hands in Devonshire and Buckinghamshire have so greatly progressed in design, as to show favourably beside those of famous foreign competitors.

or even in 1855, they halt at the point of only being very nearly good in 1862. This may be a perplexing statement, and not quite intelligible to some, but it is easily explained. The difference between the ornamental and high style of Art has already been noticed in respect to silver work: it is the same difference which now determines the better or best qualities of form in glass. In 1851, English makers were, with few exceptions, far behind the foreign makers in glass, although the works of the latter were only ornamental in style. Since that period the productions of the best, and, indeed, of nearly all the British makers, have attained high success in purely Grecian forms—that is, forms based upon the higher types of beauty, and not mere copies of Grecian objects—while the French, and other foreign makers, still maintain the ornamental type, which, as previously shown, is essentially a lower development, substituting the conventionally elegant for the absolutely beautiful. With but small progress, except in some manipulative details, such as surface ornamentation, the French are precisely where they were in glass in 1851, while the British makers have gone right ahead, neglecting alike the conventionally ornamental and the picturesque to seize the higher and purer forms of beauty. And this the British workers in glass have achieved to an extraordinary extent. Take the many beautiful forms produced by Dobson and Pearce, with ornamentation which passes from Art-industry into high-class engraving, or some drinking cups by Phillips, or the flower vases by Story and Son, or the tazzas by Lloyd and Summerfield, or some jugs and cups by Copeland, or, above all, some of the sets of Pellatt and Co.; and all these display forms far higher in character than any to be seen among the other exhibiting nations. The works of Pellatt and Co. have also

We engrave two of the FANS of M.

DUVELLOROY, manufacturer of Paris.

"Old Dunfermline" upholds its ancient fame as a manufactory of damask linens; that we select for engraving is the fabric of Messrs. BIRRELL BROTHERS, who, in 1862, distance all competitors, as they did in 1851, being now, as then, foremost among the best producers in Great Britain. The specimen we engrave is a TABLE-CLOTH, made for an especial purpose, the design being of a most excellent order. It is supplied to the manufacturers by Mr. J. N. PATON (the father of the renowned artist), to whose mind and pencil Dunfermline

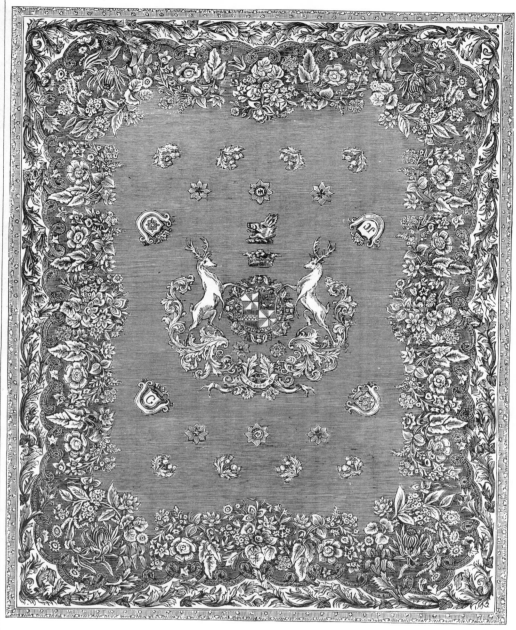

has been long and largely indebted. This example—which we select from many of equal merit—has been produced for the Marquis of Breadalbane, bearing the Campbell and Stewart arms, quartered with the galley of Lorn, and having also the insignia of the Order of the Thistle, and the Prussian Order of the Black Eagle. Although we have chosen the specimen that best suits our pages, it is to be regarded only as supplying evidence of the capabilities of this eminent firm; all its productions—for every-day use, and for all orders of purchasers—have been equally subjected to the influence of good taste and appropriate character in Art.

this higher quality, as in those ornamented with the single horizontal line, that, while others display ornamentation in high Art of more or less merit, Pellatt and Co. combine the purest forms with the finest qualities—simplicity and beauty—of legitimate Art-industry—that is, a form of Art suited to the many, and which the many can both purchase and produce. This is the triumph of successful industrial Art, and in no class has it been so generally achieved as among these workers in glass. There are other forms of ornamentation adopted by some which do not deserve the same commendation, and as the false quality seems to spread, it may as well be glanced at. Some workers in glass appear to take for granted that if they can only produce authority for their "shapes," if they can call it a copy of a Venetian or some other form, that is quite sufficient to secure approbation, or at least to relieve them from responsibility respecting the

quality of the forms so described. There never was a greater or more pernicious error. That every country has produced fools is not offered as an excuse for folly, far less is it to be put forward as a reason why folly should be applauded; and it may with equal truth be affirmed that every nation in all departments has produced bad and indifferent works. Even some of the vases collected by Sir William Hamilton are so evidently imperfect in form as to admit of no dispute upon the subject; some of the specimens of Venetian glass at the Kensington Museum are marred in beauty by inverted forms. One of the most common examples of following the artists in their errors is found among glass manufacturers, when a drinking goblet is made as a whitesmith makes a funnel, and this, supported on a stalk, is called a drinking-cup. When the inherent ugliness of the object is noted, it is supposed a sufficient answer to say it is a

G G

We commence this page with engravings of three of the productions of the PATENT PAINTED AND GILDED LEATHER CLOTH COMPANY, whose warehouses are in Cannon Street West, and who have manufactories at West Ham, Essex, and also in France and Belgium. These fabrics are

making rapid way into several branches of Art-manufacture. The subject is one that will require at our hands enlarged treatment hereafter.

Of the KAMPTULICON of Messrs. F. G. TRESTRAIL & Co., of Walbrook, we give two specimens. This new and very useful fabric (composed of a mixture of cork and India-rubber) for covering floors—recommended by several important advantages—is very largely used in all parts of the kingdom. In the many examples furnished by Messrs. Trestrail & Co., the colours are substantial and the varied designs are good and appropriate.

copy from a pure Venetian cup. And so the upper portion may be; but that neither makes it better nor worse as a specimen of form, while it is generally greatly inferior to the Venetian examples in this. The Venetian artists in glass so felt the inherent defects of such forms that all modes of ornamental balance were attached to the stalk, although even that did not answer the purpose intended; while the modern imitators of these vicious types are prevented by modern ideas from adding the ornament which the Venetians felt to be indispensable. There are many modifications of this same evil deference to so-called authority, without consideration given to the character of such authority, in many of the articles exhibited in glass; although, as we shall see presently, this class of manufacturers overrides the defect more successfully than some others by the larger proportion of high class forms, combined with pure style of ornamentation, which they have, as a body, produced. Two other styles, or rather two offshoots from the same style, must also be noticed, because of their falsity and prevalence. The one is the attempt to introduce colour, and the other the attempt to reproduce the forms through which colour was displayed in an exaggerated, uncoloured style. Both seem clearly the products of a ruder age, or of a declining age, in their original development, and the reproduction of them now is neither more nor less than a vulgar and ignorant delusion. It is not contended that colour can, in no circumstances, be introduced into glass with advantage, nor are the circumstances under which such advantages might arise now before us; but because other nations spotted some of their glass with bits of purple, green, and blue, it is no more reason why we should follow the example, than that we should wear glass beads because barbarians consider

Messrs. BEMROSE AND SONS, of Derby, exhibit excellent examples of bookbinding in leather, wood, vellum, &c. Those we select for engraving are "A Manual of Wood Carving," which is appro-

priately bound in wood, carved by Mr. W. BEMROSE, jun. (the opposite side being a specimen of their new style of "DIAPER CARVING"); and the "Book of Job," an effective example of illuminated

One of the most perfect examples of the bookbinder's art that has been produced since John

Grolier made it famous is that which adorns a folio volume of Dante, executed and exhibited

by Mr. JOSEPH ZAEHNSDORF, of Brydges Street, Covent Garden. It is a production of marvellous

vellum binding. The designs are remarkably good and appropriate, and do great credit as well to the taste as to the skill of the artists who have conceived and executed these very meritorious works.

skill and great industry. The engravings we supply will do it more justice than words can do.

themselves ornamented thereby. In the first place the projecting "bolt-like" form of ornamentation is a mistake, because it is evidently an iron rather than a glass characteristic; while colouring the imitation "bolts" or "rivets" only intensifies the blunder, because tawdriness is added to the original falsity. In the Russian department there is an example of this style of glass, and although far from perfect, according to western ideas of taste, yet there is about it a feeling of semi-civilised show which impresses the spectator with a conviction that it really represents those for whom, as well as by whom, it is produced; it looks the legitimate offspring of barbaric pomp, but when the eye turns to the similar manufactures of French and English makers who badly ape the rude show of other lands, the interest excited by the one becomes transformed into a much less amiable feeling towards the other. Of the large, rich style without colour, or of the better or worse among the bad who

so use colour, it is unnecessary to speak, because the time has gone when any skill of combination, or any beauty of cutting, can make such mistakes popular, so that to warn makers against these retrogressive paths is perhaps superfluous, as no feeling above the quintessence of vulgarity is likely to inspire the purchasers of such inartistic trash. These remarks may seem in ill accord with the assertion that the manufacturers in this class have most nobly sustained the relative progression and absolute superiority of their country; but it is because of this high general position that their perversions are more dangerous both to themselves and others. Ignorance is less blameworthy than sinning against superior light. While British glassmakers have overcome the reproach of the former, they are in danger of being ensnared by the latter evil; and, as French experience shows, the last state of such is worse than the first, there being less hope of progress from perverted knowledge than from simple igno-

We engrave two FRAMES, of very graceful design and refined character, the production of Mr. W. E. SANDERS, of Queen Anne Street,

Cavendish Square. They are specimens of leather carving; the leather—tanned sheep skin—is cut and raised by a pen-knife and a few small tools.

It is difficult by engraving to convey an idea of the elegance of these objects; the designs, as well as the execution, are by Mr. Sanders.

From the numerous examples of the Sewing Machine exhibited we select one, because it is the one that has been best subjected to the influence of Art; it is, indeed, a very handsome piece

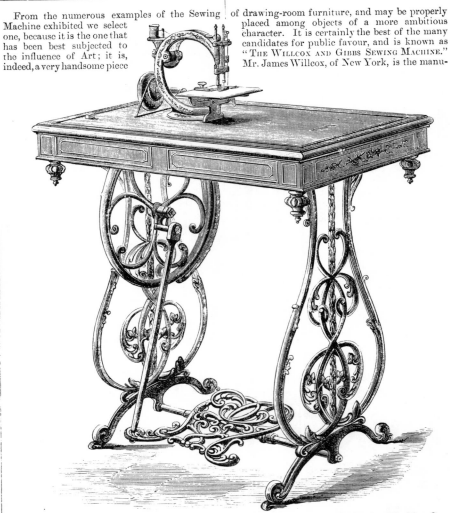

facturer and patentee; represented in London by

of drawing-room furniture, and may be properly placed among objects of a more ambitious character. It is certainly the best of the many candidates for public favour, and is known as "THE WILLCOX AND GIBBS SEWING MACHINE." Mr. James Willcox, of New York, is the manu-

"The Willcox and Gibbs Sewing Machine Company," Ludgate Hill. The Cover, which we engrave separately, has received good ornamentation.

rance. Many other individual makers and a vast variety of beautiful specimens might have been noticed in this class, because almost every stall in the British section contains articles charming alike in outline and ornamentation; but inasmuch as to notice all these is impossible, those only have been selected which most fully represent the general principles inculcated.

Whatever errors or short-comings there may be, universal accord has undoubtedly conferred the highest honours on British manufacturers of pure crystal glass; their supremacy is established beyond controversy. The political economists may take pride in this fact, no less than the Art-lover.

POTTERY.

The products of Ceramic Art in the present Exhibition occupy a conspicuous place, alike from the number, variety, and beauty of the specimens exhibited; yet there are some reasons for doubting whether the same relative progress has been made since 1851 in this class as in some others. That the general average standard is higher, particularly in the English section, is evident enough; and that we are now on a level with any other competing nation, and far beyond all who trust porcelain to ordinary laws of commerce, is matter of congratulation. A still greater triumph for our manufacturing skill, and a stronger evidence of national progress, are found in the fact that our private manufacturing firms can compete successfully with the governmental establishments of other countries, in all that is worth competing for—purity of form, and even in what is of infinitely less importance, dexterous ornamentation. Notwithstanding all this, careful examination of these ceramic sections, and especially the English, burdens us with a conviction that all is not true in that quarter, and that in spite of all the beauty and excellence dis-

THE INTERNATIONAL EXHIBITION.

Messrs. RODGERS & Co., of Sheffield, have long maintained a high position in England as manu- | facturers of cutlery, and their fame has spread into all lands. They were among the first, and | have been always of the best, producers of the works of steel that have made the town of Shef-

field renowned throughout the world. We can give no idea, by engraving, of the merits of the | many works they exhibit in a vast variety of classes; we have selected, however, a few which | have been especially subjected to the influence of Art—the KNIFE HANDLES of DESSERT KNIVES.

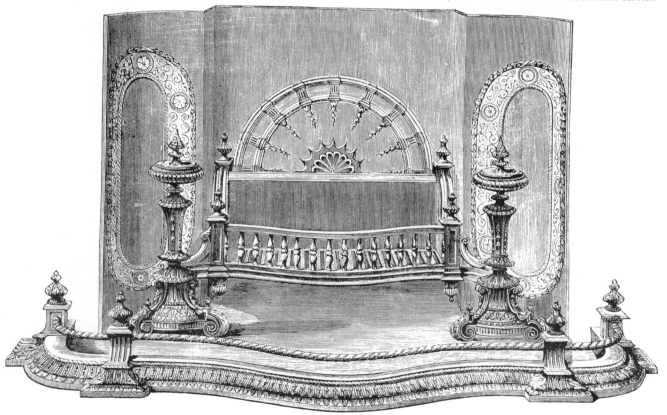

This GRATE is the manufacture of Messrs. EDWARDS AND SON, Great Marlborough Street. It | is in the style Renaissance, with ormolu fire-dogs and fender, the whole of the highest description of | workmanship. It is rightly classed among the best productions exhibited, in execution and design.

played, the progress has not all been in the right direction. Let us try to forget for the moment all that other nations have done—not in forms, because these are in many cases unobjectionable—but in ornamentation, and what would the objects and purposes of pottery suggest as fitting embellishment for such articles? Flowers, for example, may be painted with all the skill of a Huysum or a Mutrie, and, when so produced, there are few objects more seductive to an ordinarily cultivated mind; but to have a flower vase decorated with flowers, or to see exquisite roses struggling to show their charms through a sediment of tea-grounds, may display inimitable flower-painting, but it also indicates most indifferent, if not absolutely false, ornamentation. Or, let us take the articles of plates or dishes. Portraits of the Queen, or the Emperor Napoleon, may be painted on the plates with all the artistic beauty of a Thorburn or a Sir William Ross, and the dishes may be honoured—we had almost said hal-

lowed—by the highest Art of the greatest masters; but, in spite of all the genius displayed, there is surely something incongruous in cutting bread and butter across the face of Queen Victoria, or scraping preserve off the brow of the French Emperor, while there is something worse than folly in condemning apostles, and high Art, to be smeared with droppings from the gravy-spoon. No doubt the highest authority can be pleaded for such styles, and perhaps Raffaelle himself did not object to display his high Art on a plate; but he did many other things far removed from absolute wisdom, and there never was a folly done which some great name could not be found to sanction. Such questions are not to be decided by authority, especially as present circumstances are entirely different from those of the authorities followed, and the practical point is whether Peter receiving the keys is an appropriate basis for a leg of mutton. Of course not; and the hundred and one modifications of this anachronism is the perplexing

Messrs. R. W. WINFIELD AND SON, of Birmingham, exhibit a large collection of meritorious works, the principal of which are chandeliers and brackets for gas. Their brass bedsteads have also long been famous; and to these and other productions of their extensive finish, as well as of excellence in design. This firm has always held a

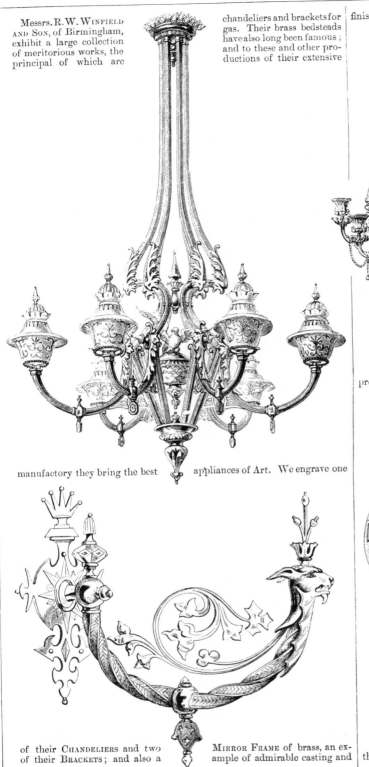

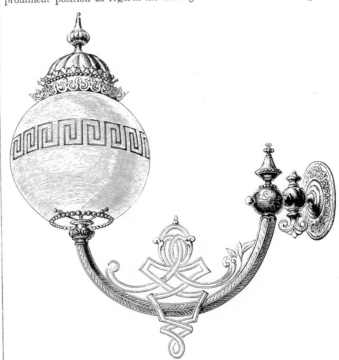

prominent position as regards the leading manufactures of Birmingham;

manufactory they bring the best appliances of Art. We engrave one

of their CHANDELIERS and two of their BRACKETS; and also a MIRROR FRAME of brass, an example of admirable casting and that position is fully sustained in the International Exhibition of 1862.

phase of the progress made in this charming art. The works of many of the former masters of this art were intelligible enough. Della Robbia was an artist in "ware," just as many of his contemporaries were artists in marble, and Palissy produced fish and fowls in baked and glazed clay, just as Gibbons produced similar subjects in oak or plane-tree; and in all such cases the genius of the artist inspired his productions with vitality and worth. So it might be with Raffaelle and his followers; and if artists prefer to display their skill upon a plate or dish, instead of on canvas or a panel, we may marvel at the oddity of choice, but there the matter ends as a work of Art. Art-industry is amenable to other laws, where utility and fitness rank first in value, and where the most dazzling high Art will not compensate for the absence of becoming ornamentation. It is in this quality that the exhibitors of porcelain seem to be deficient; and while the flowers are painted to admiration, and figure subjects are exhibited which equal the artistic beauties of any former period— while in these items there has been conspicuous progress, there are comparatively few examples of that simple ornamental elegance which is so abundantly displayed in the decoration of glass. Why it should be so may be difficult to determine; but how such a result has been obtained is seen at a glance. As a rule, the English manufacturers of porcelain are still under the dominion of French ideas, whether these are developed by French artists or not; and even when more perfect models have been in view, French influence has been the spectacles through which the artists and artisans have worked, and the outcome in pottery has been something analogous to the furniture from Turin, or that in the Italian style from France. The avowed imitations of the old grotesque, whether produced in France, Italy, or England, are still more unsatisfactory. They do display material and manipulative progress, and these are not to be

THE INTERNATIONAL EXHIBITION.

CARL HECKERT, of Berlin, exhibits a number of works in metal and

glass, of a novel and attractive character; some are CHANDELIERS,

intended chiefly for conservatories: of these we engrave two.

Messrs. CARTWRIGHT, SAMBRIDGE, AND KNIGHT, of Lombard Street, Birmingham,

exhibit CHANDELIERS of brass and bronze; though not costly, they are good in design

and execution, from the designs of Mr. SAMBRIDGE, one of the partners of the firm.

despised; but to be the clever author of a huge mistake is but slender honour compared with the glory of seizing and working out a ray of truth, however rude the development. Attempting to dress up modern ideas in Lord of Misrule costume is at best but stage work, when acting is substituted for feeling; and when it is done by those as destitute of genius as of sympathy for such labours, the productions must necessarily be unmeaning shams—ugly as they are worthless—or toys illustrative of small conceits, instead of the vigorous wit which sought utterance through a semi-enlightened grotesque, representing the age in which it was produced. Progress in such a course is, in all pertaining to the higher elements of industrial Art, equivalent to retrogression: and for this age there is more to be learned from one of old Wedgwood's vases than from all the imitation majolicas in Florence, Paris, or London. The one is an

artistic embellishment, more or less perfect, of some type essentially, because æsthetically and optically, suited to all time; the others are the mere corpses of exploded whims—bodies without those souls which made them tolerable once, but the absence of which makes them worse than intolerable now.

Among the works in porcelain exhibited, the most ambitious in effort, as well as the largest and the most costly, is the majolica fountain by Minton and Co. under the eastern dome. This was no doubt intended to show the development of modern ideas, or more properly, perhaps, modern powers of adaptation to an antique dress; and it is but justice to the memory of the deceased artist to say that he was as well qualified as his compeers to work out this problem. The too conspicuous failure at least strengthens the idea that the effort was a grand mistake. It is needless to go over the many and

Messrs. RENNIE AND ADCOCK, of Birmingham, exhibit some excellent examples of the works for which the locality is famous

all the world over. These productions are distinguished by the combination of taste in design with excellence of construction,

and consist chiefly of brass and bronze chandeliers, into which ceramic figures are occasionally introduced with good effect.

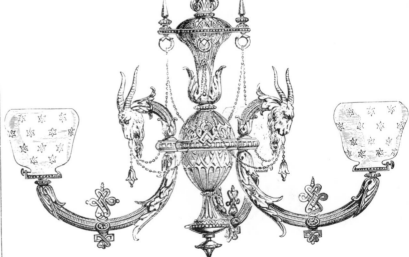

Their stall contains also lamps, brackets, time-pieces, mirrors, and various articles for the house and the toilet. We engrave two CHANDELIERS, and also a GREEK LAMP in bronze.

obvious reasons which prove that fountains cut up into small bits by spots of colour—no matter how perfect the arrangement and combination in detail—must always defeat the purpose of producing beautiful or grand general effects; even when in repose, the tinted glories of surrounding nature will suggest why to the most ill-informed on Art; but fountains are constructed to be seen in action, and then the beauty of general form, combined with concentrating the eye upon the water, is everything, while the sun, with the surrounding flowers and groves, ought to produce the necessary colour. The attempt to secure a prismatic effect through means of colour, was perhaps the aim both of artist and manufacturers; but if so, their efforts have been unsuccessful, and if tawdriness has been escaped, brilliancy has not been secured. Still, it was perhaps better that effort should once for all be made under the most favourable circumstances, because now the question has been set at rest; and both manufacturers and

the public are now able to determine, from the effect of this large and expensive work, whether it ought to be viewed as a beacon or a guide. Our opinion is decided: and but for circumstances—especially the recent decease of the lamented artist, Mr. Thomas—the reasons for this decision would have been fully and strongly stated in detail. Passing from the fountain to the stalls of Minton and Co., the transition is a cheering one, and it would take all present available space to enumerate the really fine objects in these stalls. After what has been said it will not be supposed that the imitation majolicas are included in this verdict: and yet there cannot be a doubt that the manipulative skill displayed in many of the other works, has been assisted through the effects expended in the chase after false principles so abundantly prolific in these fantastic efforts. It is thus that error often becomes a help rather than a hindrance to truth, and with them we now take final leave of these imitations, although the

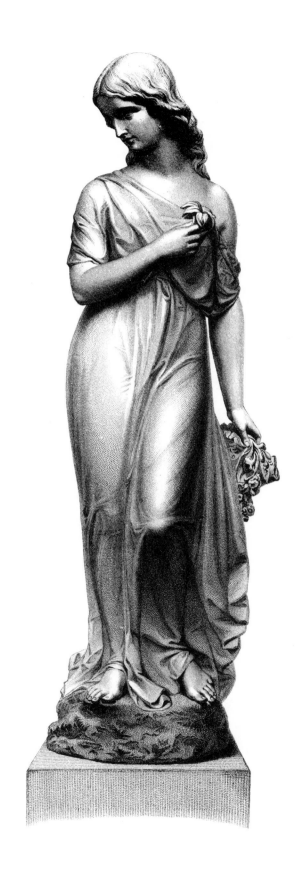

PURITY.

ENGRAVED BY W. ROFFE, FROM THE STATUE BY M. NOBLE.

LONDON JAMES S. VIRTUE.

THE INTERNATIONAL EXHIBITION.

We engrave the "PRESENTATION PLATE" of the City of Berlin to their Royal Highnesses the Prince and Princess Frederic William of Prussia, consisting of four articles of silver—a VASE with SALVER, standing on an ornamental TRIPOD, and CANDELABRA. The design is by Professor FISCHER. The manufacturers are D. VOLLGOLD AND SOHN, of Berlin. The candelabra are nine feet high, the vase four feet. These works are of the highest order of Art; we regret that our space does not permit us to describe them. Knowledge and fancy have combined to render each section the part of a great whole; rendering honour and homage to

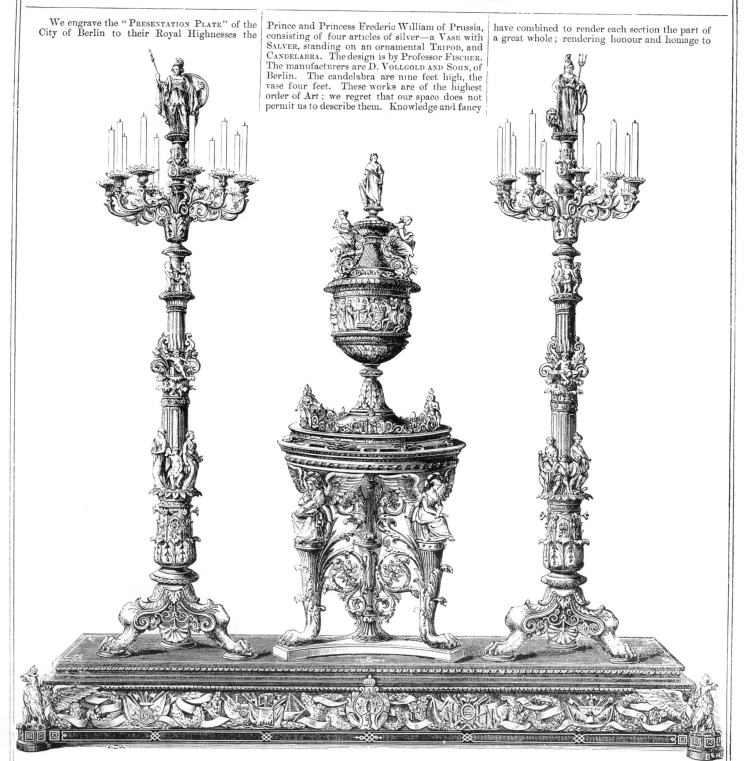

the well-beloved Princess Royal of England— welcomed to the city over which she is, by God's blessing, destined to rule as Queen of Prussia.

contributions from Italy have been the most popular fancy goods exhibited, so far as popularity is represented by sale. Among the more ordinary articles made by this firm, are tiles, both for floors and walls, and some of these are very good in style and colour; but among the long ranges of plates intended for dinner, dessert, or tea, the excellence of ornamentation is not equal to the variety. What may be called the picturesque is here predominant, for, where it does not appear in the form of birds, figures, landscape or sea views, it seems still struggling for supremacy in other, and often equally objectionable, forms, and the number of specimens in high-class simplicity of ornamentation is not conspicuous. But let those interested compare the plain white plate with gold lines, and a simple initial letter in the centre, with the most florid or picturesque of those beside it, and the superiority of the former must be instantly recognised and appreciated by all whose opinions are worth knowing. If Minton and Co. would devote the great technical skill so evidently at their command to the production of the beautiful, as zealously as they strive after the naturalistic or the grotesque, they might do a great work for the perfecting of pottery in England, and ensure for themselves a still higher reputation.

Among the productions of Sir James Duke and Nephews are some highly creditable works in all branches of Ceramic Art; and if the principles on which potters are now, as a rule, working could be esteemed sound, then some of these specimens, for delicacy and refined harmony of colour, would occupy a foremost position. But, since these general principles cannot be accepted as sound, it is with greater delight and interest that we examine articles based on truer standards; and some of the tea-sets here are of a very high order of merit, the

The TITAN VASE, manufactured by Messrs. HUNT & ROSKELL, is the great work of ANTOINE VECHTE, and undoubtedly one of the admirable Art-productions of the nineteenth century. It is not a new production; the accomplished artist wrought it prior to 1851, when it was exhibited. The various figures in

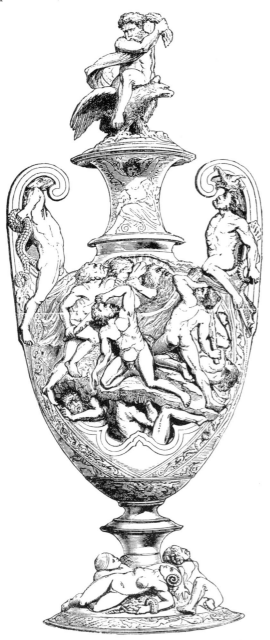

the round and in relief relate the story of the war of the Titans with the gods. The form is Etruscan, and it is "embossed from thin sheets of silver in the highest and lowest possible relief." The work has been frequently the subject of laudatory criticism; it maintains its supremacy in 1862, as it did in 1851.

We engrave a CENTRE-PIECE, manufactured and exhibited by Messrs. REID & SONS, of Newcastle-on-Tyne, of whose many excellent works we have given other examples. The figures are those of Flora and Pomona; a foliage stem and floral wreaths support

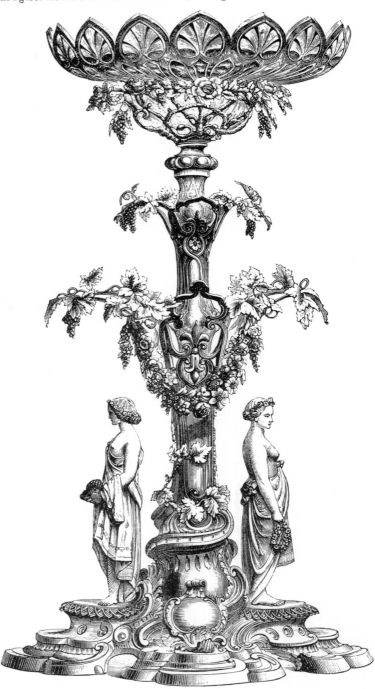

a centre bowl, with branches for either lights or smaller bowls. It is a good and graceful design, well composed, skilfully worked out, and carefully finished in all its parts.

ornamentation being in beautiful unity with the high quality of forms employed. Others are beautiful in detail; and some of these have, it seems, received high official approbation, especially a cup and saucer, the latter ornamented with four masks, connected with festoons of flowers, the whole being cleverly executed, and having a neat and simple aspect. But, in spite of all these, the official approbation included, it would not be difficult to show that masks are as false in principle on the side, as the head of Wesley would be in the centre, of a saucer. There are, indeed, circumstances and modes of adaptation which might make masks as tolerable in earthenware decoration as they are in the old bronze lamps of Italy; but painted masks, although equal to miniatures, do not belong to that class, and no ability will ever make such works seem other than placed on, instead of forming a part of, the general design. Ornament must help to make out a unity with the forms to be successful, in the better

sense; and the most perfect and beautiful work ever seen, if it failed in this, would, whatever its other merits, be but indifferent Art, as ornamentation adapted to industry. Among the works exhibited by this firm will also be found examples of that magnificent perversion so abundant in this class : a small plate, which the potter would make in ten minutes, and on which the artist expended two months' painting—the value of the one being, perhaps, a couple of shillings, the other increasing the cost to twenty-five guineas. But that point will receive consideration presently.

The works exhibited by Copeland show an entirely different development, although springing essentially from the same French root. Indeed, the influence of France and modern French ideas is most visible in the productions of Copeland, where it assumes the genial, sunny aspect of Watteau and Boucher, rather than the Academic sternness of Le Sueur, or the truer dignity of Le Brun. It seems always

THE INTERNATIONAL EXHIBITION.

Looking at the various contributions by Messrs. ELKINGTON & Co., of London and Birmingham, which are distributed in different parts of the International Exhibition, it must be admitted they have brought the working of precious, as well as some of the inferior, metals to the highest point

of perfection: gold and silver, oxidised metal, bronze and steel, are seen wrought respectively into objects of real artistic value, from a lady's card-case or an infant's christening-cup to the massive candelabrum or salver, the graceful statue, and the glittering armour of chivalry. In order to do all the justice in our power to so large and varied a display, we assign to it another page of our Catalogue. The first engraving is from a GLOVE BOX, of silver, designed by the late E. JEANNEST, with the purity of taste that distinguishes all his works. Below this is represented

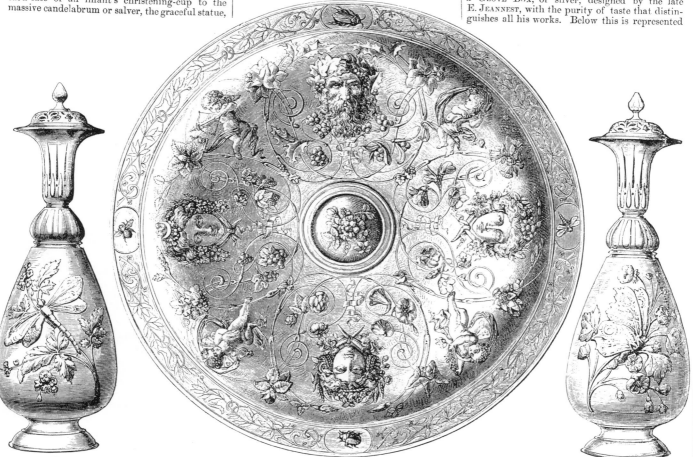

a *repoussé* DISH for rose-water, and a PERFUME BOTTLE, *en suite*, designed, and in part executed, by A. WILLMS: the former shows in its ornamentation the Four Seasons, as masks, with genii and appropriate flowers; the latter has a butter-fly on one side and a dragon-fly on the other.

summer at this manufactory, for flowers are in perpetual profusion, and such flowers as no others in the same trade produce. In some cases, such as a dessert service, flowers seem a most suitable character of ornamentation, for few associations better consort than flowers and fruit; and when such flowers are painted as Copeland's artists paint, the gratification of good Art is added to the pleasing material combination; but even the most intense delights can be overdone, and beautifully painted flowers may become too plentiful. This is manifest in some of those specimens all but covered with festoons of small flowers—so covered that the original forms are lost, or partially hidden, beneath strings of attractive roses: injustice is thus done both to the forms and flowers, for, when each is good, judicious combination improves both, but neither are made better by the sauce being out of proportion to the more substantial fare. In pottery, as in glass, form is emphatically first, and may be—perhaps ought to be—almost every-

thing, although there is a very strong tendency among our first-class potters to overlook this fundamental truth; and the result is that it is often difficult to determine whether the exhibits are ornamented forms, or forms used only to show the ability to produce a mass of clever, but unmeaning, because superfluous, ornamentation. This is a huge blunder, and it is as rampant among Class XXXV. as among any section of British exhibitors. No artistic skill yet known has been able to combine two such totally different elements as classic forms with florid French ornamentation; and the multitudinous efforts made by the potters of nearly all exhibiting nations to unite the simple elegance of Greece with the conventionalised attitudinising of Watteau, does not show that success in the vain effort prospers. Even the most splendid flower-painting seems to have neither relationship with, nor sympathy for, the Grecian forms on which it is produced; and, as in glass, silver, and, indeed, all such works, form is the primary, and

The lamented sculptor, JOHN THOMAS, had barely finished this beautiful work before he died; it was a commission from the eminent contractor, Mr. LUCAS. The subjects in relief which adorn the CHIMNEY-PIECE are taken from the "Midsummer Night's Dream;" the work is not only charming in design, but excellent in execution; not overladen, as such productions often are, but simple, graceful, and most effective. The STOVE is one of the many valuable contributions of Messrs. STUART AND SMITH, of Sheffield.

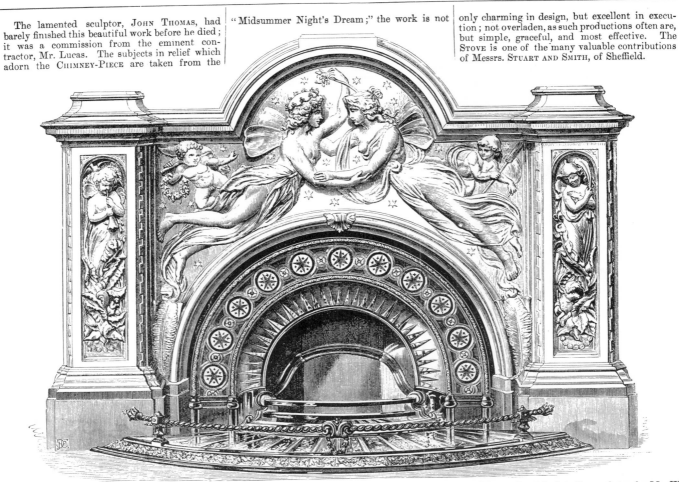

The FRIEZE, or rather REREDOS, engraved underneath, is the work of Mr. NICHOLLS, Sculptor, of Lambeth. The subject is 'The Announcement to the Shepherds,' and 'The Adoration of the Magi,' and it was furnished to the sculptor by Mr. W. BURGES, the architect employed on the restoration

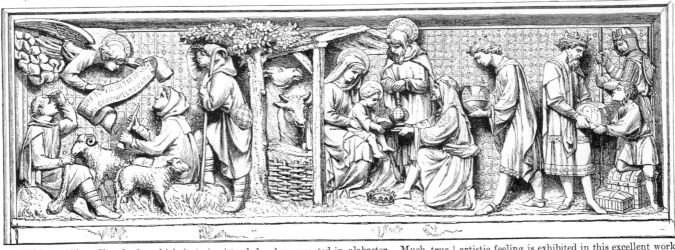

of Waltham Abbey Church, for which it is intended, when executed in alabaster. Much true artistic feeling is exhibited in this excellent work.

ornamentation a mere secondary, consideration, even when good, such efforts in decoration, however costly, are of no value at all, or rather worse than that, when out of harmony with the more essential quality. Some of the common ware exhibited by Copeland is of a high character, both for form and simple elegance of ornamentation; some jugs and basins in the lower portion of their case being among the best examples in the Exhibition. In some of these gold is used with great effect, but in two different ways, which involves a question that may as well be noticed now. Practically, gold is the least permanent of all the porcelain decorations, but, notwithstanding this, with a strange and almost uniform perversity, potters insist on putting the gold just where it must sustain the greatest amount of tear and wear. If they have a hollow and a raised "bead" round a basin—as in one of those noticed above—the hollow, which would have protected the gold, is ornamented with colour, and the gold is put on the raised bead, where it must soon be washed off, or otherwise disappear. There may be method in this perversity, but it is utterly false, for true decoration never sacrifices utility to show, far less to the mere trading interests of manufacturers. Nor would the common-sense principle be less effective—on the contrary, it would be more so—from the richness of reflected lights, which a burnished gold hollow never fails to produce, and which may be seen, as if by accident, in one of the two basins already referred to as exhibited by Copeland. This subject claims the attention both of the ornamentists and buyers of porcelain, for, while it touches the professional reputation of the one, it no less deeply affects the pockets, and mars the household amenities, of the other.

In this class the name of Wedgwood necessarily holds a prominent and honoured position—a name to which the admirers of Art-industry throughout the world accord a reverence as willing as it is

THE INTERNATIONAL EXHIBITION.

This CHIMNEY-PIECE, of very elegant design, is | exhibited by Mr. H. B. LITTLE, of Martin's Lane, | City. It is formed of a patented composition—

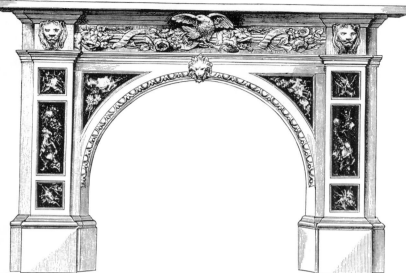

"Spurgeon's Improved Martin's Cement"—to | which our limited space only permits us at pre- | sent to refer as having many and great advantages.

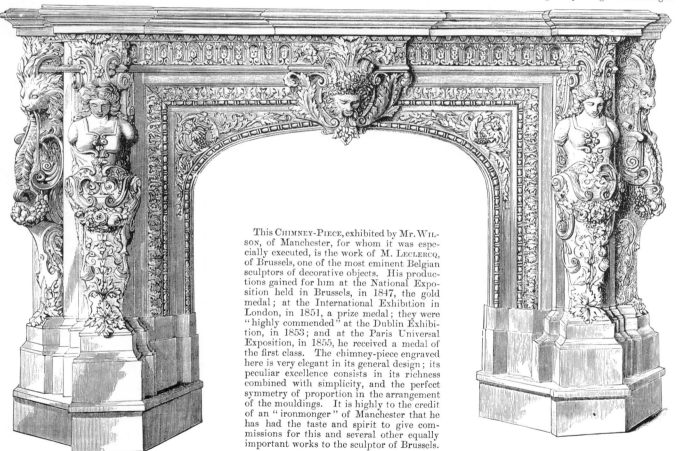

This CHIMNEY-PIECE, exhibited by Mr. WILSON, of Manchester, for whom it was especially executed, is the work of M. LECLERCQ, of Brussels, one of the most eminent Belgian sculptors of decorative objects. His productions gained for him at the National Exposition held in Brussels, in 1847, the gold medal; at the International Exhibition in London, in 1851, a prize medal; they were "highly commended" at the Dublin Exhibition, in 1853; and at the Paris Universal Exposition, in 1855, he received a medal of the first class. The chimney-piece engraved here is very elegant in its general design; its peculiar excellence consists in its richness combined with simplicity, and the perfect symmetry of proportion in the arrangement of the mouldings. It is highly to the credit of an "ironmonger" of Manchester that he has had the taste and spirit to give commissions for this and several other equally important works to the sculptor of Brussels.

eminently merited. That the present inheritors of that great name have also inherited the genius and taste of their great progenitor it would be worse than rashness to affirm; for, although in one of their stalls there are specimens of painted ware which, for bold breadth of effect, and clever artistic manipulation, are not surpassed by any other exhibitors, English or foreign, yet they are samples of that mistake which selects dishes and earthenware for the display of pictorial high Art—or rather Art that is meant to be pictorial, but which only reaches the character of ornamental. In drawing, the style is eminently French, and so is the entire mode of treatment adopted on these laboriously painted platters; and there is no better opportunity of comparing the characteristics of this style, as belonging to France, with the higher style, which we call pictorial, or classical, than by glancing from remnants of those *bassi-relievi* produced by the great Wedgwood to the painted examples exhibited practically on the same stall. In their way, the painted figures are as clever as the modelled, but how inferior as a method of ornamentation is seen at a glance. Nor is the lower quality of style the only difference, or even the most important, taking all circumstances into account. As works of Art proper, the present painting, clever as it is, cannot take rank with the former modelling, but the difference in favour of the latter is increased tenfold when the two styles of production are tested by the lower standard of Art-industry; and here, paradoxical as it may sound, the higher Art of old Wedgwood puts the lower Art of his successors to flight. Nothing is worthy the name of industrial Art which is incapable of being produced by many, for the many; but no amount of general Art-education will ever be able to produce artists sufficient to make painted works like those by Lessore

K K

We engrave another page of selections from the numerous works manufactured and exhibited by Messrs. MINTON, of Stoke-upon-Trent. The

collection comprises every possible variety of productions in Ceramic Art, not only of such as are altered and adapted

from those that time has rendered "classic," but such as are in the ordinary sense of the term "original;" their

merits have been the theme of universal praise. The manufacturers have eminently upheld the honour of the country, maintaining supremacy in

every branch of the Art. Our engravings are of various

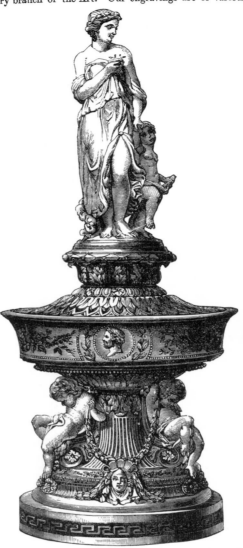

objects, yet they convey but a limited idea of the multi-

plicity of articles exhibited, from the magnificently painted

vase to the tea-cup for daily use. The best artists, foreign as well as British, have been employed to design

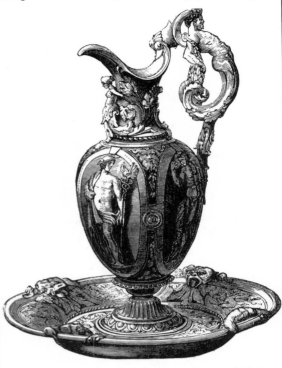

and decorate, while sound judgment and matured taste,

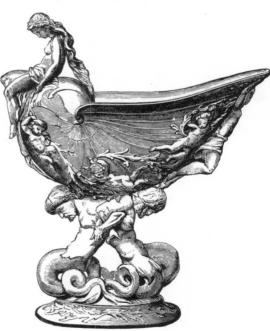

as well as long and large experience, have been brought to bear on all the issues of these justly renowned Works.

attainable by more than the enriched few. They are, in fact, pictures; and these, to be good, no matter on what they are painted, must always be high priced, because each must be a separate and independent work, executed by a high-class mind. The foundation of old Wedgwood's art was laid in a broader and deeper view of what was wanted; and the theory, as well as the practice, of his principle was to enable the many to work out the high thoughts of the few, which is the only practicable way of amalgamating Art with industry. Art may be combined with industry as gilt is combined with gingerbread, and to no better purpose. Unfortunately, this class contains many—far too many—specimens of this kind of combination, where artists paint pictures, of various subjects, on round or oval forms, made by potters, as they would on panels or canvases prepared by artists' colourmen. To prevent misapprehension or

cavil, it is not meant by this that any artist could paint on china as well as on canvas, because it requires a special training in the use of the peculiar colours employed, just as in the cases of fresco or scene painting, where the materials used are different from those used in oil pictures. But this difference of vehicle does not even touch the strength of the objection, because the artist is employed to produce a picture on clay, and just such a one as a painter in oil would produce on a different material: a work in which the picture is the subject valued, and not the plate, vase, or dish which is used as the mere surface to paint on—a thing of little or no value until it has received the Art. This is pictorial Art, no matter by what name it may be exhibited; and the furtherance of this style is not a development of industrial Art-progress in the usual acceptation of these terms. But old Wedgwood fused the Art with the

THE INTERNATIONAL EXHIBITION.

Mr. JAMES GREEN, of Upper Thames Street, manufacturer of glass for the

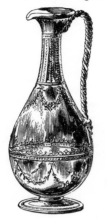

"table," and for many other purposes, supplies us from his extensive

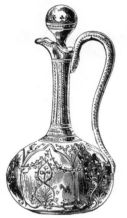

"show" with several examples of rare beauty; the forms are of the purest

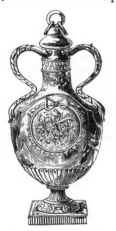

order, and the ornamentation of the highest and best character. It is

gratifying to note the efforts

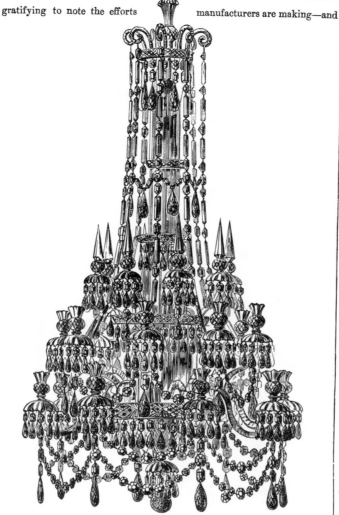

which are very obvious in the collection under notice—to give purity of

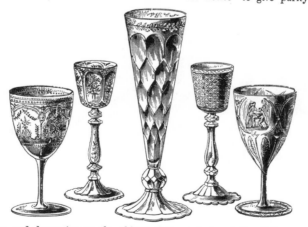

form and decoration to the objects that are designed for daily use in

manufacturers are making—and

families of comparatively restricted means; it would be easy to select

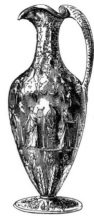

several examples from the works shown by Mr. Green which illus-

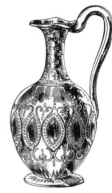

trate this important principle; we engrave some of them on this page.

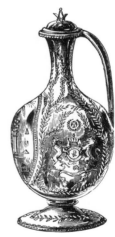

His more remarkable production, however, is a CHANDELIER of great merit; this also we have engraved.

industry, so that the one was an inherent, elemental portion of the other, and there the industry was commensurate with the Art employed. For example, an artist may take a month or a year to paint his picture on one of the vases or platters exhibited, and it is only an abuse of words to call such combination industrial Art which employs the potter a forenoon and the artist a year to produce; but, suppose Flaxman had spent a year on one of his models, workmen of reasonable skill could have gone on multiplying examples from the time it was finished till now, so that the Art once made would dignify and multiply the commercial value of the Industry. The elder Wedgwood acted rightly and most wisely in combining the two. While skilled workmen produced all that could be done by dint of handicraft, the artist overlooked and retouched the higher specimens with his moulding tool, giving sharpness to what the mould had left

imperfect, or the mere workman had blunted in producing. But, even here, the Art was, in quantity of labour, subordinate to the industry, and the genius of two or three men guided the labour of many to important national results. This was the kind of Art-industry England wanted then, although she knew it not; and this will be the only kind practically successful now, either in porcelain, or any other species of manufacture, because, although artists may work for the few, industry belongs to the many, both in its processes and commercial realisations. To amalgamate Art with what many produce, and the multitude buy, is the true Art-industry for England, and there is less of this character of Art displayed by the potters of Europe than in many of the other branches of domestic utility or ornament. The examples in the old Wedgwood style exhibited on the present Wedgwood stalls are, in spite of their inferiority both in

From the productions of Messrs. PELLATT & Co., of the Falcon Works and Upper Baker Street, we have selected subjects

for another page; they are eminently entitled to the distinction, for among their numerous

contributions are many works of rare beauty, admirable forms, and very perfect ornamentation, with reference to either

"cutting" or engraving, the one being true and bold, the other refined and delicate, from designs of a pure

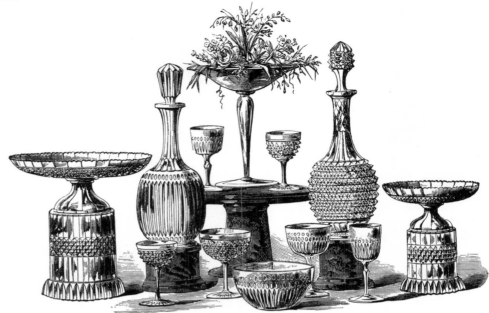

what they can do than what they continually produce, for Messrs. Pellatt are extensive manufacturers of every class and order of "table glass;" and the same good taste

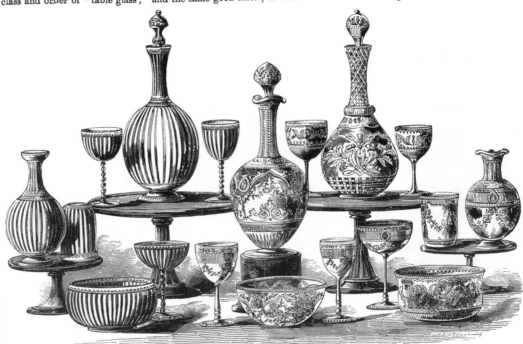

Their "show" at the Exhibition supplies ample evidence of this; all the ordinary requirements of families are as

character. Their costlier works are of rare excellence: these are to be regarded, however, rather as examples of

and sound judgment that have produced more expensive objects, have been exercised to form and decorate such as are within the reach of persons of ordinary means.

thoroughly subjected to the influence of Art as the objects that attract attention by elaborate workmanship and finish.

form and ornamentation to many of the former specimens produced by the great progenitor of this house, among the finest things in the Exhibition; and as the ghost of that great man did not rise and forbid the banns between the graceful beauty of the figures and these large, hideous vases, their mirth may well be turned into anguish, and constrain these tripping beauties to exclaim—

"To what base uses must we come at last!"

These vases are evidently French, of the very worst type, and it is only necessary to compare their ugliness with the elegance of some of the examples more akin to what our most distinguished British potter left as an inheritance to his country, to see the value of what England has gained by deference to, and dependence on, modern French thought in Art-industry.

The Royal Worcester Porcelain Works furnish many most creditable examples, and, judged by the present prevailing standard,

they are scarcely equalled by any other exhibitor. This eminent firm is better represented in utilities than many of its compeers; and some of the plates and other articles show that considerable care has been bestowed upon the necessary portions of domestic pottery. There are also some examples of substituting colour for gold edges on tea cups, which show that juster ideas of thus founding ornamentation on principles not antagonistic to utility are beginning to glimmer before the eyes of some of our potters, although as yet the best of them only appear to see men as if they were trees walking. Take, for example, the small tazza, in simple, single-coloured ornament, and compare it with the elaborately-gilded jug which acts as the background, and the difference between elegance and gaudiness is at once apparent, though even the jug is one of the best exhibited in its style of decoration. How to account for much else in these cases is perplexing, for it is difficult to see how those capable of producing

THE INTERNATIONAL EXHIBITION.

Mr. MESSENGER, of Birmingham, has long been recognised as the best British producer of works in bronze; and his collection at the Exhibition, though novelties. The brilliancy of his metal is a theme of especial praise. We engrave two of his CHANDELIERS, of new and graceful forms, two TABLE

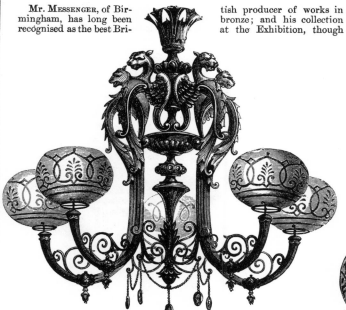

neither varied nor extensive, fully upholds his fame, with regard to design as well as manufacture.

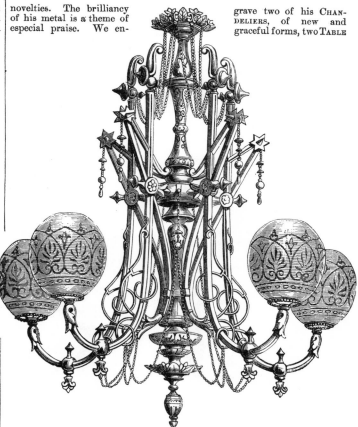

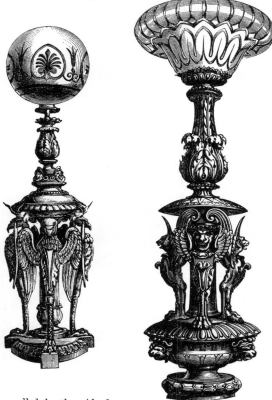

(or Standard) LAMPS, and two HALL LAMPS. These are such as are calculated for general use: there are others more remarkable, perhaps more meritorious,

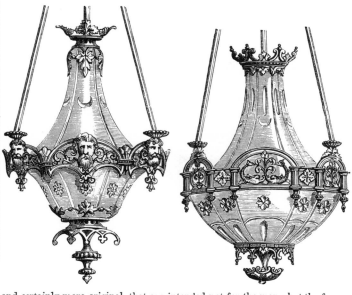

He has called in the aid of DIGBY WYATT and other eminent artists, and has studied to achieve

and certainly more original, that are intended not for the many but the few.

articles of such harmony and beauty should also exhibit such things as card plates ornamented with uncooked salmon or high game, an uncooked joint of mutton and a cabbage! It is impossible to believe that thought had any share in the production of such purposes, but this and all other such solecisms arise from the inveterate chase after the picturesque which is retarding the legitimate progress of the potter's art in England. Expense and elegance do not go hand-in-hand here any more than in larger matters, and many of the cheaper articles are by far the most harmonious. The portion of a set manufactured for the Queen is, taken in detail, made up of work of high character; but it may well be doubted whether the result be equal to the labour. Many of the other works are beautiful, and perhaps the very best object of its class in the Exhibition is the Limoges cup exhibited by this firm; but it is pre-eminently a work

of Art, and is, as it ought to be, estimated as such. Here we meet another phase of the effort to reproduce what distinguished some potters of the old time. We have just glanced at the tendency to substitute Art for industry, here we meet a tendency to substitute labour for Art. It is most interesting to be able to do all that some one else has done, and the bald standard of utility ought not to be applied to everything, far less to works of Art; but apart from the form and the ornamentation, it is difficult to see either the Art or the industrial advantages of devoting much time or talent to producing at enormous cost a blue-black ground to a vase. As a curiosity it may be admirable, and it is most proper that some should devote themselves to producing what others are willing to purchase. All we ask is, that the nature of the exchange should be fairly understood. We may as well attempt to obliterate modern che-

We engrave some of the less important contributions of M. VICTOR PAILLARD,

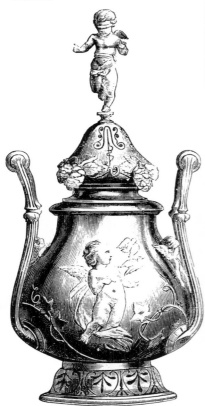

exhibits works of size and great importance in the several branches of his trade: he is at once the artisan, the artist, the manufacturer, and the merchant—designing his own productions, and

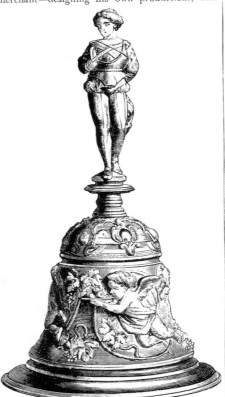

The agents for his works in London are Messrs. GILLOW, of Oxford Street. It will not be generally conceded that the French have made large or marked advances in

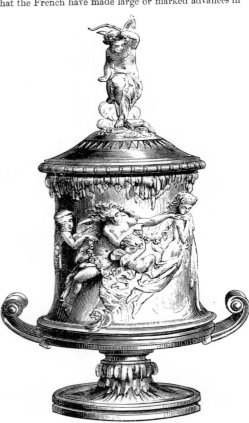

bronze manufacturer, of Paris; inasmuch as they are suggestive, and show the grace of composition and execution that can be

often working at them. His fame was but commenced in 1851; it was established at subsequent exhibitions: and he now holds foremost rank among the bronze manufacturers of the French capital—a rank to which he is eminently entitled.

this branch of Art, although it cannot be questioned that their productions still surpass those of every other country of the world. The best of the works they exhibit are not those that have been most recently pro-

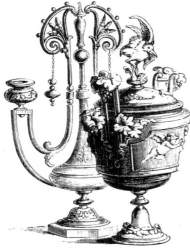

given to objects accessible to all who love the beautiful in Art. But M. Paillard

duced. The more attractive objects depend rather upon startling novelty than purity of design: some of the largest of the collections may be examined without finding a single work of really

high character. There is, however, nothing exhibited by M. Paillard that does not afford satisfactory evidence of thought as well as labour—of the work of the artist combined with that of the artisan.

mistry, and bring back the old alchemist, as endeavour to found an Art-industry upon processes and results co-existent with far back generations, unless these results can be brought into harmony with society as it is. That the Art-industry of modern civilisation can have much to hope from the prolongation or revival of what practically amounts to laborious idleness—that is, great labour bestowed on merely or mainly curious results—is neither to be expected nor desired. This is not meant to damp enthusiastic research into the best processes of the early potter artists, and if the researches of chemistry enable us to secure, by easy means, what they only reached through life-long watching toil, the gain would be conspicuous; but merely to repeat the processes of these men will add nothing to the legitimate Art-industry of the nineteenth century. This will, no doubt, be considered by some as a most mercenary and utilitarian view of such a subject, and the impeachment is admitted; but the

necessity of strongly insisting upon this phase of the question is rendered imperative by the momentous fact, that the manufacturers, more generally than not, in this Class XXXV. appear to have forgotten—judging from the displays—that the question of utility enters into the progress of industrial Art in Britain. They have confined themselves all but exclusively to mere ornament—objects that may be used by some, but which might be ignored by all without affecting the personal or domestic comfort of any; and while this may furnish work to a few, it has but a very indirect effect upon the daily industry of a manufacturing country. Art-industry for England means mingling refinement and better taste with articles made in bulk and sold in quantities; and of this kind of progress the class which includes pottery displays less evidence than many other classes in the Exhibition. That there are many fine, and some very beautiful, articles displayed by firms

We engrave three of the contributions,

in cast iron, of ZIMMERMAN, of Frankfort, whose

manufactory is justly renowned "all over the world."

The STOVE and FENDER engraved underneath are manufactured by Messrs. LONGDEN, of Sheffield, for Messrs. HODGES AND SONS, of Dublin. They are of polished steel, inlaid with ormolu, of excellent design and workmanship, and of attractive character. The chimney-piece is of rich marble.

Messrs. CHUBB AND SON, of St. Paul's Churchyard, exhibit a large assortment of their Fire-proof Safes and Detector Locks. We engrave a large Door Lock, the "stock," or case, being

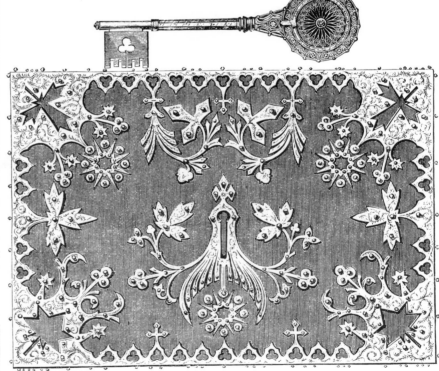

made of polished steel, the face and sides of which are covered with mediæval ornament in brass.

already named, and by many others, is most cheerfully acknowledged—and for some of these works commendation is not needful, as censure could not be hurtful, because in their individual parts they secure the admiration of all competent judges; but the heartiest and most abundant delight in such beauties is not incompatible with a regret, equally profound, that Art—and in its most naturalistic and picturesque aspects—should have been reserved for the mantel-shelfs or the boudoirs, and that its higher and simpler refinements should not have reached the china-closets of the rich, or the plate-racks of the poor. Our potters are too much bitten with mere admiration of France. They are spending their strength in perpetuation of principles as false in Art as in industry, and not till they leave their present course, and go back to that which formed the basis of old Wedgwood's success, can the country secure the measure of progress which the advantages possessed by modern potters otherwise ought to produce. There is, however, some consolation in knowing that the potters of England are not only no worse, but that they are not so bad, in these respects, as the potters of continental rivals. With the exception of a certain air of rough grandeur about the style of some of the articles exhibited by Jean, of Paris, one or two articles by Austria—especially a vase of low tone, almost in imitation of metal work—and some well-got-up specimens from Copenhagen, where the influence of Thorswalden is prominent, there is nothing to compete with the display of British goods; and when British thought is allowed its legitimate influence in the ornamentation, our pottery will become as attractive from its beauty as it now is for superior quality and the energy employed in its production.

This engraving is taken from a beautiful example of Honiton Lace—a BRIDAL VEIL—contributed by Messrs. NORTHCOTE, of St. Paul's Churchyard. It is, of course, hand-work, the fruits of continuous labour, and with the best results; there are indeed few specimens of the art in the Exhibition that surpass this—a production of English hands and taste. The design is good and effective, although it offers few original points: the composition is exceedingly elegant, the lines flow easily and gracefully, and the flowers seem to spring naturally from such

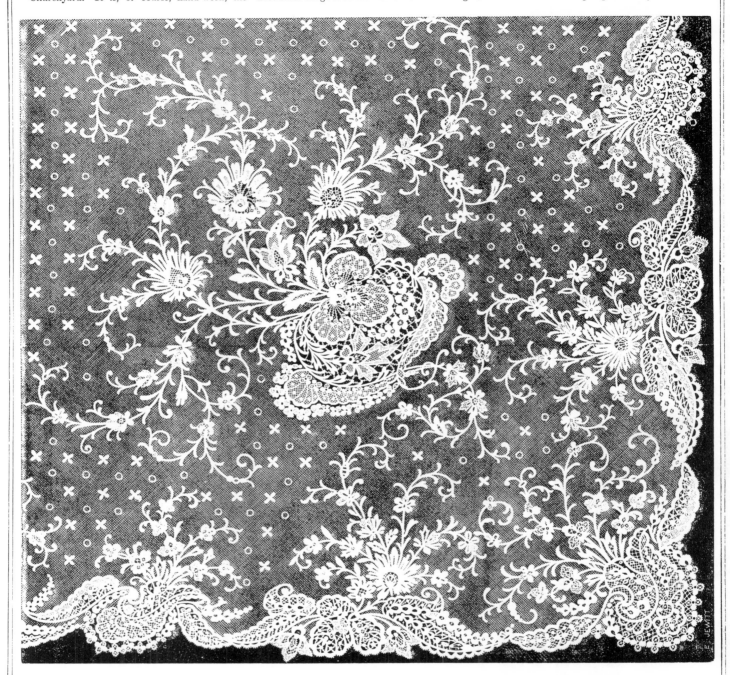

bases as seem, time out of mind, to be essential in the arrangements of patterns for lace. Devonshire sustains its supremacy in this manufacture; it continues to give healthy and remunerative employment to tens of thousands of young women, notwithstanding the natural influence of continental rivalry and the great improvements that have been of late years made in the issues of the marvellous machines at Nottingham.

DECORATIONS.

Under this heading various classes shall be grouped, because, although technically separate, for all practical purposes they are essentially one, being almost universally used in combination with each other. Ornamental painting, imitation of wood and marble (technically, "graining"), paper-hangings in their various styles, and even furniture silks, common damasks, and chintzes, all come within this comprehensive head; for although these latter may be supposed to belong more to furniture than to that which is usually known as decorations, yet the practical result is far otherwise, and they form a most essential part of successful interior ornamentation. The various branches shall be taken in the order indicated.

That there is some difference in the style of ornamental painting applicable to house decoration since 1851 cannot be seriously doubted; but that there has been any absolute progress in raising the quality of the work exhibited now, as compared with what was then displayed, is by no means so evident. Styles may be changed: Louis XVI. may give place to Louis XIV., or *vice versâ*, and while the change may be from a worse to a better general style, the quality of work in which the better is set forth may not only indicate no advance, but positive retrogression, in manipulative dexterity, or other artistic qualities. The one has reference to thought, the other to execution; and, just as a great thinker may be unable to dress his ideas in eloquent or refined diction, so the better quality of decorative style may be presented in the worse quality of executive painting. What constitutes the better or worse qualities of execution in ornamental painting is worth a moment's notice, chiefly because of the change that seems to be creeping over the ornamentists of this class—a change anything but favourable to the higher qualities of decorative

Messrs. RECKLESS & HICKLING, of Nottingham, are extensive and highly meri-

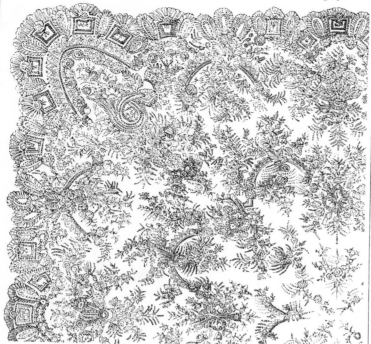

torious contributors of British machine LACE: the firm is long established; they have borne "honours" in all the exhibitions—that of 1851, London,

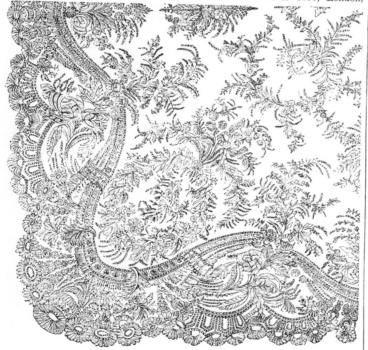

and that of 1855, Paris, more especially—at which they have competed. The

four designs we engrave are of great excellence, furnished by their

own designers, all of whom are English. The whole are "Pusher" make (i. e. made on machine, and embroidered by hand), each article

being in one piece, and having no joins or "appliqué" work.

Art. From within the memory of two generations, up till 1851, there is no room for doubt that French influence mainly guided the ornamental painting of this country, and that latterly Watteau was the great high-priest of that inspiration. Nor has there ever been higher authority in the style which he created. With him, genius, combined with glorious colour, made every touch of his pencil eloquent in the expression of beauty; and his style rested upon the principle of producing the most vigorous and harmonious effect with the least possible labour. Hence the influence of Watteau produced these two cardinal qualities—fine colour and dextrous manipulation—in proportion as the imitators reached the beauties of the master. But these two qualities exhausted Watteau's strength; and even with them, it was found, in 1851, by the many, what had long been known to the few, that, as a general style, the ornamental Art of France was far below the ornamental Art of Italy. Other influences —Indian and Moorish—also bore down against the former favourite, and the result has been that the school of Watteau has all but disappeared from the present Exhibition. Now, although the general gain cannot be doubted, neither can the manipulative loss be overlooked; and it is a sad deduction from the pleasure which higher styles and forms now used are calculated to inspire, to see these produced by the smooth feebleness of excessive labour, rather than by the sparkling brilliancy of executive power. Other influences have helped to produce this change. Formerly, the schools of Art, inspired by men of artistic souls, stimulated the quality of production in handling as much as in quality of outline; and it was charged against them as a fault that their chief attention was bestowed on the ornamental house painters in their schools. For many years, these former conditions have been changed—the masters not attempting to teach what they are unable to appreciate, and the ornamental decoration

We engrave another of the many excellent car- | pets of Messrs. GREGORY, THOMSON AND Co., | the eminent manufacturers of Kilmarnock.

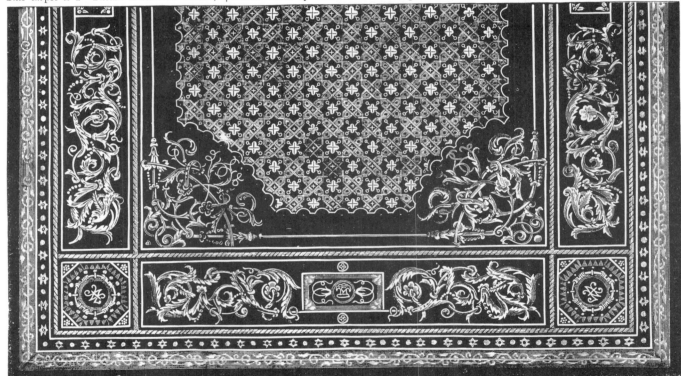

This carpet is a "PATENT AXMINSTER CARPET," | manufactured by TEMPLETON, of Glasgow, for | Mr. C. GREGORY, of Regent Street, by whom it is

exhibited. The design is by Digby WYATT. It is a work of a high order, rich, yet in perfect | harmony; the colours being skilfully blended.

being macadamised down to that level which enables incompetency to travel more smoothly over the highways of preferment. The direct results of divorcing Art from the Art-teaching of the country will be met when the general question of design is looked at. Here we meet with one of its indirect effects in the feebleness of handling now as compared with the ornament exhibited in 1851, except in those examples which are the work of Frenchmen, where the only remnant of the rich, vivacious pencil of Watteau finds a ray of refulgence. Nearly everywhere else it is labour, and that only, which challenges attention; because it is absurd to pretend that the laborious reproduction of a style such as that of Louis Seize—more familiar to our grandfathers than to us—and in as high a style of execution, is any real advance in interior decoration, although it has supplanted the worse style in fashion for a season. Even of the Italian style, which is evidently so popular, we are snatching at the bones rather than catching the spirit—in the matter of production; because, to say nothing of the highest value of that style, as the representative thought of the people who produced it, an almost equal claim lay in the vigour and beauty of production. With the exhibitors in this class it loses both characteristics, and looks but the corpse of a form once instinct with energy and Art, or at best a motley medley of incongruous parts, like a bad translation of a great work. Unity is an essential element of respectability, not to say excellence, in all ornamentation; and in many of the best, or rather most costly, examples exhibited, this quality is well-nigh absent. What, for instance, would be thought of a decoration made up as follows:—Franco-Italian pilasters supported by running ecclesiastical ornament, based on marble painting, and surmounted by French ornament, indifferently drawn, and profusely etched with gold, a frieze of heavy scroll-work, more akin to Grecian than,

We engrave two of several CARPETS manufac- | tured and exhibited by the eminent firm of | WATSON, BONTOR, & Co., of Old Bond Street.

They are of beautiful design, taken from exotics— | a new and fruitful field for designers, that cannot | fail to recompense largely those who work in it

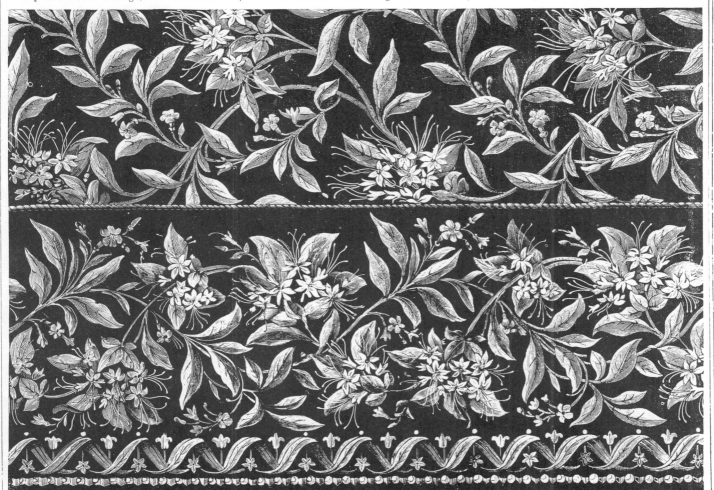

wisely. The artist has here very skilfully, and | with the happiest effect, adapted to his purpose | the graceful forms which Nature supplied to him.

perhaps, anything else—it may be modern Greek—with the antique fret, and other classic forms, wrought in about it—the whole produced in gold and colours, which create a compound of effect as far removed from the vivacity of French as from the dignity of Italian ornamentation. The combination, when looked at in words, is preposterous, and it is not less so when realised in colours, however the harmony of tones employed may hide the jarring incongruities. There is no approximation to a style in such heterogeneous anomalies, and, indeed, the only advance towards securing unity with novelty— the first step towards what can be called style—is made by Purdie, Cowtan, and Co., in the design for a dining-room decoration. That this has other drawbacks is quite apparent—such as the difficulty of lighting up the dark and heavy colours; but, apart from these considerations, there is more unity and novelty in this work than in any

other exhibited of the same character. There are, of course, many specimens of respectable, and some examples of very clever, ornamentation; but these require no special remark, as they illustrate no important truth in Art. Not so, however, with one falsity that is again becoming prevalent—viz., the painting of cornices darker than the walls. This, by destroying the height and size of an apartment, is a perversion of the decorative principles, the result of which can be seen at a glance by comparing the principle adopted by Maclachlan with that adopted by Trollope in the examples of decoration. One effect many of the other wall and room decorations have in common, that is, superfluity of gold; and in some cases, so prominent is this feature, that it might be taken for granted that every practical decorative artist would require a special staff of gold-beaters—the surest index of artistic poverty, both in thought and execution.

We can do but scant justice, by engraving, to the RIBBONS OF COVENTRY, yet no report of the Exhibition would be

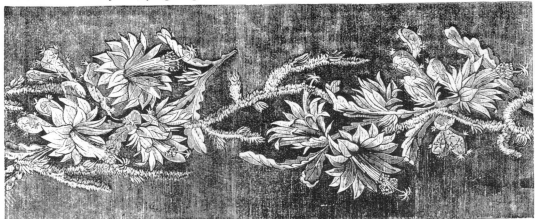

from that of Mr. Newsome. It will be our duty ere long to enter largely on this subject: for the present we must be content to congratulate these eminent manufacturers on the results of their

complete without some examples of one of the most important manufactures of our country, and one that

has undergone marvellous improvements of late years. "The uses of adversity" have been learned in the

venerable city the "precious jewel" has been there sought and found. The specimens shown by its principal manufacturers, Messrs. RATLIFF, Mr. C. NEWSOME, Messrs. J. & J. CASH, and

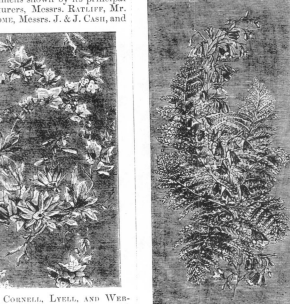

Messrs. CORNELL, LYELL, AND WEBSTER, will safely bear comparison with those of St. Etienne. The ribbon that heads this page—an adaptation of the

The small specimen is from that of Messrs. Cornell & Co., the other two being

cactus flower—is a work of singular merit, from the loom of Messrs. Ratliff; that to the left is from the loom of Mr. Cash, so is that of the fern and heather.

thought, taste, and labour—their Art and their Art-manufacture—and the public on the benefit derived from these qualities in combination; hereafter we hope to accord to them greater justice

Any two individuals—the one an upholsterer, the other a gilder—could produce the side of a room in panels, with gilded mouldings on a white ground, and red silk centres; there is no decorative Art either in the ideas or in the working out; and to have produced such specimens, which were plentiful as blackberries fifty years ago, as examples of progressive decoration, displays either astounding modesty, or the most sterile poverty of invention, combined with more than ordinary dulness of perception. The only thing which could have made this old style of ornamentation worthy of exhibition, would have been the new and harmonious combinations of colour, or the novel disposition of the gold, either in its quantities or relations; and this has been tried by several firms, with more or less success, without any having achieved marked superiority in their efforts.

Among the other and truer examples of decoration, that by the late John Thomas holds an honourable and conspicuous position;

and had the tone of the silk been less positive in the panels, the effect would have been still better; although now this specimen in the Furniture Court is, as a whole, one of the most artistic and practical in the Exhibition; and it is not difficult to see how the style indicated here might be carried out into an elegant, and withal magnificent, whole. In many not dissimilar specimens, as regards intention, but far inferior in result, the same style of thought and effort is evident, and there are one or two variations of means not unworthy of notice. Kershaw's imitation of silk is one of these; and the principle here adopted could be worked up into the most gorgeous effects. What that principle is has not been stated, but it looks like the result of "combing" on a silver or metal ground, and, if so, the expense will prevent it ever becoming more than a clever example of what may be done without reference to cost. In the imitations of woods and marbles there has been no healthy progress since 1851, if, indeed,

THE INTERNATIONAL EXHIBITION.

The Window we engrave was executed by Messrs. James Ballantine and Son, Edinburgh, for South Bantaskine House, on the site of which the battle of Falkirk was fought in 1745. The figures of Prince Charles Stuart and his generals, Lord George Murray and Lord John Drummond, are arrayed in the costume of the period, studied from authentic sources; and the vivid colours of the Highland dress and accoutrements come out very brilliantly in the glass. Above and beneath the figures their armorial bearings are blazoned, and inscribed in the base are the following verses, by some old Jacobite poet, describing the character and achievements of these the chief leaders in the rebellion.

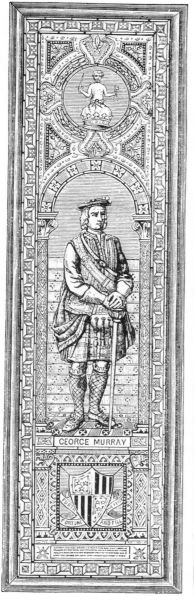

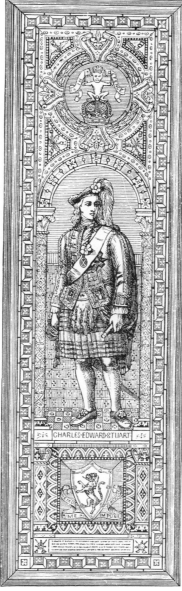

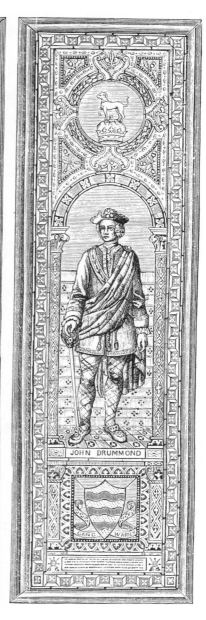

LORD GEORGE MURRAY.

Murray, the first to lead in battle fray,
On Falkirk Muir thy courage won the day;
Far in the van was ever heard thy cry—
"Follow me, men, we conquer or we die!"

CHARLES EDWARD STUART

Charles' eagle glance like lightning scanned the field,
And where the worn and wounded seemed to yield,
Anew their drooping hearts with love he fired,
Anew their frames with energy inspired.

LORD JOHN DRUMMOND.

Drummond, thy valour, loyalty, and zeal,
Were all devoted to thy Prince's weal;
Perth's gallant hosts dispersed the Stuart's foes;
And Stuart's standard o'er Bantaskine rose!

there has not been manifest declension, for labour has now taken the place of genius, and the one is invariably inferior to the other. A good copyist can always produce "literality," and a man may spend more time over copying a piece of marble than what would buy the real material. It is needless to say that, however like, such imitations are commercially worthless, and that he only is the clever grainer who can gather up and reproduce the general characteristics of the wood or marble he is imitating, so that his work can be at once artistic in quality and reasonable in price. Imitations, painted as artists paint pictures, are useless for purposes of trade, and in this respect the labour of '62 is far behind the genius displayed in '51; while, as a matter of fact, the imitations are rather worse than better, just as what constitutes the general characteristics of any marble is more akin to the whole than the closest imitation of any individual or exceptional pieces. In this higher quality of imitation there is nothing in the present Exhibition to compare with what Kershaw, Moxon, and others, exhibited in 1851; and the best graining exhibited now is by the former of these names.

There are many examples exhibited in what is known in this country as the German style of decoration; but these have no right or title to be treated as works of decorative Art in any higher sense than as paper-hangings may be so considered, because the German specimens display no higher qualities than what block-printing can, with equal effect and greater facility, produce; indeed, few of the hand-painted ornaments of this class can compare with the artistic skill which Delicourt used to throw into his best specimens of colour-printing; and it would be a waste of time to notice at further length works, although painted by hand, which teach nothing, and only show the combined results of mediocrity and labour, through colours as raw as the forms they fill up are conventional and

Messrs. W. WOOLLAMS & Co., of High Street, Manchester Square, maintain the position they have long occupied as manufacturers of WALL PAPERS. We engrave one of the many excellent examples they contribute; it is adapted from the

We engrave one of the PAINTED GLASS WINDOWS of Messrs. CLAYTON

Pompeian style, and is a fine specimen of harmony in colour as well as in perfection of finish. In this important branch of Art the advance has been great in England—graceful simplicity having taken the place of gorgeous costliness.

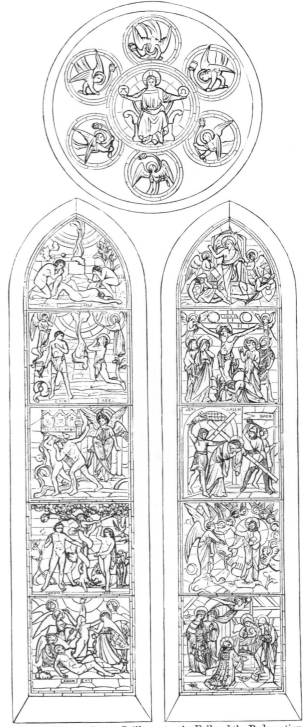

AND BELL, of Regent Street. It illustrates the Fall and the Redemption.

insipid. Turning from these, then, to specimens of paper-staining, a large but not an increasingly important class of product, which might well occupy much attention and much space. Readers of the ART-JOURNAL are aware that to this subject of paper-hangings considerable attention was devoted at the beginning of the year 1861. In those papers the French method of production was gone into, and carefully contrasted with that of the English. A comparison of the results respectively obtained followed the investigation of means employed, and to these papers readers specially interested in this class are now referred. To the general reader it may be enough to say, that the conclusion then arrived at was this—that the French, from employing both artistically and materially higher and more expensive forms of production, secured not only a proportionately higher result, but a superiority even above the ratio of the means employed. Such general conclusion was based upon an examination of the present with the past processes and productions of both countries; but the existing international display does not encourage the idea of progression: on the contrary, it may well be questioned whether the art of paper-staining—not mechanically, but in its higher elements—is equal to what it was some years ago, especially in Paris. It is, no doubt, different in some important respects, and has changed with the general change in style of house decoration; but in it, even more than in hand-painted ornamentation, the change of style has been accompanied with more than a corresponding loss of power. In mechanism and labour the progress has been clear enough, and there, perhaps, never were more skilfully elaborated examples of that craft, than the pictures by Zuber, or the 'Garden of Eden,' by Des Fosse. It would be hazardous to name the number of blocks required to print such works, and when each block has to be worked with its tint into the whole, the skill and care required in

The establishments of Messrs. MECHI (Alderman) AND BAZIN, of Regent Street

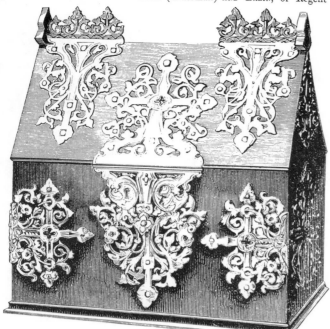

and Leadenhall Street, are renowned for the production of various "elegancies"

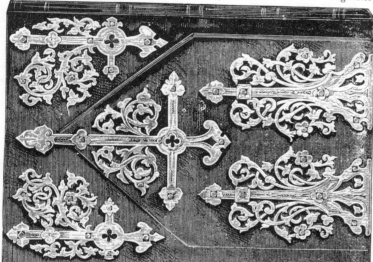

for the drawing-room and boudoir, as well as for household necessaries of the best

order. We select a few of the many objects they exhibit—their manufacture. The

principal is a WRITING TABLE SET, in ebony and silver, skilfully

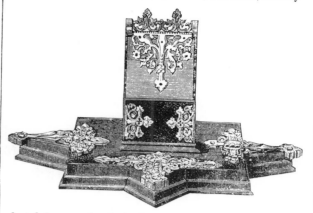

adapted from works of the fourteenth and fifteenth centuries.

They are all in excellent taste. We have left ourselves no space

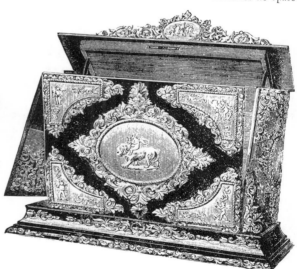

for descriptive details; but the works are sure to be examined.

the production must be manifest. Unfortunately, increase of labour does not necessarily augment the value of any Art or Art-industry. On the contrary, these are more truly estimated by the extent with which genius is able to supersede labour, and, tried by this standard, these block-printed pictures are more likely to show the decay than the advancement of this branch of French industry. As pictures they are utterly worthless, being destitute of those qualities of individuality and thought, which constitute the true value of works of Art; as examples of wall-decorations, they represent a bygone age, which there is no prospect of reviving, at least in that form, so long as the chariot-wheels of general progress remain unreversed. Fifty thousand block-laid tints could not make a creditable picture, unless the artist, like Albert Durer, was to adopt wooden blocks for the utterance of his own thoughts, and in this age no such man would

probably adopt distemper colours as a medium; but five colours is nearer the number a high-class paper can well bear, and all the others used for this purpose lead to labour and sorrow, both to producer and purchaser. So long as naturalism was predominant, that ornamental style of drawing and colour, in which the French have no equal, combined with their dextrous manipulation, made them masters of the situation. Now, when that style has been all but exploded, notwithstanding their refined ideas of colour, they produce nothing remarkable, either in novelty or beauty, although all they do has still a marked manipulative superiority. Apart from this, which of course is a most important commercial quality, we look in vain for anything striking—not in the vulgar sense, but as adapted to the altered change in style among the French exhibitors in this class; and while there are many specimens of paper-hangings which, from

MESSRS. J. AND J. HOPKINSON, of Regent Street and Conduit Street, exhibit a variety of Grand, Boudoir-Grand, and Cottage, PIANOFORTES; each

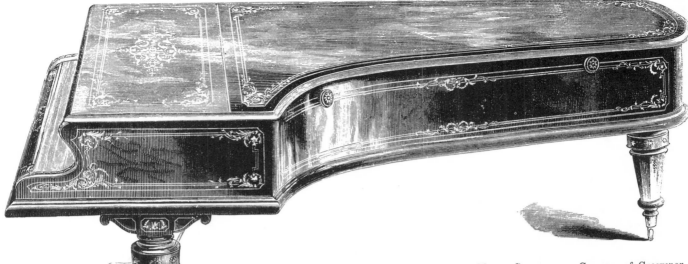

instrument having some speciality, either in me-

chanism or construction. That of which we give an engraving is in an elegant walnutwood case, inlaid with ivory, tulip, and various woods. The ornamentation is very beautifully executed. The work is, altogether, one of the most graceful and elegant that has been produced for a refined drawing-room. Our description must be limited to the exterior; but the reputation of the firm has been long established for the combination of clearness of tone and delicacy with firmness and power; and they have obtained "honours" at all the exhibitions at which they have competed.

Messrs. COLLARD AND COLLARD, of Grosvenor Street and Cheapside, have held foremost rank as manufacturers of the PIANOFORTE during the whole of the century. Their reputation is not confined to Great Britain; it has gone over the whole civilised world. Our duty is, however, limited to the decoration to which the "cases" have been subjected. The one we engrave is a work of great beauty: a gorgeous yet harmonious display of

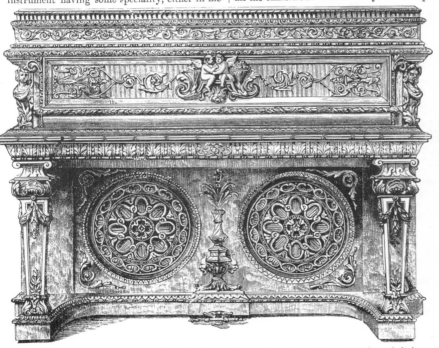

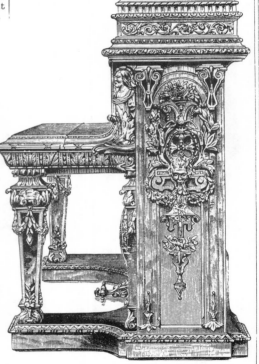

artistic skill, designed and wrought with the best possible effect. There are other of their works to which the observation may with equal justice apply.

simplicity and lack of colour, are highly creditable to the makers, and admirably adapted for ordinary purposes, there is not one great example of the qualities for which the French were formerly pre-eminent, being successfully turned to account in the new path which general Art-progress is now steadily pursuing. They have raised no Owen Jones to re-create, no Digby Wyatt to modify the re-creations, and their highest boast must be that, like England, they have some who can adopt the thoughts of such with moderate success, and many—very many—who do not better the thoughts they so un-blushingly borrow. Such a state of things cannot be esteemed as progress, and it looks as if, at present, a mildew had passed over this branch of Art-industry in France. In the transition of style our Gallic neighbours have not shown that facility and fertility of invention for which they have long been credited; and, without due

care, this halt in Art-resources will not improbably produce a hitch in their commercial relations, with regard to this product. At least, it is helping to clear a fair field for British skill and enterprise in this branch of industry, and it will be the fault—and to the dishonour—of the English makers, if they do not now secure a fair share of that which the French have long held as a monopoly—the markets of Europe and America in the better and best class of paper-hangings. There is some evidences of awakening to this prospect on the part of one or two English firms, and the most prominent of these is the incli-nation to spend something on designs. In the articles on French and English paper-hangings already referred to, it was stated that designers for paper-hangings had hitherto been put on a level with writers of show-tickets—men who hawked their wares from door to door, taking, after the usual huckstering, what they could get for the

The SIDEBOARD we engrave is the production of Mr. HENRY OGDEN, Cabinet-maker and Upholsterer, of Manchester—a Provincial manufacturer whose works successfully compete with those of the Metropolis. It is made of light Dantzic oak, inlaid with dark English oak, the contrast producing a very happy effect. The carving, of which there is perhaps too much rather than too little, is highly and effectively wrought; portions of it, indeed, may be classed among the best examples of the Art. The work is massive in character, being intended for a large dining-room. It is of excellent and appropriate design as a whole,

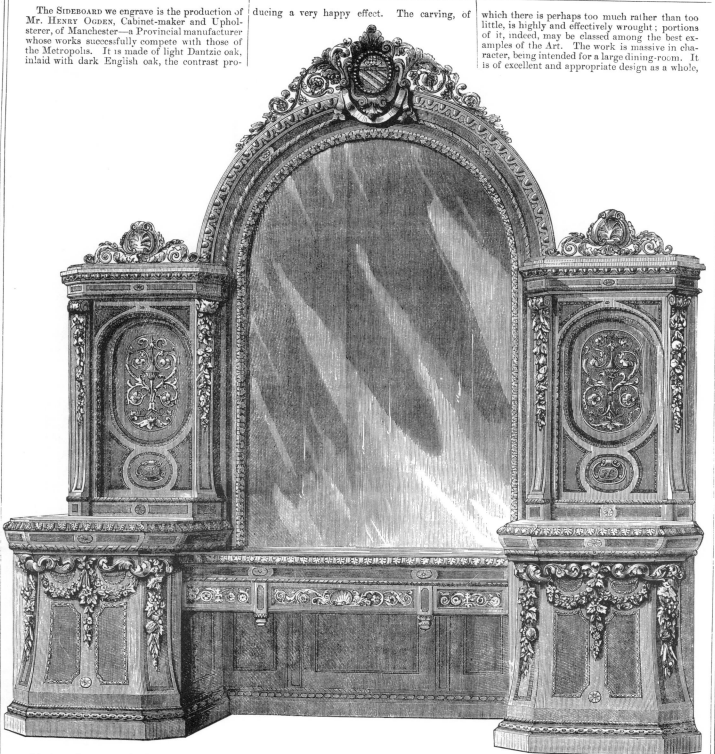

and in its various parts: the designer is Mr. ADAM BROACH, the artist of the house, and it is executed solely by English workmen in the establishment.

product, not of their brain, but of their power of "adaptation"—a euphoneous word, covering an ugly process. We repeat the statement—and the noise it occasioned was in proportion to the sting that truth inflicted; but there is evidence in the present Exhibition that the adapting process has given way to some extent, and that some of our manufacturers are beginning to find out that generosity, like honesty, is the best policy. In several of the spaces there are designs of evident originality and power, and first among these are some examples from Leeds. Like many others, the designer of these patterns has been bitten by the Gothic mania, although not to a hopeless extent, and his works contain internal evidence that he is extracting the good without imbibing the other characteristics of mediævalism. That is deplorably rampant even in paper-hangings, and the most sacred symbols are indecorously made to be distorted or cut up to suit the construction of a room, or to do duty as a background for the display of some "worldly" picture. It is not wonderful that some should thus attempt to extract gain out of godliness; but it is wonderful that the all but universal reverence for the higher mysteries of Christianity should not frown such works into obscurity, especially as many of them are as bad in Art as they are destitute of spirituality. These examples from Leeds, however, escape such errors, and show that even Gothic has no necessary connection with the cant of mediævalism, with which the lower class of minds are attempting to overload it. Vulgarity, unfortunately, can be imported into all things, and the most ungainly things exhibited are those in which the vulgar in taste have made religion bear their crushing and uncongenial weight. The other English manufacturers of paper-hangings who show good

The British Furniture Court might supply materials for a full volume of engraved illustrations; the difficulty is to select from among the many excellent works exhibited. The work of which we give an engraving on this page is a very beautiful example of its class, contributed and manufactured by Mr. M. BRUNSWICK, of Newman Street. It is an ebony and ivory CABINET, in two parts; the style Italian, of the seventeenth cen-

Messrs. KEITH & Co., of Wood Street, London, contribute a variety of examples of silk FURNITURE HANGINGS, manufactured

by them. Of these we engrave four specimens. In all cases the designs are of considerable merit, and very pure in character.

tury. The upper part, with two doors, is ornamented with inlaid ivory, and two engraved ivory panels, representing subjects from the fable of "Love and Psyche," after Raphael, taken from the engravings of the period, of which they are *fac-similes*. This part rests on a table, with drawers, supported by four columns or pillars, ornamented with ivory; the whole is enriched with precious stones of various descriptions.

Some are richly dowered with floral graces; others, more severe, are adaptations from mediæval ornament. Messrs. Keith have

designs manifest a vigour and invention which must alarm French competitors. Even the quality of work is proportionately very far ahead of what it was a few years ago; and although what the jury has declared to be good workmanship is never likely, from the style in which it is produced, to be popular, yet, when adapted to a style more in unison with British energy and thought, it will produce results full of prospective encouragement to this branch of British trade.

The other exhibiting nations in this class show little that merits either detailed remark or much approbation. The chief display comes from Austria, and from the specimens sent, it is evident that, apart from custom-house difficulties, the Austrian market is open to either England and France, or both, for the worst of the paper-stainers in either country are better than the best in Austria. It is difficult to convey any idea in words of the feebleness and washed-

like character of these productions, and these Austrian manufacturers have not even the merit of being able to copy the French patterns creditably. From Belgium and the Low Countries, exhibits are not quite so bad, but the manufacturers there do not show the same energy and skill in the production of paper-hangings which their fellow-countrymen do in many other departments of industry. The truth is, the Art of these countries has never taken an industrial form, simply because it was never of the ornamental type, all their best efforts in wood-carving and the like being based upon the higher pictorial attributes of representation. In this their best industrial artists have played a noble part, and shown a great example, for even when surrounded with artists whose genius was shedding a lustre over the coarser and lower qualities of the picturesque, these workers in woods, metals, and other industrial materials, resisted the lower, and succeeded in inspiring their works

THE INTERNATIONAL EXHIBITION.

obtained "honours" at all the Exhibitions that have taken place of late years. They manufacture for many of the leading upholsterers, and

Messrs. PIM BROTHERS, of Dublin, are renowned manufacturers of the Irish fabric, TABBINET. We

engrave two of their "patterns," reserving remarks on the manufacture for a future occasion.

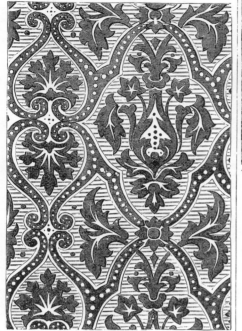

We engrave the CASE, carved in oak, that contains | the Eau-de-Cologne of the famous Jean Maria

those we engrave are produced as commissions executed by them from their own designs. No. 1

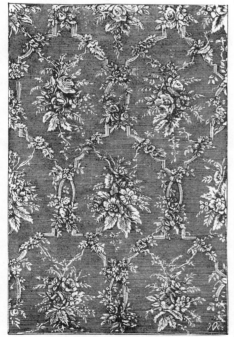

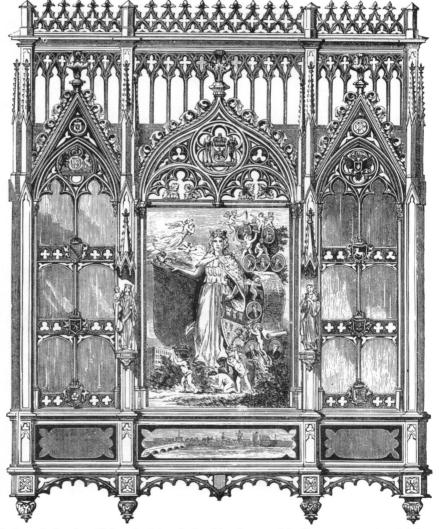

is designed and manufactured for Messrs. HINDLEY AND SONS; No. 2 for Messrs. GILLOW & Co.; and No. 3 for Messrs. JOHNSON AND JEANES.

Farina. It is a beautiful work of Art, designed | and executed by STEPHAN, an artist of Cologne.

with the higher and purer influences which sprung from the nobler phases of industrial Art. These nobler influences seem destined to play a still more influential part in such industries as that now under consideration, and should Italy devote its energy and artistic power to industry and commerce, the surpassing skill of its artisans in all that relates to ornamentation, would be the only force which England would have to fear in this direction. English manufacturers can keep their own, and make way in the present path of progress against all the powers of France; but if the Italians brought their skill and knowledge, acquired through fresco-painting, into the manufacture of paper-hangings, they would be rivals hard to conquer in the race for fame.

Among other nations, Sweden exhibits some examples of paper-hangings of a quality which show that the manufacturers of that

country know the value of good work, and some of the specimens shown are more than respectable, both as to colour and general finish; but in the cheaper kinds of goods these Swedish patterns prove that British manufacturers have nothing to fear, either as regards quality or price. Some of these patterns, of equal quality in fabric and in a better style of printing, can be produced from sixty to seventy per cent. cheaper in this country than Swedish makers are inclined to sell at—a difference which shows more eloquently than words the wide field open to the British manufacturers for this class of manufacture. From an attentive survey of this section of Class XXX., we conclude that paper-staining is barely sustaining its old vitality and reputation in Paris; that it has made great progress in this country during the last few years, and will still further partake of that life which the abolition of fiscal

The "Norwich Gates," of wrought iron, manu- | factured by Messrs. Barnard, Bishop, and Bar- | nard, are especial objects of admiration. They

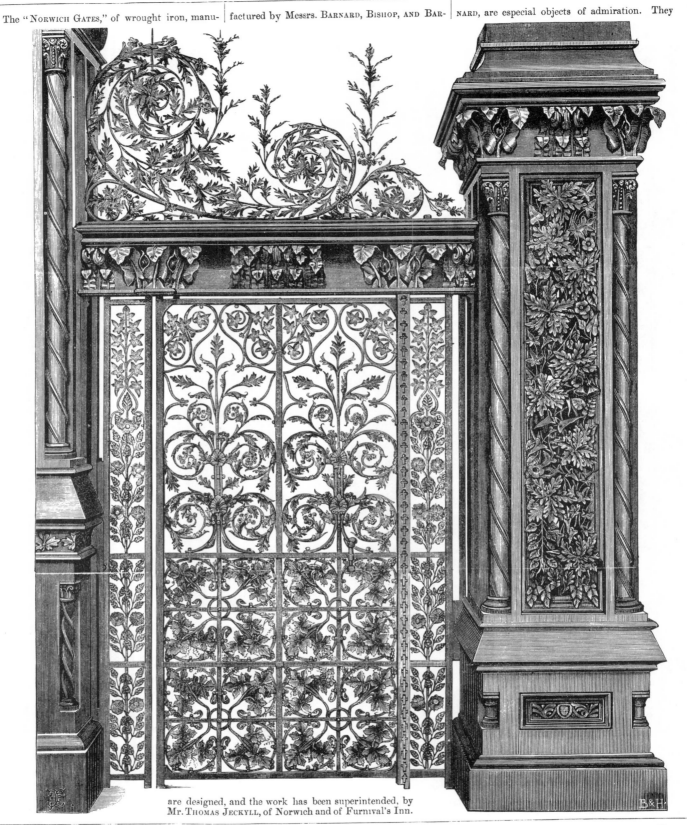

are designed, and the work has been superintended, by
Mr. Thomas Jeckyll, of Norwich and of Furnival's Inn.

restriction infuses into all branches of trade; that our manufacturers are entering, for the first time, into a race on equal terms with the French for the markets of the world; and that, with such profits before them as Swedish prices indicate, there is every motive for the display of energy in securing a foreign trade for what will become less and less used among the higher and wealthier classes at home, who, even now, treat the best kinds of paper-hangings as a *bourgeois* and plebeian style of interior decoration.

Of furniture or decorative silks and their substitutes, there is an abundant display in the various Courts, and here, more than in any of the articles of decoration thus grouped together, is there room for

difference of opinion as to what is demanded by good taste. For a wall, whether hand-painted or papered, the purpose sought is to find a suitable background for all beside—inmates, furniture, and pictures. The purposes of a carpet are equally intelligible and easily defined; but silk hangings, for example, are themselves ornamental, and, along with the chair coverings, form a portion of the "all things" for which base and background are provided. It is evident, therefore, that much greater latitude is permissible in such matters, and that nearly as wide a scope is open to the choice of silk damasks as of silk dresses for the ladies, or pictures for the walls of an apartment. Of course some conditions are essential; and just as a lady's

THE INTERNATIONAL EXHIBITION.

Among the most attractive works exhibited in the Furniture Court is the SIDEBOARD of Mr. JAMES LAMB, upholsterer and decorator, of Manchester. It is a production to which has been justly awarded the highest rank, although emanating from the establishment of a provincial manufacturer. It is composed of pollard oak, walnut, and ebony, occasionally and judiciously relieved with gold. In the upper part are two life-size figures of Vintage and Harvest. Trophies of fruit, corn, &c., are introduced. The lower part

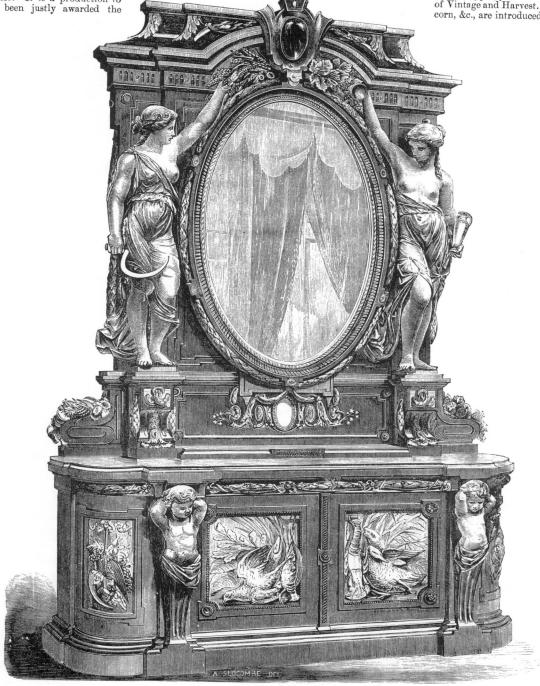

A. SLOCOMBE. DEL.

is supported by figures of boys on thermed pedestals; the central panels are arranged to form one connected relievo of game, fish, &c. Groups of fruit and vegetables fill the curved end panels. The design is by Mr. W. J. ESTALL; and the modelling is by M. HUGUES PROTAT.

dress, to be pleasing, must be in harmony with her complexion, so must the silk for a drawing-room be in general unity of tone with its surroundings; but that condition fulfilled, all else seems to be left open to individual taste or national tendencies. If Moorish grandeur is to be revived, or French vivacity displayed, there seems no reason why the gorgeous silks from Spain, or the sparkling brilliancies from Lyons, should not be represented in the damasks of either country; and provided each individual pattern of silk is harmonious in itself, it does not seem to matter, as a question of principle in Art, whether it be made up of one or one hundred colours. There is a simplicity, which is better than multiplicity, and for English purposes that is best secured through the aid of one or two shades; but practically the same breadth of effect is reached in the Indian section through the means of a multitude of tones, and every person of taste would, all other things being equal, prefer the Indian to the English fabric. Plain furniture is not equal to inlaid, if that be well done, and if the outline be good in each that settles the question of taste—the inlay, if correct, only adding to the value; so, in the matter of silk damasks, the general harmony of the apartment is the criterion of the taste displayed, the number of colours no more affecting that question than if employed in the production of a picture for the walls; and unless the silk attract too much attention for itself, it violates no principle of Art or Art-decoration if it contain a thousand colours, provided these are employed on legitimate subjects.

It would be as absurd to work glass globes with gold and silver fishes, as covering for chairs, in five colours; if the subject be appropriate for its purpose in thought and outline, the number of colours employed, if harmoniously arranged, is no disadvantage, but the reverse, as may be seen to some extent by the border in Houlds-

We engrave two of the many works contributed | by the eminent firm of JACKSON AND GRAHAM. | The one is a CABINET of ebony, inlaid with ivory,

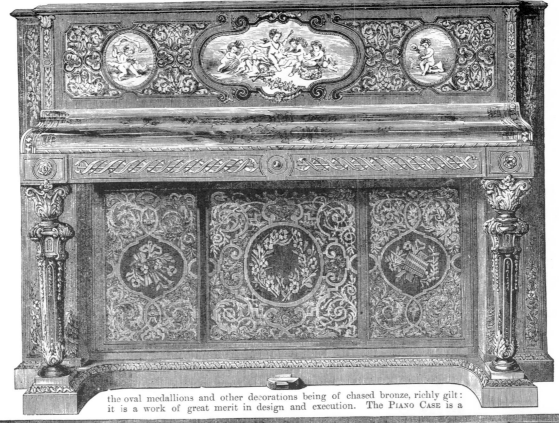

the oval medallions and other decorations being of chased bronze, richly gilt: it is a work of great merit in design and execution. The PIANO CASE is a

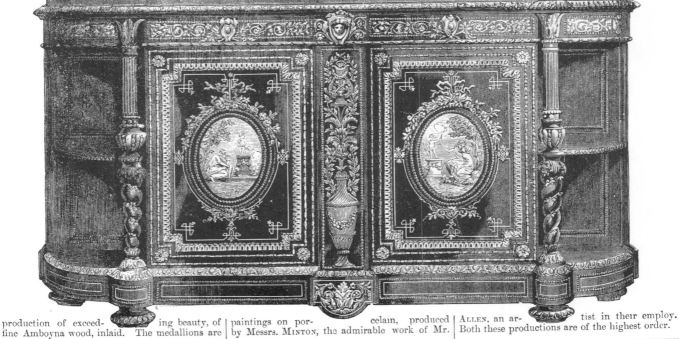

production of exceed- | ing beauty, of | paintings on por- | celain, produced | ALLEN, an ar- | tist in their employ.
fine Amboyna wood, inlaid. The medallions are | by Messrs. MINTON, the admirable work of Mr. | Both these productions are of the highest order.

worth's stand, where green, red, and blue are most harmoniously combined into one beautiful whole. The French have carried these combinations to a far greater extent, although usually cast upon a more brilliant key, and from their stand-points the effect produced on their interiors may be at once true in principle and charming in effect. With the tendency to more subdued effects in this country, it would be difficult to introduce these French silks—perfect marvels of manufacture as some of them are—with the same success, but even such failures would not be attributable to French error in æsthetics, but to our own in attempting to force one class of truths upon an opposing class of circumstances. In this respect our national manufacturers of silk most truly represent and supply our national wants with more success than in most of the other sections. In style and colour they remarkably represent the present thought and requirements of educated England, while the French manufacturers may be taken as truly to represent the present ideas of the French; but, in the meantime, in spite of friendship and alliance, these two styles cannot be made international with advantage to either, unless at the expense of great general truths in interior decoration. The silks from Spain would be more easily adapted to English purposes, although in this article of furnishing the British people will, in the meantime, be most suitably supplied at home. Houldsworth, Walters and Son, Keith, and others, exhibit many examples of high-class weaving; and although there is nothing exhibited in its class equal to Houldsworth's border already noticed, the specimens of piece goods shown by Walters and Son show an appreciation of Art-progress

THE INTERNATIONAL EXHIBITION.

We give engravings of four of the many ex-

cellent designs of TILES manufactured by the

"Poole Architectural Pottery Company,"

at their works in Dorsetshire. They are

issued in great variety, and have high repute.

We engrave one of the OVER-DOORS designed and manufactured by Messrs. WHITE AND PARLBY, of Marylebone Street. It is formed of their special material—an artistic mixture of clays and papier mâché, for which the firm has obtained much renown. They are large and meritorious contributors.

Messrs. HEAL AND SON annually provide beds for "millions,"—the higher as well as the humbler, who nightly bless the "inventor of sleep." They exhibit a series of bed-room furniture of the best order in manufacture and design.

We engrave one example, a TOILET TABLE in the style Louis Seize; it is made of mahogany, enamelled in pure pearl white. The ornament is principally foliage and tracery, the whole being of carved wood, judi-

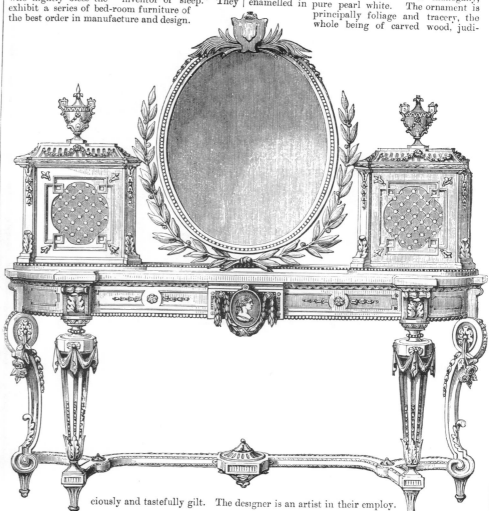

ciously and tastefully gilt. The designer is an artist in their employ.

most creditable to that house, and which is not visible among the silks manufactured by some others for the large west-end houses. That there are stock ideas as well as stock patterns, is most evident, from the efforts these houses have made to be specially represented in furniture silks, but that they also represent the progress made during the last few years cannot be affirmed. The worsted stuffs follow in the wake of the silks, and general advance in this branch is equally visible in that; so that in this section, as in that of paper-hangings, this country has every reason for satisfaction with the progress made by our manufacturers since 1851.

ORNAMENTAL FLOORINGS.

There is no department of interior decoration so much dependent upon climate as the style and character of floors. In Italy and the far south coolness is so essential to comfort, as to have made marble or its imitations the only kind of floorings thought of among those able to afford a choice. In France, Germany, and Belgium, wood, in its various forms, more or less elaborate and ornamental, plays the same important part which marbles or scaglios do in the south; while in England, where floors are merely made, as a rule, to receive carpets, plain boarding will always hold sway against more ornamental forms, except in the cases of the highly cultivated or the immensely rich. Each of these styles, with their many offshoots, are fully represented in the present International Exhibition; and to these, in order, we now direct attention. The marble examples may be said to be all seen in miniature, because in truth these are not floors so much as smaller specimens of inlaid marbles, and therefore less important for what they are than for what they suggest; and that must be a very unimaginative mind indeed, which can go

Messrs. FRY, of Dublin, are extensive manufacturers of upholstery in that city, and their efforts have very greatly contributed to increase the right appreciation of Art in the Irish capital. Their reputation was originally established as

manufacturers of tabinet, but they have considerably enlarged their trade by adding several important branches to it. We find them exhibiting not only furniture, but SILK DAMASKS for curtains (of which this page contains two excel-

lent examples), and all the varieties of "coach trimming," as well as the admirable fabric for which Ireland has long been and remains unrivalled. The BUFFET we engrave was executed for the Rev. Chichester O'Neil, of Shanes Castle.

It is a very beautiful work, formed of root of walnut, enriched with gilding and white enamel, and very gracefully and delicately carved by Irish artisans.

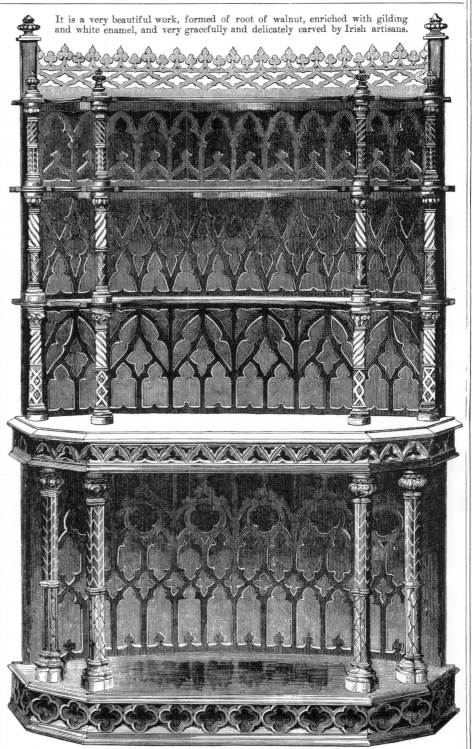

We rejoice much to record such satisfactory evidence of the progress of Art-industry in Ireland.

through the marbles sent from the various exhibiting countries, without seeing that the material exists there in abundance for combinations in this style, hitherto unthought of among the architects and decorators of England. Italy, Spain, Portugal, Austria, and Belgium, as well as nearly every other country, exhibit marbles at once beautiful and cheap, and it only requires the power of generalisation, and a moderate share of skill, to construct from among them both utility and ornament. The halls and libraries of this country could be greatly enhanced in appearance thereby, to say nothing of conservatories and other places equally ornamental; and what would thus embellish English homes, would be no loss to national industry, except, perhaps, to the stone pavior, who is the only agent at present in the "laying" of hall floors in this country, with few exceptions, which shall be noticed immediately. There are several specimens of inlaid marble of English manufacture, chiefly

by Poole and Son, but these seem exclusively devoted to the service of the Church. The largest, for one of our cathedrals, is a most elaborate example—so elaborate and so frittered away into detail, as to destroy more than half the value of the design. Some architects seem to think they will conquer by multiplicity of detail, but the mistake is as grave as those of old, who trusted to their much speaking; for however crowding of parts may indicate small fancy, it equally reveals the want of that capacity for generalisation which is the highest quality of all Art-architecture, down to floors included. The tone and combination of marbles in this cathedral floor are, however, excellent; and it is a marvel how a mind capable of producing such excellence of design and effect, should afterwards be able to descend to that littleness of style represented by the superfluity of detail which overloads such primary forms. There are some other examples, in one or two of the Courts devoted to mediæval work, of higher

The entire SIDE of a DRAWING-ROOM, exhibited by Messrs. PURDIE, BONNAR, AND CARFRAE, of Edinburgh, as a specimen of decorative Art, shows the Italian Renaissance as worked at the best periods. The general design will at once be seen from the engraving, which shows the centre and one of the side compartments, there being three main compartments in all, twenty-five feet long and seventeen feet high. The semicircular panels which surmount the doors are filled with painted groups of cupids, emblematic of Painting and Music; the centres of the long panels have painted cameo heads, representing Spring and Autumn; and the elliptical panels between the spandre!s are filled with fancy heads—these and the groups being painted in their natural colours; the cameo heads white upon a ground of purple hue. The mouldings and ornamental portions of the

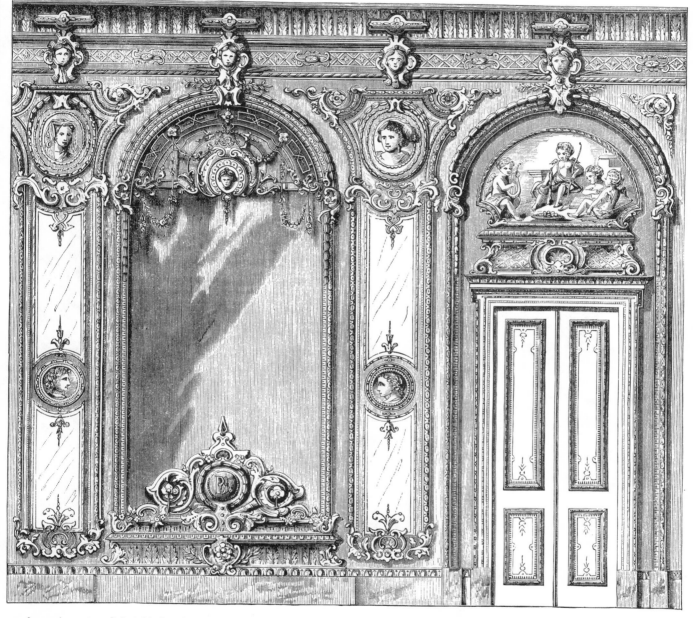

panels are in mat and burnished gold. The purple tint in the ground of the cameos is the most positive colour used; it relieves the white of the cameos, and also serves as the "point of colour" to commence the pearl-coloured marbles. All the frame-work enclosing the mirror and side compartments is painted in delicate shades of Sienna marble, which, combining with the gold enrichments and rich mauve-coloured panels, produce a very pleasing and novel effect. The whole design, both in arrangement and colour, is the work of Mr. BONNAR; and the groups of figures, medallions, &c., were also designed and painted by him; the other parts of the decoration being executed by assistants.

quality, and this chiefly because they are more simple; but these also seem attached to the Church, and although by no means useless for ordinary dwellings, yet there seems but little encouragement among the upper ten thousand for this highest class style of floor decoration.

Scaglio shall be taken next, although in some minds tiles may be considered a more important style of floor ornamentation; but as scaglio is in the overwhelming proportion of cases used as an imitation of marble, and as it is of far less importance to the people of this country, it may as well be disposed of at once. In Italy its use on floors is all but universal. How admirably adapted for the Italian houses only those can duly appreciate who have felt its refreshing coolness, but all can judge of its exceeding beauty, and the great artistic as well as industrial skill displayed in its production, by glancing at the specimens in the Italian Court. Nothing can be more adapted for the display of genius in ornamentation than this material, which is made to combine all the facilities of fresco with the finish and polish of fine marbles; and to the credit of the Italians be it said, that even their least accomplished artists in this walk seldom or never attempt to supersede the ornamental by the pictorial in the decoration of floors. It would be well if some English manufacturers would follow so wholesome an example. But whatever the advantages or beauties of scaglio for Italy, and however suitable, from cheapness, for certain interior purposes in England, yet there are climatical considerations which must be weighed and settled, before it could be safely introduced. It would, no doubt, be a great improvement if hall or other floors could be laid, cleverly ornamented and beautifully polished, at a price little above, or even considerably below, that paid for plain stone; but unless the beauty would also bear the frosts, and the polish remain reasonably proof against our changing summer atmosphere, the exchange of stone for scaglio

The principal object on this page is a

FOUNTAIN for the dinner table (form-

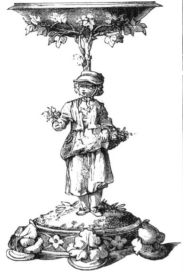

ing also a CENTRE-PIECE for fruit and

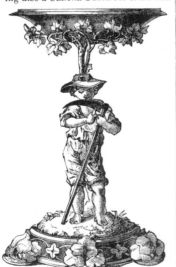

flowers), manufactured by Mr. HARRY EMANUEL, and designed by M. CHESNEAU, a French artist, who conducts

the Art of the establishment in Brook Street. We engrave also four DESSERT

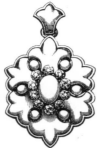

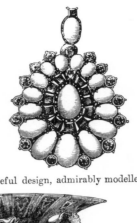

STANDS of rustic character and graceful design, admirably modelled, with

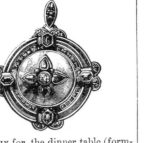

figures of children personating the

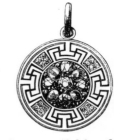

four Seasons, typified by a flower-

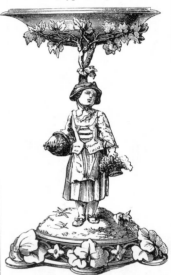

girl, Spring; a reaper, Summer;

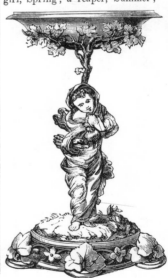

a girl with grapes, Autumn; and a wood gatherer, Winter. We add some of the many valuable jewels of Mr. Emanuel.

would be neither useful nor ornamental. The question of wear and tear is that which should now command practical attention from those interested, and if that could be satisfactorily established, there can be no doubt that, to the advance of interior decoration in England, the introduction of such floors would often be a great gain. From specimens exhibited in the English, as well as in the Italian, sections, there can be no doubt that this material can be as well manufactured, and nearly as well ornamented, in this country as elsewhere, although chiefly, at present, that is done by foreign artists; but should the question of climate, as affecting wear and tear, be settled favourably, this is precisely one of the manufactures in which Englishmen would at once excel, depending, as it does, chiefly on

imitation; and this Exhibition shows, as all former Exhibitions have done, that our countrymen are the best imitators of wood and marbles in the world.

Mosaic pavement or tiles was incidentally noticed when pottery and earthenware came under consideration; but the specimens of floors exhibited by Minton & Co., Maw & Co., and others, demand more attention, especially as an important principle is involved in some of the best of these exhibited works, looked at as mere specimens of manufacture. Here, too, the question of authority comes up, and it may be as well to say, once for all, that in questions of Art, as in other matters, authority is only valuable when defensible upon other grounds, and becomes no authority at all apart

We engrave several of the jewels contained in the case of Mr. RICHARD ATTENBOROUGH, of 19, Piccadilly. They are among the most refined

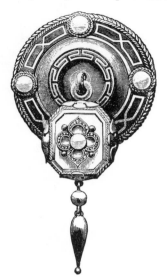

examples of Art, beautiful in design, in great variety, of highly finished workmanship, and fre-

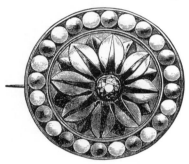

quently of large value, from the rare gems they enclose. The collection is attractive, as it ought

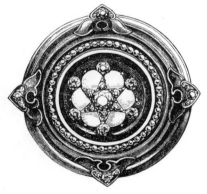

to be; and it has established the renown of the manufacturer as a jeweller. The principal object on the page is a VASE, designed and wrought

by Mr. PIERPOINT, a young English artist, who gives pro-

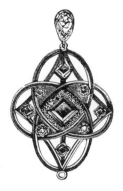

mise of holding rank beside the most famous of his contempo-

L'Allegro and Il Penseroso. The bas-reliefs are from

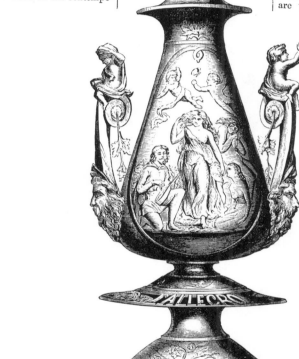

wrought. It is rightly classed among the best

work is minute in finish; the form is somewhat original and

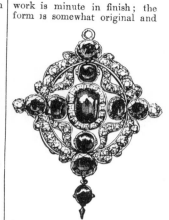

decidedly effective; the figures are well drawn and skilfully

evidences of English power in the goldsmith's art.

from sound reason. That the Greeks, Romans, or Italians have done this, that, or the other, is, taking the Art history of these nations into account, strong presumptive evidence that what they did was right; but it is nothing more; and if any one, or all, of them are found to have adopted certain courses inconsistent with principles which seem based on common sense, these courses must not be followed, merely because there is authority for so doing. In all matters involving progress. Bentham said, "we are the ancients," and for the obvious reason that the accumulation of experience is with us. With the early ages, that aggregate of qualities which make up the imaginative and poetic will probably be more abundant, and their creations will have a vigour and originality with which civilisation of later times may vainly endeavour to compete; but with principles which require to be elaborated out of accumulated experiences, there can be little doubt that the later are at least equal, if not greatly superior in position, to the earlier ages, both for elucidation and determination. This is the position of moderns with respect to floors as well as other matters, and by this test some of the productions of these makers of Mosaic pavements must be tried. It would be vain to deny that high authority can be found for the pictorial ornamentation of floors—that heads and whole figures may be produced, showing that in all the best ages of Art such subjects were used for floor tiles. Be it so; but what then? Will any amount of authority prove that a head of Venus is a proper resting-place for a dirty boot; or that a figure of Mars was a congenial resting-place for a housemaid's slop-pail? Or can any specimens of ingenuity make heads of men and women, or the bodies of satyrs or sea-horses, fit subjects to tread on or walk over? To ask such ques-

The objects engraved on this page are selected from the contributions of DENMARK. The three

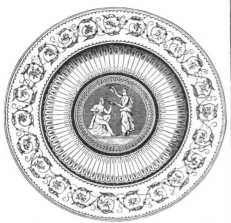

on this column are from the Porcelain Works of

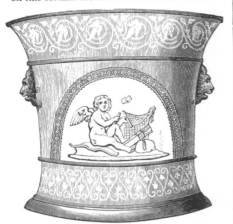

BING AND GRONDAHL, of Copenhagen. Their collection is varied and of great merit; the majority

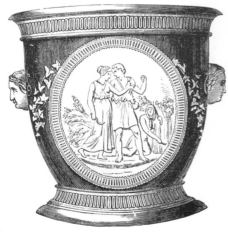

of the decorations are copies from Thorwaldsen.

The CENTRE-PIECE is by CHRISTESEN, of

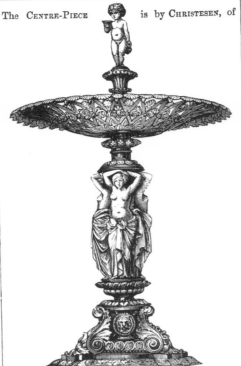

Copenhagen.—DAHL, of Copenhagen, exhibits many

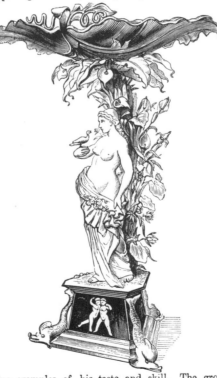

fine examples of his taste and skill. The group

in silver exhibits his ability in one depart-

ment of the art; the brooches are evidences

in another—they are of pure gold, un-

adorned. They are adaptations from the an-

cient Runic, and are probably faithful copies.

tions is to answer them, for none will venture to defend such folly in the abstract; and yet decorations so absurd in theory must be equally absurd in practice, although the quality of the carrying out may help to hide the original folly from both the manufacturers and the multitude. This is exactly the position of the large Mosaic pavements now under consideration; the details are excellent, but the design is a grand mistake—a mistake which never could have arisen if as much thought had been devoted to the adaptation of means to ends as has been lavished on the production of individual parts. The misfortune is, that ornament is first looked at—a striking design being most desiderated; but although such works secure the wonder—perhaps the applause—of the multitude for a season, yet the fact of representing a false principle will prevent it being satisfactory, even to them; and although their eyes may be dazzled, and their wonder stimulated, yet the mind remains unsatisfied, and therefore all but unimproved. What matters it that the flesh tints are well graduated, if no flesh tints should have been there; or that one hundred and fifty thousand pieces be worked into a design, if fifty thousand could have been worked into as effective a combination? In truth, these tile designs partake of that love for labour as labour, so visible in the grotesque of the chief earthenware establishments; and so long as that feeling dominates in its present form, there can be no healthy progressive development. Floors are not made for pictures in any fabric or form; and those who put permanent pictures upon them repeat, in their own fashion, the absurdity of those who used to deface the ball-room floors with landscapes in distemper, which stifled the dancers and covered them with dust.

The individual quality of the tiles exhibited having been noticed

The four works engraved on this page are ex-

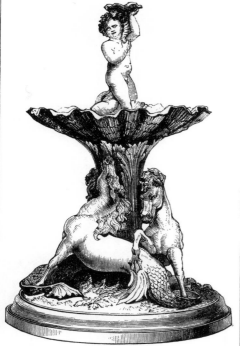

hibited in the VICTORIA COURT, and are the productions of artists of MELBOURNE. The first is

cotta), by T. S. MACKENNAL; the second is for a

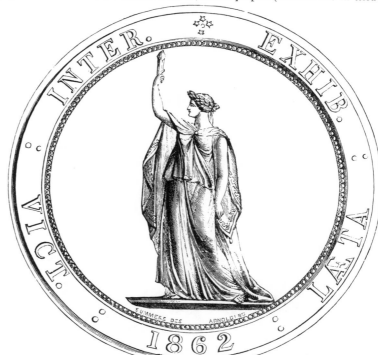

T. SCURRY. The SEAL is engraved from the one appended to prize certificates given to successful exhibitors at the Exhibition held in Victoria, in 1862. It is designed by Mr. SUMMERS, an artist long resident in Melbourne,

similar purpose (executed also in terra-cotta), by

one of the gold medallists of the Royal Academy. The die is by Mr. ARNOLDI, of Melbourne. The INKSTAND was presented to Mr. Bruce, the government railway contractor, by the *employés* on the line. The design is by Mr. LEVIGNY. Con-

a design for a FOUNTAIN (executed in terra-

siderable skill has been displayed in the introduc-

tion of nuggets of pure gold into this composition.

in connection with porcelain ware, we pass on to floor-cloths which are a direct and acknowledged copy of floor-tiles in mass. So far as effort is concerned, one of the best floor-cloths ever produced was engraved in a former number of this Catalogue, that by Hare and Co., of Bristol, in imitation, or rather an exact copy, of an old Roman pavement discovered recently at Cirencester; and to the worshippers of authority as such this discovery settled the question raised about the introduction of heads and figures into floors, for here there were both in abundance. But, after admitting that Hare and Co. have imitated the original with considerable success, little more can be said regarding either the principles of design adopted, or the manipulative qualities displayed in the work. In fact, floor-cloth is a very utilitarian commodity, and although pattern is of great account, yet quality of workmanship is still more valuable; and it is only true

principles, combined with the largest amount of wearing power, that constitute first-class floor-cloth. If what has been already said respecting the designs for floors be true, then it is evident that Hare and Co. are wrong, although they have copied a Roman tile pavement; and if any other style of getting-up be calculated for sustaining more tear and wear, then, whatever the verdict of the Jurors, that of the public will be, or ought to be, for the best floor-cloths made on the best principles of Art-industry, even if the latter be not perfectly carried out. Practically, the best floor-cloth is, with reasonable attention to pattern, that which wears best; and if so, those cloths which are most fully covered are most deserving of commendation. In this aspect the floor-cloths of Nairn and Co., Kirkaldy, Smith and Barber, and many other makers, are of undoubted excellence. Although these makers may not have

Messrs. M. H. WILKENS AND SÖHNE, of Bremen, are contributors of many excellent works in silver, the leading feature of which consists in the introduction of admirably modelled animals; of these we engrave two, a CENTRE-PIECE and a FLOWER-STAND. This firm has been long esta-blished, and is highly estimated in all parts of the Continent. They employ artists of great capabilities, and give accurate study to the spe-cialities in which they principally excel; they are general silversmiths, and their works (few in number but of very considerable excellence) will be found in the collection of the Zollverein.

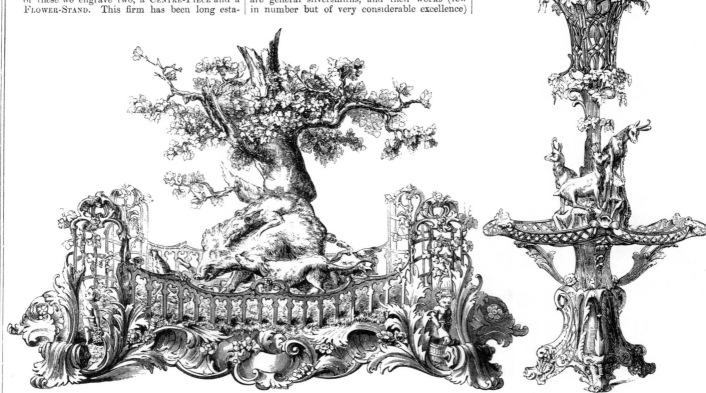

This page also contains engravings from some of the eminent manufacturers and gas-fitters of Wych branch of Art this firm has taken a prominent

the many valuable examples of brass work, chiefly Street and Cockspur Street. In this important part, and fully established the high reputation

for uses in churches, contributed by Messrs. HART, it has obtained by rightly directed efforts.

gone to the same expense in patterns, there is no necessary connection between expenditure and taste; and as the ART-JOURNAL has always maintained that elegance is cheaper than ugliness, what is true of the whole is also true of the various modifications of the principle. With the exception of one or two specimens from Switzerland, there are no floor-cloths of foreign manufacture demanding special atten-tion or remark.

In France, Belgium, and the Low Countries, where carpets have not hitherto been in general use, and where the comparative comforts of wood are more suited than marble both to the climate and circum-stances of the people, parquetrie has almost, as a matter of course, been the favourite style of floor decoration; and where both wood and labour is cheaper, there are few styles which are so capable of ornamented utility. The Belgians are especially remarkable for their skill in this kind of work, and it is perhaps useless to say that these patterns are all strictly geometric in character. Still the variety is wonderful, and many of the varieties are beautiful both in balance of parts and in combinations of tone, for there is little intermixture of what may be called colour, either through means of natural woods or stained timber, in the principal examples exhibited. There are dark, intermediate, and lighter shades of oak, and these give a solidity of appearance to the whole highly conducive to the realisa-tion of what a floor ought to be; but there seems no very substantial reason why the many coloured woods seen in such abundance and variety in the Colonial Courts should not be made to lend a new and perhaps more distinctly ornamental character to this work, thereby at once increasing European pleasure and colonial profit. There are, however, dangers to be avoided, as well as new results to be achieved;

THE INTERNATIONAL EXHIBITION.

Messrs. ELKINGTON & Co. are exhibitors of the objects

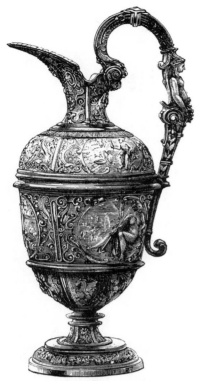

engraved on this page, of which the first is a repro-

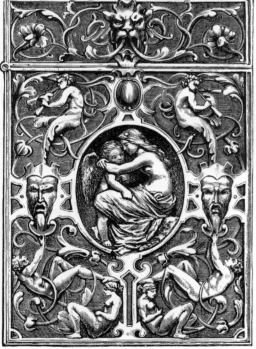

duction of the celebrated JUG known as the "Briot

Jug," in the collection of the Hotel Cluny, Paris: it is a work of rare quality for beauty

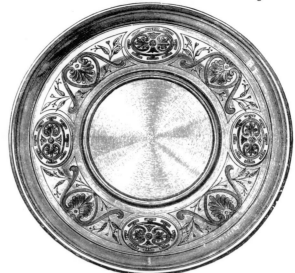

ing in the centre a medallion of Venus and the boy Cupid. The circular engraving which heads the second column is from a small TAZZA,

TAZZA, ornamented with designs, by Mr. STANTON, emblematical of the Seasons; the inner

of design and exquisite workmanship. Underneath this is an elegant CARD-CASE, show-

designed by A. WILLMS, *en suite* with the Greek Vase engraved on page 91 of this Catalogue. The large circular object is also a

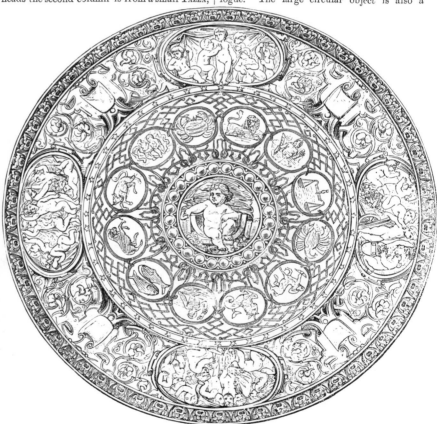

circle round the centre has the signs of the Zodiac; in the outer are the four Seasons.

and some of the most imposing specimens exhibited in the French section—those of Laurent, of Paris, made for the Spanish Duke of Alva,—show what those dangers are. From the drawings and examples exhibited by that firm, it is evident they are attempting to overtask the powers of this style, by converting what can never get successfully beyond a flat inlay into a medium for working out Grecian scroll-work, and pictorial effects in colour, light and shadow, and relief. True, taking the present examples as a test, they have not been successful in any of these qualities, and in harmony of tone the drawings are not better than the finished work; but, no matter how successful in these comparatively minor qualities, the principle adopted is utterly false when applied to floors, so that the more perfect the "relievo," the worse the decoration. Where the Belgians

have introduced coloured wood, as is the case in one or two instances, how much more perfect is their principle of flat inlaying, even although the effect be sometimes crude and spotted, from that want of harmony in which the French are so conspicuous in all pertaining to the management of colours. In England, parquet flooring is now but little used, although not unknown to the mansions of our fathers, and the various revivers of this style of workmanship, such as the London Company, will probably, through the cheapening aids of machinery, do something to adapt this elegant style to modern necessities; but, with all efforts to cheapen prices by superseding hand labour, the cost must still be far beyond the reach of all but the comparatively wealthy. For such this style has strong recommendations; it is difficult to imagine anything

Messrs. DERRY AND JONES, of Birmingham, exhibit a variety of electro-plated works, of considerable excellence in manu-

Messrs. HARROW AND SON, Gasfitters, of Portland Street, Soho, exhibit many excellent examples of their manufacture, comprising the varied produce of workers in metal. We en-

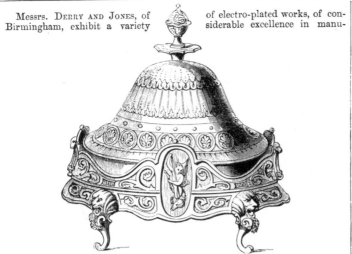

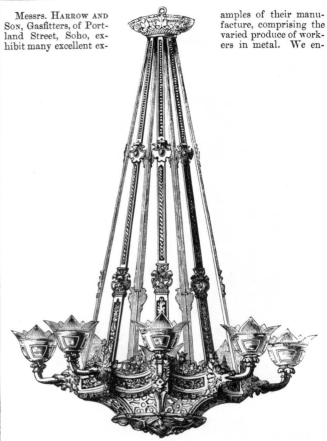

facture and of much merit in design. They consist of all the various articles

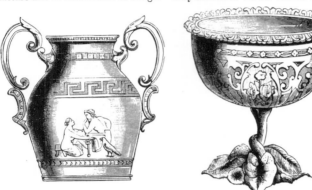

for the table, and such as are designed to ornament the drawing-room and the boudoir. They are plated on what is termed "Spanish silver"—a white metal, far

grave a CHANDELIER and a BRACKET; the former being from an admirable design produced for them by the famous wood-carver, Mr. W. G. ROGERS.

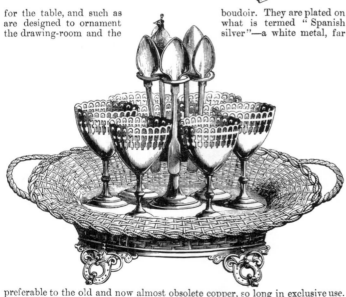

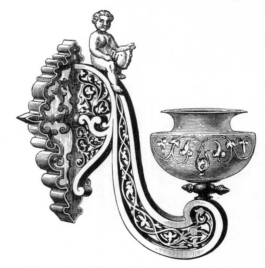

preferable to the old and now almost obsolete copper, so long in exclusive use.

It is graceful and beautiful, as well as appropriate in character. The Bracket is designed by Mr. J. H. ROSOMON, the artist of the house.

better or more luxurious for a drawing-room or library than a well-arranged parquet border, with a Turkey or Axminster covering for the centre of the floor. It is impossible not to see that at present the Belgians are foremost in the ranks of this class of manufacture, but it is also pleasant to know that some of the English workers in wood are treading fast upon their heels, both in quality of design and workmanship—for here, more than in many departments, manipulation is more important than style, although a better style costs no more in working out than a bad. In Belgium, France, and England, the parquet work is mostly, if not exclusively, in oak and similar woods, but from Sweden and the Zollverein there are examples of the same style in deal, which, from various causes, seems to offer a cheaper and therefore a more generally useful character of floor ornamentation. If to these could be added what one of the exhibitors in the Austrian section promises, an indestructible incrus-

tation on wood, whereby any pattern or colour could be added by being put into the deal parquet, the combined advantages would at once become commercially important. But whatever may come of the "indestructible incrustation," the common deal work must be had at comparatively a cheap price from a country like Sweden, and when polished might prove a highly respectable substitute for oak.

The only other covering for floors we have to notice, is the comparatively new material known as Kamptulicon, a compound which resists damp and absorbs sound better than any previously known substance applicable to such purposes; and it will have been seen from previous illustrated pages of this Catalogue, that the quality of design has not been overlooked by the producers of the new material. In this respect the examples exhibited by Tayler, Harry, and Co. are most creditable; and although this kind of floor-covering can never be elevated above the wants of the counting-house, yet

THE INTERNATIONAL EXHIBITION.

Birmingham has achieved an unexpected but unquestioned triumph in the production of jewellery. The case that contains examples of several

firms, in combination (and it is therefore we class them together), invites, rather than avoids, comparison with the many brilliant displays

that grace the Court of the Goldsmiths. We select specimens of three of the principal manufacturers, commencing with those of Messrs.

T. and J. BRAGG, which certainly take the lead, giving the centre column to those of Messrs. T. ASTON AND SON, and the third column to

THE JEWELS OF MESSRS. T. AND J. BRAGG.

those of Mr. C. T. SHAW. The designs for the

setting—pure gold—are the matters that chiefly

claim our notice; they are, for the most part, of

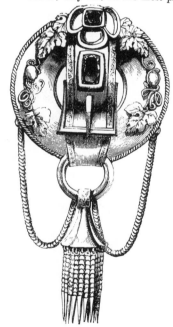

THE JEWELS OF MESSRS. T. ASTON AND SON.

rare excellence; productions, in all cases, direct from the workshops of the manufacturers where

they were designed as well as made. Generally

they contain gems of rare value, but their worth is derived mainly from the influence of Art to which they have been rightly and wisely subjected.

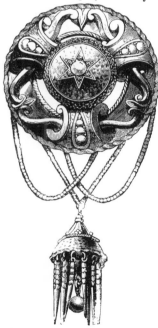

THE JEWELS OF MR. C. T. SHAW.

the elements of pleasure may be carried there also, so that the eye may be involuntarily educated to a preference for beauty. The progress in these several branches since 1851 has been substantial rather than rapidly surprising among English exhibitors; and while the Belgians and others are much as they were at that period, and only where they were at the Paris Exhibition in '55, our own countrymen have steadily pressed forward, although in some departments they are still a long distance from the winning-post.

CHIMNEY-PIECES AND MARBLES.

Chimney-pieces are the offspring of northern latitudes; and there is nothing which tends more to make or mar the general appearance of an apartment than the better or worse character of its chimney-pieces. In the palazzio of the south they are nearly unknown; in the banqueting halls of Holland and the Low Countries they form the most striking features of the apartment. So it used to be in this country; and in some of the old mansions, one of the most noble features of the domain is the old hall chimney, carved in oak. Among a few this taste for the later antique has revived the love of old oak chimney-pieces, and more than one distinguished amateur could be named, who devote thought, taste, and money to re-creating the past in this way; while, especially in some of the more mediæval provincial towns, the manufacture of modern antique chimney-pieces is as much a part of trade as the manufacture of antique chairs and sideboards; but notwithstanding these exceptional efforts, the attempted revival does not take root, and the large carved oak chimney-piece is all but unknown to the Inter-

157

S S

The new CHOIR SCREEN for Hereford Cathedral, by far the most important and the most successful example of modern metal work that has yet been executed, has been produced at Coventry, from designs by G. G. SCOTT, R.A., by SKIDMORE'S ART-MANUFACTURES COMPANY, under the immediate personal direction of Mr. SKIDMORE himself. The screen is composed of iron, brass, and copper; and the metals have been treated

of the grilles, or panels, executed precisely by the same processes as

the rest of the work, by which the lower compartments of the

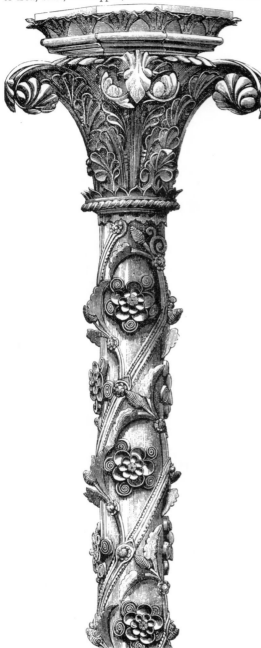

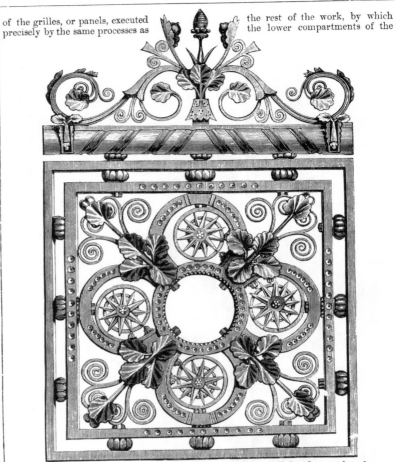

screen are closed in. The third example shows the tracery, all hand-wrought, of one of

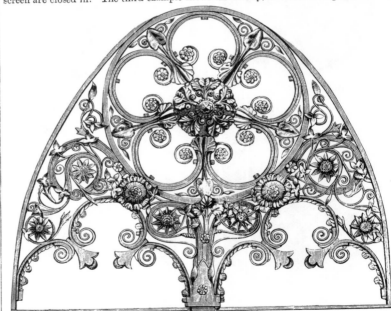

after the manner of the great artists of the middle ages. This treatment is happily exemplified in the details we have engraved on this page. The first is one of the iron shafts of the arches, with its beautiful open-work enrichment of wrought brass, and its capital of copper foliage, executed entirely with the point of the hammer. The second engraving is of one

the principal arch-heads, and indicates the arrangement of the sub-arches of the arcade.

national Exhibition. So far as represented, then, the change which has so evidently taken place in such articles during the last few years, has assumed a still more antique form—one that seeks its type in the stone constructions of the old castles before the oak ornamentations of the later baronial halls had existence, save in the low countries of the Continent. This phase of the revival is justified by sound principles. In the earlier period, when strength and defence were the main objects of domestic architecture, the stone construction naturally predominated, as most serviceable for the purposes required. When the feudal was supplanted by the civic, and the badge of villanage had been exchanged for citizenship, the anxiety for strength was superseded by the desire for

luxury. The national progress produced the transition from the stone style of the barons to the wood development now known as Elizabethan, which, in all its essential characteristics, was a construction founded on the capabilities of timber, rather than on those belonging either to stone or brick, although both were made to bend before the prevailing type. Now, when utility, although for different reasons, has again become the great law-giver, the older stone construction has re-appeared, and few will doubt the advantage of the principles involved therein, although present appearances indicate the difficulty of keeping the modern development within the bounds of modern ideas and wants. Some of the chimney-pieces exhibited by English makers cannot be considered within this essential quali-

THE INTERNATIONAL EXHIBITION.

We have selected for engraving four of the many objects contributed from the Bronze and Iron Manufactory of D. HOLLENBACH, of Vienna. They consist of chandeliers, cande-

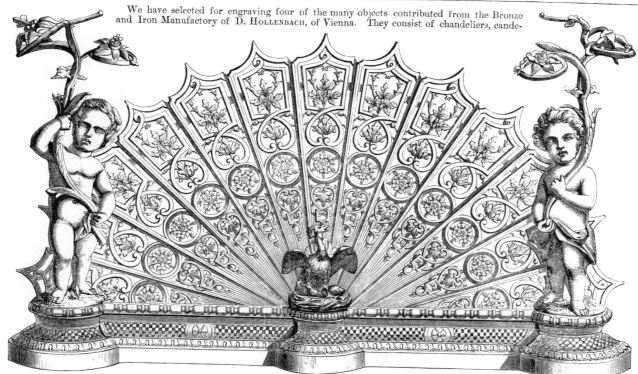

labra, clocks, stoves, fenders, and the various articles connected with the important trade which Herr Hollenbach "leads" in the capital of Austria. They are obviously designed by accomplished artists; true in Art-feeling and Art-knowledge.

fication, and the discrepancy proceeds from the too common but erroneous idea that things ancient must therefore be good. Those who required to roast an ox for their retainers, or whose artificial light was confined to a blazing fire of wood, necessarily demanded space ample enough for both purposes; but when the representatives of the old retainers cook their own dinners at their own hearth-stones—when coal has taken the place of wood, and gas, or some modification of oil, supplies the artificial light—to make the chimney openings and jambs necessary for the former state of things, re-appear, to serve under the altered circumstances, seems as little akin to reason as an attempt to restore the heptarchy. Yet, judging from some of these exhibits, this is nearly all that some of the English marble masons have thought of doing, seeking in size the distinction they might be afraid to compete for through taste alone.

As a digression must be made somewhere, having a direct bearing on this, as well as on many other classes in the Exhibition, it may as well be made here. In the introduction to these papers, several suggestions were thrown out for the consideration and guidance of the Jurors, and it is at least gratifying to know that, with one exception, these suggestions have been adopted almost in the precise forms suggested. That exception refers to the undoubted distinction between wood and stone construction—one of the most difficult problems within the wide range of practical æsthetics, and one, therefore, on which the Jurors have made no sign. The timid evasion of such a subject does not inspire very exalted ideas of the capacity engaged to confer awards on excellence, because this, in the present state of industrial Art, was one of the great questions demanding authoritative investigation and settlement; and for the Jurors to have

The renown of RUDOLPHI, of Paris, has "gone

over the world;" the exquisitely beautiful "gems"

he produces in oxydised silver have long been

famous. His "show" at the Exhibition is extensive and very varied. We engrave some of his pro-

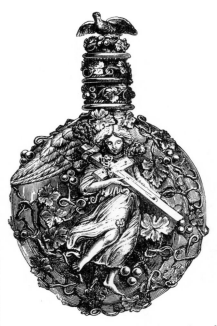

ductions; they are charming in taste and excellent in Art—depending for success on the graceful

application of Art to objects that hence derive their value. Some of the figures introduced into

brooches are as well drawn and as carefully modelled as they need have been if "life-size."

M. Rudolphi, however, exhibits a work of higher aim. It is a "chasse," for a Roman Catholic

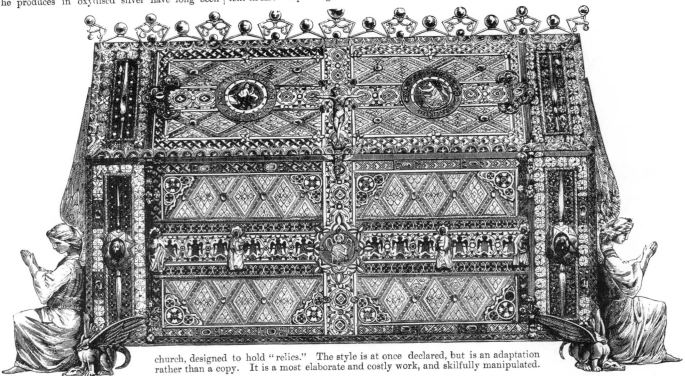

church, designed to hold "relics." The style is at once declared, but is an adaptation rather than a copy. It is a most elaborate and costly work, and skilfully manipulated.

shirked it, through silence, was like performing *Hamlet* with the part of Hamlet omitted. Still, it cannot always be left in abeyance; and as, even in chimney-pieces, it forces itself into notice, it may be as well to devote a few sentences to the recognition of the subject, whether its practical solution be or be not accelerated thereby. That there is a clear distinction between what would naturally be done in wood, as compared with what would be done in stone, seems evident enough; and, perhaps, out of this essential difference styles have found their sure foundation. There seems no reasonable ground for incredulity that the classical, under all its modifications, found its root in wood, and that the most elaborate of the Athenian temples sprung, by direct descent, from the log huts of the Atticans. Even when marble came into general use in Greece, and after science and Art had on these principles perfected construction, the origin of the type still found a place in the ornamentation; and after all the

guesses which have been made as to the origin of the fluted column, the flute still remains a timber rather than a stone form of decoration. Owen Jones has been silent on the subject, and, so far as we know, other writers have been equally discreet; but, notwithstanding reticence, it seems a palpable and obvious truth that the natural ornaments of the various materials must be governed by the kind of tool necessary for their production. Works of Art proper may be produced in any kind of material, and by any means, the end being all that involves interest to the world; but ornamentation is a much more utilitarian thing, and takes into account the capabilities and adaptabilities of material and tools, which is only another form of determining the cost. Nobody has ever thought of cutting stone or marble with a gouge—that is essentially a wood-cutting tool; and yet the flute is the production of a gouge, in theory, whatever it may be in practice. On the other hand, figures in the round, or orna-

M. DURENNE, of Paris, exhibits a marvellously fine collec-

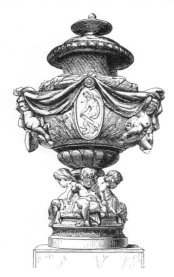

tion of works in Cast Iron; we engrave two of his produc-

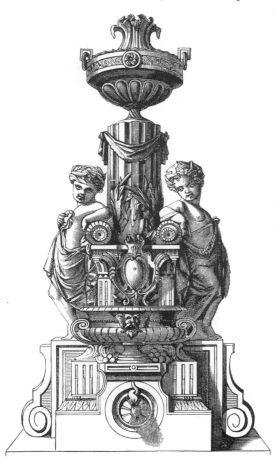

tions, and regret we can accord to them but limited justice.

The IRON SAFE on this page is of wrought | iron, the production of CARL HANSCHILD, of

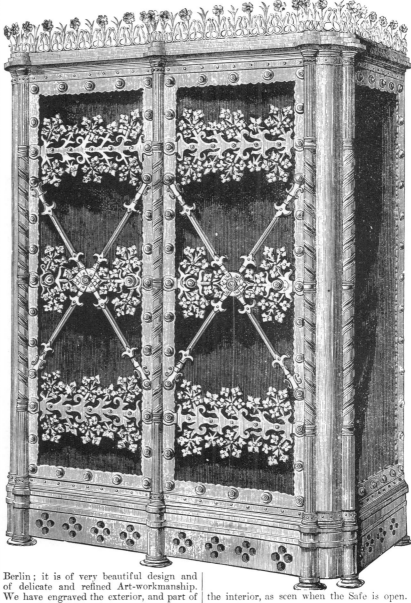

Berlin; it is of very beautiful design and of delicate and refined Art-workmanship. We have engraved the exterior, and part of | the interior, as seen when the Safe is open.

ments in *bas* or *alto-relievo*, are as evidently the work of the chisel—chipped and worked round from the hand—a stone-cutting tool which has been in use, under whatever form, among the stone and marble masons of all ages. Phidias might have cut the Elgin marbles in wood as well as in marble; but, so far as we remember, no such works have been found in wood; and it was this kind of ornamentation which elevated the original Greek type from a timber to a stone construction, although its square forms and its "flute" still cling to the lower development, as a tell-tale of its humbler origin. What was true of temples is equally true of mantel-pieces dependent on Greek forms, and no less true respecting the character of their ornamentation. So far as the material of a chimney-piece is seen to be marble, the idea of wood, whatever its style of ornamentation, is neutralised; but paint a fluted pilaster so that the marble is hid, and no effort of imagination will enable the eye to conceive it other than a piece of wood; and this not because of the paint, for many stone chimney-pieces are so treated without destroying their stone characteristics, but because of the essentially wooden character of the ornamentation. What is true of flutes is more or less true of certain characters of moulding, as well as certain forms of construction. That stone has, for cheapness, been sawn and used as a veneer, either for chimney-pieces or other purposes, matters nothing, because both are wood processes rather than stone; and the fact that such chimney-pieces are used would no more prove the identity of wood and stone construction than the modern practice of so confounding the members of moulding as to prevent people knowing whether they are the one

T T

Mr. PULHAM, of Broxbourne, is a large exhibitor of works in TERRA COTTA, not only for

conservatories, and general ornamentation of grounds. They are of excellent design, carefully and skilfully modelled, and so "baked" as to be uninfluenced prejudicially by weather. Mr.

Pulham exhibits a variety of VASES, of which we engrave two. His principal contribution, how-

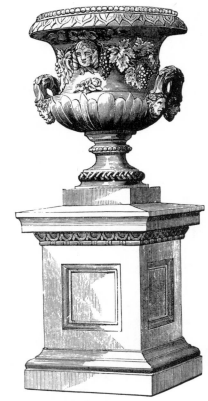

architectural purposes, but for those of gardens,

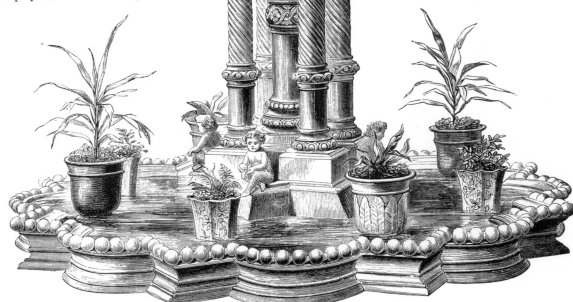

ever, is a FOUNTAIN, which, in the Exhibition,

plays perpetually, near the entrance to the Horticultural Gardens. It is an agreeable object, not too large for any moderately sized conservatory.

or the other. Formerly, and even in very recent days, architecture was so followed, that one moderately acquainted with this practical application could tell at a glance whether mouldings were wood or stone from the characteristics of the members—those in wood always being more numerous, and wanting the simple dignity of those in stone. Since architecture has become more a hunt after novelty than the working out of recognised proportions and styles, the ornamentation has partaken of the novelty sought in the general structure, and the old facility for distinguishing between wood and stone is in great measure lost. Take one of the most conspicuous examples in the Exhibition for illustration. The marble chimney-piece exhibited by Hartley, is, taken as a whole, a very noble work, imposing in its general outlines, and dignified in its proportions. So much do these qualities predominate, that no effort of imagination could reduce it from a stone to a merely wooden construction; and if the marble was painted imitation wood, it would have the stone feeling and characteristics still of massive grandeur, both as a whole and in its chief detail. True, the spiral column indicates the turner's lathe rather than the mason's chisel, and the white panels in the front square pillars give it a veneered look, neither conducive to solidity nor essentially marble in character; but, with these drawbacks, it would still be essentially stone, and, if painted, the pillars would be more stone-like than at present, because the feeling of veneer would be destroyed. Take another example, equally important in its class, a large statuary marble chimney-piece exhibited by Mitchell, and there are few works of this class likely to command more general approbation. It is simple in its classicality, elegant in its proportions, and, in these days at least, novel in its general forms. Between

Mr. Naylor, of Princes Street, Cavendish Square, exhibits a large collection of admirable

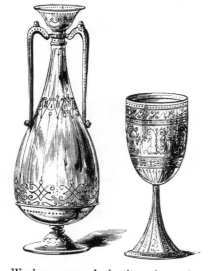

works in Glass, exclusively for the Table. The forms are good, certainly among the best and most

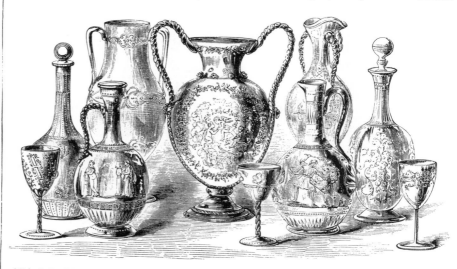

varied in the Exhibition, while the ornamentation is, for the most part, of very considerable merit.

We have engraved elsewhere the costly and "gigantic" Glass Chandelier manufactured and exhibited by Messrs. Defries; we give also engravings of their Table Glass, of a high order, possessing much excellence not only of "metal," but of ornamentation; the forms are unques-

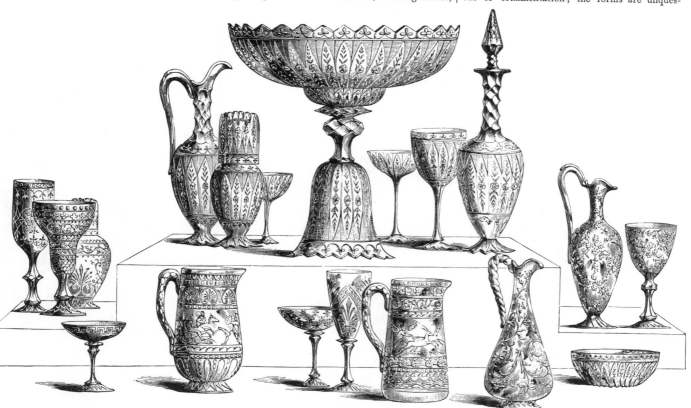

tionably good. It is gratifying to know that while these eminent manufacturers issue works for "the million," sending their productions "by the thousand" into all quarters of the globe, they can furnish works of refined taste, such as are calculated entirely to content the most fastidious.

the elegant double columns, a panel, ornamented in relief, adds richness to elegance; and, as a whole, it forms a most pleasing example of interior decoration. But, suppose it subjected to the process we have just suggested for Hartley's—suppose these flat forms and fluted columns painted, and the quality of marble hidden from the eye—there is, probably, not one person in a hundred who would not conclude this chimney-piece to be of wood, and that not because of the paint, but from the general character of both the outlines and ornamentation, with the single exception of the decorated panel between the pillars; and whether the difference can be made tangible through words or not, it is evident at a glance to those accustomed to look attentively at such matters. But all absolute difference can, through care combined with knowledge, be defined, as well as realised, when the necessary time, and thought, and skill, are devoted to the subject; and it would have done something to settle

the principles of industrial Art, had the jurors in this class been able to devote their minds to the question, with any prospect of shedding a ray of light thereon. But, like other "interpreters," these gentlemen have been swift to deliver themselves of common-places on points requiring little or no elucidation, and provokingly silent upon difficulties; they have done what anybody could have done, but have left, in nearly all instances, what their special position entitled them to have undertaken.

Among the other marble chimney-pieces, that by the late Mr. Thomas holds a conspicuous place, although it shows no important progress since 1851, for then the works modelled by that artist for a Birmingham manufacturer embodied the same structural idea, and were, as a whole, produced with equal artistic ability. But there is a great step forward in this, that while the former examples were composed out of various materials, which had as little affinity as iron and

The two objects engraved in this column are selected from a variety of contributions in Earthenware, manufactured by Messrs. PICKMAN & CO.,

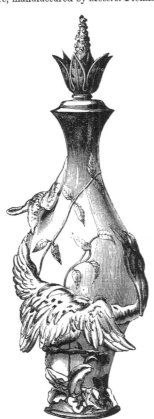

of Seville, by whom the Cartuja Pottery was established in 1841, in that city, on the banks of the Guadalquiver; the firm has a very large trade, supplying nearly the whole of Spain and

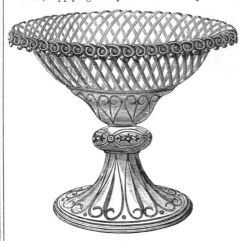

its dependencies with porcelain and earthenware. The materials are of considerable excellence, and the designs, in some cases, original and good.

Messrs. W. & G. PHILLIPS,

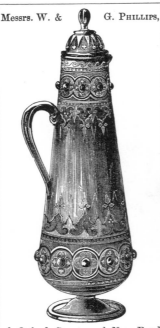

of Oxford Street and New Bond

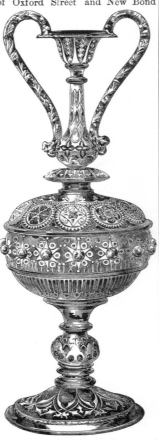

Street, are large contributors of

GLASS "for table uses," generally, we believe, the manufacture of THOMAS WEBB, of Stourbridge, the designs being furnished by

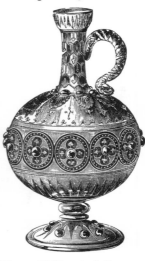

Messrs. Phillips, and the ornamentation added by them. These examples of the art are rightly classed among the best in the

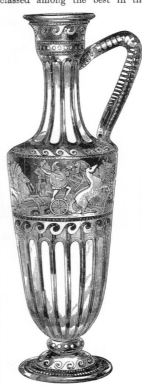

Exhibition. The skill displayed in their productions has been largely appreciated; the introduction of certain novelties (to which

our space permits us only to

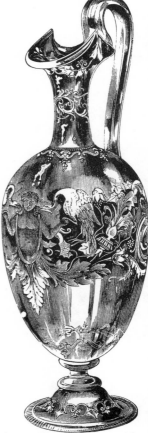

allude) are intended to show

the capabilities of the material.

clay, that now exhibited is made out of pure white marble, and therefore the striving after incongruous effect has been avoided, that was so conspicuous eleven years ago. Had this been looked at as a work of Art, much might have been said respecting the feeble and in some respects false style of treatment adopted in the figures, and also about the drawing; but although this last cannot be excused upon the plea that the treatment is ornamental, it mitigates judgment by lowering the standard; and although not a great artist, Mr. Thomas, in this, as in his other works, showed himself to be a clever and facile ornamentist. Among the other marble workers the Belgians occupy an important position, and their exhibits are at least as important in this class as those of any other exhibiting nation, England not excepted. Commercially, these Belgians do a very large trade in marble chimney-pieces, and, as a whole, they must be judged rather from a commercial than from an artistic stand-point. They occupy both creditably to themselves, and some of the chimney-pieces in the Belgian Court are, for all ordinary purposes, among the best exhibited. Some of them are indeed too florid, and others, altogether or in parts, of doubtful taste; but, adapted as they are to the wants and circumstances of every-day life, we cannot equal them for quality, character, or price. This is no doubt utilitarian commendation, but it is none the less valuable on that account; for when the dwellings of the many are to be improved in any branch of interior finishing, those who best supply that general want are the true heroes of progressive Art-industry. The stone chimney-pieces are both curious and numerous,—the one chiefly because of the Gothic *furore* that has dictated the design; and all that has been said of the fantasies of Gothic in relation to grotesque paper-hangings and other

This column contains three engravings from works in TERRA-COTTA, by Mr. MILLICHAMP,

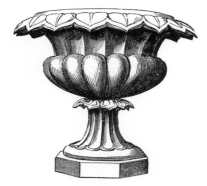

of Lambeth: his productions are not in great variety, but are of much excellence in design and

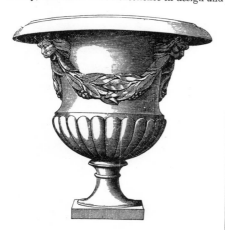

material. Ancient and time-honoured forms have generally supplied the models; but sound judg-

ment has been exercised to produce the copies.

The first group on this column is selected from the case of Mr. W. BROWNFIELD, of Cobridge, Staf-fordshire, whose contributions of EARTHENWARE are varied and of a high order. They consist prin-

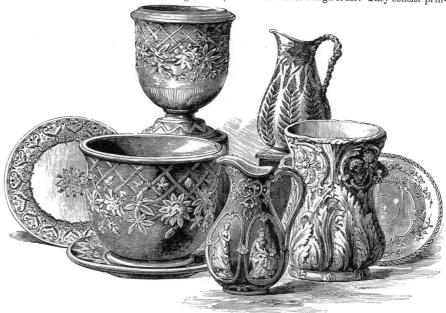

cipally of household utilities, breakfast, tea, and dinner services, of good patterns, chamber services, &c. But he exhibits also objects of a meritorious Art-character, ornamental as well as useful, for the drawing or dining-room. Mr. Brownfield has fully earned the honour he has received.

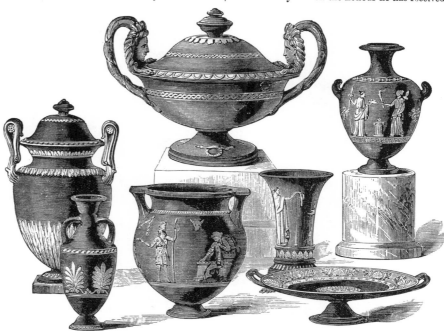

Messrs. J. & M. P. BELL, manufacturers, of Glasgow, to whom Art in that city is very largely indebted, exhibit a series of productions of many kinds, that are quite on a par with the best issues of Staffordshire. We have selected objects ornamental rather than useful; but of the ordinary utilities they show many examples of great excellence in design and in manufacture.

branches, seems to apply still more strongly to many of these stone chimney-pieces in the same style. They are, in fact, Gothic demented, and nothing but time is likely to cure those bitten by the expiring mania. To go over such objects in detail would serve no useful purpose, for it is idle to reason respecting principles either of Art or common sense with those who are the blind adherents of a dogma which they can only defend by reference to the authority of some twelfth-century monk, but whose principles of action they can neither comprehend nor explain. This, however, may be perhaps affirmed with safety, that, could the spirits of these monks start from their tombs, and see the insipid ugliness of many objects now produced on their supposed authority, they would probably institute a combined action against the perpetrators, for the wrong done to their artistic or architectural reputations. Among the chimney-pieces in wood, that by Trollope and Son is a successful example of general effect, while the details are individually good. The still larger and more elaborate one by Fourdinois, of Paris,—in the upper and wood portion,—displays power of design and great manipulative skill, although, if judged as a work of Art, grave objection might be taken to the ostentatious parade of very doubtful anatomy in the bas-relief; and the whole design looks as if intended for a marble rather than an oak construction: it is, in fact, a marble work carved out in oak; some of the other French chimney-pieces are the reverse, especially one very large one, which is a pure wood design worked out in marble, so much so that it is difficult to believe it is not painted.

To the material out of which chimney-pieces are made there seems no bounds, for after marble, stone, wood, and iron have been exhausted, the china manufacturers of Dresden, the zinc-workers of France, and the majolica makers at home, have brought a portion of surplus

It is sometimes the privilege of a manufacturer to apply Art to the homeliest materials, to render agreeable and even instructive to the eye that which is apparently incapable of giving pleasure, except by suggestions of utility. The objects we engrave on this page (preceding the elaborate

of modern times, has successfully striven to give to the articles he produces so good, and sometimes so elegant, a character as to render them in harmony with the encaustic tiles, and other floor decorations, which now generally enrich the halls of modern buildings. The productions of

and costly instrument that is to adorn a richly-ornamented dining-room) are merely COCOA-NUT FIBRE MATS—the necessaries of every household. But the ingenious and enterprising manufacturer, Mr. TRELOAR, to whom the country is largely indebted for one of the most valuable "introductions"

Mr. Treloar are, therefore, far from "out of place" in a collection of the works of Art-industry, and we introduce into this Catalogue, with much satisfaction, examples of some of them as evidence of the progress we are called upon to report in every branch of recent British Art-manufacture.

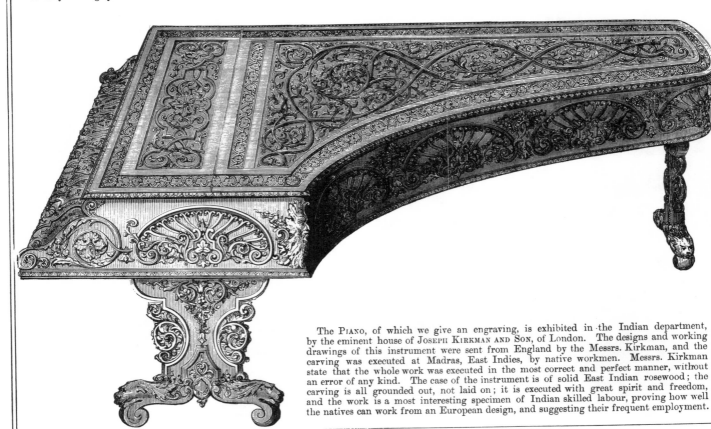

The PIANO, of which we give an engraving, is exhibited in the Indian department, by the eminent house of JOSEPH KIRKMAN AND SON, of London. The designs and working drawings of this instrument were sent from England by the Messrs. Kirkman, and the carving was executed at Madras, East Indies, by native workmen. Messrs. Kirkman state that the whole work was executed in the most correct and perfect manner, without an error of any kind. The case of the instrument is of solid East Indian rosewood; the carving is all grounded out, not laid on; it is executed with great spirit and freedom, and the work is a most interesting specimen of Indian skilled labour, proving how well the natives can work from an European design, and suggesting their frequent employment.

energy to such productions; and it would have been satisfactory to have been able to add that the success had been equal to the zeal. Of these three last, the zinc-workers bear off the palm in point of taste, for while the durability of zinc chimney-pieces may be doubted in a coal-burning country, the forms of these cheap constructions shock no principles of Art, and spare the feelings of those who may perchance see them in their sequestered nooks. The same cannot be said of those made in china or porcelain, for among all the specimens of industry exhibited, these are the representations of the falsest principles in Art. There is of course no accounting for taste, and if foreigners prefer such a chimney-piece as that in the Dresden Court—made up of a motley mass of china flowers in relief, painted in what has been meant for natural tints, figures got up in the same style combined with painted plaques, and the whole combined in such profusion as to produce what may be called, for lack of other

more descriptive words, the superb gingerbread style—if Germans or others prefer such things, they must be left to their choice as beyond all hope of recovery to purer taste, and we can only trust that no such affliction will befall any portion of our countrymen. But suppose they escape the tawdriness of Dresden, and be smitten with the majolica of Minton, what would be the substantial gain as respects Art-industry? The majolica chimney-piece exhibited by this firm is designed by an artist entitled to respect, and it displays some of those qualities with which that artist's name is so honourably associated; but in spite of these it is the embodiment of ugliness rather than of beauty, and as destitute of agreeable lines as it is poverty-stricken in invention. Suppose the wheels of Art-progress rolled back to this point, what would the people gain by substituting this reminiscence of the past—if such it really be—for the intensest crudities of the present? Or should the dwellings of England be

THE INTERNATIONAL EXHIBITION.

We engrave on this page three of the very beau- | tiful LACE SHAWLS manufactured and contributed | by Messrs. FERGUSON AINÉ ET FILS, of Paris.

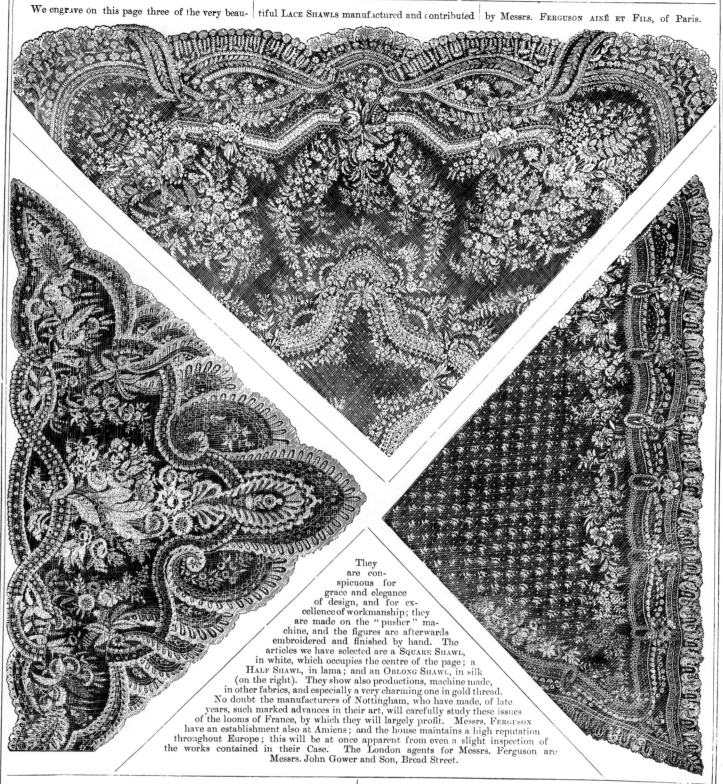

They are conspicuous for grace and elegance of design, and for excellence of workmanship; they are made on the "pusher" machine, and the figures are afterwards embroidered and finished by hand. The articles we have selected are a SQUARE SHAWL, in white, which occupies the centre of the page; a HALF SHAWL, in lama; and an OBLONG SHAWL, in silk (on the right). They show also productions, machine made, in other fabrics, and especially a very charming one in gold thread. No doubt the manufacturers of Nottingham, who have made, of late years, such marked advances in their art, will carefully study these issues of the looms of France, by which they will largely profit. Messrs. FERGUSON have an establishment also at Amiens; and the house maintains a high reputation throughout Europe; this will be at once apparent from even a slight inspection of the works contained in their Case. The London agents for Messrs. Ferguson are Messrs. John Gower and Son, Bread Street.

studded with chimney-pieces of this type does the artist or any other individual believe that we would be nearer the standard of beauty—the object of all Art—than we are at present? There is a barren as well as a florid style of ugliness, and that the one may be exchanged for the other is evident not from this chimney-piece alone: but *cui bono?* Is the one better than the other, and if so, why? This seems entitled to some answer from those who stand forth as the heralds and leaders of the change, and none is more likely to offer an able defence than Mr. Digby Wyatt. Until such defence appears, the public will, probably, pronounce the exchange a delusion, a mockery, and a snare, withdrawing the mind from progress, and fixing it on mere change. Such things are of worse than no value, because they lend the weight of influential names to forms which those without names would be scorned for attempting.

TERRA-COTTA AND CLAY PRODUCTS.

These, although technically separate substances, may be treated as one class of works, and one of rapidly increasing progress, both as regards general utility and Art. What is now an every-day commercial process in clay, would have astonished men twenty years ago; and the advance, even since 1851, has been most conspicuous among British brick and cognate manufacturers. For generations artists have worked in clay with as much genius and vigour as at present; the red clay figures, so familiar to all the older visitors of Dieppe, were as full of character and picturesque treatment as those in that broken fragmentary assemblage, now exhibited in the Italian section of the International Exhibition. But the progress towards perfecting the production of more ordinary articles, and of

We engrave in this column one of the many contributions of AUBUSSON TAPESTRY, sent by the eminent firm of REQUILLART, ROUSSEL, and CHOCQUEEL, of Paris. They occupy the highest posi-

On this page we engrave a SCOTO-AXMINSTER | CARPET, of Byzantine design, and also a BRUSSELS

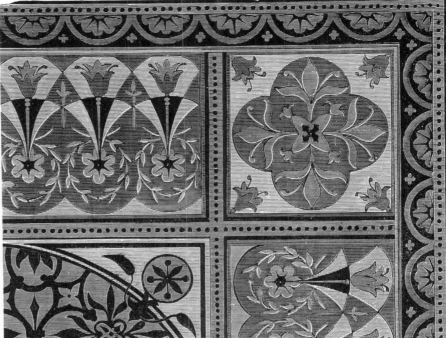

CARPET, of Messrs. RICHARD WHYTOCK & Co., of | Edinburgh, a firm long identified with the carpet

tion in the French capital, and are, we believe, the largest manufacturers of carpets in France, famous for their materials, dyes, and the beauty of design they apply to their productions.

trade of Scotland, as the inventors and manufactu- | rers of the patent tapestry and velvet pile carpets.

adapting the material to new purposes, has been most conspicuous, and now there are hundreds of beautiful and useful developments of clay unthought of by the last generation, while the energy displayed and the knowledge acquired through pursuit of these new purposes, have wonderfully improved the old articles of manufacture, from the paving brick to the chimney-pot—or perhaps more properly throughout the entire range of brick construction. In a general way, there are, perhaps, more bad bricks made at present than during any former period of our history, chiefly because the standard has been changed from quality to price, the latter being everything, and the former comparatively nothing, to those who build to sell; but it is equally true that there are also better bricks now made, so far as manipulative skill represents improvement, than at former periods, and this superiority is due, in a great measure, to the rapid extension

of clay manufactures. Thus Art-progress, like charity, is twice blessed, smiling on him who gives as well as he who gets, and multiplies the profits of both. The mind and eye have long been familiar with terra-cotta figures, although these have been single, or rather individual, works of Art; and among them it was not often that such works as the large male figure in the Italian section was to be found, and never, till recently, found as an example of Art-industry in Britain. But a terra-cotta stove is an idea of yesterday, and an indestructible terra-cotta, to be used for outside facing or veneer, is an idea barely realisable by minds only accustomed to the old adaptations of clay. Stone, wood, and "compo" cornices we know, but ornamental figures in baked clay, as bold in their projections as in stone, and as sharp as if cast in plaster of Paris, are realisations still unknown to the bulk of Englishmen able

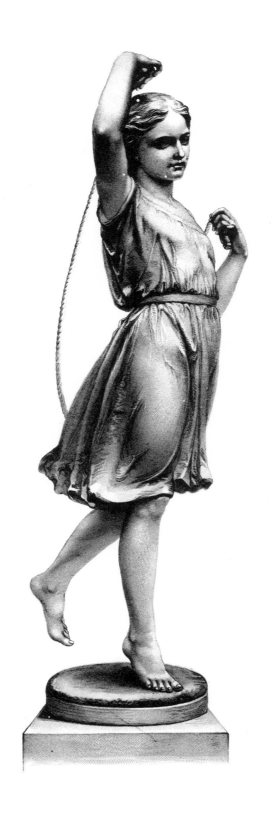

THE SKIPPING-ROPE

ENGRAVED BY G. J. STODART, FROM THE STATUE BY Mʀˢ THORNYCROFT.

LONDON. JAMES S. VIRTUE.

THE INTERNATIONAL EXHIBITION.

The principal object engraved on this page is certainly a wonderful piece of work—a triumph of Ceramic Art. As an effort of

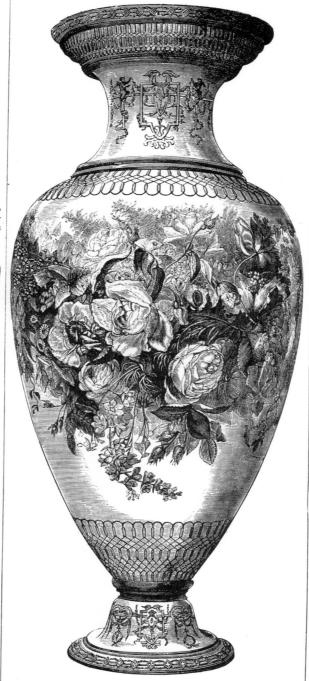

most deservedly obtained "golden opinions" for this truly great production of his Works. Its height is nearly five feet; the flowers are the natural size, painted by Mr. HURTEM. The

are from models by MONTI: they also are evidences of difficulties over-come—difficulties that can be appre-

"potting," it is of the rarest excellence, while, as an example of flower-painting on porcelain, it is perhaps the most perfect specimen

ciated only by those who understand the processes through which such pro-

supplied by the Exhibition. Mr. Alderman COPELAND, by whom it has been produced, at his manufactory, Stoke-upon-Trent, has

very striking and beautiful figures in statuary-porcelain, also engraved on this page, represent "Night" and "Morning," and

ductions must pass (being, moreover, of one piece) before they are "finished."

to build a house or mansion for themselves. No doubt stone is greatly superior to brick, as marble is better than stone, and when the standard of appreciation is regulated by cost, then will a plain stone house be preferred to an ornamented brick one; but there can be no better houses for England than those which well-burnt brick supplies. If to these the ornament now so inexpensively offered was judiciously applied as what it is—if a red brick frieze was treated as brick, and not as stone, which it never can successfully imitate, combined with other ornaments, treated and combined in the same realistic style—there seems no limit to the variety and consequent enlargement of this branch of trade; some of these brick mouldings and other ornaments have been successfully employed, and every year is likely to see an increase of such practice. The pillars, by Blanchard, in Florentine Gothic, or the fountains and other garden decorations produced by Pulham, show some of the

newer purposes to which this class of material can be adapted with success; while some of the objects made from "Martin's cement," and some pillars from Coalbrookdale, are admirable specimens of moulded clay. The bulk of these exhibits are connected with building purposes, in construction or decoration, but there is another class of objects in clay, of a more strictly ornamental character, for interior purposes, and among these the figures of Blashfield and the vases of Pulham hold a conspicuous place, alike for variety, artistic skill, and dextrous manipulation. The building bricks of Blashfield we shall hereafter notice at length.

DESIGN.

In an exhibition intended to display the progress of Art in combination with industry, the subject of design, as applied to the

On this page are engraved some of the exquisitely beautiful works of Messrs. MINTON, of Stoke-upon-Trent. The large VASE (of which there are two in the Exhibition) measures rather more than two yards in circumference. The support is formed by a group of four cupids nearly "life-size," joined together by the arms. The central part is decorated with a wreath of large roses of various colours. The modelling was executed by Mr. ALBERT CARRIER. The CANDELABRA,

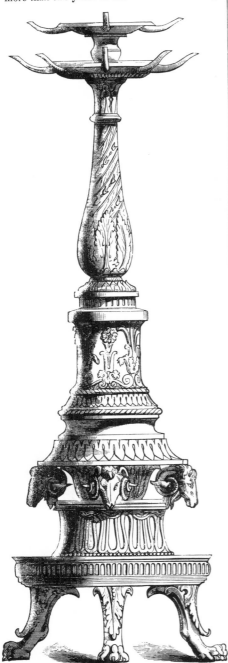

in Palissy ware (one of which we engrave), were

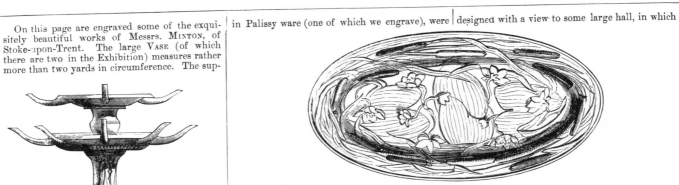

they would appear objects of much beauty and utility.

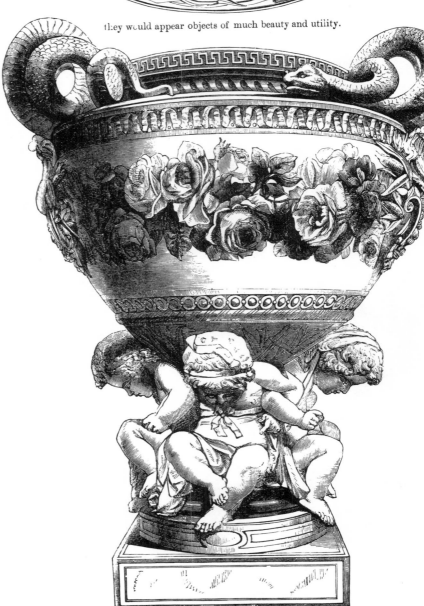

The style is Greek, finely modelled by Mr. EUGENE

designed with a view to some large hall, in which

PHŒNIX. We engrave, also, a small Water-lily DISH.

different products and manufactures, is of the last importance, and to this, therefore, we direct attention. The evidences of design displayed in the various objects exhibited have been already noticed, so far as opportunity offered; and to prevent misapprehension it may be stated, that only such works have been noticed throughout the essay on the classes it embraces, as were supposed to illustrate some principle, either by the conspicuous presence of some palpable error, or the equally conspicuous presence of some important truth in Art. This ground need not therefore be retrodden; and in glancing at design, attention shall now be confined mainly to those drawings which designers have exhibited as examples of their skill, and to one or two questions so intimately associated with the subject as to be inseparable from an estimate of its aspect and progress in England.

The question which meets us at the threshold of this subject is,— What is design? And judging from many specimens in the International Exhibition, it is one which many draughtsmen seldom ask, and never answer. It certainly cannot be a huddling together of things or parts incongruous, and converting them into a porcelain vase, a piece of plate, a cabinet, or a carpet. In other works, this would be called a chaos rather than a cosmos; for the very life germs of design are unity, harmony, and congruity, which are essential to beauty. Just as in the vegetable kingdom, one kind of seed renders the evolution of a daisy possible and necessary, while another kind of seed as necessarily sends forth roses, so has each elemental thought in design its own necessary development in the hands of the true designer; and he who can evolve this unity of expression from

The engravings on this page are of the principal parts of a

DESSERT SERVICE, manufactured

specially produced for them. The service is unquestionably a *chef d'œuvre* of British Ceramic Art: a very beautiful example of the *pâte tendre*, for which the works at Stoke-upon-Trent have obtained a "world-wide" renown. Its production has been a labour of time and cost; success has followed and rewarded both. The figures are of parian, lightly coloured

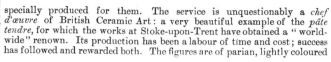

other portions of this admirable service. It was designed by the truly great artist,

JEANNEST, "who died too soon." The numerous and varied works exhibited by

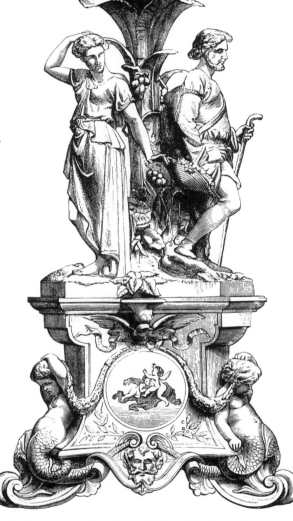

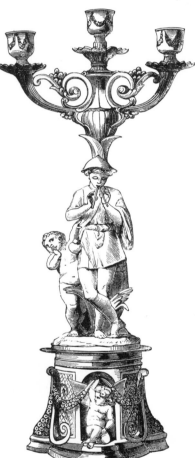

by Messrs. MINTON for Messrs. GOODE, of South Audley Street, designed and

and gilt: they are admirably modelled, while the cupid groups are skilfully and very gracefully painted by Mr. THOMAS ALLEN and other artists employed at "Minton's," who have largely aided to render the productions exhibited by the firm so creditable to the Art-progress of the country. We engrave the CENTRE-PIECE, and

Messrs. Goode are evidence that they are guided by a knowledge and love of Art.

his root of thought, is necessarily the most perfect artist. Design is not storing the mind with other men's thoughts, and then retailing them out as occasion requires; neither is it pilfering the work of others, piecemeal or in the gross, attempting to hide the theft by paltry alterations; but it is an expression in fitting combinations of the purpose and invention of the individual mind, so that it shall, with pleasure and intelligence, show forth to other minds the embodied idea of the artist. It is clear that, to a man of thought, this is no hap-hazard occupation—not a pursuit in which a mixture of dexterity and ignorance can ever hope to excel; and although genius discovers the deep truths of Art with sympathetic instinct, yet even genius can do but little without a substratum of sound knowledge, and the wider the range of acquired learning, the more certain the success and permanent glory of genius devoted to design. The necessity for such knowledge will probably be admitted, when design

treats of high Art, classical, historical, or epic. If an artist lays out his strength upon a picture in which figures are to play the part of emblems, he may not consider it too much trouble to make himself master of the knowledge necessary to illustrate his subject. Haydon was a remarkable example of such laborious fidelity in the working out of his historical pictures. But if this be necessary to the painter of pictures proper, it is still more essential for the high-class designer, for ornamental or decorative purposes. Take the harp or lyre as an every-day illustration, and, as generally used, it would seem to be considered that, with perhaps the exception of the Irish harp in this country, all other harps are alike, and that music is the theme symbolised by each. It was not always so, however, and may not be so now. The old Romans represented great learning and judgment by the harp. The Egyptians used its three strings to express their seasons. Others have ascribed to them still more recondite idealism;

The numerous works exhibited by Messrs. ROSE, of Coalport, and Messrs. DANIELL, of New Bond Street, have been objects of universal admiration:

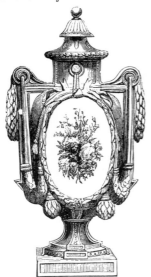

they have upheld and extended the renown obtained by the ceramic manufactures of England. The engraving on this page, in addition to two

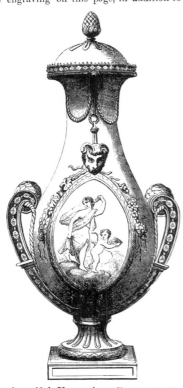

most beautiful VASES, is a CANDELABRUM, modelled by WORRELL, and executed by STREPHON. It is a production of great merit, standing nearly

four feet high, and so constructed

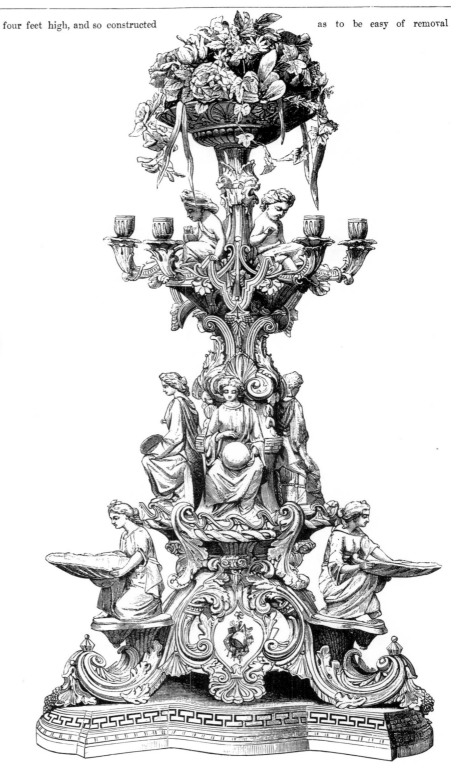

as to be easy of removal

in pieces. The figures supporting and ornamenting are all allegorical, and all appropriate.

and no matter whether these ancients were right or wrong, the practical question is, would a designer, by introducing a figure with a Roman or Egyptian harp, necessarily produce an emblem of music, or would his figure present a jumble of parts brought together by ignorance? The golden rod, the coiled serpents, the twined oak leaves, the twisted ivy intermixed with laurel, the iris flower, and almost all other objects used for decorative purposes, have from of old had meanings attached to each; and the province of the true designer is not merely to use with skill whatever comes to hand, but also to prevent his method of expression jarring with the idea he wishes to express. If, as Homer sometimes affirms, the iris is the emblem of eloquence, that flower would be most unsuitable as the portion of a design meant to suggest quietude and repose; and if, by the creeping ivy, the ancients signified the skill attained by long experience in constitutional debate, the converting ivy into a border for a panel of dead game shows at least a different idea in decorative designs. It may be that these ancients were wrong, and that one plant will express any idea in design just as truly as another; but that does not satisfactorily bridge the difficulty. The same may be said of words. *About* would express the celestial idea as truly as *above;* but as the latter word has been that adopted and universally understood, it would be for those who proposed the change to show why that change should be made. So it is in Art emblems, which are but words in another form; and it is for those who are perverting these emblems from their recognised uses to show what Art is to gain by the perversion. The subject could be pursued to any length; but these examples are sufficient to show the principle contended for, that design is an art based upon wide-spread general

We engrave three of the carved BROOCHES in

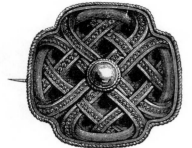

BOG-OAK contributed by Mr. CORNELIUS GOGGIN,

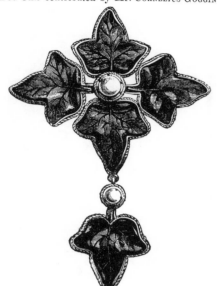

of Dublin. The setting is of silver gilt. The manu-

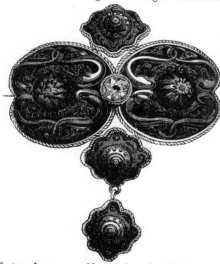

facture forms a considerable branch of Irish trade.

The very beautiful object we have engraved underneath is an INKSTAND, the manufacture of ZULUOGA of Madrid, produced for the Queen of Spain, It is of iron, inlaid with silver and gold. There are few works in the Exhibition to compare with, and none to surpass it, in delicacy and refinement of workmanship.

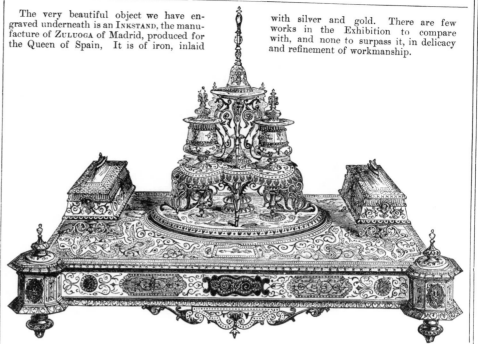

Mr. FORRER, of Hanover Street, Hanover Square, is an "ARTIST IN HAIR," and the four BROOCHES that follow are of his manufacture.

The gold mounting, although generally simple and elegant, is to be considered as subordinate, the value of the object being derived mainly from the memories associated with it.

It is impossible to overrate the exquisite

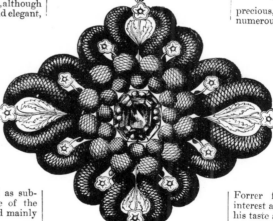

delicacy of Mr. Forrer's work —it is truly the work of an "artist." Those to whom such relics—almost imperishable—of dear friends are

precious, (and they are very numerous) will thank Mr. Forrer for the additional interest accorded to them by his taste and skill.

intelligence, as well as on artistic aptitudes,—that it is the offspring of genius nursed to maturity by knowledge, not the mean decrepid imp which tacks together the tawdry patch-work, so often uttered in its name. Design, in this higher sense, may be learned, but it cannot be taught, except very indirectly; and because of this *dictum* it seems to have been concluded that in England the teaching of such design should cease. But a fallacy lurks under the word used. If it is meant that genius cannot be implanted by mere teaching where it does not exist, the axiom is indisputable; but if it be meant that genius cannot be stimulated into more vigorous action by enthusiastic teachers, or that it cannot be taught the principles which the genius of another has elaborated in the same walk, the assertion would be treated as palpably absurd if applied to other branches of knowledge, and only passes muster respecting Art because of the public ignorance on that subject. The highest style of design is manifestly the want of

this country, and the best means to supply that want is, therefore, a question of growing national importance.

In sketching the progress of Art-industry, from 1851 to 1862, in this and other countries, it was impossible to ignore the existence and influence of schools for teaching Art, and several pages were devoted to these institutions. It was then shown, from official sources, that the schools of design established in 1837, after several tinkerings, were in 1851 declared a failure,—that the whole system of industrial Art-instruction from that period was remodelled,—and that there were grave differences of opinion as to the relative merits of the system which has been substituted for that previously existing. It was then suggested that the Commissioners should take some means of showing the value of these different systems of tuition, as the best method of settling the conflicting claims to superiority. Each system must be judged by its "fruits." The public could

We engrave a panel, one of many excellent examples of WALL-PAPERS,

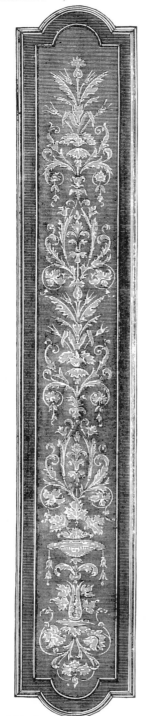

The DAMASK TABLE CLOTH engraved underneath is of the excellent and famous manufacture of Messrs. PIRRELL BROTHERS, of Dunfermline. It has the armo-

rial bearings of James Hay Erskine Wemyss, Esq., of Wemyss and Torvie, M.P. for Fifeshire, being those of Wemyss and Erskine quartered, and having in the

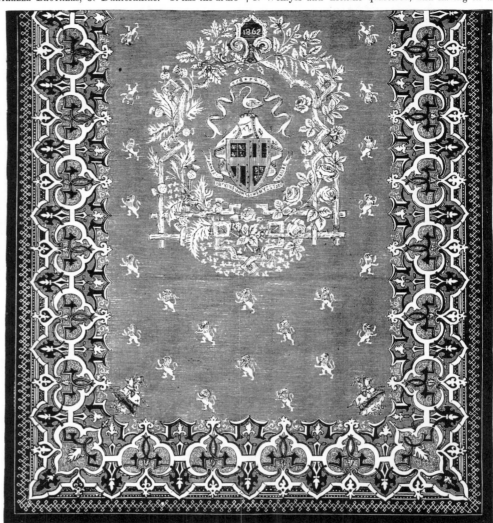

corners the emblem of Macduff, Thane of Fife, of whom he is the lineal representative. The design is

by Mr. J. N. PATON, to whom this branch of Art has been so long and so largely indebted in Dunfermline.

exhibited and manufactured by Messrs. SCOTT, CUTHBERTSON & Co.

We engrave one of the examples of SILK DAMASK for curtains contributed by Messrs. JACKSON AND

GRAHAM, of Oxford Street. The design is of a good and graceful character—as are all the issues of this firm.

only be expected to pay for results, and the way to test results was to show how many designs and designers each system had produced. That suggestion has been partially adopted, not by the Commissioners as such, but by the heads of the department at Kensington; and without the slightest desire to prejudice the result, it is neither unreasonable nor unnecessary to compare what is wanted by the country, with what has been asked for by the department. If the Admiralty desired to inform parliament on the respective value of wooden ships and iron-plated steamers as instruments of war, they would not ask for a return of all ships in the service, from the *Duke of Wellington* to the smallest craft. However valuable that information might be for other purposes, it could not produce what is required; and the common-sense axioms applicable to the efficiency of ships are equally applicable to Art-teaching. Nothing is to be gained

either for Art or the "Department" by not looking this subject fully in the face. The difference between supporters and opponents does not refer to the necessity for, and advantages of, Art-teaching. Upon these, both are equally earnest and agreed. The difference regards the relative value of two distinct systems, and the return asked by the authorities from the manufacturers, of all those engaged in any capacity in the production of works displayed in the International Exhibition, who have attended schools of design, may prove a valuable document for some other purposes; but, unless dates are added, it can throw little light, directly or indirectly, on the comparative values of the past and present systems of Art-education—the only question in which the public and parliament have any practical interest. It is impossible to doubt that all schools must do some good, and Schools of Art are no exception to this general rule; but

The CARPETS on this page are contributed by | Messrs. JACKSON AND GRAHAM, of Oxford Street, | London; the one is the ordinary "Brussels," the

other a "Patent Axminster." In the various | issues of this house there is ample evidence of | knowledge and taste; and these "issues" com-

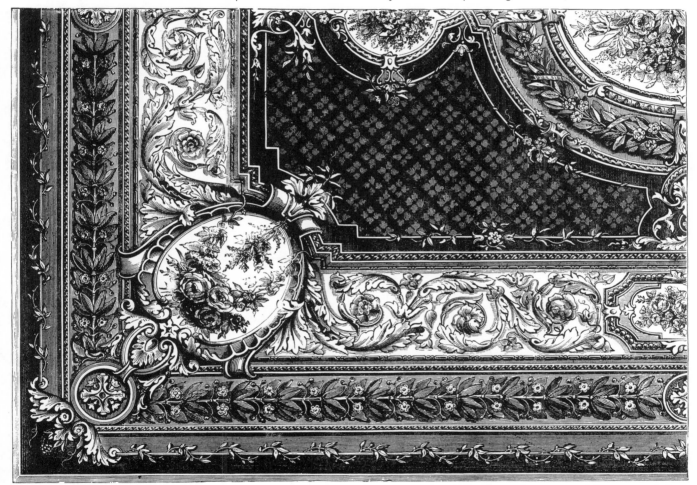

prise nearly all the articles required in furnishing | a mansion. We have engraved several of their | works, yet by no means fully represented them.

neither is that the question to be settled. In 1852, the annual cost of Art-teaching and its cognates was £15,000, and during that and the previous existence of the schools, the entire cost for the sixteen years was £87,000. In 1860, the annual cost had reached £103,382; while the cost from '54 to '60, a period of seven years, had reached an aggregate of £539,321; and the point to be ascertained is, not the value of Art-teaching in the abstract, but whether a six-fold annual increase of cost has produced a corresponding increase in results? A mere record of all who have attended the schools can throw no satisfactory light upon this, and it would be impolitic for the Department to arm opponents with the accusation that it had attempted to wrap up the truth by asking, and perhaps presenting, only half the statistics necessary for complete elucidation.

What makes some such division between the two systems of instruction of more immediate interest and importance is, that, apart from all other considerations, the former and cheaper system seems to have produced results in the International Exhibition creditable to it and to England, while those of the newer and more expensive system are neither so patent nor conspicuous. In many of those classes where the English manufacturer shoots far ahead of continental rivals, in design as well as in fabric, the medals have been awarded to articles produced by designers educated under the old system; while, so far as is yet known, the same success has not attended those educated under the later and more costly system. It is impossible to go over the several classes in detail: but take glass or carpets by way of illustration. It is universally acknowledged that Dobson and Pearce stand first among the exhibitors of all nations in glass, both for beauty of design and purity of metal; but

The GREAT CLOCK of Mr. JAMES W. BENSON, of Ludgate Hill, has attracted universal attention. Its construction has, we believe, ob-

tained general and strong approval; it is one of the largest chiming clocks as yet manufactured in this country, and is

adapted for a cathedral, town-hall, or any public building of magnitude, or any place where it is necessary to have a clock pos-

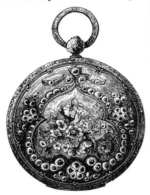

sessing great power, and able to overcome natural or mechanical impediments. Our business,

however, is only with the CASE. It is designed by Mr. LIDDELL, architect. The foundations were constructed by Messrs. KELK AND LUCAS, the contractors for the building, and all the

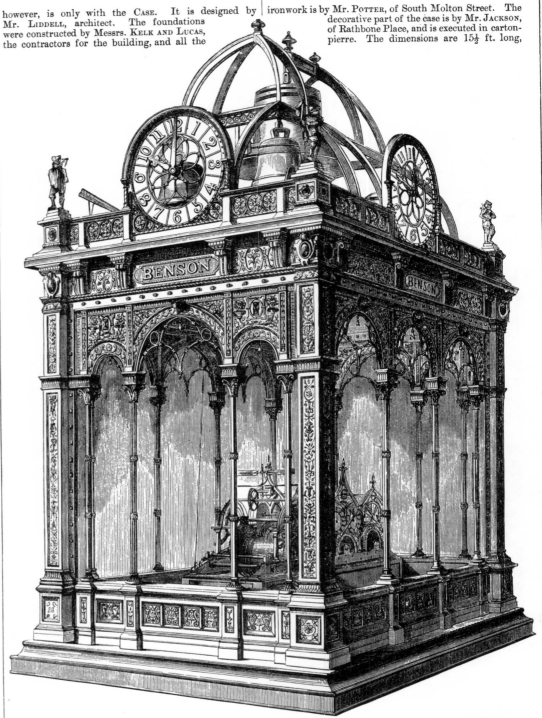

12 ft. broad, 14 ft. 8 in. in height to foot of upper dials, and 22 ft. 6 in. high over all. The work altogether is one of great merit, and amply deserves the distinction

ironwork is by Mr. POTTER, of South Molton Street. The decorative part of the case is by Mr. JACKSON, of Rathbone Place, and is executed in carton-pierre. The dimensions are 15½ ft. long,

we give it. We engrave also some of the WATCH CASES of Mr. Benson; they are from designs made expressly for him; the works also are of his manufacture.

Mr. Pearce was educated under the old system, at the discarded School of Design, and it will not be doubted that he is good proof of the practical value of that method of Art-education. Take carpets, and the same conclusion forces itself on public notice,—the best designers were educated at the old schools. In other classes the same result is found, and it may not be inopportune to glance at one or two points of contrast in systems which seem to have produced such different results. Design being the development of thought, what the manufacturers want is men who have thought, and can develop it in a style adapted to manufacturing wants. The old schools of design attempted to meet both these requirements, and although their means were moderate, they are not without trophies of success. The masters could not create genius, but they could stimulate Art-sympathies by pointing to what others had achieved, in a spirit calculated to raise the enthusiasm of the pupils, while they

could offer what experience proved to be the best methods of working out pictorial thought. They could not teach technical adaptation, but they could keep the minds of students alive to those cardinal truths upon which all successful adaptations rested. In both aspects their system was imperfect, and most imperfect in the last; but it was displaced by a system which, although infinitely more perfect upon paper, is charged with the two defects of costing more and producing less. The idea of teaching adaptation to manufactures was discarded, and attention was concentrated upon the teaching of principles; but another change accompanied this, and the men who could embue principles with life, energy, and discrimination, were superseded by those in whose hands the most vital principles became dead stock. The one failed in applying, the other ignored the application of, the Art taught to special manufactures; but while the former, in teaching principles, could not help teaching adaptation,

Messrs. BELL, of Glasgow, exhibit a CANDELABRUM, 5 ft. high, of "iron-stone

Messrs. HINDLEY AND SONS, upholsterers, of Oxford Street, London, exhibit, among other works of

great merit, a BOOK-CASE, of which we give an engraving; it is of light oak, admirably carved, the

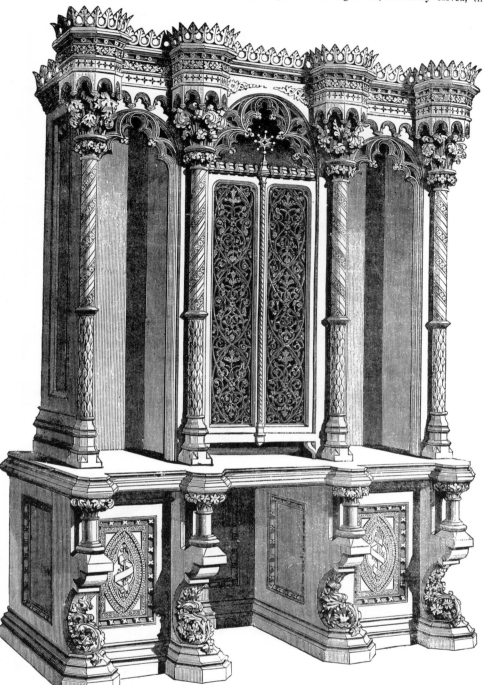

porcelain," intended for a hall or staircase.

design a judicious and very effective mediæval adaptation. The contributions of this eminent firm sup-

ply evidence of sound judgment and advanced taste in the designer, and of able and skilful workmanship.

the latter has had principles systematised, labelled, and tied with red tape. The one class, being fired with artistic aspirations and elevated with scholarly impulses, the most casual remark was more or less instructive; the other has degraded Art-education into the repetition of a soulless routine, which mere mechanism could carry out more perfectly. Certificated masters, when the man is not better than the system, are line-making instruments; the most that could be hoped for from the present system would be, to see the people universally converted into copying machines. This is not absolutely useless as a branch of common school education, although it cannot merit the name of education in Art; but it is worse than useless in relation to the teaching of design, because it begins by confounding principles with rules. Any journeyman can learn rules, and beat these into apprentices or pupils, without knowing more of principles than those he attempts to teach; and while such a process may cramp,

it is not likely to stimulate, genius: it never has done so, and, it may be affirmed with safety, it never will. Leslie, who affirms that Art may be learned but cannot be taught, eulogises the wise neglect of Fuseli in allowing Wilkie, Haydon, Etty, Mulready, with others, including Leslie, to develop themselves; but almost in the next page he shows us how Fuseli's wise neglect was practised. Westmacott and the "Keeper" began to talk over the Elgin marbles in the hearing of the students. Fuseli was not so ardent an admirer as Westmacott. In reply to a remark in praise of the Theseus, Fuseli exclaimed,— "The Apollo is a god, the man in the mews (the Monte Cavallo) is a demi-god, and the Theseus is a man." "You will admit," said Westmacott, "that he is a hero?" "No," replied Fuseli, "he is a strong man."

This example of Fuseli's wise neglect contains an illustration of how he was teaching principles invaluable to those by whom he was

The CABINET engraved underneath is the manufacture of the eminent firm of GILLOWS, of Oxford Street. It is exceedingly graceful and refined in design and execution. It is in the style Renaissance, the grounding in lancewood, with purple wood bands, inlaid with white wood, the columns carved in boxwood. The plaques of porcelain, by Copeland, are illustrative of poetry and science. The ends are fitted for the display of Art-works; the top is also richly inlaid The whole is of English design and manufacture. Two very elegant chairs, *en suite*, are exhibited with this fine production of Art.

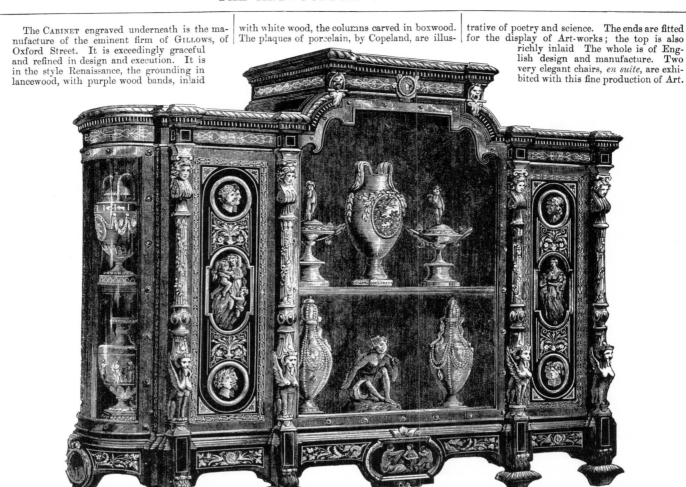

We engrave the upper part of one of the many carved CASES in which the contributions of Bavaria are exhibited, many of which are excellent examples of design and workmanship. This case, which contains the pencils and drawing materials of GROSSBERGER AND KURZ, is produced by ADELHARDT, carved by EIBL, and designed by Professor EBERLEIN—all of "venerable" Nuremberg— " Quaint old town of toil and traffic."

There is in this court many such productions as that we engrave, to which we hope the attention of our wood-carvers has been directed.

surrounded; while he allowed them to find out their own rules for producing their drawings from the antique, he was training them, by his conversations and discussions, to grapple with and think out the highest principles of Art. That discussion involved the entire range of generalisation, composition, and expression; and it is not difficult to imagine how it was re-discussed over the coffee in Rathbone Place by Wilkie, Haydon, and their compeers. The new system ignores such themes; it has exchanged principles for rules, but experience is anew demonstrating that designers are not made by machinery, and that nothing worthy of Art will rise at the call of mechanical task-masters. For all national purposes, the object of teaching Art is to strengthen the imagination into vigorous practical productiveness; and how is that to be done if the teaching be separated from artists and the higher Art-influences of the nation? Pupils should be thoroughly imbued with knowledge; they should learn geography and botany, and become experts in straight lines, ovals, and reductions; but when all this has been acquired, the knowledge so gained, useful as it is, bears the same relation to design that a carver's tools do to his finished work. What advantage is it to the development of thought that pupils should waste weeks and months on many of the prize examples exhibited at Kensington, where laborious etching appears to be esteemed the one thing needful from the students? True, neat-handedness is a high qualification for some classes of industries, but this kind of labour has no necessary connection with design. A youth might lay lines, as an engraver does, with unimpeachable regularity, over forms, so as to produce relief, or he might stipple till he became blind to effect the same purpose, and after he has succeeded, what has been acquired? The general history of engravers can answer that question; and while it is fortunately true that some engravers, with artistic capacity,

The SIDEBOARD we engrave on this page is manufactured by Messrs. C. & W. TRAPNELL, of Bristol. It is of light oak, elaborately and ably carved from the design and modelling of Mr. C. TRAPNELL, the senior partner of the firm. In this work the "constructive" and the "decorative" are in harmony, and seem to have been thoroughly understood, while the various details are all in good taste—the panels and frieze mouldings more especially. There are few examples of the art of

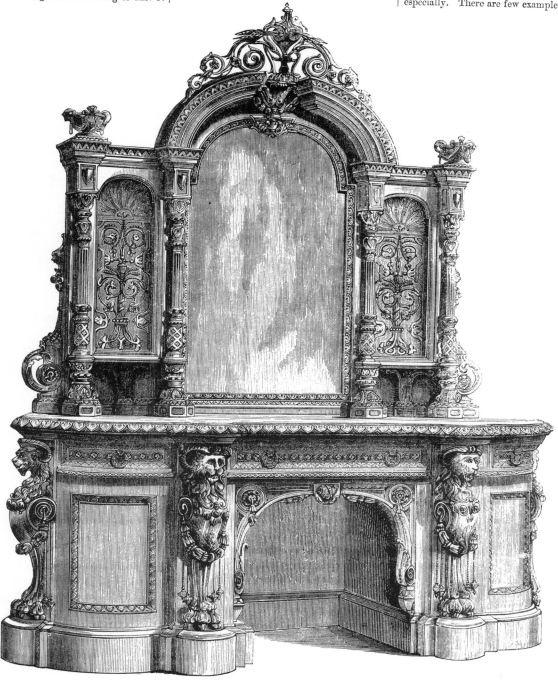

the cabinet-maker that surpass this in excellence, as a provincial work, both in design and execution, and exclusively the produce of English workmen: the distinction it has obtained and the general attention it attracts are amply merited. It is gratifying to find Bristol so well represented.

have often, by neglect of the formal routine of their craft, produced great works,' it is equally notorious that those who have spent their strength upon the regulating of these lines, treating them as the end rather than the means, have invariably come to nought in their profession; so must it be with those who are taught to spend their strength in going through the same process with chalk. It has been demonstrated in hundreds of examples that machinery can produce this effect of *relievo* in lines; and the paucity of designs from the pupils brought under the influence of this tuition, for the last ten or twelve years, shows that it has produced no greater benefits to designers than it formerly did to engravers. In truth, the whole basis of such work is one gigantic mistake—a mode of producing pretty things on paper, such as may be very captivating to those ignorant enough to mistake prettiness for Art—a system of small touch which any dunce could either teach or learn who has ordinary patience and eyesight, with nothing else to do, but which no artist in the world's history has either practised or taught of his own volition, except as an occasional freak, or in obedience to the demand of a vitiated and inartistic public. For all purposes of design, or even for the pictorial expression of industrial thought, the roughest sketching with charcoal, where the effect is rubbed in with the thumb, is a more practically useful style of Art-education than these efforts of laborious idleness. The studies which Fuseli used to correct with his left hand for the students, or which the artists who first had the charge of our national Art-education encouraged, appear to have produced a race, each in its own domain, to which the present debilitated scheme is raising no successors; and it seems difficult to believe that the authorities or the public can be satisfied with the present most untoward state of things. One-third of a generation, and two-thirds of one million sterling, absorbed by

The engraving that heads this page is part of a carved CASE, exhibiting the pencils of BEROLZHEIMER, of Fürth.

Messrs. EDWARDES & Co., of Regent Street, carvers in wood and stone, exhibit

The BOOK-CASE, with writing-table, of oak, is the work of Mr. JAMES FORSYTH, sculptor, who is a large contributor of productions in

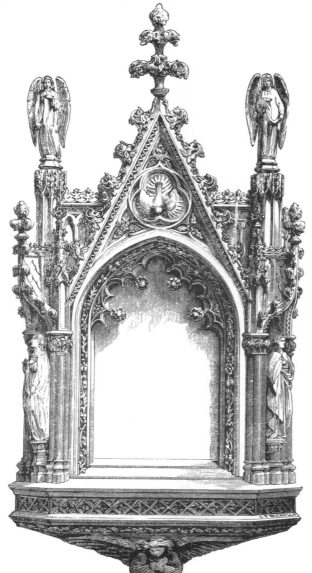

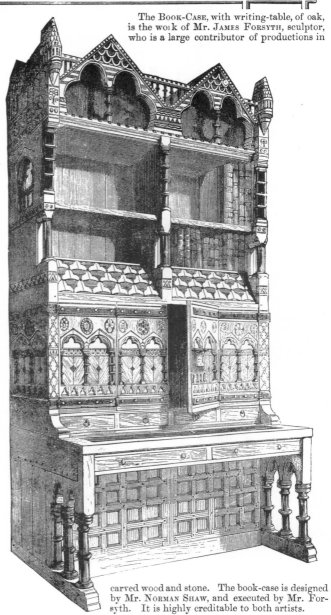

several of their productions; we engrave a MURAL TOMB, carved in marble.

carved wood and stone. The book-case is designed by Mr. NORMAN SHAW, and executed by Mr. Forsyth. It is highly creditable to both artists.

the present system, ought to have produced better results. Unfortunately, every district in the country has some near example of this truth, that, whatever its other advantages, the present style of Art-teaching is not producing results in design commensurate with its cost, and no general return of pupils under all the schemes can settle the merits of opposite systems.

But there is another side to the present system of Art-education. No scheme of unmixed error, and producing evil and disaster, could exist, however buttressed by official influence; and, as the schools have ceased to turn out designers, they have endeavoured to turn out neat-handed workmen—that is, young men who have undergone a vigorous training in neat-handed drawing. That this lower quality is one not to be despised, thousands of practical illustrations in the International Exhibition sufficiently prove; and that the schools

throughout the country are exerting considerable influence in this way, on nearly all branches of Art-industry, may fairly be conceded. Nor was this influence unneeded, for none who can look back on the Exhibition of '51 can forget the deplorable want of neatness and finish which many of the otherwise clever works displayed. Everywhere, and by everybody, this fault was recognised, as that one defect which appeals most strongly to, and is most easily appreciated by, those least conversant with Art. To provide a remedy for a deficiency so important was one of the first duties of the Art-teachers of the country, and the means adopted were sure to be successful. There are no two generalisations, from the history and development of Art, more uniformly true, than that artists of genius have, as a rule, been indifferent to neatness of production; while those without genius, who have betaken themselves to drawing, have had nothing

We engrave underneath part of the ebonised CASE (erected by Mr. CRACE, from the design of Mr. SEXTON), which contains productions manufactured and exhibited by the NORTH BRITISH INDIA RUBBER COMPANY.

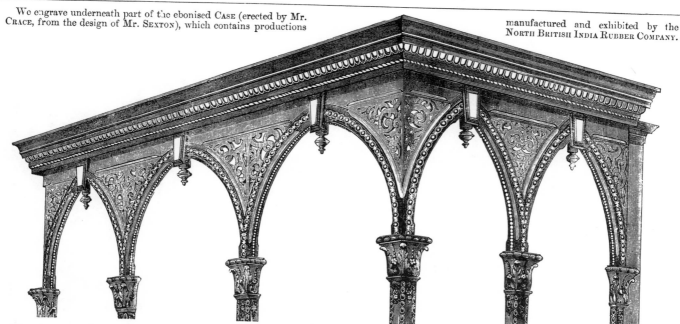

The very elegant OBLIQUE GRAND PIANOFORTE, of which we give an engraving, is one of the contributions of the renowned firm of COLLARD AND COLLARD. The decorations are richly carved and gilt in the style Louis Seize. The Oblique Grand Pianoforte is an instrument of comparatively recent introduction. The application of Collard and Collard's important improvements in upright pianofortes, have tended in no small degree to

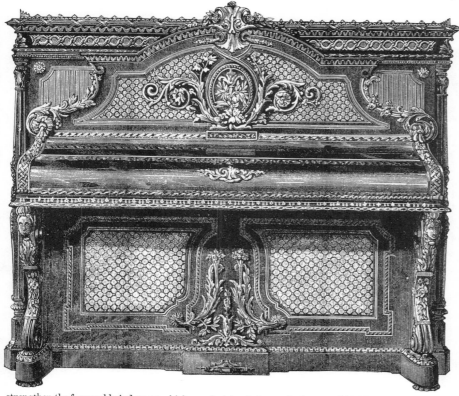

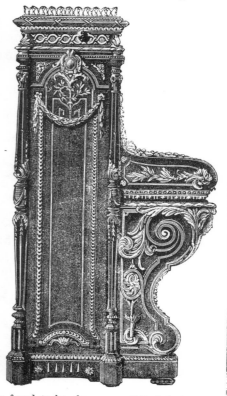

strengthen the favourable judgment which musical connoisseurs have bestowed on them. Convenient and elegant in form, and highly effective in power of tone and perfection of touch, these instruments are found to be—for rooms of limited size—a desirable substitute for the full Grand Pianoforte.

but mere neatness as a passport to toleration. This distinction between drawing-masters and artists is one universally known and recognised; and the first great step in recasting the schools of design was to get rid of genius, and lay in stores of manipulative talent. Nothing could have been more successful, the entire current of the pupil's thoughts, as well as Art-education, was changed: and instead of dreaming over great designs in charcoal or rough ideas in black chalk, they were turned to the less congenial work of drawing lines or curves perfectly by free hand, reducing the size of some ornamental form within a certain number of minutes, or etching by line or stipple the shadow from a plaster cast or drawing, as if being all trained to become Bartolozzis or Sharps. That the pupils of Massaccio and Raphael, of Michael Angelo and Del Sarto, of Bartolomeo and the Caracci, knew nothing of such lessons, is probably true; but such pupils intended to be artists. It may be doubted whether Cellini, Donatello, or Della Robbia, provided a similar course of study for their disciples, because artists could have no sympathy with such; but for that reason it was sure to commend itself to a Committee of Privy Council, selected solely upon political grounds, and who, from no fault of theirs, fully represented the Art-ignorance of the nation while presiding over and directing the Art-instruction of the country. For such authority neatness was essential. They got what they demanded; and if the element of design has been all but extinguished, the neat-handedness of the artizans has been increased, and the general productions of England have been, to that extent, bettered. Nor has this been the only advantage which the substitution of drawing-masters for artists has secured. The thinkers were apt to be erratic; to perplex the student with suggestions; to do

The HARMONIUMS of Messrs. BOOSEY AND CHING, of Holles Street, London, are familiar to every household where music is a luxury. The one we engrave is a very beautiful instrument; the case is of walnut wood, richly carved. The contributions of Messrs. Boosey merit the honours received.

all good; the simpler patterns prevail in the issues of this establishment. It is the modern

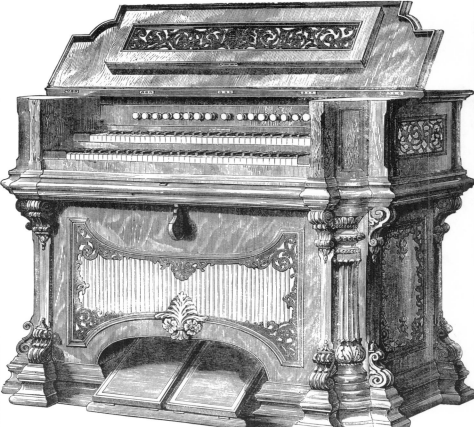

and improved taste to prevent the walls of a drawing-room from being the part of its decoration that most prominently attracts the eye.

We give some examples of the excellent WALL

PAPERS exhibited in great variety by Messrs. SCOTT,

CUTHBERTSON & Co., of Whitelands, Chelsea. They

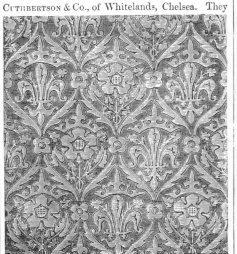

are of all classes,—costly as well as cheap,—and

The productions of this house are, generally, wisely and judiciously designed with that view.

as Fuseli did with Westmacott—get into discussions on great principles; or to waste the time of pupils in trials of forms or effects which turned out practically worthless. The drawing-masters insured the students against all such risks, and concentrated attention on things already done. These had been produced better and worse by different artists; but the safe conclusion was adopted, that within a given circle, whatever was was right; and as the later Spanish painters boasted themselves better than Velasquez, because they painted smoother, so the drawing-masters assisted the students to "tidy up" what the ancients had left in a less highly finished state. This devotion to recognised standards, even when these did want helping out, has also been of essential service to the Art-industry of this country, by combining with other influences, first, to make repetition of the past the standard of present excellence, and more recently, as in the International Exhibition, by toning down the

efforts after invention within the limits endorsed by the assent of many generations. Growing taste may have also helped towards this end, but the chief merit belongs to the Department of Science and Art, who has made it the key-stone of its Art-teaching, and, through other influences, the fashionable theory in Art-industries. Whatever the drawbacks, this is a present advantage to all classes of producers and consumers; and although there is still much in the same path undone, to the Department and its teaching belongs the credit of much that has been accomplished. If design has not prospered, the next best kind of knowledge has been freely spread; and what to avoid, what to borrow, and how to reproduce it with neatness, are at least serviceable attainments—more serviceable in Art-industries than in Art, but not to be despised in either. Whether the manufacturers who want designers proper to compete with those of other nations, or the people, who suppose that schools of design

THE INTERNATIONAL EXHIBITION.

This page contains engravings of some of the many beautiful works contributed by

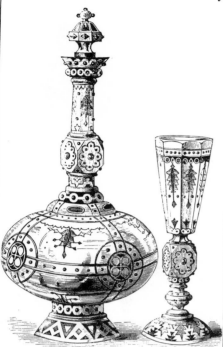

Russia: the first is a DECANTER and WINE-GLASS, from the IMPERIAL MANUFACTORY; the

duced. The three engravings that follow are productions in silver of the firm of SAZIKOFF, of

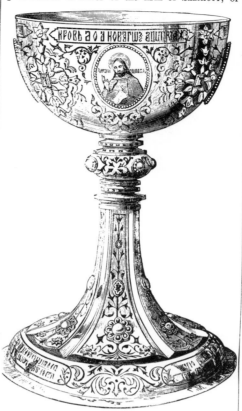

St. Petersburg and Moscow. They are original

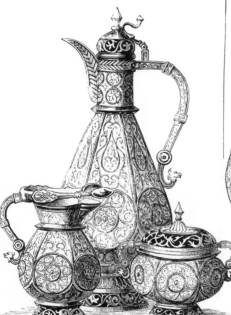

colours and imitation jewels are skilfully intro-

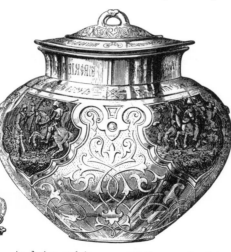

in design and in ornamentation—rendered costly by Art. The CHALICE is enriched by rare gems and workmanship. The CLARET-JUG and CIGAR-CASE, of silver, in the third column, are the productions of GOODKIN, of

Moscow. The whole of the works exhibited by Russia in the International Exhibition—and they are numerous and varied—are of a high

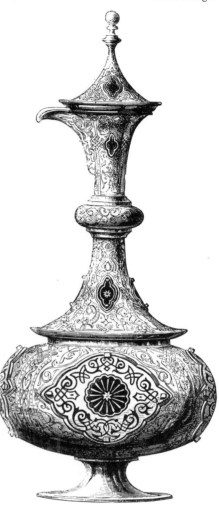

order of Art, designed with great ability, and executed with exceeding skill. They have all,

or nearly all, found purchasers in England, although the prices are generally large—not, however, beyond their value as rare artistic novelties.

are answering to their popular title, will remain satisfied with the lower quality of outcome, are questions looming in the distance. These do not stand alone, but are mixed up with broader and still more important issues to general Art-interests of the kingdom, and of which the union of Art and Art-industry in the International Exhibition is at once suggestive and instructive—suggestive that the Art-education of the nation should be under those specially qualified to teach it; and instructive as proving the necessity of this by an irresistible demonstration, that the principles of all Art, pictorial and industrial, are indivisible: different applications of the same essential truths.

From the professional designers of England little or nothing has been exhibited apart from manufactured works. Nor do this class—they cannot, as a rule, be called artists—constitute more than a very small fraction of the industrial community; while those who are really

worth the name are usually attached to manufacturing firms, who employ all their time, and carefully hoard all their serviceable artistic thought. The designs of this small but important class must be looked for, not in the gallery appropriated for drawings, but among the many completed specimens of manufacture scattered throughout the Exhibition; and to the most important of these reference has been already made in glancing at the various classes of Industrial Art. From several causes, that was not done so perfectly as was desired: first, because, in the earlier days of the Exhibition, much that was in the building could only be imperfectly seen; but also from the fact that, in several classes, works of importance were not placed in the building till after the article bearing on that class was published in the ART-JOURNAL ILLUSTRATED CATALOGUE. The consequence of this has in some few cases been that works of less importance are given as examples of principles contended for or dis-

Besides some very elegant JEWELS—generally

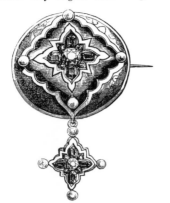

of large value, setting precious stones—manu-

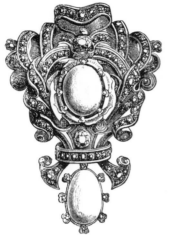

factured by Mr. JOSEPH ANGELL, of the Strand,

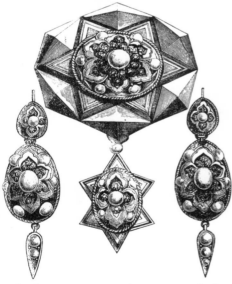

London, we engrave a CANDELABRUM of silver.

The figures are designed to represent Science, Art,

figure of Peace. The figures are very

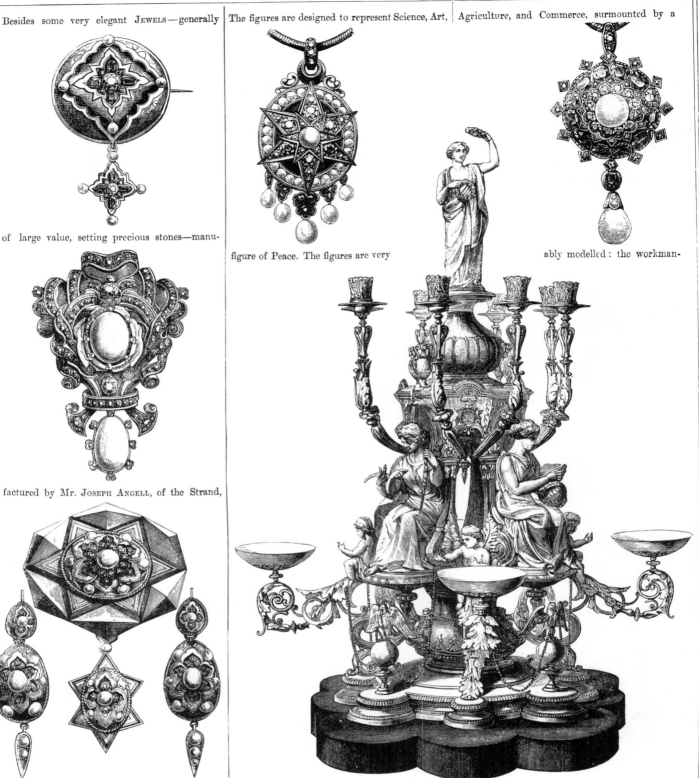

ship of the whole is skilful and brilliant :—alto-

Agriculture, and Commerce, surmounted by a

ably modelled : the workman-

gether it is a fine production of Art-manufacture.

puted, in lieu of other works in the same class since added to the Exhibition. Furniture forms one case in point. These more important examples might not only have been more worthy of individual notice, but might also have more fully illustrated the truths contended for, besides opening the way for the discussion of subsidiary questions of detail; yet they do not seem to affect the broad general conclusions reached from examination of these classes as a whole, and do not, therefore, infringe on the truth or otherwise of those general principles of design enunciated in previous chapters. Nor is this cloud of regret for unwilling silence on later added works without its silver lining; for it would have been impossible, in the interests of truth and the general body of exhibitors, to have ignored

instances in which the works of one man are unblushingly exhibited as the products of another, or where, by the chicanery of commission or omission, or these combined, exhibitors of one nation assume the credit of works notoriously the product of another, both in design and execution.

In that portion of the gallery set apart for designs, the drawings are arranged in an effort after chronological order; and in the period ranging between 1740 and 1780 there are many very interesting specimens by Chippendale, Lock, and others. It is impossible not to admire the artistic spirit evinced by every touch of Chippendale's pencil; but, as the longer a bowl on the wrong bias runs it gets further from the " jack," so, the more elaborate Chippendale

The exquisitely beautiful *repoussé* TABLE, exhibited by Messrs. ELKINGTON & CO., the surface of which we engraved on a former page (91), we are now enabled to give in its complete form. The design and the execution of the whole of the ornamental portions are by M. MOREL LADEUIL, one of the

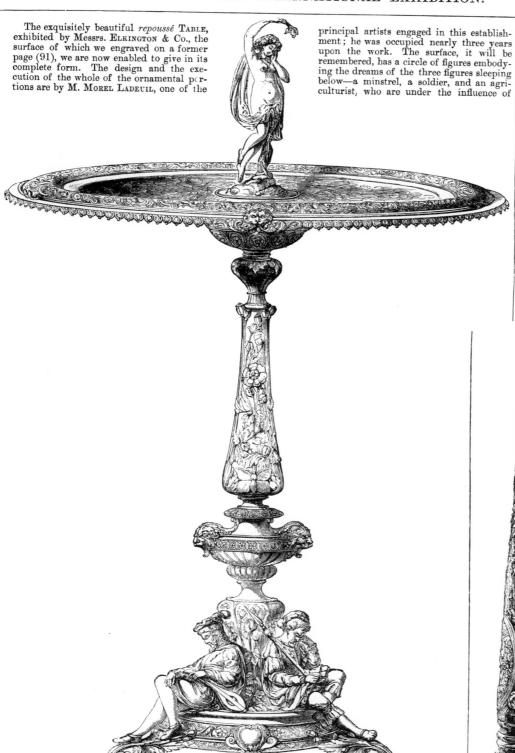

principal artists engaged in this establishment; he was occupied nearly three years upon the work. The surface, it will be remembered, has a circle of figures embodying the dreams of the three figures sleeping below—a minstrel, a soldier, and an agriculturist, who are under the influence of

belong to the same eminent manufacturers. The upper one is a beautiful enamelled PIANOFORTE CANDLESTICK, designed by A. WILLMS, in which the

butterfly forms a prominent feature of the ornament. The lower is a reproduction of the famous TANKARD,

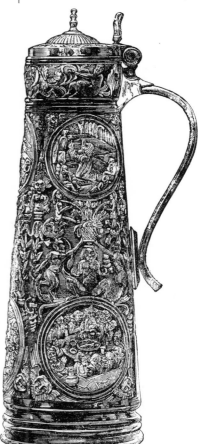

the goddess standing above, in the act of strewing | poppies around. The other two objects on this page | known to fame as "Martin Luther's Tankard."

becomes, he gets further from the truth in design. He was a strong man, overcome by the Art-vices of his age; but even his error has a charm which other men cannot impart into their truth. He was a designer in the best sense, however perverted the style in which he clothed his thoughts; and although a follower of the worst ages of France in the general type of his expression, he was no mere copyist of French designs, but infused his own spirit into works remarkable for harmonious unity. His fantasies may now provoke laughter, but it cannot be denied that they were inspired by genius, and guided by method; and in these days we have often to tolerate the fantastic in design, without the illuminating ray which Chippendale shed over all his eccentricities, as they appear to us, but which brought him great renown with his own and the succeeding generation. Of Lock and the others little can be said. They lived, made

drawings, and died. From the Schools of Design little has been produced beyond satisfactory mediocrity, and nothing to inspire anticipating hope. The school at Birmingham sends both drawings and designs: Stanton draws and designs, exhibiting dexterity in means as well as beauty and novelty in results; while Jackson exhibits the legitimate outcome of the general system of Art-teaching adopted in these schools—ability to draw out with care what Willms has suggested and designed. But even the most ardent admirer of native industry will not be able to accept this as *all* that such schools should produce; although it will be hard to find among their exhibited examples much that is entitled to a higher place in Art. One good carpet has been sent from Glasgow, designed by Kilpatrick; and the metal work and cups by Smallfield are highly creditable—individually as well as relatively; these

Messrs. CHRISTOFLE, of Paris, not only contribute grand, massive, and costly works in silver and in elec-

tro-plate; they exhibit productions of small cost, yet of exceeding beauty of design, and great sharpness

and clearness in casting. Those we engrave on this page are merely "bits," intended for the use of CABI-

NET-MAKERS to introduce into articles of furniture,

other purposes, and are highly suggestive. There are, indeed, few manu-

facturers of any order who may not avail themselves of the graceful artistic

"hints" of Messrs. Christofle. This house carries on an enormous trade, not

only in France, but in the several other countries of the world. It will be

obvious to those who examine their works, large and small, in the International

They are applicable for other purposes, and are highly suggestive.

Exhibition, that their fame has been obtained mainly by the employment of

true artists and skilful artisans in the

creation of their works—as regards not only design, but modelling and finish.

constitute all that claim special mention among the scores of feeble attempts exhibited. In other parts of the Exhibition there are, here and there, designs by some of these students practically embodied in manufactured articles. In one corner paper-hangings, in another a mosaic table; there one small thing, and yonder another; but even where medals have been awarded—as to the mosaic table—it has not been for the quality of the design, but for the best specimen of marble inlaying hitherto produced in England, or some similar cause. Yet there is nothing in such designs absolutely bad; on the contrary, some of them are very well; but in design, as in poetry, this quality of respectability makes its productions intolerable to gods and men, because there is more to hope from vigorous badness than from unimpeachable mediocrity.

In the French section, design was well represented in 1851; it

also formed one of the chief attractions of the Exposition in 1855; but the display on the present occasion is remarkable only for what is not there. In the Exposition at Paris, the clever combinations of Matthieu, the bold harmonious depth displayed in the designs by Naze, the elegant patterns for shawls designed by Longs, although rather raw in colour, were still worthy of high commendation; the beautiful designs for lace by Girollet, and drawings of scarfs by Pas, beside whole rows of choice designs for tapestries, church vestments, and other things, formed a gallery as interesting to the general public as it was instructive to those who felt sufficient interest to go through it in detail. There was, moreover, a fine collection of photographs from natural flowers and plants, well calculated to assist designers in their work; but what was then a grand array of interesting works has now degenerated into a small collection of rather

THE INTERNATIONAL EXHIBITION.

The ROYAL PRUSSIAN IRON FOUNDRY does not contribute largely to the Exhibition; its "show" is a small group,

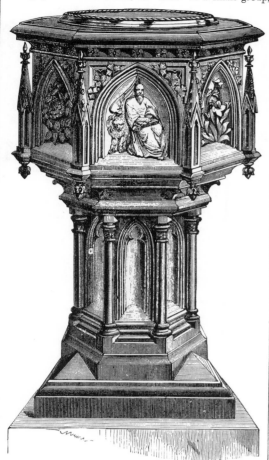

of which we engrave the chief objects—a LAMP STAND, the leading feature in which is a group of boys playing

on musical instruments, the design by Herr STRACH; a FONT, upon an octagonal shaft composed of columns and

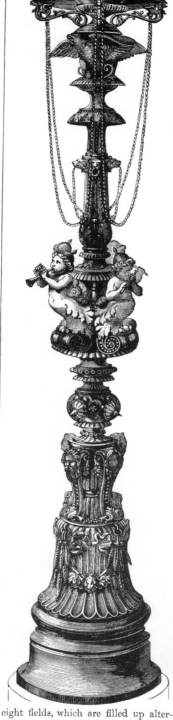

pointed arches—the upper part presents eight fields, which are filled up alter-

nately by the four Evangelists and flowers—the design by Herr STÜLER; and a VASE, the figures in bas-relief, representing War and Peace—the prin-

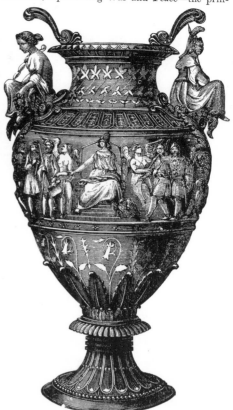

cipal figure, Borussia, being seated on a throne receiving representatives of the Arts and Sciences, &c. This also is from a design by Herr STÜLER. They

are works of a high order of merit; the castings, sharp and clear, uphold the renown of the "Foundry." They are in parts inlaid with gold or silver.

indifferent designs. The same cleverness in handling is visible now as then, while some of the same artists still display their prowess and vigour, alike in colour and drawing; and the delicacy of the muslins by Naze shows that the French artists are still remarkable for those qualities which formerly made them arbiters of European social taste. But even with these they neither appear in number or in strength such as was their wont, and the reason is obvious. The progress of this and other nations in higher and purer styles of Industrial Art, has left the French designers stranded high and dry upon the rocks and shoals of shrivelled fancy and ill-used naturalism. Wanting versatility, or rather failing to appreciate and adapt themselves to the change, they have stuck fast where they were in 1851; and the French commissioners wisely judged that a large display of the stagnation would neither increase national honour nor individual profit. Still, there are symptoms of French artists yet

retaining a position, though not their former position, in design; it will not, however, be among that class who do in design what Ary Scheffer did in high Art—represent German thought in French expression.

None of the other exhibiting nations show specimens of design applicable to industry. Many examples of something between pictures and decorations may be seen in the west gallery, and most of these are equally bad for either purpose; but, as they are arranged with pictures, they must be treated as such, if touched upon at all. From this general conclusion Denmark must be exempted, for the Danish Court contains examples, both in colour and form, of a style far above that displayed by similar European states—a style which combines imagination with reality, and clothes both with artistic skill. These are subjects that will probably supply the ART-JOURNAL with valuable material for comments hereafter. If space and opportunity

Messrs. YATES, HAYWOOD, AND DRABBLE, of Ro-

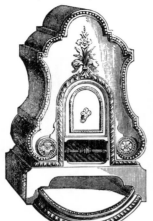

therham, and Upper Thames Street, London, hold high rank among the iron manufacturers of York-

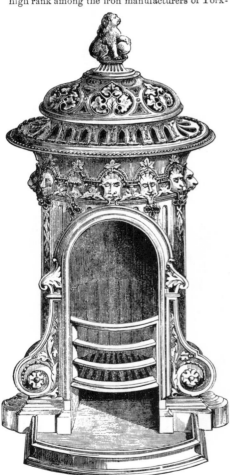

shire, and have long been renowned for the excel-

lence of their productions. The HAT AND UM-

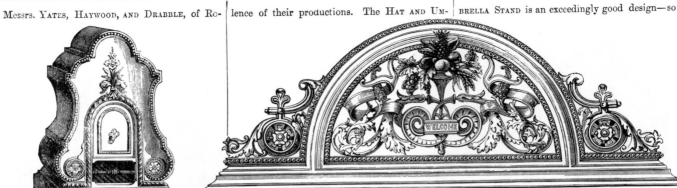

good, that we have enlarged a portion of it. We

BRELLA STAND is an exceedingly good design—so

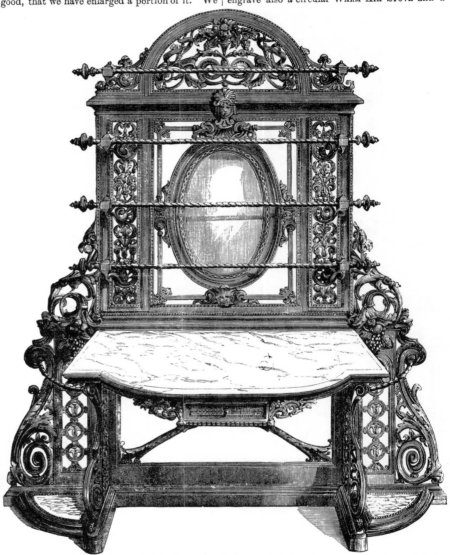

engrave also a circular WARM AIR STOVE and a

"GILL STOVE," in which are combined "conve- | nience, utility, and economy" with good Art.

had been fiftyfold more abundant, there would still have been sufficient material to justify detailed criticism of the various articles exhibited, and not without advantage to the elucidation of important truths in construction or ornamentation, or both. To notice even a tithe of these would be a task beyond the endurance of readers; for however valuable such works may be, the mind becomes satiated even with good things when heaped up in excess. There is one subject, however, that has not been touched upon in this essay, which enters so materially into all questions of comparative Art-industry, that although secondary in one aspect of the International Exhibition, is yet, in another aspect, primary. Hitherto we have been dealing with the comparative development of artistic and decorative principles: now we shall glance at comparative national prices; and although individual instances from various states may be selected

that would be against any general average, yet sufficient study and attention to relative prices will sustain these general conclusions. Italy, as showing the highest development of Art-industry, will also be found the most expensive for the higher class works,—not more expensive in proportion to the quality displayed, because some of these, as in wood-carving, can be found nowhere else—but still more expensive, from a utilitarian point of view, just because of the Art-excellence offered. This high-priced quality sheds its influence on works of second, third, fourth, and fifth-rate merit, an example of which will be found in the Italian Furniture Court. There will be seen, unpolished and unstuffed, simple frames, which in England would be called a couch, a sofa, and an easy chair—four others, representing a drawing-room, dining-room, parlour, and kitchen chair, seven in all, and for these unfinished frames the

Birmingham is striving to be the rival of Sheffield in the production of stoves, and other works in wrought and cast iron. Among the best of

its exhibitors are Messrs. HENRY CRICHLEY & Co., whose many excellent works may fairly compete with those of the great emporium of the trade.

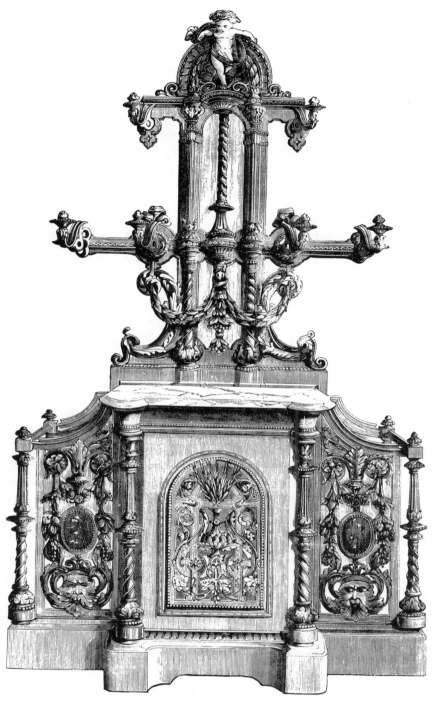

We engrave a HAT AND UMBRELLA STAND manufactured by them. It is of iron, bronzed by a peculiar, and, we believe, costly process, but produced also in the "natural" colour, which, while less expensive, has a better effect. The design tains two of the minor productions of Messrs. Crichley, the one being a DOOR-PORTER, and the is exceedingly good; the moulding and casting are also of much excellence. The column contains two of the minor productions of Messrs. other a small WARM AIR STOVE. The works are designed and modelled by Mr. C. H. WHITAKER.

Italian wholesale price is £100 sterling! But if these could be finished, in polishing, stuffing, retail profit, &c., the gross cost could not be less than £200 for the seven, while the very best articles of the same character could be had from the most expensive house in London, of English manufacture, for less than two-thirds of that sum. No doubt the carving would be different, but it need not necessarily be worse, because these are by no means even second-class specimens of Italian skill, while the English articles, as a whole, would be infinitely more suitable for English utilities and English taste. So it is in fifty other examples; and the general conclusion is that, while for objects of vertu or specimens of curious and ingenious Art-industry, where utility is put out of court, and prices become of little consequence, the best Italians stand pre-eminent, yet for everything pertaining to the every-day purposes of domestic life—whether for the mansion or the cottage—the English manufacturer not only produces better articles, but gives better value for the money; so that in this important aspect of the International Exhibition, England has much to teach and nothing to learn from Italy as represented in this Exhibition. The popular belief is otherwise. It is difficult to see how men who work for two shillings a day should not be able to get up chairs cheaper than where labour is three times as expensive; but, whatever the causes and the theory, the fact is indisputable, and, doubters only require to visit the Italian Court to be convinced. In the Zollverein the results are, as nearly as possible, reversed; and there is no room for doubting, from whatever causes arising, that where qualities are equal, in the same class,—furniture for instance,—the German prices are below those of England, although there are such anomalies as to raise suspicion that the low prices of many articles exhibited are not the normal prices of the same quality of workmanship. If this were guaranteed, then the question of price

Messrs. WILLIAM BAILY AND SONS, iron founders, of Gracechurch Street, London, supply us with an excellent GATE of their production. They are large and meritorious contributors to the Exhibition.

Messrs. BENHAMS AND FROUD, of Chandos Street,

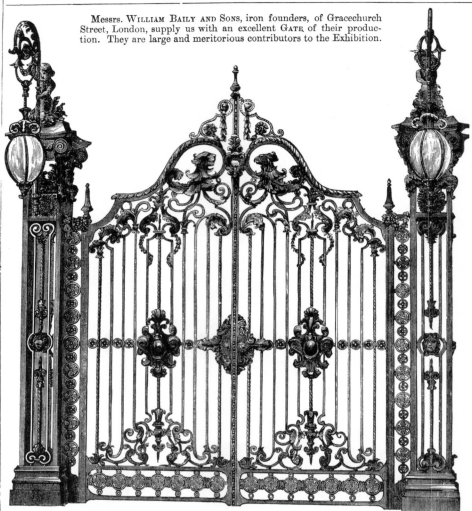

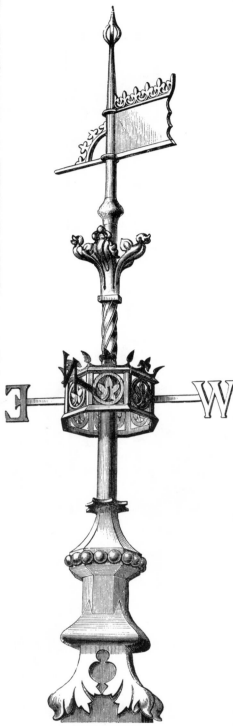

The FLOOR CLOTH Manufactory of Messrs. NAIRN

most important improvements into their fabric.

& Co. is at Kirkaldy. They have introduced several | We give two examples—postponing remarks. | are "copper-smiths," manufacturing a vast variety

between many classes of German and English manufactures would be settled, and not in favour of our countrymen. And that the difference in prices has been appreciated will be found in the probable fact that this class of German manufacturers have done a larger amount of "business" than those of any other exhibiting nation. This branch of German Art-industry, embracing furniture and its accessories, would justify much more attention in these pages than it has yet received; and it will probably furnish material for a separate article on some future occasion. In the French sections the relations of prices are analogous to those of Italy, with this important difference, that, while the Art displayed by the Italian is, in the best works, superior to that of England, it is only the artizanship of France— that is, the more dextrous workmanship—which can illustrate the difference between French and English goods. But in several classes, such as furniture, there is no such evident superiority; and,

while some works have been sold which, from their artistic merits, are placed beyond the range of mere Art-industries, yet it may well be doubted whether the French will be commercially satisfied with the result; they too will feel that the British manufacturer is rather gaining than losing ground in the general markets of the world—including their own—even with regard to articles that used to be considered among French *specialities*. Of Austria nothing requires to be said; but some of the northern nations (Denmark and Sweden) have evidently the capacity, if they could find the capital, to become powerful rivals in some branches of industry where utility plays a prominent part, and where wood forms the raw material.

What then is the conclusion of the whole matter? It will be remembered that, in the introductory chapter to this essay, it was affirmed without hesitation that in the period between 1851 and 1862 the principles of Art-industry had been undergoing a silent but cer-

of articles for many purposes from copper, including mediæval and other brass-work for ecclesiastical and domestic use, weather vanes and finials, and matters of more direct utility, into the construction of which Art has but partially entered. We engrave parts of three ALTAR RAILS, of brass, and a WEATHER VANE, in wrought copper. The weather vane is designed by Mr. S. J. NICHOLL, architect; it is a work of a thoroughly good order, in "style" and manufacture. To the long list of articles in copper issued by this house, we can at present do no more than refer.

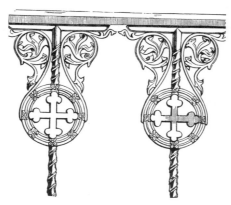

Messrs. HILL AND SMITH, of Brierly Hill, Staffordshire, are manufacturers of various necessities or utilities for the field and the park; they are eminent and extensive manufacturers of hurdles and agricultural implements, and of "continuous iron fencing." From such works the Art element is necessarily absent; their productions, however, which they show largely, will no doubt find prominent places in publications addressed to the

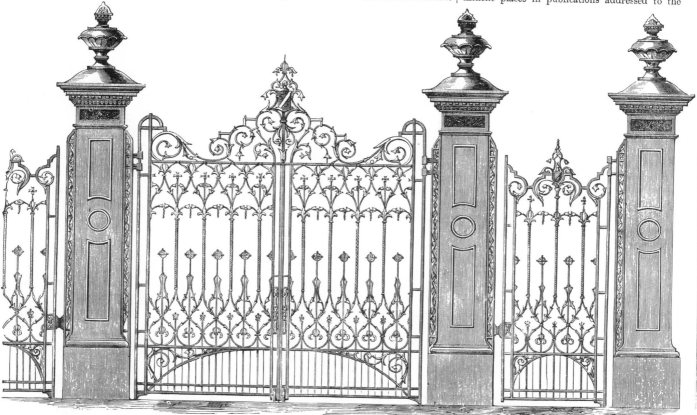

important classes for which they labour, although not suited for this work. They supply us with an excellent design for an AVENUE GATE. It is of exceedingly good character, not too elaborate, and consequently not too costly for general use, and an admirable example of casting and manufacture.

tain revolution. That, while in the former period those of the worst ages of France were rampant among the manufacturers of England as a class, in the years which have since elapsed the principles of France have been supplanted by the higher principles of Italy. That was a conclusion forced upon all who paid attention to such subjects; but the breadth and depth of that revolution was only fully demonstrated by the Exhibition. Then it was seen how completely the higher Italian thought was overpowering the lighter quality of French fancy, and how generally the western nations, including France, were accepting the nobler influence. Another abstract generalisation has, if possible, been still more clearly demonstrated as a reality. Glancing at the Art-education so long prevalent in France, modern French declension was charged to the pride of artistic ancestry, and the plethora of artistic rules. From both snares this country was free; and it was concluded that, in ultimate pre-eminence, a soil of simple ignorance would yield better and more abundantly than one of perverted knowledge. Nothing has been more forcibly taught by the Exhibition than the soundness of this induction; for in almost every class the progress of the British manufacturers has been comparatively more rapid than that of their French competitors, while in several most important departments our countrymen have left all competition behind, and taken their place at the head of the world's industry, both for design and skilful production. What those classes are, and wherein their superiority exists, has been already stated, and requires no recapitulation; but the general truth can never be too often reiterated—first, as a warning that other nations will not—can not—accept inferiority as a final result, and therefore progress must still be the watchword of the

On this page are engraved two STAIRCASE BALUSTERS, two BALCONY PANELS, and a "BAL-CONET," or window guard, some of the contributions, in cast iron, of the GENERAL IRON FOUNDRY COMPANY, of Upper Thames Street. These are but selections from a great quantity

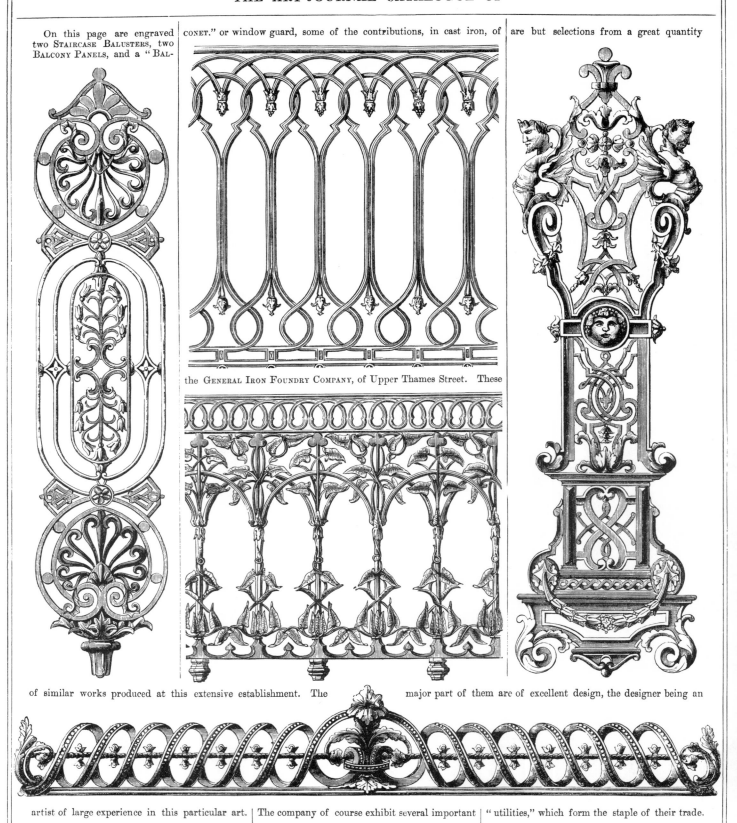

of similar works produced at this extensive establishment. The major part of them are of excellent design, the designer being an artist of large experience in this particular art. | The company of course exhibit several important | "utilities," which form the staple of their trade.

conquerors ; and, second, as an encouragement for those who still lag behind to gird up their loins for bolder efforts and grander sacrifices in pursuit of certain victory. Nothing can stay the onward pressure of indomitable spirit ; and now that the puerile notion of the natural incapacity of Englishmen to succeed in Art has been roughly but practically exploded, the British manufacturer requires only to dare, not merely to succeed, but to excel, in any of those branches of industrial Art which English ignorance and indifference have hitherto assumed to be the monopoly of foreigners. Nothing but the International Exhibition could have proved this so successfully to Europe, and especially to Englishmen ; and, whatever its other merits or defects, it has taught this lesson—one above all price to the broadest, deepest interests of England—that, even in questions of industrial Art, self-reliance and self-development are at once the surest paths to commercial wealth and contemporary fame. Institutions fraught with such lessons cannot die ; and however shortcomings may be mourned over or rebuked, the advantages will be accumulating while the defects are passing to oblivion, and the lessons yielding fruit a hundredfold when the bickerings and differences have been forgotten. These beliefs have stimulated the sense of responsibility, and guided the pen in this effort to extract some of those lessons with which the Exhibition was so pregnant—lessons which multitudes

The frame makers are not satisfactory contributors to the Exhibi- tion; among the best is Mr. C. Rowley, of Manchester, of whose

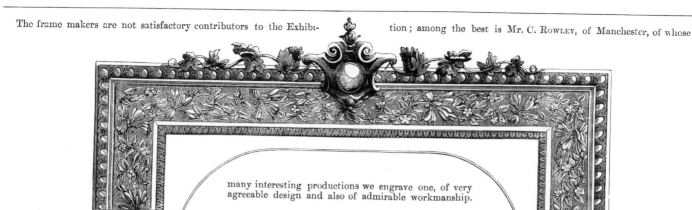

many interesting productions we engrave one, of very agreeable design and also of admirable workmanship.

Messrs. Ralph Allison and Sons, of Wardour Street, exhibit the very beautiful Pianoforte we

The design, in the aggregate and in parts, is in

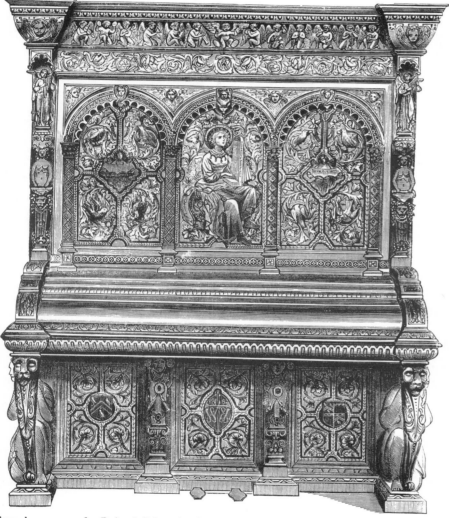

have here engraved. It is of light oak, elabo- rately, yet appropriately and very ably carved.

harmony with the purpose of the instrument.

of minds and hands combined to offer, and which in their technical aspect it would have required many men to understand and teach. No such hopeless task was undertaken or contemplated in this essay on the classes to which it refers. The object aimed at was, as nearly as possible, the reverse. Ignoring all but a few of the simplest and most obvious truths of technology as such, the effort has been to test all industries by the standard of first principles, based upon utility as the truest test of industry; and then by those essential principles of Art which must govern the ornamentist now as truly as they guided Raphael in the production of his frescoes, or Phidias in the produc- tion of the Elgin marbles. That such a task should have given universal satisfaction in its accomplishment was not to be expected. That those who had spent sleepless nights and laborious days, besides lavishing their hard-earned savings on their productions, should, like stoics, smile when efforts were ignored or pronounced to be violations

of artistic or industrial truths, was not to be anticipated. But the cost of honest and legitimate criticism had been counted, and the general result has thus far been satisfactory. One has complained as if the end and object of all comment ought to have been the gratification of some leading manufacturer; another as if the Exhibition ought to be considered a mere extension of the shop; but the mass of both classes, designers and producers, have been singularly forbearing under the discussion of points and principles so keenly touching their profession, reputation, and material interests; and nothing but a con- sciousness of inherent strength could accept with equanimity the full force of free but friendly criticism. They receive respectful grati- tude and increasing admiration for the course pursued; for, while the two complaints already noticed neither impugned a fact nor affected a principle, able and intelligent men, whose principles or practice have been doubted or denied, might have burdened us with con-

A very beautiful example of the work of the silversmith is exhibited by Messrs. PHILLIPS BROTHERS, of Cockspur Street. It is four feet high, and of considerable weight and "money's

worth"—its weight 630 oz., its cost £600. It has, however, a higher value—that derived from excellence in Art. A very effective design, with much of originality, is associated with skilful workmanship. Altogether, it is one of the pro-

his Majesty the Emperor of Brazil to Sir J. Drummond Hay, C.B., her Majesty's Minister at Morocco, in acknowledgment of "great and timely services rendered by him on the occasion

of the wreck of the Imperial Brazilian corvette *D'Isabel*." It is especially gratifying to record the liberality of the Emperor for services rendered to his subjects at a distance from his Em-

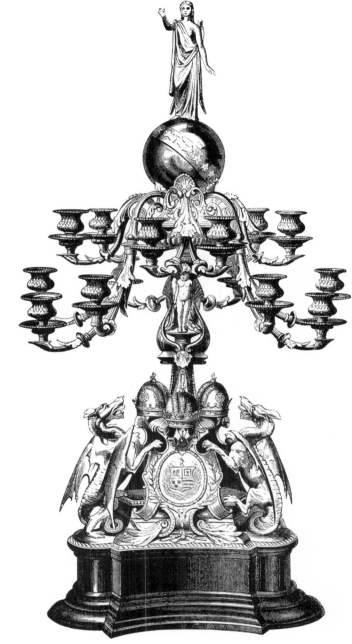

ductions in which England takes pride, as maintaining her supremacy in competition with "all nations." But there is another interest excited by this work: it is a TESTIMONIAL presented by

pire. The graceful and generous act of his Majesty has impressed the thousands who have, in the Exhibition, been made acquainted with the fact—honourable alike to the giver and the

receiver, and to be regarded also as a compliment to our country. We engrave also two of the JEWELS of Messrs. Phillips; they are among the most perfect Art-works of the Exhibition.

troversy on points tenfold more perplexing and plausible, and thus have added the irritation of debate to the anxieties of responsible criticism. The highest honour, next to elucidating and spreading truth, is the admission and recantation of error; but the consideration is appreciated which permitted attention to one thing at once.

In taking leave of the various sections embraced in this essay, a feeling of profound humiliation burdens the utterance of the word "farewell." The daily growing vastness and grandeur of the subject— the accumulating evidence that what could be overtaken was small— the fact that little could be noticed, far less criticised, in the space allowed—however humbling, stimulated also to "be just and fear not;" and according to the measure of capacity and knowledge, I have not been disobedient to that stimulating voice.

JOHN STEWART.

[Having thus far proceeded with such notes on the International Exhibition as we believed might forward its great object—instruction, it will be our duty, in succeeding Parts of this Journal, to enter into details connected with some particular branches of it, by which we may communicate more information, although positive criticism may be less. If the LESSONS of the INTERNATIONAL EXHIBITION be many, its WARNINGS are not few: the wise man will carefully study both—acquiring a knowledge, not only of what is to be his teacher, but of that also which he is to avoid. We shall endeavour to place both before him during future months, when the subject will necessarily occupy a prominent place in this ILLUSTRATED CATALOGUE of its principal contents. With this view, we shall have to deal with topics that, if properly treated, cannot fail to be fertile of education, not alone to the manufacturer, but to the artizan, and, indeed, to the general public. The recent improve-

THE INTERNATIONAL EXHIBITION.

The four objects introduced on this page are selected from the extensive contributions of

Messrs. ELKINGTON & Co. The first is an elegant BOUDOIR MIRROR, enamelled, small in size, even for such a purpose as that for which it is intended; nevertheless it forms a beautiful ornament for the table. The second is a silver

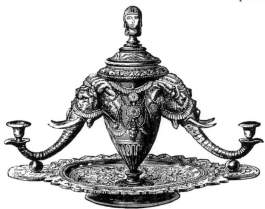

Music, and Dancing. At the head of this column is an INKSTAND, designed in the eastern style; and below this are a VASE and DISH, for

TANKARD, in the Greek style, with figures and bas-reliefs in ivory: these are symbolical of theatrical Art, and represent Comedy, Tragedy, rose-water; the vase is ornamented with allegorical figures and reliefs emblematical of the Sun and Moon, as typified by Apollo and Diana;

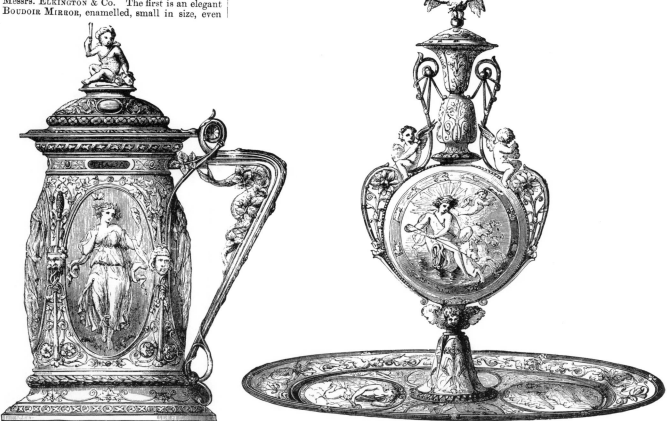

the dish exhibits representations of the four elements; we shall have more to say of this group hereafter. The whole of these works were designed by A. WILLMS, the directing artist of Messrs. Elkington's establishment. The tankard, vase, and dish were chased by MOREL LADEUIL.

ments in machinery, by which processes are greatly facilitated, and results more advantageously obtained, will necessarily become a leading feature in our review of the Exhibition; so also will the various woods that modern discoveries have made known, and which are even now abundantly contributing to the resources of the cabinet-maker. The various dyes, also, that Science has of late years placed at the command of the manufacturer, will claim our especial notice; and, above all, it will be our business to explain the vast amount of raw materials, not merely in clays and stones, but from a thousand mines, that have been, within a comparatively short period of time,

"Opened to the searcher's skill and toil."

For the treatment of these various and most important topics we shall be indebted to writers who are well able to deal with them,

writers of large experience and matured knowledge.* The influence of Art on Art-manufacture will also receive consideration commensurate with its importance. In a word, we shall labour to obtain from the International Exhibition all of its UTILITY as a school for the producer. Much and well as it has been studied, its teaching can be rendered permanent only by being kept continually before the mind and eye. The engraved illustrations we publish will be of incalculable value long after the Art-gatherings of so many nations are scattered; hence one manufacturer may instruct another, and every workshop of the world profit by the general result.]

* ROBERT HUNT, ESQ., F.R.S.
PROFESSOR ANSTED, F.R.S.
PROFESSOR ARCHER, Director of the Industrial Museum of Scotland.
THE REV. CHARLES BOUTELL, M.A.
T. BEAVINGTON ATKINSON, ESQ., &c. &c.

This page contains engravings from some of the admirable works of Mr. G. A. ROGERS. They are works of the purest and highest Art, and uphold a renown second to that of no wood carver

in Europe, for Mr. Rogers is an artist in the best sense of the term. We have no space to describe these productions, nor is it necessary. The larger piece is an OVER-DOOR at Boodle's

Club; the others are objects all small in size, but of rare merit—beautiful and valuable, exquisitely designed and finished. Mr. Rogers has occupied the high position he holds during, we

believe, nearly half a century. A time will come,

if it is not now, when his works will be appreciated. He is a master who has had many pupils,

although he has never had a "school." The wood

carvers of Great Britain owe him much, and

readily acknowledge their debt to a great artist.

THE MEDIÆVAL COURT.

In 1851, the Mediæval Court of the first of the Great International Exhibitions was one of the consistent and eloquent exponents of the Art and the Art-manufactures of the period. There had been a revival of the Arts of the middle ages, and in that Mediæval Court those revived Arts declared to the world what they were capable of doing, and what they actually were doing, in England, in 1851. There is also a second Mediæval Court in the Exhibition of 1862; but this Court appears to have no higher motive than simply to endorse and to transmit the traditions of its predecessor. This is altogether right and satisfactory. A Mediæval Court, as a thing of to-day, has become an anomaly; and it would be by no means an easy task to discover a more singular assemblage of works, than those which have assumed to themselves in their collective capacity the title of "Mediæval Court," in this year's International Exhibition. Unconsciously, and evidently without any such intention, this Court has given the *coup de grace* to modern mediævalism. The thing itself could exist at all only as either a misapprehension or a mistake in the first instance, and then as the visionary aspiration of an eccentric enthusiasm; and the two Mediæval Courts of 1851 and 1862 have exemplified modern mediævalism in Art to the very life. Eleven years ago, a collection of reproductions and copies of the works of the middle ages was exactly what the condition of the mediæval revival at that period would naturally produce. And that original Mediæval Court told its tale after an impressive fashion. It demonstrated the ardent zeal of the revivers of the old Arts, their

We occupy this page with examples of the beautiful works contributed by MM. WIRTH, and which form

leading attractions in both the French and Swiss Courts. They are in great variety, from the elabo-

rately carved cabinet to the smallest accessory of the toilet, and are in all cases fine works of Art. A list

of these "varieties" would occupy a large space. In 1849, the brothers Wirth first established a manu-

factory of wood carving at Brienz, in Switzerland, exerting artistic knowledge and skill, and

hundred workmen, and in Paris to eighty; and they have formed a regular school of Swiss

they use, by which processes are greatly facilitated; they have educated able artist-artisans,

accomplishing a large commercial success. They now give employment at Brienz to five

carving. They have introduced many improvements into their art, especially into the tools

and are regarded as the benefactors of the district in which Providence has placed them

devotedness, and their own practical powers as artists. Its collections were such as the men of the middle ages themselves might have felt quite easy in accepting as their own. It was decisive in declaring the fact, that the long-dormant Arts of the middle ages had been restored to energetic vitality; and it was also no less suggestive of the manner in which this revival ought to be developed and worked out in the course of the succeeding decade of years.

Since 1851, however, the revived Arts of the middle ages have been called upon to encounter a struggle of unexpected and most trying severity. That the lovers of what (for want of some better-defined title) is styled Modern Classic Art, should array themselves in opposition to their mediævalising contemporaries, was simply the natural result of a revival of mediæval Art; and the revivers must have been prepared from the first for all the resistance that could be brought to bear upon them, through an alliance between the severe classicists and the more lax, but not less vehement, advocates of the Italian and French Renaissance. But they could scarcely have anticipated the mischief which they themselves were destined to inflict upon their own cause. It may, indeed, be safely asserted, that neither the men who produced the first Mediæval Court, nor those others who sympathised with them in taking a delight in it, ever contemplated such a second Mediæval Court as that with which of late we have become familiar. Certainly, they would have indignantly rejected all anticipations of so palpable and positive a retrogression. They would unquestionably have refused to believe in the possibility of a second Great Exhibition containing a Mediæval Court, of which it would only be said that it so far resembled its predecessor as to exhibit the same dominant mediævalism, while even this resemblance was so tame and spiritless, and so entirely devoid of all freshness and expression, that it was indicative only of

C. S. MATIFAT, of the Vieille Route de Neuilly, | Paris, Bronze Manufacturer, exhibits not largely, | but several of his works are of high merit in

design and manufacture : from these we select three of those | hitherto unapproachable ; also a SLIP, | RAILING made to protect a looking-glass at Bridge-

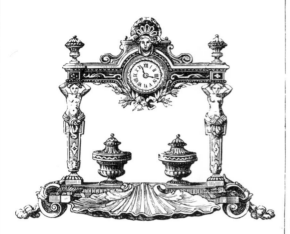
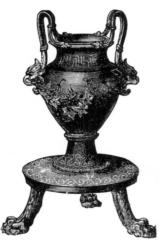
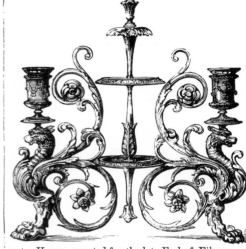

graceful objects in the production of which France has been | copied from a window-rail ; and a | water House, executed for the late Earl of Ellesmere.

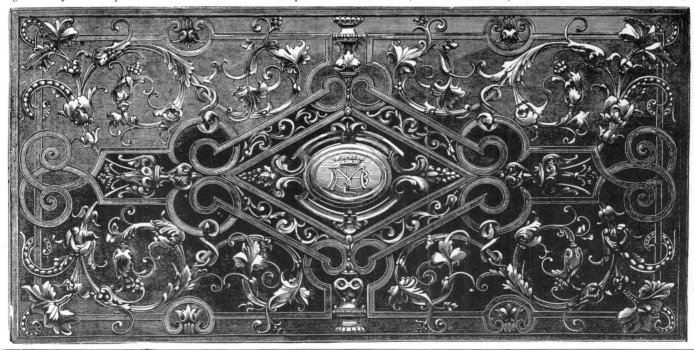

that decadence which experience declares to be the forerunner of a decline and fall.

Happily, the evidence of this year's Mediæval Court is conclusive only as far as the limit of its own range. It disposes of the entire question of modern mediævalism in Art, but it does nothing more than this. The Exhibition has had a great deal to say about the revived Arts of the middle ages, altogether distinct from the sayings to which the Mediæval Court has given utterance. True to its own title in its direct acceptation, and consistent in both looking back to past times and in working far away from our own time, this Court has shown what living men desire to do with Art, while they fancy that some mysterious process empowers them to think and work as, probably, they might have done about a century before the Black Prince was Prince of Wales. We are quite satisfied, as we have said, with this Mediæval Court as it has been. More than satisfied,—

we regard it with sentiments of profound gratitude. If the mediævalising of the revivers of middle-age Art has done more than everything else to damage their own revival, to retard its progress, and to check its salutary action, now at length we have a test by which to try the modern Mediæval brought before us by the mediævalisers themselves. The very best things in this Mediæval Court are mere parodies of something which refuses to be parodied successfully. They belong neither to one period nor to another. They are allegories of cabinets and organs, of carpets and draperies—allegories, however, that are endowed with only a very shallow significancy. It is to be hoped that the gentlemen who have produced these various works, now they have convinced the public that modern mediævalism is equally harmless and worthless, will be induced to step out of the middle ages, and to realise the fact of their existing in the second half of the nineteenth century. There is an abundance

M. G. J. Lévy, of Paris, successor to

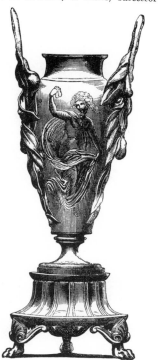

the long famous firm of VITTOZ & Co., one

the French capital, exhibits a large collection of works of varied order—clocks,

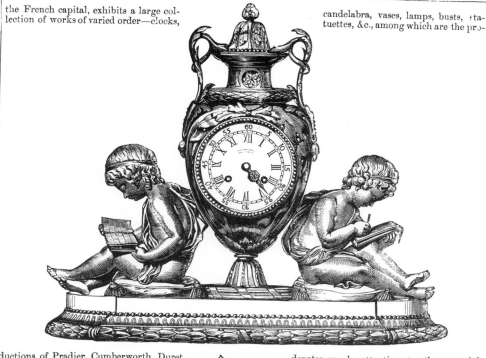

ductions of Pradier, Cumberworth, Duret, Schœnwerck, Carrier, &c., the principal designers of works of that class. M. Lévy

candelabra, vases, lamps, busts, statuettes, &c., among which are the pro-

devotes much attention to the graceful utilities of the drawing and dining rooms. Many of his exhibits show the influence

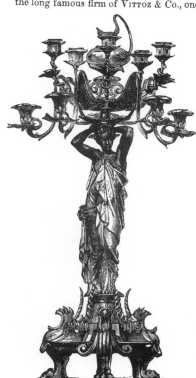

of the leading bronze manufacturers of

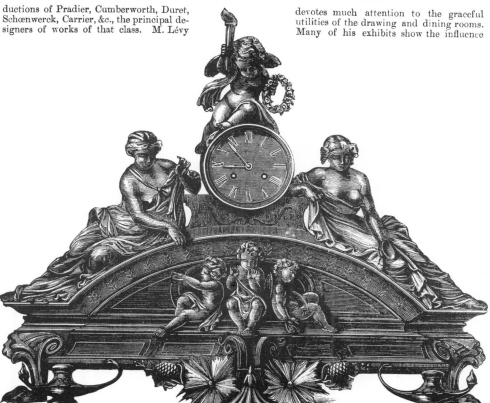

of good Art on objects of daily use, as well as on those of costlier and more elaborate character.

of honorable and useful work awaiting them; only, before they take it in hand, they must liberate their minds from excessive sympathy with the past, and look both around them and forward towards the future.

The Arts of the middle ages arose in the middle ages, and they flourished through their direct association with their own era. They grew out of the exigences of the intellect of those times, and adapted themselves to contemporaneous circumstances, and to sentiments then prevalent. These same Arts are, indeed, replete with precious teachings for all times; and yet it does not by any means follow that they may be advantageously reproduced in *fac-simile* at any time. We may study them, confident that certain benefits will result to us from our study; and this is perfectly consistent with what is equally true—that a mere imitation of their former operation indicates that

error in judgment which inevitably leads to a mistaken course of action. And then, on the other hand, nothing can be more absurdly irrational than to reject what the Arts of the middle ages can teach so well, upon the alleged plea that any such study must necessarily involve a modern mediævalism. Here, as in other matters, a middle course lies open invitingly before us. Whatever we find to possess intrinsic excellence in the Arts of the middle ages, combined with the faculty of consistent application to our own times, we may gratefully accept; and, as we know that our predecessors in departed centuries matured their own thoughts for their own advantage, and applied their Arts to their own use, so we may take their teaching, and associate it, in its practical application, not with them, but with ourselves. The contributors to the Mediæval Court, in all probability,

Mr. Edward White, of Cock- tion of them on this page. The watches are, we believe in matured skill, and are not

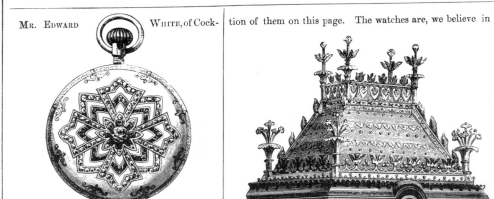

spur Street, is an extensive contributor of

only graceful ob- jects for the several

Watches and Clocks, and shows also some

rooms in which they are intended to be

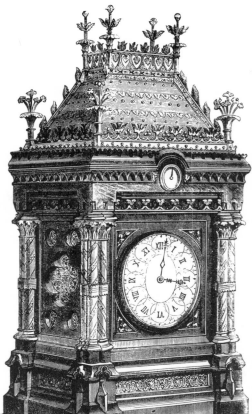

all cases, his own manufacture, from his own designs. The clocks he exhibits are perhaps the best that are shown by a

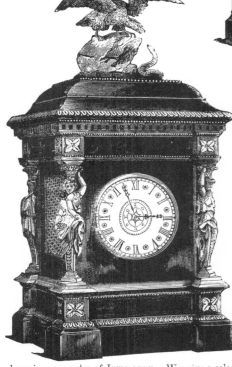

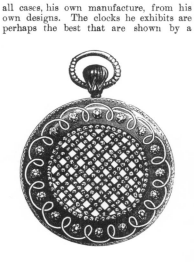

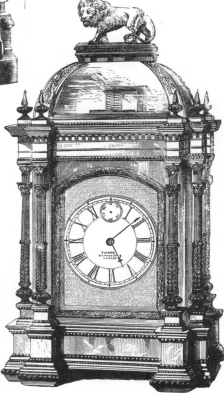

charming examples of Jewellery. We give a selec- British exhibitor : some of them are of carved wood, others of ormolu. They are designed with sound judgment and placed, but are of good construction and "finish."

would claim for their works precisely that character which would define them to be happy adaptations of old Arts to modern conditions. We are not able to accord to them any such pretension. They have really done nothing of the kind. On the contrary, their sole endeavour has been to adjust certain modern incidents and accidents to the practice and the principles of middle-age Art; thus inverting the true process of successful adaptation. They have worked as if they were men of the middle ages who, by some caprice of fortune, chanced to find themselves living *amongst* the most recent of the moderns; and so they have produced a hybrid mediævalism. Their works, having nothing in common with the reign of Queen Victoria, have also failed to accomplish even a tolerably perfect reproduction of what might have occupied places of honour, had it pleased either

Henry III. or Edward III. to have taken in hand an International Exhibition.

This failure is simply a condition of seeking to carry back the experience of the year 1862 to the Arts of the year 1262,—a very different thing from bringing down the old Arts to the circumstances, the usages, and the tone of thought and feeling of to-day.

But, while thus the Mediæval Court has shown what the result of reviving the Arts of the middle ages might have been, had the revivers all been of one mind in desiring simply to think over again the thoughts of the early artists, and execute over again (with, here and there, some damaging modifications) their works,—beyond the narrow confines of this Court another class of revivers are found to have been devoting themselves to thinking out afresh the principles

The Ceramic works of M. JEAN are reproductions in style of the older *faience* of France and Italy; but they are by no

means slavish copies of them, as they present an originality of form, and a freedom from mere conventional style,

tially imitate. They

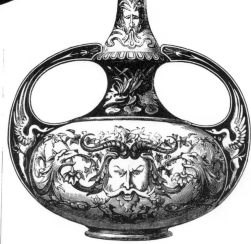

manufactures; for the painter's hand, in all its freedom

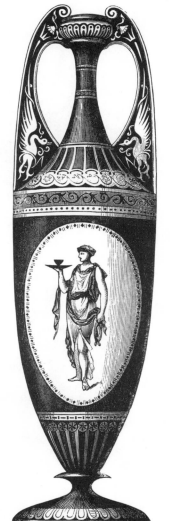

that gives them a character of their own, and but hints at the older art they par-

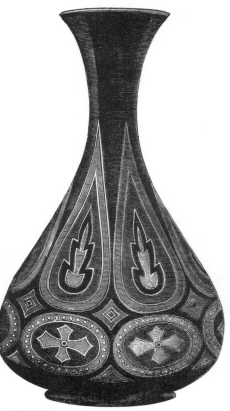

are essentially Art-

of touch and breadth of colour, is as visible on their surfaces as it would be on the canvas. The pictures on them all are executed with singular

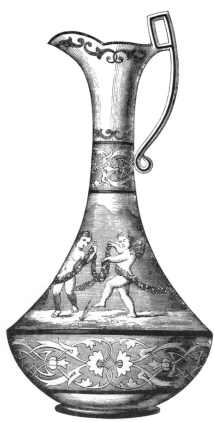

boldness and ability, and recall the best days of fictile manufacture, when the painter finished what the potter fabricated. In the present instance the

touch of the brush and the general treatment of each picture is precisely preserved in all its vigour and freshness, as if ignoring a clay surface.

of mediæval Art, with the view to developing those principles in harmony with a new train of ideas. In other words, the Mediæval Court has *not* represented the existing condition of the revived Arts of the middle ages, because the revival has been rescued by another class of the revivers from any peril lest it should relapse into the lethargy from which it was aroused. And, more than this, the Exhibition has shown that the old Arts are actually in action, under safe guidance, producing really good work, and giving promise of still better. It is true that, even now, the idea is still prevalent that the Arts of the middle ages, in their practical working, must in some degree be mediæval; and yet the influence of this idea is felt and acted upon, happily, only in exceptional instances. The true

character and the real value of the early Arts are beginning to be generally understood; and so is the utter absurdity of regarding them as inseparable from a revived mediævalism. It has been discovered that living artists may cherish the authority of early Art, without binding themselves to a servile compliance with early usage,—that they may feel, and think, and act independently for themselves, still preserving unbroken their fellowship with the artists of the middle ages, and still loyally adhering to their allegiance to mediæval Art. And, in the adoption of a distinctive title for the revived Arts of the middle ages—a title which makes no allusion to any era or period—the non-mediævalisers have done well. Whatever its abstract value, the term *"Gothic"* belongs as well to our own Art, and our own

Mr. ALDERMAN SPIERS, of Oxford, exhibits a variety of articles, manufactured either by, or for,

him; of these we make a selection. They are of high excellence in their several classes; the DRESSING

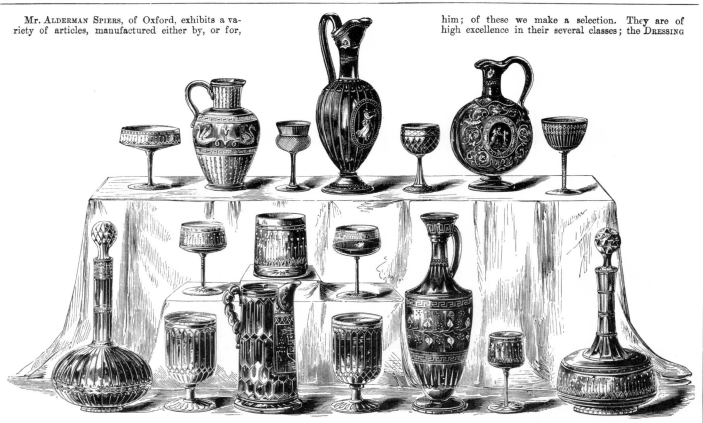

CASES are of rare beauty; the articles Wedgwood gems, and the TABLE GLASS vies with the very best in the International Exhibition. The "novelty"

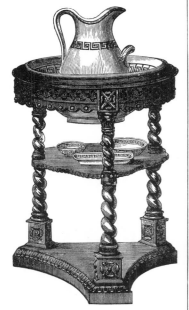

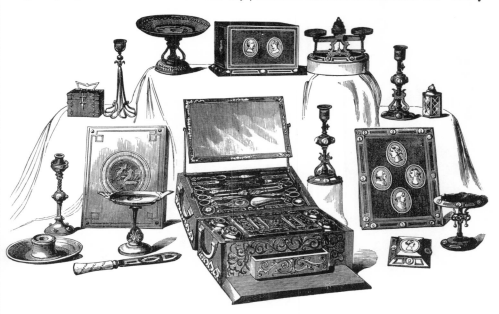

for the writing table are adorned with however, is a WASHSTAND, "combining the largest capacity with the smallest requirement of space."

artists, as to any other artists, and to any other style or period of Art. We ourselves gladly recognise and accept this term "Gothic;" and we apply it to the revived Arts of the middle ages when they systematically repudiate mediævalism. Accordingly, we should have rejoiced in having seen, in this year's Great Exhibition, a "Gothic Court," instead of one that was called (and, under the circumstances, appropriately enough called) "Mediæval." The elements of a Gothic Court were present—not collected and concentrated upon any one point, but scattered here and there throughout Captain Fowke's thoroughly ante-Gothic structure. This very scattering, however, was sufficiently significant in declaring that "the Mediæval Court" was not to be accepted as the exponent of the living Gothic. That the Hereford screen should have been present in the Exhibition, and yet should have stood apart from the Mediæval Court, was the most emphatic declaration possible of a

want of sympathy between the ablest professors of Gothic Art and the modern mediævalisers. There, also, was the Pearson monument, with its exquisite statuettes, and its noble architecture in iron; and there were the splendid collections of Gothic metal-work contributed by Hart and Hardman, and the smaller, but not less admirable, group of similar works by Benham, and his able coadjutor, Norman Shaw; and there was Keith's case of works in the precious metals: and many other collections of various objects were there,—not forgetting the important contributions from France, and other foreign countries,—all of which ought to have been grouped together, had the object been to have formed a Gothic Court that should have been truly worthy of such a name. Mediævalism, in a less or a greater degree, might have been detected in many of these works; those of Skidmore being excepted, and Hart's and Ben....n's collections exhibiting only casual traces of the essentially mediæval

Messrs. STOREY AND SON, of King William Street, London, are exhibitors of GLASS and PORCELAIN, in which they are very extensive dealers, though

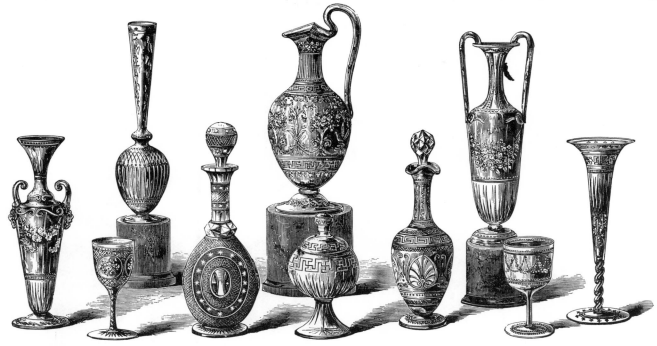

not manufacturers, usually furnishing their own designs, and procuring works made exclusively for them. Several of these works are evidence of judgment and taste. Their collection contains many objects of cost and corresponding value; generally, however, they are graceful utilities. suited for

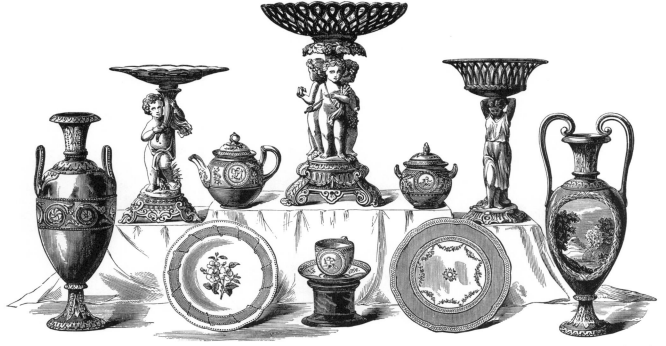

ordinary households. Our engravings sufficiently describe their excellence. Few of the contributors have made a better or more varied display.

influence. These different groups declared the earnestness, and the prevalence also, of the Gothic feeling; and, what is most remarkable, they showed how thoroughly the inclination of very many of our ablest artists is most decidedly towards Gothic Art. The same fact was no less conclusively demonstrated by the architectural drawings, in which Gothic Art was supreme, both in the excellence and in the numbers of the designs. We have heard much of late—too much sometimes—of "the battle of the styles," the contest between the revived Arts of antiquity and of the middle ages—between the classic and the Gothic styles. In the Great Exhibition this long-sustained and hard-fought strife was not renewed. There were no classic and Gothic collections set forth before the world in open rivalry. ⌐ there were these two things patent to everybody, both of them bearing with much significancy upon this same battle,—the one, that the Gothic was successfully shaking off the trammels of an obsolete and incongruous mediævalism; and the other, that the days of modern mediævalism, so far as it might affect the success of Gothic Art, were numbered. And, further, the Great Exhibition swept away all doubts as to the sources from which our own highest manufactures must seek improvement in their artistic character. In thus directing us to the Arts that flourished in distant, and even in remote, eras, the Exhibition showed that no essential antagonism really exists between the noblest and most artistic productions of different eras. For example, Castellani's exquisite groups of gold jewellery, all of them studied with scrupulous carefulness from either ancient or mediæval authorities, showed how felicitously the best works of Greek, and Roman, and Byzantine, and Gothic Art, might be placed side by side, as illustrations, not of style, but of Art. It might be said that this jewellery is only mimetic, and that at the best it does no more than reproduce ancient and early works. Such

This column contains engravings of two of the DAMASK SILKS, for furniture, manufactured and exhibited by Messrs. WALTERS AND SONS, of London. They are of the highest quality in manu-

facture, and successfully compete with the best productions of the Continent. The designs are in all cases of considerable excellence, of various styles, so as to suit the rooms for which they may be required, but generally "quiet" in pat-

tern and colour. Messrs. Walters are, we believe, the most extensive manufacturers in England of these productions; it is gratifying to know they are Art-teachers wherever their works are adopted.

Messrs. WILLIAM SMEE AND SONS, of Finsbury Pavement, London, are large exhibitors of furniture, in which elegance is combined with utility; it is not of the costliest character, but is remarkable for judgment and taste in design,

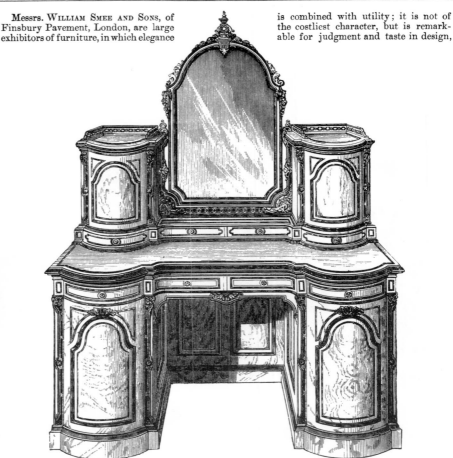

and excellence of workmanship. We engrave a TOILET-TABLE of simple and pure form; also the panels of fret-work of elaborate design, and highly finished; the mouldings and ornaments through-

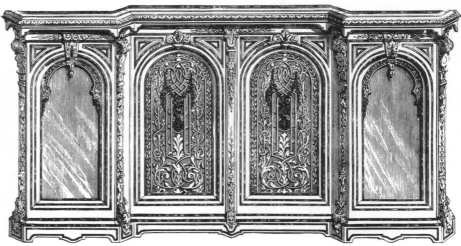

lower portion of a CHIFFONIER, of fine Italian walnut wood, relieved with tulip wood, having out are richly carved. These works are entirely by English designers and artisans.

certainly is the fact: but this reproduction is so faithful, it is so perfect, both in its exemplification of early processes and its illustration of early Art, that it sets the latter before us in actual operation, and shows us what sort of model it is that we have to study. Signor Castellani does not consider that the resources of the goldsmith's art were exhausted either by the Italo-Greeks or their Gothic successors. He has searched out the principles of their styles, and has investigated the processes by which they worked; he has also shown us what an artist of our own times may accomplish, when working *exactly* as an Italo-Greek or a Gothic goldsmith worked. And he says, " Learn to work after this fashion; this is true Art: master this, make it your own, learn to be true artists, as those men of antiquity and the middle ages were true artists; and then think, and invent, and work independently, by yourselves and for yourselves." The step in advance has been boldly taken by Skidmore,

who shows us in his screen that our Gothic architectural metal-work, having already passed through the reproducing period, has risen above all copying, and attained to an independent originality of its own. From such a starting-point as this, the way is open and clear for further and continually progressing advances.

Not so with the Mediæval Court. Could we suppose that, after another ten or eleven years, a third Great Exhibition would be held in London, the Mediæval Court No. 3, if it were to profess still to be a Mediæval Court, would be a faint parody of the second of the series. Probably it would exemplify modern mediævalism *in extremis*, or, more probable still, it would undertake no more than to commemorate the fact of its extinction. The second Mediæval Court has been so decidedly inferior to the first, and it has also been so completely isolated from the best Gothic of its own Exhibition, that, at the same ratio of decadence, there is scarcely a hope left for

THE INTERNATIONAL EXHIBITION.

This column contains en-

gravings from an excellently carved

CABINET, of oak, contributed and ma-

nufactured by KNUSSMANN, of Mayence.

This engraving shows the application of WHITE AND PARLBY'S new cement to the formation of curved and ornamental surfaces of buildings, by which are skilfully produced large ornamental forms of every description. It is especially adapted for ornamental coves, gallery fronts, domes, ceilings (flat, pendented,

or domed), and for all large, complicated, and elaborate curved ornamental surfaces.

Mr. THOM'S KNIGHT, of Bath, exhibits a work of exceedingly good design, and of the very highest order of workmanship. It is a LIBRARY TABLE of oak and ebony, surmounted by a CABINET occupying its whole

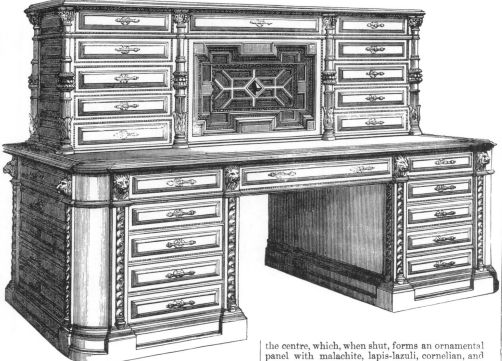

length, containing drawers on each side, and a desk in the centre, which, when shut, forms an ornamental panel with malachite, lapis-lazuli, cornelian, and serpentine; and when open, discloses an arrangement of the materials necessary for correspondence.

modern mediævalism to survive through another Great Exhibition cycle. We shall regard the second Mediæval Court, consequently, as the last as well as the second of its race.

What impression this Mediæval Court may have produced upon the minds of foreign artists, and indeed of intelligent Art-loving foreigners in general, has been to us a subject of wondering speculation. We have repeatedly studied the grave faces, now and then visibly expressive of no ordinary perplexity, which have been habitually present in this Court. The catalogues, of course, have supplied them with the minimum of information. The Court itself has announced that it is both English and Mediæval, and that is all; and the labels of the Ecclesiological Society have not done much to help our inquiring visitors. The works in this Court have been equally uncommunicative. They were certainly newly exe-

cuted, and yet there was a strange would-be antiquity about them, difficult to be understood and to be accounted for. The chimney-piece, with its broad and lofty carvings in stone, for Colonel Cocks—palpably fresh from the chisel, and executed with singular skill—would have been accepted as an excellent copy of some old work, had it not been for the formality with which the stag's antlers are arranged in equidistant rows, and for the monotonous exactness of their uniformity. An early heraldic artist, if he had desired to sculpture these rows of branching horns, would not have made them all exactly alike; but, treating them like the many-times-repeated white harts of Richard II. in Westminster Hall, while preserving in all a unity of character, he would have impressed each member of the series with a distinct individuality of its own. The shield of arms, and the stag, its supporter, are admirably rendered; and the

The EBONY CABINET of M. A. CHAIX, of Paris, is justly classed among the best works in furniture exhibited by any country. It is designed to contain objects of *vertu*, and is intended to stand in the centre of a room. With that view, the elliptical form has been chosen. The four figures represent Poetry, Painting, Architecture, and Sculpture. Above the cornice pro-

Messrs. GOODALL, card manufacturers, of Camden Town, exhibit a large collection of specimens of PLAYING CARDS, to which it is a pleasant duty to direct

attention. They are, in all cases, from the designs of good artists, and may certainly be regarded as Art-

jecting over the columns are four carved figures holding branches and palms. The whole is crowned by the emblematical group of Romulus and Remus suckled by the his-

torical wolf. The work is exquisitely beautiful in design, and admirably executed in all its parts—not alone in those that are more prominent, but in the smallest of its details.

teachers. Those who play at "whist," therefore, may be unconsciously receiving lessons that will bear practically on the ordinary avocations of refined life. It is

frieze-like group (representing an incident in the life of St. Neot) is clever, spirited, and effective. Decided nondescripts are the book-case, the two buffets, and the escritoire (the first with paintings illustrative of "Pagan and Christian Art," and the last with a middle-age version of the "Story of Cadmus"), from designs by the same artist. The two organs, good instruments, after Gray and Davidson's manner, look as if they were prepared for performance at a masquerade. The "King René cabinet" keeps up the masquerade idea; and a polychromatic reredos shows how tawdry an affair might be mediævalised out of inlaid marbles, and destined to adorn a church. A very different thing is an inlaid bookcase and writing-table, in which there is much of genuine Gothic feeling combined with a *minimum* of mediæval association. We have engraved this most creditable production in the last preceding section

of our Catalogue, and we now have much pleasure in recording that it is the conjoint production of Mr. Norman Shaw and Mr. James Forsyth. The recumbent effigies, three in number, are decided improvements upon the prevailing monumental sculpture of the day, though they might have had more originality in the method of their treatment. The best of the group by far is the memorial of the late Canon Mill.

The carpets, the curtains, the hangings for walls, and several other objects, not very numerous, and certainly in no way remarkable for variety of either design or colour, may be grouped together, and pronounced consistent with a "Mediæval Court," devised and executed in the years 1861 and 1862. The textile fabrics are at once poor and showy, and certainly as far from attractive as the bitterest opponent of mediæval Art could have desired. The machine-

the high privilege of every manufacturer more or less to influence the taste, for good or evil, of those by whom his productions are seen. He may

be, and often is, a teacher whose lessons are of great value. These improvements in playing cards,

by which the eye and the mind are both gratified while a game is played, are recent though very important introductions into ART-MANUFACTURE.

The SIDEBOARD we engrave is the production of Messrs. JOHNSTONE AND JEANES, of New Bond Street. It is one of the many graces of the Furniture Court, which supplies so much satisfactory evidence of British progress in a

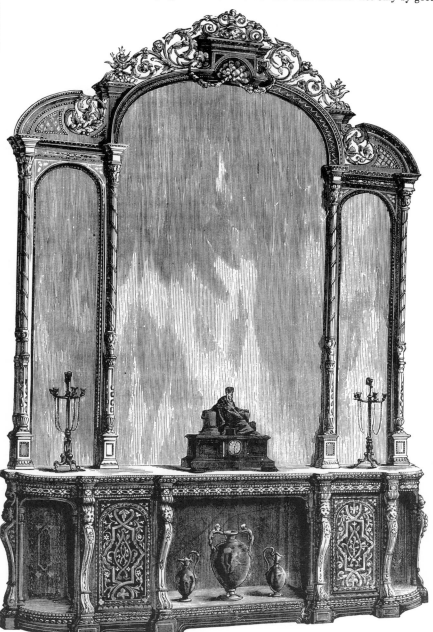

and substantial manufacture, but by continual study to introduce Art into all their works. The sideboard is designed and executed by artists and artisans of the establishment—en-

most important branch of Art-manufacture. The firm of Johnstone and Jeanes is one of the oldest in London, having been established in New Bond Street for upwards of a century; its renown has been obtained not only by good

tirely English. It is of walnut wood, inlaid with various lighter woods. The carving is of great merit, and altogether the production is one of the most successful in the Exhibition.

cut wood-work of the Messrs. Cox alone remains to be specified; and certainly it maintains the reputation of the machinery. The designs adopted by the Messrs. Cox we cannot commend, particularly that of an ambitious altar-railing of elaborate metal-work.

Such was the Mediæval Court that has just been broken up, and its components dispersed. It has done its proper work—not as its projectors proposed, but still in a manner that, we believe, will prove far from unsatisfactory to several of them. It was a mistake to have had any "Mediæval Court" at the International Exhibition, since such a Court could prove to be only either untrue to its name, or anomalous and inconsistent in its character. The true Mediæval Court has been formed from the magnificent loan collections, that were placed with such munificent generosity within the reach of the public in the South Kensington Museum. If the "Court" at the Exhibition had not sealed its own doom, the loan collections at

the Museum would have dealt upon it a blow which it would have been vain indeed to have resisted. Those noble collections almost seem to have been formed expressly in order to vindicate the genuine Arts of the middle ages from the mediævalism of the Mediæval Court. The contrast needs not to be discussed. It has left nothing to be desired. Both the Museum collections and the Court of the Exhibition, in one sense, may be said to convey the same lesson, only they deal with it from two different points of view; for, while the former declare how nobly the Arts of the middle ages are qualified to discharge the duties of teachers, the latter shows that to study them is one thing, and to copy them is quite another. Among the warnings which the Great Exhibition has left behind it, as not the least valuable memorials of its chequered existence, the Mediæval Court will take rank second only to the Exhibition Building itself. *That* must ever secure to itself a bad pre-eminence over every other

This CABINET SIDEBOARD is of carved oak, the production of Messrs. LOUIS AND SIEGFRIED LÖVINSON, of Berlin. It is admirably carved, and may be regarded as one of the finest works in the collection. According to a German critic, "it resembles in its interior an elegantly and comfortably furnished house," and as a "sideboard" has an extent of convenience and accommodation almost inconceivable. The ex-

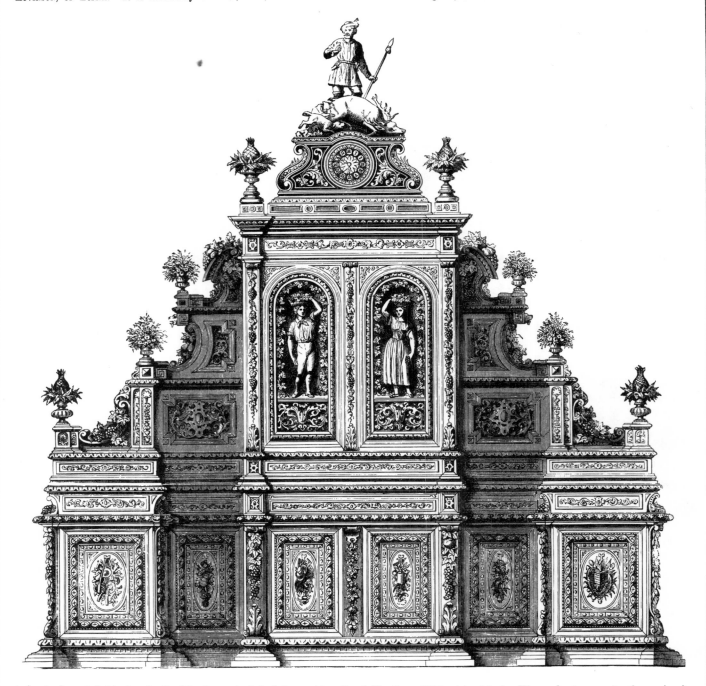

terior is decorated "in keeping." The figures represent Agriculture, Horticulture, the Vintage, and so forth; the figure which surmounts the whole being emblematic of Hunting. Without following any particular style, the artist who designed this remarkable work has dared to be original. His production merits the praise it has received. Messrs. Lövinson exhibit other works, which are produced at very low prices.

Art-warning. But the Mediæval Court has also raised its voice of warning, and spoken with no hesitating or feeble utterance. Far from any such equivocal expression, this Court has clearly and conclusively shown what are the certain consequences of traversing over again paths which have long been forsaken, and of substituting painstaking imitation for the operation of original and independent thought. The law of the copyist has been in full force in the Mediæval Court, and the sentence of that law is—*failure*, failure even in perfect copying. Now that we have discovered how much the Arts of the past possess which they can teach and which we shall do well to learn, from the example of the Mediæval Court let us be admonished that we study early Art as artists who would train and discipline themselves in the school of authority and experience, jealously cherishing, as we study, our own freedom of thought and action, and resolutely determined never to rest content with any movement that does not lead us onward on an honourable career of our own. And, assuredly, for the Gothic revivers the Mediæval Court will not have existed in vain. If any lingering doubts until now have obscured the clearness of their vision, this Court can scarcely have failed to have dispersed and dissolved them. They must renounce mediævalism at once and for ever, unless they are prepared to encounter the alternative of renouncing all pretension to the reputation of true artists—unless, also, they are willing to leave the revived Gothic to sink through their enfeebled grasp into a hopeless inanition. There is abundance of life in Gothic Art— witness the Hereford screen. It is quite possible, also, that its healthy vitality should be exhausted—witness the Mediæval Court of the International Exhibition.

CHARLES BOUTELL.

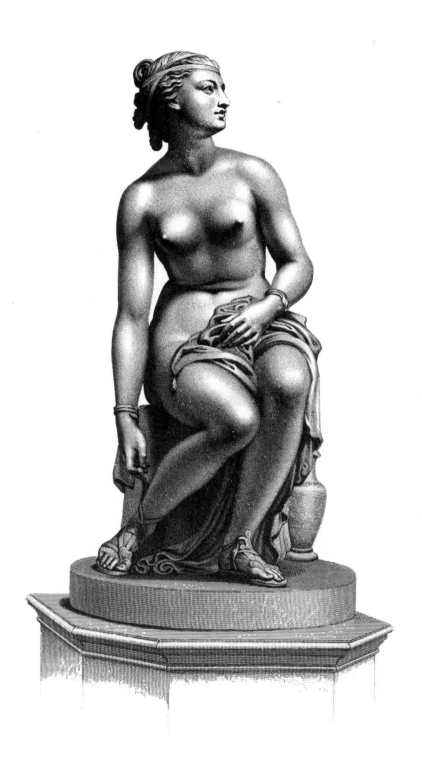

PREPARING FOR THE BATH.

ENGRAVED BY W. ROFFE, FROM THE STATUE BY J. GIBSON, R.A. IN THE POSSESSION OF THE EARL OF YARBOROUGH.

LONDON, JAMES S. VIRTUE.

THE INTERNATIONAL EXHIBITION.

The whole of the hundreds of thousands who have visited the International Exhibition have seen, under the centre of the eastern dome, the MAJOLICA FOUNTAIN manufactured by the "MINTONS," of Stoke-upon-Trent, from the design and model of the late JOHN THOMAS, who, unhappily, did not live to see his great work erected. It is thirty-six feet high by thirty-nine feet in diameter. At the summit there is a group, larger than life size, of St. George and the Dragon; four winged figures of Victory, holding crowns of laurel, encircle a central pavilion, on the top of which the group rests. Underneath is a series of smaller fountains. The outer basin which encircles the

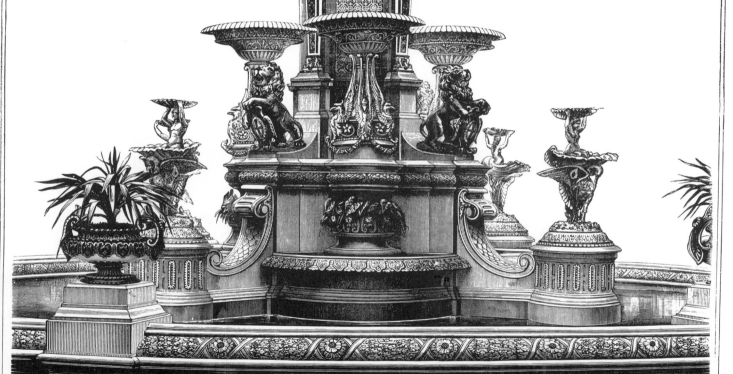

whole of this remarkable work is ornamented with an oak leaf, alternating with the Rose of England, and is divided by eight graceful flower vases.

NOTES ON THE RAW MATERIALS USED BY ARTISTS
(SEEN IN THE INTERNATIONAL EXHIBITION).

It has been customary to represent Art as a grave-looking lady, dressed in antiquated costume, generally surrounded with palettes and brushes, mallets and chisels, wheels cogged and plain, busts, engines, vases, and other curiosities of civilisation. Would it not better suit our modern notions, and vary the monotony of this mode of representation, if we were to make our personification a pleasant, lively little fairy, wielding the wand of Science, and accompanied by a knot of curious, sharp-eyed, needle-fingered gnomes, —Faradays, Grahams, Playfairs, Brands, Odlings, and a host of others, not forgetting the clever Miller's-thumb, who with their conjuring tricks so transform everything they touch, that we are lost in wonder and amazement?

Let us then have our own way for once; and having started our elfin queen of Arts, we will watch her operations, aided by her elves, and we shall see that they far outstrip all the wonders of our boyhood's fairy lore. She waves her magic wand over the verdant mountain sides, and the green carpet of nature is roughly torn up, the rocks are rent and tumbled down from their resting-places, where they have reposed for thousands of years, and the treasures of the mines are uncovered, to be grasped by eager hands. She casts her spell upon the flowers, and, even as they fade, their lovely colours are seized by her servants, and are made into materials for her

It is a pleasant task to render homage to the name of WEDGWOOD. The Exhibition affords ample proof that the mantle of the great master of British Ceramic Art has been inherited by his descendants. Some of the works engraved on

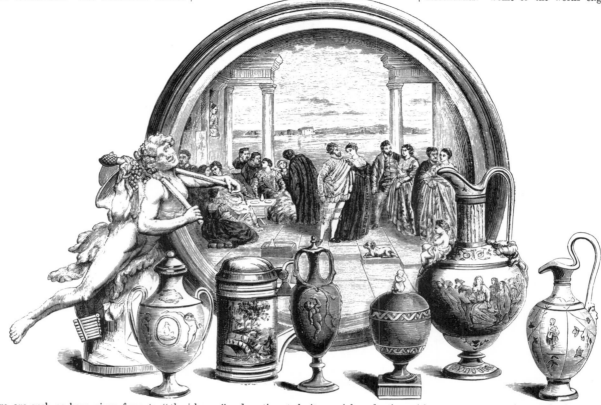

this page, are such as have given fame to "the | house," and continue to be its special productions ; | but our more prominent selections are those of

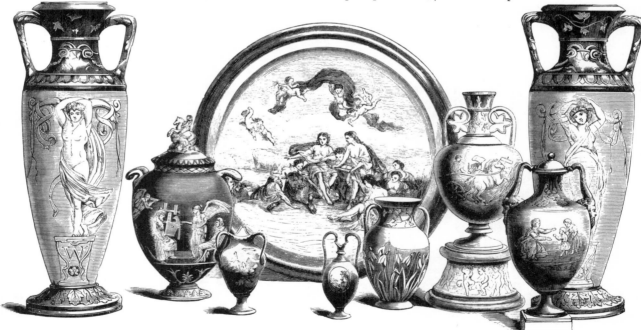

M. LESSORE, the artist whose " paintings on china " | have excited the intense admiration of persons of all | countries by whom the Exhibition has been visited.

fanciful creations. The mighty tree of tropical forests, equally with the insect which crawls on its leaves, yields at her bidding its life-blood to become brilliant hues for the robes of Beauty. The leviathans of the forest and the flood shed their teeth at her command, to furnish materials for the quaint or graceful conceits of her votaries. Her power extends to the depths of the ocean, and at her command the pearly shell and rosy coral branch are yielded up to receive new forms and new applications. She wills, and from the masses of rock thrown from the mountain side, figures, perfect in form, and dazzlingly pure, are called forth. The ponderous dingy stones, in the hands of her gnomes, yield up glittering treasures of metals and precious stones, to become, by the labour of cunning workmen, "things of

beauty," or, under still more elaborate manipulation, to reappear in gorgeous colours upon the living canvas.

If we carefully examine the history of each common or rare substance which the artist uses in his operations, certainly, at first sight, they are almost magical in their development ; but as we trace them upward, we soon find the wondrous realities of science surpass all the marvels of elfdom, and sweep away all but its poetry.

We purpose to write short notes upon the history and development of those materials which are used by artists,—such as the metals which are now wrought so skilfully into works of great beauty as well as utility ; the metallic oxides, and other mineral substances used in making pigments ; the materials for enamels, for glass,

THE INTERNATIONAL EXHIBITION.

The contributions of the Royal Manufactory of Sèvres to the International Exhibition are numerous, varied, of the rarest quality and the highest

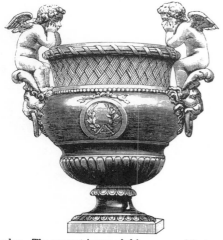

value. The present issues of this renowned factory, if they do not in all ways vie with those of a century ago, are in some respects superior to its

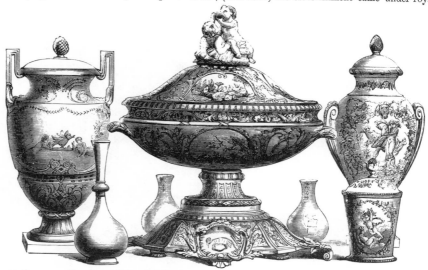

protection—royalty monopolising its labours, and paying the cost. Now, as then, the best artists

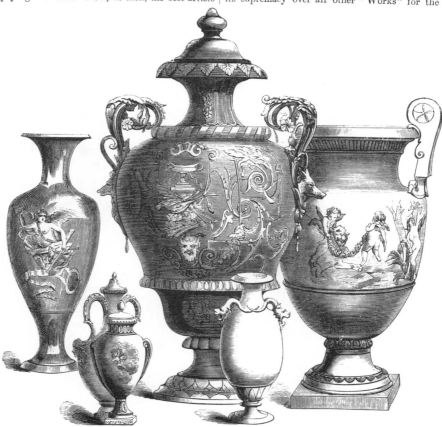

production of Ceramic Art. It is under the management of M. Regnauld, a gentleman of

productions in the time of Louis Quinze, when (A.D. 1760) the establishment came under royal

of France are employed at Sèvres, and maintain its supremacy over all other "Works" for the

extensive experience, large intelligence, and thorough knowledge and skill in pure and true Art.

and for porcelain; the materials used for statuary and works in stone; and also the vegetable and animal materials used in the various special operations of the artist.

Of the metals, only gold, silver, platinum, aluminium, copper, iron, and zinc are generally used in their metallic state for the production of artistic work, but combinations of these and other metals are also employed in various ways.

Gold may be ranked first, as it usually is, not only on account of its universal application as a standard of value, but also because, in all probability, it was the first of the metals which became known to man. The reasons for such a supposition are very plain;—it is second only to iron in the universality of its diffusion; it is the only metal which commonly occurs in a native state, that is, in a pure metallic state. In the localities where it is found, it can be seen in glittering scales, mingled with the gravel, or in "nuggets" sufficiently large to arrest the most indifferent observer. Then it has a quality which would soon make itself apparent, namely, its ductility, and the consequent ease with which it can be worked into shape. That it would soon become valuable as an article of exchange can easily be imagined, and the first forms given to it for the purpose would be those admitting of most easy carriage. This would be determined by the habits of the people; and as there is every reason to believe that the articles of clothing worn in primitive times were not only few in number, but of very simple contrivance, the modern custom of pockets was not thought of;—hence the ring form was given to the pieces of gold, to admit of their being strung together and worn externally upon the person. This eventually led to the fashioning of armlets, anklets, torques—large enough for the waist, or small enough for the lips, nose,

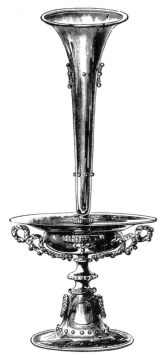

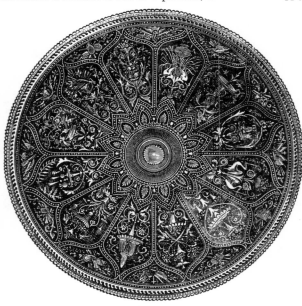

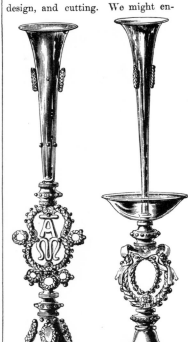

To the contributions of Messrs. Dobson have all, foreigners included, willingly admitted that none of their exhibits compete with those of the eminent firm in St. James's Street. Mr. Pearce is an artist as well as a producer, and his works supply

design, and cutting. We might en-

conclusive evidence of the value of Art-knowledge in Art-manufacture. The famous TAZZA, here engraved, has perhaps found more

AND PEARCE the palm of supremacy has been universally awarded. There are many

grave with advantage the whole of the

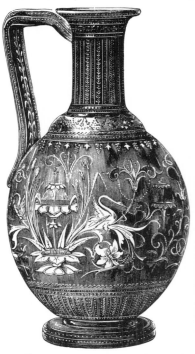

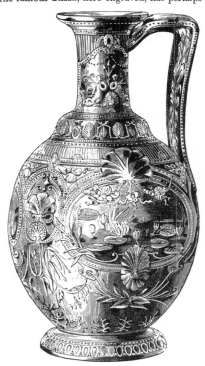

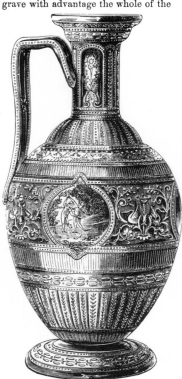

excellent exhibitors of TABLE GLASS, who

general admiration than any other work in the Exhibition. We have selected three of the VENETIAN (adapted) COPIES, and three of the CLARET JUGS; they are exquisite examples of the art, in form,

works exhibited by Dobson and Pearce.

or ears—and other simpler forms. This originated the goldsmith's art, and out of it, in all probability, arose the whole series of metallurgical operations; and hence it is that we find some of the earliest indications of Art have been developed in working this precious metal. But it is not its quality as a material for manufacture with which we have to do, however artistic such works may be rendered; it is the application of gold—and this applies also to the other metals—to the operations of the artist, which now claims our attention. First, then, we must speak of the application of gold in its metallic state—either pure, or sparingly alloyed with some other metal—to the purposes of decorative Art, for which its wonderful ductility most admirably fits it; we refer only to gilding by means of leaf-gold, and not to the beautiful operations in electro-deposition, which belong rather to metallurgy than Fine Art.

The fact that gold could be beaten out very thin, and used for the purposes of gilding, was known to the Greeks and Romans. It is referred to by Homer in the "Iliad," and by Pliny, and it is very probable that it was even known still earlier to the Assyrians and Egyptians, as it is found on the coffins of mummies discovered at Thebes, so applied as to indicate considerable familiarity with such uses of the metal. But it is not to be supposed that the art of producing gold leaf so fine as that now employed was known to the ancients. Pliny speaks of 1 oz. of gold being beaten into 750 leaves, each 2 in. square; whereas 16 dwts. are now beaten into 2,000 leaves, $3\frac{3}{8}$ in. square. Its uses, however, were the same—to give richness and brilliancy to baser materials, and to assist in decorative details.

Early in the history of the art of painting, we find leaf-gilding occupies an important position. It probably originated with the

We engrave a group of the works in GLASS exhibited by Mons. L. J. MAES, of Clichy-la-Ga- renne (Seine). The collection is of a very varied order as to form and colour, and generally of

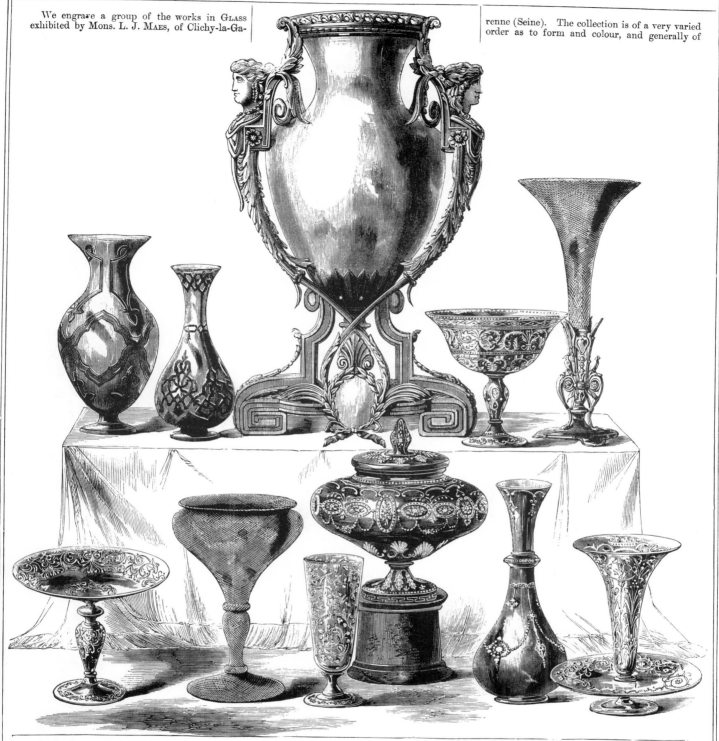

great excellence. Some of the engraved speci- mens rank with the best in the Exhibition. The works have long been famous: the manufacturer has obtained many "honours," and is eminently entitled to them, holding rank among the most meritorious producers of Art-works in Europe.

Assyrians and the Persians; was sparingly employed by the Greeks; lavishly indulged in by the Romans during the Romanesque period; and, like a flood without control, fairly overwhelmed everything in the Byzantine period. The re-introduction of the Byzantine in our own time, in conjunction with the Renaissance and other highly decorative styles, has again brought gilding into extensive use amongst modern artists; and we sincerely hope its brilliant and seductive glitter may not dazzle their eyes, and blind them to the real merits of true Art.

The production of leaf gold and silver, for both are similarly pro- duced, is amongst the most interesting of the many Industrial Arts. The wondrous ductility of these metals allows of their being beaten out, as before stated, into leaves of almost incredible thinness; but not by the mere blows of the hammer, which, if directly applied, would soon break the thin leaves into pieces. First the ingot of gold, more or less alloyed with copper or silver, according to the tone of colour required, is rolled out by pressure into a thin ribbon of regular dimensions, namely, $1\frac{1}{2}$ in. in width, and of such a thick- ness that exactly 10 ft. of this metallic ribbon go to 1 oz. Two ounces and a half of this ribbon are cut off, and are called *a beating*, which, after being annealed and carefully smoothed to remove any blistering, is divided very equally into 170 pieces, which are placed exactly over each other between 171 pieces of vellum, 4 in. square, usually old manuscripts or deeds cut up, and constituting altogether what is technically called a *mould*. This mould, with the pieces of gold, is beaten with a 17 lb. hammer for nearly an hour; after which each piece of gold, now extended into a leaf about 3 in. square, is quartered, and each quarter put in the same way as before between the leaves of another mould, now called a *shoder*, and made of 681 small square sheets of those finely prepared lamina of the intestines

The examples of WALL PA-

We engrave the CENTRE CA-BINET, of walnut wood inlaid with holly, manufactured by

Mr. THOMAS FOX, of Bishopsgate Street. The design is simple and elegant

Cabinet are those of SCOTT,

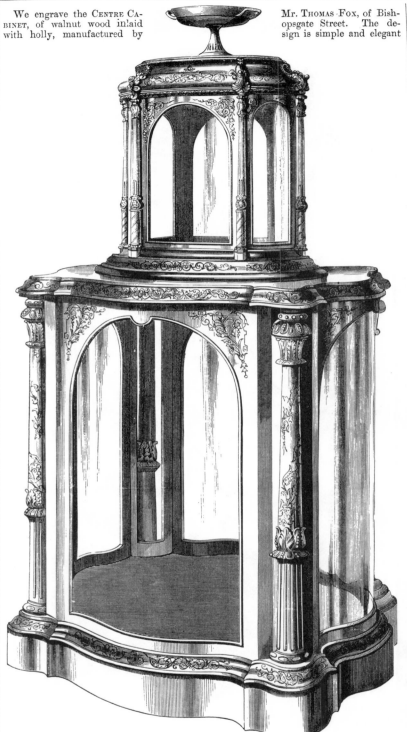

PERS on either side of the

—forming a receptacle for articles of *vertu*, and well adapted to stand in the centre of a drawing-room. The work has an especial merit—the mouldings being produced by laying fret cut veneers on complex forms. It is entirely by English designers and artisans.

CUTHBERTSON & Co., Chelsea.

of the ox, called "gold-beater's skin," which is also beaten with a mallet or hammer weighing 8 lbs., until the gold leaf appears at the edges of the shoder. Again the operation is repeated of quartering each leaf of gold, and placing each quarter between the leaves of another and finer shoder, $3\frac{1}{2}$ inches square, and continuing the beating until the gold again reaches the edges. The number of sheets in this last operation is 2,720, and the gold is so thin that the light passes through it; nevertheless, it is easily managed by the artist, and is laid upon varnished surfaces, to which it adheres, and is made to assume the appearance of polished gold by the use of a burnishing instrument. One very remarkable circumstance, connected with the foregoing operations, is the fact, that the excessive thinness to which this metal can now be worked is due, in a very great measure, to the perfection attained in the preparation of gold-beater's skin,

which, as just stated, is made from the intestines of the ox. There are several manufacturers of this material, but the principal in England is Mr. Puckeridge, of Kingsland Road, London, who is said to consume in his manufactory the intestines of not less than 10,000 oxen annually.

Such are the curious stages through which the glittering scales, picked laboriously out of the river sands of western Africa, or obtained by various means from the quartz rocks of Australia, California, and other parts, are passed, before they are ready for the artist to spread upon his work. The chemist uses different means, and adapts them for other purposes, two of which only will occupy our attention in these notes.

The first of these is the well-known "purple of Cassius," of such infinite use to the artist in stained glass and porcelain painting.

THE INTERNATIONAL EXHIBITION.

We engrave one of the many beautiful examples

of SILK DAMASK for curtains, manufactured by Messrs. WALTERS AND SONS, of Newgate Street.

From many admirable works manufactured and contributed by Mr. J. G. CRACE, of Wigmore Street, we select for engraving a CABINET of walnut wood, 9 ft. 6 in. in height, and 5 ft. wide.

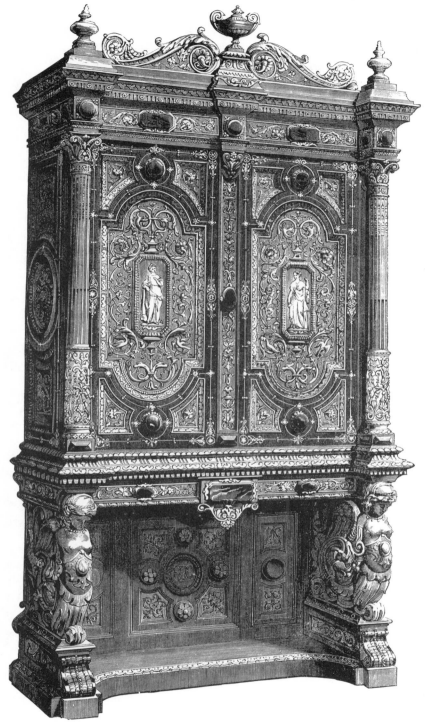

The style adopted is that prevalent in Italy during the first thirty years of the sixteenth century, the purest and most elegant of the Italian Renaissance period. The columns, friezes, panels, and mouldings, are carved, the centre of each door has a medallion of Painting and Sculpture.

This beautiful metallic colour—which is of the richest purple if used as a pigment on the surface of glass or porcelain, but which, when melted in the glass, gives the well-known ruby red so much admired in the best Bohemian glass—is a compound of the terchloride of gold with the perchloride of tin, which is said to have been discovered by Dr. Andrew Cassius, of Leyden, about 1685; but although he has given his name to the definite compound now known as purple of Cassius, the old alchemists were aware that gold, in certain combinations, gave a ruby colour to glass. Secondly, this same chloride of gold, which, in combination with tin produces the gold-purple, is alone used as an important agent in the art of photography,—for art it is, notwithstanding the decision of the Royal Commissioners of the International Exhibition to class it with machinery and similar matters. By its peculiar reducing action upon the salts of silver, this gold compound communicates an agreeable purplish or violet tone to the otherwise deep brown shades of the nitrate of silver. Thus we have seen that the glittering metal, gathered from the rocks and sands of distant countries, besides being made to spread in thin films over decorated surfaces, also tints with rosy hue or rich crimson the cathedral window, and enriches the shades of the sun pictures of the photographer.

SILVER also has its wonders. It is not so generally diffused as gold, nor does it often occur in a native state, but its ores in large veins traverse the rocks at great depths in mountain chains, chiefly

Beauvais and the Gobelins are both Royal establishments, and both are under the direction of M. BADIN, an accomplished gentleman and experienced artist. At the Gobelins are produced, chiefly, large works; copies of pictures, and so forth; Beauvais, on the contrary, has confined its

issues in a greater degree to its original aim— that of domestic service. The subjects chosen are therefore decorative rather than strictly pictorial, that is, they are not so exclusively confined to copies of pictures: flowers, fruit, scroll-work, and other enriched designs, such as chairs and

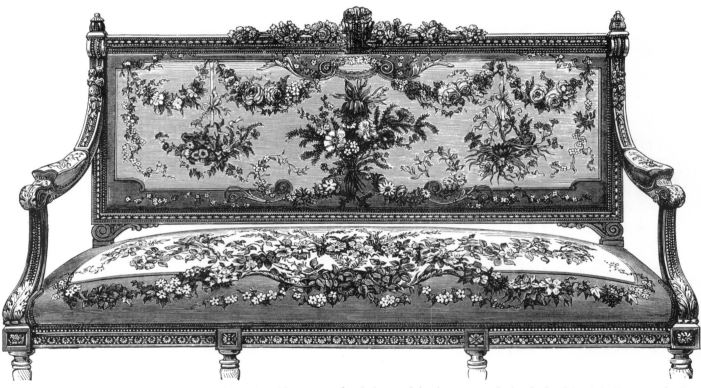

sofas require, are here principally to be found. Nothing can exceed the beauty of the general designs of the Beauvais work; its flowers, fruits, and enrichments equal paintings, and in vigour and clearness rival that of the Gobelins. From its productions we engrave two BACKS OF SOFAS, wrought for the boudoir of the Empress, who is happily a liberal and enlightened "patron" of the highest and best Art-productions of France.

in South America; or else it is found mingled with lead, and requires nice art for its separation. Like gold it is very ductile, and is capable of extension, by the same processes, into very thin sheets, which are used in the same way, though not so extensively. Its especial interest to the artist as a material for Art-operation is found in the fact that some of its salts are marvellously sensitive to the action of light, and have led to the invention of photography and all its wonders. If silver be dissolved in nitric acid, it will reappear in dull, white, transparent crystals, which are easily soluble in water. If any of this solution be spread over a surface of organic matter, it turns black on the slightest exposure to light. The whole art of photography depends upon this quality; and the aim of the artist is to obtain the most delicately smooth and colourless film of organic matter evenly spread, upon which the picture is projected, and its lights and shadows affect the sensitive salt of silver, which has been applied to the surface exactly in proportion to their depth; the light portions of the picture reflecting most light, form dark shadows on the prepared surface, and the dark parts the reverse. As the organic medium is usually collodion,—which will be mentioned amongst vegetable matters,—and the surface on which it is spread is glass, it receives a picture called a negative, the reverse of the original; and as this action of the light on the silver can be stopped instantaneously, and the picture produced "fixed," as it is termed, this negative on glass serves the purpose of an engraved plate; for by laying it on paper, properly prepared with the same solution of nitrate of silver, and allowing the light to pass through the glass, the paper is affected, and a picture with the shades reversed is made, and is consequently like the original. A thousand ingenious modifications of this process have been suggested by the busy brains of the chemist, but the above is substantially a true description of the process under its most simple

THE INTERNATIONAL EXHIBITION.

We engrave on this page four examples of CHINTZ, the productions of the very famous establishment at Cummersdale—Messrs. STEAD, McALPINE, & Co.—but these works are designed and printed for Messrs. D. WALTERS AND SONS, of London, and they, therefore, share the

merit of their production. They are all floral—studied from the natural flowers; skilfully and

whole of the designs are by Mr. W. PEARMAN. The advance that has been made in this branch

duce of France—not long ago unapproachable; to the eminent establishment at Cummersdale we

happily grouped and distributed; the colours being arranged with admirable harmony. The

of Art-manufacture of late years has been great—so great, that it now competes with the best pro-

are indebted for the equality, if not the supremacy, to which England may now justly lay claim.

conditions. Many other salts of silver are employed in this art; but it is not intended in these notes to enter into the subject of photographic chemistry, further than indicating, as we have done, the important part which this beautiful metal performs in an art with which we are now so familiar, but which, had it been described to our fathers, would have been regarded as less credible than any tale of fairy transformation that ever was imagined.

COPPER, like silver, is usually raised from the mine in the state of ore, that is, in chemical combination with other minerals, and requiring much labour and skill to effect a separation; so much, indeed, that it would be difficult to make some persons believe all that has to be done before the beautifully smooth plate of metal is ready for the burin of the engraver. Deep in the bowels of the earth the miner labours at the rock, laboriously hewing out the metalliferous parts, which he knows how to distinguish, although often to the un-

practised eye not differing much from the other portions, except in weight. These are raised to the surface, and afterwards undergo a multiplicity of operations, for the purpose, in the first place, of separating all the non-metalliferous portions, and, secondly, for setting free the copper from its alloys. Such a large amount of care and skill is required in these processes, that had we time and space to describe them, it would seem almost incredible to the reader that they could be used with profit. Nevertheless, it is now found that ores containing only four per cent. of copper may be worked profitably.

Copper was a favourite material in the hands of the ancient artists: alloyed with other metals, it made those beautiful bronzes which still remain to us models of taste in Art, and skill in metallurgical science. The Romans derived it from various parts, but chiefly from Cyprus, whence it was called *Æs Cyprium*, and *cuprum*, and gave rise to our word copper. Modern artists also know the value of this

Of the works of HUNT AND ROSKELL we engrave the BREADALBANE VASE CANDELABRUM, produced for the Marquis of Breadalbane, as a fitting recep-

The other engraved object is the MANCHESTER ART-TREASURES EXHIBITION

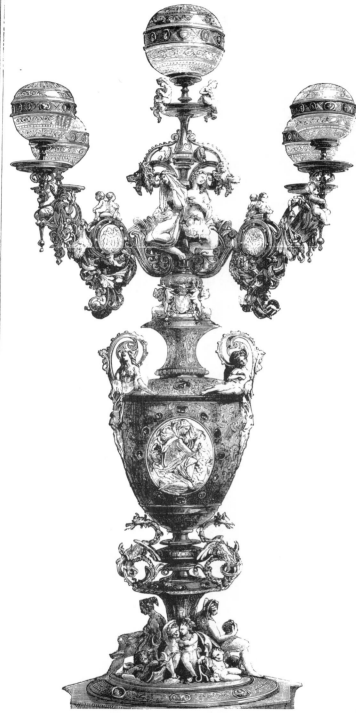

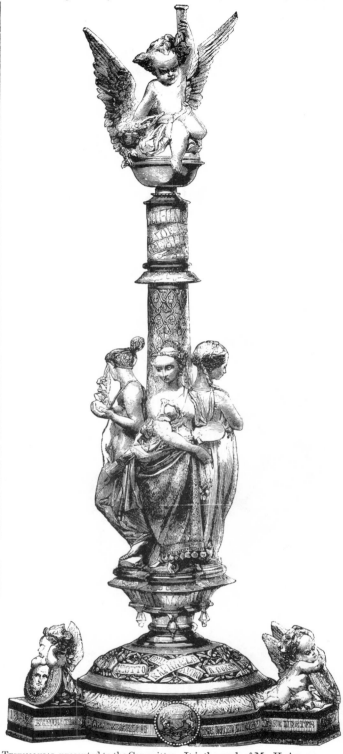

tacle for the famous "Poniatowski gems." It is in height nearly six feet, is of silver and iron, richly damascened with gold, and is one of the admirable works of the renowned artist VECHTE. We are compelled to omit the base.

TESTIMONIAL, presented to the Committee. It is the work of Mr. H. ARMSTEAD.

beautiful metal: its close texture, its hardness and tenacity, and its power of receiving a fine polish, have, with other qualities, made it the favourite metal for engraving upon; and its wonderful applicability to the galvano-plastic art probably was the chief cause of the discovery of the electrotype.

Plates of copper have been used by painters instead of wooden panels, for painting on, and are admirably adapted for small pictures and miniatures; and the malleability of this metal, and its liquidity when melted, render it peculiarly well fitted for either hammered work or for castings. Its beautiful alloy with zinc, which we call brass, is also well fitted for various Art-purposes. But it is not only in its metallic state that the artist employs copper; chemistry produces upon it changes which convert it into more than one beautiful pig-

ment. These, when the result of natural chemical changes—as in the case of mountain green, or bice, which are different names for the beautiful colour prepared from malachite (native bicarbonate of copper) —are very fine permanent colours. When, however, they are artificially prepared, although little inferior in brilliancy, they are less trustworthy on canvas, and should be employed with great caution. Besides those mentioned, there are Scheel's green, emerald green, Bremen green, Brighton green, Brunswick green, Mitis green, Schweinfurth green, and verditer—all well-known pigments—owing their colour to the copper of which they are chiefly composed. And besides these there is the exquisitely beautiful chrome green of the enamellers, which, although properly a preparation of chromium, is made with the assistance of the ammoniacal salts of copper.

The FAN, of which the two sides are engraved, is one of the most beautiful Art-works that has been produced in England: the manufacturers are Messrs. LONDON AND RYDER, of New Bond Street. It is the wedding gift of his Highness the Maharajah Duleep Singh to her Royal Highness the Princess Alice. The actual value of this work is great—we believe it was the most costly present the young princess received—but its worth

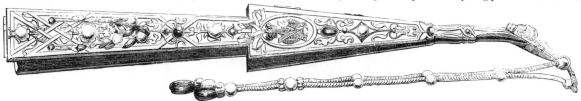

is not to be estimated by the emeralds, diamonds, rubies, and pearls by which it is lavishly adorned. It is an exquisite work of Art; a truly regal offering. The monogram A M M—"Alice Maud Mary"—is on either side, in the one case environed by orange blossoms, in the other springing

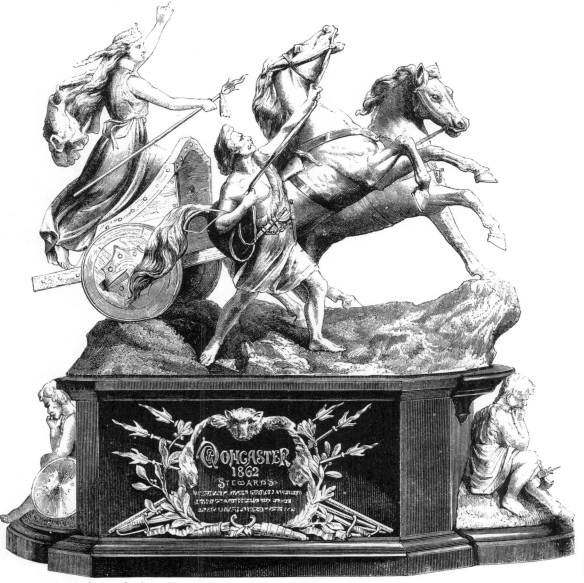

from a rose of a single carved ruby. The giver, with delicate taste, places his own initials in Sanscrit to form the loop of the fan. The GROUP, a masterly work of another order, is also the production of Messrs. London and Ryder: the model is by Mr. H. HALE. It represents Boadicea, queen of the Iceni, in her war-chariot, haranguing the Britons. It is admirably modelled and wrought. The work is the DONCASTER PRIZE of 1862.

To LEAD the artist is indebted for one of the most important of the materials employed in painting—the white lead, which forms, when properly prepared, not only a white colour, but also a vehicle and diluent for most other colours. This material is made by acting upon thin plates of lead with the fumes of vinegar or acetic acid. The *rationale* of this process is not well understood, but the result is the formation of a beautiful white carbonate of lead, which, when thoroughly rubbed down with oil, forms the white lead of the painters. Besides this—the uses of which are so well known—several other white pigments are made from this metal, namely, flake white (only a fine kind of white lead), mineral white (carbonate of lead prepared by precipitation), French white, Venetian white, &c.: also the beautiful yellow colours known as chrome yellow, Naples yellow, and patent yellow; and the red colours known as chrome red, orange red, and the well-known red lead, all of which are of great importance in the art of painting. We must notice also the application of metallic lead to the formation of coloured-glass windows, without which it would be impossible to carry out artistic designs in glass.

IRON, by far the most important of all metals to man, is also of great value to the artist, independently of its admirable adaptability for such artistic works as those of Quentin Matsys, and the no less beautiful productions of Mr. Skidmore and Messrs. Barnard & Co.—the now well-known Hereford screen and Norwich gates—the whole of the latter and the beautiful panels of the former being entirely formed by hammering malleable iron into the exquisite foliage and tracery of which they are formed.

LOUIS SY AND ALBERT WAGNER, of Berlin, are goldsmiths to his Majesty the King of Prussia. They exhibit several admirable works in silver, the principal of which we engrave. It is a SHIELD, wrought in frosted silver, with arms inlaid in enamel—a wedding present from the nobility of the Rhenish Provinces to their Royal Highnesses the Prince and Princess Royal of Prussia—our own Princess, the Princess Royal of England. The four reliefs represent the four Rhenish Provinces, historically depicted, offering

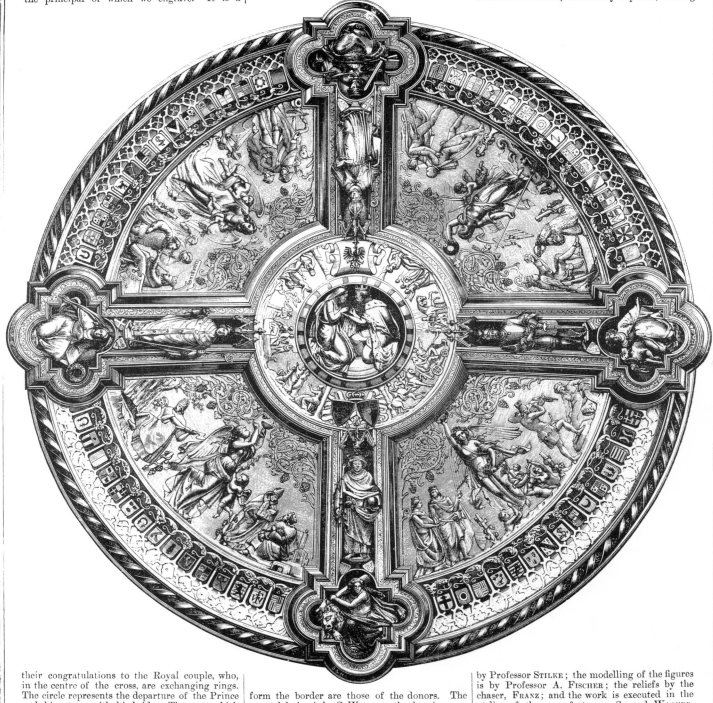

their congratulations to the Royal couple, who, in the centre of the cross, are exchanging rings. The circle represents the departure of the Prince and his return with his bride. The arms which form the border are those of the donors. The general design is by C. WAGNER; the drawings are by Professor STILKE; the modelling of the figures is by Professor A. FISCHER; the reliefs by the chaser, FRANZ; and the work is executed in the atelier of the manufacturers, SY and WAGNER.

The oxides of this metal, occurring as they do most abundantly in nature, and possessing rich shades of yellow, red, and brown, were probably the first pigments employed by man when he painted his own face instead of having his face painted. The Indian red, light red, umber, terra di Sienna, and the various coloured ochres, hold their places on every palette, and constitute the soundest and most certainly permanent of all the colours in use; and the natural supply of these is so abundant, that there is no need for manufacture, careful trituration and levigation being all that is necessary.

There are two other colours becoming day by day more familiar to the careful painter, who looks to the future as well as the present, namely, the cadmium and strontium yellows, which quite rival the brightness and beauty of the chromes, and far surpass them in stability. CADMIUM— rather a rare metal, chiefly obtained as a product of the process of smelting zinc—when combined with a proper proportion of sulphur, forms the beautiful orange yellow sulphuret called "cadmium yellow;" and STRONTIUM, in its chromate, yields a bright and delicate canary yellow, which is very permanent. To the curious fluid metal, MERCURY, or quicksilver, we are indebted for the valuable red pigment vermilion, one of the most ancient of the artist's materials. It was well known to, and largely employed by, all the civilised nations of antiquity: we see it on the pictured walls of the Assyrians and Egyptians, and it was one of the chief decorative materials of the Greeks and Romans; but the vermilion of those nations was the native ore of quicksilver, which we call cinnabar. They were unacquainted with the art of making it, although it was probably known from a very early period to the Hindoos and Chinese, and the latter are still unrivalled in the art of making it. We have obtained the word vermilion in a curious way;—it is this: on a species of oak in southern Europe and Asia, an insect, known to

The manufactory of M. DURENNE is the most famous in France for the production of works in cast-iron—works, that is to say, of the higher order of Art. His groups, statues, vases, bas-reliefs, and more especially animals, are marvel-lous achievements in design, modelling, and cast-ing, being generally as sharp and brilliant in manipulation as they could have been in bronze; while produced at singularly small cost, con-sidering their great merit. He is, no doubt, destined to be a large contributor to the parks,

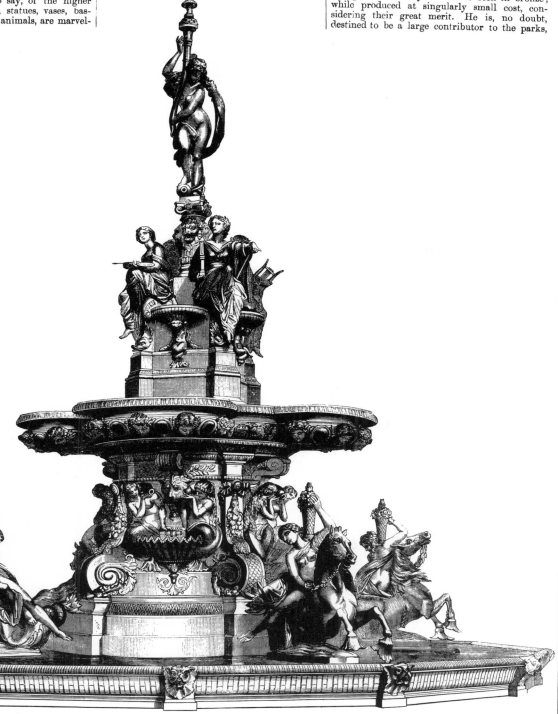

gardens, and conservatories of England. The work we engrave is the FOUNTAIN that obtained universal admiration in the Horticultural Gardens. We have not space to describe it, but the en-graving does for it more than words can do. The figures are designed and modelled by KLAGMANN.

naturalists as the *Coccus kermes*, is found, and as it in one stage resembles a red berry, it was assumed by the Romans to be one; but finding, on opening it, the parts of a live insect, they believed it was transformed into a little worm, "*vermiculum.*" This *coccus* or *kermes,* as it is now called, yields a beautiful crimson dye; hence its name, *vermiculum,* now changed to vermilion, became a generic distinction for a scarlet colour, and was in time applied to the mineral pigment, which superseded the use of the insect dye. The Romans generally called it *minium,* and there is every reason to believe they confounded cinnabar (red sulphuret of mercury) and red lead, although it was certain that one variety of the quicksilver ore was specially known and designated *cinnabaris* or *rubrica* by the Romans, and by the Greeks *Miltos.* With this one colour were probably executed the first pictures of Greece, in a style which

was called "monochromata," a fashion known also to the Romans, who used the pigment to colour their statues, and even their living generals, as in the case of the statue of Jupiter, and of the general, Camillus, mentioned by Pliny. But the ancient "monochromata" were not all painted with this colour; some were painted in white by the magnificent Zeuxis, of Heraclea, which were as famous in their time as the wonderful *Camaieu* paintings of Jacob De Wit, Roenstraeten, and other painters of the Dutch school are at the present time. Vermilion is now manufactured chiefly in England and Holland, its most extensive use probably being the colouring of sealing-wax.

COBALT is another metal which ministers to the wants of the artist, and furnishes him with a most beautiful colour. It also supplies the glass-stainer with the only rich blue colour yet known.

From the Gothic Metal-work exhibited by Benham and Sons, of Wigmore Street, we have se-lected an Andiron, or "dog," for an open fire-place,

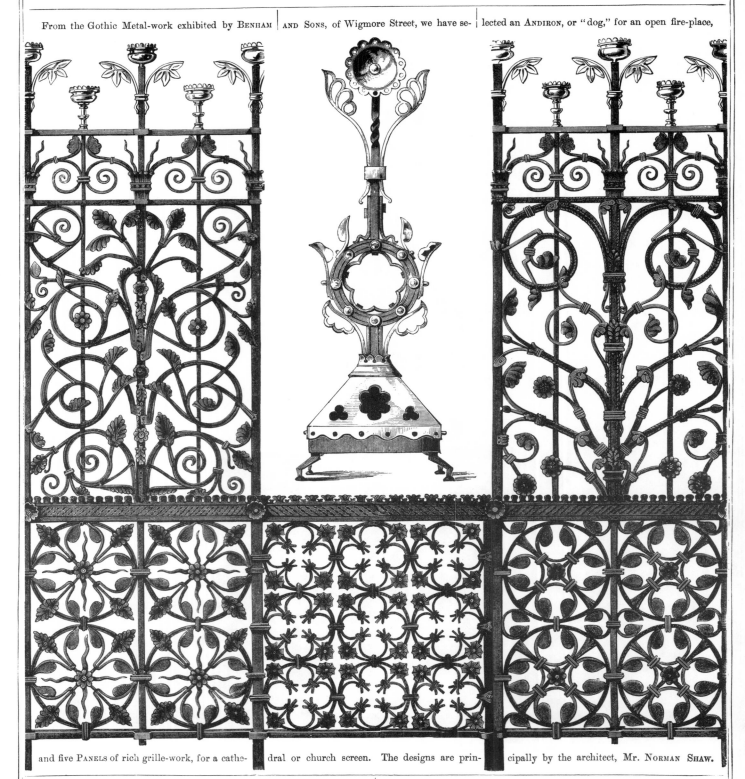

and five Panels of rich grille-work, for a cathe-dral or church screen. The designs are prin-cipally by the architect, Mr. Norman Shaw.

This metal is never found native, but usually occurs in the form of a dark grey, stony ore, of most unpromising appearance. It is obtained chiefly from the copper-mines of Norway and Sweden; and not very long ago its hard veins running through the lodes of copper were considered a great evil by the miners, who attributed their frequent occurrence to the spite of evil disposed sprites called *kobolden*, whence our name of cobalt for the metal. Long after the commencement of this century, a prayer was read in the churches of Norway praying for protection from the *kobolden*. Now, however, that mist, like many others, has been dispelled, and the cobalt ores, which are so useful to the painter and others, are of more value than the copper itself. The Thenard's, or cobalt, blue, so useful to the painters, and for its quality of colouring glass, is also invaluable to the enameller, whose blues are all obtained from this source, as it admits of a range of shades from the light turquoise to violet blue.

Chromium is the only other metal which will now be mentioned, although several others administer less directly to the requirements of Art. In a metallic state it is very rarely seen, but its sesquioxide, under the name of *chrome green*, is one of our most beautiful opaque green colours, of especial value to the enameller; and its combinations with lead and potash produce the fine yellows so well known as chromes. It is usually associated with iron, and is found in large quantities combined with the iron ores of many parts of the world.

Besides these, there are some so-called non-metallic minerals, which especially subserve the purposes of the artist; first amongst which is the exquisitely beautiful Lapis-Lazuli, or azure stone, remarkable for its peculiarly fine blue colour, which, when prepared for use, is called *ultra-marine*. This charming mineral, which is ranked amongst precious stones, although usually ranged with non-metallic minerals, may in truth be traced back to the two metals

The several groups of objects in metal which are | represented on this page, have been selected with | a view to exemplify the various productions of

the Messrs. HARDMAN, the celebrated mediæval metal-workers, of Birmingham. These examples LECTERN in brass, SCREEN-GATES in wrought iron, and a GAS-STANDARD in brass and iron; also a collection of SACRAMENTAL PLATE in the precious metals, enriched with jewels and enamels, with a

 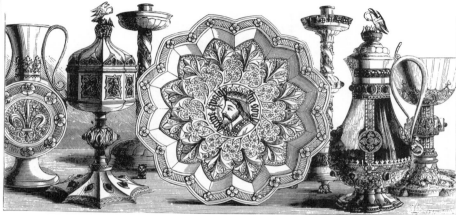

series of objects for domestic use, and a BRACE-LET and two BROOCHES. These works are all of the highest merit, not only in reference to design, which is of the purest order, but in the refined skill in manufacture for which they are pre-eminent. Messrs. Hardman have obtained the

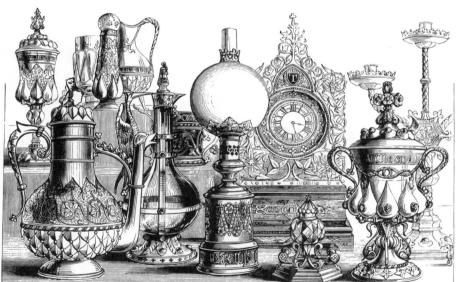

are all true to the traditions of the fourteenth and fifteenth centuries. They comprise an EAGLE-highest honours in the art to which they have devoted their especial attention, manufacturing nearly every class and order of work (the common as well as the most costly) for ecclesiastical uses.

sodium and silicon, which are found combined in it. The beauty of the stone is greatly enhanced by a number of specks of gold-like iron pyrites, and of some white material. It was very highly prized by the ancients, who gave the names of *cyanos* and *sapphiros* to its two varieties; and it is curious to observe that the method of making an artificial lapis-lazuli was said to have been discovered by one of the kings of Egypt, and the Egyptians were very proud of the invention. What this artificial stone was composed of is unknown now; very probably it was only the blue glass often found in the form of small rings, &c., in tombs, and which is also spread as a blue glaze over the little earthen figures of deities found associated with them; but it is not likely that this artificial production, formerly the glory of an Egyptian king, was the same as that which constitutes the glory of the French chemist, Guimet, who, in 1828, having carefully analysed the true lapis-lazuli, suc-

ceeded, by synthetical combination of its component minerals, in reproducing an excellent imitation of the real ultra-marine—the name given to lapis-lazuli in the state prepared for the painter's use. This extraordinary discovery has almost annihilated the manufacture of the pigment from the natural stone, and has so reduced the price of ultra-marine that a pound can now be obtained for the same price which was formerly given for a scruple of the native sort, or more than five hundred times cheaper; besides which, considerable variety of tint can be produced in the artificial sort, and, as far as can be seen, its permanency is equal. This cheapening of so important a colour has had immense effect upon those branches of decorative Art applied to the interior of buildings, and has enabled us not only to rival, but to surpass the ancients in our colour decorations.

The decaying vegetable matter of which peat-bogs are generally composed is also seized upon by the artist and made to live again

The English bookbinders who were contributors to the Exhibition made no such efforts as were made by foreign workers; there was no

display of costly examples that were curiosities—rather than utilities; but

the general character of their productions was undoubtedly good, the binders having, in nearly all instances, called the artist to their aid, and

furnished designs on covers that were of very considerable merit as works of Art. Among the best and most extensive of the contributors was Mr. BONE,

of Fleet Street, four specimens of whose BOOKBINDINGS we engrave. They are

for the ordinary class of books, but they supply evidence of very large advance.

upon the canvas. From this material, and also from decayed wood, are made the two fine brown pigments called Vandyke brown and Cologne earth. Their employment in painting is very extensive; and as they mellow by time, much of the rich mellow toning of old pictures is due to that quality. This effect is now almost produced by the use of asphalte as a pigment, the best of which is that called "mummy," which is a compound of bituminous and resinous matters found in the Egyptian mummies, being the preservative materials used in embalming the bodies; but it is very questionable whether the artist is even justified in using this material, the composition of which can never be relied upon,—certainly he ought not to employ it except very sparingly, as it is liable both to crack and to run, and has already caused the destruction of many otherwise fine paintings.

The colours derived from peat and bitumen may be considered a fair link between the mineral and vegetable substances used by artists; and to the same intermediate class properly belong JET and AMBER. The former is a sort of fossilised bitumen, or natural pitch, which is chiefly used for small ornaments and mourning jewellery. It is easily carved, and being of a close, compact grain, and a perfect black colour, receives a very beautiful polish; it is, in fact, a variety of coal closely resembling the Cannel coal now so extensively used in our gas-works as the most productive gas-making material. The jet used in this country is chiefly obtained from the geological formation called the *Upper Lias*, or *Alum-shale*, of Whitby, in Yorkshire, where the action of the sea on the cliffs washes it out, and really artistic works are occasionally produced in this material. It is not, however, often chosen for such purposes,

We devote this page to the productions of Mr. Magnus. The Pimlico Slate Works have become renowned throughout Europe, and are

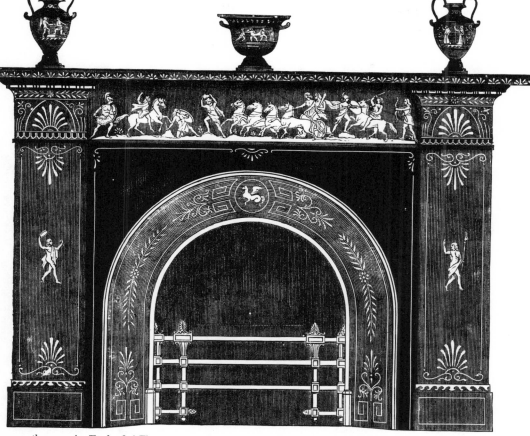

as popular in France as they are in Eng'and. | The energy and enterprise of Mr. Magnus tri- | umphed over discouraging difficulties; he has

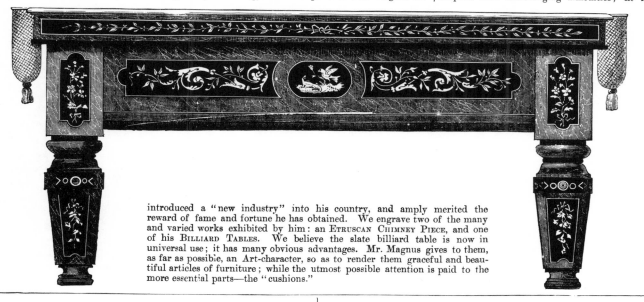

introduced a "new industry" into his country, and amply merited the reward of fame and fortune he has obtained. We engrave two of the many and varied works exhibited by him: an Etruscan Chimney Piece, and one of his Billiard Tables. We believe the slate billiard table is now in universal use; it has many obvious advantages. Mr. Magnus gives to them, as far as possible, an Art-character, so as to render them graceful and beautiful articles of furniture; while the utmost possible attention is paid to the more essential parts—the "cushions."

being too easily destroyed,—it is both brittle and inflammable,—but it is largely employed for rosaries, crosses, mourning ornaments, and similar trinkets. Its name is a curious illustration of the way in which words become altered, until scarcely any resemblance of the original is preserved: it was first known as a product of the shores of the river Gaga, or Gages, in Asia Minor, and thence was called *gagat*, which has been corrupted into jet.

Like jet, Amber is occasionally used, in consequence of its great beauty, for carving objects of Art. Many will remember the very fine carving of a cluster of grapes, for the possession of which two small birds, carved in ivory, are fighting, which was shown in the Hanse Towns Court of the International Exhibition, and is now in the Industrial Museum of Scotland. The bunches of grapes, and the branch and leaves, are all of natural size, and carved from

one piece of amber. Pieces of such size and purity rarely occur; when they do, they offer great temptations to the artist for the exercise of his skill and taste. There is no reason to doubt that amber is a fossil resin, and the fact that it frequently occurs associated with cones of a species of *pinus*, in the amber diggings of Poland, almost proves its origin from coniferous trees. It is usually found in small pieces, and is by no means rare in some parts of each of the continents, but it rarely is found of any large size. The two largest pieces of which we have any record is one found in 1576, in Prussia, not far from the Baltic coast, which weighed eleven pounds, and was considered worthy of being presented to Rudolph II., at Prague; and a still larger mass, weighing thirteen pounds, found in the same locality, which realised the extraordinary price of £750. Its most common application is to the manufacture of beads for

Of raw materials, manifesting the amazing wealth and vast resources of the greatest and most important of all our colonies—CANADA—there was a large and valuable display, but its active and enterprising people contributed little or nothing in the way of Art-works. We engrave,

Messrs. HEATON, BUTLER, AND BAYNE, glass painters, of Camden Town, supply us with

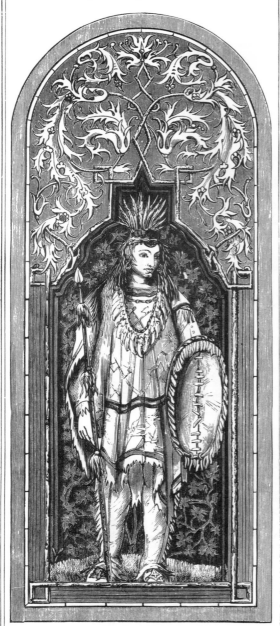

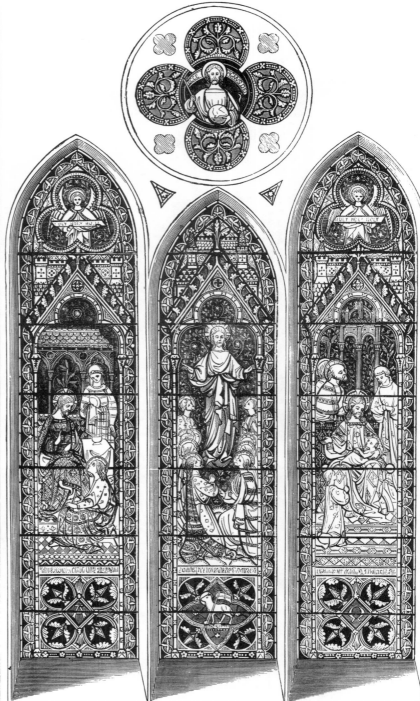

however, one of their productions, a WINDOW OF STAINED GLASS, manufactured by Mr. W. BULLOCK, of Toronto. It has much merit, both of design and execution, and its interest is enhanced by the portrait of a Canadian Indian in his full war-dress—accurate in character and costume.

an engraving of another of their many excellent works. It is the east window of Whit-

tington Church, Salop : a fourteenth century window, with three subjects under canopies.

rosaries, and mouth-pieces for pipes. No Turk or German is happy without an amber mouth-piece for his chibouque or meerschaum, and for this purpose immense quantities are consumed. There are several varieties,—the most common is of the colour known as amber-yellow, and when cut and polished is very transparent. This sort often contains embedded insects—another proof, if one were wanted, of its vegetable origin as a resin. Another, which is much lighter in colour, with a slight green tinge, resembling, when polished, the beautiful chrysophrase, is not so much valued, although intrinsically the most beautiful of all the varieties. Those which are most esteemed are the opaque varieties, sometimes called *fat amber*. They are of a light canary colour, and have a dull, wax-like appearance. Of these fat ambers there are two well-marked varieties, the one, as described, having a light canary colour ; the other having the same colour, with a slightly greener tinge, which is very highly

prized. Amongst the resins of commerce the large masses of so-called African copal and the Kaurie gum of New Zealand strikingly resemble amber, both in their substance and shape, and also in offering these same shades of colour, and in having both transparent and opaque specimens. Amber still retains its resinous inflammability, and an oil can be distilled from it which is sometimes used in varnishes. The "black amber" of the Prussian amber diggers is only jet, but it often produces a much higher price than that mineral, because it is supposed to be by some a black variety of amber.

Amongst the mineral substances which possibly had a vegetable origin in the carbon elaborated by the vegetation of forests, countless ages ago, is one of the utmost importance to the artist, namely, BLACK-LEAD, GRAPHITE, or PLUMBAGO. This curious material, although called commonly black-lead, should not, if pure, contain an atom of lead or any other metal ; it should be nearly pure carbon,

This SLIP is also the production of Messrs. HEATON, BUTLER, AND BAYNE. It is the side light of a baronial mansion. The very large number of contributions in

painted glass in the Exhibition, evidence the great progress of the art in England, not only with reference to churches, but also as regards the decoration of houses.

This WINDOW of "stained and painted glass" is the production of Messrs. CHANCE BROTHERS, of Birming-

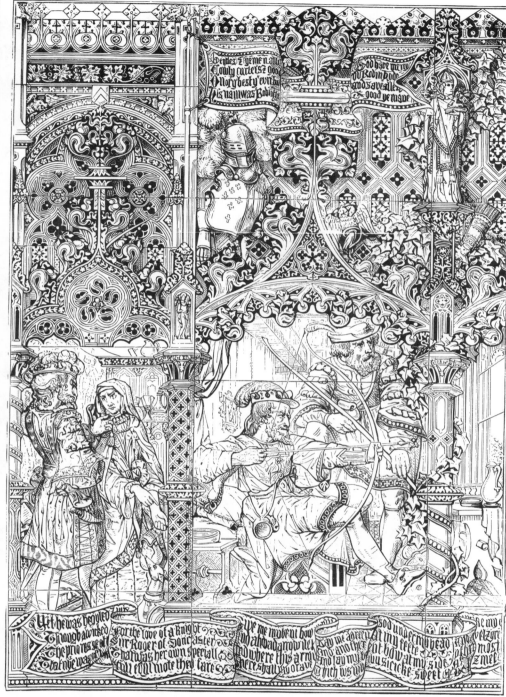

the Art-manager of the firm. The subject is "THE LAST SHOT OF ROBIN HOOD,"—a subject familiar to all readers

ham,—a house renowned throughout the world. It is the work of an eminent artist, SEBASTIAN EVANS,

of old British ballads. It is an excellent example of its class, very skilfully composed and admirably executed.

and in this respect is allied to the diamond, to coal, and to charcoal. Its use in the formation of drawing pencils is too well known to require further mention, but its production is too interesting to be passed over so lightly. Like the metals, it is usually procured by mining to great depth, being chiefly found associated with the granite and metamorphic rocks, in which it occurs either in embedded masses, or in holes in the granite, which are called "pockets" by the miners. From iron having been found mixed with it, some mineralogists called it a carburet of iron; but this error is quite abandoned, although traces of it remain in many books, and are still perpetuated by the modern system of book manufacture. Black-lead, or more properly, graphite, has been found in all quarters of the globe, but its most remarkable deposits are, first, the well-known Cumberland mine, at Borrowdale, where it occurs in beds, embedded in a trap-rock, lying below the clay slate of the locality. This mine was dis-covered in the side of the mountain in which it is situated nearly a century since, and has hitherto furnished the finest black-lead in the world for artists' pencils. It has consequently been a mine of wealth to its possessors, and has realised in one year the large sum of £100,000, the graphite being worth from thirty to forty shillings per pound. Strange to say, the great value of graphite for the purpose of pencil making does not depend upon its actual purity, but upon the peculiar aggregation of its particles; therefore analyses of this mineral, showing extreme purity, may easily mislead the uninitiated manufacturers, who imagine they have only to seek for purity to insure success. Graphite of very fine quality is obtained from Mexico and from Ceylon, the latter being the purest yet discovered; nevertheless, for the reason stated, it is inferior for the purposes of the artist to the Borrowdale mineral. The International Exhibition has brought to light the new sources of this mineral in Eastern Siberia, and few

Messrs. MUIRHEAD, jewellers and silversmiths, of Glasgow, are exhibitors of works of a varied

and excellent order. We engrave two pieces, parts of a DESSERT SERVICE; the designs are good,

and they have considerable merit in execution. We have selected also for this page examples of

their jewels—a BRACELET and three BROOCHES, containing the various pebbles and "gems" indi-

genous to Scotland. They have much originality of form, and are recommended by their solidity,

which renders them useful as well as elegant. There were many exhibitors of this class of

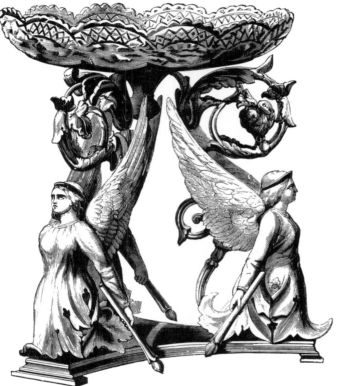

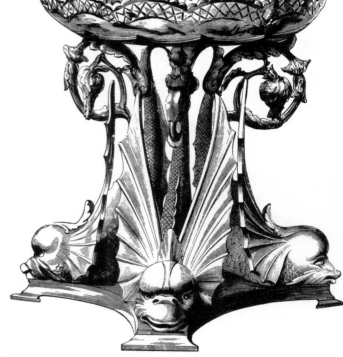

works—the special and peculiar productions of Scotland. They

were, as they ought to have been, highly attractive, for

they manifest industry as well as skill, and supply real

stones at little more than the cost of mere imitations.

persons who walked down the Nave can have failed to be struck with those cases in which the Siberian graphite is so tastefully displayed by their exhibitors, Messrs. Alibert and Sideroff. The works of the former are situated about 130 miles west of Irkutsk, in north longitude 53°, and east longitude 96°. The workings are at considerable depth below the surface, where the mineral is found in "nests" or "pockets" of the underlying granite. The quality of this graphite can scarcely be surpassed, and it has been eagerly bought by Mr. A. W. Faber, the celebrated pencil-maker of Stein, near Nuremberg, whose agents, Messrs. Heintzmann and Rochusson, 9, Friday Street, Cheapside, are already selling them in this country. Twelve degrees farther north, in nearly the same longitude, occurs the still more wonderful deposit of this mineral, on the estate of M. Sideroff. It is situated on the banks of the Lower Toongooska,

a tributary of the river Yeneesay. For 1,910 feet the Lower Toongooska washes along a bank of graphite 365 feet in thickness, which has been denuded by the action of the river, and which bears on its surface, marks of friction from the stream, and abundant traces of the glacial action produced on the breaking up of each winter's ice. It is known that this vast bed of black-lead extends inland to the foot of a mountain of gneiss rock, which commences to rise about 3,500 feet from the banks of the river; but whether it passes into the mountain, whether it is overlaid by the gneiss, or whether it is tilted up by it, is not yet known; certain it is, however, that the bed is enormous in extent, and far exceeds anything else of the kind yet discovered. Its thickness is known to increase considerably as it goes inland, and its quality appears to be increased with the depth of the superincumbent strata. This is consistent with what we

SIGNOR CASTELLANI, of Rome, whose name is

known throughout the world as a jeweller of

the highest order, enriched the Exhibition

with a small case containing gems of Art of

rare character and of great value. They are,

in nearly all cases, either copies or adaptations from ancient models, found in the several museums of Italy; but the taste, judgment, and intelligence of the accomplished artist have been exercised to fit them

On page 195 of this Catalogue is an engraving of a flagon and dish—the latter seen in perspective—

for modern requirements without impairing their original grace and beauty. We engrave six of the BROOCHES, but there was scarcely one of the series that might not have been advantageously studied.

the productions of Messrs. ELKINGTON & CO. To enable our readers to form an estimate of the artistic

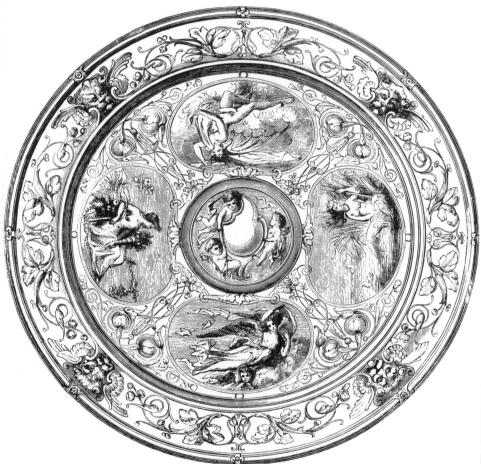

merits of the DISH, a full view of it is now introduced. The four medallions surrounding the centre represent the four Elements. It is a very remarkable specimen of silver-work, designed by M. WILLMS. The accomplished artist—one of the great men of the age—surpassed his competitors of all countries.

already know of graphite, which, as before stated, owes its best quality rather to the amount of aggregation or cohesion of its particles than to its extreme purity. Hence is it that the admirable process of Mr. Brockedon has enabled him to supply with perfect certainty almost any quality of black-lead for pencils, his best actually surpassing any that are made direct from the finest Cumberland graphite. This process consists in levigating the graphite, and carefully freeing it, as far as possible, from all foreign ingredients, and then compressing it again into a condition even more solid than it originally possessed. From cubes so made the portions for the pencils are afterwards sawn by the same means as from the unprepared mineral.

When it is borne in mind that the Cumberland black-lead is supposed to be almost, if not quite, exhausted, and that too in the face of an immensely increasing demand for other purposes than those of the artist, the importance of this discovery will be understood and appreciated.

In these notes upon the mineral substances which minister to Art, either directly or after certain chemical or metallurgical transformations, there is one large series which are purposely omitted, as they could not by any means be brought within the limits of this article,—we mean the variously coloured marbles, alabaster, and other ornamental stones used in the Decorative Arts, especially those used for inlaying, seal engraving, cameo cutting, &c.; and besides these, the materials used for modelling, the clay and the gypsum, the materials of the potters and the glass-blowers, and many others of a similar nature, which may be treated in a future article if desirable.

The VEGETABLE KINGDOM furnishes us directly with some

The Wardrobe is the manufacture of Messrs. William | Smee and Sons, of Finsbury Pavement. It is of birch-wood, inlaid with tulip- | wood, richly carved—a fine example of cabinet work.

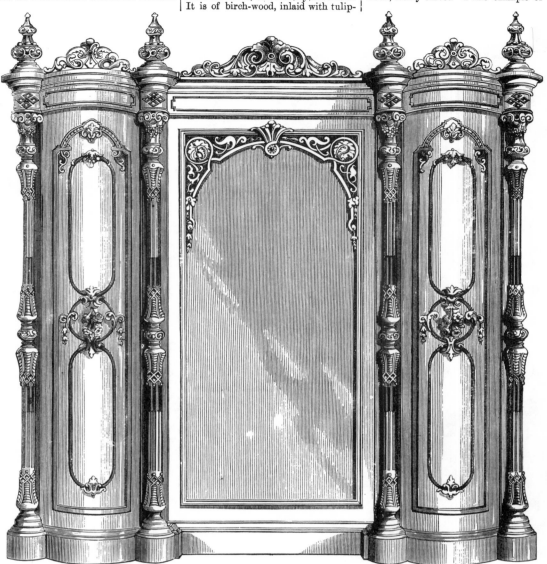

Giusti, of Rome, was a large and valuable | contributor to the Italian Court—so rich in pro- | ductions of Art-manufacture. His examples of

wood-carving excited very general admiration. | The slip we engrave is of part of one of his | small but exquisitely wrought Picture Frames.

important materials, more especially amongst the woods. Every lover of Art must have witnessed with pride and pleasure the extraordinary progress which the revival of the art of wood-carving has made of late years in this country. It has always been one of our specialities; and whatever decadence other branches of Art may have suffered, wood-carving has never fallen very low; it may now be considered on a par with the best of foreign countries. The wood chiefly used in this country is that of the Lime Tree (*Tilia Europæa*), which, from its smooth, compact texture, moderate hardness, and good colour, fits it admirably for the purpose. The Pear Tree offers another very favourite material to the wood-carver, especially to the Italian and French artists; its texture admits of a fine, smooth, clear cut, and its colour is of a warmer tone than the lime. Many of our artists also use pear-tree wood.

We are all familiar with the beautiful Box, though not in its condition of a tree, for with us it is purposely grown dwarf, either as an ornamental shrub, or to make those beautiful evergreen borders which assist so very much in adding the charm of neatness to our flower-gardens. This same plant, however, the *Buxus sempervirens* of the botanists, in many parts of Turkey attains the dimensions of a tree, often with stems fifteen or eighteen inches in diameter, and very hard. Its texture is remarkably even and fine; indeed, so close is the grain that when well polished it resembles rather a piece of marble. This quality of smoothness renders it admirably adapted for the engraver's art, and it is consequently the kind most employed by the wood-engraver. In it lines of wonderful sharpness may be easily cut, and yet so strong is it that it bears the press without risk of giving way. When used by the wood-sculptor

Mr. AMADEE JOUBERT, of Maddox Street, is an extensive and highly meritorious contributor to the Exhibition. We engrave a drawing-room CABINET, of very novel and effective style, in

walnut and marqueterie of fancy woods. Branches for candles are held by Caryatides, these branches being so arranged as to be reflected in the glass. The ends of the cabinet form jardinières. The

work is designed and the carvings are modelled by | H. C. JOUBERT. It is an elaborate and costly work, | every portion of which has been carefully studied.

it offers more difficulties than the lime or the pear, and from its liability to split is not so desirable. Very large quantities, indeed many hundreds of tons, of this wood are annually imported from Smyrna, and it meets with a ready sale, being not only used for the artistic works indicated, but also for making rollers whereon are engraved the patterns for printing textile fabrics, which are constantly in demand, and also for the general purposes of useful ornamental turnery.

The wood of the OLIVE TREE (*Olea Europæa*), and also of the CYPRESS (*Cupressus disticha*), are much used in Greece and Turkey for fine carved works, and the latter especially appears to be admirably adapted for the purpose. It is light coloured, of a close, smooth grain, easily cut, and almost imperishable, as far as time goes; it is

not liable either to split or change colour, and, doubtless, could be had in abundance if required. A very extraordinary, minute cypresswood-carving of a religious subject connected with the Greek church, in which were several hundred figures, was exhibited in the Greek Court of the International Exhibition; and another, but larger one, in the Russian Court. The olive wood is not so well fitted for wood-carving, for, although possessing a texture like box, its colour is not sufficiently uniform, being often broken up with dark streaks. These are the chief but not the only woods used by the artist; others are chosen according to individual fancies, but these in their several countries are always in demand for such purposes.

The instability of vegetable colours generally prevents the artist from drawing much from this source; nevertheless the water-colour

The ROYAL PORCELAIN MANUFACTORY OF VIENNA supplied us with but few objects calculated for

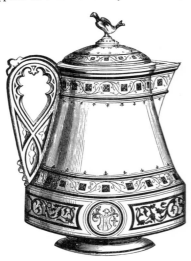

engraving. We have selected two—one a JUG, which forms part of a gracefully designed suite;

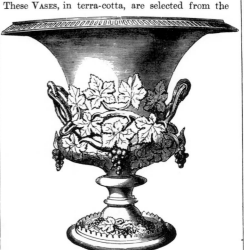

From the very

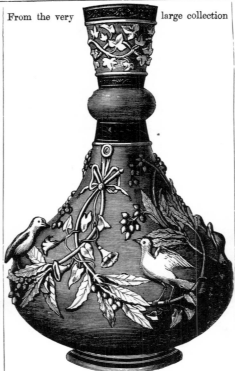

large collection

exhibited by the MARQUIS GENORI-LISCI—from his

These VASES, in terra-cotta, are selected from the

contributions of Sweden; being the production

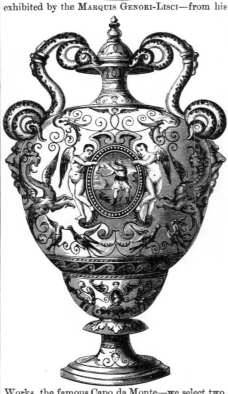

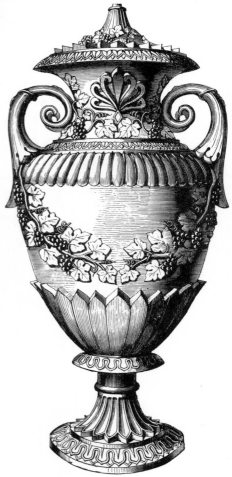

the other a very beautifully painted VASE—a work of pure Art—richly decorated in colours and gold.

Works, the famous Capo da Monte—we select two.

of STENKOLSWERK, manufacturer, of Skane, Sweden.

painter finds some of these colours indispensable. Thus we obtain from the Siamese, GAMBOGE, which they procure by wounding the leaves and twigs of a species of *Garcinia*—not certainly known to botanists—and for several mornings afterwards removing the thickened yellow juice which has in the meantime exuded. This is kneaded into lumps or rolled into pipes or sticks, and when quite dry is ready for use. Its extraordinary value to the water-colour painter is too well known to require comment; none of his pigments are of more essential utility.

Another oriental plant, which waves in vast fields on the Indian plains, and now also in many other tropical and sub-tropical countries, is the INDIGO (*Indigofera tructoria*), which yields enormous quantities of one of our most valuable blue dyes, and also constitutes one of the most useful blues amongst the water-colours. The history of the

manufacture of this colour is very strange. After the plant has been harvested, it is placed in large tanks of cold water, to which it gives a yellow colour. This coloured water is drawn off into proper receivers. and is then much agitated with poles or otherwise, until all the yellow matter in the water becomes oxygenised by contact with the air, and turns blue and heavy, sinking to the bottom of the receiver as a dark blue paste, which is afterwards carefully dried, and cut into cubes and packed for export.

MADDER and BURNT MADDER are also two well-known and useful colours, obtained from roots of a weedy straggling plant, originally a native of the south of Europe and the Levant, but now cultivated in most of the European countries and in many parts of Asia. Like indigo, its most extensive use is in dyeing, in which art it is, perhaps, the most important of all colours; but it is not of such

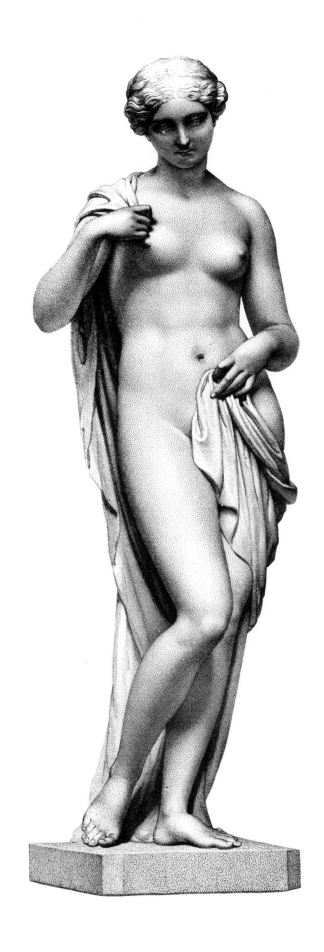

THE DAY-DREAM.

ENGRAVED BY R. ARTLETT. FROM THE STATUE BY P. MAC DOWELL, R.A.

We give on this page examples of some of the more peculiar productions in porcelain of the

ROYAL WORCESTER WORKS — "Raphaelesque."
The effect is founded on the creamy tint of the

ivory body, which enables the colours to be softened and shaded together in a very remarkable

manner, partaking somewhat of the character of the Buen Retiro, and somewhat of the Capo de

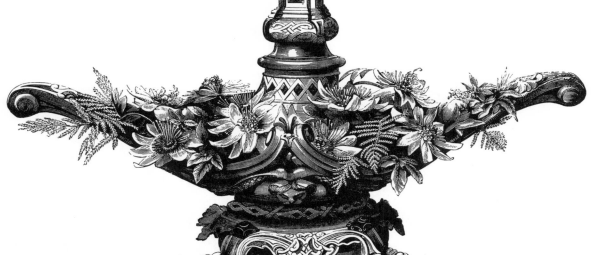

Monti. Mr. R. W. BINNS, F.S.A., the Art-Director of the works at Worcester, has dared a novelty in his art; he exhibited many specimens of greatly varied design, and obtained the applause due to the ingenuity and enterprise of the artist and the manufacturer. Of these productions we engrave three on this page, the largest being a beautiful CENTRE for a DESSERT SERVICE.

essential importance to the painter in water-colours as the two last mentioned.

The only other vegetable water-colour of importance is SAP GREEN. It is made by drying and hardening the juice of the berries of the Buckthorn (*Rhamnus catharticus*). The process of manufacture is extremely simple. The berries are carefully separated from their stalks, and a large quantity placed in a tub, and set by for seven or eight days, during which they ferment. The juice is then squeezed out and strained, and to each gallon about two ounces of alum are added; the whole quantity is set in a sand bath to evaporate until it is rather thicker than molasses, when it is poured into bladders, and hung up to harden, after which it is fit for use. With some artists this is a favourite colour, and probably would be with many more if it could be depended upon, but the temptation to imitate it with the much more easily obtained juice of privet berries is so great, that it is unsafe to trust to it, the spurious sort being very liable to change its colour.

When we reflect upon the extraordinary beauties of the floral world, it is a matter of no small surprise that so few permanent colours are obtained from them, and that we are obliged to seek both permanence and brilliancy from mineral substances of the most unpromising appearance. Our loveliest blues are not from the Violet and Forget-me-not, but from the dingy cobalt ores and the lapis-lazuli. Our best yellows are not from the marigold or sunflower, but from the most unpromising masses of chrome ore. Our reds are not from the scarlet geranium or cardinal lobelia, but from the ores of quicksilver and of iron; and it is but very lately we have been astounded by the elimination of colours, before which Flora herself would turn pale, made from the most disgusting refuse of the gas distillery. Such are the wonders of science in favour of Art.

We engrave two of some admirable works in Por-

celain—excellent in design and execution—manu-

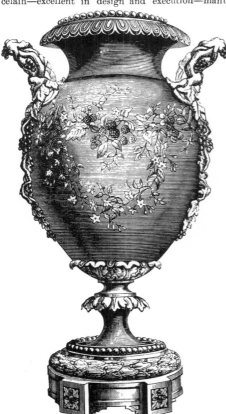

factured and exhibited by DE BETTIGNIES, of Paris.

Messrs. AD HACHE ET PEPIN-LEHAILLEUR,

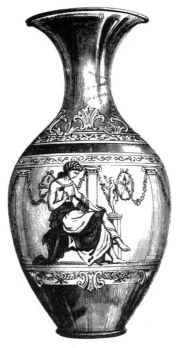

Porcelain Manufacturers at Vierzon, ex-

order of Art, gracefully designed, and very beautifully painted. Of these we engrave four

examples. The establishment holds a foremost rank in France, and has obtained many " honours."

hibit the usual order of dessert, dinner, tea, and

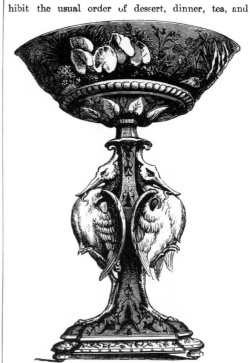

toilet services, with some "fancy articles" of a rare

Amongst the curiosities of the vegetable kingdom which are turned to ornamental if not to artistic purpose, must be mentioned the VEGETABLE IVORY and the COQUILLA NUTS ; both are used for ornamental turnery, and are beautiful materials, and the former, as shown by the admirable work of Mr. B. Taylor, of St. John Street Road, in the Eastern Annexe of the Exhibition, is evidently capable of wider application. This vegetable ivory is now largely imported, generally under the name of "Corrozo Nuts," from Brazil. It is the seed of one of the most exquisitely beautiful of that most lovely of all the vegetable tribes, the Palm. These seeds are found in considerable number in the large fruit which is called *Cabezade Negro* by the native Spaniards. This palm (*Pytelephas macrocarpa*) has a very extensive range of growth from the low valleys of the Andes of Peru, at an elevation of 3,000 feet, to the banks of the Magdalena, in New Granada, from which latter place, where it is called *Tagua*, we derive the chief portion of the imports to this country. The palm itself is magnificent in the extreme ; unlike most of its beautiful congeners, the vegetable ivory palm has no tall column-like stem to support its leaves ; the stem is short, and, like some of the ferns, lies on the ground, but from its growing point springs such a cluster of gigantic feather-like leaves, as defy all description to express their beauty. Each leaf, when full grown, is fully twenty feet in length, gracefully curving over at the top, so that collectively the whole crown of leaves looks like a stupendous plume of delicately green ostrich feathers. When very young, the nuts are eaten as delicacies, but when perfectly ripe they are nearly as hard as ivory, and exceedingly like it in texture and colour. They have long been turned to ornamental purposes by the natives, but it

The collection of works in porcelain and earth- | enware, exhibited by M. ROUSSEAU, of Paris, | excited universal admiration; his productions

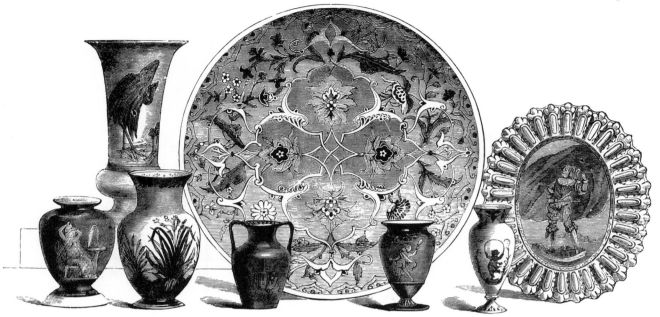

are of the highest order of Art, so painted and | decorated as to satisfy the artist and the con- | noisseur, while fully comprehended and estimated

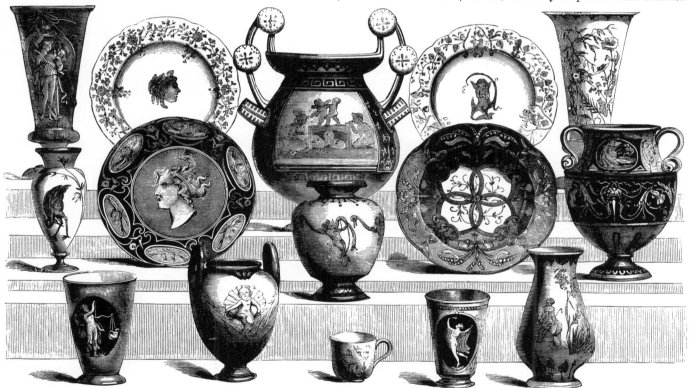

also by the general public. They were shown | in immense variety, and every piece was recom- | mended by some rare and peculiar excellence.

is only within the last ten or fifteen years that they have been much used in Europe. Now, however, immense numbers are imported, and made by the turners into a great variety of ornamental articles in imitation of real ivory; but the dimensions of the nut, rarely as large as a small hen's egg, will not admit of articles of any size being made of it, except as in the case of Mr. Taylor's, before mentioned, where the ornaments produced were formed by a combination of a number of nuts. There is another great and still more serious objection to its employment, which ought to prevent its use in any works requiring much labour or skill, namely, its change of colour. When first cut it is dazzlingly white, but in time a very peculiar dinginess affects it, and its beauty is consequently seriously impaired. The vegetable ivory may therefore be regarded rather in the light of a vegetable curiosity by the artist, than as a material upon which he can advantageously expend his talents.

The Coquilla Nut is the produce of another beautiful South American palm (*Attalea funifera*), closely allied to that which produces the cocoa-nut. Unlike that fruit, however, the coquilla nut has a very small kernel compared with its size; but the shell is exceedingly thick, and has a close compact texture of a rich brown colour, and capable of receiving a high polish. It is from the shell then, and not from the kernel, as in the case of the vegetable ivory, that the turner makes from coquilla nuts the numerous pretty objects now commonly seen in the shops. It is especially adapted for ornamental handles of cabinet drawers, and other similar small articles, for, although twice the size of the Corrozo nut, it is not large enough for most purposes. Its colour is, however, very permanent, and where small surfaces of its rich yellowish-brown tint are required, in wood mosaics, it would answer admirably, and would quite rival the favourite Kyaboucca wood for such purposes. Many hundreds

This column contains engravings of three of the works in ORMOLU

contributed by Messrs. HOWELL

AND JAMES. They are gracefully

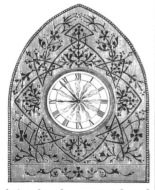

designed and ornamented, and were among the best productions of their class in the Exhibition.

Messrs. MIROY BROTHERS, of Paris, who have also an establishment in London, exhibited a

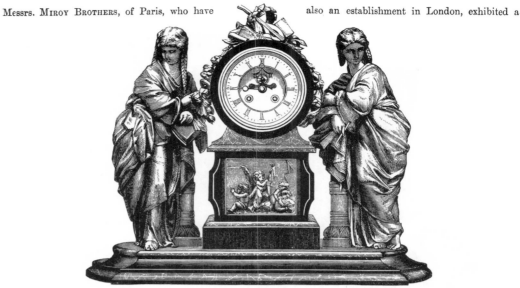

large collection of works in bronze; among the most beautiful were several CLOCKS, of which we engrave two.

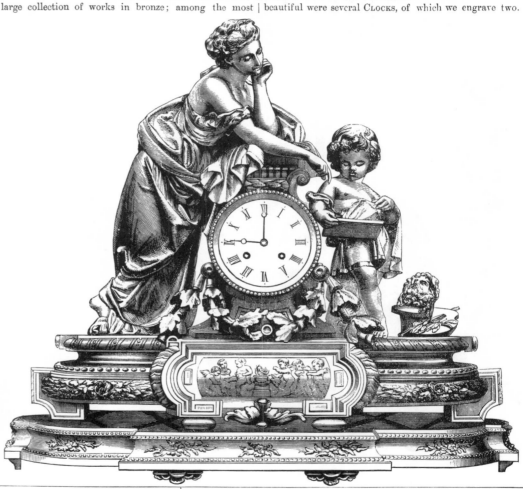

of thousands of these Coquilla, Corrozo, or Corrozzo nuts are annually imported into Great Britain. It may be interesting also to know that the peculiar brown material called Piassava, or " Bass," whereof the brooms are made which have lately almost superseded the old-fashioned besom, is procured from the same palm, which receives its trivial name *funifera*, or rope-bearing, from the rope-like bundles of this fibre, that almost cover its stems.

One of the fibrous materials belongs of right to this article as a material for artists' use, namely, COTTON WOOL. It has done as much almost as any material, amongst the numerous collection which forms the photographer's laboratory, towards the advancement of his beautiful art. But in order that it may be adapted to his purposes, it has to pass through certain chemical processes, which destroy every resemblance of the beautiful down that was wafted over the fields

of Georgia, or the arid plains of India. The fibre is first thoroughly cleaned, and then soaked in a solution of saltpetre in sulphuric acid, in the proportion of ten ounces of the nitre to eight and a half fluid ounces of the acid. After being soaked in this mixture for three or four minutes, it is transferred to clean cold water, washed free from any trace of the acid, and then carefully dried. When this is perfectly done—for even an atom of water spoils it—it is mingled in the proportion of eight parts with one hundred and twenty-five parts of rectified sulphuric æther. After a little time, one part of rectified alcohol is added, and the whole well shaken again until it has a thick, ropy appearance. This, after a few days, subsides, and the clear supernatant fluid is decanted, and forms that highly important photographic agent COLLODION. In the first stage, with the acid and nitre, gun-cotton, sometimes used as a substitute for gunpowder,

Mr. E. WHITE, of Cockspur Street, exhibits, among other excellent examples of CLOCKS, in ormolu and bronze, one of a high order of de-

sign; the design by himself, manufactured by his agent in Paris. The base, columns, &c., are of Algerine onyx; the figures, mouldings, &c., are

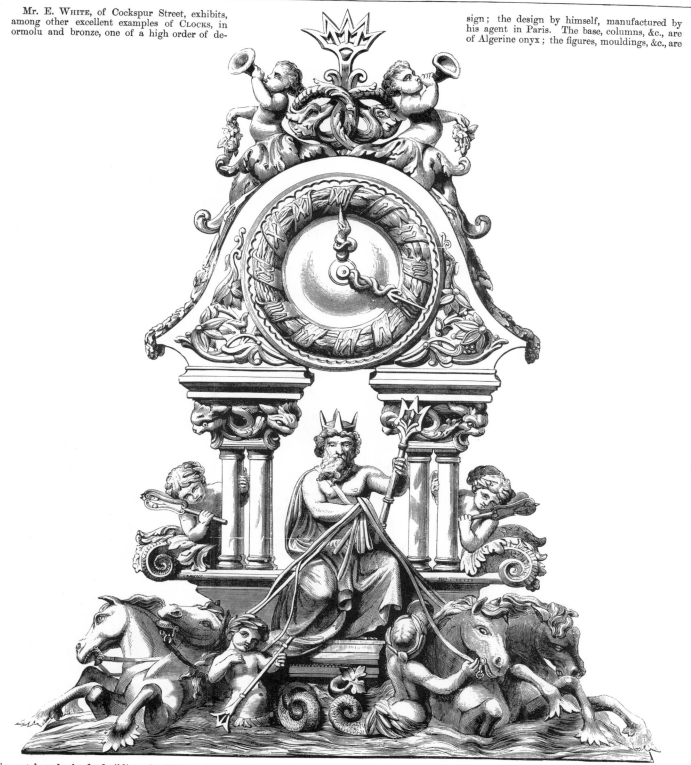

in metal work, the dead gilding of which harmo- | niously contrasts with the onyx. It is a work of | great beauty, and among the best in the Exhibition.

is made; and in the second process, the gun-cotton is converted, by its solution in æther and alcohol, into collodion. The real value of this material is that it enables us to spread a thin film of organic matter, of perfect smoothness, and which dries almost instantaneously, over any surface, and thus furnish one of the chief requirements of photography. It is upon this surface of cotton wool that the picture is actually received, and not upon the glass, which is only a means of supporting and protecting it from injury.

The oils used by painters are all of vegetable origin, and since the days of the Van Eyks have been considered indispensable. The most important are the Hazel-nut Oil, Linseed Oil, and the essential oil of the pine tribe called Turpentine. The NUT OIL is *par excellence* a painter's oil. Its specific gravity is light (being 0·9260) compared

with that of linseed, which is 0·9347. It has greater drying qualities, very little colour, and is in every respect superior as a vehicle for pigments to the best linseed oil. This oil is so liable to adulteration, that many careful artists, who think no time misspent which is taken to ensure durability in their work, prepare it themselves. It is a tedious process, and to be done well requires, first, the removal of the shells from the nuts, then pounding them in a very clean Wedgwood mortar until they form a paste. This paste is put into a strong horsehair bag, and submitted to great pressure between two pieces of board, usually applied by means of two extemporised levers. The author has seen an ingenious artist convert two pieces of an old easel, and two small boards, almost instantaneously into an oil-press, which answered excellently for squeezing out half a pint of nut oil.

We engrave on this page some of the works in embroidery trimming

exhibited by Mr. RADLEY, of Lamb's Conduit Street,

who stands at the head of his trade in London and in

Paris. The large engraving represents a front view of an ARABIAN BED. The

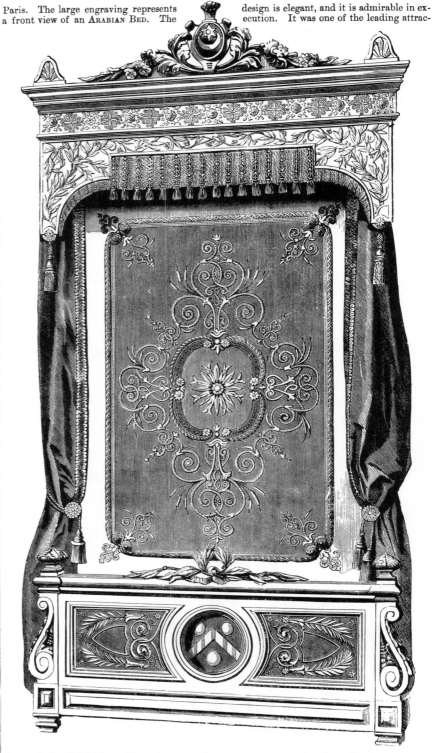

tions of the Exhibition. The other two ob-

design is elegant, and it is admirable in execution. It was one of the leading attrac-

jects are PANELS for the walls of state-rooms.

Under proper management, hazel nuts yield about sixty per cent. of oil, but not much more than half this quantity is obtained by the amateur oil-presser. After pressing, it requires to be clarified, and is then almost colourless and tasteless. The oil of walnuts is often used instead, and is nearly, though not quite, as good.

LINSEED OIL is expressed from the seeds of the Lin, or Flax plant, after being previously ground into a coarse meal. This is put into strong bags, and submitted to the action of hydraulic presses, or machine-worked stampers, and the oil is so completely expressed that the cake is turned out so dry and hard as only to be broken with difficulty. It is best suited for the painter's purpose after it has undergone a chemical process called *boiling*, which consists in boiling it with litharge (the fused yellow protoxide of lead) and acetate of lead. This process requires careful manipulation, and its result is to give a

drying power to the oil, which will enable it, when laid on in thin layers, as in painting, to dry in a few hours, and in drying to form a fine varnish-like coat. The thinness of this layer, and its tendency to dry, are both increased by the use of the third oil, viz., TURPENTINE, which, as before stated, is an essential oil; that is to say, it is volatile, and is procured by distillation, instead of compression, from the resinous exudation of several species of the Pine or Fir tribe. It is so well known that no description is needed. It acts as a diluent to the other oils, when used as vehicles for the paints, and thus, by greatly extending their surface, very much facilitates the drying process. Moreover, as the volatile character of the turpentine leads to its evaporation from the paint before it is completely dry, the escape of its particles from and through the skin of paint breaks up the surface, so as to lessen the too varnish-like gloss which would be

Among the many admirable lace-manufacturers of Nottingham, Messrs. HEYMANN AND ALEXANDER hold high rank, and we are pleased to give publicity to some of their productions. They are large producers of LACE CUR-

taste and appropriate character; sometimes they are elaborate and full of "pattern;" usually, however, they are of simpler and less obtrusive ornamentation, and, therefore, to our minds, more desirable. We engrave

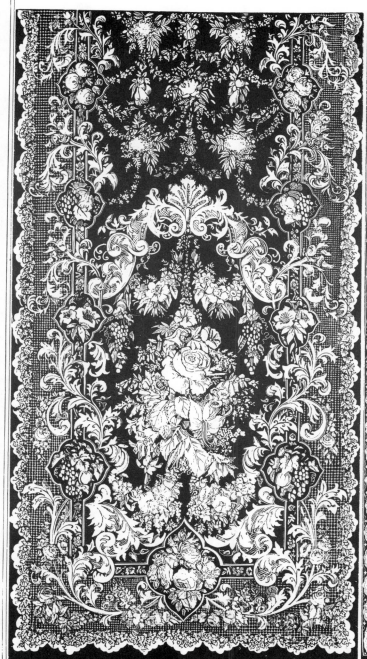

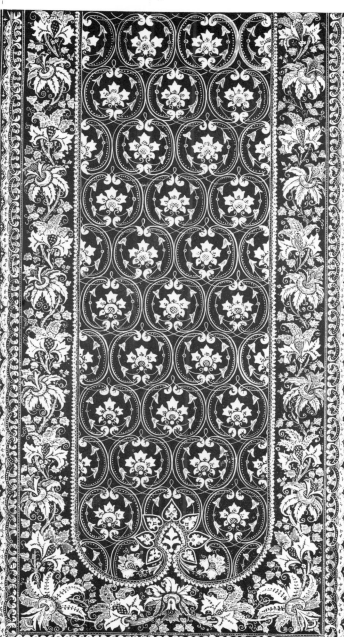

TAINS—machine-made—with all the appliances of modern improvements, and manufacture also the many varieties of plain as well as fancy cotton lace. Their contributions to the Exhibition all bear evidence of good

an example of either order. They are designed by Mr. S. W. OSCROFT, a pupil of the School of Design, Nottingham. In this important manufacture the productions of Nottingham now surpass those of France.

the result of using the oil alone. This peculiarity is much used amongst house-painters, who diminish the glare of common house paint by "*flatting*," as it is called, with "turps," or turpentine.

The artist lays all the kingdoms of nature under contribution to supply his numerous wants, and it is questionable if he could dispense with either of them. Certainly he could not do without the Animal, which we have left to the last. There are few branches of high Art or decorative Art in which brushes of some sorts are not required, and these are all derived from the animal kingdom. First of all we have the familiar Camel-hair Pencil with which we make our first infantile essays in daubing. This is one of the most important tools of many artists; its name is admirably chosen, for it is strictly the hair of the camel in contradistinction to the finer material or fur with which the animal is much more abundantly covered. This stately creature, "the ship of the desert," notwithstanding its

exposure to intense heat in the almost burning deserts of Africa, has really a thick coating of fur, which, like the turban of its master, acts rather as a cooler than otherwise; for if its non-conducting properties prevent the animal heat from escaping, those same properties keep off the much greater heat of the sun. But thickly sprinkled, for some wise purpose, through this close mat of fine fur, are a large number of long silky hairs. These are the treasures of the brush-maker, and are carefully picked out, and arranged with the points all one way, ready to be made up in brushes, or pencils, as they are generally called. This same pencil-making is a very nice art, and may be brought to a great perfection, not always apparent on a cursory examination, but which is fully appreciated when submitted to the test of use. The camel-hair comes to us from Mogadore, and from Egypt and Turkey, usually picked out from the fur, but not always. There are three qualities in our commerce: the finest,

A very notable feature in the contributions of | enamel and gold. Of this service we engrave | the centre-piece. The other objects on this page

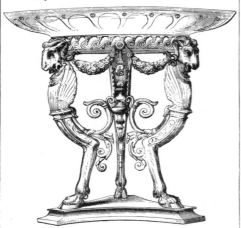

Messrs. ELKINGTON was a magnificent DESSERT

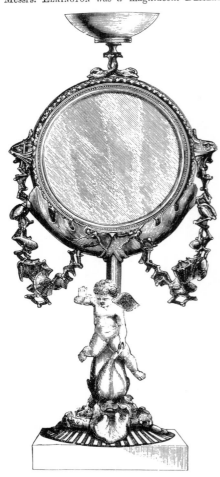

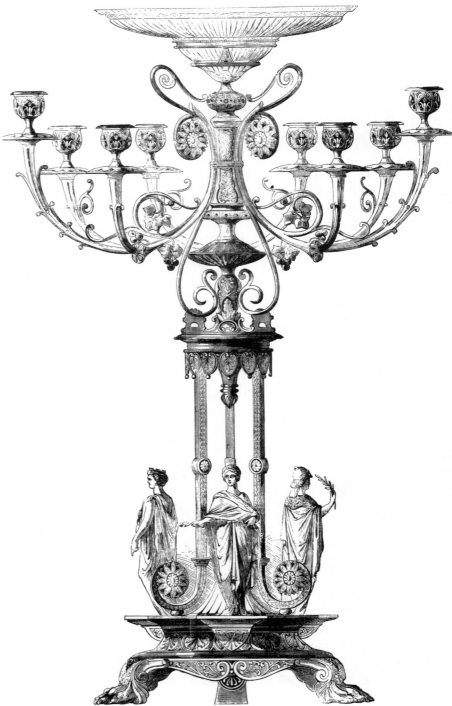

SERVICE, designed by A. WILLMS, in the Pompeian style, and executed in silver, enriched with | are from the same manufacturers; the upper a COMPOTIER, designed by the late admirable artist, | E. JEANNEST, in the Pompeian style; the lower a very elegant MIRROR, by the same designer.

which is nearly black in colour, the second reddish, and the third grey.

Most of the so-called fur animals, like the camel just mentioned, have the two kinds of covering—the one fine, soft, and close, being the *fur* proper; the other longer, stiffer, and more sparingly distributed over the skin. These long hairs are obtained from several, such as the Fitch, the Sable, the Marten, and others of the same family (*Mustelidæ*). The process of removing these hairs was formerly tedious and difficult, but an ingenious invention, patented by Mr. Roberts, the eminent furrier of Regent Street, has simplified it much. Mr. Roberts, seeing the well known fact that the long hairs all penetrate deeper into the skin than the fur, invented a plan of paring off a thin layer of the under part of the skin, by which means the long hairs are rendered loose, their lower extremities being thus cut through, and they are then easily shaken out without injur-

ing the fur. Pencils made of these hairs require even greater care than those made of camel-hair; their points must be arranged with the nicest exactness, in order to ensure, when brought together, a beautiful gradation to one central point, a task only accomplished by very skilful hands after much practice.

Of the larger kinds of brushes or "tools" used by artists, those made of hog's bristles are the most important; indeed they may be said to be the staple articles of this kind. Almost every size is used, from the house-painter's brush to cover large surfaces, down to the fine pencil for minute touches. The best bristles come from Russia, where they form a very important article of trade. From the Baltic provinces we receive the bristles, well packed in casks, but tied up into little bundles. The same comparative care is required to ensure goodness in the artist's bristle "tools" as in his finest "hair pencils," and every bristle is carefully sorted for the purpose. To sort out a

The CANDELABRUM and CHANDELIER here engraved are of cast iron, from the renowned foundry of COUNT STOLBERG, at Ilsenburg, in the Harz, who has enriched the Exhibition by some

blishment are cast not only objects of size, but some as thin as a wafer, with details so minute as to be

scarcely perceptible without the aid of a glass. Both these productions are from the designs of A. WOLFF.

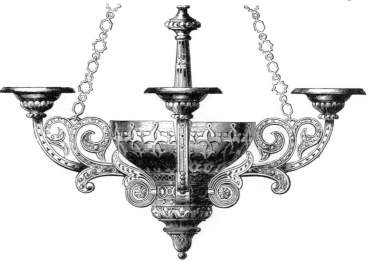

The three CHANDELIERS engraved underneath are the manufacture of the renowned firm of WINFIELD, of

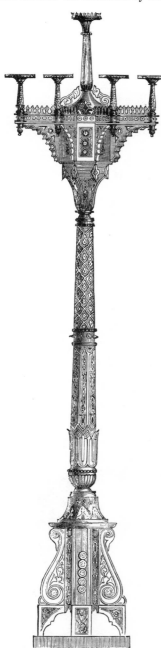

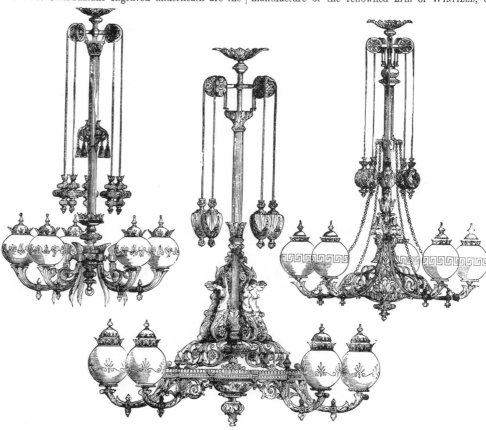

of the most remarkable of the works it contains; and they are produced at a cost so small as to have astonished all who examine them. In this esta-

Birmingham; they are of bronze, gilt, and exhibit considerable taste and skill in design, while the workman-

ship is of the highest order of merit. Few foreigners surpass the British manufacturer in brilliancy of metal.

pound of bristles is a task which few would like to undertake, but it is now made very easy and simple by one of the most ingenious contrivances which the present age of inventions has brought forth. The bristle-sorting machine of Mr. W. S. Yates was seen by thousands during the Exhibition, in actual operation in the Western Annexe, and nothing was more complete and satisfactory than the manner in which it rapidly separated a handful of mixed bristles into fourteen different lengths, so as to be available at once for the manufacture of a variety of brushes.

The hair of the badger is very important in the manufacture of artists' brushes; but it is scarce, and has to be brought from abroad. Goat-hair is also used for pencils, but not very extensively: goat-hair pencils are, however, favourites with some oil-painters.

Next in usefulness for artistic purposes to the hairs of animals are their teeth. Elephant's teeth, at least the two called the tusks,

have been in demand from very early ages for decorative Art. We repeatedly find allusions to IVORY in the Bible, and those allusions are of a kind which indicate unmistakably that the commerce carried on in that beautiful material, was an old established one. But it is only when we come to Grecian history that we learn the exact nature of its applications to the production of works of Art. The sculptor Phidias introduced the art of forming large statues of ivory; the Romans prized it highly for similar purposes; and during the Byzantine era, the fashion of employing ivory was again revived for choice objects of Art—such as drinking-cups, tankards, and small bas-relievos. In the former part of the present century, the art of working in ivory had fallen to mere ornamental turnery, and the employment of thin sheets of this material by miniature painters; but within the last few years it has been extensively used for manufacturing purposes, and in many ways administers to that growing

This CABINET is of carved oak, the manufacture of MAZAROZ-RIBAILLIER, of Paris, one of the most renowned fabricants of the French capital. It

is a fine example of Art, the style Greek; the carvings are of the rarest order, and the entire design of the work is of great excellence. It is

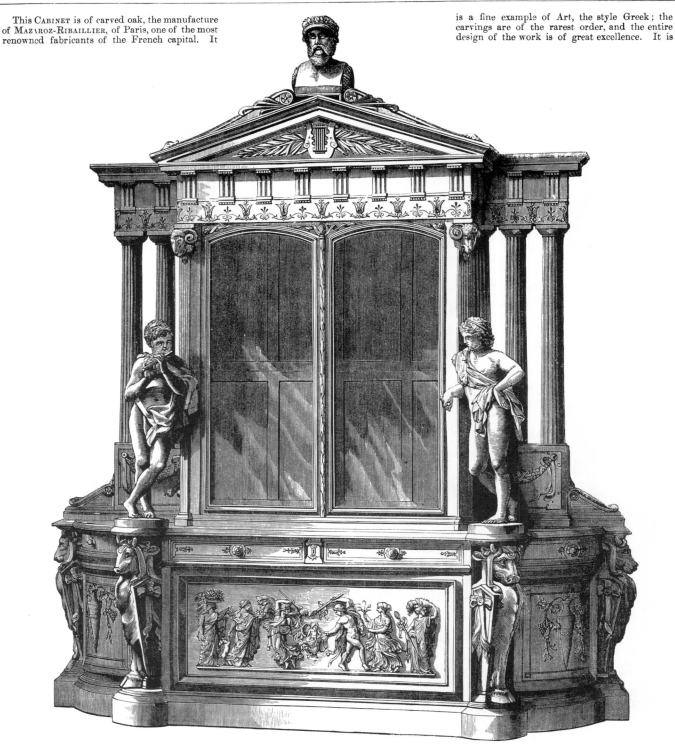

obviously intended for a dining-room. The artist under whose directions this admirable work has been carried out is M. E. VANDALE, Jun.

love for Art which, thanks to the indefatigable labour of a few honest men, has become the most remarkable feature of the age.

Other teeth than those of the elephant have been similarly applied, and especially those of the Walrus (*Trichechus rosmarinus*), which is superior in hardness but slightly inferior in whiteness to the true ivory. There is reason to suppose that much of it was obtained from the shores of the North Seas in the fourteenth century, and used for ivory, and the microscope has shown several choice old carvings made from walrus teeth, which had previously been believed to be those of the elephant. A little practice will enable the eye to detect the difference, the peculiar lozenge-shaped grainings being wanted in the walrus ivory. Whale's teeth have also been employed, but to a very limited extent; bone was extensively used by the Venetian artists in the fifteenth century.

The shells of the sea also aid in the production of works of beauty;

and the cameo, once so costly when only the onyx and a few other rare stones were used to produce it, is now procured with ease from the great Conch shells (*Strombus gigas* and one or two other species), which are brought to us from the West Indies and other tropical shores. The fact that these shells, besides the external discoloured crust, are composed of two very distinct layers (the one immediately below the crust being a very pure white, and sufficiently hard to receive a fine polish; and the other, usually of some dark rich brown colour, and almost flint-like appearance), admits of the most exact imitation of the onyx cameos, the figures being carved in the upper layer or white portion, and the lower or coloured layer left for the base. Certain portions only of the shells are available for this purpose, namely, those in which these peculiarities are fully developed.

The shells of the Mother-of-Pearl (*Meleagrina margaritifera*), which we receive from Manilla, Panama, and a few other places,

The suite of BED-ROOM FURNITURE, manufactured and exhibited by Messrs. BIRD AND HULL, of Manchester, of which we engrave a portion, has been universally admired as much for its unobtrusive elegance as for

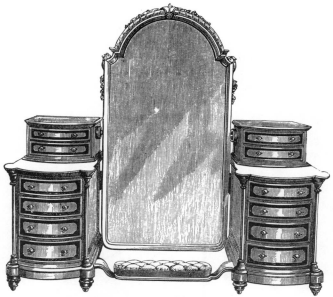

the purity and simplicity of the material, being composed entirely of woods grown in our own hedge-rows—the sycamore and alder. The excellence of

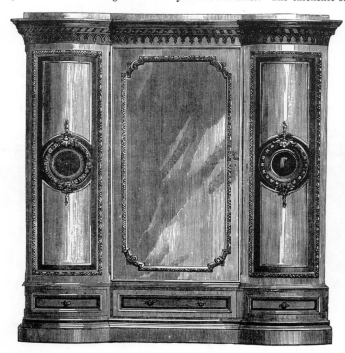

the workmanship of this and the EBONY CABINET (also engraved) will bear comparison with any productions of the kind in the Exhibition. It is gratifying to know they are produced entirely by workmen of Manchester.

We cannot better occupy the space left to us on this page than by commenting on the more than satisfactory progress made by nearly all British cabinet-makers, as manifested by the large collection of works of all classes and orders in the Exhibition; they have consequently supplied us with many subjects for engraving, and our selections are as yet by no means exhausted. Those who compare these productions with those of 1851 will readily admit that in no branch of Art-manufacture has advancement been so apparent. The observation applies not only to

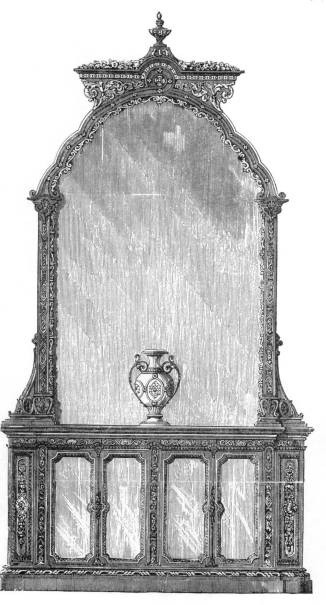

the metropolis, but to the provinces—not alone to the manufacturer, but to the artisan; both have studied the best authorities; the one has consulted the artist for his designs, which the other has been found competent to work out. The British cabinet-maker may now fearlessly take his place beside the Art-producers of Germany, Italy, and France.

are often most beautifully carved by the monks at Jerusalem, and sold in the neighbourhood of the Holy Sepulchre. Most of the works there may be regarded in the light of a mere manufacture, but occasionally others are seen bearing remarkable evidences of superior taste and skill, and suggestive of a much more extensive employment of this very beautiful material in the production of works of Art.

The animal kingdom also furnishes some of the colours used by artists, and foremost amongst these is the useful CARMINE. If we wish to glance at the origin of this beautiful colour, we must examine the Prickly Cactus on the dry plains of Mexico, and we shall see crawling on it a bright scarlet-bodied insect (*Coccus cacti*), ugly in shape and wingless. This is shaken off and killed by heat; it is afterwards dried, and becomes part of the commerce of the world, under the name of Cochineal. The colour-maker takes a quantity of

this material, and having crushed it to powder, and boiled it in water in the proportion of about four gallons to a pound, after settling until the liquid is perfectly clear, it is poured off, and is then of a brilliant crimson colour. To this is added a solution of the bichloride of tin, and immediately a fine precipitation takes place upon the sides of the vessel. When this ceases, the water, now nearly colourless, is carefully drawn off by means of a syphon, and the precipitate is allowed to dry, when it readily peels off from the sides of the vessel, and is then fit for use as a pigment. There are many other ways of making it, according to the fancy of the manufacturer; but the one just given is held to be a very good one, and affords the most concise idea of its preparation.

Another insect, closely allied to the Cochineal, is found on certain trees in India, and principally in Burmah. These are the lac insects (*Coccus lacca*). At first they move about freely; but as they

We engrave the elaborately carved SIDEBOARD of Spanish mahogany, the manufacture of Mr. JOHN STEVENS, of Taunton. It is a fine example

of the skill of provincial carvers, and in all respects a remarkable work, considered as the production of a provincial town. The manufacturer

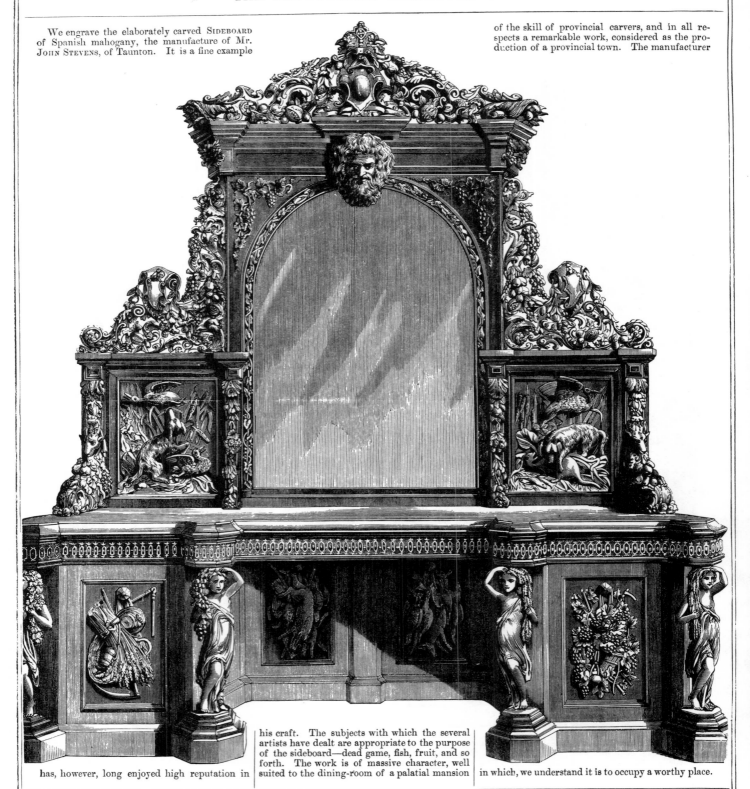

has, however, long enjoyed high reputation in

his craft. The subjects with which the several artists have dealt are appropriate to the purpose of the sideboard—dead game, fish, fruit, and so forth. The work is of massive character, well suited to the dining-room of a palatial mansion

in which, we understand it is to occupy a worthy place.

proceed with their metamorphosis, they secrete a peculiar substance, which, properly prepared, is the Shell-lac of commerce, and the material from which our French polish and sealing-wax are made.

Not only do we draw the teeth, strip off the shells, and parch and boil the bodies of those animals whose materials we thus enlist into the service of Art, but we also make the diseases of one, at least, subservient to the same purposes. Thus that exceedingly beautiful colour with which flower painters colour the delicate anthers of many flowers, is actually the produce of a serious disease in the liver of the ox or cow. This disease causes the formation of a biliary calculus, or gall-stone, in the gall-bladder of the poor animal, and this, which is carefully sought for by the butchers, who know the value of the perquisite, is ground down and made into the very costly cakes of yellow colour, known as "gall-stone." The bile, too, of these animals is

also often used by water-colourists, in consequence of its wonderful power over grease.

These brief and very imperfect notes upon the materials used by artists, will at least have sufficed to show there is as much talent of one kind required to prepare for the artists those necessities of his occupations, as there is on his side required talent of another kind to develop their uses; and this knowledge, if cultivated in a fair and frank spirit, must aid in encouraging those feelings of friendly mutual respect which constitute the best of all stimulants to the advance of Art and Science. The Art which looks disdainfully, as if from an eminence, is not our favourite. Give us the busy, inquiring spirit, diving into all the secrets of the earth, and conjuring up new creations of form and beauty from the most unpromising elements.

THOMAS C. ARCHER.

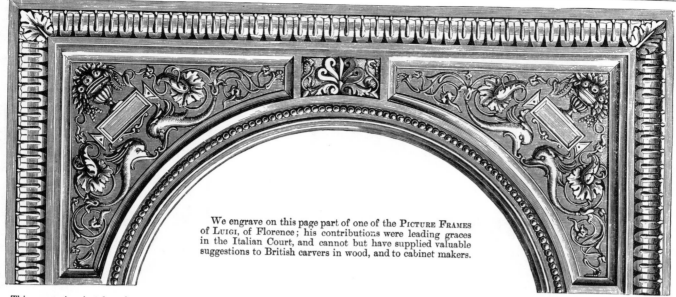

We engrave on this page part of one of the PICTURE FRAMES of LUIGI, of Florence; his contributions were leading graces in the Italian Court, and cannot but have supplied valuable suggestions to British carvers in wood, and to cabinet makers.

This engraving is taken from an elaborately-carved BEDSTEAD, the contribution of P. SCHMIDT, of Vienna; it is of oak, every portion being elaborately wrought by the "cunning hand" of the workman; the design is obviously the pro-

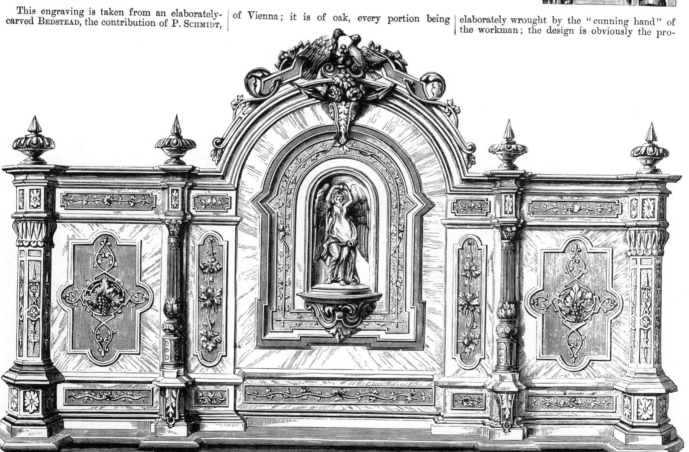

duction of an accomplished artist. The manufac-turer holds high rank in Vienna, and justly obtained such "honours" as he could obtain in England.

MACHINERY EMPLOYED IN ART-MANUFACTURES.

BY ROBERT HUNT, F.R.S., ETC.

THERE was no more attractive division of the International Exhibition than the Western Annexe. At all times this, in every way the most satisfactory portion of that huge building, was crowded with eager, inquiring visitors. You witnessed, perchance, a fashionable crowd, on the high-price days, listlessly strolling through the intricacies of the French department, or pacing, with proud indifference to the triumphs of industry around them, the length of the Nave. Then, if you entered the Annexe, there was at once an awakening evident on all sides, as if the agency, which was moving the wondrous machines exhibited, had exerted its power upon the living, breathing machines who had wandered within its influence. The Castle of Indolence style, which so frequently distinguished the visitors who loved to sit beneath the domes, or on the benches near "The Dream of Joy," was never seen amidst the machinery in motion. Mind had given impulse to those vast masses of iron and brass, and its effect was felt by every observer brought within its influence, and was manifested in the animation displayed on every face.

The triumph of the Western Annexe was, however, on the "one-shilling" days. The hard-handed and the brawny-armed were there, and they had brought with them their wives and their children, and it was worth something to hear them talk! They knew the giants that now made sport for their pleasure, and they talked of, and even talked to, them as old acquaintances. Now and then they met with a stranger: their expression of surprise was amusing; per-

Madame ENGELMANN GRUEL, of Paris, whose | fame as a binder of books is not only French,

but European, exhibits several examples of | the art she carries to a rare degree of perfec-

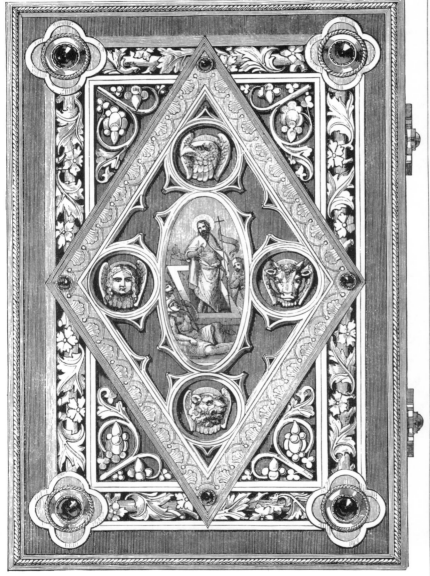

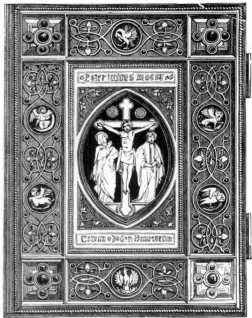

We engrave both sides of the COVER of a BIBLE—specimens of book-binding exhibited by BREUL AND ROSENBERG, of Vienna. It was one of the leading attractions of this class in the Exhibition, very beau-

tiful in design, and admirably wrought; the metal work is of gilt bronze, the figures being in enamel. On one side is represented the Temptation, on the other the Crucifixion, surrounded in both cases by

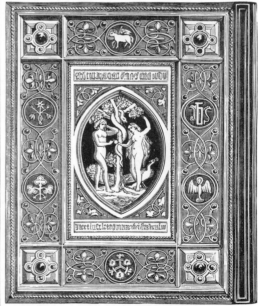

emblematic symbols. There were other admirable works exhibited by this eminent establishment. Austria fully upheld its old renown in this department of Art—the exterior ornamentation of rare and valuable books.

tion. We engrave one specimen, and part of | another, of great merit in design and execution.

chance they were puzzled at some complicity in the arrangement of the iron muscles, but eventually they made it all out, and found that, after all, their new friend belonged to an old family. The vigour of everything in the Western Annexe—whether it was the rapidly revolving spindle, the whirring disc, and the swift cascade, the hydraulic lift or the steam hammer, the bag-making machine or the carpet loom—stimulated the mental powers equally of young and old, and a curious spirit of inquiry seemed to pass through the place. Let us endeavour to preserve a faithful record, in brief, of this remarkable section of the Exhibition.

On entering the Annexe, we were stopped by the finest marine engines the world ever saw. Masses of iron, which a few years ago man would have declared impossibilities, were welded into cranks, and finished with a delicacy that could not be exceeded in the mountings of some precious gem. These were indeed giants, such as the Cyclops could not have achieved, such as the Titans could never have created. Scattered here and there amongst those mighty works, were miniature models, beautiful in the minuteness of their detail, and in their exquisite finish. These showed how the monster machines would play with the ocean, and bear proudly from shore to shore the necessities of war, or the blessings of peace.

Next, beyond these, we were introduced to the machine tools—the instruments employed in the manufacture of the machinery exhibited. These were arranged against the western wall, and in

The binding of the VICTORIA PSALTER, designed by OWEN JONES, and executed in relief on leather by LEAKE's patent process, supplies us with an example of book-binding as shown in the Exhibition. The work is bound by Messrs. LEIGHTON, SON, AND HODGE; it was printed by Messrs. DAY AND SON, and is a beautiful specimen of their chromo-lithography. Mr. Owen Jones was far too limited a contributor to the

Exhibition; the influence of his pure taste and sound judgment, however, must have been noticed—as it was felt—in many branches of British Art-manufacture. To him, perhaps, more than to any other English designer, the English manufacturer is indebted for much of his later progress.

the central group, where also were some most ingenious woodworking machines. On the eastern side everyone will remember the locomotive engines, the travelling cranes, and the various objects which belonged to railway construction.

Engraving machines, type making, printing, and paper making formed the next group. Cotton and wool spinning machinery followed upon these. Who does not remember the incessant whir of this group, illustrating, as it did, the triumphs of British genius over difficulties of no common order? Of these more must be said as we proceed. Looms very naturally followed the spinning machinery; and of several novelties in those, together with the magnetic loom, a careful description must be given. Flax spinning and weaving formed, we scarce know why, a separate group at the northern end of the Annexe. Sugar mills—the rollers of which were wonders of forge-power—vacuum pans, and, indeed, all the appliances for the preparation of sugar, were illustrated. Brick-making machines, ice machines (in which the magic feat of producing a given measure of frozen water, by the consumption of a given weight of coals, was demonstrated in two several and equally ingenious ways), pumps, hydraulic engines, blowing machines and mills, completed the series of machines in motion—the production of the English workmen, the result of the constructive power of the British mechanical engineer.

In the ART-JOURNAL we can only deal with those machines which are, to a greater or less extent, subservient to the purposes of Art-manufacture. The first series with which we are solicited to become acquainted are the wood-working machines. The principal articles comprised under this head are sawing, planing, moulding, mortising, and tenoning machines, and machines for reproducing carved forms. Commencing with the more simple forms, the vertical saw frames

We engrave other of the productions of the | Imperial manufactory of SEVRES. The selections | we have made to fill this page are varied, and

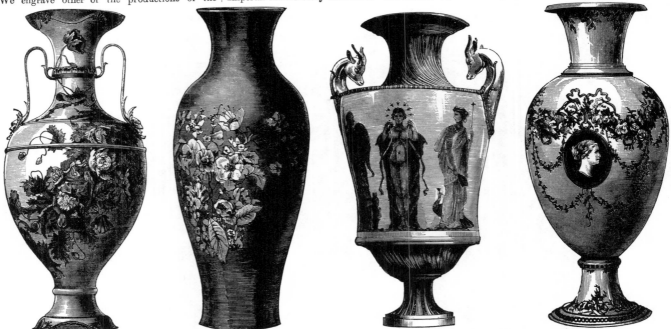

convey a reasonable idea of the amazing wealth of | the collection. It is, however, very difficult to | do them justice by engraving—considering the

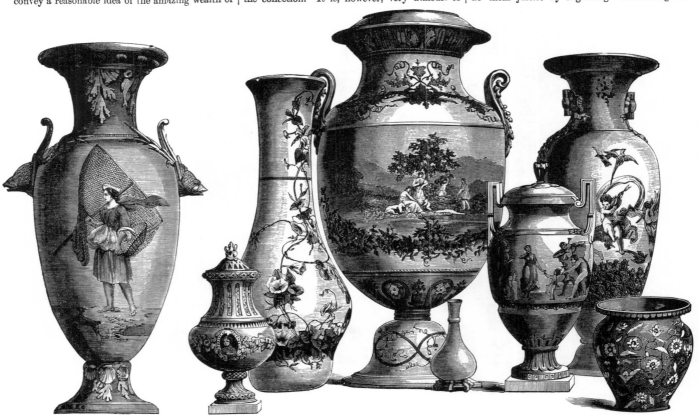

entire absence of colour. A large proportion | of these works are of the rarest excellence in form, | in general design, and, especially, in painting.

may be named. These were exhibited in various modifications, as were also circular saw benches; but scarcely any of these require any special description. Mr. William Geeves exhibited a saw frame, in which the saws were placed horizontally instead of vertically; the framing and arrangements resembled those of a horizontal steam engine: this pattern has been adapted to frames carrying as many as sixteen saws. A peculiar modification of the circular saw was shown in a machine for bevelling the edges of barrel staves—one of a large number—employed in the manufacture of ammunition barrels at Woolwich Royal Arsenal. This machine has two circular saws mounted on jointed frames, so that the angle between their cutting planes may be varied according to the amount of bevel required.

The band saw, which is an endless ribbon saw, working over two large rollers, was exhibited by Powis, James, and Co. This instrument has the advantage, over the vertical frame saw, of being continuous in its action; and the blade being thin and narrow, it can be used for cutting along curved surfaces. Indeed, this application was shown in the production of some very intricate designs, and some elegant curves. Greenwood and Batley exhibited a similar machine, the difference being that the frame carrying the upper roller was made adjustable by a toothed sector and pinion, in order that the inclination of the cutting plane to the surface of the table may be varied at pleasure.

Mould cutting and planing machines, as being used in the pro-

The four DESSERT PLATES on this column

are selected—as containing valuable sug-

gestive material—contributed by MM.

ROUSSEAU, porcelain manufacturers, Paris.

From many graceful works con-

Mr. Goss, of Stoke-upon-Trent, exhibits works in porcelain and earthenware; they are

tributed by Mr. STEVENS, of Smith Street,

Westminster, we select two glass-mosaic

FLOWER-POTS, and a FERN-CASE.

generally of a cheap order, frequently for "the masses," of good designs and ornamentation.

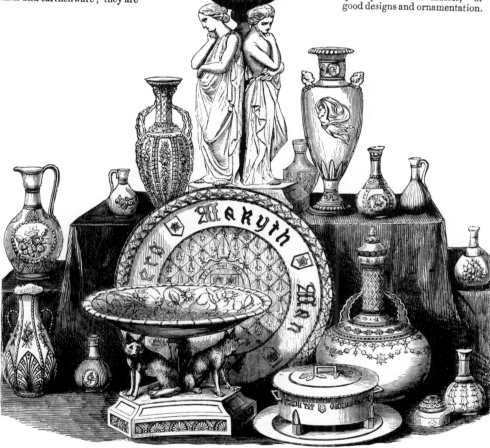

duction of plain and ornamental surfaces, demand our consideration. Many of our larger firms exhibited planing machines. In these it is well known that the arrangement used is generally a combination of fixed and rotating cutters, with a roller feeding motion; the fixed plane irons being employed for smoothing the upper face of a flooring plank, while the other face is planed by horizontal cutters, and the sides tongued and grooved by vertical ones, the whole of these operations being performed simultaneously. These machines are constructed also for making mouldings, by removing the straight-edged fixed planes, and replacing them by a tool of the appropriate pattern.

Immediately connected with machines of this character, we must not allow the models exhibited in illustration of boat-building by

machinery, in the class devoted to Naval Architecture, to escape attention. The arrangements of those machines are in the highest degree complete, and show not merely, that machinery may be brought to form, and, mainly, to put together, the system of curved forms necessary for the construction of a boat, but that it may be made to produce curved forms in almost any variety. It is not possible in this place to describe the various machines. Every one who has looked at a boat of elegant form must know how varied are the curved forms which must be produced and assembled to produce the perfect whole. These are obtained by a series of saws and cutters, such as have been already described, altered to meet the exigencies of the boat-builder.

There were many "shaping machines," applicable to works in

Mr. HARCOURT PAGE, of Coventry Street, is one of the few "carvers and gilders" who have upheld the reputation of England in their branch of industrial Art. His contributions are of an excellent order, as regards design as well as execution; and

perhaps as examples of composition frames, they hold highest rank among the works exhibited. The specimens we

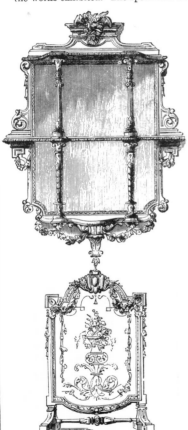

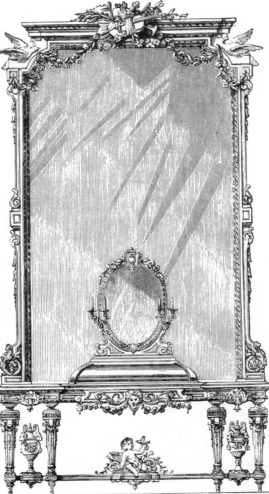

graceful and effective design. The object, however, that excited most attention, and asserts the strongest claim to merit, is a BOUDOIR

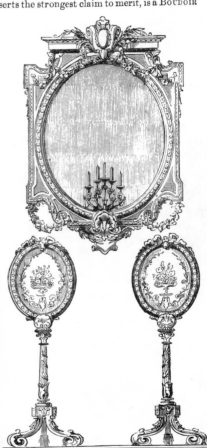

engrave show their variety: they comprise a large LOOKING-GLASS, a MIRROR,

a GIRANDOLE, a CONSOLE TABLE, and FIRE-SCREENS, the slip which commences the page being the top of a gilt LOOKING-GLASS, of

GLASS, of novel and peculiar construction, the nature of which we have not space to explain.

metal, which possessed the highest amount of ingenious contrivance. The universal shaping machine, for example, of Muir and Co., is one of the most meritorious description. This is capable of cutting round work, and of producing hollow work of a large size. The radial drills and mortising machines were no less admirable. Indeed, the exhibition of machine tools and other tools by Fairbairn, Whitworth, and many others, were evidences of the expenditure of thought which has been brought to bear on the applications of machinery to handicraft, one of the most remarkable being Kinder's universal wood-shaping machine, which has been well described as "a mechanical slave, taking from the workman's mind the task he requires, and relieving his muscles of almost all exertion" (Mallett). This machine will plane, cut edges, form regular or winding bevels, work oblique sections of irregular figures, cut tenons with shoulders of any pitch, groove, rabbet, sink hollows of all sorts of irregular or regular forms and bases, and strike beads and mouldings on straight or curved edges. Its inventor proposes this machine for every class of joinery, cabinet-making, wheelwrighting, agricultural implements, cart making, &c.

Messrs. Cox and Son were exhibitors of wood-carving machinery, as invented by Mr. T. B. Jordan, which we have, on more than one occasion, described in the ART-JOURNAL. We may briefly state in this place, that it operates in the following manner: the object to be copied, and the block or blocks to be operated on, are placed side by side on a horizontal bed; by means of two motions, at right angles to each other, the table can be moved by hand, so as to cause a fixed vertical rotating drill to act on the surface of the block at the same time that the workman causes the model to pass under a fixed copying point; the cutting power of the tool in depth can be varied by the use of a treadle, increasing or diminishing the down-

We engrave two of the PA-TENT SLOW-COMBUSTION STOVES, manufactured by Messrs. MUSGRAVE BROTHERS, of

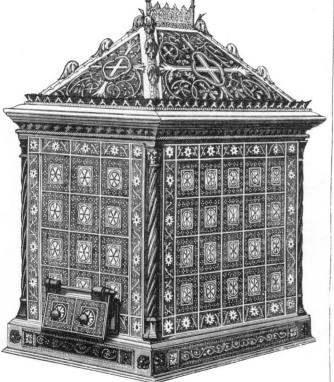

Belfast. Their peculiar constructive advantages are universally ad-

mitted, while they are very beautiful examples of Art-manufacture.

Messrs. TOULMIN AND GALE, of Sise Lane, City, and New Bond Street, are extensive exhibitors of works in leather and fancy wood, decorated with

silver-gilt and ormolu mountings, for the writing-desk and toilet-table.

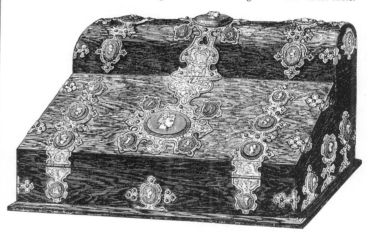

They have paid special attention to Art as an important auxiliary to

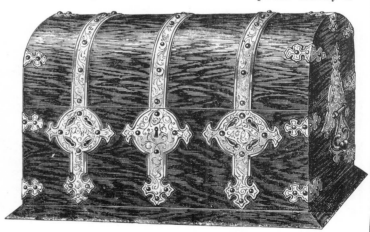

their trade. Their collection is large, and of great excellence. We engrave three objects: of good design and character, and of admirable workmanship.

ward pressure. Greenwood and Batley exhibited a machine not very dissimilar to this, which was employed for cutting out the lock seat in gun stocks. This resembled Mr. Jordan's machine, in so far that the cutter worked parallel to a tracing point moved over the finished pattern; but a series of drills, each having its power of action limited to a particular depth, are employed, instead of providing for a varying cutting power by a motion governed by the tool; these cutters are arranged on a cylindrical frame, and each one has its own tracing point. The motion was communicated by frictional bevel-wheels, and two small fan-blowers were added, in order to keep the work and pattern free from chips and cuttings. In immediate connection with those wood-working machines, Mr. Edwin Smith, of Sheffield, exhibited a pointing and carving

machine, for the use of sculptors and carvers. It was capable of producing (in marble, stone, or wood) statuary, busts, and other ornamental objects, in the round and in relief. There are many ingenious contrivances in this machine; it works with great facility, and appears capable of producing copies with great accuracy.

Passing from the English to the foreign exhibitors, we find that France sent us numerous wood-shaping machines, amongst which the most remarkable was the band sawing machine, or endless ribbon saw, of M. J. L. Perin, capable of cutting out curved forms of the most irregular and complicated character. Neither Belgium, Prussia, nor Austria contributed machinery of the class we have been describing; but Colonel Likhatcheff sent from Russia two machines, one intended for bending the staves of barrels by pressure between

We had the pleasure to engrave a work of magnitude and cost, the production of

Messrs. HARE, floor-cloth manufacturers,

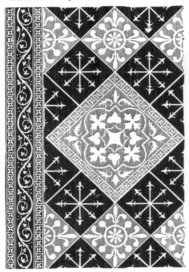

of Bristol; they produce also floor-cloths

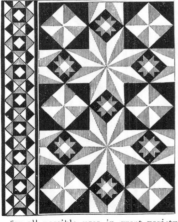

for all possible uses, in great variety.

Messrs. R. W. WINFIELD AND SON, of Birmingham, have obtained universal repute for the manufacture of metal bedsteads. The engraving underneath repre-

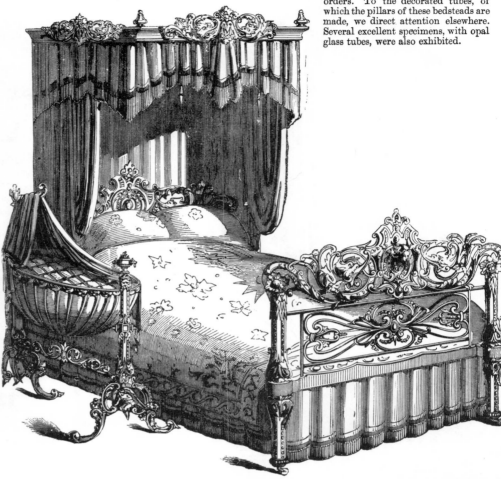

sents two of their productions—a highly ornate brass BEDSTEAD, and an elegant CHILD'S COT. These are selected from a varied collection of all classes and orders. To the decorated tubes, of which the pillars of these bedsteads are made, we direct attention elsewhere. Several excellent specimens, with opal glass tubes, were also exhibited.

This engraving is taken from one of the end PANELS of a GRAND PIANOFORTE, manufactured by PLEYEL,

WOLF, & CO., Paris, the beautiful case of carved ebony being from the famous manufactory of FOURDINOIS.

moulds, and cutting the edges by means of a horizontal saw; and another was ingeniously contrived for cutting out the interior curve of the stave by means of a peculiarly arranged semi-annular saw.

Spinning machinery, in variously graduated systems of arrangement, having for their object the cleansing, sorting, and twisting of the fibres of the raw material, were fully exhibited. These cannot be described here; but it must be remarked that the exquisite delicacy of the machinery displayed, exhibiting the perfection of workmanship, was the subject of continued admiration. One of the most attractive of these machines was Sharp, Stewart, and Co.'s reel-winding frames for silk, linen, or cotton sewing-thread. By this beautiful machine one girl does the ordinary work of six hand-spoolers, as it winds six bobbins, or reels, at once; all the attendant has to do being to supply empty bobbins to six hoppers, and to remove the full ones as they are thrown off when filled with thread. The machine *itself* fixes the empty spools in their working places, guides the thread on to them, and when two hundred yards are wound on, cuts a nick on the end of the spool, and draws the thread into it to be there fastened, then cuts off the thread and discharges the full spools, and at once begins winding again on to a fresh lot of empty bobbins. It fills a set of spools in one minute, placing two hundred yards of thread upon each spool or reel, fifty-four seconds of that time being occupied in winding, and six seconds in changing the full for empty bobbins. One of these machines is said to fill, on an average, about twenty gross per day of ten working hours. According to an estimate made by one of the best authorities on these subjects in this country, upwards of three thousand persons are employed in the United Kingdom in spooling sewing thread

Messrs. DYER AND WATTS are, if not the inventors, the great

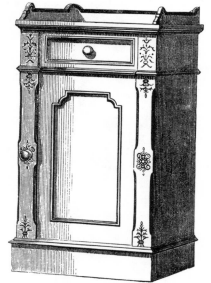

improvers, of FURNITURE in stained deal, now in very general

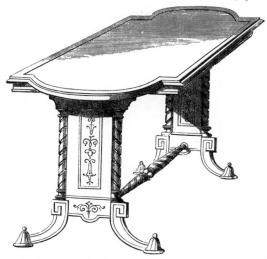

use, having not only the advantage of comparatively small

cost, but being also simple and singularly "neat," and

specially calculated for bedrooms. They are of polished pine, so tinted as to produce

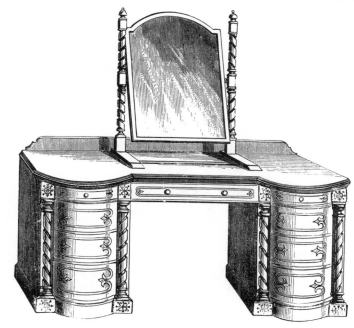

are generally graceful and appropriate. The introduction of this class of work has been

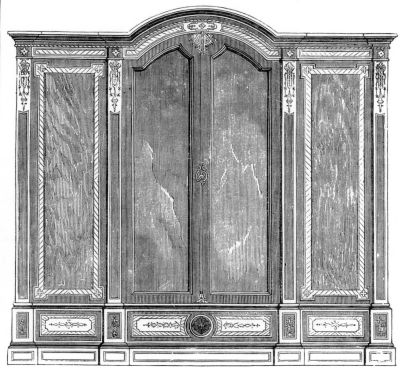

highest credit for the skill they have exerted to render the works not only valuable for

all the effect of inlaying. The workmanship is of the best order, and the designs a valuable boon to "persons furnishing," and Messrs. Dyer and Watts deserve the the cottage, but desirable for the mansion. The processes merit detailed description.

by hand machines, and they produce between three and four hundred millions of reels, or spools, per annum, of an average length of two hundred yards of thread. This is, for ingenious and skilful design, and for finished excellence of workmanship, a remarkable machine; and many of this character may be regarded as amongst the finest examples of automatic engines ever produced. Among the cotton-spinning machinery, the combing machines—which also separate the longer from the shorter fibres—and the wonderful "mules," were regarded with most interest. Flax spinning, with its analogous but simpler machinery, was well displayed. The manufacture of woollen yarns, and the process of silk-spinning, found good exhibitors. From these, however, we must pass to a set

of machines which come more directly under the class of those which are employed for Art-manufacture, namely, weaving machines.

The collection of power-looms for the manufacture of every kind of textile fabric, from the plainest to the most complicated in design, found place in the Western Annexe. It may be necessary to state that the invariable parts of every loom are—1. *The warp beam*—a horizontal roller, on which the parallel horizontal threads to form the warp are wound. 2. *The reed*—a narrow grating of fine steel bars, mounted on a vibrating frame, for the purpose of driving up the weft; each warp thread passes through one of the fine apertures between the dents. 3. *The shuttle*—a small boat-shaped instrument, carrying the weft threads, which is propelled backwards and for-

MM. JEANSELME, SON, AND GODIN may produce costlier and more elaborate works than the CABINET engraved on this page, but none of a purer and higher order of Art. It is of ebony, carved; there is no "enrichment" of any kind, no disturbing introduction of gilding or metal; it is,

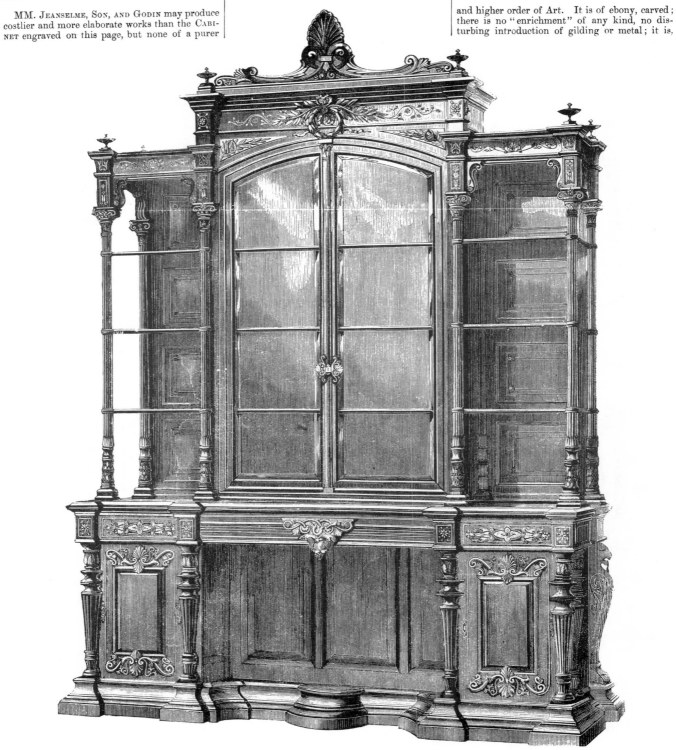

however, so exquisite in design, and so perfect in execution, as to be, perhaps, the best of many excellent works in this department of the Exhibition.

wards across the warp by a pair of wooden arms, called *picking sticks.* 4. *The healds,* or *heddle:*—a series of cards provided for the purpose of lifting or dividing the warp threads. 5. *The taking-up roller,* placed in front of the loom, on to which the finished cloth is wound. It should be understood that there are three motions attending every throw of the weft thread : the shedding, or dividing of the warp ; the shool, or passage of the shuttle across the divided warp ; and the driving up of the weft by means of the reed. In the plainest fabrics the heddles are arranged in lifts or leaves, so that alternate threads of the warp are raised or depressed for each throw of the shuttle. In weaving patterns, the process of combing the heddles into lifts is adopted for the production of simple geometrical figures. In the production of transversely striped or checked articles, differently coloured weft threads are employed, and for this purpose the shuttles are carried in sliding or rotating boxes. In more complex weaving each heddle is worked by an independent lifter, the proper division of the warp being effected by the Jacquard arrangement. Several admirable looms were exhibited ; amongst others, all of great merit, and presenting features of novelty, W. Smith and Brothers exhibited a loom for weaving damask ; one for half woollen, with three shuttles, and a very fine loom for weaving woollen cloth two yards wide, with three shuttles ; and a winding machine for either bobbins or pirns. Tuer and Hali exhibited an improved carpet-loom, capable of producing pile velvet, patent tapestry, or ordinary Brussels carpet, of any width required, with or without the Jacquard arrangement. All the working motions, except the crank, were placed outside the loom, in order to render them more easily accessible : the motion for inserting and

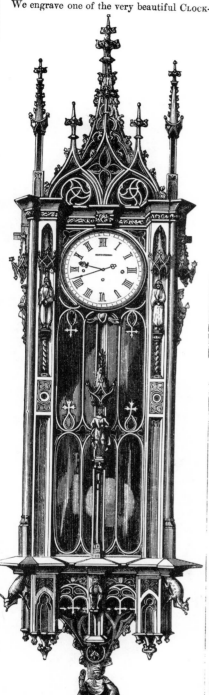

We engrave one of the very beautiful CLOCK-

This elegant piece of furniture formed one of a group exhibited by Mr. THOMAS FOX, of Bishopsgate Street. It is novel in design and structure, and adapted for the end or side of a drawing-room. The table part is gracefully shaped,

with dwarf cabinets at each end, enclosed by rounded glass panels, for the reception of objects of vertu, the cornices of which form the bases of four carved columns, surmounted by shelves for statuettes. The lower part is divided into

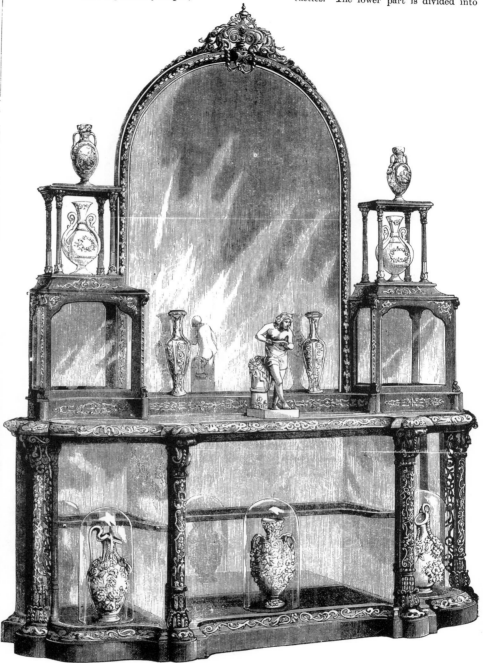

CASES of the firm of MARENZELLER, of Vienna.

compartments by the introduction of figured scroll glass panels, supporting shelves; the frame-work and mouldings are of fine walnut-wood, relieved by inlay-

ings of scroll foliage ornaments cut in holly-wood. This very charming work was purchased by Major Godfrey Rhodes, of Rawdon Hill, Otley, Yorkshire.

withdrawing the wires on which the pile or loops are raised, was governed by one cam. The loom was exhibited making patent tapestry carpet, in which the pattern is produced by plain weaving, each thread of the pile warp being dyed in various colours, the whole working up into a flowered pattern when woven. A loom exhibited by Booth and Chambers is distinguished by various novel peculiarities—among others, the warp-beam is mounted so as to cause the warp threads to be equally strained, whether the roller is full or empty, without varying the balance weights; the taking up of the cloth is accomplished by eccentric wedges on a plain beam, thus dispensing with the use of the emery-covered roller, which is objectionable on account of its preventing the use of wetted weft. There were several other looms for plain and ornamental weaving, each possessing some points of novel interest.

France exhibited some looms; amongst others a model of an arrangement for employing electro-magnets in a loom, on Bonelli's system (to be described presently). There was also a project by M. E. Mouline for replacing the ordinary picking motion by a travelling magnet, carrying the shuttle across the warp at a low speed, and with an equable motion. In this arrangement the inventor proposes, in order to compensate for the low rate of speed, to use looms of much greater breadth than those usually employed. M. Ronze was also the exhibitor of a new kind of Jacquard loom for weaving richly figured fabrics, working with only half the number of cards usually employed. Durand and Pradel exhibited a plan by which the perforated pattern for the Jacquard loom is made on a continuous web of paper, instead of using a chain of cards. This alteration is stated, by the inventor, to produce a saving of two-thirds in the

We engrave another of several CLOCK-CASES, carved in oak, the manufacture of MARENZELLER, of Vienna. The contributions of Austria to this department of the Exhibition were numerous, and of great excellence, generally

Messrs. ASSER AND SHERWIN, of the Strand, exhibited a BAGATELLE BOARD, of excellent workmanship, and good, though simple, design. It is a graceful piece of furniture for the

drawing-room, with advantages in construction that enhance the pleasure to be derived from the game. The work is of walnut wood, very skilfully, though not elaborately, carved.

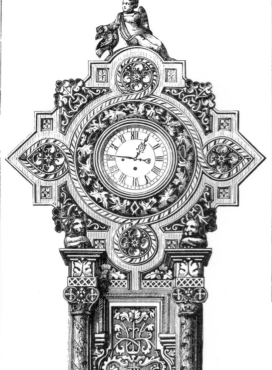

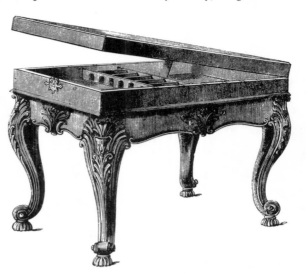

FRANCIS THEYER, of Vienna, exhibited a striking and interesting collection of fancy wares of wood, with bronze, marble, and leather, and others of neatly-carved woods.

We have selected several to form a group. The objects are generally of simple designs, but of exceedingly refined workmanship. They consist chiefly of contributions to the drawing-

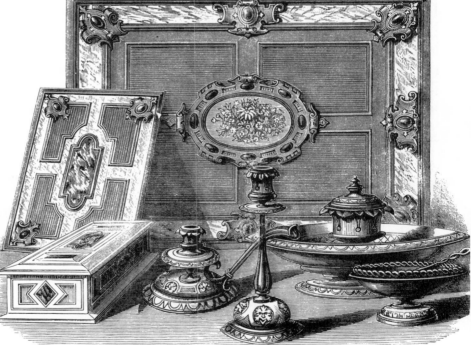

pure in design, and of good workmanship, while they seem to have been produced at no great cost; the prices were such as to lead to the conclusion that they were created by machinery, and not "hand-labour." They are, however, Art-works of an admirable order.

room, for the writing-desk and the toilet-table, and

are at once elegant and novel in style and character.

price of the pattern. Austria, although it was evident from the exhibition of textile fabrics that her manufacturers employ much ingenious machinery, was not an exhibitor of any, for either spinning or weaving. The same may be said of the Zollverein, and also of Belgium. These countries exhibited the results—and these, in many cases, were exceedingly beautiful—but the means by which those results were obtained were not shown. From Italy we derive the original invention of the electric loom of Bonelli, which now claims our attention as being a most ingenious adaptation of electro-magnetism to the Jacquard loom. This invention, which has been employed for more than sixty years for weaving figured goods, is well known to many of our readers; but since it is somewhat complicated, many, of even those who have carefully watched its workings amidst the weaving machinery in the Annexe, may be yet

at a loss to understand its operations. It is not easy, without drawings, to give a clear notion of the arrangements; but, as Bonelli's machine cannot be understood without some knowledge of the principles of the Jacquard, a description of it must be attempted. The figures on a woven fabric are formed by the relative positions of the warp and woof threads above or below each other. Consequently some of the warp threads are raised above the woof threads at one time, and they are below it at another. The regular repetition of this movement, which is determined in the process of "reeding in" the pattern, is secured by the "healds," or harness for guiding these threads, each thread having its appropriate heald. Originally these were raised by draw-boys. Jacquard made it an ordinary mechanical operation, which derives its motion from a simple pedal, put in action by the weaver's feet. This harness is acted on

We devote another page to the admirable productions of the WORCESTER ROYAL PORCELAIN

WORKS—a compliment to which that renowned

establishment is eminently entitled. In the

selections we have made, prominence has been given to the "exhibits" suggested by the old

enamels of Limoges, among which is the CHALICE

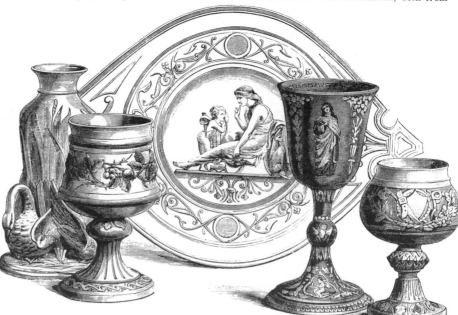

the purity of the workmanship, and the novelty of

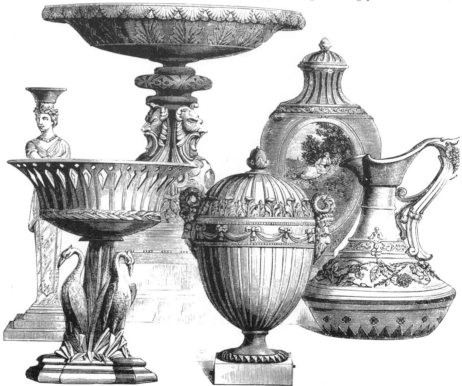

on panels of diapered gold ground, the enrich-

which excited so much admiration, both from

the style, the figures being painted in colours

ments of the spaces being in white enamel.

by a system of needles or skewers; and these are made to act, in the desired manner, by a series of perforated cards. It will be understood that if one of these pierced cards is brought against the end of a set of horizontal needles, they will be differently acted on, accordingly as they are opposite the holes or the solid parts of the card. In this way some of the needles are brought into action, and lift the warp threads at one time, while others are lifted at the next move of the machine, when a new card is brought up against the needles. Thus the needles are raised according to arrangement with the warp threads attached to them; then, by the passage of the shuttle carrying the coloured thread, as well as a shot of the common weft, one element in the pattern is completed. Card after card is brought regularly into action, and thus the entire pattern is produced. If our description is clear, it must be evident to all that such a number of cards must be provided and mounted, as equals the number of

throws of the shuttle between the beginning and end of any design which is to be woven: hence, in many cases, their number is considerable. Instead of the numerous pierced cards of the Jacquard arrangement, Mr. Bonelli has but one single plate of brass, pierced with holes—four hundred, we were told, was the number in the machine exhibited,—this acts precisely as the cards act, by the holes being filled or left open, according to the design. The design is drawn with a resinous substance upon a sheet of tin-foil, strengthened by being attached to a sheet of paper, thus forming an endless band, which is moved forward upon a roller. A series of metal points, weighted, insulated from each other, and equal in number to the holes in the brass plates, rest in line upon the design and the plain surface of the tin-foil. When these metal points are in contact with the tin-foil, a metallic connection is completed: this is interrupted when the points are resting on the varnished

Messrs. W. LISTER AND SONS, eminent silversmiths, of Newcastle-on-Tyne,

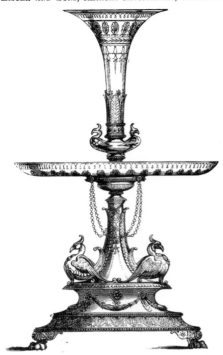

exhibit a DESSERT SERVICE, excellent in design and execution, of which we

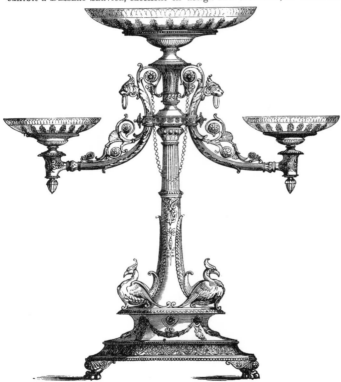

engrave two pieces. All the examples of their works are of a high class.

This engrvaving is of one of the huge GLASS CHANDELIERS manufactured and contributed by the famous glass manufacturers, Messrs. OSLER, of Birmingham. It is a very

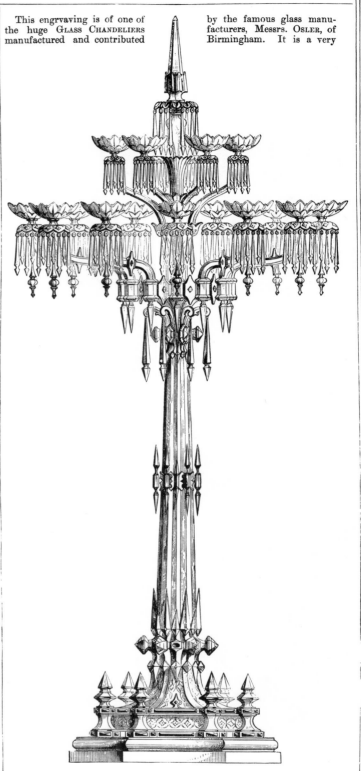

triumph of the art—an art in which Messrs. Osler are unrivalled.

design. Each of these four hundred points is in communication with an electro-magnet; four hundred are, therefore, arranged parallel to each other, one end of the wire of each being connected with a voltaic battery, the other pole of which is in continuous contact with the tin-foil of the pattern sheet. When the pedal is depressed by the weaver the points descend on the design, those touching the metal surface closing a circuit; the others, touching the varnish, remaining unaffected. All the electro-magnets which are thus made active, attract an equal number of soft iron cylinders, brought against them by the simultaneous movement of the frame. Upon raising the pedal, the frame recedes with the cylinders which have not been attracted, leaving about half an inch behind those which have not been retained by the electro-magnets. These cylinders are now divided into two groups, of which the foremost one in the receding-frame is caught by the perforated brass plate, which slightly descends, and lodges behind the small heads with which the cylinders are provided. A certain number of holes are thus regularly closed, and the one plate is made to act in a similar manner to any number of perforated cards. The advantages are, that the design can be far more easily drawn on tin-foil than the cards can be perforated—that even during the process of weaving the pattern can be varied, or entirely altered, without suspending for one moment the operations of the loom. Beyond this, it is affirmed, that on the ground of cost, the advantages are considerably in favour of Bonelli's electrical loom. Manufacturers being provided with enormous stocks of perforated cards, adapted to their looms, cannot

These VASES are selected from the many beautiful productions exhibited

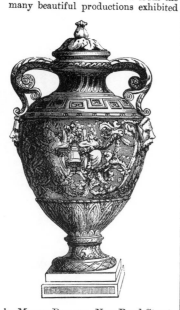

by Messrs. DANIELL, New Bond Street, from the works at Coalport. The forms

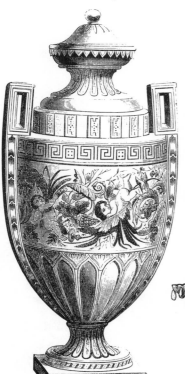

are based on the best models, and the paintings are examples of high excellence.

This CHANDELIER, of the purest crystal glass, formed one of the many attractions of the stall of Messrs. DOBSON AND PEARCE, of St. James's Street. Though elaborate and full of details, the design is graceful and harmonious, and the effect on the eye refreshing.

be brought readily to change them for the electrical arrangement. There appears also to have been some difficulty in insuring certainty of action in the electrical loom; but from the well-known industry and knowledge of the inventor, there can be but little doubt that complete control, and consequently regularity and precision, will in a little time be secured.

From the United States, owing to the unfortunate condition into which that country is plunged, but little of interest was forwarded. The most important machine exhibited was a loom for weaving tufted pile carpets. The arrangement of this machine was very peculiar, no Jacquard pattern being used. The yarns for forming the pile warp were wound on to horizontal reels, which were mounted into an endless chain. At every stroke of the loom one of these reels was removed from the chain; the neces-

sary length of yarn to form the pile was reeled off by a series of hooked wires, and cut off by a vibrating knife-blade. The tufts were secured in their places by the next shoot of the shuttle, and the reel was returned to its place in the pattern chain, to be replaced by the following one, and so on. This loom was capable of producing twenty-five yards of Axminster carpet daily.

In this place, as having some connection with the weaving machines, it may be noticed that almost every variety of sewing machine found its exhibitor. Many of these were of exceeding ingenuity, and proved in a striking manner the amount of thought that had been bestowed on the mechanical operations necessary to secure a representative for the human hand. A small number of very interesting and beautiful machines was included under the group of blocks for shawl printing, and engraving for calico printing. Some of these were

Mr. BLANCHARD has been long known and

ing manufacturer of TERRA COTTA in England, to him the country is much indebted for many

tion examples of several classes, some of them being

to which we are limited

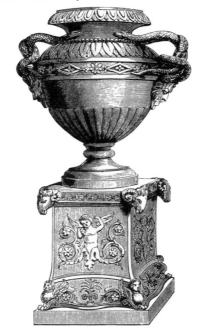

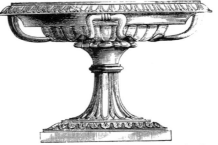

of elaborate and very beautiful design, Mr. Blanchard

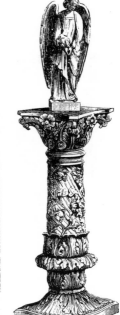

of the improvements to which the several processes have been, of late years, subjected. We

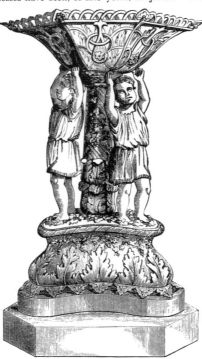

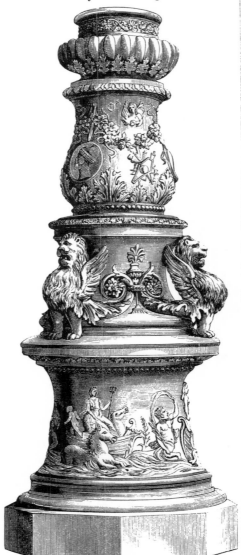

permits us to do no more

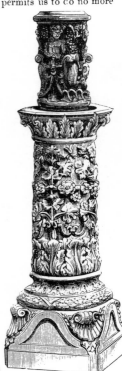

recognised as the lead-

select from his extensive and varied collec-

obtaining the aid of competent artists. The space

than supply the engravings.

shown in the Process Court, others in the lower part of the Western Avenue of the Western Annexe. Morgan's patent machine for making shawl printing blocks, produces a hard printing surface by the insertion of brass wire pins into a prepared block of wood ; the effect of flowing lines is more or less perfectly produced according to the fineness of the wire employed. The finest patterns have been obtained by using wires one-sixty-fourth of an inch in diameter. A very ingenious process was shown, the invention and patent of Mr. John Wright. Moulds are produced, in the first place, by the action of finely pointed tools, heated by a gas flame, which are made to char wooden blocks. Type metal casts of the burnt-in pattern, so obtained, form the printing blocks. There were two varieties of this machine exhibited, one producing a single impression, and the other capable of forming patterns on the upper and under surface of the wood blocks by the simultaneous action of two heated points

worked by one heddle. Pantagraphic machines for engraving rollers for printing calico, or for paper hangings, were exhibited by Lockett and Co. The sketch is drawn on a large scale, on a flat piece of zinc, and by going over it with a tracing-point a number of reduced copies, corresponding to the number of diamond points employed, are produced on the roller. This pantagraph is capable of supplying twenty-four reduced copies of a design at one time from a single pattern, and of including any reduction of a pattern included within the limits of one-half and one-twelfth of the original size. An application of electricity in this direction was exhibited by Mr. Henry Garside. It was intended for engraving the designs on brass or copper rollers for calico printing. This was done in the following manner. The cylinder was first coated with a resisting varnish, through which the design was scratched by a series of diamond points, arranged so as to be worked each by a separate electro-magnet.

MM. Duvelleroy, of Paris, and Regent Street, London, are manufacturers,

mense variety, and at prices rising from one halfpenny to two hundred pounds. These fans are frequently decorated by renowned artists, and sometimes contain pictures of rare value,

they are beautiful works of Art, charmingly de-

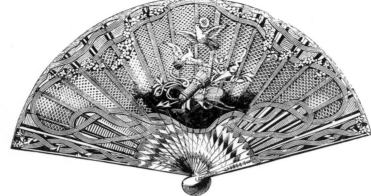

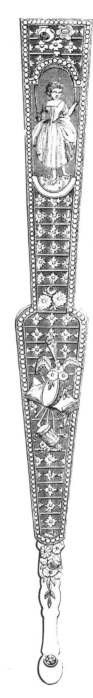

while especial attention is paid to the mounting, in order to combine grace with strength. They occasionally copy from the finest productions of old times, but more usually issue

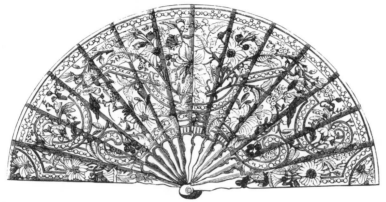

such as have the recommendation of novelty. MM. Duvelleroy have obtained "honours" in all the exhibitions of the century, and there are few of the sovereigns and princes of Europe

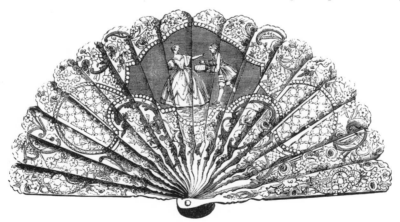

for the world, of those "necessary luxuries," Fans, which they produce in im-

who have not been their "customers;" to them, indeed, we are mainly indebted for the perfection to which the articles have been brought—rivalling those that have descended to us as legacies from our great grandmothers. We have selected some of the best of these examples;

signed, exquisitely carved, and very admirably painted.

the action of the magnets being determined by their being put in or out of circuit, according to the requirements of the pattern. The pattern is drawn in a non-conducting varnish on a small bright metal cylinder, revolving horizontally; a tracing-point pressed against the pattern, and moving by a self-acting slide motion, puts the magnets in or out of circuit, according as it is in contact with the bright metal or the varnish covered surface. The requisite reduction of the pattern is effected by means of a train of spur wheels, by which several revolutions of the pattern cylinder are made for each revolution of the roller to be engraved. The traced outlines on the roller are subsequently etched in by nitric acid, or some other biting liquor.

But for the limits to which we are necessarily restricted, mention might be made of several other mechanical contrivances bearing on Art-manufacture; all more or less aiding the great purpose of pro-

gress, and facilitating the rapidity, while lessening the cost of production. We trust, however, that the brief descriptions we have given of the more important machines that have such an application, will show the large amount of thought that has been bestowed on the subject. As examples of the mechanical ingenuity of the age in which we live, these may be pointed to with great pride, as triumphs of human power over brute matter. Mind, indeed, has imparted, as it were, some of its powers to iron and steel, and by it, compelled the Physical Forces, Heat and Electricity, to do its bidding, in relieving human hands from the wearying and monotonous labour to which they were formerly subjected. We trust there have been established the means of aiding the labourer to rise in the social scale, and to improve and exercise his intelligence for the benefit of the commonwealth.

Robert Hunt.

We engrave on this column part of a

PICTURE-FRAME, by LUIGI, of Florence.

This engraving is of a comparatively humble object —a COAL VASE—the production of Mr. LOVERIDGE, of Wolverhampton. It is a good and original design, constructed with much skill, carefully painted, and richly gilt.

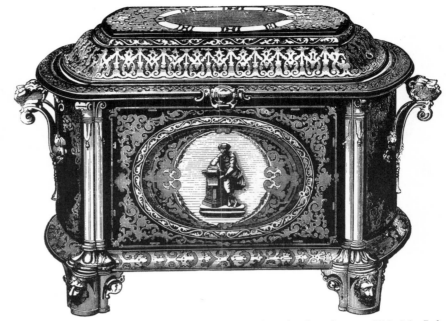

The JEWEL-CASE here engraved, exquisitely carved in oak, is the production of PIETRO GIUSTI, of Sienna, whose fame has been long established in Italy, and is now fully recognised in England. There can be no

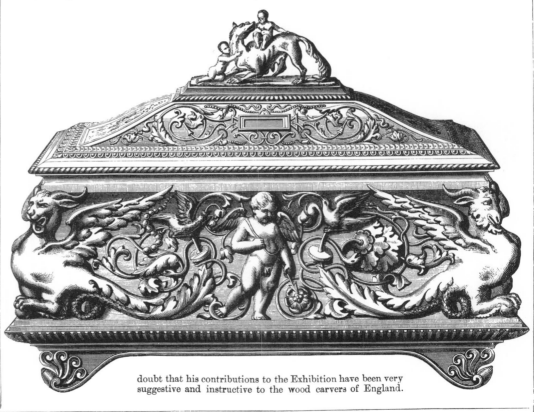

doubt that his contributions to the Exhibition have been very suggestive and instructive to the wood carvers of England.

THE HARD WOODS USED IN TURNERY AND WOOD ENGRAVING.

BY P. L. SIMMONDS.

FEW but those who have looked into the subject would suppose that foreign woods were imported to the value of nearly twelve millions sterling annually, besides our own supplies of British oak and home-grown woods, which are utilised for various purposes. Notwithstanding the extensive adoption of iron for constructive purposes in ships and buildings, there has been no diminution in our consumption of foreign building woods. Indeed, the imports in the past two years show an increased value of one million and a quarter over the imports of six or seven years ago. The second great class of woods—dye woods—has remained somewhat stationary, and this may arise from the extensive use of mineral dyes within the last few years. The class of foreign hard woods and furniture woods has, however, increased considerably in consumption within the past ten years, an indication of the greater demand for the purposes of Art and luxury, and possibly from the stimulus given by exhibitions, since that of 1851, which have served to bring into notice many new and beautiful woods previously unknown or disregarded. Since 1856 the value of the hard woods and ornamental woods imported into this country has doubled. It would be impossible in the compass of a brief article to pass under notice all the principal woods used for furniture, and we shall confine ourselves, therefore,

The side and top engravings are of a CABINET which contains the pencils of STAEDTLER, of Nuremberg. It is of carved wood—a very beautiful work both in design and execution, the production of J. ADELHARDT, of Nuremberg. This

eminent cabinet-maker has obtained very

This STOVE is the manufacture of Messrs. ADAMS, of the Haymarket. It is massive in character, and suited to a hall or dining-room. The design is of much excellence, and the work-

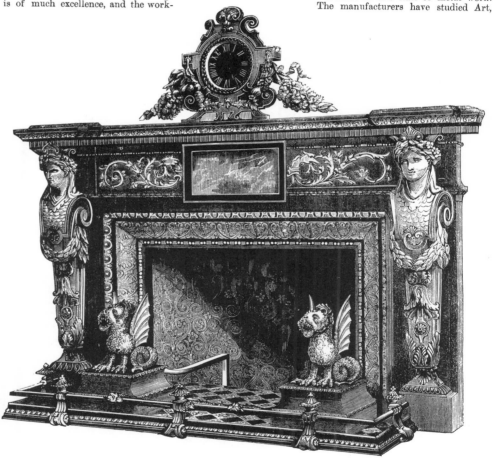

manship of the highest and best order. It is especially gratifying to note the progress that has been of late made in this class of metal work. The manufacturers have studied Art,

high renown in the "quaint old town."

and they have generally sought and obtained the aid of artists. A few years ago, a good model was the

result of little else than chance; now-a-days, a bad or incongruous design is not the rule, but the exception.

to a glance at the hard woods used by the turner and engraver. Several of these woods are also employed for other purposes, but we shall speak chiefly of their application in turnery.

The principal woods used by the turner are—African Black-wood, Angica, Barwood, and Camwood; Bully tree, Botany Bay oak, Box-wood, Brazil-wood, and Braziletto; Canary-wood, Cocus-wood, Coromandel, Ebony, Fustic, Iron-wood, Jack-wood, King-wood, Letter-wood, *Lignum vitæ*, Madagascar Red-wood, Nutmeg-wood, various Palms, Partridge, Princes' and Purple woods, Queen-wood, red Sanders, Rosewood, Satin, Tulip, Yew, and Zebra-wood. Of these we shall now proceed to speak *seriatim*.

Of the sources of the African black-wood nothing certain is known. It is referred by some to the *Cocobolo prieto*, from Madagascar and

Eastern Africa, a tree which we cannot trace. Possibly it may be from *Afzelia Africana*, but more probably it is the black iron-wood, or South African ebony, *Olea laurifolia*, a most valuable hard wood, brownish, close, and heavy; excellent for turning and carving, and much used in the Cape colony by cabinet-makers. Angica is a Brazilian wood, which is used also by cabinet-makers. The tree producing it has not been correctly determined, but is believed to be a species of *Aylanthus*. The barwood and camwood of commerce, although imported under distinct names and from different parts of Western Africa, are both the product of the same tree, *Baphia nitida*. The wood yields a brilliant red colour, which is used for giving the red hue to English bandana handkerchiefs. It is not a permanent colour, however, and is rendered deeper by sulphate of iron. We

Messrs. HOBBS & Co. have established renown in Europe, as well as in America, by the production of LOCKS that defy the "picker and stealer," and they have gained honours in all the exhibitions that have been held in the several cities of the continent and in England.

The HALL HANDRAIL of wrought iron, manufactured by M. BAUDRIT, of Paris, attracted general attention in the French Court—both for its design and execution—and was rightly classed among the best of the many excellent contributions in metal sent by France to the International Exhibition.

With their internal construction we have nothing to do: and it is not often that works of this class are made to pass under the eye of the artist. One of them, however, was so wrought by the chaser, from a good design, as to justify its introduction into these pages.

We engrave another PANEL of the very beautiful PIANOFORTE, of carved ebony, the work of FOURDINOIS, of Paris, the piano being the production of the famous firm of MM. PLEYEL, WOLFF, & Co., Paris.

imported in 1861, 1,154 tons of camwood, valued at £20,457, and 2,075 tons of barwood, valued at £6,171. These woods may be distinguished by their rich purplish tinge. The bully tree or beef-wood is said to be a South American wood, obtained from British Guiana, and has been referred, but erroneously, to *Robinia panacoco.* The wood passing under the name of "panacocco" is *Ormosia coccinea.* Botany Bay oak, sometimes called beefwood, is the trade name for the wood of *Casuarina stricta* and other species of *Casuarina,* of New South Wales. Among those which were sent to the recent Exhibition by the colony, were the forest or shingle oak, or beefwood (*C. suberosa*), a wood of great beauty, but only fit for veneers; the spreading oak, swamp oak, and white oak, all woods of little value in an ornamental point of view. Some of the wood imported under the name of Botany Bay oak is well adapted for inlaying and marquetry. It is of a light yellowish brown colour, often marked with short red veins. One variety is extremely beautiful, and nearly as hard as tulip-wood. It is finely dappled with rich intwining strokes, on a high flesh-coloured ground.

Boxwood is one of the most important hard woods which we receive for the special uses to which it is applied.· The mediæval collections testify to the exquisite skill of some of the old wood carvers on this material. Boxwood is also of great use to the turner, the mathematical instrument maker, the musical instrument maker, and the wood engraver. The largely extended use of woodcuts in the illus-

THE INTERNATIONAL EXHIBITION.

A CLOCK CASE, in silver, elaborately chased, the production of HUNT AND ROSKELL, "presented to Colonel Sir Proby Thomas Cautley, K.C.B., Bengal Artillery, by men of various races resident in India, in token of their common admiration of the genius which conceived and the skill which executed the Ganges Canal." It has typical figures of the Indus and the Ganges. The summit is a group of three figures—Science, crowned by Commerce and Agriculture. It is designed by Mr. T. BROWN, and modelled by A. J. BARRETT.

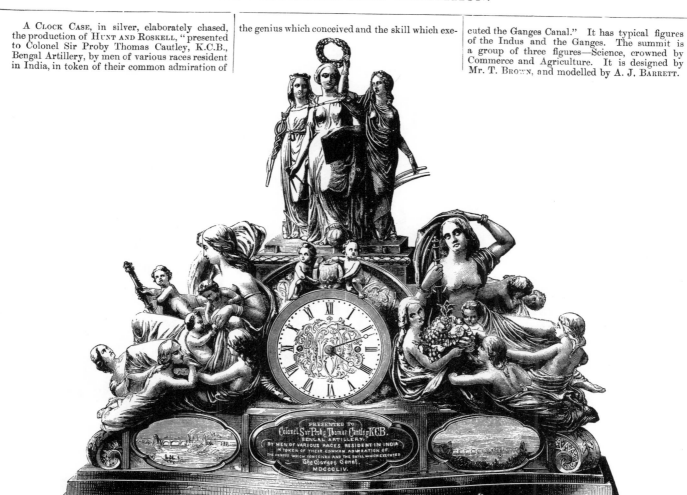

We engrave the upper portion of a GARDEN or HALL SEAT, in walnut wood, carved, the production of BARBETTI AND SON, of Florence, exhibited in the Italian Court. It is unquestionably one of the purest and best examples of true Art contained in the Exhibition—exquisite in design and

admirable in execution. This may be the work of artisans, but is also that of artists. It was, we hope, carefully studied by British cabinet-makers.

trated literature of the day has led to an universally increased demand for this the best material known for the purpose. Whether all the boxwood imported is furnished by *Buxus sempervirens*, is not known. It is, however, not improbable that *B. balearica*, a larger species, may furnish some of that which comes from the Mediterranean. The wood of this species is coarse, and of a brighter yellow than the common species. Rondelet, in a table of the mean heights of trees, gives that of the trunk of the box at 16 feet, and the mean diameter at $10\frac{1}{2}$ inches. In 1820 the imports of foreign boxwood were 363 tons, the duty being as high as £7 18s. 6d. per ton, and on that from British possessions £1 13s. 4d. In 1831 the imports had risen to 484 tons, the duty having been reduced in 1826 to £5 on foreign grown, and £1 on British grown. The duty is now only 1s. per ton for statistical purposes. The average imports of the last three years have been about 3,500 tons, showing the great increase of the trade in this important wood. The value in 1860 was about £11 per ton, and in 1861, £10. From the Russian port of Soukoum Kali, in the Black Sea, 1,450 tons of boxwood, valued at £10,384, were shipped in 1861 to Constantinople; the greater part of this was sent on to England. The market price of the wood at Soukoum Kali was 4s. 2d. the pood of 36 lbs. But little boxwood of any size is to be obtained now in the United Kingdom, and we draw our chief supplies from Turkey; while France depends much on Spain.

The importance of finding some wood calculated to come in to the aid of boxwood, the most generally useful of all the European hard woods, has long been felt. Notice was drawn to the subject at the Madras local exhibitions a few years ago, and it has occupied attention in several of our colonies. Among the large and varied collections of woods from different countries, shown at the recent Exhibition, we did not notice any which, upon trial, appeared

Messrs. MORTON, of Kidderminster, uphold the | renown of the long-famous manufactory of British

CARPETS. We engrave two of their productions; | both are excellent in character, simple yet effec-

tive, sufficiently well "covered," without being glaring in colour, the designs being in harmony | seen from any point of view. They are designed by Mr. J. K. HARVEY, the artist of the establishment.

These VASES are in artificial stone, the manufacture

of Messrs. F. and G. ROSHER, whose establishment is

at Queen's Road West, Chelsea. They are durable as

stone, not affected by weather, and are produced at

small cost. We give also an example of garden edging.

adapted for the purpose. We may, however, incidentally mention those which have been pointed out as suited for wood engraving. The essential properties requisite for this purpose are uniformity of structure, and considerable toughness, hardness, and retention of any sharp angles to which it may be cut, whether on the end or on the side—colour, except for certain purposes, is of little consequence. Dr. Hunter, of Madras, has furnished the following results of experiments on woods for engraving, made under his superintendence at the School of Arts, Madras:—The guava-wood (*Psidium pyriferum*), though close grained and moderately hard, with a pretty uniform texture, was found to be too soft for fine engraving, and did not stand the pressure of printing. It answered well for bold engraving and blocks for large letters, and for this purpose has been used for several years. The small wood from hilly districts was found to be harder and finer in the grain than that from large trees. Satin-wood proved to be hard, but uneven in the grain, coarse in the pores, and, like many other large woods, harder and denser in the centre than near the bark. As it was found to splinter under the graver, it was condemned. The small dark-coloured kinds of sandal wood of 5 inches in diameter, grown on a rocky soil, proved to be the nearest approach to boxwood in working quality, hardness, and durability under pressure. It cuts smoothly, the chips curl well under the graver, and the oily nature of the wood seems to preserve it from splitting when cut. Many hundred engravings have been executed upon this wood, and some blocks have yielded upwards of 20,000 impressions without being worn out. The question of price

THE INTERNATIONAL EXHIBITION.

We engrave two FERN CASES of terra-cotta, manufactured under the "Watsonian Patent" for Messrs. F. & G. ROSHER, Queen's Road West, Chelsea. The first is a graceful object for the conservatory

Messrs. HINDLEY AND SONS, of Oxford Street, large and meritorious contributors to the Exhibition,

one of whose works we have already engraved, | supply us with a SIDEBOARD of richly carved

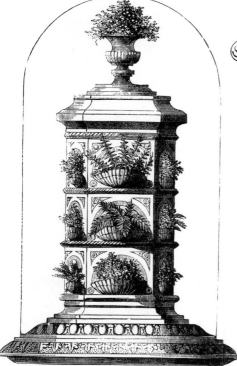

or the drawing-room, the other is to show the applicability of the fern bricks in other ways; for the great merit of this most ingenious invention is, that it can be introduced into any conservatory,

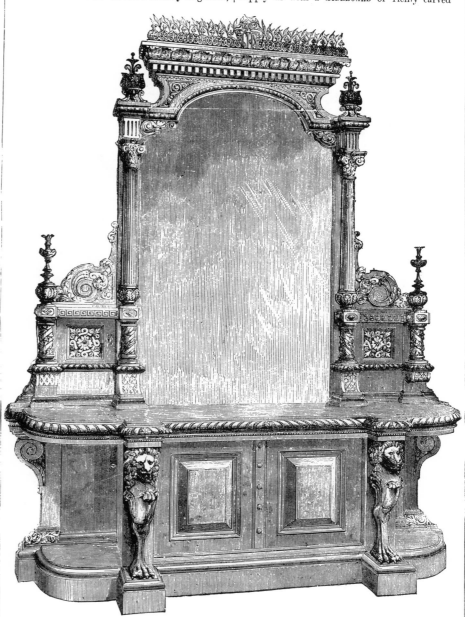

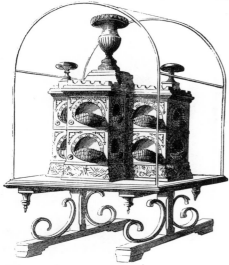

walls, or adapted to any design. The shells for the ferns are made to slip in and out. This fern case undoubtedly surpasses all productions of the kind, with reference to either elegance or utility.

walnut wood, excellent in design and in execution. | We engrave also the top of a carved CABINET.

has, however, to be taken into consideration, in order to see if it can compete with boxwood in England. Two species of *Wrightia* were experimentalised on without success. The palay (*Wrightia tinctoria*) has a pale, nearly white wood, close and uniform in the grain, but too soft to stand printing. It cuts smoothly, but does not bear delicate cross-hatching. Although unfit for wood-engraving, it is well suited for turnery, carving, and inlaying with darker woods. Veppaley-wood (*W. antidysenterica*), on inspection under the microscope, appeared to be suitable for the purpose, from the closeness of texture and the polish left by the chisel in cutting it across the grain; but the uneven quality and the softness of the outer parts showed that it was not fit for engraving. The wood of the wild orange bears a strong resemblance in appearance to box in

working qualities, and is often as hard. The wood of the wild Ber tree (*Zizyphus jujuba*), common almost everywhere in India, gave good promise under the microscope, but proved to be a soft, spongy, light wood, that did not stand cross-hatching or pressure. A small garden tree, the China box (*Murraya exotica*), proved on trial to be like the wood of many of the orange family—hard and close in the grain near the centre, but softer near the bark. The cross section was, however, very irregular. The wood of the coffee tree was found to be soft, uneven in the grain, and not fit for engraving, though well adapted for ornamental carving or inlaying. This wood works beautifully on the turner's lathe, and cuts very sharply under the chisel, gouge, or graver; it is deserving of more attention for ornamental carving and inlaying. It harmonises well in colour with

The two columns on this page contain engravings of some of the BROOCHES of Mr. RICHARD GREEN,

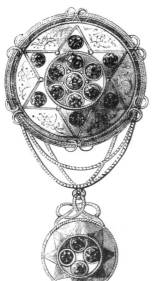

of the Strand. His "speciality" is for the production of jewels under

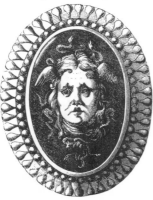

the value of twenty pounds, and he issues these in every possible variety,

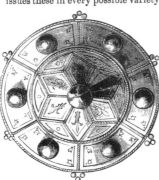

with real gems set in pure gold. In such cases the jewels themselves cannot be of high value, but the

We engrave a CABINET, manufactured and contributed by Messrs. LITCHFIELD AND RADCLYFFE, of Hanway St. and Green St.; it is a beautiful work in ebony,

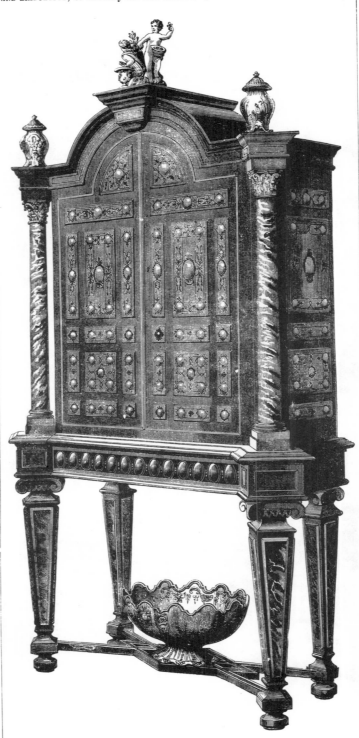

inlaid with ivory, and ornamented by gems, judiciously and skilfully introduced.

settings are always in the purest

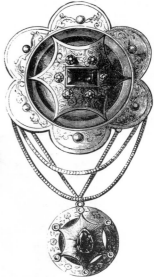

and best taste, some being from

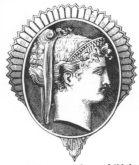

original designs, others skilful co-

pies or adaptations of the antique.

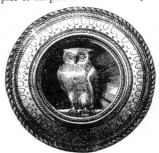

the wood of orange and that of the Manilla tamarind (*Inga dulcis*). There are a few other woods which may be incidentally noticed. The white beech (*Fagus sylvestris*) is much used for carved moulds, for picture frames, and large wood letters for printing. It is easily worked, and may be brought to a very smooth surface. The extremely hard wood of the white-thorn (*Cratægus punctata*) is used by wood engravers, and for mallets, &c. The dogwood (*Cornus florida*) is well adapted for the same purposes as boxwood. It is so remarkably free from silex, that splinters of the wood are used by watchmakers for cleaning the pivot-holes of watches, and by the optician for removing the dust from small lenses. The wood of the olive has occasionally been used for engraving. A very compact, fine,

and uniform wood (*Dodonæa viscosa*), procured from the Neilgherries, under the name of iron-wood, used for turnery and making walking-sticks, worked well under the graver and on the turning lathe; but the piece sent was too small to print from. The close-grained wood of *Podocarpus nerifolius*, a Burmese tree, has been suggested as a substitute for boxwood, but I have not heard that it has been tried. Another close-grained but undefined wood, locally called Baman, much used by the Karens for bows, has been also pointed out as probably adapted to take the place of box. The white, close-grained wood of *Gardenia lucida* is apparently well adapted for turning. This wood, like that of several other species of *Gardenia* and *Randia*, is used by the Burmese for making combs. A kind of plum-wood,

The HILL POTTERY, at Burslem, conducted by Messrs. HILL BROTHERS, in conjunction with their uncle, Sir James Duke, Bart., M.P., made a

strong and successful effort to uphold and extend the reputation of British Ceramic Art at the International Exhibition. We have given,

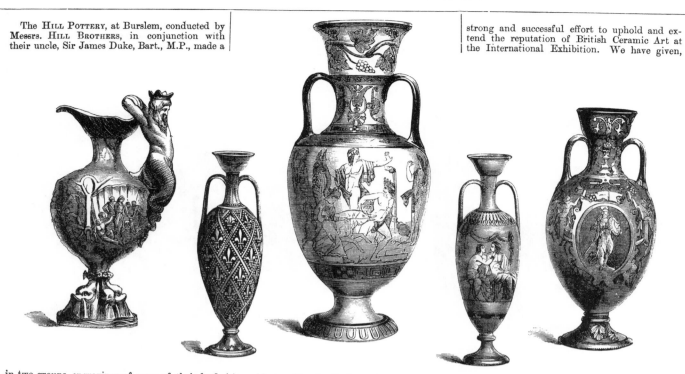

in two groups, engravings of some of their lead- | ing objects. Nearly all the varieties of produc- | tions in porcelain and earthenware were shown

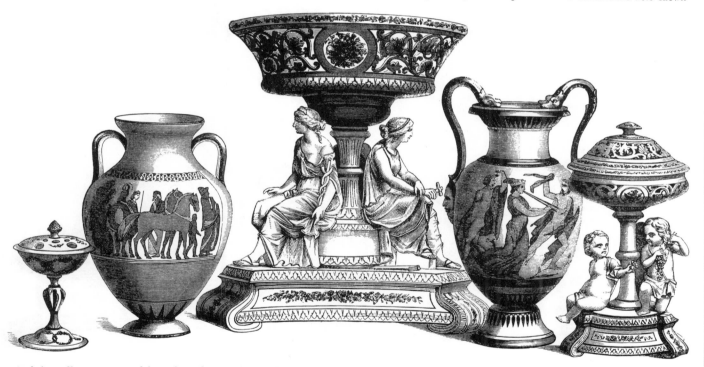

at their stall; some are elaborately and very | beautifully painted, others are skilful and accu- | rate copies from pure and popular Etruscan forms.

rather coarse in the grain, is used in China for cutting blocks for books. As a good deal of wood-block printing is carried on in Japan, it would be interesting to ascertain what wood is used by this intelligent and ingenious people for the purpose. Both the stone-wood (*Callistemon salignus*), a remarkably hard wood found sparingly distributed in Gipps Land, and the *Pittosporum bicolor*, have been used in Victoria for wood engraving. The wood of *Pittosporum undulatum*, from New South Wales, was brought forward here by the commissioners of that colony last year as calculated to be serviceable for wood engraving. Although favourably reported upon by the late Mr. P. Delamotte, it is not likely to be of much use to the wood engraver here. Mr. Delamotte stated that although the samples of wood he received were probably inferior ones, having been felled at the wrong season of the year, yet it was well adapted for certain kinds of wood engraving. It is superior to the pear and

other woods, generally used for posters, and is the produce of a small tree, with very close-grained, hard, white wood. When seasoned carefully, it would be well suited for turning. Sound transverse sections of more than 10 to 16 inches are, however, rare. The boxwood of Tasmania (*Bursaria spinosa*), another of the *Pittosporums*, which is very close and even-grained, of a yellowish colour, unmarked, has the appearance of being well adapted for wood engraving. The *Celastrus rhombifolius*, a dense, hard, and heavy yellow box-like wood of the Cape colony, where it is called Pendoom, might be useful to turners and musical instrument makers, especially for flutes, clarionets, &c. It is much used in turnery, but does not grow to any size, never exceeding 4 to 5 inches in diameter. The cork-wood of New South Wales (*Duboisia Myoporoides*) is almost as light as the wood of the lime, very close-grained and firm; but easily cut, and hence especially adapted for wood carving.

The sword of which we engrave the HANDLE is a fine example of wrought iron, admirably modelled and sculptured. It is designed and engraved by Mr. J. W. ALLEN,

and was presented, by subscribers, to CHARLES RATCLIFF, Esq., F.S.A., &c., Captain of the 1st Warwick Volunteers.

Portion of an ALTAR-RAIL, the work of Mr. SINGER, of Frome.

The CENTRE-PIECE for a dessert service, here engraved, is a work in silver-gilt, of great merit, both in design and execution. It is the production of Messrs. MUIRHEAD AND SON, of Glasgow, and is an honourable evidence of Art-progress in that city. It was a

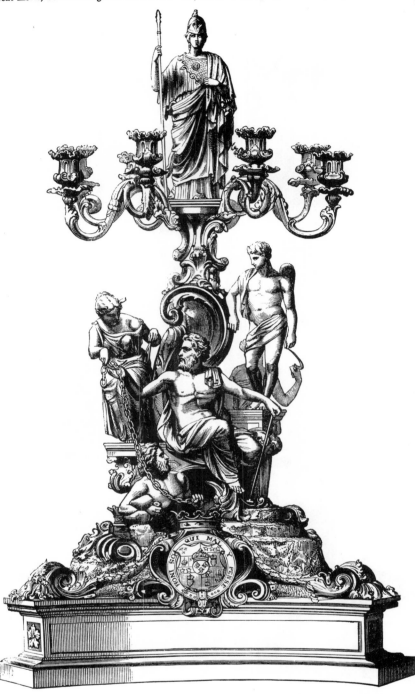

"commission" from the tenantry of the Duke of Hamilton, and was presented by them to his Grace—a proof of gratitude for services rendered, and respectful affection manifested by the cultivators of the soil towards its lord. It is of considerable size and weight.

Leaving the engraving woods, we now pass on to the commercial woods of the turner. Brazil-wood and Braziletto are the produce of leguminous trees, at one time much in demand as dye-woods. The former is the produce of *Caesalpinia echinata*: it grows abundantly in South America, and is imported chiefly from Pernambuco and Costa Rica: hence it is sometimes called Pernambuco-wood. When first cut it is of a light colour, but becomes a dark red on exposure to the air. The peach-wood, Nicaragua-wood, and Lima-wood of commerce, are supposed to be produced by the same tree. The imports of Brazil-wood in 1861 were 5,101 tons, valued at £102,262. Braziletto wood is furnished by *C. Brasiliensis*, which grows in Jamaica and other parts of the West Indies to the height of about 20 feet. This wood is much used for ornamental cabinet work, and both species are employed in turnery and for making violin bows. Canary-wood is obtained from the *Laurus indica* and *L. canariensis*, trees natives of Madeira and the Canaries. Cocus-wood, or Kokra, is said to be obtained from Cuba and other West Indian islands, and is referred to *Lepidostachys Roxburghii*. It is much used in turnery, and for making flutes and other musical instruments. It is a wood of small size, being usually imported in logs of about 6 or 8 inches diameter. The alburnum is of a light colour, while the heart-wood is of a rich deep brown, and extremely hard. Calamander, or Coromandel-wood, is obtained in Ceylon, from *Diospyros hirsuta*. It is a scarce and beautiful wood, exceedingly hard, fine, close-grained, and heavy. It consists of pale reddish-brown fibres, crossed by large medullary plates, or isolated elongated patches of a deep rich brown colour, passing into black. These latter are chiefly conspicuous in well-defined veins and broad

On this page we engrave portions of the CEILING | of a DRAWING ROOM, designed and executed by | Messrs. PURDIE, COWTAN, & Co., Oxford Street.

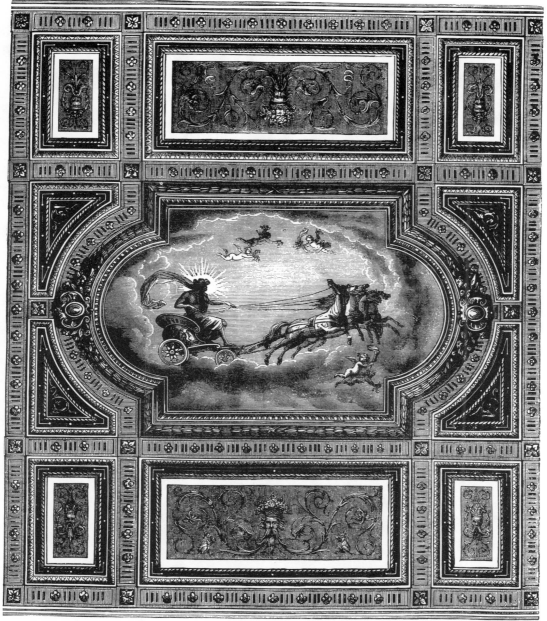

Enough is given to show its general effect and its | very great merit. The centre piece is an AURORA— | the SEASONS being represented in four side panels.

spots, admirably contrasting with the lighter parts. The lustre is silky where the medullary plates are small, but higher and more varying where the plates are larger and the grain coarser. Calamander-wood is considered by many persons the handsomest of all the brown woods : the root has the more beautiful appearance. This wood is now scarce. Another species (*D. Ebenaster*) furnishes in Ceylon a very fine wood, bearing a close resemblance to Calamander. The planks of Calamander shown at Paris in 1855 and at London last year were very fine. Belonging to the same genus as the Calamander is the Ebony of commerce, which, from its colour and denseness, is so much used by turners, and for inlaying work by cabinet-makers. Of 1,500 tons, valued at about £15,000, imported in 1861, the bulk came from India and Africa, and a small quantity, 268 tons, of inferior, worth only about £5 a ton (instead of £11 10s.), from Cuba. The carved ebony furniture from Ceylon at the Exhibition was much admired. There are several woods which pass under the general name of ebony. The green ebony, obtained from Jamaica and other parts of the West Indies, is supposed to be

This column contains four engravings from

"CHRISTMAS PLATES," the manufacture of

Mr. ALDERMAN COPELAND, M.P. They are

charming designs, appropriate to the "fes-

tive season," that brings joy to many homes.

We give engravings of several of the glass INK-STANDS, productions of Mr. BROCKWELL, of London. They are very varied in form and character, sometimes mounted in ormolu and brilliantly "cut."

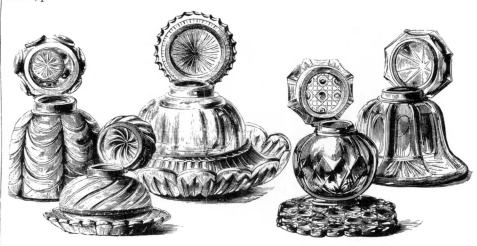

The beautiful STOVE GRATE exhibited by Mr. JOHN FINLAY, of Glasgow, here engraved, is patented by him for several manifest improvements. The enterprising proprietor has a large manufactory --chiefly employed in the fabrication of these stoves. They enjoy a high and deserved reputa-

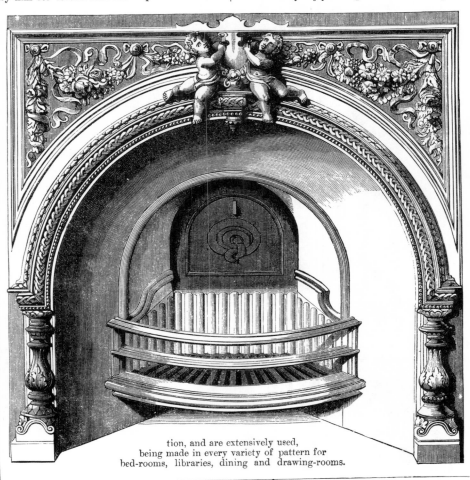

tion, and are extensively used, being made in every variety of pattern for bed-rooms, libraries, dining and drawing-rooms.

furnished by *Brya Ebenus*, a small tree. The duramen of the wood is a dark green, the alburnum, or outer wood, of a light yellow. The wood is hard, and susceptible of a very high polish. It is much used for rulers and other small work, also in marquetry. Another green ebony is said to be obtained from *Jacaranda mimosifolia*, in Brazil. The name, green ebony, is also applied to the wood of *Excæcaria glandulosa*, of Jamaica. Red ebony is an undefined wood of Natal. Several species of *Diospyros* are known to yield in great abundance the black ebony of commerce. Those of the East Indies are *D. Ebenus, cordifolia, Ebenaster, Mabola, melanoxylon, Roylei,* and *tomentosa.* The ebony from the west coast of Africa is usually the most perfect black, that from the Mauritius and Ceylon being variegated, more or less, with cream brown. *D. cordifolia* is a dark brown, and difficult to work. Ebony is much affected by the weather, and, to prevent splitting, it should be covered. Ebony of very superior quality is procurable in the western districts of the Madras presidency, as well as the Northern Circars. We have seen sixteen-inch planks of a fine uniform black, chiefly obtained from Coorg and Canara. Smaller pieces are procured from Cuddapa, Salem, Nuggur, &c.; but there is no steady demand, though it is a peculiarly fine timber for cabinet work, and some of it is well veined for ornament. Ebony may be obtained in Siam, but the quality is not very superior; a little is exported thence every year to China by the junks. The species of *Diospyros* have this peculiarity, that the black heart-wood is surrounded by white sap-wood. The task of determining the species which yield the best wood, and verifying

Mr. WERTHEIMER, of New Bond Street, of whose | numerous and excellent contributions to the Ex- | hibition we have already given examples, claims

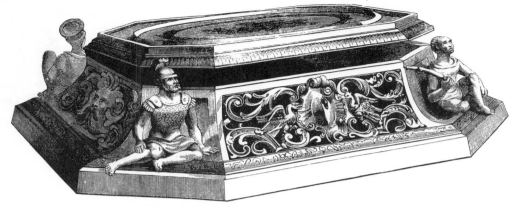

additional space for a very beautiful CABINET— | It is of varied woods, inlaid with exceeding skill, | having brilliant ormolu mountings. We give also

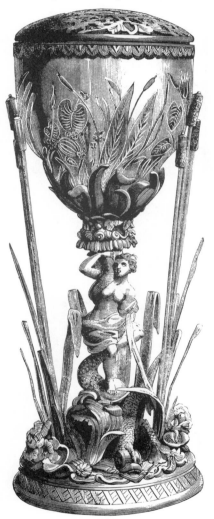

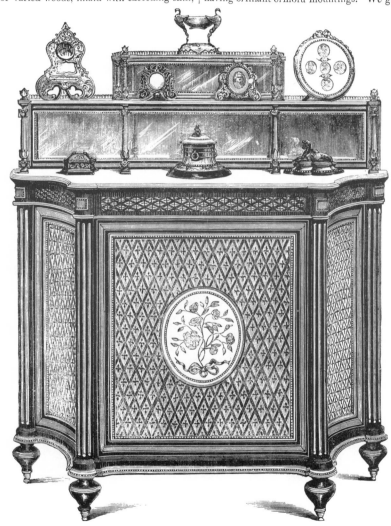

one of the most attractive objects of his collection. | a CASKET, in the style Louis XV., beautifully chased | and mounted, and a FLOWER STAND in ormolu.

the specific names, is important, and merits careful elucidation. Fustic is a hard, strong, yellow wood, obtained from *Maclura tinctoria*, a West Indian tree. It used to be employed in cabinet work, but was found to darken and change colour on exposure to the air and heat. It is chiefly used as a dye-wood. The imports in 1861 were 8,458 tons, valued at £50,444. The principal imports come from Venezuela, the West Indies, Mexico, and New Granada, and through the northern Atlantic ports. Iron-wood is a common name for many trees producing hard, ponderous, close-grained woods. In America it is applied to the *Ostrya virginica*, a tree which only grows to a small size; but the white wood is compact, finely grained, and heavy. There is an iron-wood in Brazil, but the tree yielding it is not defined. One of the iron-woods entering into commerce is the *Metrosideros verus*, an East Indian tree, whilst some species of *Sideroxylon* furnish other iron-woods. The iron-wood of Norfolk Island is the *Olea apetala*. Another close, hard wood, which sinks in water, is the *Argania sideroxylon* of Morocco. Jack-wood, or Cos, as it is locally called in Ceylon, is an excellent furniture and fancy wood, obtained from the *Artocarpus integrifolia*, a tree allied to the bread-fruit. It is a coarse and open-grained, though heavy wood, of a beautiful saffron colour, and emits a peculiar, but by no means unpleasant, odour. King-wood, one of the most beautiful of the hard woods imported, reaches us from Brazil, in trimmed billets, from 2 to 7 inches in diameter. It is probably from *Spartium arbor*, or some undefined species of *Triptolomœa*. It is also called violet-wood, being streaked in violet tints of different intensities,

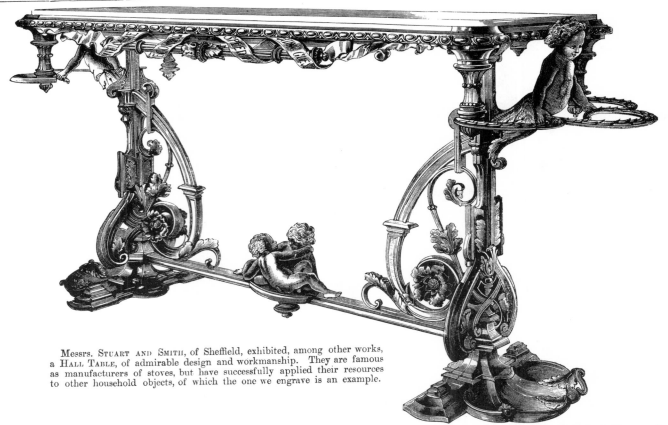

Messrs. STUART AND SMITH, of Sheffield, exhibited, among other works, a HALL TABLE, of admirable design and workmanship. They are famous as manufacturers of stoves, but have successfully applied their resources to other household objects, of which the one we engrave is an example.

This very elegant oblique GRAND PIANO is one of | the instruments exhibited by Messrs. CHALLEN. | DUFF, AND HODGSON, of Oxford Street. It is

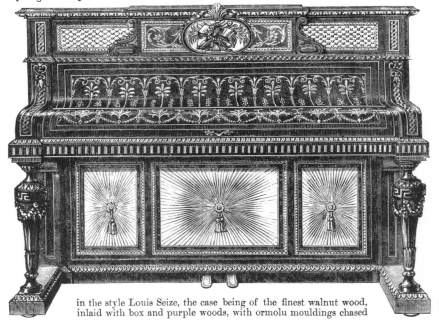

in the style Louis Seize, the case being of the finest walnut wood, inlaid with box and purple woods, with ormolu mouldings chased

and gilt. The ornamentation is simple, yet the work is highly wrought, and in admirable taste.

finer in the grain than rosewood. The smaller pieces are frequently striped, and occur sometimes full of elongated zoned eyes. Letter-wood, or snake-wood, is a scarce and costly wood of British Guiana, obtained from *Piratinera Guianensis*. It is very hard, of a beautiful brown colour, with black spots, which have been compared to hiero-glyphics. The spotted part is only the heart-wood, which is seldom more than 12 or 15 inches in circumference. Its application to cabinet-work and to small turnery articles was shown in the British Guiana collection. *Lignum vitæ* is a common, well-known, hard, ponderous wood, the produce of two species of *Guaiacum* obtained in the West Indies, which is used for a great variety of purposes requiring hardness and strength. The Madagascar red-wood is as yet undescribed. Nutmeg-wood is another name for the wood of the Palmyra palm (*Borassus flabelliformis*), which is used in turnery, for cabinet work, and, from its mottled character, for

umbrella and parasol handles, walking canes, rulers, fancy boxes, &c. The stems or trunks of several palms obtained in the East and West Indies are imported, to a small extent, for fancy use. They furnish a great variety of mottled, ornamental wood, black, red and brown, and speckled, and are used for cabinet and mar-quetry work, and for billiard cues. Among those so used are the cocoa nut, the betel nut, Palmyra, &c. The nuts of two South American palms, the vegetable ivory nut (*Phytelephas mac-rocarpa*), and the dark coquilla nuts from *Attalea funifera*, are largely used by turners for small fancy articles. Partridge-wood is a name for the wood of several trees coming from South America, which have usually, but erroneously, been ascribed to *Heisteria coc-cinea*, but are more likely to be from *Andira inermis*. It is used for walking-sticks, umbrella and parasol handles, and in cabinet work and turning. The colours are variously mingled, and most

We engrave a CABINET PIANOFORTE of Messrs. HOPKINSON, Regent Street. | Their fame has been established not only by the record of the "Jury," as "at | the head of the list," in the Exhibition, but by

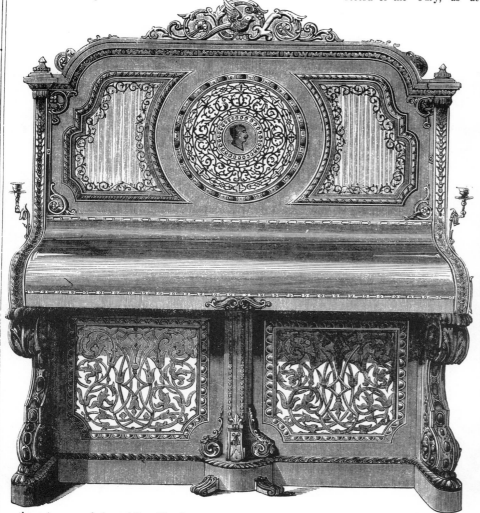
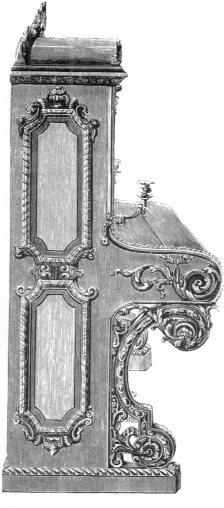

the patronage of the public. The decorations of | this piano are in pure taste, quiet, yet elaborate, | and the workmanship is of the very best order.

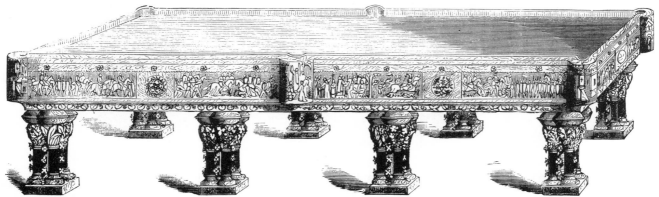

Messrs. THURSTON & Co., the famous BILLIARD TABLE makers, exhibited a work of great cost and | of considerable merit. It is of oak, with panels elaborately carved in low relief. They illustrate | the Wars of the Roses by no less than fifteen different subjects, from drawings by J. M. ALLEN.

frequently disposed in fine hair streaks of two or three shades, which in some of the curly specimens resemble the feathers of the bird. Another variety is called pheasant-wood. Prince's-wood is a light-veined brown wood, the produce of *Cordia Geras-canthus*, obtained in Jamaica, almost exclusively used for turning. Purple-wood is the produce of *Copaifera pubiflora* and *bracteata*, trees of British Guiana, which furnish trunks of great size, strength, durability, and elasticity. The colour varies much in different specimens, some being of a deep red brown, but the most beautiful is of a clear reddish purple, exceedingly handsome when polished. It is used for buhl work, marquetry, and in turning. Varieties of King-wood are sometimes called purple and violet woods, but they are variegated, while the true purple-wood is plain. Queen-wood is

a name applied occasionally to woods of the cocus and green-heart character, imported from the Brazils. The wood of *Laurus chloroxylon*, of the West Indies, furnishes some. Red Sanders wood is a hard, heavy, East Indian wood, obtained from the *Pterocarpus santalinus*, imported from Madras and Calcutta, chiefly as a dye wood. It takes a beautiful polish, and somewhat resembles Brazil-wood. Rosewood is a term as generally applied as iron-wood, and to as great a variety of trees, in different countries; sometimes from the colour, and sometimes from the smell of the wood. The rosewood imported in such large quantities from Brazil is obtained from the *Jacaranda Brasiliana*, and some other species. The *Physocalymma floribunda* of Goyaz, in Brazil, is said to furnish one of the rosewoods of commerce. It is the *Pao do rosa* of the Portuguese. The fragrant

We engrave a SIDEBOARD in light oak, manu-factured and exhibited by Messrs. CLEMENT GEORGE AND SON, of Berners Street. It is de-signed by their own artist, in the pure Italian style, the whole of the work and carving being executed by their ordinary workmen. There is much novelty in the form and treatment of the work, but more especially in its lower portion. It is minutely and elaborately carved, yet with a

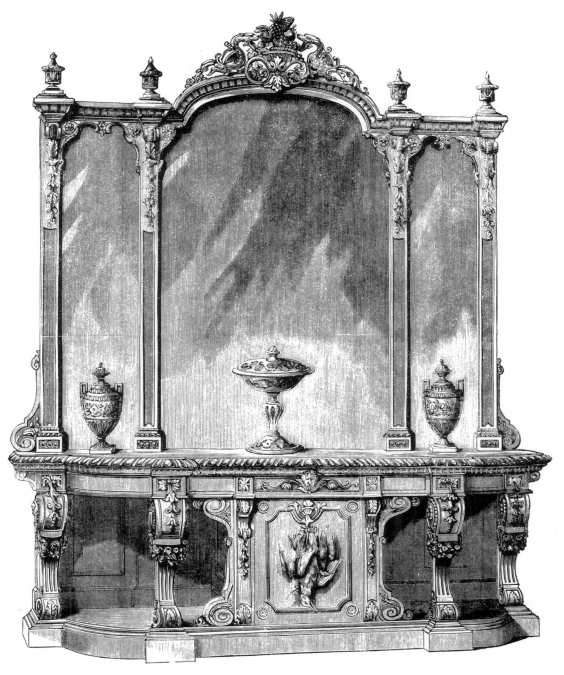

sufficiently bold hand. Messrs. George also ex-hibited two chairs in the same style, one for dining-hall, and the other for library. This firm exhibited a table and chessmen, in the Queensland Court, manufactured from the cy-press, pine, and Myall timber—the "Myall timber" having the perfume of violets. For this work the Commissioners of Queensland awarded them a complimentary medal.

rosewood, or *Bois de Palisandre* of the French cabinet-makers, has been ascertained to belong to two or three species of Brazilian *Trip-tolomeas*. The imports of rosewood in 1861 were 2,441 tons, of the computed value of £46,884. In 1820, when the duty was as high as £20 the ton, the imports of rosewood were only 271 tons. In 1826 the duty was reduced by one half, and in 1830 the imports had risen to 1,515 tons. The shipments of Brazilian rosewood are chiefly made from Bahia. In 1857, 16,870 logs were sent from there, and in 1858, 17,834 logs, of a total value of about £28,000. The great bulk of the shipments go to France and Germany. A rosewood is obtained from Central America and Honduras, from a species of *Amyris*. East Indian rosewood, a valuable mottled black timber, is obtained from *Dalbergia latifolia* and *sissoides*; these furnish the well-known Malabar black-wood, which is heavy and close-grained, admitting of a fine polish. The principal articles of carved furniture in the East Indian collection were made from this wood. A similar kind of rosewood is procured on the west coast of the Gulf of Siam, but the grain is not so close as the South American wood. A large quantity is exported yearly from Bangkok to Shanghai, and other Chinese ports. The East Indian Satin-wood is the produce of *Chloroxylon Swietenia*. It is close-grained, hard, and durable in its character; of a light orange colour; and, when polished, has a beautiful satiny appearance; unless protected by a coat of fine varnish, it loses its beauty by age. This tree occurs abundantly in the northern parts of Ceylon. That variety called, on account of the pattern, "flowered satin," is scarce. The tree also grows in the mountainous districts of the Madras presidency. The West Indian satin-wood is obtained from *Maba Guianensis*, in the Bahamas, and from an unnamed tree in Dominica. The wood of the European Yew, *Taxus baccata*, being hard, compact,

Messrs. HOLLAND & SONS, of Mount Street, were | works being of the very highest order, combining | worth in Art with excellence of workmanship.

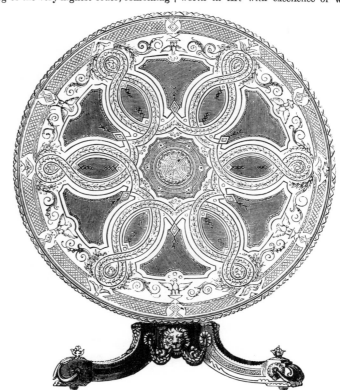

important contributors to the Exhibition, their | We engrave three of their productions—a SCREEN, | in satin-wood and gold, commissioned by the

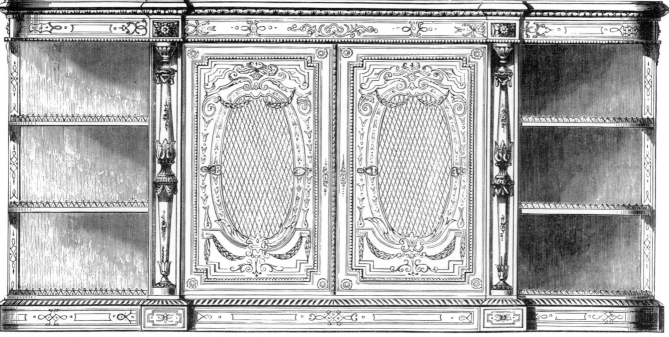

Queen, constructed on a new principle invented | beautiful in design, of inlaid silver wood; and | which is "Tuya" wood, the marquetrie being
by Mr. COLLINS, of Osborne; a TABLE, very | a rare CABINET, exquisitely inlaid, the ground of | of various coloured woods—natural colours.

and of a very fine, close grain, is occasionally used for fine cabinet work, or inlaying, and by turners for making snuff-boxes, musical instruments, &c.; parts near the root are often extremely beautiful. For the combination of colour with figure, it ranks at the head of the eyed or spotted woods. Brazil furnishes tulip-wood, and zebra-wood; the latter, which is scarce, is from the *Omphalobium Lamberti*, a large tree of Demerara. It resembles king-wood, except the colours, which are generally dispersed in irregular but angular veins and stripes. Zebra-wood is a beautiful wood for cross banding. Some very good specimens of colonial turning in goblets and ornaments, from the native ash, red gum, cherry tree, and black-wood of South Australia, were shown at the International Exhibition of 1862. One or two new woods have recently been introduced, but not to any large extent; of these we may mention the following Australian woods. The scented Myall (*Acacia homolophylla*) is a very hard and heavy wood, of an agreeable odour, resembling that of violets. It is especially adapted, from its pleasant odour, for glove and trinket boxes, and any interior applications where, not being varnished, it would retain its pleasant scent. It has a dark and beautiful duramen, which makes it applicable to numerous purposes of the cabinet-maker and the wood-turner. It rarely exceeds a foot in diameter, but has been used for veneers. Musk-wood (*Eurybia argophylla*) is a timber of a pleasant fragrance, and of a beautiful colour, well adapted for turning and cabinet work. The *Pomaderris apetala* furnishes us with a soft

Few objects in the Exhibition attracted more attention than the ROBINSON CRUSOE SIDEBOARD, manufactured and exhibited by Mr. T. H. TWEEDY, of Newcastle-on-Tyne. It is needless to describe it. The carved panels picture leading incidents in the ever-famous story: they are exceedingly well executed; and certainly the work merits the very general popularity it undoubtedly obtained.

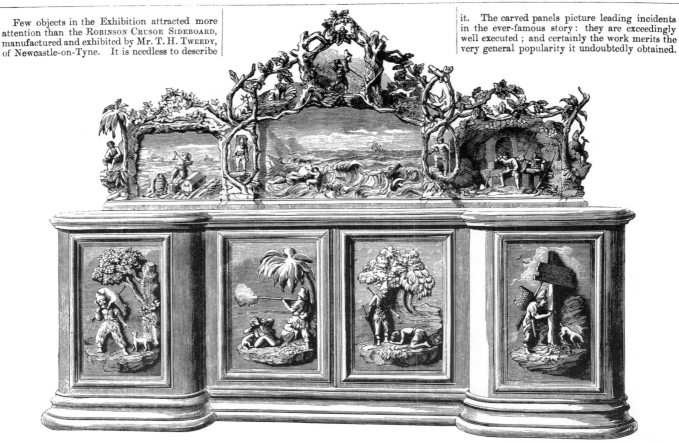

We have already engraved a Book-Case, in the "Pompeian style," contributed by Messrs. HOWARD AND SONS, Berners Street; we now engrave

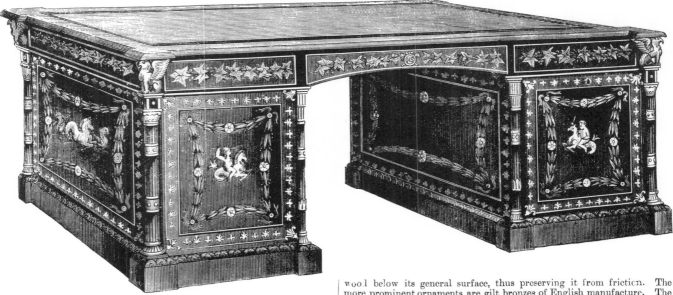

another of the set of LIBRARY FITTINGS. The decoration is carved in the wood below its general surface, thus preserving it from friction. The more prominent ornaments are gilt bronzes of English manufacture. The workmanship is of the highest class, the design being of exceeding elegance.

useful wood of a pale colour, well adapted for carver's and turner's work. One of the most complete, extensive, and tastefully designed applications of the hard or fancy woods of commerce was the model of the Royal Exchange, shown by Messrs. Robert Fauntleroy & Co., in which there were specimens of more than five hundred ornamental woods from different parts of the world.

We may close with a word or two on a few other woods occasionally used. The mountain ash (*Pyrus aucuparia*), the "rowen tree" of Scottish song, yields a beautiful light wood, quite equal to satin-wood in appearance, and, as well as holly, box, horse chestnut, and apple, very serviceable in inlaying. The root and burr of *Quercus pedunculata*, and *Q. sessiliflora*, also rival many foreign woods. The close texture of the maple-wood, with the beauty of its grain and its susceptibility of a high polish, doubtless contributed to its continued use for the manufacture of the pledge cup and wassail bowl. Hence its Scandinavian name of *mazer* came to be applied to the cup made from the wood of the tree; and when, at a later period, other woods, and even the costliest metals, were substituted, the old designation of the mazer cup was still retained. The late Mr. T. H. Turner, in a series of papers in the *Archæological Journal*, on "The Usages of Domestic Life in the Middle Ages," remarks:—"Our ancestors seem to have been greatly attached to their mazers, and to have incurred much cost in enriching them. Quaint legends in English or Latin, monitory of peace and good fellowship, were often embossed on their metal rim and on the cover."

P. L. SIMMONDS.

This engraving is from one of the

We engrave the top of an admirably carved LOOKING-GLASS, which surmounts a sideboard *en*

suite, the production of Messrs. R. STRAHAN & CO., Dublin, valuable contributors to the Exhibition.

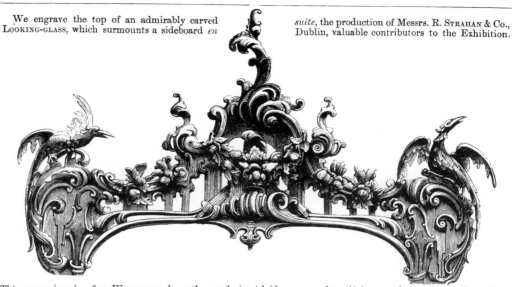

This engraving is of a WARDROBE, in satin-wood, in- | laid—a very beautiful example of Art-workmanship,

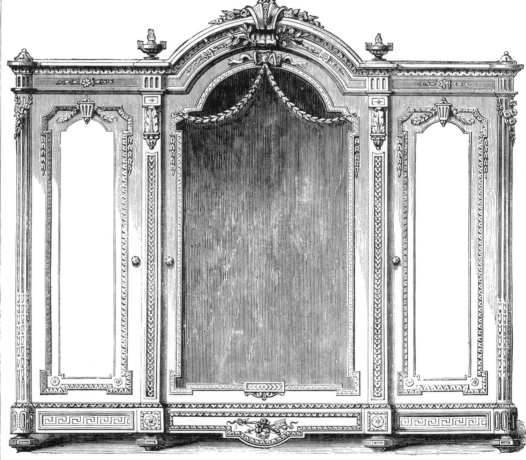

WALL PAPERS of TURNER AND OWST. | the contribution of Messrs. HEAL AND SON, whose "gar- | niture" for bedrooms is known "all the world over."

ON CONSTRUCTIVE MATERIALS IN THE EXHIBITION, CONSIDERED IN REFERENCE TO ART-PURPOSES.

BY PROFESSOR T. D. ANSTED, M.A., F.R.S., ETC.

INTRODUCTION.

AT all periods of history there would seem to have been, in every country in which civilisation has made any progress, a certain selection of constructive material adapted to the time, the place, and the special objects of Art; a certain development of constructive power corresponding to the available material; and a peculiar phase of Art, modified in its turn by circumstances of local convenience. Thus, before any historic data can be assigned, we find in Greece and the adjacent islands, where limestone rock everywhere abounds, and where the whole soil is made up of large loose blocks of such stone, wonderful and gigantic walls composed of stones closely fitted without cement. In the early days of Egypt, in the great cities of Asia Minor, and elsewhere in the East, bricks became available for a variety of purposes. Later, in Egypt and the East, and more recently among the northern tribes inhabiting Europe, there was a marked tendency to sculpture hard stones, such as jade, porphyry, and the toughest granites. In India, in Greece, and more recently in Italy, statuary marble has generally been preferred for this purpose. Limestones, and impure marbles, and plastic materials, have elsewhere been adopted; and there are few mineral substances that have not at one time or another been made use of as the channel of communi-

CHARLES INGLEDEW, Berners Street, exhibited three very beautiful DINING-ROOM CHAIRS, covered with richly decorated morocco leather. Of these we give engravings. They are partially carved, and are models of excellence in furniture of this class, the introduction of which, or, at all events, the great improvements in them, are to be attributed to this manufacturer. The object attained is the combination of strength with elegance.

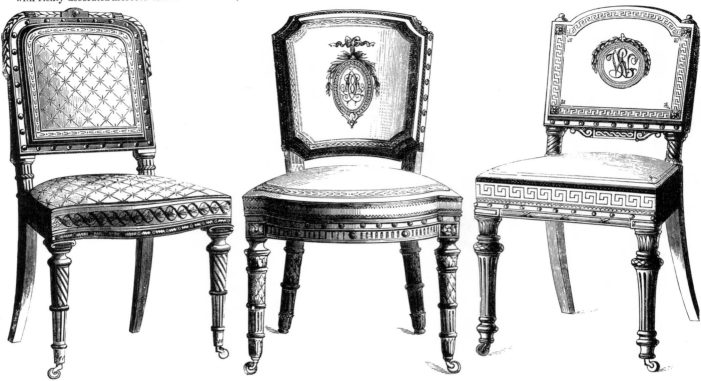

This SIDEBOARD—one of the productions of the | eminent firm of TROLLOPE AND SONS, of Parlia- | ment Street—is a work of high order; it is pure

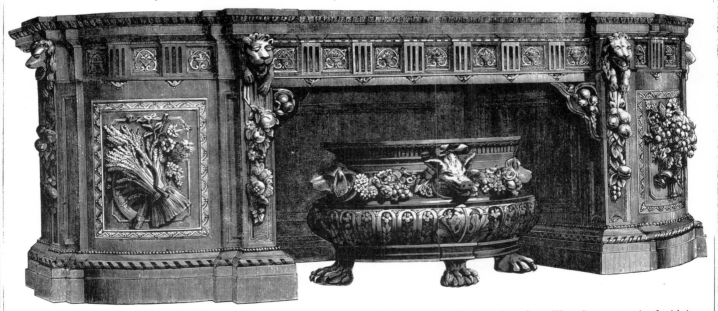

in character, admirably suited for the place and | purpose intended, and beautifully carved. We | introduce also a WINE COOLER associated with it.

cation between the artist and the outer world—as the medium by which to transmit taste, poetry, and cultivation, and teach the multitude by imitative and creative forms sculptured in some solid and permanent material.

The subject, then, of the present article is very large and inclusive, and within the limit of a few pages it can only be handled in a very general way. But it is a subject that possesses many points of interest, and some of these we may be able to present to the reader while considering its illustration in the recent International Exhibition. It will be convenient to consider Art-materials under the following general headings:—(1) Hard stones capable of taking a high polish; (2) Marbles, serpentines, and alabaster; (3) Stones of various kinds occasionally sculptured, but not usually susceptible of high polish; (4) Plastic materials; (5) Moulded artificial stones. Each includes a large number of materials.

1. *Hard stones taking a high polish.*—If one may judge by the positive evidence of specimens, these substances, as has already been intimated, were very early made use of for Art-purposes. Undried bricks, even if previously used, have not been preserved: and it is doubtful how far they could be employed. Adopted by races coming from the extreme East, the sculpture of hard stone was soon carried to wonderful perfection by them; but this manufacture lasted only for a time. At present the Scandinavian nations of Europe seem to rival the Asiatics in this respect. So extremely difficult, however, is the work, and so slow the operation of sculpture in stones of larger size than mere gems, that it can rarely be carried on except where labour is very cheap. Russia and Norway seem to yield in 1862, as they did in 1851, almost all that is new: while Japan and China, and even India, can send abundant specimens of work whose age is either known to be great, or is not known at all. Little progress can

This very beautiful CABINET of carved oak is | the production of MM. PECQUEREAU, *père et fils,* | of Paris. It is a work of refined skill, honour-

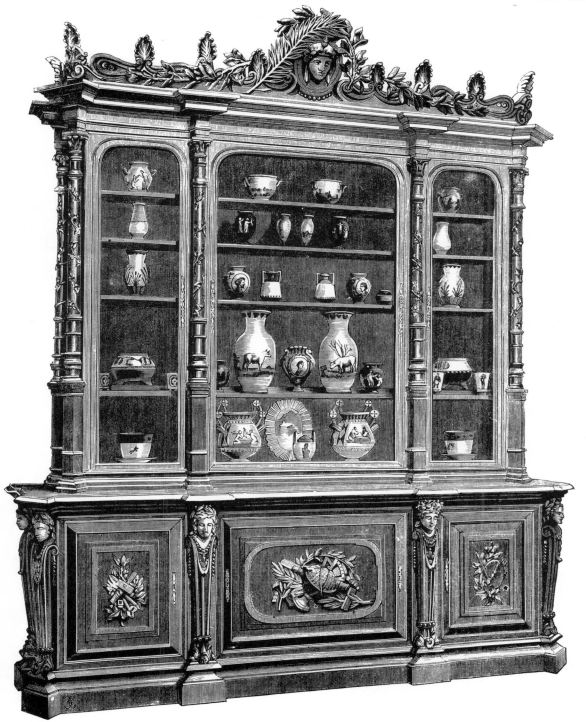

able alike to the artist by whom it was designed, | and the artisans by whom it was executed. It is | filled with Ceramic Art from the stall of Rousseau.

be recorded in processes; and as for mere material, there was nothing in the Exhibition just closed so remarkable as a block, or rather a large pebble of polished *nephrite,* or jade, from Siberia. This stone weighed 1290 lbs., and must have cost much labour even to bring it into the somewhat unsightly form in which it was exhibited. Around it were grouped several vases, some of considerable size, of the very hard porphyries of Russia and Norway—stones far harder than are met with in other countries of Europe. These were only remarkable for their high polish, there being no attempt at originality in the forms. On the whole, there were neither so many nor such remarkable objects of this kind exhibited as on the former occasion, nor does any novelty of style or material seem to have been attempted.

As an Art-question, there is much that is instructive in the study of these specimens. While the sculpture of gems has exercised the intellect of some of the most original and able artists of the ancient world and middle ages, there is little proof that any of these larger masses of hard stone have ever been taken in hand by other than mere imitators. Vases sculptured in alabaster or marble, or moulded in clay and cast in bronze, have been taken as models and imitated with great cleverness by the northern workmen; but this is all. In the East, all the larger jade ornaments are without much meaning, and in no case do they seem adapted specially to the material of which they are constructed. It is true, indeed, that in Egypt works of Art of a high order have been constructed of syenite of extreme hardness; but it is more than possible that the stone has hardened very considerably with the lapse of time; and generally the design, in the case of large sculptures in hard stone, is simple and easily understood, so that it could be left in the hands of mere mechanics to execute in detail. While, however, we wonder with reason at the vast extent of labour that has been devoted to the small result of

We engrave three of the papier-mâché TEA TRAYS of Birmingham—a

class of Art-manufacture in which the famous town has ever taken a

lead. These are the productions of KNIGHT, MERRY & Co.; good

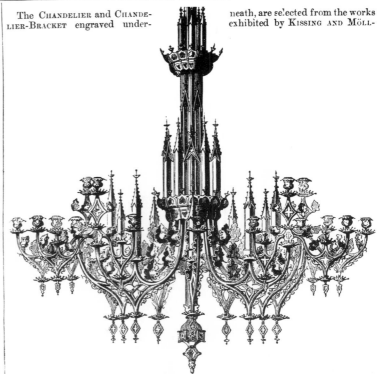

The CHANDELIER and CHANDE-LIER-BRACKET engraved under- neath, are selected from the works exhibited by KISSING AND MÖLL-

MAN, bronze and iron manufacturers, of Iserlohn, in Westphalia. The house holds a high position throughout Germany; its issues are excellent in design and exc-

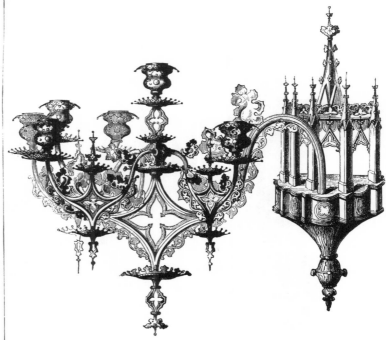

in design, and of great excellence in finish and in workmanship.

cution, of various styles, some of mas-sive form and character, others small and graceful, fitted for the drawing-room, the dining-room, or the boudoir.

producing a little vase of no especial beauty of form, we must not forget that in northern climates, it is a great triumph of Art over nature to be able to hand down shapes, and perpetuate ideas of any kind, in spite of all accidents, and almost in defiance of malice and mischief. In this respect porphyry deserves to be used for public monuments more extensively than we generally find it.

It will be seen from the tenor of the above remarks that we do not rank very highly the specimens of polished work in hard stones in the late Exhibition. There were, indeed, many specimens of por-phyry and rare minerals extremely difficult to sculpture, and these were interesting as specimens of mechanical labour, but they pos-sessed no Art-value, nor does it seem quite in accordance with the genius of the present day to devote to a purpose so little important

the enormous time and labour necessary to execute a sculpture in such material. Most of the granite works of any excellence were rather architectural than artistic.

2. *Marbles, serpentines, and alabaster.*—Of marbles there is every-thing to say with regard to execution, literally nothing with regard to material. There were certainly more promising specimens of the old material from new localities in 1851 than in 1862: but they led to nothing. The marble quarries of Carrara, still treated in their old way, are worked continually, and the picked stones are selected for all superior work. Neither the old quarries of Greece, nor the recent stones from the Iberian peninsula, though once more exhibited, nor yet the really fine marbles of India, have pleased or satisfied the artist so well as to induce an important demand for them. We can

Messrs. Jeakes & Co., of Great Russell Street, have long been renowned for the production of STOVE GRATES of all classes and orders. Their contributions to the Exhibition were numerous and good. That which attracted most attention is a mediæval DOG GRATE, of large size, calcu-

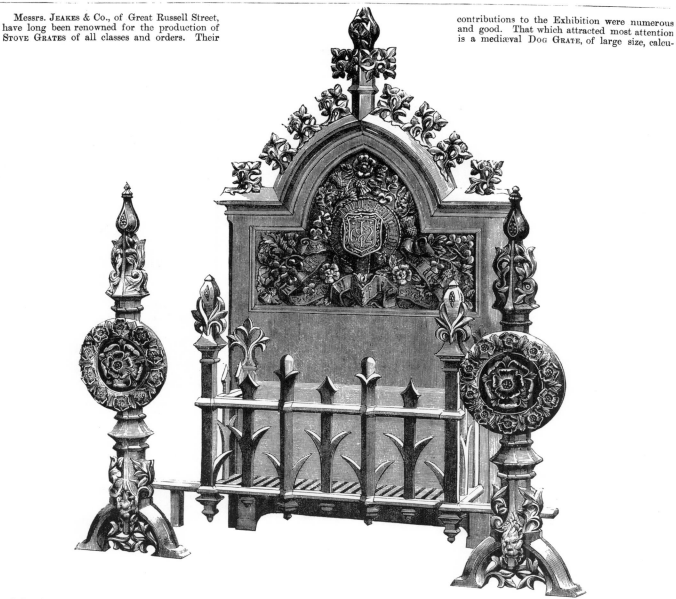

lated for the hall of a baronial mansion. This we engrave as an excellent example of their work. It is of great purity of design and manufacture.

The engraving above is from one of the carved PICTURE FRAMES, the work of LUIGI, of Florence, valuable contributors to the Italian Court.

only say that the singular form of crystallisation presented in statuary marble, known and used for several thousand years by all those whose own hands work out their own ideas from the shapeless block—that this substance, rare and costly even as a stone, is still wastefully tossed out of the earth, and rudely conveyed to the great Art-capitals of the world, there to receive the impression which, in some cases, is but a paltry repetition of an unworthy fancy, but which may, under proper hands, be chiseled into a work that shall carry down to future ages the essential qualities and poetry of our age, and of some of our contemporaries. This is not the place to enlarge on the Art-value of the sculptured treasures lately at South Kensington, but the reader will not fail, as he reads this, to remember those exquisite works—some in the nave, some in the Roman court, and not a few elsewhere—which prove that true Art has not departed from amongst us, and that Italy, once more relieved from the pressure of the tyrant's hand, may yet rise up like a giant, and again astonish and instruct the world. The way is also open to Greece, but she has been longer depressed, and the symptoms of recovery to her ancient Art-vitality are not so sure.

There is more variety in marbles than in any other kind of stone, and this variety extends to almost every quality and property, as, for example, colour, hardness, texture, cost, and durability. In spite of this great variety, the instances are very few in which any of the tinted marbles, or, indeed, any other than Parian and Carrara, have been used for purposes of high Art. The others are available for decoration and furniture, and abound in many countries. They are

This page contains an example of the FLOOR CLOTH, manufactured by Messrs. HARE, of Bristol, other specimens of whose work we have given in this Catalogue. It contrasts well with the imitation of the mosaic pavement—the famous Roman remains at Cirencester (page 42);

the one being evidence of the capabilities of the | Art, the other showing its application to "every- | day use." There is no attempt to do more

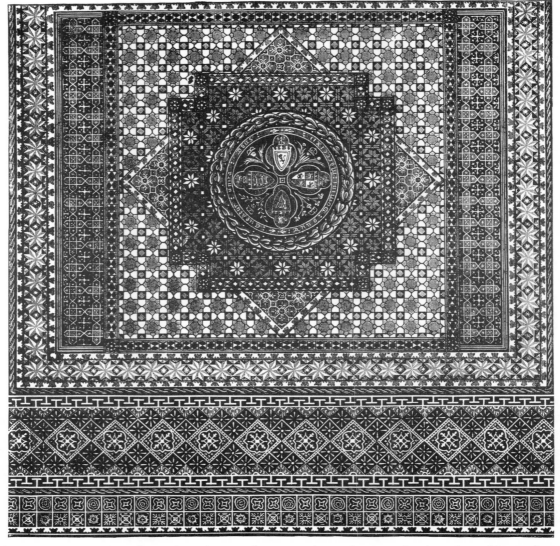

than supply fitting forms in harmonious colours. | It may be accepted as "a sample" of the works | that issue from this extensive establishment.

extensively worked and used, and varieties are from time to time successfully introduced. Italy is extremely rich in these; but Spain, Portugal, France, Belgium, various parts of Germany, Hungary, Greece, and England, among European nations, and many districts in other continents, have supplied material perfectly available. Many of our own colonies have sent interesting specimens, and there cannot be a doubt that abundant coloured marble will always be found. The taste in using such materials is the true test of Art-progress in a country. It is bad to attempt more with them than can from the nature of the case be accomplished. It is good even to put aside the higher aspirations when the material does not lend itself to the work. The true artist not only has genius to design, but taste to adapt. If he is limited in material, he will do only what his material properly admits of. He will prefer moulding a figure from common brick clay to chiseling a stone where tint, or veins, or surface would suggest ideas not in harmony with his subject. Genius, however, is shown not only in the group and the human figure. Essentially creative, it can devise a subject for every material; and thus it is no mark of talent of high order when we find beautiful designs apparently spoilt for want of a better medium. It is not necessary to refer to such cases by name, but they abound in every country at the present time, —they are among the weak points of modern cultivation of Art for the decoration of houses and other interiors. They were certainly present in abundance in various parts of the late Exhibition.

The variety of coloured marbles found in England is very great, and they are especially worked in Derbyshire, though of late years Devonshire has also entered into competition in this department with some success. Watched over and fostered with great care and judgment by the late Duke of Devonshire, the Derbyshire work had already attained in 1851 a high degree of mechanical perfection, and

The admirable establish-

plies us with other objects—in addition to those we have already engraved—which eminently merit publicity. Its contributions were not only extensive and varied, but of the highest Art

TABLE, a HALL STOVE,

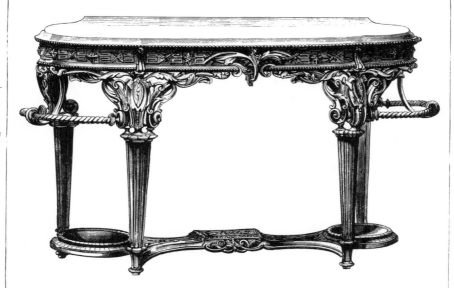

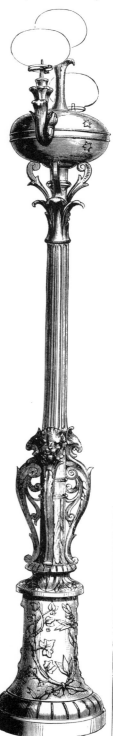

character—in the common as well as the more costly productions of the foundry—usually from designs by the best artists of England and France. Thus, while it furnishes millions of dwellings with stoves and other household necessaries of a cheap kind, it adorns also the mansions and the

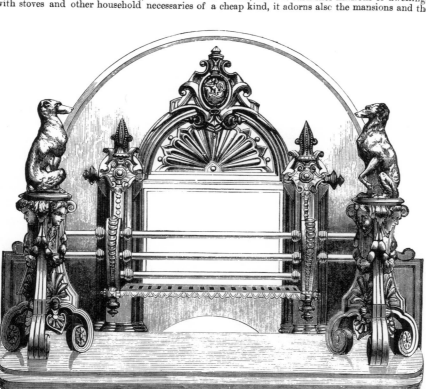

ment at Coalbrookdale sup-

palaces of the aristocracy. Issuing from these renowned works, iron assumes the value of bronze. Their works were creditable to the manufacturers and the country. We engrave on this page a HALL

and two LAMP PILLARS.

then exhibited a cultivated taste which was highly creditable to the country. It does not appear, indeed, that the sale of the more classical forms was such as to induce great competition among the makers, or reduce the price of these works, but the general result was satisfactory. We could not observe any great advance in the goods exhibited lately. There were new names and some new designs, but an absence of originality of design. This is to be regretted, and is not a satisfactory result of the establishment of Art-schools. But time is perhaps more required in the case of marble manufacture than of any other secondary Art-object, for the number of workers is more limited, the number of purchasers is smaller, and the home competition is less efficacious. Those who possess the means are sorely tempted to avail themselves of the purer taste and freer execu-

tion of Florence, and neglect the Derbyshire material, beautiful as it unquestionably is, and admirably adapted as it is for a large class of objects. It is not often that so kind and judicious a patron is to be found as the late Lord of Chatsworth at all times proved himself to be. The Devonshire style of work has not greatly changed since 1851, but the execution seems superior.

Serpentine is of two kinds. The Lizard variety is hard, exceedingly warm and rich in tone, and capable of receiving a very high polish. For works of any magnitude, however, it is ill adapted, as it abounds with white veins, and is scarcely ever without some serious flaw in a surface of a few square feet. More than any other kind of marble does this material require careful reference to its subject, as all its peculiarities are so strongly marked that it is **far more likely than**

The IRON BEDSTEADS of Messrs. PEYTON, of Birming- ham, have long been famous, not only in England, but engrave one of those that obtained for them "honours" at the Exhibition, and also an UMBRELLA

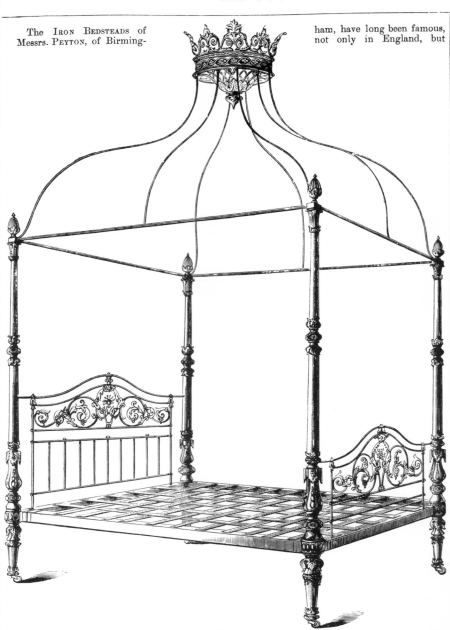

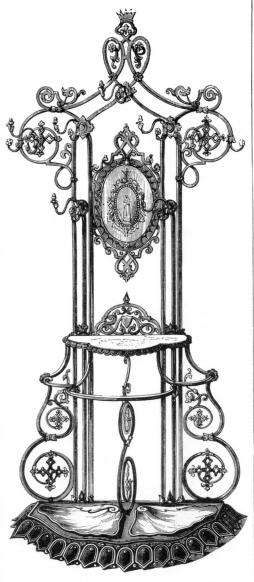

throughout the world. We have had frequent | occasion to describe their peculiar merits. We STAND, simple and elegant—a novelty in Art-industry.

We fill up this page by engraving one of the | borders of "WALL-PAPER" exhibited by Messrs. | TURNER & OWST, room-paper manufacturers, Pimlico.

any other to be incorrectly employed. Slabs and tables, monumental tablets, and chimney-pieces, involve forms successful enough generally, yet having little to do with Art in any important sense. But when more than this is attempted, it is very rarely indeed that articles of large size have answered expectation. There is no exception to this remark in the articles exhibited at Kensington. Many very beautiful small objects were shown—some of them ingeniously taking advantage of the material. Obelisks and pyramids, and other attempts on a larger scale, were unsightly, not only from the cracks and veins in the stone, but from its want of adaptation to the subject, owing to the extreme depth of the colour and the strong contrasts of different parts.

The Florentine serpentine is much softer, of different lustre and texture, and takes a kind and degree of polish quite distinct from that of the Lizard. It is rarely used for large work. Small ornaments made of it are beautiful, but the tint of green is heavy and gloomy, and admits only of a very limited use. The Italians wisely refrained from sending any Art-specimens of importance manufactured of this material.

Alabaster is extremely soft, both to the eye and the tool, and is so very readily sculptured, but at the same time so easily injured, as to be a somewhat exceptional material. Great artists, who desire fame in future ages, have rarely attempted any work of importance in this material; but for copies, and work only required for the moment at a low cost, as for the decoration of houses, and sometimes the interior of churches, it is very convenient. In colour it has many advantages, being sometimes of the most exquisite white, and not unfrequently tinted, veined, and even coloured very beautifully, in a

The CABINET that occupies this page is the principal contribution of Messrs. JAMES AND THOMAS SCOTT, cabinet makers, Edinburgh. It was deservedly one of the main objects of attraction in the Furniture Court of the Exhibition. In

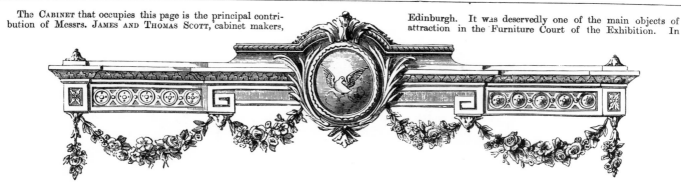

design, as well as in manufacture, it was placed high among the works of British makers, and would have received the honours to which it was eminently entitled, but for its late arrival. The work is entirely the production of Edinburgh

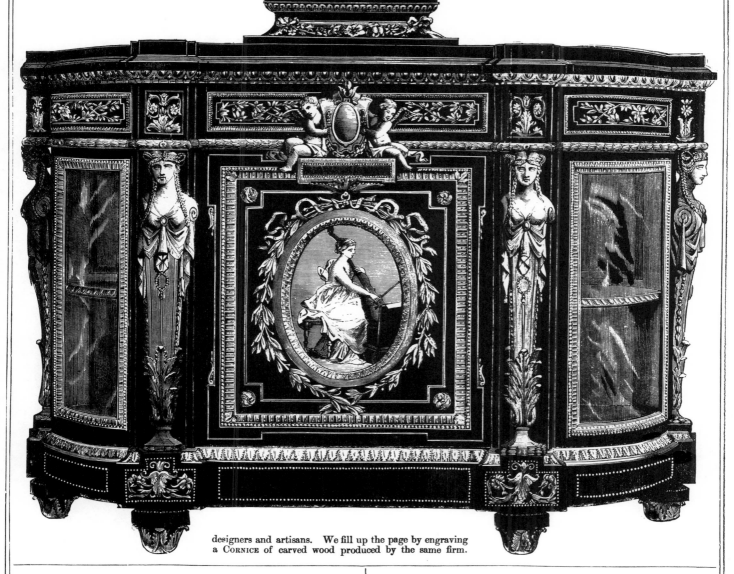

designers and artisans. We fill up the page by engraving a CORNICE of carved wood produced by the same firm.

manner by no means unfitting it for Art-purposes. Still, for high Art, it can hardly be recommended, and has rarely been used. A beautiful variety of marble, or rather a tinted stalactitic limestone—transparent and resembling alabaster—is obtained from Egypt, and was exhibited in various forms from Italy. It was also used by the ancient Romans.

3. *Stones not susceptible of a high polish.*—A very great amount of labour has been expended, and much genius has found a worthy field for exertion, on rough stones, soft and easily sculptured, but durable enough to be employed architecturally in various countries, either for internal or external decoration. If England cannot boast of her statuary marble, she is at least rich in limestones admirably adapted for such purposes, and excellent results have been at all times obtained. Many of the common building stones are of this kind, Portland being the best, but the hardest. Bath is the easiest to work, but, except with care, is very liable to injury. Carved clunch, obtained from the lower and harder part of the great chalk deposit, has not unfrequently remained uninjured for centuries in the interior of our churches. Even soft chalk has sometimes been used. Caen stone, a material from Normandy, of the same geological period, and in many respects similar to our Bath stone, is also well adapted for decorative work in architecture; and there are numerous other varieties of limestone in almost all the countries of Europe that serve the same purpose. It is perhaps difficult to draw the line very precisely, and state for what Art-purpose such material is best adapted. That better results are obtained in it than would be obtained in marble can be said only in a qualified sense, but there is doubtless a rough facility of execution, which, in the hands of an intelligent

We engrave a group selected from works in PORCELAIN manufactured and contributed by Mr. JOHN LOCKETT, of Longton. His productions range from those of a high class to the cheapest issues of the pottery, many being of great excellence in painting and in general character.

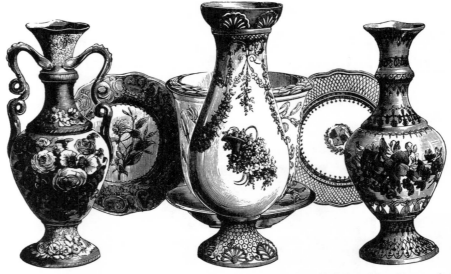

Messrs. JOHN MILLER & Co., of Edinburgh, contributed examples of engraved GLASS, which competed with the best of the many admirable works supplied by the Metropolis. The glass— also of Scottish manufacture—is of a remarkably clear and pure order. Especial study has been

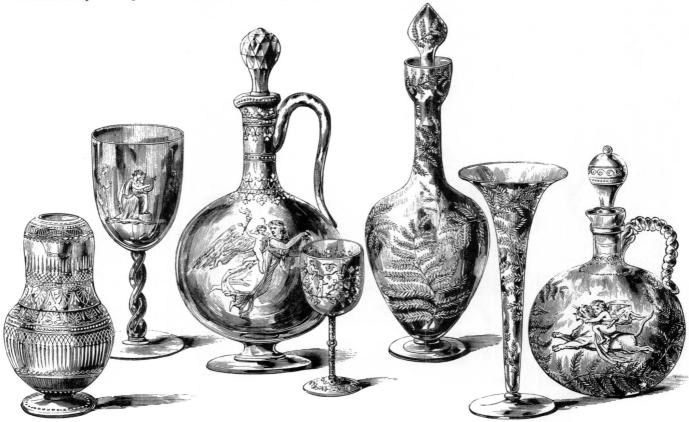

paid to render the ornamentation in harmony with the forms; several of the engravings are triumphs over difficulties, exquisitely cut, and very successful copies from well-known statues and bas-reliefs. Messrs. Miller upheld the renown of Edinburgh in productions of Art-industry.

person, admits of peculiar and sometimes startling effects. Many a mason and common workman has thus learnt his power, and has been led to higher styles of Art,—many a one has lived and died in his vocation as a stone-cutter able to make such material speak very effectually, but not able to go beyond this, and take a master's position in marble. There were many specimens of this kind of work in the Exhibition, both from our own country and abroad. Some are strikingly good, and in good taste—more, perhaps, in proportion, than of specimens of sculpture in marble. The selection of material is naturally governed much by the neighbourhood and the common stone employed. Caen stone, being a general favourite for colour, texture, and hardness, is perhaps that which is most frequently conveyed to a distance. The French seem to excel in this depart-ment of Art, and their cleverness of design was shown in the numerous chimney-pieces and other specimens of decorative work sent for exhibition.

Sandstone has occasionally been used for purposes of sculpture. The group of 'Tam o' Shanter,' admirably carved in one of the coal grits of Scotland, was an instance. In the nature of things, such specimens must be rare—nor are they to be desired. It is no proof of falling off in Art to say there were fewer instances of irregular and exceptional use of material in the Exhibition of 1862 than in that of 1851.

Unpolished granite, except when employed for tombstones, is now not often sculptured into any form that is not architectural. The other hard materials are still more rarely used. Indeed, the cost of the work is altogether too great to justify such use.

THE INTERNATIONAL EXHIBITION.

The Door-Stopper—of bronze and also of iron—here

engraved was exhibited by Mr. Thomas, ironmonger, Sloane Street, manufactured for him from his design.

Engraved from a Fire-Dog by Messrs. Jeakes & Co.

This engraving is from one of the Glass Chandeliers manufactured by Messrs. Defries and Son, of Houndsditch, to whom, we believe, every part of the world is indebted

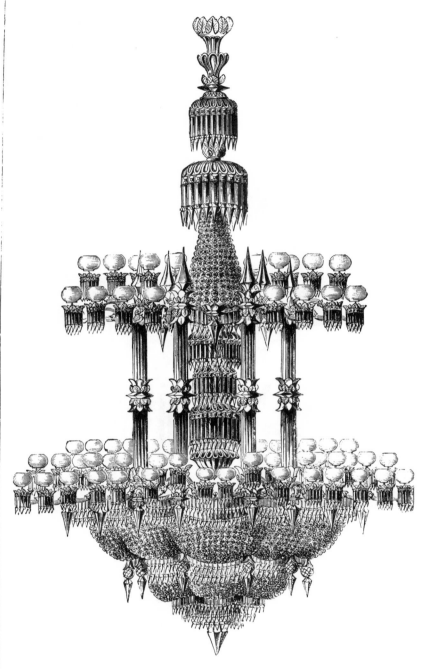

for "lights" of this description, their importation trade conveying the pure crystal glass of England literally to all the nations of the earth. At home, however, they have also done

much to "enlighten;" nearly all our theatres and a very large number of our public buildings exhibit their works; and the peculiarly brilliant effects we see in leading shops—making the night brighter than the day in their vicinage—are the inventions of this firm.

4. *Plastic materials (not cements).*—Under this head we propose to consider all that important group of clays which, with more or less mechanical preparation and selection, form the basis of such artificial stones as require to be burnt in a kiln, or baked in an oven after manufacture. Baked clay (terra-cotta) has so long been a material used for Art-purposes, and so many admirable works have been designed in it, that it is, and always must be, regarded as especially interesting among constructive materials.

Clays are all fundamentally identical, consisting of silicates of alumina, more or less altered, and mixed up with more or less of foreign ingredients, chiefly silica, iron, and lime. Of these foreign ingredients some, as the alkaline earths and alkalies, chiefly act as

fluxes; some, as oxides of metals, act as colouring matter; some, as the manganese oxides, are both fluxes and pigments. When prepared by the help of water, mixed with a powder made of similar pottery that has already passed through the fire, and worked into a fine paste with sand and burnt flints, the kind called pipe-clay acquires fresh and useful properties. When derived directly from the decomposition of granite, the clay is called *kaolin*, and is chiefly used for the finer kinds of porcelain. When it has not undergone crystallisation, and exists in a very pure state, forming regular beds, it is in the most favourable state for modelling. The varieties of clay have therefore distinct uses.

One of the great difficulties in dealing with clay for Art-purposes

We have devoted space to some of the admirable jewellery of M. WIESE, of Paris: they were

leading attractions in the French Court. We engrave on this column an exquisitely embellished

SCENT-BOTTLE, and a BROOCH. The latter is a fine specimen of engraved aqua marina, carefully set.

Messrs. COLLINS AND GREEN, of Blackfriars Road, are extensive manufacturers of CHIMNEY-PIECES,

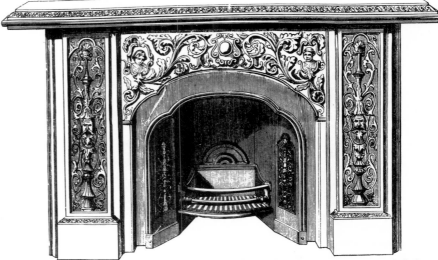

not only plain, for ordinary uses, but of an elaborate and artistic character, many of their pro-

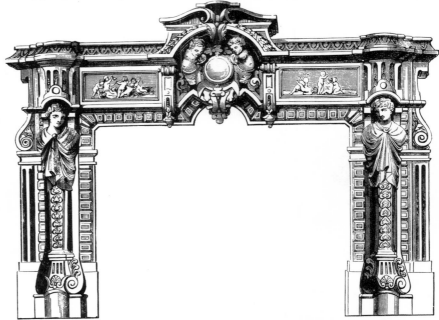

ductions being of the very highest class. They are in all conceivable varieties, and for all kinds

of rooms, from the cheapest to the costliest, and are always examples of admirable workmanship.

arises from the great and irregular contraction this material undergoes in the kiln, when exposed to great heat for the purpose of burning. Nothing but long experience can secure a result of any value, and even then a constant watch is necessary to check the firing, and prevent injury to portions of the work. In spite of these difficulties, terra-cotta has yielded some most exquisite and valuable results, and these are not confined either to age or country. Italy, at all times, has supplied works of the highest merit, and the Italy of old Rome, the Italy of the middle ages, and the Italy now rising like a phœnix from its ashes, have each in turn employed the creative power of her sons in this manufacture. France also has been very successful in the same department; and neither England nor Germany have fallen short. The Exhibition recently closed, as well as that of 1851, have well illustrated the use of this material;

and beyond other exhibitors, Messrs. Blanchard's works have been there admired and rewarded.

The perfectly plastic nature of clay fits it admirably for at once accepting and retaining the impress of the artist's highest powers, and little manipulation is required to obtain a good result. For modelling, indeed, nothing can compare with clay, but it is rather different when the operation of burning is to follow. Then, of course, allowances must be made for shrinking, warping, and unequal drying; so that of many beautiful models but few successful results can be expected. It is clear, from the measure of success generally attained, that working in this material affords excellent opportunity for the display of talent of various kinds; and it is applicable to architectural decoration, as well as to special works of Art. The cost also being moderate compared with sculptured

THE INTERNATIONAL EXHIBITION.

We engrave a group of the BENT WOOD FURNITURE, the manufacture of Messrs. THONET, of Vienna, who have also an establishment in London. It has obtained large popularity in England as well as on the Continent, combining in a remarkable

degree lightness with strength, and being produced at singularly small cost. By a peculiar process in manufacture, the wood is bent to any shape. The designs are generally graceful and good, the great purpose of "use" being always kept in view.

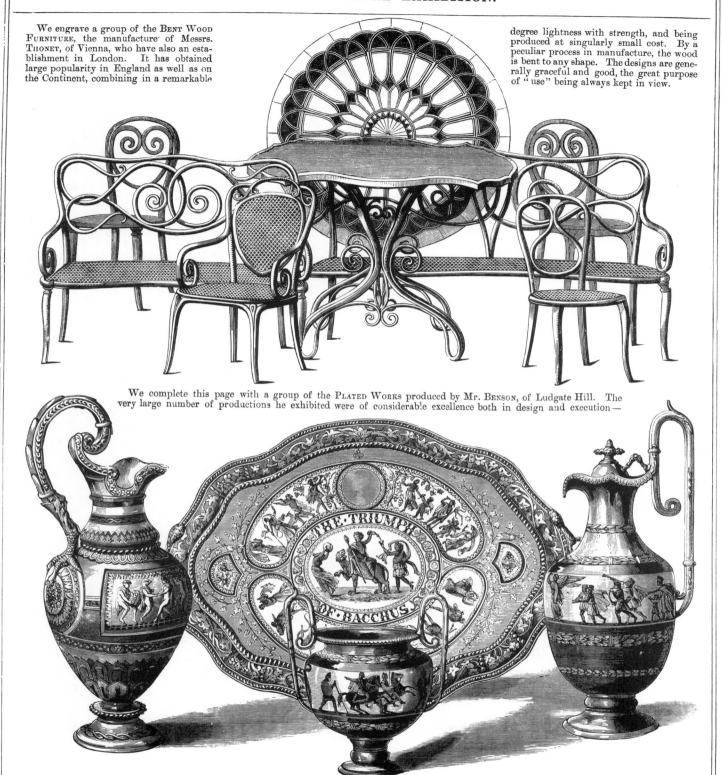

We complete this page with a group of the PLATED WORKS produced by Mr. BENSON, of Ludgate Hill. The very large number of productions he exhibited were of considerable excellence both in design and execution—

those more especially the forms of which are | taken from the antique; they are admirably en- | graved "in keeping," and adapted to modern uses.

work, it has been largely used. Owing to the fact that it resembles brick in its composition and texture, and owing also to its great inherent strength, it can safely be used for large works. In this case it is made in parts, and accurately joined with cement. In other cases it can be used structurally, being combined with moulded bricks, and bonding with them perfectly. There is, perhaps, hardly a due appreciation of terra-cotta among the public generally. The Rood Screen, at St. George's Chapel, Windsor, the figures in the pediment at Greenwich Hospital, the caryatides at St. Pancras Church, in London, the large statue of Britannia on the Nelson monument, at Yarmouth, and many other important works of various dates in our own country, are good examples of its power of resisting atmospheric exposure, in which it certainly exceeds

most varieties of stone. That it is also capable of taking and rendering the feeling of the artist is equally certain, for many of the smaller works recently executed in England, France, and Italy, are of a very high order of merit.

The terra-cottas of ancient Rome are well represented in the Townley Collection, in the British Museum. They are studies worthy of the most careful examination; and many of them, being little touched by time and uninjured by exposure, will bear comparison with works in marble of similar date. The material used in Italy was, however, comparatively coarse, and often consisted of little more than brick earth. The selection of the finer qualities of clay, and the mixture of these with old burnt pottery and burnt flints reduced to fine powder, produces a far more manageable clay

Mr. J. L. COULTON, decorator, of Robert Street, Hampstead Road, exhibited in the Furniture Court a charming specimen of ARABESQUE WALL DECORATION. It is designed and painted in oil-colours by Mr. COULTON; it is in the style Louis Seize, and is intended for a drawing-room. The

pilasters illustrate on the one side Painting and Music, on the other Sculpture and Science. The centre panel represents Mercury kneeling and presenting the caduceus to Peace, who is crowning him with laurel. The English producers of works in this class have greatly progressed.

than is found native. The advantage of this mixture is felt both in the moulding-room and the kiln; and colour can also be obtained adapted to the circumstances under which the work is to be exposed: the ordinary tints vary from a rich cream to a warm red. The works in terra-cotta exhibited in 1851 were many of them very good, and their merit was duly acknowledged. A decided improvement both in style and execution was manifest in the Exhibition lately closed, and it is evident that the manufacture has made good progress. There is still room for improvement in design, especially for works belonging more especially to the Fine Arts, as distinguished from architecture. In reference to the latter, the work recently executed for the Horticultural Society in the grounds adjacent to the Exhibition building, may be mentioned as very creditable. As far as material affects the result, in terra-cotta works, it may be said that, although unquestionably some natural qualities of clay are much better than others, there are few countries and few localities that are unsupplied. On the whole, the finer and purer, and the more free from grit and stone, and from iron and lime, the better is the clay. Rocks of all geological periods yield available varieties. Besides the use of clay in terra-cotta, the adaptation of porcelain clay to Art-purposes must not be omitted. The shrinkage, however, which interferes so greatly with the obtaining of a perfect form in the former less heated substance, becomes almost unmanageable when the alteration of material is so great as to convert clay into porcelain. The results obtained are thus the more creditable, and they afford remarkable illustrations of extraordinary ingenuity in

Messrs. KEITH & Co. are extensive and highly meritorious manufacturers of CHURCH PLATE, and other objects in metals. They work from designs supplied by artists who are thoroughly conversant with the style required; and they are especially aided by

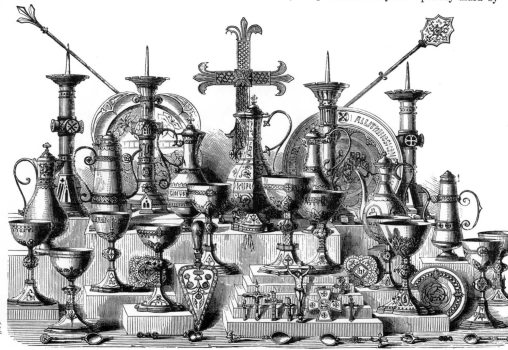

the Ecclesiological Society. Their productions issues will be obtained by an examination of this page; but we can give no notion of the brilliancy

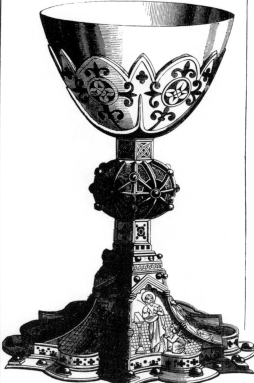

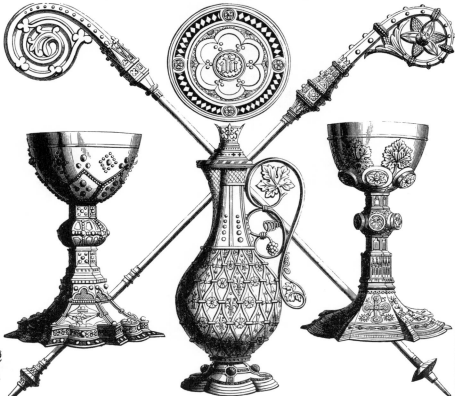

are very varied. A fair idea of their numerous of the materials, and but little of the sharpness, delicacy, and truth of the workmanship generally.

overcoming mechanical difficulties. The objects lately exhibited in English porcelain were so admirable that it seems almost hypercritical to enter into the discussion of their defects. Those peculiar modifications known as *majolica* were, above all, valuable, and amongst them the fountain designed by the late Mr. Thomas attracted so much deserved attention that we need only allude to it here.

5. *Cements.*—By cements we here mean all those compositions, not being clay, used for Art-purposes, and adapted to render either the original form given by the artist in moulding, or the casts obtained from models thus made. Using the term thus widely, it is seen to include the common kinds of artificial stone manufactured of "Portland,"

"Roman," or "Atkinson's" cement, or other similar compositions; the less common, but ingenious "siliceous stone," patented some years ago by Mr. Ransome, and largely manufactured; and the more recently introduced "concrete stone," introduced by the same manufacturer. Cements, as formerly used and understood, are exceedingly valuable for building and engineering purposes, and for some works in architecture; but though much employed in cheap ornamentation, they are ill adapted for that purpose, as not possessing the strength and resistance to weather which enables them to be employed structurally for support. They therefore generally tend to weaken rather than strengthen a building, and they add to instead

The beautiful series of works which these several engravings illustrate, are amongst the highest as well as the most successful efforts of modern Art reproductions. Essentially based upon the designs, and elaborated by the costly manipulation of the enamels, of Limoges, they are executed upon a ceramic, instead of a metallic, base. They are strictly but

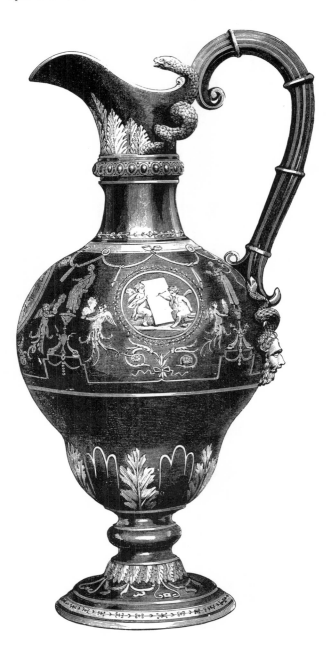

works are produced by Messrs. BATTAM AND SON, exclusively for Mr. ALDERMAN

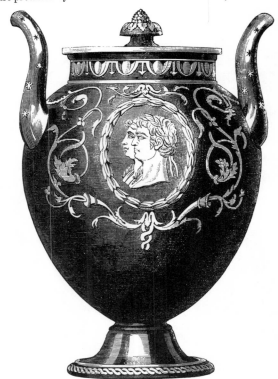

COPELAND, at whose establishment in New Bond Street they may be obtained.

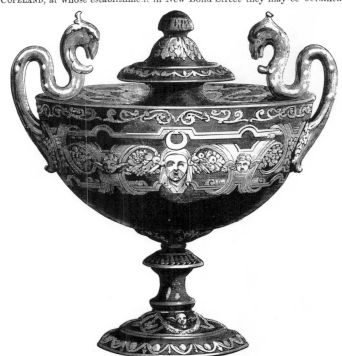

adaptations of that style made famous about the sixteenth century by Pericaud, Pierre Remond, Leonard Limousin, Jean Courtois, &c. The principal medium of operation is white enamel (oxide of tin), a semi-transparent body, and the shadows of the paintings are produced by the reflex of the dark ground, which is more or less powerful, according to the thickness with which the enamel is applied. These

Not only in the peculiar character of the designs, but also in the *nuances*

of supporting weight. Thus, for caryatides, capitals, mouldings, balusters, trusses, columns, and many other constructive purposes, they are inapplicable. On the other hand, for cheap vases, and for certain ornamental work in gardens, they are not in themselves inapplicable; but generally the taste introduced in their manufacture has not been such as to do any credit to the material, and they endure exposure to English weather so badly as not to justify any great expenditure of talent in designing for them.

Unlike the cements, the siliceous stone is as nearly indestructible as any stone can be. It consists of silica sand cemented only by a kind of glass; and were it not that, owing to the deposit of salts in the act of manufacture, there is a tendency to unsightly exudation,

and to a dampness of surface that attracts mossy vegetation, there would be hardly any drawback to its general use, except, perhaps, on the score of expense. Even these disqualifications have been very greatly removed by care in manufacture, and many Art-works executed in the material are not only creditable to all concerned, but even remarkable in the admirable surface and sharpness of edge. This material has the advantage of being moulded while plastic, and does not contract in the kiln where it is burnt. It thus retains a better face even than terra-cotta, while preserving form more perfectly.

The very curious and interesting "concrete stone" is, however, more promising, and for higher Art-purposes, as well as for ordinary decorative stone-work, it seems likely to take the place of all other

of the enamelling, and the general treatment of the subjects, they are decidedly the

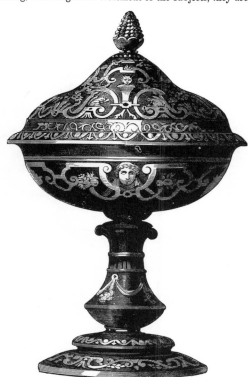

finest works of their class that have as yet been produced in Great Britain, and

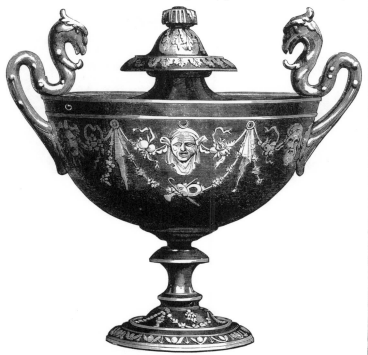

the admiration they excited at the International Exhibition was justly merited.

This engraving is of a superb PORCELAIN VASE presented to W. H. Kerr, Esq., of Worcester, by artists and workmen in his

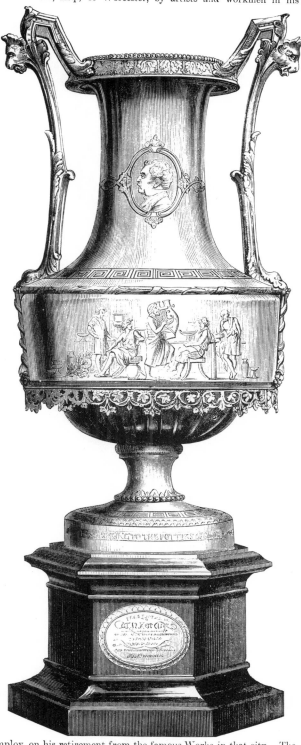

employ, on his retirement from the famous Works in that city. The painting is by Mr. T. BOTT, and the mounting by Messrs. MANNING.

artificial stone. Unlike terra-cotta, it requires for its production no careful preparation of raw material and subsequent burning, and consequently no established works on a large and costly scale. Only a temporary shed is needed, wherein can be worked up any fragments of stone, sand, or clay that may be at hand, with the liquid silicate of soda, brought from the manufactory. Once made into a consistent mass of any required form, one dip into, or a wash with, another solution (chloride of calcium), converts the whole almost instantaneously into a perfectly hard, permanent, and durable solid, only needing to be washed with fresh water and air-dried to be fit for placing in any position, either in a building, a garden, or elsewhere. The result is almost magical; and the specimens already

produced by Mr. Ransome, some of which were exhibited at the last meeting of the British Association, at Cambridge, may be regarded as sufficiently promising to justify great hopes of its ultimate success, as the best artificial stone that has yet been invented. This new material is so completely manageable in regard to form and colour, that it leaves nothing to be desired. There is absolutely no contraction in drying, and no change seems to take place after it is once hardened. Its strength exceeds that of most stones, and it can be used to support weight with perfect safety. It has been made already in blocks of more than two tons weight, and seems capable of extension, if necessary, even beyond this point.

As a means of obtaining repetitions and copies of great and costly

The collection of jewels and plate exhibited by Mr. HANCOCK,

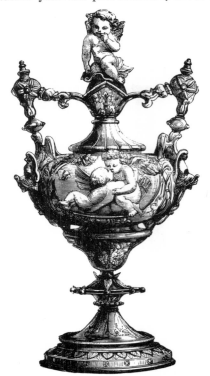

of Bruton Street, was undoubtedly among the most beautiful

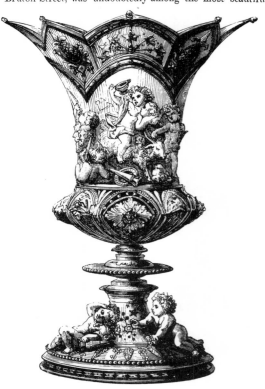

and valuable of the many rare contributions of works in the

precious metals. It included every class and order of the art, and established the

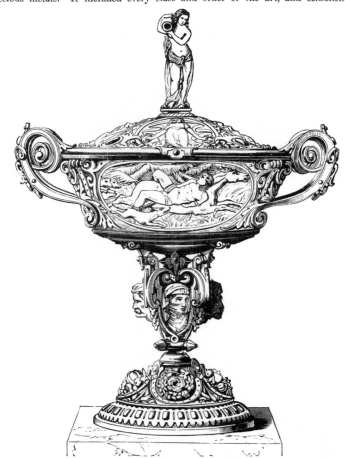

widely-spread renown of the manufacturer. The specimens engraved are—1. "A Vase,

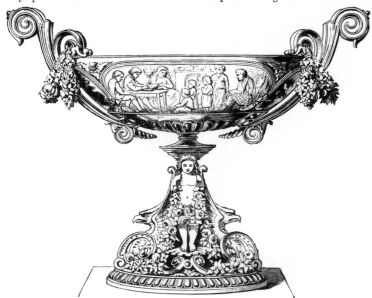

in the Cellini style;" 2. "The Craven Vase;" 3. "The Cup of Byron;" 4. "The Tazza of Burns." The two last named are designed and modelled by the sculptor, RAFAEL MONTI.

works of Art in a durable material, of pleasant colour and extreme hardness, nothing has been presented of late years which can compare with this. No doubt, like all inventions, it will have to pass through a series of ordeals, and must be tested thoroughly by experience before it is finally adopted; but that it is in the highest degree suggestive of progress there can be no doubt. In this respect the invention well deserved the medal that was awarded by the Jurors in the recent Exhibition, although the object exhibited (a slab serving as the bed of a steam-engine) involved no application beyond the barest and simplest exhibition of size and strength.

CONCLUSION.

Such are among the constructive materials used in the Fine Arts, as illustrated in the Great International Exhibition: materials of great variety—some of them of extreme beauty, some of them the roughest and coarsest substances in nature; materials available for all purposes—some only sculptured for minute and delicate luxuries; some, in their abundance, strength, and durability, adapted to hand down to the remotest time a record of the state of Art in each generation. Few materials were unrepresented, though many of those

The house of Messrs. DENIERE FILS, of Paris, has been famous for nearly half a century: it maintains the high position it has occupied so long. We select three of their works in gilt bronze—a CLOCK and two CAN- DELABRA — conspicuous for beauty of design and brilliancy of metal.

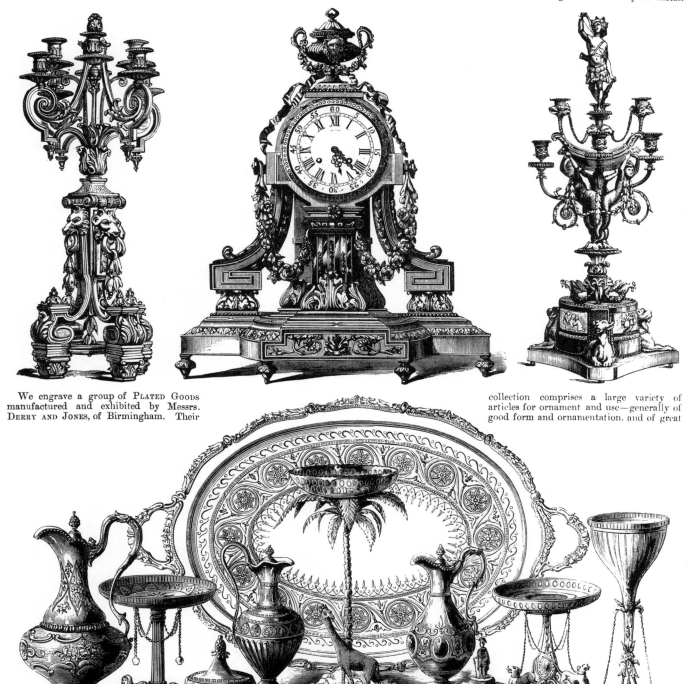

We engrave a group of PLATED GOODS manufactured and exhibited by Messrs. DERRY AND JONES, of Birmingham. Their collection comprises a large variety of articles for ornament and use—generally of good form and ornamentation. and of great excellence in manufacture. Their study is less to produce "works of price," than to give a high Art-character to all the issues of their House.

exhibited were employed with little regard to their essential qualities. One result is satisfactory—namely, the greatly-increased ornamentation of common material. This is seen especially in works in terra-cotta, and in some of the polished coloured marbles; but in these, although designs are more varied, and show a tendency to improve, it is to be feared that the buyer needs more cultivation than the manufacturer. In fact, till the middle and higher classes of England—those who ornament their houses and gardens with stone-work, real or imitative—educate themselves into a higher and purer feeling for Art than they have at present, and learn to know what Art means, and what it is capable of indicating, the amount of genius and talent of whatever kind that exists among the masses will have little chance of developing itself properly and profitably. It is much more likely to remain cramped and wrongly directed, for the mason and the designer of works of this kind must endeavour to please, and not to teach. When there is an intuitive taste in the educated and rich of our country, inducing them to prefer pure and simple beauty of form to false and whimsical shapes, over-laden with ornament—then, and not till then, will the style of manufactures improve, and constructive material become adapted to the purposes for which it is used.

T. D. ANSTED.

British contributors of GLASS PAINTINGS were nu-

advance. We have accorded justice to some of the more eminent of those artists whose works upheld the renown of England and Scotland in the International Exhibition. We

are entitled to be repre-

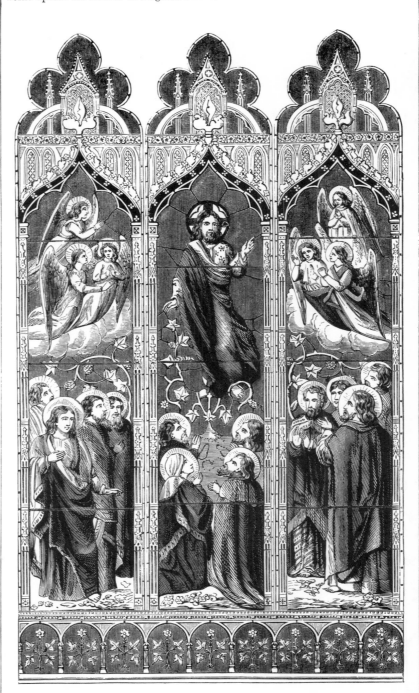

merous; many of them displayed great excellence, and all manifested large

devote this page to the productions of Messrs. CLAUDET AND HOUGHTON, of London, who are extensive producers for churches and mansions, and public buildings generally, and who

sented in this Catalogue.

ART IN ITS INFLUENCE ON ART-MANUFACTURE.

BY J. BEAVINGTON ATKINSON.

MANUFACTURES, whether the products of hand or of mechanism, arise from utility: the Fine Arts, on the contrary, less directly utilitarian, are the offspring of beauty. Architecture in its two-fold aspect, of structure and decoration, will best serve to illustrate the inherent relation between Art and Manufacture of which we here propose to speak. Among man's earliest wants was the need of a habitation, and hence huts and buildings, at first rude and unadorned, were made simply strong enough to withstand the winds, and tight enough to keep out the waters. Yet soon the savage, as he rested from war and the chase, would desire that his dwelling should grow

into a delight, and in vacant hours, given to fancy, would he carve the lintel, decorate the trunks of trees which stood for columns, and hang the walls with the rich furs of beasts or the more gorgeous plumage of birds. Thus did the bodily structure of an architecture, at first merely useful, assume the allurements of beauty; thus did the rude work of the hands crave through the imagination an adorning; and thus have we perhaps the earliest type of manu-facture, that is, man's handiwork, budding into Art.

Furthermore, architecture serves not merely as an illustration to our argument—she is within herself the shrine in which Arts and manufactures are held. From architecture in succession are developed sculpture and painting. The halls of the palace are carved with the exploits of the king, the walls covered with paintings of the victories won by his people; and so by the time when civilisation has fairly

THE INTERNATIONAL EXHIBITION.

The two engravings on this column are from | Messrs. Goode, Gainsford, & Co., of the Borough, | London, exhibited a large number of skilfully

examples of WALL PAPERS manufactured by Turner

designed and excellently manufactured CARPETS. | They have wisely aided the prevailing taste

AND Owst, of Pimlico, manufacturers who have successfully competed with the best producers of France.

for simplicity in the arrangement of forms and | colours in those essentially British comforts.

completed her works of utility and beauty, do we find that the temple, the palace, and the private house are the centres around or within which the Arts and the manufactures congregate. Then it is that capitals are cut with the acanthus, that the honeysuckle buds and blossoms under cornice or on frieze, that the laurel, the ivy, and the vine are entwined into floral borders; then it is that tapestries are hung at doors or on walls, that curtains shadow windows, carpets cover floors, couches fill recesses, candelabra give light: so that luxury, interweaving Art into every manufacture, makes the structure at once useful and beautiful. Thus each of the decorative Arts, rising one by one in due subordination to an architectural purpose, takes its appointed station in a household compact for harmony.

It will now be clearly seen how the Ornamental Arts, and Art-manufactures, coming out of and attendant upon architecture, derive from this one parent their type and style. It will be understood how climate, race, and structural materials, which have controlled the various national orders of architecture, have prescribed at the same time the forms of all accessories, and that thus have been established the laws which govern the decorative Arts. It will be evident why an Egyptian capital is clothed with the Nile-growing papyrus, why the fret on a Greek temple is repeated on a Grecian vase, why a pilaster from an Italian palace is transferred to an Italian cabinet, why the pointed arch of the Gothic church or cloister is found on an ivory shrine or in a jewelled casket. Thus, in fine, the

Messrs. BRUNSWICK, of Newman Street, are | We engrave one of their works—a CABINET—and portion of

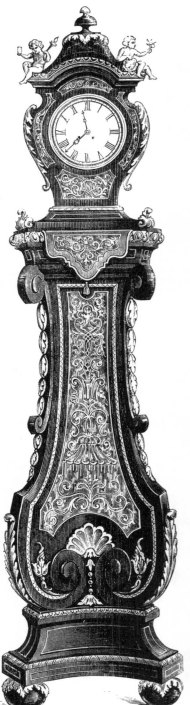

another, and also a CLOCK-CASE, richly and elaborately

inlaid. It is to these manufacturers we are mainly indebted for the introduction into Eng- | land of this branch of Art, which not long ago was exclusively the production of the Continent. They

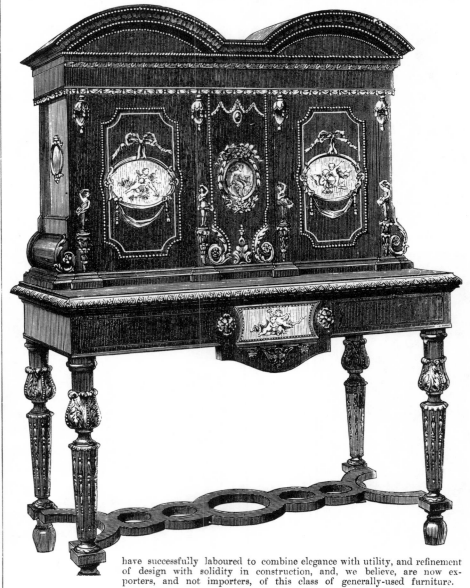

leading manufacturers of BUHL FURNITURE.

have successfully laboured to combine elegance with utility, and refinement of design with solidity in construction, and, we believe, are now exporters, and not importers, of this class of generally-used furniture.

further we proceed to develop the relation subsisting between Art and Art-manufactures, the more apparent it will become that architecture, in its diverse yet distinct epochs, is the common centre from which decorative products take their rise and throw off their radiation.

We have thus almost insensibly sketched in general outline the leading Art-manufactures of the late International Exhibition, both in their origin and purpose. Figures in bronze or other metals manifestly fall under the category of sculpture, an art which claims closest consanguinity to architecture. Terra-cottas, vases, and ceramic works generally, were known to Assyrians, Greeks, Romans, and middle-age Italians, and of course, practised by these several nations, partook of the style of each. Furniture—such as couches, cabinets, wall-papers, and even tables and chairs, which are placed in the interior of buildings—must, whether the constructions be Classic,

Renaissant, or Gothic, in like manner conform to the character of the dwellings which these several articles are designed to decorate. Textile fabrics, also, though often used for personal attire, cannot easily rise to the dignity of Art-manufactures without conforming to those strict laws that inhere to architectural structure. Thus have we reduced these varied Art-products to a central unity, in which they find concord and governance. Thus do we see subsisting between all true Art-manufactures a fellowship in birth and in spirit, as if each were striving according to its office to fill up the measure of a beauteous life. And it is this fashioning into beauty, this purpose which dwells within the plastic form, this expression of high intent which is stamped upon brute materials, that endow manufactures with the soul of Art. And herein is seen the worth of those noble Art-products which, coming from the hand of genius, have from time to time commanded the admiration of the world.

These specimens of BOOKBINDING, by J. AND J. LEIGHTON, are remarkably choice examples of hand-tooling upon leather, from designs by LUKE LIMNER, who has done much to

elevate taste in these matters; the larger being from a rare copy of "Cat's Emblems," in folio, and the other from a Bible, in morocco and velvet, with rich gilt clasp, &c. The

bookbinders generally have made large and marked advances since the Exhibition of 1851; and this very beneficial result is owing mainly to the fact that they resort to artists for aid.

We engrave a MURAL CABINET, the production of the renowned firm of THEYER, of Vienna, whose numerous contributions to the Exhibition were of rare excellence, and

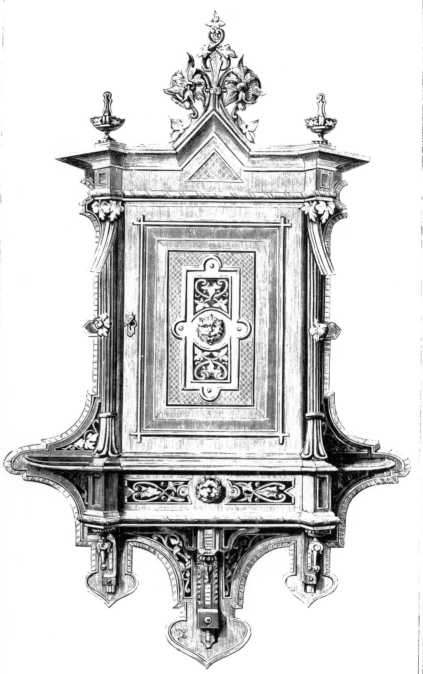

who have, no doubt, taught many serviceable lessons to our wood-carvers and cabinet-makers. They were by no means the only foreign producers who gave them instruction.

And when we call to mind that a lump of clay may be moulded into a work which will fetch its weight in gold, when we remember that a piece of silver stamped with a Grecian die may outvalue one hundred pounds, we shall in some degree be brought to realise the worth of that Art which, in so many ways, proves itself among the most potent of earth's creators.

The double term "Art-manufacture" denotes a twofold basis or nature. A manufacture is something which supplies a general want—something made to meet a necessity in life. Thus we have manufactures of woods and of metals, manufactures of silks and of cottons for the clothing of the body and the furnishing of the house; and this primary end of utility demands, of course, as an indispensable condition, that the thing made shall be useful. The ironwork in its design must be sufficiently stout, yet not too heavy; the silk good in quality and well spun; the cotton durable and cheap. Hence obviously the maxims which lie at the groundwork of all manufacture are economy of production, and subservience of means to the required ends. Then, when manufacture, which in its first stage of mere utility is somewhat rude, rises into an Art-product, beauty as a further constituent becomes added to the primary use. Yet is it now conceded on all hands that this beauty must approach as an ally, not attack as an antagonist. Hence all true decoration must, as we have said, conform to utility and grow out of lines of construction, so that no strength which is needful for stability may be weakened, and no uses which are imperative sacrificed to an art that might otherwise content itself with ministering merely to the pleasure of the eye and the delight of the fancy.

The late International Exhibition contained, we need scarcely say, endless examples, some of which we will now proceed to adduce, of each great style that the world has known. We are not called upon

We engrave another of the elaborate WOOD CARVINGS of Messrs. LOUIS AND SIEGFRIED LÖVINSON, of Berlin. To these ingenious and

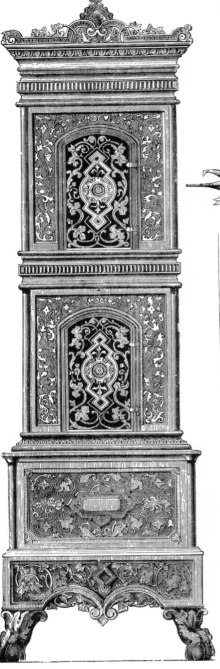

We engrave a silver CANDELABRUM, the work of Messrs. E. and E. EMANUEL, goldsmiths and jewellers, of Portsmouth. It is part of a service

designed and manufactured expressly for the Exhibition. On the base is a large group, representing Britannia, seated on a lion, distributing

enterprising manufacturers, and other cabinet-makers of Germany—as well as to those of France — the British producers have been much indebted for many valuable suggestions.

rewards to the representatives of the four quarters of the globe. The allegory is carried out in the

other articles of the service, which is designed with much talent, and executed with considerable skill.

here to pass a eulogy on the special merits of Grecian ornamentation; yet we should be wanting in gratitude did we not acknowledge that to Classic Art several among the choicest of our British manufactures owe their beauty. It was from classic masterworks that our English Flaxman derived his chastened style. It was in Rome herself that he studied for long years the noblest remains of antiquity, till his own creations at length breathed the same spirit. We look upon Flaxman, indeed, as himself one of the most express illustrations of the apt union of an ideal art with a utilitarian manufacture. He it was who thought it no condescension to pass from marble to potter's clay; and having illustrated Homer, Æschylus, and Dante, he sat down to design a Wedgwood cup and saucer.

The stall in the nave of the International Exhibition which arrested the eye by the blue and white ware from the Staffordshire Etruria witnessed to the undying loveliness of those Grecian forms which Flaxman restored to our daily use. On the same shelves might also be noticed modern reproductions of the middle age majolica, painted by Lesore, one of the most illustrious examples in our own times of an artist possessed of true genius directing his talents and devoting his life to Art-manufacture. Other of our British factories have followed more or less in the same direction, with a like happy result. Sir James Duke, and also the Messrs. Battam, have reproduced the vases and tazza of ancient Greece and Italy. Mr. Alderman Copeland has, in like manner, associated high Art with manufacture in

Messrs. PARKER AND STONE, of Clerken-

well, London, are "wholesale

jewellers"—workers for "the trade"

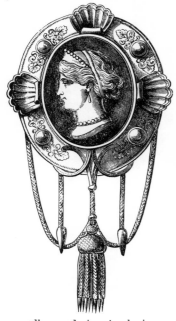

generally—producing jewels in great

variety and for all the uses to which they are applied. They are among the largest manufacturers in Europe, their

works varying in price from those of small cost to those

of great value, but exhibiting good taste in design, and

being famous for sound workmanship. We have selected

several from the stock they exhibited; these were principally, though by no means exclusively, BROOCHES and BRACELETS.

We engrave the HEBE FOUNTAIN, an elaborate

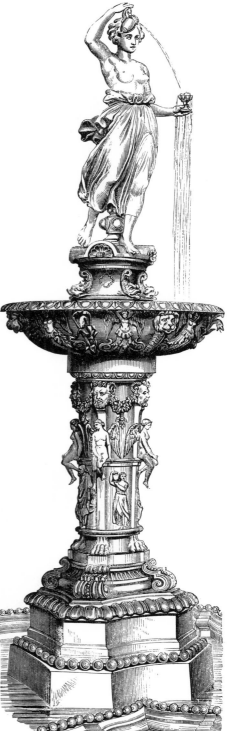

and skilfully-executed example of terra-cotta, manufactured by Mr. PULHAM, of Broxbourne.

his Parian statuettes, reduced from approved originals. Messrs. Minton, and also the Messrs. Maw and Mr. Bashfield, have severally executed with signal success mosaics according to the ancient manner, decorative tiles both Roman and mediæval; also terra-cottas after the best historic models. With some exceptions the designs of our English porcelain and earthenware manufacturers are in stricter taste than the more pretentious productions of foreign nations. The ceramic works, however, from Copenhagen, showing the influence of Thorwaldsen—an influence, be it observed, somewhat analogous to that of our own Flaxman—were marked by that chaste form and that simple ornament which pertain to the antique. As for the other continental displays—extremely alluring,

no doubt, to the untutored eye, which is never more delighted than when dazzled—they were, for the most part, pampered productions of royal dynasties redolent in wealth. The imperial manufactory of Sèvres enjoys a fame justly gained by many glorious achievements, and the present resources of this great establishment must be patent to the most casual observer; but the matchless powers at command have evidently betrayed artists and directors into a lavish luxury which ever proves fatal to sober judgment. A like censure may be passed on the ceramic contributions from the royal factories of Dresden, Berlin, and Vienna. Dresden has long indulged in a confectionary Art—a style which, congenial to a nursery, was promoted to the palace. Cupids flying like pretty moths to the flare

The carved furniture of RIPAMONTI, of Milan, grouped in the Italian Court, attracted very general attention. Its merits were of the very highest order, not only as to design, but as to execution; yet it did not find a purchaser in 1862, but came into the hands of Mr. Woodgate, of High Holborn, a "dealer" of sound taste and liberal enterprise. It is a BEDROOM SUITE, in the purest style of the Renaissance; it is worked

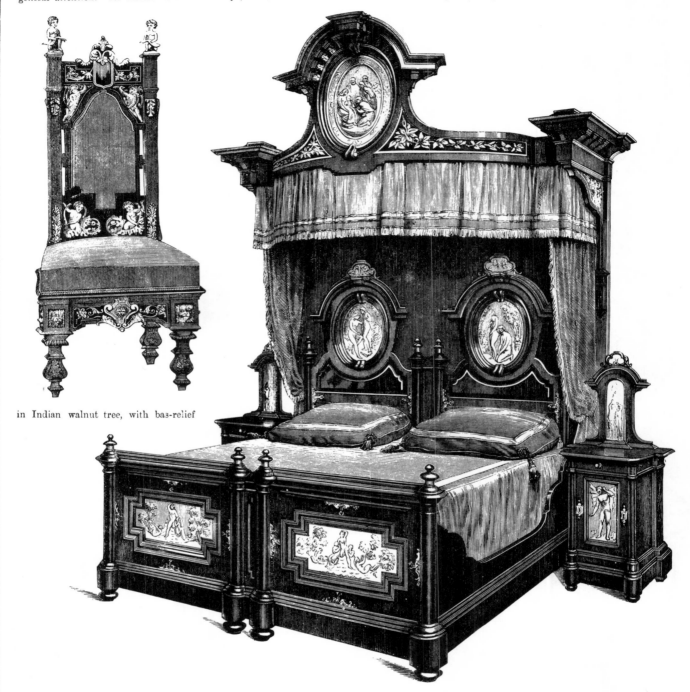

in Indian walnut tree, with bas-relief

panels of maple, mounted with highly-chased bronze mouldings, and double gilt. We engrave the BEDSTEAD, and one of the CHAIRS. The whole forms one of the most complete sets of furniture ever made—even in Milan, so noted for the magnificence of its Art and its Art-industry.

of a candle, and then caught against the melted wax and roasted in the hot flame, would fairly designate the favourite subjects in this fancy Art-manufacture. The royal porcelain of Berlin, exhibited under the western dome, not wholly free from this small child's play, reached to more ambitious flight. In common, however, with some of our more aspiring English compositions, the style of decoration here adopted was too directly pictorial for plastic art. For example, personifications of the Muses, painted by Kaulbach on the walls of the New Museum, Berlin, because of their direct pictorial treatment, form inappropriate adornings to a vase, necessarily curved in contour. The Greeks, in dealing with surface decorations—as, for instance, in the sculpture of the Parthenon frieze, and in the designs on the so-called Etruscan vases—surrendered the freedom permitted to a picture for the severe and balanced symmetry required in a bas-relief. Thus it will be seen that the legitimate alliance of Art with manufacture often involves nice discrimination. Manufactures have many forms and functions, and the Arts have, in like manner, divers manifestations. Hence, in the union of Art with manufacture, it may become sometimes difficult to determine which of the sister Arts shall obtain the preference. Sculpture, with its cognate branch of bas-relief, is manifestly better fitted than painting for the more plastic manufactures, such as wrought and cast iron, and moulded and baked clays. On the other hand, where an extent of flat surface has to be covered by hangings or carpets, a somewhat more pictorial style is usually permitted. Specimens of the various ceramic works just passed in review may be found in the Illustrated Catalogue of the ART-JOURNAL for the present and the past year.

Works in the precious and in the more utilitarian metals call in degree for the same criticism which we have already passed upon ceramic products. The simplest designs here, too, are the best. The

There were few of the bronze manufacturers of France whose exhibited works surpassed

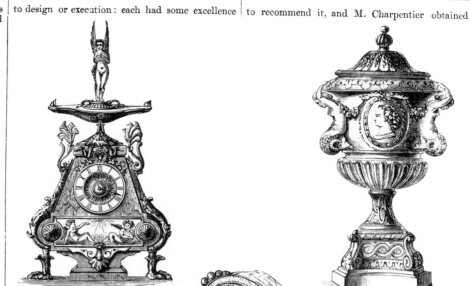

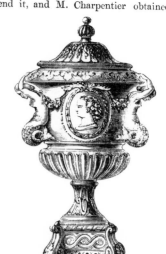

to design or execution: each had some excellence

the meed of honour to which he was

to recommend it, and M. Charpentier obtained

eminently entitled. We engrave

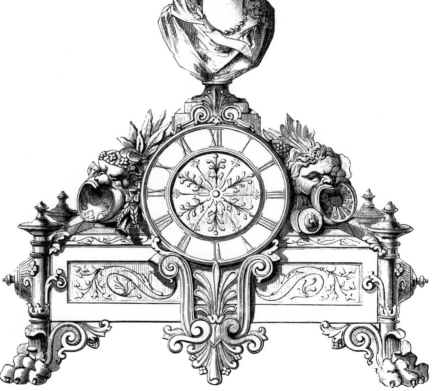

those of M. CHARPENTIER, with reference either

on this page four objects, selected from the many

valuable productions of his establishment in Paris.

Art-manufactures, however, which employ as a material silver and gold, are beset with temptations from which the humility of mere clay seems preserved. In these precious metals there is so much of the pride of life, so much of an ostentation which is apt to be vulgar, that the experience of most countries has proved that to maintain seemly moderation is all but impossible. Objects, moreover, in silver, in silver-gilt, or in gold, have necessarily so much of glitter, and their actual bulk and weight often bespeak a moneyed value so great, that excellence in design becomes, as a matter of fact, less looked for. And thus we believe it is not too much to say, from the experience of centuries, that no works are so atrocious as those which are able to command the rapture of the multitude just by the cost of their metal. From an Art point of view, indeed, no spectacle can be

more melancholy than the glittering displays towards which the eye of patronage has been long too lenient—race cups, regatta goblets, presentation plate, epergnes and table services in general, which in Art hold precisely the same position as after-dinner speeches do in oratory.

We readily admit, however, that the International Exhibition of 1862 contained many productions of exceptional merit. Castellani's jewels, revivals of Etruscan, Roman, and Mediæval masterworks, were, it has been well said in the Jurors' Report, studies for the archæologist, the artist, and the workman. Again, the Poet's Shield, and the Titan Vase, by Vechte, in style and subject of course wholly different from the reproductions by Castellani, are among the most vigorous and original creations of the present day. Vechte, indeed,

We engrave four specimens of French LACE, the manufacture of Messrs.

DOGNIN & Co., of Paris and Lyons. They have successfully treated some

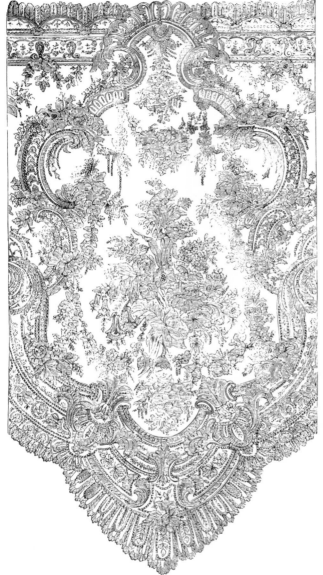

of the most difficult subjects in the art, and their productions are con-

spicuous for the correctness with which they are executed, and the admirable manner in which the various parts are blended into one harmonious whole: The

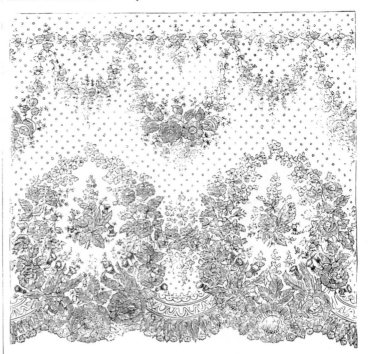

principal of this eminent firm lately received from the hands of the Emperor the

Cross of the Legion of Honour, as a public acknowledgment of his high merits as a lace manufacturer, which he has well sustained for a number of years.

may be deemed a Michael Angelo in design, and a Cellini in execution, cast into a modern French mould. Yet does he, by strong individual genius, stand by himself in bold independence, prodigal in exuberant invention. The works designed and modelled by the sculptor Monti, the Shakspere Vase, the Milton and Byron cups, and the Burns and Moore tazzas, are in style less severe and more decorative. Thus must it be conceded that Vechte and Monti are each, after the precedent set by the best epochs, marked examples of men distinguished in genius, yet willing to adorn manufactures by the poetry of their conceptions. Works by other artists also demand, did space permit, more than passing notice. Among such meritorious labours, we may mention a design in silver by a truly great artist, the late E. Jeannest; a table in *repoussé*, dedicated to "Sleep," executed by Ladeuil; the Pakington and the Outram shields, and

the Kean testimonials, works of Armstead, an English artist; and a vase and rose-water dish, imaginative designs, by Willms. All these important Art-manufactures have received careful illustration in the CATALOGUE of the ART-JOURNAL.

In conclusion, we may observe that the above designs are allied to the pictorial treatment of Ghiberti in his famed Florentine doors, rather than to the strict principles of the bas-relief as practised by the Greeks in the Parthenon frieze. Flaxman, as a draftsman for the silversmiths of his day, was more scrupulously classic; and we incline to the opinion that the vases, and other like works, of the Vatican, the Capitol, and of the Museo Borbonico, Naples, will still furnish to our modern artists types of the noblest forms. Yet the popular power of fascination possessed by a more pictorial style is undoubted. The classic method, it must be admitted, is compara-

Messrs. ROBERT KERR AND SON, of Paisley, have long been eminent as manufacturers of SHAWLS—the peculiar and very beautiful fabric of "Paisley," which has obtained renown throughout the world. We have selected one of them for engraving. It is a remarkable production,

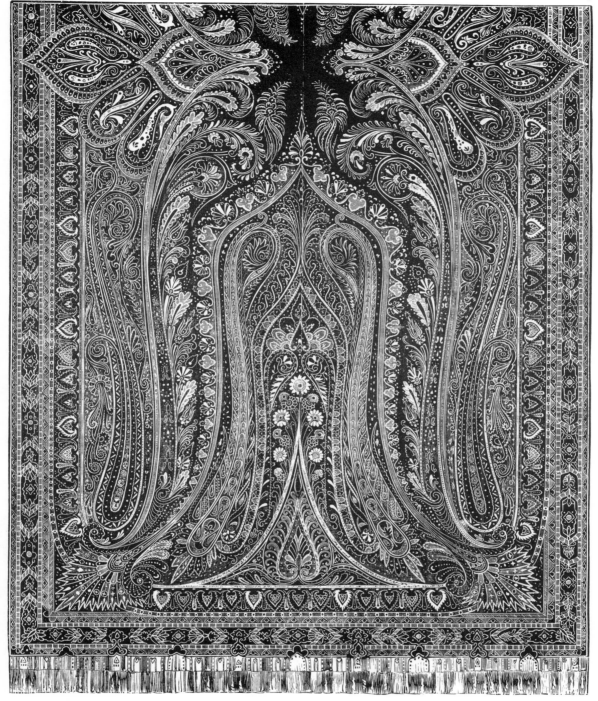

composed of seven colours, and having 770 shoots of weft on every square inch, requiring 30,000 Jacquard cards to make it. The work is a triumph of the loom; although produced at great cost, "the machine" brings it within the reach of most wearers of this graceful article of female dress.

tively circumscribed; and it were indeed absolute folly to limit the resources of Art by laws which may be, after all, technical rather than essential. We have, therefore, not the slightest objection to an avowedly pictorial treatment of surface decoration, provided only the work be the best of its kind. The worst charge, perhaps, that can be laid against any design, is that it has no treatment whatsoever; and in this despicable predicament many, especially of the most pretentious of modern creations, are accustomed to find themselves. Nothing, indeed, can be lower than the literal naturalism, nothing more hopelessly common-place than the mean every-day forms which are thrust into works that, we are sorry to say, are not designed for the plebeian multitude, but gain the patronage of the aristocracy of birth and of wealth in this land. What judgment can we pronounce on vases with eight-oared boats rowing across their surface, or displaying ships sailing in full canvas over a sea of sparkling silver? What can be thought of heaped-up or long-drawn-out compositions of camels, elephants, horses, and cattle, marching like a Wombwell's menagerie through the streets? What Art can be found in Bedouins with guns, Sepoys with knapsacks, Sheiks shaded by umbrellas, sultanas reposing beneath palm branches, all done into frosted and burnished silver, as tempting to gaze on as the sugared top of a mid-Lent cake, and just as beautiful? All this is but the work of Nature's journeymen, so abominably has humanity, and all that is noble in Art, suffered parody. "Oh, reform it altogether; and let those that play your clowns speak no more than is set down for them." All such Art, if Art it may be called, is "villainous, and shows a most pitiful ambition in the fool that uses it."

That we should proceed in like manner to the criticism of each of the numerous classes of Art-manufacture contained in the Exhibition is manifestly impossible. We must content ourselves with such

The very beautiful PLATEAU here engraved was designed by Sir COUTTS LINDSAY, and ma-

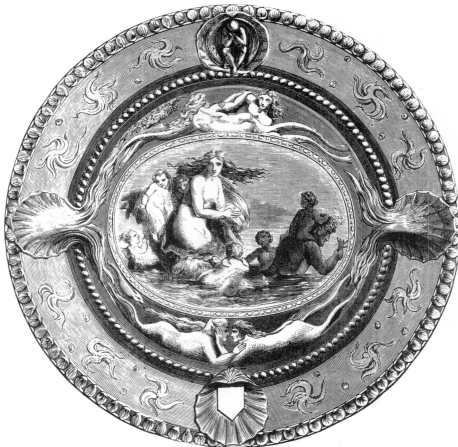

nufactured by Messrs. MINTON for Messrs. GOODE, of South Audley Street: it is a rare and charming

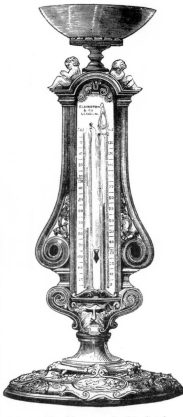

Although the many varied and admirable contributions of Messrs. ELKINGTON have occu-

pied considerable space in this Catalogue, we may devote another column to their illustration. We do so more for our convenience

example of painted majolica. The LION

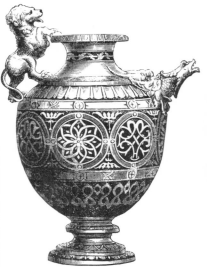

EWER is a fine specimen of reproduction of the celebrated "Henry II. ware," pro-

duced also for Messrs. Goode,—as was the CLOCK made

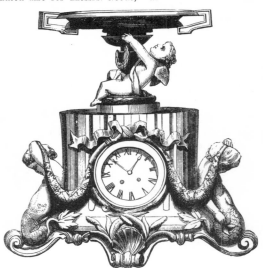

from a design by Mr. W. J. GOODE. There were few works of "Mintons" that surpassed in excellence these three.

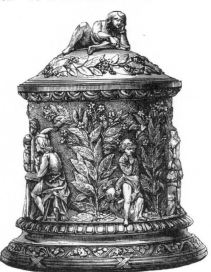

than for their honour; but these objects serve to show the excellence of their minor works.

examples only as serve to illustrate the conditions under which Art may best succeed in infusing her life and her spirit into the body of our national manufactures. We have already endeavoured to show how the various decorative Arts spring from architecture as their root; and accordingly the Jury of Architects, including Professor Donaldson, Mr. Scott, Mr. Smirke, and Mr. Tite, report that "the objects shown for architectural beauty" virtually extended into numerous sections and classes, and stretched well-nigh over every portion of the Exhibition. Mosaic pavements, parqueted floors, paper-hangings, imitative painting of marbles and woods, ornamental bricks, stained-glass windows, brass and other domestic metal-work, wrought and cast-iron gates and screens for the entrance to public parks and gardens, or for the interior of churches, will serve in their mere enumeration to indicate through how many materials and in how many ways architectural types and ideas translate themselves into corresponding manufactures. Our leading architects, under the impulse of recent revivals, have drawn largely on the resources of Nature, and taxed to the utmost the powers of mechanical reproduction; so that Nature, Art, and Manufacture seem each day to blend more and more into indissoluble union. From native or more distant quarries have been brought coloured marbles for columns and other architectural embellishment. And thus, by aid of these and like Art-manufactures, the exterior and the interior of our public and domestic buildings have grown of late years ornate in varied colour,

THE INTERNATIONAL EXHIBITION.

The examples of

METAL-WORK which

The SHIELD engraved underneath is the work of ELKINGTON, and was executed for Messrs. ELLIS BROTHERS, silver-smiths, of Exeter. An in-

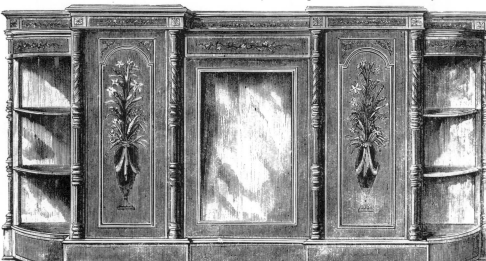

division of the county of Devon, as a grateful record of his services." It is of silver, weighing 500 ounces, obtained entirely from Devonshire mines.

The CABINET is the work of Mr. LEVIEN, of London; it is inlaid with various coloured woods of

scription round the centre states that it was "pre-sented to the Right Hon. Baron Churston Ferrers, by his former constituents of the southern

It commemorates incidents memorable in the history of that fairest of English counties, and contains portraits of some of its many "worthies."

New Zealand, which Mr. Levien was mainly instru-mental in introducing to English Art-manufacture.

occupy the two outer columns on this page we have selected from the many meritorious works of Mr. HART. They are of all classes,

not alone for church purposes, but for or-dinary domestic uses. The excellence he has achieved in his varied

productions is univer-sally appreciated, plac-ing his name high among the British ma-nufacturers in articles of this important class.

and decorative, even as the middle-age architecture of Northern Italy, in the beauty of moulded form.

The limited space at our command compels us to exclude many topics on which we would gladly have touched. Yet can we not wholly pass in silence the extraordinary revival known to Gothic art, with its attendant reproduction of mediæval works. The Gothic palace of Westminster has been for mediæval metal-work a foster-ing school—scarcely less prolific in its fruits than the forest roof of crowded pinnacles and statues at Milan proved for the art of marble sculpture. In addition to this great national senate-house, which certainly it must be admitted has been decorated even to excess, other secular Gothic edifices have been erected in provincial towns; and when to these we further add the innumerable Gothic churches which have risen in the land; when we reflect, moreover, that every one of these structures, whether secular or ecclesiastic, has received in

screens, altar-rails, candelabra, gas-fittings, painted floor-tiles, moulded bricks, stalls, chairs, and other furniture, appropriate decoration, we may arrive at some conception of the extent of our English Gothic revival, and of the corresponding diversity, and, indeed, the univer-sality, of those Art-manufactures. which have come to supply the newly-created want of appropriate decoration. The knowledge and the skill brought to bear upon this movement have been truly mar-vellous.

The multitudinous services which Art has conferred on manufac-ture will now be sufficiently apparent. On a somewhat converse proposition—the boon which our modern manufactures have bestowed upon Art—we will now say a few words. The Arts through the multiplying power of machinery have, in these our days, become widely diffused, and thus works which in past ages were the exclusive possession of the prince in his palace, are at last, through a translated

We engrave a superb CABINET, carved and gilt, | the production of NOSOTTI, of Oxford Street, a | carver and gilder of high and established repute.

This very elegant work was executed by him for | the Countess of Waldegrave, and graces her | drawing-room at Strawberry Hill. Four painted

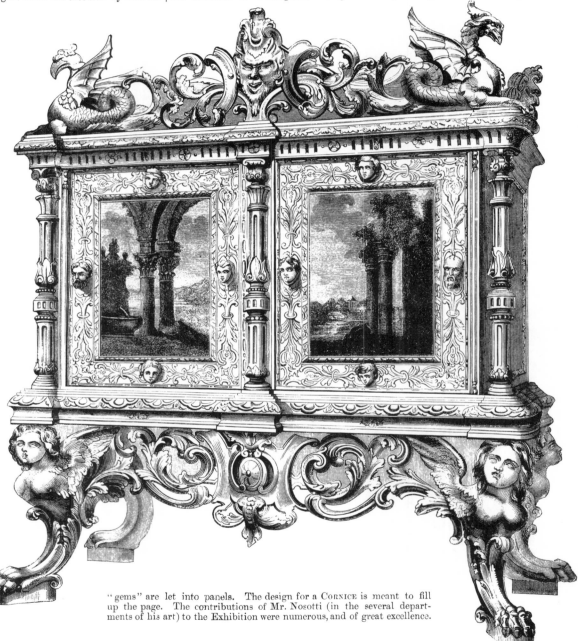

"gems" are let into panels. The design for a CORNICE is meant to fill up the page. The contributions of Mr. Nosotti (in the several departments of his art) to the Exhibition were numerous, and of great excellence.

medium, brought within the reach of the peasant in his cottage. The loom and the printing-press have not only added to the manual power of man—they have given, if possible, even to a more marvellous degree, diffusive wings to his inventive imagination. The public speaker or the writer has scarcely uttered the word or penned the sentence, ere his thoughts, printed on a broad sheet, are carried to the ends of the earth. And even so the artist-designer finds his fancies woven, as it were, with swiftest fingers into the textile fabrics of cotton, of wool, or of silk, and forthwith hurried into every mart where trader or consumer barters for merchandise. Think what additional power and spell over the multitude a Raphael might have gained had he lived in an age when his smallest but not least beauteous thoughts could have been caught up as they fell from his bounteous pencil, and multiplied forthwith into a thousand duplicates! Ponder on this vast agency of civilisation, this means so potent to the refined culture of the multitude, when the precious thoughts of a great man, elaborated, it may be, slowly and in silence, or struck out as brilliant flashes—consider, we say, the enhanced power for popular education, when, as it were, this life-blood of the imagination can be poured into the minds of the multitude, and good seed sown broadcast on the land !

What the invention of printing was for literature, the adaptation of wood-engraving to the printing-press has been for the art of design. The columns of our own Journal, indeed, illustrated with drawings upon wood from the choicest Art-products of all countries and epochs, and thus diffused by thousands into the workshops and

THE INTERNATIONAL EXHIBITION.

Mr. ROBOTHAM, of Birmingham, exhibited a large collection of works in wire, which attracted very general attention for the graceful manner

in which they were designed, and the great merit of their execution. We engrave a BIRD-CAGE, as one of the best examples of his various productions.

M.M. PULLIVUYT & Co., of Paris, whose works are at Mehun-sur-Yèvre, are exhibitors of porcelain in great variety for ornament and use. Many of them are of high excellence in design—pure and graceful Art-works.

The CHIMNEY-PIECE of MARCHAND, of Paris, was among the most admirable and valuable works in the Exhibition. It is a judicious mixture of bronze, marble, and ormolu. The style is obvious: it is a very perfect triumph of manufactured art.

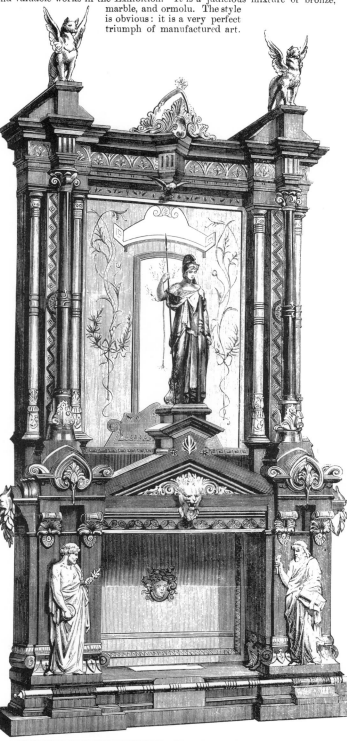

dwellings of every capital in the civilised world, afford, among many other examples, a striking proof of the high ministration of machinery and manufacture to Arts which are brought to adorn the household, and add to the joy of daily life. And now, in the still more recently perfected process of chromo-lithography, the actual colours of exquisite paintings are transferred from stone with scarcely less accuracy than words and engravings are printed from cast type or cut wood. By this method it is well known that the Arundel Society has brought to the knowledge of the untravelled Englishman some of the choicest fresco pictures of Italy. We are living in an age of colour, and by the comparatively cheap multiplication of works gently attuned to harmony, the eye of the English decorator may become sensitive to that ineffable concord of colour which was to the middle-age artisan a direct intuition.

In fine, "Art in its influence on Art-manufacture" may be pic-tured, as we have seen, by the light of metaphor. Art, as we have said, is prefigured by mind or soul, and Manufacture by matter or body. Again, Art is the offspring of imagination, and Manufacture, on the other hand, of sober intellect. Art, as we have shown, is beauty, and Manufacture is utility. Art supplies, as it were, wings to soar into mid air; and manufactures are as feet to walk the solid earth. And even as the body must be dead without the soul, so must manu-factures be dense and dark without the light of beauty. Manufac-tures, indeed, severed from the Arts, would be as Nature robbed of the radiance of the sun—like the landscape deprived of colour—like woods denied the melody of birds. Art then, let it be our consola-tion to know, will not cease to shine on manufactures till Nature her-self shall suffer from eclipse.

J. BEAVINGTON ATKINSON

This Catalogue is fitly closed by engravings of the beautiful covers of a

illustrative drawings are by some of the most accomplished Artists and

BOOK OF PRAYERS, presented by united artists to the EMPRESS OF AUSTRIA. Within and without it is a perfect production of Art and Art-industry : the

Professors of Art-industry of Vienna, while, as a specimen of binding, nothing more entirely excellent was exhibited by any country of Europe.

THE SCVLPTVRE OF THE EXHIBITION

MODERN SCULPTURE OF ALL NATIONS,
IN THE
INTERNATIONAL EXHIBITION, 1862.

BY J. BEAVINGTON ATKINSON.

SCULPTURE has been justly termed the most ideal of the Arts, yet with equal reason might she be called the most real. Architecture is not directly imitative; Painting does not embody illusive form with substance; and thus it seems reserved for Sculpture alone to reproduce in solid length, breadth, and thickness, figures just as they stand in nature. In this sense, then, Sculpture is the most real among the sister Arts; yet is she, as we have said, at the same time the most ideal. Everything, indeed, that she attempts, should be perfect after its kind. Her field is, perhaps, narrow: she cannot embrace, as painting, a distant horizon, or represent by a multitude of figures an intricate action; and thus, limited to a circumscribed sphere, it becomes the more incumbent that the forms and incidents selected shall be the choicest and the best. She has, moreover, to live in marble—a material which, not readily fashioned to circumstance, may fitly forsake the minor detail of trivial accident for the broad treatment suited to essential truth. But this very marble, which seems too stern to move before a melting breath, is firm to stand the brunt of time; and therefore Sculpture may, and indeed must, rear her form as for eternity, crown her front with an undying beauty, and live for all time in garb and features which know neither change nor decay. Hence, we repeat, is it specially demanded that Sculpture, though real, should rise to an ideal height; that the nature which she embodies shall be the most perfect of nature, that the truth she enshrines shall be the most enduring of truth, and the beauty she celebrates the most lovely of beauty. Such, then, are the conditions to which the sculpture of all nations, whether ancient or modern, must conform—such the standard which separates creations of highest merit from works of lower mediocrity. The Greeks it was who mastered that

noblest treatment which educes the ideal from the real, and creates for sculpture a central and perfect beauty, free from the im-

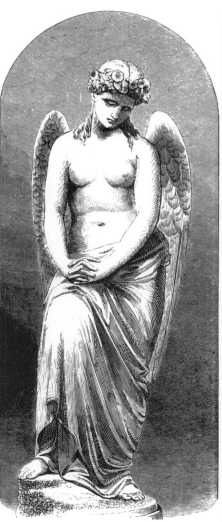

THE PERI.
(J. S. WESTMACOTT.)

perfections inherent to individual examples. In the land of Greece the sky was serene, and the very air, balmy and buoyant, gave

play to fancy and seemed to foster a life sportive in poetry. A free government secured to each citizen liberty of action and boldest scope to thought. The public games trained a lofty race after the highest type in form and function of which humanity is capable; and the popular religion then came to raise this humanity into godhead, so that it was said of Phidias, he made gods better than men. Thus the eye, fed by noblest images, and the mind thirsting after divine perfection, the artist sought to transfer the bright ideal into marble, and found it possible to clothe imagination in godlike beauty; for, says Winckelmann, "the highest beauty is in God, and our idea of human beauty advances towards perfection in proportion as it can be imagined in conformity and harmony with that highest existence. This idea of beauty is like an essence extracted from matter by fire, it seeks to beget unto itself a creature formed after the likeness of the first rational being designed in the mind of the divinity." Thus it is not surprising that the art of sculpture, as perfected among the Greeks, was the most ideal and Godlike which the world has yet witnessed.

The doctrine here inculcated, though unfortunately in this country at the present moment the reverse of popular, has obtained the sanction of the best authorities. Mrs. Jameson says, "True, the gods of Hellas have paled before a diviner light; 'the great Pan is dead;' but we have all some abstract notions of power, beauty, love, joy, song, haunting our minds and illuminating the realities of life; and if it be the especial province of sculpture to represent these in forms, where shall we find any more perfect and intelligible expression for them than the beautiful impersonations the Greeks have left us?" After the like manner, Mr. Edward Falkener, in his "Dædalus," extols the idealistic method practised by the Greek sculptor in these words:—"Thus, divesting the body of all human passions, the Greek sought to make it superior to human nature, and to partake only of the divine. The highest degree of human beauty was imparted, but it was referred by the mind of the beholder to corresponding spiritual excellence. This, therefore, became the aim of the sculptor. He sought to convey to the marble the hidden attributes of the soul, to awaken by bodily forms the secret operations of the mind." Again, Gustave Planche, one of the greatest of European critics—a teacher bold enough to say that reality is but the means leading to

* We are mainly indebted to the LONDON STEREOSCOPIC COMPANY for the power to engrave so large a number of the works in sculpture contained in the International Exhibition, and gratefully acknowledge our debt; we have but selected from the very extensive "series" issued by the Company.

ideality as the end—shows that the 'Theseus' of Phidias transcends all existing

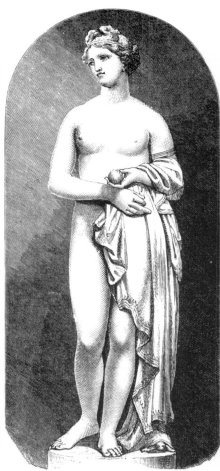

VENUS.
(J. GIBSON, R.A.)

models, and proves that the Greeks, in this and other like works, did not so much transcribe as transfigure the forms of nature. "The Theseus," says Gustave Planche, "is beautiful because it is true, and it is true because it translates the idea of Phidias instead of transcribing a literal reality." Accordingly Canova, when he saw for the first time the Elgin marbles in London, pronounced at once the opinion that, "they were the finest things on earth, and declared that he would have walked barefoot from Rome to have seen them." He added that "the union of life and idea was perfect, and that they would overturn the whole system of form in high Art." Haydon at that time—now nearly fifty years ago, when a student burning with high ambition—was, he tells us, so completely imbued with the divinity and perfection of these marbles from the Parthenon that "he would joyfully have died in their defence." In conclusion, to quote the eloquent words of Fuseli, "the Graces rocked the cradle of Grecian Art, and Love taught her to speak." "Situation, climate, national character, religion, manners, and government conspired to raise it on that permanent basis, which, after the ruins of the fabric itself, still subsists and bids defiance to the ravages of time: as uniform in the principle as various in its applications, the Art of the Greeks possessed in itself, and propagated, like its chief object, man, the germs of immortality."

We thus make Greek Art the introduc-

tion to the modern sculpture of all nations for three reasons. First, because Greek Art above and beyond the mere accidents of country, epoch, and religion embodies those immutable verities which belong to all time. Secondly, because all modern schools of sculpture take their historic rise more or less directly from the middle age renaissance, a revival which, spreading from Italy over the face of Europe, had for its express end the re-birth of the classic. And thirdly, because under the present phase of sculpture throughout the world, and especially in England, it becomes more than ever imperative to revert to the law and the order established of old in ancient Greece —to show how Phidias was at once the most truthful yet imaginative, the most naturalistic yet ideal of sculptors, and thus, if possible, to free our galleries from those transcripts of a common nature, those reproductions of vulgar incidents, which have proved the degradation not only of individual artists, but of national schools.

Yet let it not be supposed that we seek to bury the instant life of our people in the grave of a dead past, even though that past be of Athenian Pericles. We speak of a living Greece, and we cherish only those elements in classic Art which cannot die. Cast upon modern times, a change must come over the spirit of our dreams. English

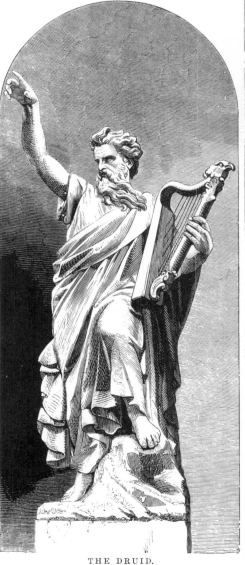

THE DRUID.
(W. THEED.)

statesmen do not address the senate in Roman togas, and English sculptors must make their works

conform as best they may to the manner and the fashion of the day. Nevertheless,

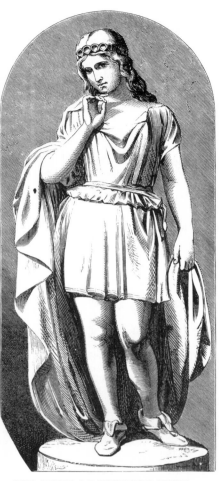

THE WEPT OF WISHTON-WISH.
(J. MOZIER.)

all that essentially inheres to the nobility and manhood of our race may be gathered from those ancient marbles which, through inborn divinity, seem to have won immortality. It remains, then, for all modern schools of sculpture, not to copy, but to follow after the example of the antique; in short, living sculptors must do what Phidias did—take of the noblest nature and fuse her elemental forms in the alembic of genius.

The modern SCHOOL OF ITALY, directly descended from the classic, has fallen on a rich inheritance. The marbles of Athens were taken as spoils by the Latin empire. Rome, the mistress of the world, was crowned queen of the Arts, and even when she lost her dominion of power she regained her sway through the spell of imagination. When Rome was sacked, her sculptured gods and heroes lay buried; but as soon as Italy in the middle ages awakened once more to life, her sleeping statues also rose from their graves. Thus, since the day when classic Art was revived under the Medici, the soil of Italy has been fertile in works of imagination, and birth has been given to genius which could again fashion the native hills of Carrara into forms of plastic beauty. "The goddess loves in stone, and fills the air around with beauty," and Italy, though her imperial garment be soiled and rent,

"Is still impregnate with divinity
Which gilds her with revivifying ray:
Such as the great of yore, Canova is to-day."

Canova, indeed, has sometimes been termed the Phidias of modern Italy; and as Phidias represented the age of Pericles, and Michael Angelo the glory of the Medici, so did Canova reflect the refinement yet degeneracy of Italy in the eighteenth and nineteenth centuries. Canova, in common with the other great sculptors of his school and country, was, in style it is true, essentially classic, but the chastity of the ancient Greek was in his hand corrupted, and the vigour of the old Roman emasculated. Exquisite indeed is the softness which Canova gave, and that many of the modern Italian sculptors still give, to flesh, and admirable the delicacy they have thrown into gossamer drapery, so that the marble seems almost to breathe and blush with life, and swoon to softest sentiment. Yet these graces, in themselves so winning, wanting the charm of simple nature, show themselves prone to degenerate into direct affectation. It was said of Canova that his women seldom looked modest, and his men never manly. It must be confessed that his figures have the air of the dancing-master, and seem as if draped by the hand of a milliner; and so the school of Canova, which now reigns throughout Italy, forsaking the severity of the antique, is surrendered to the soft fascination of romance. The old Roman has given place to the young Italian, Hercules

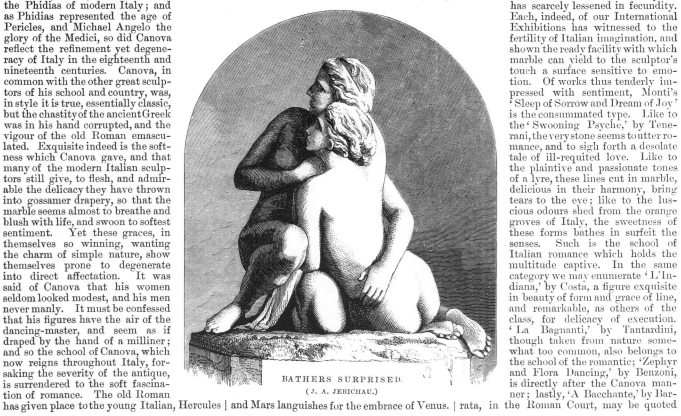

BATHERS SURPRISED.
(J. A. JERICHAU.)

has been transformed ino Endymion or Adonis, and Mars languishes for the embrace of Venus.

Yet if Italian Art has lost virility, it has scarcely lessened in fecundity. Each, indeed, of our International Exhibitions has witnessed to the fertility of Italian imagination, and shown the ready facility with which marble can yield to the sculptor's touch a surface sensitive to emotion. Of works thus tenderly impressed with sentiment, Monti's 'Sleep of Sorrow and Dream of Joy' is the consummated type. Like to the 'Swooning Psyche,' by Tenerani, the very stone seems to utter romance, and to sigh forth a desolate tale of ill-requited love. Like to the plaintive and passionate tones of a lyre, these lines cut in marble, delicious in their harmony, bring tears to the eye; like to the luscious odours shed from the orange groves of Italy, the sweetness of these forms bathes in surfeit the senses. Such is the school of Italian romance which holds the multitude captive. In the same category we may enumerate 'L'Indiana,' by Costa, a figure exquisite in beauty of form and grace of line, and remarkable, as others of the class, for delicacy of execution. 'La Bagnanti,' by Tantardini, though taken from nature somewhat too common, also belongs to the school of the romantic; 'Zephyr and Flora Dancing,' by Benzoni, is directly after the Canova manner; lastly, 'A Bacchante,' by Barrata, in the Roman Court, may be quoted

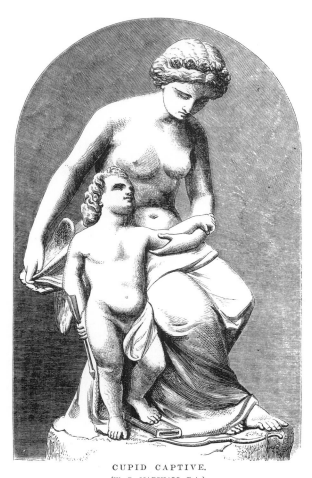

NYMPH AND CUPID.
(T. THRUPP.)

CUPID CAPTIVE.
(W. C. MARSHALL, R.A.)

as an example of the same style pushed to the excess of the voluptuous. In Italy, as in other countries, a re-action has of late

years set in against the school of the romantic. The severity of the classic gave place, under the sway of Canova, to the tenderness of sentiment, till at length, as we have seen, marble was ready to melt, even with the weakness of water. In the history of the Arts the remedy for this nerveless languor has been again and again found in a simple return to nature. Health and vigour are thus once more imparted to enervate limbs, and renovated life lays hold of forms long stricken with decay. One penalty alone has usually to be paid in return for this restoring process. With access of strength, generally comes attendant rudeness, and so, just in proportion as nature is gained is Art lost. Hence schools of direct naturalism, whether in painting or in sculpture, have proved themselves, almost without exception, low minded, and that for the reasons already given. Sculpture, as we have shown, while by her cubic contents the most solid and real among the Arts, is in type and spirit the most ideal. Yet, in forgetfulness of this first principle, sculptors expressly devoted to the literal transcript of nature, have, for the most part, been content to seize upon material form rather than on mental expression; and thus works embodying the lowest types are justified, on the mistaken plea that what is true to nature is necessarily good in Art. In romantic sculpture we have seen sentiment carried

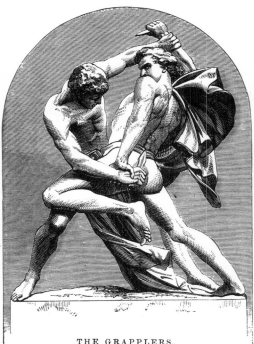

THE GRAPPLERS.
(J. P. MOLIN.)

undue ascendance. Character, for example, which fitly pronounces individual expression, is, in works of direct naturalism, pushed sometimes to the verge of the repulsive. Furthermore, in this school æsthetic treatment is apt to become subordinate to what may be termed mere photographic transcript, and instead of such noble portrait statues as the Demosthenes of the Vatican, the Æschines of the Lateran, and the Aristides of the Museo Borbonico, we are now doomed to memorial figures of which only a tailor or shoemaker can be proud.

The naturalistic schools of sculpture admit of division into sub-classes, according to the distinguishing characteristics of each. For instance, there is the species which seeks after illusive detail, as in Monti's veiled vestals, and in Fontana's 'Cupid caught,'* by an elaborately wrought net. When this sculptured detail is devoted to the laborious study of the head and features, as in Woolner's marvellous portrait busts of Tennyson, Maurice, and Sedgwick, the manual toil finds sufficient justification in the mental expression which each incised line seems to register. Another aspect of naturalistic sculpture has been fitly termed the picturesque, a manner pleasingly seen in Magni's 'First Footsteps,' a mother, dressed as a Roman peasant, leading her infant in his first walk; also in Spence's popular statue 'Highland Mary,' a figure with a shawl thrown pictorially over the head and shoulders. The Roman and the other Italian Courts of the International Exhibition contained several capital examples of this new school, which, on the dying out of the Canova style, is now, as we have seen, rising into power. Guglielmi's 'Sposa e l'Indovina,' includes a detailed study of an old gipsy fortune-teller, almost as startling for repulsive reality as if the Fates of Michael Angelo or the Witches of Shakspere had been transferred to marble. A pretty figure, 'Modesty,' by

Corbellini, may be quoted as a favourable instance of the delicate detail in which the school of Milan is known to indulge, seen especially in the exquisite modelling of the girl's sleeve, loosely falling from arm to wrist. Vela's 'Morning Prayer,' a simple girl, with book in clasped hands, kneeling on a cushion, is also commendable, not merely for delicate marking of each accident of drapery, but still more for that truth and pathos which come as the best rewards of single devotedness to nature. But the most signal and successful manifestation of this school of humble naturalism is afforded in Magni's famed 'Reading Girl.' Enough has been said to indicate that the work does not pertain to the highest walk of the sculptor's art; yet, within a more humble sphere, this figure in its treatment is wholly beyond the reach of censure. The result may serve to show how, even in cold sculpture, "one touch of nature makes the whole world kin," for truly did 'The Reading Girl' speak to the hearts of all people in a language which not even Babel has yet confounded.

We will next say a few words on the school of FRENCH SCULPTURE— a school as remarkable for abounding talent as for deficient taste. It has been well observed, indeed, that the French style is marked by just those merits which are most wanting in the

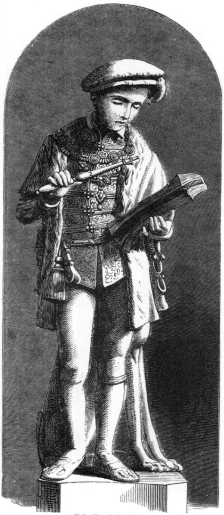

EDWARD VI.
(BARON DE TRIQUETI.)

THE QUEEN.
(J. DURHAM.)

to excess; in naturalistic sculpture, on the

* This statue, as many of our readers may remember, was engraved some long time back in the *Art-Journal*: so also were several others referred to by Mr. Atkinson—as, for example, Spence's 'Highland Mary,' Geef's 'Lion in Love,' one of Rauch's 'Victories,' Calder Marshall's 'Sabrina' and 'Dancing Girl Reposing,' &c. &c.—[ED. *A.-J.*]

English—largeness of manner, vigour in

THE INTERNATIONAL EXHIBITION.

conception, and firm mastery of modelling. On the other hand, French sculptors indulge in a licence, and are guilty of an excess from which our own artists and the English public would instinctively recoil. French literature and manners and French Art are found, in fact, to be one and indivisible. The same spirit speaks in diverse forms—a spirit bold, adventurous, vaulting in ambition, glorying in power—a power ever ready for revolt, and often guilty of extravagance. In the sphere of the drama the thrilling situations and plots which of late in this country have been applauded and then condemned as sensational, had been long the habitual food of the frequenters of the Parisian theatres. Thus, in France, the walks of literature and the varied manifestations of Art abound in that excess of cleverness, that fertility of resource which, despising as it were the humble and easy paths of moderation, break loose into a wild career of unbridled genius. Difficulties which might deter more timid adventurers are not so much shunned as sought, for through opposition comes triumph, and battle is crowned by victory. The French as a nation aspire to be masters of the world; and so French artists, unequalled for enterprise, and at the same time freed from deterring scruples, possess themselves boldly of the realms of the imagination; and having fought hard for conquest, they then run riot over their domain.

French sculpture is strong in repose,

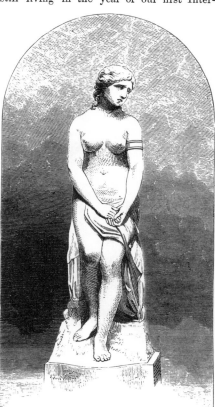

ÆNONE.
(W. BRODIE, R.S.A.)

born towards the close of last century, and still living in the year of our first International Exhibition, was the Canova of the Gallic school. The statue of Phryne, the Athenian courtesan, exhibited in Hyde Park in 1851, was an example of the exquisite softness which this sculptor of romance could infuse into marble, and equally an instance of the meretricious sentiment that has proved fatal to the school. With the brilliancy known to critics of the Paris salons it has been said that Pradier mistook the apotheosis of the passions for the purer mythology of Greece, and that instead of a hymn to the gods he sounded a dance for the rapture of the senses. With artists of this pseudo-classic bent, the stately march of divinities on Olympus becomes the tripping step on light fantastic toe of the Casino. The Venus of Milo, the Graces as modelled by the Greeks, were tempered by the pure and almost awe-striking

" Spirit of Beauty, that doth consecrate
With her own hues all she doth shine upon
Of human thought or form."

As a contrast, compare with the 'Fates of Phidias,' from the Parthenon, Pradier's 'Poésie Legère,' and Clesinger's 'Nymph bitten by a Serpent.'

The French school of sculpture, however, is many-sided. Happily it is not given over entirely to romance. If it be fertile in genius as gentle and sensitive as that of Canova, on the other hand it is not wholly barren in the grandeur of Michael Angelo. The master-works known to the salons of Paris are, as we have said, when in action, vivacious, and when in repose, vigorous. The 'Dancing Faun' of Lequesne, sent by the Imperial government to our last International Exhibition, a free and bold adaptation of the classic style, affords a striking example of the power and resource attained by the well-trained French artist. Lequesne having obtained in Paris the first prize for sculpture, was sent, with a pension, to the

Academy in Rome, for the further prosecution of his studies. This 'Dancing Faun' and other fine works were the products. Such firmness and precision in modelling, such mastery of anatomy, such freedom in action and swiftness in motion, can only be obtained through that long and systematic training which France has secured to her artists, but which unfortunately is still denied to our English students. Duret had also the advantage of a pension in Rome, and his well-known figures, 'A Neapolitan Improvisatore' and 'A Neapolitan Dancer,' show as the result an easy victory over arduous difficulties. The style of these inimitable creations, not classic, certainly not romantic, may be designated as picturesque. But to whatever manner they may technically belong, it must be admitted that few compositions, either in ancient or modern Art, can vie with these figures for life, spirit, or expression. A rare excellence, most difficult of attainment, and yet when reached sufficient in itself to confer pre-eminence, is specially worthy of note. One spirit permeates and breathes, one idea speaks through every feature and limb. In the 'Tarantella' each nerve is strung to ecstasy, and all the muscles dance in unison. In the 'Improvisatore' ready wit and thrilling laughter play upon the lips, sparkle in the eye, point the finger, and animate even the toes. This is that subtle and silent language of expres-

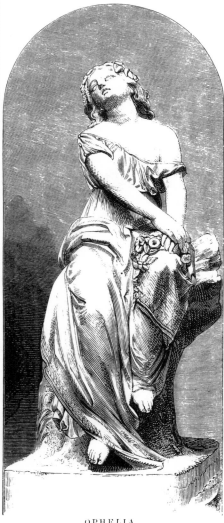

OPHELIA.
(W. C. MARSHALL, R.A.)

vivacious when in action, and for expression somewhat infected with affectation. Pradier,

sion which sculpture, as perfected form, can, above any of the sister Arts, attain unto.

THE BRIDE.
(G. STRAZZA.)

'The First Cradle,' by Auguste Debay, is another work which has justly acquired a European reputation. In this singularly original composition, Eve, bending fondly with motherly affection, holds on her knees and encircles in her arms, her two infant sons, Cain and Abel. In largeness of manner, and by the arrangement of the lines, this group approaches the grandeur of Michael Angelo. In Perraud's 'Adam,' placed under the eastern dome of the International Exhibition, a work which was honoured by the purchase of the French government, the manner of Michael Angelo becomes more decidedly pronounced. The tremendous development of muscle, which might almost better become Hercules than Adam, is, in this figure, as in the marbles of the great Florentine, pushed well nigh to extravagant excess. The treatment of the anatomy, indeed, and even the pose of the body, are deliberately taken from the famed 'Torso Belvedere' of the Vatican, the antique fragment which Michael Angelo is known to have adopted as his model—a work that the poet Rogers, when in Rome, apostrophised in the following lines, which, recalling the glories of classic Art, may, at the same time, serve in the imagination to keep alive the image of that grand style, that noble ideal in form, after which the most lofty schools of European sculpture would still aspire:—

" And dost thou yet, thou mass of breathing stone—
Thy giant limbs to night and chaos hurl'd—
Still sit as on the fragment of a world,
Surviving all, majestic and alone ?
Aspiring minds with thee conversing caught
Bright revelations of the good they sought :
By thee that long-lost spell in secret given,
To draw down gods and lift the soul to heaven."

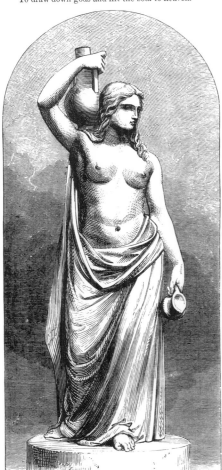

REBECCA.
(E. DAVIS.)

Two of the grandest compositions in the late International Exhibition yet remain to

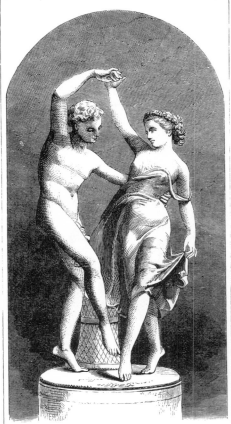

ZEPHYR AND FLORA.
(G. M. BENZONI.)

be mentioned—'Agrippina and Caligula,' by Maillet, from the Musée du Luxembourg, and 'Cornelia,' by Cavelier, contributed by the Imperial government. These works rise to the majesty and power befitting historic sculpture. Though directly Roman in cast of drapery, the treatment is large and generic, giving to these marbles, as it were, a life beyond life, that shall endure like to the characters which history hands down, through the accident of time and each change of fashion. 'Nyssia at the Bath,' by Aizelin, and 'Diana Reposing,' by Clesinger, are also works of a first-rate order—classic, as we have shown all highest sculpture must be, so far as the classic was the absolute truth for all ages—and yet French in manner, inasmuch as all vital creations must be impressed with positive nationality—and withal original, because while eclectic by virtue of a wise selection of excellencies belonging to other schools, these creations, like others before mentioned, assert an individuality boldly independent. In conclusion, a simple figure, 'Edward VI.,' by Baron de Triqueti, may be mentioned, were it only for the sake of contrast with the styles already designated. Triqueti, we believe, has been already known for his adaptations of mediæval sculpture to modern times. Gothic forms, confessedly rude, and often in direct violation of discovered truths, which in these days can no longer be contravened with impunity, have been, by our Gothic revivalists, far too blindly and slavishly reproduced. Gothic sculpture, if it is not to prove a snare to our present practice, must, as we have shown with classic, not be so much copied as transformed. What is free, what is vigorous, all that is simple and earnest in Gothic figures, are still rightly taken as our exemplars. That which is ungainly must be forsaken. Triqueti in this portrait statue of 'Edward VI.' has happily hit on the just mean; indeed, his

treatment is so unrestrained by conventionalism of any kind, that the figure is little else than simple nature dressed in picturesque garb.

Did space permit, it were interesting to trace more at large and with greater detail the distinguishing characteristics of the French school of sculpture, to show how closely it is allied to its sister school of painting, to point out how both painting and sculpture have reproduced the history and the literature, and reflected the manners, of the nation. We have said enough, however, to indicate the leading outlines of the subject.

The STATUARY OF BELGIUM has been closely allied to that of France, but is of constitution less robust. Kessels's 'Discobolus hurling the Discus,' was the most true and healthful contribution to the International Exhibition from Brussels. The 'Group representing a scene at the Deluge,' by the same sculptor, though sketchy and somewhat rude, is both simple and tragic in the telling of the story, and thoroughly independent in thought and treatment. The other works by which the school of Belgium was represented were imbued with the sentiment belonging to the style of the romantic, and won proportionably on popular favour. 'The Angel of Evil,' by Joseph Geefs, is a devil sick, and so far a saint: the sting of Satan is taken out—the demon, gentle and languid, is almost sentimental and romantic, and has none of the muscle by which Michael Angelo would have made a hero sublime. 'The Lion in Love,' by William Geefs, the brother of the preceding, exhibited in Paris, is, says Edmond

JEPHTHAH'S DAUGHTER.
(J. MOZIER.)

About, in his "Voyage a travers L'Exposition des Beaux-Arts," in 1855, " a pretty

THE INTERNATIONAL EXHIBITION.

group, belonging to an elegant style of sculpture, but cut and polished to excess." A bronze 'Victor,' by Theodore and Jean Geefs, in the late Exhibition in London, though a striking figure, was muscle without power, and rose but to the dignity of the flabby heroic. The sugared sentiment of the school found, however, its most dainty and delicious effusion in Fraikin's 'Venus Anadyomene,' a lovely phantom of delight—indeed, the goddess of beauty wafted across the sea, as in a well-known picture by Botticelli, in Florence. It has been said of Fraikin, the author of this work, that " he has the same luxurious appreciation of feminine beauty, and the same power of producing it with his chisel, that Etty had with his pencil," a power, let us add, of more besetting danger to a sculptor than to a painter. The directly naturalistic style of portraiture was upheld by Tuerlinckx's 'Statue of Margaret of Austria,' certainly one of the most signal and successful examples of the realistic school in the Exhibition. In conclusion, the reader will infer from the general tone of these criticisms that Belgian sculpture occupies an inferior position to Belgian painting.

The SCHOOL OF GERMANY can boast of great names, renowned in the annals both of the dead and of the living. Dannecker was the contemporary of Canova, and the mission of the German, like that of the Italian, was to amend the mannerism of the eighteenth century, and to adapt the sternness of the classic style to the yielding romance of modern times. 'Ariadne on the Panther,' the masterpiece of this German revival, is

SATAN.
(C. CORTI.)

every line, in motive the very personification of poetry, this work has rightly gained the applause of Europe. Dannecker died at a serene old age, in the year 1841. Schwanthaler, who belonged to the succeeding generation, the sculptor of the colossal 'Bavaria,' and the facile modeller of those thousand and one figures which adorn the pediments, palaces, and streets of Munich, was of genius more swift in growth and more rapid in decay. He died in 1848, at the comparatively early age of forty-seven, worn out by his labours. His invention, like that of the American Crawford in Rome, was inexhaustible, but he wanted the power of maturing a first conception into detailed completeness. The fame which his works enjoyed among his contemporaries will not be confirmed by posterity. Schwanthaler gathered around him a multitude of scholars, fired by his genius and enticed by the tempting facility of his practice. The school of Berlin like that of Munich, is illustrious in its chief sculptor. Rauch, no less than Dannecker and Schwanthaler, has won a universal reputation. Like our English Gibson, this renowned Prussian sculptor was a pupil both of Canova and Thorwaldsen, and thus the historic pedigree of his style has noble root. Rauch's well-known 'Victories' give him rank among artists of imagination, but his fame perhaps chiefly rests upon his portrait busts and monumental statues, of which the memorial to Frederick the Great, in Berlin, is sufficient surety of the artist's immortality. A reduced bronze copy of this grand equestrian monument was

sent to the International Exhibition. It may be worthy of passing remark that, like Marochetti's composition in honour of Charles Albert, this no less complex arrangement by Rauch is made to embrace styles naturalistic and real, costumes classic and modern—an experiment, though perilous, not unsuccessful in its issue. In conclusion, the following contributions may demand passing notice :—' Jason and Medea,' by Kaehssmann, and 'Mars, Venus, and Cupid,' by Kissling, both sent by the Emperor of Austria, and alike remarkable as signal and servile examples of the Canova school. Carl Cauer's ' Hector and Andromache' must fall under the same category. Engel, the Hungarian sculptor, who won high honour in the International Exhibition of 1851, sent to that of 1862 a group, 'Amore Rapito,' skilfully composed for harmony of line. Hähnel, a pupil of Schwanthaler, was represented by his model for the Wellington monument, to which had been adjudicated a prize in the London competition; and Rietschel, the pupil of Rauch, by several of the basreliefs which gained him reputation. On the whole, the schools of German sculpture may be pronounced careful in study, but somewhat wanting in fire and originality.

The SCHOOLS OF THE NORTH—of Scandinavia, and countries bordering on the Baltic—possess, as might be anticipated, a vigorous individuality. Thorwaldsen, born at Copenhagen in the year 1770, is of this sculpture of high latitudes the father and the chief. The last exhibition, containing many of his famed productions, the 'Jason,' the 'Mercury,' and ' Alexander's Triumph,' was a witness to

VENUS.
(C. A. FRAIKIN.)

sufficient to secure the immortality of its author. Boldly original, carefully studied in

PUCK.
(MISS HOSMER.)

the artist's immortality. A reduced bronze copy of this grand equestrian monument was

his genius. His style, founded on the classic, was yet closely moulded from the life. His

works, with few exceptions, such as certain careless passages in his great frieze, show that

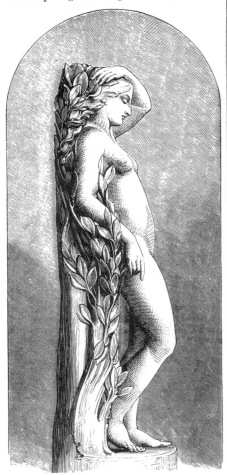

DAPHNE.
(M. WOOD.)

maturity of study, that deliberate mastery of his subject, which, as we have already said, are specially called for in the sculptor's art. Like the German Schwanthaler, he had indeed an invention copious and inexhaustible, but unlike to the sculptor of Munich, and others of the same prolific genius crowded with commissions, he never hastily extemporised in clay, but studied laboriously both the masses and the details of every figure. The result is that his thoughts will not, as the shadow of a dream or the flash of a vision, melt into thin air, but endure through all time as great ideas graven on tables of stone. Among the figures which last year once again came before our notice, we would specially point out the 'Mercury,' simple as the purest antique, truthful as nature herself, and for execution admirable in the precision of pronounced muscle, and the purpose dominant in every detail. Jerichau, also a Dane, belongs to the same school. His noble group 'Hercules and Hebe,' a clever adaptation of the 'Torso Belvedere' and the 'Venus of Milo,' created a furore when first brought before the world, and obtained the patronage of the King of Denmark. Jerichau's 'Girls surprised while Bathing,' the 'Venus,' by Thorwaldsen, and the 'Flora' of Bissen, may be taken as examples of the treatment of female forms which prevails in these northern schools: the latitude being chilly, the temperament is possibly more chaste. And yet another luminary has risen above the wintry horizon—Jean Petter Molin, a Swede, the sculptor of 'The Grapplers,' certainly to be ranked as one of the most original groups in

the late Exhibition. These figures are directly individual and naturalistic, just as the Discoboli and the Gladiators among the Greeks and the Romans. The action is intense, the motion of dashing arm and springing foot rapid as a flash of light, each nerve and muscle is strung to utmost tension, or swells with bursting passion. It is indeed a work of life and nature, telling us that the old Norse spirit, which was ever eager to rush to arms, is ready still to rise for justice or revenge. The valour of the Sea-kings has indeed begotten an art manly and bold.

The schools of ENGLISH AND AMERICAN SCULPTURE remain to be noticed. The English, compared with the contemporary styles established on the Continent, is marked by distinctive characteristics of its own. It does not possess all the soft fascination of the Italian—it is not so firmly pronounced in the modelling as the French—it is scarcely so studied in the treatment of drapery as the German. In short, to quote the words of Mrs. Jameson, "in the English school, with some brilliant exceptions, the general faults are negative—a want of largeness of style, a poverty of invention, a want of fire and vigour in conception and of elegance in execution." On the other hand, our English artists are in the possession of merits which tend to restore the balance in their favour. Their works are in expression and sentiment deep and pure, in incident pleasing and simple, and in execution, if not bold, at

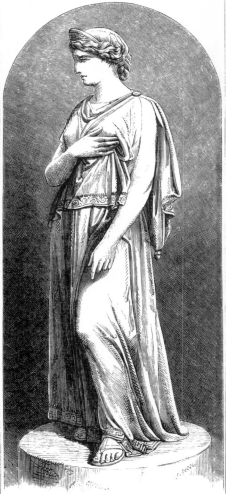

HERMIONE.
(J. DURHAM.)

least careful. American sculpture, subject of course to individual exceptions, admits of

the same general description. Indeed, when we take into account that America is a

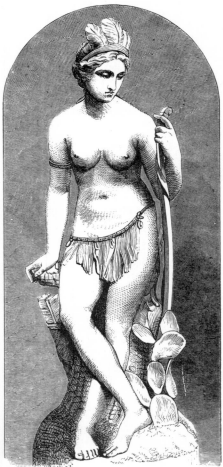

AN INDIAN GIRL.
(MOZIER.)

country comparatively still in her youth, it is surprising that the plastic arts of her people, not marred by greater crudities, should have already approached so nearly to maturity. Transatlantic artists, it is well known, have produced works which would prove an honour to any nation; in fact, throughout the short history of American sculpture, the evil has been not so much want of skill in the artist as want of knowledge in the patron. No school can be expected to advance when rewards fall to the lot of the charlatan, and when clever stonemasons, possessed of pushing trading ability, usurp the place of the true artist.

The re-birth of our English sculpture may be traced to classic parentage. The French style of Roubilliac, inflated and rampant, was fortunately displaced by a manner which, for moderation, is more consonant with the sobriety of our national character. Since the time of Banks, Bacon, and Flaxman, we have not, with few exceptions, been put to the humiliation of borrowing from the Continent the genius we might require. For the last century we have possessed a native school which, dissevering itself from the mongrel crew that had taken root in the land, sought, as we have said, new and more legitimate descent from classic times. The antique spirit which Banks infused into his works was the admiration of Reynolds, who ever strove to restore, both to the arts of painting and sculpture, their ancient dignity. Bacon's statue of 'Mars,' which obtained the gold medal from the Society of Arts, and nearly a hundred years later was again submitted to public scrutiny in the late Interna-

tional Exhibition, is an express example of that academic style which, during the last half of the eighteenth century, had grown in the ascendance. And then, coming to John Flaxman, who illustrated Homer and Æschylus after the manner of the Greek Vases, and modelled the 'Shield of Achilles,' lent by her Majesty to the Exhibition, we have the consummated type of that class of artists who survive even to the present day—men who, for the most part fixing their residence in Rome, devoutly drink of the Egerian spring, and seek to restore our modern sculpture to the ideal truth and beauty found in the master works of Greece and Rome.

The 'Venus,' the 'Cupid,' and the 'Pandora,' by Mr. Gibson, seen last year in appropriate combination with a Greek temple, figures avowedly fashioned after the spirit and manner of the antique, may be taken as among the most studious and successful examples of the school to which they belong. Of these three several conceptions of beauty, love, and destiny, the 'Cupid' is the masterwork; so happily, indeed, combining Greek traditions with the truth

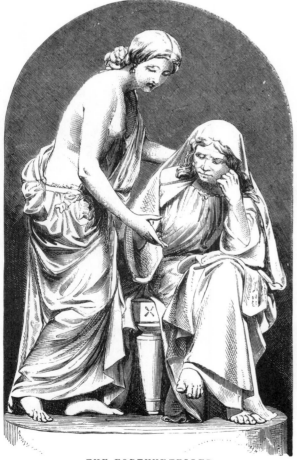

of nature and the free and graceful motion

of life, as to reconcile the severity of the antique with the more tender sentiment in which modern Art is expected to indulge. The divinity, however, that obtained on many grounds chief notice was the 'Venus,' with golden apple in hand and tinted as ivory. Sculptors, when they reach a European reputation, naturally wish to give some one decisive proof of the lofty ideal to which their imaginations can soar; they desire to gather into one figure the scattered forms of beauty and of love which perhaps for long have haunted the fancy: and to a statue possessed of these attributes is ascribed, as is most fit, the name of Venus. Thus, in modern times, there is the Venus of Canova and the Venus of Thorwaldsen; and from the classic age have come down to us the Venus of Milo, the Venus of the Capitol, and the Venus de Medici—all consummated types of female loveliness. In a sphere such as this, where the choice of examples is as wide as tastes are varied, criticism is in danger of falling into the mere expression of personal predilections or antipathies. Suffice it to say, that this creation by Mr. Gibson, if not among the

THE SOUND OF THE SHELL.
(A. MUNRO.)

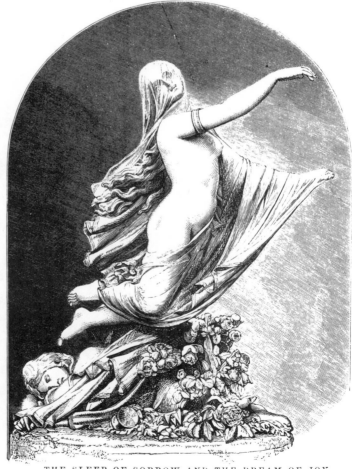

THE FORTUNE-TELLER.
(L. GUGLIELMI.)

THE SLEEP OF SORROW AND THE DREAM OF JOY.
(R. MONTI.)

most successful of his works, may still | be admitted to the assembly of the gods, | and that the apple which has just been re-

ceived from the hands of Paris, was fairly won.

THE READING GIRL.
(P. MAGNI.)

conditions of bas-relief as little else than bald and artificial. Thus it was 'The Overthrow of Pharaoh' failed in winning at the International Exhibition that applause which its rare merits deserved. We feel, however, persuaded that when this and its companion compositions shall reach their final destination, and form part of the monument to be erected not far from Edinburgh, justice, though tardy, and coming indeed for the artist too late, will at last be done to the vigour, the originality, and the mature study displayed by these exceptional works.

That the schools of British and American sculpture trace, as we have said, their parentage back to the classic, will be still more evident by a simple enumeration of the artists whose works more or less evince the study of the antique marbles. Cardwell, Theed, Thrupp, Lough, Mozier, Durham, Ives, Miss Hosmer, and others, are each known, at least by some one individual figure which recalls the simplicity, the symmetry, the costume, or the calm, unimpassioned mien of the classic manner. 'Zenobia Captive,' by Miss Hosmer, is a figure of command, with an elaborate cast of classic drapery. 'The Pandora,' by Mr. Ives, exhibited like many other American works in the Roman Court, combines the independent study of nature with the severity and the pensive thought habitual to the antique. 'Hermione,' by Durham, robed as a Greek statue of modesty, with hand resting on her breast, seems to say—

> "My past life
> Hath been as continent, as chaste, as true,
> As I am now unhappy!"

'Jephthah's Daughter' and 'Esther,' are perhaps the most artistic among the works of Mr. Mozier. 'The Wept of the Wishton-Wish,' by the same artist, is, in the peculiarly

eccentric cast of the eye, a direct violation

FIRST FOOTSTEPS.
(P. MAGNI.)

With heartfelt regret we have to record the untimely death of the sculptor of the grand bas-relief 'The Overthrow of Pharaoh in the Red Sea.' Alfred Gatley we knew well, and seldom has it been our fortune to meet with a man of higher truth and honour, or with an artist so single in his devotion to his Art. The two great works by which he will be remembered, 'the Pharaoh,' sent to the late Exhibition, and its companion bas-relief, 'the Song of Miriam,' awaiting in the artist's studio at Rome final transfer into marble, are marked by characteristics rarely found in modern sculpture. Alfred Gatley had a mind of singular independence, which in these arduous commissions, obtained expression in figures bold and original. The style he chose admitted of no facile compromise of the classic with the pictorial. It descended not to seek an easily-purchased popularity by softly-blended forms, after the manner of the romantic. The school to which he belonged was stern and strict. Beauty entered only at the call of power, and grace gave place to energy. The English public, accustomed to the prettiness of smaller treatment, simply failed to comprehend the largeness of this manner. The sharp precision of the execution was to the untutored eye merely hard, the historic truth to national type and costume seemed nothing less than archaic, and the severe compliance with the stringent

DEFENDING THE PASS.
(G. HALSE.)

of that equanimity which Winckelmann, in common with all writers, has laid down as inherent to the noble art of sculpture. "There are," says Sir Joshua Reynolds in his tenth Discourse, "many petty excellencies which the painter attains with ease, but which are impracticable in sculpture; and which, even if it could accomplish them, would add nothing to the true value and dignity of the work." 'Milo attacked by a Wolf,' by Mr. Lough, a favourite subject, because giving opportunity for intense muscular display, belongs to that heroic school of which the statues of Hercules and the works of Michael Angelo are examples. For the 'Comus,' a noble figure by the same artist, the Apollo Belvedere seems to have stood as the model. The memorial figure of Henry Hallam, by Mr. Theed, through the skilful treatment of academic robes, avoids the sculpturesque incongruities of modern costume. 'The Nymph and Cupid' and 'The Return of the Prodigal Son,' by the same artist, are all within the strict limits prescribed by ancient practice, with, however, a certain touch of common nature, and an unbending towards domestic affection, which serve to bring cold marble down from her chilly heights into the warmer sphere of human sympathies. In the 'Bard,' also by Mr. Theed, the hard stone seems inflated under a tempest of fiercest inspiration. And then coming to Mr. Caldwell's 'Diana

about to Bathe,' one of the most delicious figures in the whole Exhibition, we find the severity of the classic relaxing into softest sentiment; the sternness which is often taken as the too exclusive attribute of the Greek here melts into tenderness, so that while within the precincts of the ancient gods, we already approach the confines of modern and mundane romance. Thus, in the territories of the imagination, like even in the realms given up to dreams, do forms melt softly the one into the other, and schools, supposed to be antagonistic, are seen to mingle till they merge distinctive characteristics in blended outline and unison of expression.

The school of romance which has found votaries among English and American sculptors is emphatically the offspring of modern times. Round about a Grecian goddess was an awful presence and a grandeur inaccessible. Even Venus was deemed by the ancients something more than mortal, for we are told that love with the philosophers and artists of Greece became the associate of divine wisdom. Juno we all know as crowned in regal pride, an imperious queen of stern brow, to govern by a nod. Amazons, again, inspired dread by strength of arm, and were singularly obdurate to the approaches of affection. Now it must be confessed that our present tastes incline less to the goddess or the Amazon than to the yielding nymph, till at length we descend to the

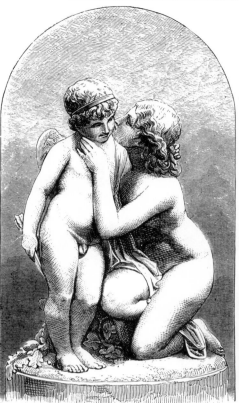

NYMPH AND CUPID.
(E. MÜLLER.)

"phantom of delight" pictured by Wordsworth—

"A creature not too bright or good
For human nature's daily food;
For transient sorrows, simple wiles,
Praise, blame, love, kisses, tears and smiles."

A change indeed came over the spirit of our Art, and sculpture, like unto philosophy, has been brought from heaven to earth; and thereby it is made, let us frankly admit, to approach all the more closely to human sympathy. Tenderness of affection, or winning grace, and the transport of beauty, all go to fashion the school of our modern romance, a style which, though not suited to a Greek temple or a mediæval church, is yet admirably fitting for a *salon* or a boudoir.

Richard Wyatt, born in London in 1795, and for nearly thirty years a dweller in Rome—a man of retired and tranquil life, and said to have been of manners gentle and amiable—was for us the genius of romantic sculpture. What Canova had been for Italy, what Pradier became for France, Wyatt was for England. His works sent to the last Exhibition—'Ino and Bacchus,' 'Nymph and Cupid,' and 'Girl Bathing'—were delicate in sentiment, gracefully gentle in flowing line, and exquisitely soft in execution. The 'Ino and Bacchus' of Mr. Foley, among the most poetic and rapturous of works executed in our own times, and here noteworthy as a facile rendering of a Greek myth, may be compared with Wyatt's treatment of the same theme. Foley expresses himself with impulse and eloquence; Wyatt's utterance was somewhat more tender and heartfelt. Baily—often, and not without reason, termed the poet of our English sculptors, for he knows how to impress marble with melody, till it speaks in the sweet cadence of love and beauty—is, like Wyatt, famed for

his female figures. His 'Eve at the Fountain' hath, in the words of Milton,

"That innocence and virgin modesty,
That virtue and the consciousness of worth,
Which would be woo'd, and, not unsought, be won."

The severity in which early sculpture took its rise has in this lovely figure—one, indeed, of the most delectable manifestations of our modern manner—passed into soft womanly beauty, soul-like and sensitive. This gentle sentiment, from which Milton in his melting moments was not free, gushes forth in still more copious streams throughout the writings of our other national poets. J. S. Westmacott's statue of 'The Peri,' who, Tom Moore tells us,

"At the gate
Of Eden stood disconsolate,"

may serve as a favourable example of the delicious sentimentality which is now suffused into the marble illustrations of our popular lyrics and dramas. Lawlor's 'Titania,' and Calder Marshall's 'Ophelia,' fall under the same class—admirable works, yet infected with a certain melo-dramatic taint—undoubtedly essentially clever, even as a telling piece upon the stage, and, withal, decidedly agreeable—much more pleasing, indeed, than the staid severe classic, or that stiff mediæval manner which, out of death and the grave, was but imperfectly emancipated into life. Calder Marshall's 'Sabrina,' and 'Dancing Girl reposing,' are exquisite and well-known examples of the same romantic school. To these may be added 'The Day-Dream,' by MacDowell, 'The Startled Nymph,' by E. G. Papworth, Jun., 'Titania Asleep,' by F. M. Miller, and 'Elaine,'

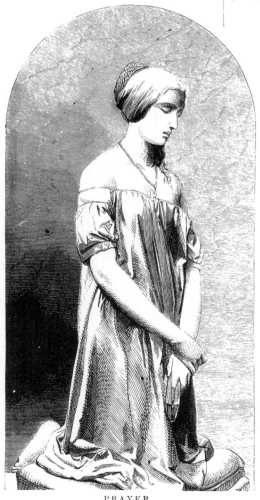

PRAYER.
(V. VELA.)

level of simple humanity, and embrace the

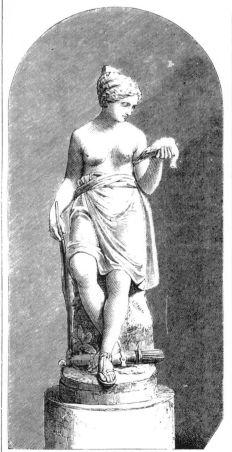

NYMPH OF DIANA.
(J. ALBERTONI.)

by Shakespeare Wood—each, more or less,

after its kind a favourable instance of our poetic school of sculpture. Miss Hosmer's clever impersonation of mischief-making little 'Puck,' is in style more individual and real. True to the life, it is probably the best reading which the character has yet received. 'Egeria,' by Foley, 'Rhodope,' by Fuller, and 'Daphne,' by Marshall Wood, severally betray the modern spirit, as speaking from beneath the mask of a classic subject. 'Egeria' is noble, combining beauty with power—a figure specially worthy of note, because it does not content itself with those smooth generalities which are the bane of our English school of romance, but is, on the contrary, carefully studied and firmly pronounced in the undulating detail of swelling muscle. Knowledge in sculpture, no less than in philosophy, constitutes power. We reserve for the last a figure which may serve as the very image of modern romance—the 'Daphne' of Mr. Marshall Wood—a subject also rendered by Bernini, as must be well remembered by all visitors to the Villa Borghese—yet treated by the meretricious Italian how differently! The 'Daphne' of Mr. Wood is indeed so beautiful, she could scarcely have escaped the love of Apollo; we see her fall into gentle sleep, as the olive springing at her feet is about to embrace her delicate form, and thus she passes through the gates of death into the life of nature, and is at peace.

Naturalistic or picturesque sculpture obtained in the first International Exhibition its easy and noisy triumph over the multitude by a work common in incident, called 'The Unhappy Child.' A naughty little boy in a fit of temper has broken his drum. The drumstick is actually thrust through parchment and wood, and the boy is kicking and crying in towering passion. We need scarcely add that at the sight every mother, and child, and nursemaid, was in high delight. Such subjects are always popular. Mrs. Thornycroft, in two pretty works worthy of all praise, 'The Skipping Girl' and 'The Knitting Girl,' is happy as usual in the treatment of graphic incident. E. G. Papworth, in 'The Young Emigrant' and 'The Young Shrimper,' also becomes as pleasing as he is picturesque. J. Durham's

'Go to Sleep'—a boy at bed-time with a pet dog in lap, exclaiming, as would seem, "hush!" "sleep!"—is a work simple and charming; so likewise are always the children of Mr. Munro, of which 'The Sound of the Shell'—two children wistfully listen-

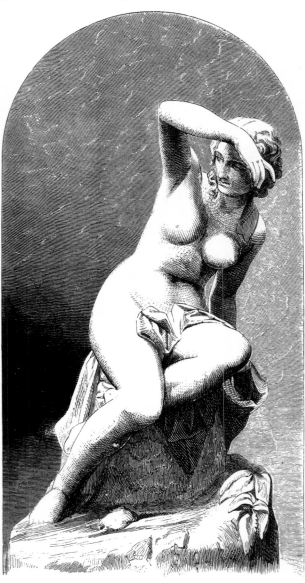

LA BAGNANTI.
(TANTARDINI.)

ing to the moan of the sea echoed from the caverns of a shell—affords a winning example. The romantic and even the classic styles of which we have previously spoken, may be transformed into the picturesque merely by costume, as when Mr. Spence threw a Scottish plaid around the head of his 'Highland Mary;' and again when the same artist, in his effective group, 'The Finding of Moses,' enters upon the circumstantial detail of head-dress, necklace, and cradle. This high elaboration, to which several of our artists in marble are now tempted, carries sculpture into that Pre-Raphaelite finish that has long become the vogue in the sister art of painting.

There is a naturalism, not picturesque, which is simply the noblest nature — nature large, vigorous, manly. This is the naturalism that in all ages of the world has been strong to break the barriers of tradition, which has overleaped the narrow limits of the schools, and entered upon the largeness and the liberty of a world created free to choose the evil or the good. This was the naturalism known to the ancient Greeks, who, though subject to the teachings of the still more ancient Egyptians, owed, above all, a sacred allegiance to those living forms around them of beauty and of power which each day moved to love or awed through fear. In our time few indeed are the creations that can claim this noble birthright. In England we might quote 'The Eagle Slayer,' with some other works; from the catalogue of American sculpture we may be expected to name 'The Sibyl' and 'The Greek Slave.' And then we have done. This consolation, however, remains, that though man's works be finite, nature is still infinite, craving from the hand of the artist wide and perfect fruition. The yet unhewn marble quarries of Carrara hold imprisoned forms of unknown beauty, which only await the sculptor's chisel to set them free.

In this our review we have sought to give to each separate style its due rank in the battle of Art, yet whatever may be the issue of the petty conflicts now waging, let us always for our solace remember there is an art which, like nature herself, will, notwithstanding all change, live on in progressive development.

1862